VISUAL JUDAISM IN LATE ANTIQUITY

VISUAL JUDAISM

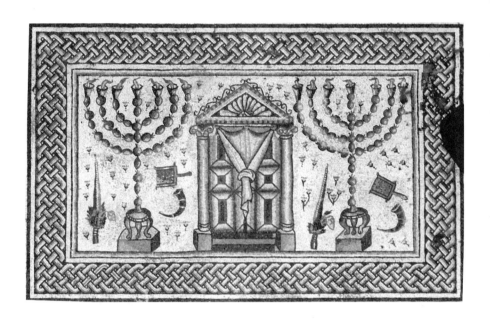

IN LATE ANTIQUITY

Historical Contexts of Jewish Art

LEE I. LEVINE

Yale University Press | New Haven and London

Published with assistance from the Mary Cady Tew Memorial Fund.

yalebooks.com/art

Designed by Barbara E. Williams
Set in Espinosa Nova type by BW&A Books, Inc.
Printed in China by Regent Publishing Services Ltd.

Library of Congress Cataloging-in-Publication Data
Levine, Lee I.
 Visual Judaism in late antiquity : historical contexts of Jewish art / Lee I. Levine.
 p. cm.
 Includes bibliographical references and index.
 ISBN 978-0-300-10089-1 (cloth : alk. paper) 1. Jewish art and symbolism.
2. Middle East—Civilization—to 622. I. Title.
 N5460.L48 2012
 704.9'489609—dc23 2012003770

A catalogue record for this book is available from the British Library.

This paper meets the requirements of ANSI/NISO Z39.48-1992 (Permanence of Paper).

10 9 8 7 6 5 4 3 2 1

Frontispiece: Fig. 124
Jacket illustrations: (*front*) Mosaic floor featuring zodiac motif with Helios holding
sphere and staff at its center, Ḥammat Tiberias synagogue; (*back*) Wall painting of Moses
being drawn from the Nile by Pharaoh's daughter, Dura Europos synagogue.

In loving memory of
my brother-in-law, Barry J. Karp (1937–2007)
and my father-in-law, Irving K. Karp (1911–2011)

CONTENTS

PREFACE

T HE IDEA of addressing the topic of Jewish art in antiquity crystallized following the publication of my book *The Ancient Synagogue: The First Thousand Years* (New Haven: Yale University Press, 2000; 2nd rev. ed., 2005). While preparing that volume, I was somewhat stymied by the challenge of writing a chapter on synagogue art, not so much because of the plethora of views on almost every aspect of the topic as because of the realization that this field is replete with wideranging and, not infrequently, problematic methodological approaches. Symptomatic in this regard is the extensive variety of sources used to support a given theory, at times invoking literary material from as much as a millennium earlier to almost a millennium after the appearance of a particular depiction. Given this situation, I settled for writing a chapter that focused on the study of synagogue art from a methodological perspective, delineating the main issues and what could be said responsibly about each. Although this was obviously a compromise of sorts, it was a viable solution that kept me from veering too far off the volume's course (and timetable).

However, the need to address this topic continued to engage my attention, and my subsequent exploration of the various issues related to Jewish art in Late Antiquity was greatly facilitated by the research I conducted during my sabbaticals (at Harvard University and the Center for Judaic Studies at the University of Pennsylvania), teaching courses and seminars on the subject (at the Hebrew University of Jerusalem, Harvard University, and the Jewish Theological Seminary), and giving lectures in a variety of academic institutions (the Herbert D. Katz Center for Judaic Studies at the University of Pennsylvania, Princeton University, Yale University, the University of California at Berkeley, the University of North Carolina in Greensboro, the University of Texas at Austin, Rice University, and McMaster University) and at numerous conferences in Israel and the United States. My thoughts on various aspects of the overall topic were further refined while writing a number of articles and editing, inter alia, a collection of studies on the subject together with Z. Weiss: *From Dura to Sepphoris: Studies in Jewish Art and Society in Late Antiquity* (Ann Arbor, Mich.: Journal of Roman Archaeology, 2000). The present volume is thus the product of a decade of thought, research, and fruitful conversations with many colleagues.

In the course of preparing this book, I have enjoyed the support of a number of institutions and academic frameworks. My sabbatical stays at Harvard and the University of Pennsylvania, as well as several summer sojourns at the Jewish Theological Seminary, have afforded me opportunities to make substantial progress in my research. Throughout my forty-year academic career at the Hebrew University of Jerusalem, I have benefited from the institution's support and network of academic services, which have facilitated my work immeasurably.

I am most grateful to many colleagues who have commented on various chapters of this manuscript, and it is my privilege and pleasure to thank them for their graciousness and innumerable insightful remarks and suggestions: Professors Ra'anan S. Boustan, Richard Kalmin, Hayim Lapin, David Levine, Peter Machinist, Jodi Magness, Amihai Mazar, Ezra Mendelsohn, Shalom Sabar, Daniel R. Schwartz, Joshua J. Schwartz, Seth Schwartz, Mark S. Smith, Jeffrey H. Tigay, Christoph Uehlinger, Zeev Weiss, and Ziony Zevit.

I am extremely indebted to Ḥani Davis for her meticulous and discerning reading of the manuscript and for her superb editing skills. Her thoughtful suggestions have been incorporated throughout the book. Finally, I would like to acknowledge Yale University Press's commitment to publish this volume and extend my gratitude to Michelle Komie, Heidi Downey, Sarah Henry, Miranda Ottewell, and Barbara Williams for their efforts in bringing this volume to fruition.

LEE I. LEVINE

1. INTRODUCTION

Ancient Jewish Art: A Century of Research

THE STUDY OF ancient Jewish art is a relatively new field, fueled by the ongoing archaeological discoveries beginning in the late nineteenth and early twentieth centuries.[1] The first serious effort in this direction focused on the architectural and artistic remains of many Galilean synagogues. From 1905 to 1907, Heinrich Kohl and Carl Watzinger conducted a detailed survey of eleven such structures, the results of which are recorded in their *Antike Synagogen in Galilaea* (1916), a volume that remains indispensable to this day.

The first organized excavations took place immediately after World War I. The synagogue at Na'aran was discovered after a Turkish shell exploded near British lines,[2] and in 1921 the Jewish Palestine Exploration Society (later renamed the Israel Exploration Society) launched its first project — the excavation of an ancient synagogue in Tiberias.[3]

About a decade later, a slew of excavations brought to light previously unimaginable evidence of a flourishing Jewish artistic scene in Late Antiquity. The 1928–29 discoveries of synagogues at Bet Alpha, Gerasa, and Aegina, and the magnificent remains from the Dura Europos synagogue in Syria (1932), highlighted this development. These were soon accompanied in rapid succession by the excavations of synagogues in Stobi (Macedonia), Apamea (Syria), Ḥammat Gader, Ḥuseifa, Eshtemoa, and Jericho, culminating in the discovery of the Bet She'arim necropolis in the Lower Galilee in 1936.

A major milestone in the study of Jewish art was the publication of Erwin R. Goodenough's monumental *Jewish Symbols in the Greco-Roman Period* (1953–68), which provided conclusive evidence for an extensive and varied Jewish art in Pal-

1. See, for example, the artwork first discovered in the synagogues of Naro/Ḥammam Lif (North Africa), Priene (Asia Minor), and Elche (Spain).

2. See chap. 11.

3. The first volumes devoted to the Jewish catacombs of Rome also appeared around this time (1919); see Müller, *Die jüdische Katakombe am Monteverde*; Müller and Bees, *Die Inschriften der jüdischen Katakombe am Monteverde*.

estine and the Diaspora in the Late Roman and Early Byzantine eras. Not only did this magnum opus bring together a wealth of examples of ancient Jewish art that few could have imagined beforehand, but Goodenough's theory regarding the deeper meaning of this art (attesting to a pervasive Jewish mysticism independent of and opposed to a marginal rabbinic culture) also generated much discussion, even though it was almost totally rejected by the scholarly community.[4]

Consequently, there was a profound irony in Goodenough's efforts; although his grand theory in the service of which all the material in these volumes had been mustered was almost universally rejected, it was precisely this vast array of evidence that made a lasting impression on the scholarly world. Moreover, in ways he could not foresee at the time, Goodenough's work has had a profound effect not only on the study of Jewish art but also on our understanding of the parameters of Jewish culture and religion in antiquity. One of the implications of his theory was that rabbinic culture had a limited impact on the Jews of Late Antiquity and that Jewish art did not reflect the world of the sages. Although his theory won few adherents, the issues he raised have remained at the forefront of Jewish studies ever since.

As a result of a seemingly never-ending chain of discoveries in subsequent years, the amount of raw data and accompanying scholarly studies has increased exponentially. The magnificent mosaic floor in the Ḥammat Tiberias synagogue was discovered in 1961, as was the synagogue in Ostia, Rome's port; the next year saw the excavation of the imposing Sardis synagogue, followed by other Diaspora synagogues since then. In the wake of the 1967 war in Israel, intensive excavations were mounted in the southern Hebron and Golan regions, and all told twenty-five synagogues have been discovered in the latter, only three of which were known beforehand. In 1993 a stunning discovery in Sepphoris revealed an imposing synagogue mosaic that has stimulated research on a variety of Jewish art-historical subjects.[5]

Most studies initially focused on excavation reports and analyses of significant archaeological finds, and these publications, of varying length and detail, were issued regularly. By far the most riveting discovery has been that of the Dura frescoes, which attracted almost immediate attention and generated a wealth of studies throughout the 1930s and 1940s,[6] culminating in Carl H. Kraeling's official and monumental final report (1956) as well as volumes 9–11 of Goodenough's *Jewish Symbols* (1964). Cecil Roth's volume on Jewish art and architecture (1961; subsequently re-

4. M. Smith, "Goodenough's 'Jewish Symbols' in Retrospect," 53–68.

5. See chap. 13.

6. See, e.g., du Mesnil de Buisson, *Les peintures de la synagogue de Doura-Europos*; Sonne, "Paintings of the Dura Synagogue"; Sukenik, *Synagogue of Dura Europos*; Wischnitzer, *Messianic Theme*; Kraeling, *The Synagogue*, 346–48; Gutmann, "Early Synagogue and Jewish Catacomb Art," esp. 1322–24.

issued by Bezalel Narkiss in 1971) offers a survey by renowned experts covering the entire span of Jewish history.[7]

The last half of the twentieth century witnessed an increase in the pace of scholarly activity, owing in part to the formalization of the study of Jewish art and archaeology in institutions of higher learning, particularly in Israel. Foremost among these is the Hebrew University of Jerusalem, where these disciplines became a central component of the Art History Department and the Institute of Archaeology, whose graduates eventually created similar programs in other major Israeli universities (Tel Aviv, Haifa, Bar Ilan, and Ben Gurion) and colleges. Additional expressions of this newly emergent emphasis were Leo A. Mayer's pioneering *Bibliography of Jewish Art* (1967) and the Art History Department's founding of the *Journal of Jewish Art* (later renamed *Jewish Art*) in 1974, as well as its establishment of the Center for Jewish Art in 1979 under the leadership of Narkiss. In turn, this flurry of academic activity prompted the organization of international conferences and research projects devoted to Jewish art.

At the same time, other initiatives emerged to facilitate the growing interest in Jewish art and archaeology. The inauguration of the *Israel Exploration Journal* in 1950 provided an important English-language platform for publishing archaeological discoveries in Israel, and in the 1960s the Israel Exploration Society became an active player in archaeological endeavors, sponsoring annual archaeological conferences that attracted thousands and publishing archaeological reports as well as the highly regarded Eretz-Israel series, with Hebrew and English sections. At this time, the society also began publishing *Qadmoniot,* a popular Hebrew archaeological journal that provided an accessible and attractive format for disseminating information about archaeological discoveries via studies and surveys, as well as lively discussions and debates. Concurrently, the Israel Antiquities Authority began to publish short excavation reports (*Ḥadashot Arkheologiyot* in Hebrew and *Excavations and Surveys in Israel* in English), as well as a Hebrew and English monograph series ('Atiqot). These efforts were crucial in raising public awareness of and interest in the archaeology of Israel as well as in attracting a younger generation of scholars to the field.

Among Israeli academicians, Michael Avi-Yonah's contributions to ancient Jewish studies in general and to Jewish art in particular are unmatched. His scholarly interests ranged far and wide, and *The Jews of Palestine: A Political History from the Bar Kokhba War to the Arab Conquest,* which he first wrote in Hebrew in 1946, remains a basic text to this day. Similarly, his 1966 volume on historical geography (*The Holy Land: From the Persian to the Arab Conquests, 536 B.C. to A.D. 640*) has never been superseded.[8] Avi-Yonah was primarily an art historian, and it is to this area that he devoted most of his scholarly efforts, including *Oriental Art in Roman Palestine*

7. Several decades later, a similar comprehensive volume was published by Sed-Rajna, *Jewish Art.*

8. For a complete compilation of over 400 bibliographical entries of Avi-Yonah's writings, see Cassuto Salzmann, "Bibliography of M. Avi-Yonah."

(1961), *The Madaba Mosaic Map* (1954), and *Mosaic Pavements in Palestine* (1932–35), as well as scores of articles on synagogue mosaic floors and artistic motifs, a number of which have been reissued in his *Art in Ancient Palestine*. Avi-Yonah was *primus inter pares* in the study of the Jews and Judaism in the classical period, but nowhere has his contribution been more substantial than in the field of Jewish art, which flourished in no small measure owing to his prolific work.

DEFINING ANCIENT JEWISH ART

The term *art* has been variously defined over the ages and even within any given period. As indicated by the title of this volume, our study will focus on the historical contexts of Jewish art, primarily on mosaics and paintings, and to a more limited extent on architecture and small finds such as coins, seal impressions, and oil lamps. These parameters were not chosen arbitrarily but were determined by the nature of the material finds discovered to date. The fact that almost all such art from Late Antiquity was found in synagogues and cemeteries has governed the scope of this inquiry. Our goal is neither to compile a catalogue of everything that might be considered Jewish art, including works from the purely decorative sphere, nor to address the materials, techniques, and styles used in the creation of this art. Rather, it is to examine the relationship of artistic remains to the cultural, social, and religious contexts of Jewish society in its different historical frameworks. On the one hand, we will investigate what this art tells us about a particular community, and on the other, what the widespread use of specific motifs, or the lack thereof, reveals about the social and cultural horizons of a given community in Late Antiquity.

The above agenda is contingent upon the broader definition of the term *Jewish art,* which has been a source of controversy for generations. Any such definition must take into account the fact that the Jews were not notably creative in their material culture, neither in comparison to other ancient cultures (for instance, those of Egypt, Assyria, Greece, Persia, and Rome) nor in comparison to their own accomplishments in the literary and religious spheres. As a result, creativity in the material realm throughout antiquity has often been measured by the motifs the Jews adopted and adapted as well as by those they rejected. Only in Late Antiquity does a unique and recognizable Jewish art first appear.

While the possible definitions of Jewish art are numerous, we will begin with several contrasting notions. A maximalist approach considers that anything made or used by Jews on a significant scale should be defined as Jewish. Thus, whatever a Jew produces, be it for Jews or non-Jews, or anything used by Jews, be it the product of another Jew or a non-Jew, should be considered Jewish. In this sense, the definition of Jewish art would be similar to that of Etruscan, Greek, or Roman art, and we should then understand the term as referring to the art of the Jewish people.[9]

9. Roth, *Jewish Art*, 19.

A minimalist position, in contrast, posits that only that which is strictly Jewish—that is, an object with a specific and exclusive Jewish association—should be considered Jewish art.[10] By this definition, the representation of a menorah or some other religious symbol would be fitting, but not the zodiac signs, floral and geometric designs, or even biblical scenes—all of which have parallels outside the Jewish fold. In this vein, the definition of Jewish art would be closer to that of Christian and Islamic art, in which religious tradition has played a decisive role in determining what should be included.

However, just as the former definition appears to be too inclusive, so the latter seems overly restrictive. The maximalist position, which is often suggested with regard to modern art, is irrelevant for antiquity, as we know virtually nothing about the artists who produced this art or whether Jewish artisans might have produced art for non-Jews. The minimalist approach, for its part, arbitrarily restricts the realm of creativity, leaving us to consider only particularistic motifs without regard to the overall process of adopting and adapting (as well as rejecting), which can reveal a great deal about the "absorbing" culture's identity, sensitivities, and borderlines.

A third approach seeks a middle ground, whereby all art intended for use in a distinctly Jewish setting, be it a communal Jewish building or some other context that served the wider Jewish community, should be considered Jewish. In Late Antiquity, the premier building that fits such a definition is the synagogue; the art found therein may be considered Jewish because it was intended for the community and almost certainly met with its approval. One might also include Jewish cemeteries, such as Jerusalem's necropolis of the Second Temple period, the Jewish catacombs in Rome, or the Bet She'arim necropolis, since these were religiously and culturally laden funerary sites in which the regnant artistic motifs of the time were invoked.

Admittedly, this definition, too, leaves something to be desired. One may ask, for example, whether the Doric capitals of the Jerusalem Temple were Jewish by virtue of their context on the Temple Mount, or whether the floral designs on a synagogue mosaic floor should be regarded as Jewish art. Does use by a community make such a motif Jewish, or do we regard it merely as a neutral and universal element? Despite such valid questions, most scholars opt for this middle-of-the-road approach, not only owing to its intrinsic merits but also because it affords a wider scope of material to work with when trying to understand the significance of the art associated with Jews in antiquity.

Thus, we propose to designate Jewish art, in the apt formulation of Richard I. Cohen, as that "which reflects the Jewish experience"[11] of the community at large. This would include ritual objects that are exclusively associated with Judaism and biblical motifs representing Jewish historical memories and religious models (even if also used by Christians for their own purposes and with their own interpreta-

10. A. Ovadiah, "Art of the Ancient Synagogues in Israel," 308, 317–18.
11. R. I. Cohen, *Jewish Icons*, 7.

tions). Moreover, the zodiac motif, however foreign in origin, also fits this criterion as it was appropriated by Jews and virtually eschewed by others and thus appears almost exclusively in Jewish religious settings.[12] In addition, all of the above are found in synagogues that were attended and financed by their respective congregations.[13]

It should be pointed out, however, that the above definition applies almost exclusively to Late Antiquity. At this time in particular, the religious profile of Jews, as of other contemporaneous groups (pagans included), assumed great importance in determining self-definition and self-identity. This is not to say, as has been claimed,[14] that the religious component was not important to Israelite and, later, Second Temple Jewish self-identity; earlier, geographical, ethnic, and cultural dimensions were also significant factors.[15] Consequently, in discussing these earlier eras, which serve as background for our far more extensive coverage of Late Antiquity, we will not only survey the artistic remains of the first millennium BCE, taking note of the religious and cultural interactions between the art used by the Israelites and Jews in their wider social context, but will also address the impact of foreign influences on Hasmonean and Herodian art, for which the available evidence is abundant.

In this study we will offer interpretations based on the particular setting of a given artistic representation. Needless to say, we have no illusions that this is the only legitimate approach or correct understanding. As with the study of texts, no single interpretation of a work of art is ever exhaustive; what follows is one suggested reading, hopefully an informative, reasonable, and perhaps even convincing one.[16] There is no denying that scholars regularly strive to build convincing and compelling cases for a particular interpretation; with regard to the distant past, much rests on arguments anchored in texts that are mobilized to support a specific claim.[17] Our study, however, will focus primarily on the historical perspective, using the immediate social, cultural, and religious contexts as the main points of reference in interpreting Jewish art of Late Antiquity.

12. See chap. 16.

13. See V. B. Mann and Tucker, *Seminar on Jewish Art*, 10–11. Kayser ("Defining Jewish Art") defines Jewish art by its "cultural function," whereby the determining factor is the function of the art object and whether it plays an important role in Jewish life.

14. S. Schwartz, *Imperialism and Jewish Society*, 179–292; Mason, "Jews, Judaeans, Judaizing, Judaism"; Boyarin, "Rethinking Jewish Christianity," 8–27.

15. See L. I. Levine, "Jewish Identities in Antiquity," and chap. 3.

16. See Barrett, "About Art Interpretation."

17. See Hirsch, *Validity in Interpretation*, passim, and particularly 207: "Even though we can never be certain that our interpretive guesses are correct, we know that they *can* be correct and that the goal of interpretation as a discipline is constantly to increase the probability that they are correct." See also Hirsch, *Aims of Interpretation*.

JEWISH ART IN LATE ANTIQUITY FROM
A HISTORICAL PERSPECTIVE

The last century of research has made it eminently clear that Jewish art, according to the definition suggested above, flourished for the most part only in Late Antiquity, when it was far more extensive, diverse, and impressive than anything produced in the previous 1,500 years. Indeed, this phenomenon constitutes one of the most remarkable developments in the evolution of Jewish culture in antiquity. For more than a millennium throughout the First and Second Temple periods, Israelite-Jewish art was limited in its range of motifs and modest in its presentation. There was relatively little interest in displaying objects that reflected the theological ideas, social values, or historical memories of the Jewish experience. By contrast, the Late Roman period (early third century CE) witnessed a significant change in the display of such art by Jews across the Roman Empire, making it comparable to the art of other contemporary ethnic and religious communities. This religious component in Jewish art assumed an even greater role in the Byzantine era. Why this happened and how this newly emerging artistic creativity found diverse expression is a primary subject of this volume.

Since our study approaches Jewish art from a historical perspective, it requires an understanding of the wider social and communal contexts in which this art was created.[18] The key to unlocking the meaning of synagogue art lies primarily, though not exclusively, in the local context, wherein each community determined the form and content of its visual expression.[19] Thus, by ascertaining the local factors responsible for such representations, we can begin to fathom the primary motivations, meanings, and significance of the art in places such as Dura Europos, Bet She'arim, Hammat Tiberias, and Sepphoris.

This approach, admittedly, has its downside. In many cases, we do not have enough information about communal life in a particular locale. For example, we know nothing about the sixth-century Bet Alpha community and precious little about the Jews of Rome and Sardis in Late Antiquity. Regrettably, our discussions in such instances will perforce be more limited, and certain important issues will not be broached for lack of evidence.

A historical approach plays itself out in other ways as well. First, it addresses the interrelationship between text and artifact, that is, the way textual evidence is often used to explain archaeological data. Historians in general, including art historians, frequently succumb to the powerful allure of the written text, according it primacy

18. Arguing for an emphasis on the historical dimension in the study of art, and thus more fully integrating it with historical concerns generally, is R. R. R. Smith, "Use of Images": "Re-siting dislocated ancient images in their contexts of ancient use, locating the ideas that informed them, and reconstructing the mentalities with which they were approached and understood constitute challenging tasks that classical archaeology has taken up only recently" (101–2).

19. See chap. 19.

over material remains.[20] This might be expected, as historians often dip into artistic and archaeological realms to illustrate or clarify a historical point they wish to make, paying little attention to the visual evidence in its own right. It is thus the literary evidence that governs their terms of reference; material remains are merely a handmaiden in the service of more central historical issues.

Given the fact that artistic representations are "frequently undefined and indeterminate in purpose,"[21] art historians, for their part, turn to literary material to interpret artistic motifs; they, too, do this as if written sources are to be uncritically mined and given priority ipso facto. Such an approach invites imaginative and speculative associations and connections; as a result, a gap between literary sources stretching over the first millennia BCE and CE and a particular artistic expression from Late Antiquity is often bridged with little critical analysis. A fuller understanding of these sources, with their limitations and problematics, is rarely addressed and perhaps not even recognized. Given this situation, visual evidence, whether for historical or artistic purposes, should be allowed to speak for itself and not automatically subsumed by one or another literary tradition.

Indeed, the relationship between the written word and the visual image may also be considered conversely, namely, art at times might lead the way.[22] It is quite possible that the text, rather than influencing the visual, might serve as a commentary on an artistic rendition appearing on a synagogue floor. Such an option ought to be considered, particularly when the textual evidence considerably postdates the visual.[23]

Finally, a historical approach to artistic remains must also take into account that there may be little, if any, connection between the text and the visual. Furthermore, the written sources we have regarding Jews in Late Antiquity preserve very little historical information about religious leadership and institutions in Palestine or the Roman Diaspora. A more fundamental concern, however, is the premise that written material almost always reflects the ideas, values, and proclivities of a society's elites while archaeological remains often represent the religious, cultural, and social ambience of local communities and their leaders.[24] Indeed, a number of scholarly articles and books over the last few decades claim that there was a significant gap between church leaders and ordinary Christians.[25] It is this emphasis on the consumer and the historical context that R. R. R. Smith advocates as a necessary focus in the study of Greco-Roman art:

20. Rabb and J. Brown, "Evidence of Art," 1–2.

21. Ibid., 2.

22. E. Kessler, "Art Leading the Story."

23. For examples of this, see, inter alia, chaps. 16, 18, and 20.

24. See chaps. 19, 22, and 23.

25. See, for instance, Burrus, *Late Ancient Christianity*; Krueger, *Byzantine Christianity*; as well as MacMullen, *Second Church*.

The visible stylistic evolution and variety of ancient images were not simply the result of personal artistic creativity but more decisively of important historical change and difference. Changing styles represented the changing self-perception of ancient societies—the more homogeneous and collectivist the society (fifth-century Athens, for example), the narrower the range of styles; the more complex the society, the greater number of concurrent styles (the Roman empire, for example). The meaning of ancient images was relative, not absolute, relative to their historical and physical circumstances, to their audience, to their place in a tradition, an evolving visual language or system of representation. The same visual form can mean quite different things in different times and places, so that detailed reconstruction of context—purpose, setting, audience—is essential before reasonable interpretation can begin.[26]

The reality described by Smith applies to Jewish art in Late Antiquity as well.

STRUCTURE OF THE VOLUME

The overall organization of this monograph is chronological, spanning a period of almost two thousand years, from circa 1200 BCE into the seventh century CE. We commence with several chapters that provide the background of the art of Late Antiquity, that is, the art of the Israelites-Jews throughout the First and Second Temple eras (ca. 1200 BCE to ca. 135 CE). Our discussion of Israelite art in the former era involves objects that bear some sort of religious connotation and examines their relationship to the biblical account of Israelite religion at the time.[27]

Second Temple art, for which a relative abundance of evidence has been recovered, focuses primarily on the last two hundred years of this period. In contrast to earlier and later periods in antiquity, this art stems in large part from the urban-based rulers and upper echelons of society. Moreover, with the rise of the Hasmoneans in the second century BCE, the Jews parted from the regnant practice of figural art, generally eschewing such representations for the next three hundred years or so.[28]

26. R. R. R. Smith, "Use of Images," 73.

27. Although there is a clear chronological gap between the Israelite and Jewish periods in the first millennium BCE, with the latter commencing in the Babylonian-Persian era, there is also a significant degree of continuity from one to the other. The Jews of the sixth century BCE and thereafter most certainly viewed themselves as the successors of the earlier era, not only ethnically and socially but religiously and culturally as well. Use of figural art, for example, continued for centuries, until Hasmonean times. No less important for our purposes is that there are literary sources, i.e., the Bible, with which to compare and contrast the earlier material remains, much as the art of Late Antiquity must be considered in relation to later written sources, particularly those of the rabbis. Similar methodological issues emerge in both instances and will be considered below.

28. We find an interesting pattern in these two earlier periods, to be repeated once again in Late Antiquity; each of these eras commences with a very limited amount of artistic mate-

The following section in this volume, focusing on the Late Roman era—the first phase of Late Antiquity—is devoted to the emergence of a very new and different type of Jewish art in the third century CE, appearing to date at three sites in Palestine and the Diaspora—Dura Europos, Bet She'arim, and Rome; an appendix by Uzi Leibner and Shulamit Miller presents the remarkable figurative mosaics from around the turn of the fourth century found in the Kh. Ḥamam synagogue north of Tiberias. We will suggest that the transformation affecting the wider Late Roman society, with its increased religious orientation and use of religious symbols, had an impact on the Jews as well and indeed goes a long way toward explaining the dramatic shift in the Jewish artistic repertoire at the time.

The remaining chapters, which comprise the bulk of the volume, address the Byzantine-Christian orbit of the fourth to seventh centuries, when Jewish art flourished in both Palestine and the Diaspora. The first chapters present new perspectives regarding Jewish historical contexts under Byzantium, examining modern scholarship's changing views of this era, from espousing the decline and marginalization of Jewish society to arguing for a great deal of creativity in both the literary and material spheres. This is followed by an overview of Jewish art in Late Antiquity and then by an analysis of the artistic remains from four major Byzantine sites—Ḥammat Tiberias, Sepphoris, Bet Alpha, and Sardis—which provide much of the material that will inform our discussions in subsequent sections of the book.

The next group of chapters discusses the most striking motifs in Jewish art, first and foremost being the representations of Helios and the zodiac as well as other Greco-Roman motifs. A discussion of religious objects and biblical themes, the most important religious components of Jewish art that have also contributed to the emergent sacred status of the synagogue, follows. This section concludes with an analysis and critique of a number of prevalent theories regarding Jewish art at one or more sites.

The next section deals with Jewish art in its wider social context. The first chapter is devoted to the communal dimension of this art but also considers additional components, such as characteristic regional tastes and trends in both Palestine and the Diaspora. It also addresses the existence of a popular, synagogue-based common Judaism that seems to be reflected in diverse communities throughout the Empire. The following chapters assess the relationship of the rabbis, and then the Patriarchs, to contemporary Jewish art. Running counter to the prevailing consensus in art-historical studies, it will be claimed that the rabbis had very little, if any,

rial, which expands exponentially toward the end of the period. The reasons for this are not uniform. In the first two periods it resulted from the establishment of a strong centralized political entity in Jerusalem, while in the Second Temple period it was supplemented by the Hasmonean and especially the Herodian adoption of Greco-Roman styles, techniques, and patterns that had become ubiquitous and highly prominent. In Late Antiquity, Jewish use of art was part of the wider trends of the time, which affected local rural communities no less than urban centers.

influence on synagogue art, while during the two hundred or so years of the Patriarchate (three hundred years, if we include the tenure of R. Gamaliel as a sort of proto-Patriarch)[29] the holders of this office (often in alliance with the wealthy urban aristocracy) appear to have been actively involved in the use of a variety of artistic motifs.

The last two chapters attempt to integrate many themes in the above discussions. The first focuses on Late Antiquity, with a special emphasis on art and Jewish identity in the Byzantine-Christian orbit. The epilogue offers a broad overview of the role of art in Jewish society throughout antiquity, noting, inter alia, the fluctuating attitude toward figural art, the delicate balance between particularism and universalism, and the gradual emergence of a uniquely Jewish art that initially surfaced, though in a very limited and tentative way, in first-century BCE Jerusalem and peaked several centuries later, in Late Antiquity.

Perhaps the most overarching conclusion in this study is the importance of artistic material for gaining a fuller understanding of ancient Jewish society, a society that apparently was more open to adopting and adapting outside influences than is usually associated with antiquity. Even in periods when figural art was studiously avoided, art continued to be widely used, albeit in a more attenuated way. For all their recognized and justified importance, our limited written sources go only so far in elucidating the past, but together with artistic data the picture of ancient Jewish society becomes far more nuanced and complex, and thus more complete.

29. Scholars disagree as to whether the Patriarchate (see chaps. 6 and 21) commenced in the time of R. Gamaliel II (ca. 100 CE) or a century later, under R. Judah I (ca. 200 CE). See Goodblatt, *Monarchic Principle*, 176–231, for the former opinion, and S. Stern, "Rabbi and the Origins of the Patriarchate," for the latter. A more transitional approach posits that the office emerged in several stages, beginning with R. Gamaliel II (and thus the aforementioned term "proto-Patriarch") and culminating several generations later under R. Judah I. Thus an official and recognized office of the Patriarchate functioned for over two centuries, disappearing in the early fifth century. See L. I. Levine, "Status of the Patriarch," 28–32; Stemberger, *Jews and Christians in the Holy Land*, 261–68; my forthcoming "Emergence of the Patriarchate"; and chap. 21, n. 1.

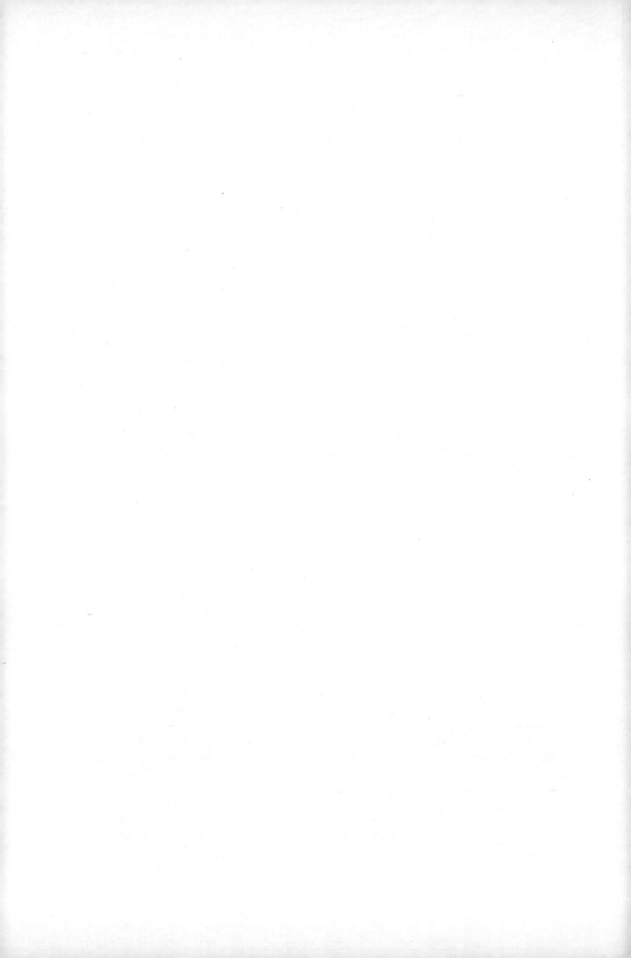

I

EARLY HISTORICAL CONTEXTS

2. ISRAELITE ART

THERE IS A general consensus today that the earliest traces of Israelite society appear in the transition from the Late Bronze Age to the Iron Age, and it was only then, in the twelfth and eleventh centuries BCE, that a recognizable entity began to emerge in the highlands (the Galilean, Samarian, and Judaean hills)—what was to eventually become the Israelite people.[1]

ARCHAEOLOGICAL EVIDENCE OF ISRAELITE ART

The archaeological remains span much of the eight-hundred-year period under examination (thirteenth–fifth centuries BCE) and come from urban and rural Israelite settlements in both the kingdoms of Israel and Judah.[2] While the artistic remains for the pre-Monarchic era are extremely sparse, the amount of such material, together with the literary data, increases steadily over time, and most dramatically toward the close of this era. By the late ninth to seventh centuries BCE, Israelite society was exhibiting a wide range of religious beliefs, cultic practices, and cultural proclivities, including artistic remains.

Statuette of a Bull

A bronze statuette of a bull was found in a twelfth-century BCE context at a cultic site in northern Samaria (fig. 1). Measuring 17.5 centimeters long and up to 12.4

An extensive treatment of this subject appears in my "Israelite Art."

1. Halpern, *Emergence of Israel in Canaan*; Coogan, "Canaanite Origins and Lineage"; Callaway, "Settlement in Canaan"; Bloch-Smith and Alpert-Nakhai, "Landscape Comes to Life"; Bloch-Smith, "Israelite Ethnicity in Iron I"; Killebrew, *Biblical Peoples and Ethnicity*, 21–49.

2. See, inter alia, the following surveys of the archaeological remains: Shiloh, "Iron Age Sanctuaries"; Dever, "Contribution of Archaeology"; Dever, *Did God Have a Wife?* 110–75. See also Vriezen, "Archaeological Traces of Cult"; P. Beck, "Art of Palestine during the Iron Age II" (2000) ("Art of Palestine during the Iron Age II" [2002]); Nakhai, *Archaeology and the Religions of Canaan and Israel*, 161–200.

In what follows, we will focus on those artistic remains that have important implications for the religious-cultic and cultural dimensions of Israelite society, thus excluding purely decorative artistic representations from Hazor, Ramat Rachel, Lachish, Tel en-Nasbeh, and Bethsaida.

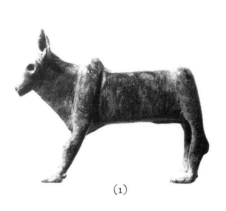

(1)

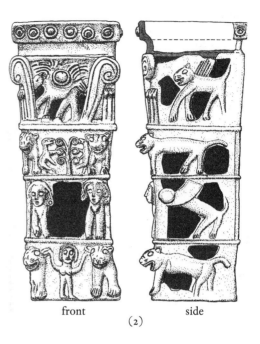

front side

(2)

FIG. 1 Bronze bull statuette from northern Samaria.

FIG. 2 Cult stand from Taanach.

centimeters high, it is one of the largest such figurines yet to be found in ancient Israel.[3] Amihai Mazar has suggested that the statuette was a local product made under Canaanite influence or acquired through trade with the local Canaanite population, but it has also been proposed that the statuette may have been manufactured elsewhere (suggestions range from the Galilee to Syria) and was brought to the site by peoples who moved into the region.[4]

Cult Stands

Israelite art appears on a number of tenth-century BCE northern cult stands, several from Megiddo and three from Taanach. Two of the Taanach stands, exhibiting a rich iconography, are quite unique and relatively well preserved. The best and most striking of these was discovered in 1968.[5] It is red-slipped, 54 centimeters tall, and hollow.[6] Each of its four clearly distinguished tiers, possibly resembling a four-story building, contains a different scene (fig. 2). In the first tier, a young bull or horse faces left, with a winged sun disk above it and flanked by two voluted

3. A. Mazar, "'Bull' Site"; Ahlström, "Bull Figurine"; Zevit, *Religions of Ancient Israel*, 176–80.

4. A. Mazar, "'Bull' Site," 32; Ahlström, "Bull Figurine," 80–81. Opinions also differ as to whether the statuette was a cultic object and not merely a votive offering. See L. I. Levine, "Israelite Art."

5. The description of this object draws heavily on Hestrin, "Cult Stand from Ta'anach"; P. Beck, "Cult-Stands from Taanach"; Frick, *Iron Age Cultic Structure*, 114–29; Zevit, *Religions of Ancient Israel*, 318–25.

6. Hestrin ("Cult Stand from Ta'anach," 61) states that it is 60 cm tall.

columns.[7] In the second, a sacred tree stands between two poorly shaped animals identified as goats or ibexes, flanked by two lionesses that presumably served as their guardians. In the third, an opening in the center, perhaps representing an entrance to a building, is flanked on either side by two sphinxes with bodies of lions, wings of birds, and female heads covered with some sort of headdress. In the fourth, a naked woman, usually identified as Asherah or Astarte, stands in the center, facing front and touching the ears of two flanking lions—again, a well-known motif in Egypt and Syria. Ruth Hestrin identifies the images of the sun disk and bull in the first tier as representations of Baal, while the second and fourth tiers are associated with Asherah;[8] she suggests that "the shrine was intended for the worship of Baal and Asherah, probably in a local shrine located in Taanach."[9]

Kuntillet 'Ajrud

In the mid-1970s a sensational discovery spurred a major reevaluation of the parameters and complexities of the Israelite religion, with arguably serious implications regarding the importance of its artistic component.[10] Zeev Meshel excavated the site of Kuntillet 'Ajrud, located in the eastern Sinai Desert some 50 km south of Qadesh Barnea, near the Israeli-Egyptian border. It was identified first and foremost as a way station, but also seems to have functioned as a cultic center dating to circa 800 BCE. The art reflects a wide range of Egyptian, Phoenician, Syrian, and Israelite influences, and a specific connection with the kingdoms of Israel and Judah is indicated by the inscriptions and by evidence that the *pithoi* found there were produced in the Jerusalem area.[11] Mention should be made of the names

7. Bull: P. Beck, "Cult-Stands from Taanach," 395; Dever, *Did God Have a Wife?* 219. Horse: Glock, "Taanach," 1432; J. G. Taylor, *Yahweh and the Sun*, 36, 255–65; Lewis, "Divine Images and Aniconism," 48.

8. Hestrin, "Cult Stand from Ta'anach," 77.

9. See also Frick, *Iron Age Cultic Structure*, 127; Bretscheider, "Götter in Schreinen," 20–25. A number of scholars agree that the Taanach cult stand provides the clearest visual depiction of Asherah in an Israelite context (Hendel, "Aniconism and Anthropomorphism," 219 n. 53; Lewis, "Divine Images and Aniconism," 46). Zevit, on the other hand, concludes his discussion with the assertion that the deity represented by these signs may be YHWH" (*Religions of Ancient Israel*, 323). On the Asherah-Yahweh motifs on this stand, see J. G. Taylor, *Yahweh and the Sun*, 28–37; Hadley, *Cult of Asherah*, 169–79.

10. The literature on this site is prolific. We have drawn primarily from the following: Meshel, "Kuntillet 'Ajrud" (1992); Meshel, "Kuntillet 'Ajrud" (1997); P. Beck, "Drawings from Horvat Teiman"; Dever, "Asherah, Consort of Yahweh?"; Ahituv, *Echoes*, 313–29; Keel and Uehlinger, *Gods, Goddesses, and Images of God*, 210–48; Hadley, *Cult of Asherah*, 106–55; Zevit, *Religions of Ancient Israel*, 370–405.

11. See Meshel ("Kuntillet 'Ajrud" [1992], 108–9), who emphasizes the northern Israel connection, and Zevit (*Religions of Ancient Israel*, 379–81), who underscores the ties to Jerusalem.

of four gods—Yahweh, Asherah, Baal, and El—who appear near the bench room at the site.[12]

Inscriptions

The most important inscriptions[13] from this site read as follows: (1) "Say . . . say to Yahelyau and to Yo'asah . . . and to . . . I bless you by Yahweh of Samaria, and by his Asherah"; (2) "To Yahweh of Teiman[14] and his Asherah: Anything you ask of a compassionate person, Yahweh will recompense him with whatever he wishes (lit., according to his heart)"; (3) "Amaryau says: Say to my lord, Are you at peace? I bless you by Yahweh of Teiman and by his Asherah. May He bless and guard you, and may he be with my lord forever (?)"; (4) "Lengthen their days and they will be filled, [and they] will give to YHWH [of] Teiman and his Asherah. Do good, YHWH of Teiman."

The close relationship between Yahweh and Asherah is not limited only to Kuntillet 'Ajrud but is also demonstrated in another inscription from the last quarter of the eighth century BCE at Khirbet El-Qôm (identified with biblical Makkedah), southeast of Lachish and west of Hebron.[15] Although deciphering and interpreting this last-noted inscription has proven to be a formidable task, engendering many and varied suggestions, there is a general consensus on the reading of the section that is of interest for our discussion.[16] Naveh translates the first three lines as follows: "Uriyahu the governor wrote it / May Uriyahu be blessed by Yahweh / My guardian, and by His Asherah. Save him."[17]

Art

Perhaps no less dramatic than these inscriptions are the painted drawings found primarily on the *pithoi,* walls, and potsherds at Kuntillet 'Ajrud.[18] The most notable of these is a scene dominated by two large Bes[19] figures (fig. 3) displaying their char-

12. For the inscriptions from this site, see Renz and Röllig, *Die althebräischen Inschriften,* 47–64; Dobbs-Allsopp et al., *Hebrew Inscriptions,* 277–98; Ahituv, *Echoes,* 313–29.

13. On these inscriptions, see Zevit, *Religions of Ancient Israel,* 373–74, 394–400; Dobbs-Allsopp et al., *Hebrew Inscriptions,* 293–97; Ahituv, *Echoes,* 318–24.

14. Lit., the South, presumably a reference to the southern part of the country (either Judah, the coastal area, the Negev, or a combination thereof) in contradistinction to Samaria. Ahituv (*Echoes,* 322), however, suggests the city or region of Teiman in Edom, located in the vicinity of Petra.

15. Dever, "Iron Age Epigraphic Material."

16. Lemaire, "Les inscriptions de Khirbet el-Qôm"; Lemaire, "Khirbet el-Qôm and Hebrew and Aramaic Epigraphy," 231–32; Zevit, "Khirbet el-Qôm Inscription"; Zevit, *Religions of Ancient Israel,* 36.

17. Naveh, "Graffiti and Dedications," 28; see also Ahituv, *Echoes,* 220–24; Dobbs-Allsopp et al., *Hebrew Inscriptions,* 408–14; Zevit *Religions of Ancient Israel,* 361.

18. P. Beck, "Drawings from Horvat Teiman"; Zevit, *Religions of Ancient Israel,* 381–405; see also Dever, *Recent Archaeological Discoveries,* 140–48.

19. The name of the Egyptian god Bes may be connected to the phrase "to guard," often invoked by people in distress or seeking protection.

FIG. 3 Kuntillet 'Ajrud, Pithos A: painting with inscription: "I bless you by Yahweh of Samaria, and by his Asherah."

acteristic features—feathered crowns, lionlike faces, tunics, and tails (or genitals) hanging between their legs. The lower left foreground depicts a cow and suckling calf, and above them are the fragmentary remains of a chariot horse. To the right of the Bes figures is a seated woman in profile playing a lyre. Because the inscription mentioning Yahweh and Asherah appears directly above the two Bes figures, it has been suggested that they represent these deities.[20] Alternatively, William Dever argues that one of the Bes figures represents Yahweh, while the seated woman is Asherah.[21]

The core issues are whether the inscriptions and drawings are independent or interrelated entities, and whether they convey a single message. Advocating a minimalist view, Pirhiya Beck has discerned at least three different artists, each reflecting a different cultural milieu.[22] This, of course, does not preclude the possibility that the person who wrote these inscriptions identified the drawings with Yahweh and Asherah. Christoph Uehlinger and Judith M. Hadley reject the proximity or overlapping of the inscriptions and drawings as a compelling consideration for their interpretation.[23] At the other end of the spectrum, Mordechai Gilula, David N. Freedman, Dever, Herbert Niehr, and Ziony Zevit not only argue for a connection between the various components but also claim that this drawing indeed represents Yahweh and Asherah.[24] Whether we label this type of representation as a form of syncretism or an expression of an expanded, more complex Yahwistic worldview

20. Gilula, "To Yahweh Shomron and His Asherah," 129–37; Hadley, *Cult of Asherah*, 136–37.

21. Dever, *Did God Have a Wife?* 164–67. Hadley (*Cult of Asherah*, 152–55) suggests that the goddess is represented elsewhere on the *pithos* as a stylized tree flanked by ibexes above a striding lion.

22. P. Beck, "Drawings from Horvat Teiman," 43–45.

23. Uehlinger, "Anthropomorphic Cult Statuary," 142–46; Hadley, *Cult of Asherah*, 152–55.

24. Gilula, "To Yahweh Shomron and his Asherah," 129–37; Freedman, "Yahweh of Samaria and His Asherah"; Dever, "Asherah, Consort of Yahweh?"; Niehr, "In Search of Yhwh's Cult Statue," 81; Zevit, *Religions of Ancient Israel*, 374–400. For reservations in this regard, see Keel and Uehlinger, *Gods, Goddesses, and Images of God*, 228–33, 369–70.

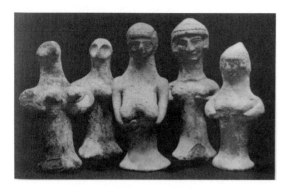

FIG. 4 Pillar figurines from Jerusalem.

incorporating other deities, this last-noted group of scholars assumes that the worship of more than one deity was clearly a recognized phenomenon in Israelite life of the First Temple period.

Figurines

Some three thousand Iron Age terracotta pillar figurines,[25] the overwhelming majority of which are of females,[26] have come to light at numerous Israelite sites and date from the tenth to sixth centuries BCE, with the bulk stemming from the eighth to sixth centuries.[27] Such figurines are well known throughout the eastern Mediterranean, beginning in the second millennium BCE[28] and continuing through the classical era and beyond. It has been long debated whether these statuettes with well-accentuated breasts represent goddesses—perhaps a mother goddess or Asherah, in a maximalist position, or, in a minimalist vein, a votive offering expressing a wish for fertility.[29]

Particularly ubiquitous are the pillar figurines from the southern kingdom of Judah, dating to the eighth and seventh centuries (fig. 4). In her excavations in the 1960s on the eastern slopes of the City of David, Kathleen M. Kenyon discovered 429 animal or human figurines, the bulk of the latter being primarily female pillar figurines. Subsequent to Kenyon's report, Thomas A. Holland published an inventory of 597 clay figurines found in Jerusalem since the beginning of excavations in the nineteenth century,[30] and Raz Kletter assembled 854 such figurines from forty-

25. For a general discussion of Israelite figurines, see Pritchard, *Palestinian Figurines*; Holland, "Study of Palestinian Iron Age Baked Clay Figurines"; Kletter, *Judean Pillar-Figurines*; Zevit, *Religions of Ancient Israel*, 267–76.

26. Considered as such owing to their large breasts, round figure, pole-like lower torso, and no separation of the legs. The base is usually wider than the body.

27. Keel and Uehlinger, *Gods, Goddesses, and Images of God*, 327–41; Kletter, *Judean Pillar-Figurines*, 40–42.

28. Although this type is evidenced millennia earlier, e.g., at Jericho; see Kenyon, *Digging up Jericho*, plate 19A.

29. Compare, for example, Hestrin ("Understanding Asherah"), Dever ("Will the Real Israel Please Stand Up?" 37–58), and Kletter (*Judean Pillar-Figurines*, 81), arguing for a maximalist position, as against C. L. Meyers (*Discovering Eve*, 162) and Lewis ("Divine Images and Aniconism," 44–47), advocating a minimalist one. The Asherah identification rests on several considerations: (1) the many references to Asherah in the Bible, either as a goddess or a cult object (e.g., Exod. 34:13; Deut. 16:21); (2) the pillar shape of the figurine in Judah resembling a tree, a symbol of the goddess; and (3) the fertility dimension of these figurines, which parallels a central function of this goddess.

30. Holland, "Study of Palestinian Iron Age Baked Clay Figurines," 132–54.

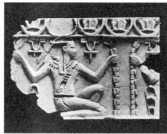

(1)

(3)

(2)

FIG. 5 Samaria ivories:
(1) The god Hah, squatting
(2) Winged sphinx with human head
(3) Lion struggling with bull

two sites throughout the region; 75 percent came from the Judaean hills, 15 percent from the Judaean *shephelah* (or coastal plain), and some 10 percent from the northern Negev.[31] Finally, Yigal Shiloh's excavations in Jerusalem between 1978 and 1985 yielded 1,309 ceramic figurines. Thus, when added to the earlier finds, close to two thousand such figurines were found in Jerusalem alone. Such a quantity has not been approximated at any other site.

Most of the figurines discovered in these assemblages are of a type unique to Judah, and it appears that the pillar figurine is the sole anthropomorphic representation found in this region. Shiloh's excavations in Jerusalem confirm that these representations, which were found distributed evenly throughout the excavated residential areas, were produced from the eighth to sixth centuries BCE—despite the reforms of Hezekiah and Josiah. Thus, whether from alleged cultic sites (per Kenyon) or residential houses, these locally produced figurines appear in similar concentrations and clearly reflect a common practice among the local populace.

Samaria Ivories

The use of ivory for decorative purposes in public and private buildings was known as early as the fifth millennium BCE but became ubiquitous throughout the ancient Near East only in the second and first millennia BCE.[32] An ivory hoard from Iron Age Israel was discovered in 1932–33 in Samaria, capital of the northern kingdom of Israel. Most of the five hundred ivory fragments were discovered near the acropolis, probably on the site of the Israelite palace, and date to the ninth

31. Kletter, *Judean Pillar-Figurines*, 43–48.
32. Barnett, *Ancient Ivories.*

or eighth century BCE.[33] Over two hundred of them bear carvings with decorative (nonfigural) motifs, animals, sphinxes, human figures, and Egyptian gods (fig. 5). It may not be coincidental that 1 Kings 22:39 speaks of "the ivory house that he [Ahab] built." Whether this refers to a building featuring ivories, a room wherein such objects were kept, a paneled wall, or simply furnishings is unclear.[34]

The Nimrud Prism of Sargon II

A hexagonal prism recording the achievements of Sargon II was found in Nimrud, capital of the Neo-Assyrian Empire in the ninth and eighth centuries BCE. It describes the conquest of the northern kingdom of Israel:

> With the power of the great gods, my [lord]s
> [aga]inst them I foug[ht].
> [2]7,280 people, together with [their] chariots,
> and the gods in whom they trusted, as spoil
> I counted. Two hundred chariots for [my] royal force
> I collected from their midst.[35]

The Assyrian practice of seizing the natives' divine images as booty is well known.[36] If accepted as fundamentally accurate and not mere hyperbole, this statement attests to two realities: polytheism existed in the Israelite capital; and one of its expressions took the form of cultic statues. However, we have no way of knowing whether these statues were anthropomorphic or theriomorphic, although Bob Becking has opted for the former, suggesting that they may have included representations of Yahweh and Asherah.[37]

Not everyone accepts the inference that statues were taken from Samaria. Other interpretations suggest that the phrase in question may have been merely formulaic in its description of a city's conquest and has no intrinsic historical value.[38] Alternatively, Sargon may have mistaken the bronze calves of Beth-el with Samaria's gods,[39] or the writer might have had standards or banners in mind.[40] Finally, Nadav Na'aman claims that the prism's inscription is an unreliable source and, in fact,

33. Avigad, "Samaria (City)," 1304. For a ninth-century dating for all the ivories, see Crowfoot and Crowfoot, *Early Ivories from Samaria*, 1–6. An eighth-century date is suggested by Winter ("Phoenician and Northern Syrian Ivory Carving"). See also Avigad, "Samaria (City)," 1306.

34. Crowfoot and Crowfoot, *Early Ivories from Samaria*, 1; Barnett, *Ancient Ivories*, 49.

35. Gadd, "Inscribed Prisms of Sargon II"; Becking, *Fall of Samaria*; Becking, "Assyrian Evidence for Iconic Polytheism," 158–67.

36. Cogan, *Imperialism and Religion*, 22–41.

37. Becking, "Assyrian Evidence for Iconic Polytheism," 166, 162 n. 23.

38. Mettinger, *No Graven Image?* 136.

39. Cogan, *Imperialism and Religion*, 104–5.

40. Uehlinger, "Figurative Policy," 301–15, esp. 308.

"a literary embellishment by the later author, and does not reflect a genuine memory of the captivity of the cult images of Samaria."[41]

FIG. 6 *Massebot* from Gezer.

Massebot

Standing stones, or *massebot,* are well known throughout the ancient eastern Mediterranean and have been found in Israelite settlements such as Arad, Dan, Hazor, Megiddo, the "Bull" site, and Lachish (fig. 6).[42] Rough slabs of stone or finely hewn rectangular, tapered, conical, arched, or obelisk stones without any kind of relief, figural representation, or inscription, they served as memorials, legal monuments, commemorative markers, or objects of worship and veneration for cultic purposes. While not necessarily identified as a deity in and of itself, a *masseba* symbolized (and might have guaranteed) the presence of a god for veneration purposes, perhaps even marking his place.[43] The Bible attests to the use of *massebot* in a variety of contexts (Gen. 28:18–22, 31:13 and 43–53, 35:19–20; Exod. 24:4), and Isaiah prophesied that in the days to come a *masseba* to Yahweh would be built on the Egyptian border and an altar to Yahweh would be set up in Egypt itself (19:19).

While some biblical traditions look upon *massebot* favorably, others are far more critical: If they represent foreign gods and worship, then they are to be destroyed (Exod. 34:13; Lev. 26:1; Deut. 7:5, 12:3). Later Deuteronomic writers or editors, perhaps reflecting a strident "Yahweh-alone"[44] stance, took a dim view of the role and implications of *massebot* and banned their usage (16:22). Thus, we find that Hezekiah and Josiah, both probably influenced by a Deuteronomic (or proto-Deuteronomic) predisposition, made every effort to remove them from their realms (2 Kings 18:4, 23:14).

In his pioneering study of *massebot,* Trygve N. D. Mettinger claims that this well-rooted ancient Israelite aniconic tradition (which was characteristic of West Semitic societies in general) can be traced back at least to Solomon (to wit, the empty

41. Na'aman, "No Anthropomorphic Graven Image," 395–98; quote, p. 398.

42. Mettinger, *No Graven Image?* 39–134. The subject has been addressed on many occasions. See, e.g., Graesser, "Standing Stones"; Manor, "Massebah"; Zevit, *Religions of Ancient Israel,* 256–65; Bloch-Smith, "Will the Real *Massebot* Please Stand Up"; and esp. Mettinger, *No Graven Image?* See also a review and critique of the latter by Lewis, "Divine Images and Aniconism."

43. For a study of the term *massebot* in the Bible, see LaRocca-Pitts, *"Of Wood and Stone",* 205–28. On the religious dimension of the *massebot* as an embodiment of the divine, see Sommer, *Bodies of God,* 49–54.

44. This term is generally associated with Morton Smith (*Palestinian Parties and Politics,* s.v. "Yahweh-alone party," 347).

throne represented by the cherubim) "and may antedate it by centuries."[45] He distinguishes between the common de facto aniconic practice known in some surrounding societies, on the one hand, and what he terms "programmatic aniconism in its uncompromising form," which became the norm in the Exilic period with the crystallization of a full monotheistic worldview, on the other.[46]

Noncultic Objects: Seals, Bullae, and Stamped Jar Handles

Seals played a significant role in ancient Near Eastern cultures.[47] Although initially functioning as talismans, they were also used for sealing documents in literate and bureaucratic cultures that were developing politically, socially, and economically.

Of the known Hebrew seals and impressions, approximately five hundred are aniconic or nearly so, and a little over a quarter of these (about a hundred and thirty) have some sort of floral design. Two hundred iconic seals exhibit a range of motifs, including floral, human, animal, and mythological representations, and a dozen depict celestial bodies.[48]

It is generally agreed that the earlier ninth-and eighth-century seals, bullae, and stamped handles reflect Egyptian and Phoenician iconography. Having much more contact with Phoenicia, the kingdom of Israel adopted a series of iconic motifs from its northern neighbor,[49] although a number of Judahite royal seals from the eighth century BCE also reflect similar Phoenician influences, and later eighth-and seventh-century objects from Judah likewise reflect Syrian and Mesopotamian influence. Of special note are the almost one thousand LMLK ("belonging [or pertaining] to the king") seal impressions found on jar handles. These seals featured either the four-winged beetle or two-winged sun disk of Egyptian influence and have been interpreted as royal Judahite insignia from the late eighth and early seventh centuries.[50]

Moreover, whereas the ninth-and eighth-century seals were more iconic and anepigraphic, this preference changed dramatically in the subsequent period as the use of inscriptions and aniconic features became more pronounced.[51] Interestingly,

45. Mettinger, *No Graven Image?* 15. See also Na'aman, "No Anthropomorphic Graven Image."

46. Mettinger, *No Graven Image?* 195–97; Mettinger, "Israelite Aniconism," 174–75. Mettinger's approach was adopted by a number of other scholars; see Hendel, "Aniconism and Anthropomorphism," 224–28; Hurowitz, "Picturing Imageless Deities"; Lewis, "Divine Images and Aniconism," 40–53; Cornelius, "Many Faces of God"; J. G. Taylor, *Yahweh and the Sun*, 93.

47. The material in this section is drawn primarily from Avigad and Sass, *Corpus*; Sass, "Pre-Exilic Hebrew Seals," 194–256.

48. Sass, "Pre-Exilic Hebrew Seals," 244.

49. Peckham, "Israel and Phoenicia."

50. A. Mazar, *Archaeology of the Land of the Bible*, 455–58.

51. Keel and Uehlinger, *Gods, Goddesses, and Images of God*, 354–61.

these two phenomena may be related to the development of literacy and the inclusion of names on seals and bullae. As a result, there may have been less of a need (and perhaps also less space) for iconic representations. This phenomenon may also be tied to the increased religious proclivity in this era to emphasize a more "Yahweh-alone" and aniconic posture.

THE CONTRIBUTION OF ART TO AN UNDERSTANDING OF ISRAELITE RELIGION AND CULTURE

With the steady increase in the number of archaeological finds, visual material has assumed a greater role in assessing the cultural and religious realities of Israelite society. The fact that archaeological data shed light on segments of society that do not usually find expression in priestly, prophetic, Deuteronomic, or wisdom literature has opened new vistas for understanding the breadth and variety of religious and cultural activity among the Israelites. Symbols and depictions that lend themselves to interpretation as divine figures and cultic symbols are particularly intriguing, for they run counter to the normative prescriptions in biblical literature. By the very nature of the finds and their provenance, it would seem that these are remnants of what may have constituted a component—perhaps even a significant one—of the religious beliefs and practices of the period, and this, in turn, affords an important perspective on the biblical text itself.[52] Social and religious patterns within Israelite society, either ignored or disparaged by the biblical text, are now illuminated by this material.

For example, the contribution of artistic remains to the expression of Israelite beliefs and practices may be found in:

Sun-related religious practices. Solar worship in ancient Israel has been discussed frequently in scholarly literature over the last few generations.[53] Among the most explicit data in this regard is the appearance of sun disks along with representations of horses and bovines at Taanach, Hazor, and Jerusalem, for example. Such finds seem to mesh with the biblical evidence, such as the personal and place names noting the sun (Samson, Bet Shemesh), "illicit" sun worship (Deut. 4:19, 17:3), phrases associating Yahweh with the "Hosts" or the "Hosts of Heaven,"[54] numerous allusions

52. Whether this distinction qualifies as the difference between an "official" and "popular" religion, see Doeve, "Official and Popular Religion"; and, more pointedly, Berlinerblau, *Vow and the "Popular Religious Groups,"* 13–45; Berlinerblau, "Preliminary Remarks"; as well as the review of Berlinerblau's book by M. S. Smith ("Berlinerblau's *The Vow*," 148–51). However, see the reservations of Zevit ("False Dichotomies").

53. McKay, *Religion in Judah*, 32–35, 45–59; Spieckerman, *Juda unter Assur*; Stähli, *Solare Elemente*; J. G. Taylor, *Yahweh and the Sun*; M. S. Smith, "Near Eastern Background of Solar Language"; M. S. Smith, "When the Heavens Darkened"; and the comprehensive treatment of Keel and Uehlinger, *Gods, Goddesses, and Images of God*, 283–377. See also M. Smith, "Helios in Palestine"; Maier, "Die Sonne im religiösen Denken," 350–52; Sarna, *Studies in Biblical Interpretation*, 365–75.

54. Mettinger, "YHWH Sabaoth."

to such worship in the prophetic writings (Ezek. 8:16–17),[55] the designation of Yahweh as "a sun and a shield" (Ps. 84:12),[56] and finally the actual widespread worship of the sun in Jerusalem (2 Kings 23:5, 11; Ezek. 8:16–18) during the seventh and early sixth centuries BCE.[57]

Were such images merely decorative, or did they bear symbolic meaning? To what extent did these symbols reflect actual cultic worship? Did such worship relate to the cult of Yahweh, and if so, how? Finally, was this indeed an idolatrous practice reflecting the Bible's terms of reference, or was it an expression of an early, more inclusive Yahwism that had fallen into disrepute by the sixth century, when the editing process of biblical traditions was well under way?[58]

Asherah. The contribution of archaeology to a more nuanced understanding of Israelite religion is nowhere more exemplified than by the symbol of the goddess Asherah. The biblical references to Asherah as a mere wooden object or a symbolic tree (or pillar) do not do full justice to this figure. One should also consider the association of Asherah with Yahweh; was she his consort, his wife, a member of his court, or a foreign deity?[59]

The abundance of material finds associated with Asherah (for example, the Kuntillet ʿAjrud inscriptions and drawings, the Taanach cult stand images, and the pillar figurines) seems to indicate that this goddess was revered in both the south and the north, in rural as well as urban areas.[60] The biblical evidence presented by John Day is likewise of consequence, especially the appearance of the four hundred prophets

55. Ackerman, *Under Every Green Tree*, 93–99.

56. See also Sarna's interpretation of Psalm 19 as a polemic against solar worship ("Psalm XIX").

57. Ackerman, *Under Every Green Tree*, 37–99. M. S. Smith notes the following: "To summarize, solar language for Yahweh apparently developed in two stages. First, it originated as part of the Canaanite, and more generally Near Eastern, heritage of divine language as an expression of general theophanic luminosity. . . . Second, perhaps under the influence of the monarchy, in the first millennium the sun became one component of the symbolic repertoire of the chief god in Israel just as it did in Assur, Babylon, and Ugarit. In Israel it appears to have been a special feature of the southern monarchy, since the available evidence is restricted to Judah; it is not attested in the northern kingdom. Furthermore, it seems to have been a special expression of Judean royal theology. It expressed and reinforced dimensions of both divine and human kingship. This form of solarized Yahwism may have appeared to the authors of Ezekiel 8 and 2 Kings 23 as an idolatrous solar cult incompatible with their notions of Yahweh" (*Early History of God*, 157–58).

58. For the assumption that the Yahwist cult could well have included images, see Albertz, *History of Israelite Religion*, 65. See also LeMon, *Yahweh's Winged Form*, 59–112, 187–94.

59. On the coupling of Yahweh and Asherah, see Olyan, *Asherah and the Cult of Yahweh*, 23–37, 74; Weinfeld, "Feminine Features," 526–29. In a somewhat different vein regarding Asherah, this time not as a separate goddess but as an embodiment of the divinity of Yahweh, in what is termed the "fluidity model," see Sommer, *Bodies of God*, 44–49, as well as 58–79.

60. Regarding Asherah's status throughout the Land of Israel, see Ackerman, "Queen Mother."

of Asherah on Mount Carmel (1 Kings 18:19) and the description of the cult surrounding her image in Jerusalem in the days of Manasseh (2 Kings 21:7) and Josiah (2 Kings 23:4, 6–7).[61]

Nevertheless, the preponderance of biblical evidence (legal, prophetic, and narrative) clearly seems to refer to Asherah as a cultic object, pillar, or inanimate wooden object that could (and should) be cut down. Was this always the case, or was it but the judgment of the later Deuteronomic editors? Indeed, many references to Asherah seem to consider her more as a goddess than as a mere cultic symbol (for example, Judg. 3:7; 1 Kings 18:18–19; 2 Kings 21:7, 23:4).[62]

While it is conceivable that Asherah meant different things to different people in different places at different times, the bulk of evidence seems to indicate that such worship was, in fact, well known, particularly in northern Israel.[63] In this regard, we have not only the archaeological evidence to thank but also the Bible itself, which, despite being in utter opposition to such worship, alludes time and again to this cult and its attendant beliefs.

Israel and Canaan. Biblical literature, and Deuteronomy in particular, asserts throughout that there was a deep and unbridgeable chasm between Canaan and Israel (Deut. 7:1–5). Nonetheless, modern scholarship has demonstrated the degree to which many facets of Early Israelite material and religious-cultic life were influenced by Canaanite culture, so much so that it has been posited that one component of the proto-Israelite confederation of the thirteenth and twelfth centuries BCE apparently hailed from Canaanite society, bringing with it a varied cultural legacy.[64] Thus there is every reason to believe that, rather than being antithetical to the local Canaanite population, the emerging Israelite society was in fact in some sort of dialogue and interaction with Canaanite and other contemporary cultures.[65]

61. Day, *Yahweh and the Gods and Goddesses of Canaan*, 42–48. See also Freedman, "Yahweh of Samaria and His Asherah"; Olyan, *Asherah and the Cult of Yahweh*, 70–73; Dever, *Did God Have a Wife?* 176–251; as well as Schroer, *In Israel gab es Bilder*, 21–45.

62. M. S. Smith, *Early History of God*, 125–33; McCarter, "Aspects of the Religion," 143–49.

63. Hendel, "Israel among the Nations," 55–58; Freedman, "Yahweh of Samaria and His Asherah."

64. Day, *Yahweh and the Gods and Goddesses of Canaan*; M. S. Smith, *Early History of God*, 80–91; Halpern, *Emergence of Israel in Canaan*, 47–109; Coogan, *Canaanite Origins and Lineage*, 115–24; J. M. Miller and Hayes, *History of Ancient Israel and Judah*, 84–118; Killebrew, *Biblical Peoples and Ethnicity*, 149–96. Such a view goes hand in hand with the prevalent belief today that the Israelite settlement of the land was not the result of a one-time conquest by a unified people under Joshua, but rather a far more complex process, one of nomadic immigration over centuries, the movement of parts of the Canaanite population into the highlands, and a limited series of conquests, possibly by elements that harked from the southern regions, some of which may even have come from Egypt.

65. In addition to the classic studies of Cassuto (*Goddess Anath*) and Cross (*Canaanite Myth and Hebrew Epic*, 1–215) focusing on the cultural and religious planes, see also the archaeological perspective in A. Mazar, *Archaeology of the Land of the Bible*, 328–55, and Stager,

On a broader scale, the iconographic evidence presented above highlights four important dimensions of Israelite religious and cultural practice.

First, and continuing our discussion of Canaan and Israel, we now have a clearer understanding of the extent to which Israelite beliefs and practices were similar to those of their neighbors. So much is shared by contemporary cultures that Israelite creativity may be measured, at least in part, by the varying degrees of its adoption and adaptation of outside influences (figurines, cult stands, seal decorations, and more). On a more profound level, the preference of some Israelites for an aniconic representation of Yahweh may, as Mettinger has argued, be part of a more widespread West Semitic trend, and it has also been pointed out that the Mesopotamian-Babylonian orbit seems to have contributed both to the use of symbols in place of a deity and to a decisive movement toward monotheism in the late eighth to sixth centuries BCE.[66] In this vein, it might not be an exaggeration to say that the religion of the Israelites, at its inception, was related to Canaanite religion,[67] developed in the tenth century on a national level concurrently with the native cults of its neighbors (Ammon, Moab, Edom, Egypt, and Phoenicia), and finally shared many characteristics with the dominant Assyrian and Babylonian civilizations of the eighth to sixth centuries BCE.[68]

Second, Israelite creativity may have been expressed not only by what it borrowed but also by how, where, and to what degree such material was incorporated into its local milieu. Uehlinger has pointed out that the four-winged flying scarab and the four-winged uraeus are not limited to Judahite iconography of the late eighth century, nor are the falcon-headed winged sphinxes peculiar to northern Israel. In these cases, however, they are much more conspicuous in the Israelite setting than anywhere else, and consequently they must have been of considerable importance to the local population and perhaps even identifiably Judahite and Israelite at the time.[69]

"Forging an Identity," 123–49. For the rejection of any significant Canaanite influence on early Israelite society, see Rainey, "Whence Came the Israelites."

66. Jacobsen, *Toward the Image of Tammuz*, 20–21; Jacobsen, *Treasures of Darkness*, 232–39, esp. 236; Kaminsky and Stewart, "God of All the World." See also M. Smith, "Common Theology"; Cornelius, "Many Faces of God."

67. Ezekiel's comment (16:3) is intriguing in this regard: "Your origin and your birth were in the land of the Canaanite; your father was an Amorite, your mother a Hittite" (Greenberg, *Ezekiel 1–20*, 270).

68. J. M. Miller and Hayes, *History of Ancient Israel and Judah*, 248–52. On Assyrian influence, see Machinist, "Assyria and Its Image"; Machinist, "Mesopotamian Imperialism"; Aster, "Transmission of Neo-Assyrian Claims."

69. Personal communication. An interesting parallel to this process is the adoption of the zodiac signs, seasons, and image of Helios by the Jews of Palestine in Late Antiquity, when virtually no one else continued this practice; see chap. 16. For an example in the opposite direction, namely of an Israelite conception that sharply contrasts with that of Canaanite (or, more specifically, Ugaritic) culture, see M. S. Smith, "Structure of Divinity."

A third aspect of Israelite society reflected in its art is the broad diversity of religious beliefs and practices. Artistic remains have vividly highlighted the wide range that the editors of the biblical books might have wished to condemn and erase or, at the very least, minimize or marginalize.[70] Whether we categorize this heterogeneity as the difference between right and wrong conceptions (following biblical propensities) or as variations stemming from regional, chronological, official-popular/folk, or urban-rural distinctions, it is clear that throughout much of this period many Israelites recognized more than one deity or combinations thereof.[71] Indeed, the range and intensity of polemical condemnations throughout the Bible attest to the extent of this diversity. Archaeology has confirmed many of these variations and has even added revolutionary new evidence (for example, Kuntillet 'Ajrud) of its extent and nature.

Therefore, rather than viewing the cults and beliefs dismissed by the Bible as aberrations (as they were perceived at a later stage), it would be more cautious and probably historically more accurate to regard them as recognized expressions of Early Israelite religion, and perhaps even of Yahwism itself. Indeed, the partisans of "Yahweh-alone" (per Morton Smith) or Biblical Yahwism (per Stephen L. Cook) constituted for centuries only one of a number of Israelite religious groups.

Fourth, iconographic remains also reflect the dynamic dimension of Israelite religion, which complements the synchronic diversity just noted. It is dynamic in the sense that at first, in the pre-Monarchic twelfth and eleventh centuries, the cult of Yahweh seems to have competed with other traditions (such as Baal worship), at times asserting superiority (as in the case of Yahweh ruling over a council of divine figures—e.g., Exod. 15:11; see Ps. 82:1) or reinterpreting and absorbing them (e.g., El worship). As evidence becomes more abundant for the Monarchic era, particularly in the Divided Monarchy and again in the seventh century, the variety of religious expression appearing in Israelite/Judahite contexts appears to have expanded, both within the Yahwistic orbit and beyond.[72] At the same time, perhaps not

70. Albertz (*History of Israelite Religion*) emphasizes the popular dimension of the archaeological material that we have been discussing; see, e.g., pp. 85–87 (Asherah as consort), 99–100 (cult stands), 189–95 (seventh-century Judahite practices and female deities/figurines).

71. See, however, the view of Tigay, who on the basis of textual and archaeological evidence doubts the extent of polytheism in Israelite society: "in a population in which relatively few people invoked deities other than YHWH in names or any of these other types of inscriptions (blessings, votive inscriptions, prayers, oath formulas, religious graffiti, amulets, etc.), the polytheism represented by the iconography was probably no more widespread" (personal communication); for more detail, see Tigay, *"You Shall Have No Other Gods"*; see also Sommer, *Bodies of God*, 145–74.

72. The evolution of Israelite religious culture was far from monolithic. Besides differences between city and village, institutional and popular, there was also a significant distinction between the kingdoms of Israel and Judah. On the one hand, the northern kingdom of Israel was far larger than its southern counterpart and was located close to other cultures to its north, west, and east, thus reflecting their influences. On the other hand, the kingdom of

coincidentally, adherents of the "Yahweh-alone" ideology became ever more active religiously and politically in their determination to reconfigure Israelite religious thought and practice. This ultimately successful effort resulted in the crystallization of a more conscious and reified monotheism that found growing priestly, royal, prophetic, and Deuteronomic support from the eighth to sixth centuries BCE.[73] In certain circles, the doctrine of a "pure" monotheism went hand in hand with a widely accepted aniconism and the impropriety of representing the deity visually,[74] thereby giving expression to the unique and distinctive religious approach that was to characterize later Judaism.[75]

It would be misleading to claim that art-related evidence is the principal factor in detecting the above-noted developments, although it does not lag far behind. Whatever the case, archaeological finds have been able to provide engaging and at times revolutionary testimony for these phenomena, thereby broadening and deepening our understanding of this complex process, one which gave rise to an Exilic and post-Exilic religious system far different from its beginnings centuries earlier.

Artistic and archaeological remains can no longer be relegated to handmaiden status vis-à-vis text. Rather, they deserve full recognition for the important information they bring to the discussion and, even more, for offering new perspectives on a range of issues, thereby contributing indispensable evidence to our understanding of the literary sources.

Judah was more isolated and insulated, and tended to be more conservative—at least until the seventh century, following the disappearance of her northern counterpart. Artistic remains generally confirm this distinction; see J. M. Miller and Hayes, *History of Ancient Israel and Judah*, 248–52; A. Mazar, *Archaeology of the Land of the Bible*, 463–530; I. Finkelstein, "State Formation in Israel and Judah."

73. See the engaging study of S. L. Cook (*Social Roots of Biblical Yahwism*, esp. 1–13 and 267–77) arguing for a later, eighth-century, emergence of Yahwism in biblical Israel, but also that this belief had deeper historical roots.

74. See Isa. 40:18: "To whom, then, can you liken God, what form (דמות) can you compare to Him?" See also Isa. 40:25, 46:5. For the suggestion that this assertion constitutes a polemic against the priestly concept that man was created in God's image, see Weinfeld, "God the Creator," 124–25.

75. Nevertheless, Deuteronomy still accepts the premise that other peoples have a right to worship their own gods; see Deut. 4:19–20, 29:25.

3 ◆ ART IN THE SECOND TEMPLE PERIOD AND ITS AFTERMATH

JEWISH ARTISTIC REMAINS from a span of almost seven hundred years (known as the Second Temple period, from Cyrus to Hadrian) are far more extensive than those from the earlier Israelite period, with the latter part of this era being much richer in archaeological and artistic remains than the earlier part. The situation may be compared to an inverted pyramid, in which the amount of material is woefully limited at its bottom but becomes progressively abundant, reaching a peak in the Herodian–Early Roman era, when the evidence far exceeds all the previous centuries combined. In the final phase, between the revolts (70–135 CE), artistic remains once again become meager.

The Second Temple period can be divided into the Persian, Hellenistic, Hasmonean, and Herodian–Early Roman eras. We will treat these subperiods in succession, highlighting the characteristic artistic expressions of each and how they seem to reflect the prevailing cultural and religious trends. Unlike previous and subsequent periods of ancient Jewish history, most of the material from this era stems from the ruling classes as well as from Jerusalem and its environs, which now occupied center stage in Jewish life.[1]

As in earlier times, the Jews of the Second Temple period were also heavily indebted to the art of the contemporary dominant culture(s), although their borrowing was almost always highly selective.[2] Uniquely Jewish artistic motifs such as the menorah and showbread table appear only toward the end of this period, and even then in but a few instances. The Jews maintained their artistic distinctiveness primarily in what they chose *not* to display. The avoidance of any sort of figural art (cultic or decorative) from the Hasmonean era until the Bar-Kokhba revolt is noteworthy in this regard.

1. See L. I. Levine, *Jerusalem.*
2. See chap. 2.

THE PERSIAN ERA (536–332 BCE)

The primary artistic remains from this era appear on coins with the designation "Yehud" (so named for the Persian subprovince of which Jerusalem was a part), issued beginning in the fourth century BCE, although some scholars would date the earliest minting to the end of the fifth century (fig. 7).[3] These silver coins bore decorations of both inanimate subjects (such as the lily) and animate figures, including the owl (symbol of Athens), vulture, falcon (or eagle), a leaping winged animal, the goddess Athena, and a deity sitting on a winged wheel. Various human figures are also depicted, such as a warrior wearing a helmet and the head of a Persian king, and some coins bear both a figure and an inscription, such as "Yoḥanan the priest" (who in all probability was a high priest).[4]

The most interesting aspect of these coins is the appearance of human images. It would seem that in this period, continuing earlier Judahite and Israelite practice, Jews did not adhere to a stricter interpretation of the Second Commandment, possibly because the prohibition had not yet been fully developed, was simply ignored, or was interpreted in a very limited way that may have applied only to those images involving actual idolatry or displaying the likeness of Yahweh.[5] Also of interest on these coins are the types of images, including mythological figures, that were ubiquitous among other peoples. Thus not only was the Jerusalem authorities' practice of minting coins in and of itself a foreign import but their decorative motifs resembled coins from the eastern Mediterranean, places such as Athens, the coastal region of Palestine (these commonly referred to as Philisto-Arabian coins), and Cilicia in Asia Minor.[6]

Most unusual is the large and distinctive Yehud coin depicting a bearded and helmeted man wearing a himation, sitting on a winged wheel, and holding a bird (presumably an eagle or falcon);[7] it is much heavier than other Yehud coins and

3. See Mildenberg, "Yehud"; Meshorer, *Treasury*, 1–19; as well as Rappaport, "First Judean Coinage"; Machinist, "First Coins of Judah and Samaria"; Ariel, "Survey of Coin Finds," 275–77.

4. Barag, "Some Notes on a Silver Coin"; Barag, "Silver Coin of Yohanan the High Priest."

5. Machinist, "First Coins of Judah and Samaria." It is doubtful whether the Jerusalem minting authorities would have issued such coins if the populace had harbored reservations or objections.

6. E. Stern, "Archaeology of Persian Palestine," 112–13. See also Eph'al, "Changes in Palestine."

7. The literature on this coin is enormous. For a summary of various opinions, see Meshorer, *Treasury*, 2–6; Barag, "Coin of Bagoas"; and most extensively Edelman, "Tracking Observance," 185–205. Two possible identifications of the official who initiated the minting of this coin have been offered: a member of Jerusalem's Jewish elite (e.g., a high priest) or a local Persian governor (or *strategos*) by that name. The latter has been identified with Bagoas/Bagohi mentioned in the Elephantine papyrus (the late fifth and early fourth centuries BCE) or Bagoses noted by Josephus (*Ant.* 11.297–301) with regard to the mid-fourth century. Even following Josephus, it still remains unclear whether this Bagoas/Bagohi was the *stra-*

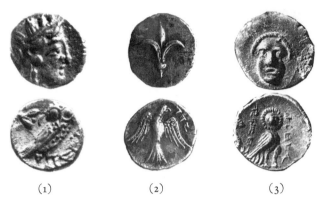

(1) (2) (3)

FIG. 7 Yehud coins: (1) Helmeted head of Athena and owl; (2) lily and falcon with outspread wings; (3) head facing front; owl with inscription: "Yeḥezqiah the governor."

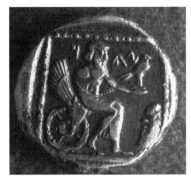

FIG. 8 Bearded male divinity seated on winged wheel and holding a falcon; above, Aramaic inscription: "YHD."

bears an Aramaic, not a palaeo-Hebrew, script (fig. 8).[8] At first the name Yehud was misinterpreted as referring either to a divinity, a generalized depiction of a composite creature,[9] or perhaps Yahweh (Yahu), the God of Israel. However since the time of Eleazar L. Sukenik there has been general agreement that the term refers to the local subprovince by that name.[10]

Nevertheless, opinions continue to be divided. While some remain convinced that it is Yahweh being depicted,[11] most scholars assume that the image in question is that of a pagan deity; Dionysus, the Sicilian god Hadranes, Baaltarz, Ahura Mazda, and others have been suggested. Not a few scholars have identified this image as that of a bearded and enthroned Zeus wearing a himation,[12] such as that appearing on a coin from Tarsus minted by Pharnabazus between 378 and 374 BCE.[13]

Persian-era Judaean coinage, with its heavy borrowing of foreign motifs, may seem surprising, particularly in light of the relative isolation of the city and prov-

tegos of Artaxerxes II (404–359 BCE) or of Artaxerxes III (358–338 BCE). For these alternative interpretations, see Barag and Edelman, above.

8. One explanation for the large-sized drachma in this case, as against the other, smaller Yehud coins, is that the former is to be attributed to a Persian official (hence the Aramaic inscription), while the latter was minted by local Jewish officials (see Meshorer, *Treasury*, 36–38; Edelman, "Tracking Observance," 201–2).

9. Mildenberg, "Yehud," 183–86; Mildenberg, *Vestigia Leonis*, 67–70.

10. Sukenik, "Oldest Coin of Judaea."

11. So, for example, Goodenough, *Jewish Symbols*, 1:271; Kienle, *Der Gott auf dem Flügelrad*, 68–74; Barag; "Coin of Bagoas," 99.

12. See A. B. Cook, *Zeus*, 1:232–37.

13. Clearly, the Jerusalem populace was exposed to depictions that were no different from those in use elsewhere in the western Persian Empire. It has also been proposed that this coin was minted elsewhere, perhaps Gaza or Philistia; see Barag; "Coin of Bagoas," 99; Gitler and Tal, *Coinage of Philistia*, 230–31.

ince reflected in a number of literary sources, particularly the books of Ezra and Nehemiah, although even the latter notes, albeit critically, some foreign influence (Neh. 13:14–28). However, the universalism articulated by Deutero-Isaiah (56:1–8, 60:1–3) and to a lesser extent Zechariah (14:16–21) offers a different perspective than the policy advocated by Ezra and Nehemiah. While Jerusalem society seems to have been less homogeneous than heretofore imagined, it is possible that the vast and heterogeneous Persian Empire not only encouraged diversity but also actively promoted it, directly or indirectly.[14] If we take into consideration that the conservative agenda of a Zerubbabel, Ezra, or Nehemiah may also have been, to some degree, a product of Persian interests and initiatives, then even these latter aspects of Judaean life should not be divorced from larger imperial trends. Thus a conservative bent seems to have flourished alongside more innovative and dynamic tendencies, as was the case in contemporary Egypt and as indicated by the Elephantine papyri. In this light, there is no better example of Judaea's cosmopolitan proclivity than the depictions on contemporary coinage.[15]

THE HELLENISTIC ERA (332–141 BCE)[16]

Following the conquest of Alexander the Great, Greek culture began permeating Judaean life, as it did throughout the Hellenistic East.[17] The most salient examples are to be found among the ruling and wealthy classes, but there can be little doubt that the middle and even lower classes were also affected, *mutatis mutandis*. Over time, with the active participation of the ruling classes, Hellenistic culture spread

14. Active Persian influence in Judaea has always been a recognized factor, beginning with Cyrus's proclamation of 538 BCE. Over the last generation, however, a more serious Persian impact on Yehud's affairs has been suggested, from the political and social roles and mandates of both Ezra and Nehemiah to encouraging the composition of a local constitution, i.e., the Torah; see Blenkinsopp, "Mission of Udjahorresnet"; Berquist, *Judaism in Persia's Shadow*; Watts, *Persia and Torah*, 3–8, and the literature cited therein.

On a different plane, Goodblatt has suggested that the use of the name Yehud for the Persian province and its recurrence in Aramaic sections of Ezra-Nehemiah (rather than Israel, which might have been preferred by the Jews themselves) may have been imposed by the Persian government (*Elements of Ancient Jewish Nationalism*, 140–42).

15. A propos, in a late series of Yehud coins (those with the inscription Yeḥezqiyah) the portrait of Athena is featured on one side and her owl on the other, while others bear only an owl and are blank on the other side, perhaps in order to avoid a figural depiction; see Meshorer, *Treasury*, 7–8.

16. Although the Hellenistic age in Jewish history is often defined as the 270 or so years between Alexander's conquest of Judaea in 332 BCE and Pompey's conquest in 63 BCE, we have divided this period into two parts: the early Hellenistic era (332–141 BCE), when Judaea was under the direct control of the Ptolemaic and Seleucid Empires, and the Hasmonean era (141–63 BCE), when Jerusalem and Judaea achieved political independence. As will be shown below, each era, particularly the Hasmonean, had different characteristics.

17. On earlier traces of such influence, see Hengel, *Judaism and Hellenism*, 1:32–35; regarding the post 332 era, see Erlich, *Art of Hellenistic Palestine*.

(1) (2)

FIG. 9 Yehud coins: Head of Ptolemy and eagle with outspread wings.

FIG. 10 Third-century stamped jar handles from Jerusalem: (1) Star with palaeo-Hebrew inscription: "Jerusalem"; (2) Rhodian amphora handles inscribed with the names of local priests in Greek.

even further throughout the various strata of Jewish society, although examples of the counter-assertion of local identity are likewise evident from the outset.[18]

Artistic remains from the third and early second centuries are woefully limited but seem to confirm these seemingly contradictory but nevertheless complementary trends. The evidence is threefold.

First, the minting of coins continued into the Early Hellenistic era, constituting a rather unusual phenomenon in the Ptolemaic Empire. No other city was allowed to continue minting local coins, yet for a period of time Jerusalem did so, using Ptolemaic motifs and the legend "Yehud" or "Yehudah." Some coins bear an image with the inscription "Yeḥezqiah the governor." Yeḥezqiah, or Hezekiah according to Josephus, lived toward the end of the fourth century (*Against Apion* 1.22.187–89) and reportedly was a high priest.[19] The images of one of the first Ptolemies, his wife (Berenice?), and a young man appear concurrently on these coins, as does the Ptolemaic eagle with outstretched wings (fig. 9).[20] These coins reflect the willingness of Jerusalem's leaders to continue using figural symbols borrowed from the outside world.

Second, the extensive excavations in the City of David over the last several generations have yielded a significant amount of material, some of which relates to this period. The principal evidence, stamped jar handles, reveals the above-noted dichotomous tendencies (fig. 10). On the one hand, several types of locally made stamped jar handles exhibit a conservative approach, featuring a palaeo-Hebrew script with the letters ט-יהד—apparently the continuation of a stamp type that ap-

18. See L. I. Levine, *Judaism and Hellenism*, 16–32; L. I. Levine, *Jerusalem*, 48–69, and the bibliography listed there.

19. See VanderKam, *From Joshua to Caiaphas*, 115–22.

20. See Barag, "Coinage of Yehud and the Ptolemies"; Meshorer, *Treasury*, 19–21.

peared in the Persian period but now using an Aramaic script.[21] A second type of jar handle (of which some 90 percent come from Jerusalem and its environs) features a five-pointed star and the palaeo-Hebrew inscription ירשלם ("Jerusalem"). Interestingly, the use of the pentagram is also found on handles from the Greek islands and thus the stamp may reflect a "Jerusalem" inscription embedded in a Hellenistic design.[22]

On the other hand, additional evidence from the City of David—over one thousand stamped jar handles originating on the island of Rhodes—attests undisputedly to Jerusalem's integration into the Hellenistic world. These amphora handles are engraved with official Rhodian stamps and are dated by the names of local priests who lived between the fourth and first centuries BCE, with the overwhelming majority dating from the mid-third to mid-second centuries BCE. These amphorae most probably contained imported wine, and such vessels were also found in many other cities at the time.[23] They offer an interesting glimpse into Jerusalem's integration into the trade network of the Hellenistic world.

And finally, in the early second century BCE, a member of the leading Judaean Tobiad family, one Hyrcanus, built a lavish complex of buildings and caves on his sixty-hectare estate in 'Iraq el-Emir east of the Jordan River, between Jericho and Amman (Josephus, *Ant.* 12.230–33). Excavations have revealed an enormous building erected on an artificial platform measuring sixty-six by forty-five meters; the site, referred to as Qasr al-Abd, has been identified alternatively as a fortress, temple, villa, manor, and palace. Animal reliefs, also noted by Josephus, once decorated the building on all sides; lions and eagles were placed along the second-story level, while two felines (panthers?) sculpted in high relief were located on ground level and served as fountains (fig. 11).[24] The overall lavishness of the estate, as well as the

21. Ariel and Shoham, "Locally Stamped Handles," 159–61. See also Avigad, *Bullae and Seals*, 25, and the literature cited therein. For suggestions regarding the meaning of the Hebrew letter ט (*tet*), see Cross, "Judean Stamps," 22–23; Avigad, "More Evidence," 52–54; Avigad, *Bullae and Seals*, 25 n. 81.

22. This parallel, as well as the most recent survey of the above-noted finds, is discussed in Ariel and Shoham, "Locally Stamped Handles," 161–63; see also Avigad, "More Evidence," 54–58.

23. Ariel, *Excavations at the City of David*, 2:13–25; see also Ariel, "Imported Greek Stamped Amphora Handles." There can be little doubt that such imports were intended for Jerusalem's inhabitants, and not necessarily foreigners residing in the city, such as the Ptolemaic military garrison. The latter's numbers were most likely insignificant at this time and would not account for the large quantity of jar handles discovered. If ordinary Jerusalemites indeed used this wine, we can assume that this was not in violation of the halakhah prohibiting the use of gentile wine. It is more likely that this later rabbinic law had not yet been formulated and that there were no religious constraints against the use of gentile wine in the third century BCE.

24. On archaeological excavations at the site and suggested reconstructions, see P. W. Lapp, "Soundings at 'Araq el-Emir"; Dentzer et al., "Monumental Gateway"; Will and Larché, *'Iraq al-Amir*; N. L. Lapp, "'Iraq el-Emir"; Berlin, "Between Large Forces," 11–12; Ji,

(1)

(2)

FIG. 11 Figural remains from 'Iraq el-Emir: (1) Sculpted lions on northern side of main building in Qasr al-Abd; (2) panther fountain in high relief on eastern side of the building.

above-noted animal decorations, are vivid testimony to the cosmopolitan tendencies among at least some of Judaea's aristocratic class in the early second century BCE.

THE HASMONEAN ERA (141–63 BCE)

While the establishment of the Hasmonean state engendered radical changes in the Judaean polity,[25] the cultural-religious sphere under the Hasmoneans, as in the preceding period, embraced contrasting and ostensibly contradictory developments. Hellenization was in evidence in varying degrees throughout Hasmonean society,[26] but at the same time cultural and religious markers were created to distinguish Judaea from the surrounding world. These include the banning of foreign wines, goods, and pottery, an emphasis on the importance of purity as evidenced by the first appearance of *miqva'ot*, the heightened centrality of the Temple and its ritual functions, and the emergence of organized religious groups.

"New Look at the Tobiads"; Netzer, "Tyros"; and most comprehensively Rosenberg, *Airaq al-Amir*; Larché, *'Iraq al-Amir*.

25. On the historical context of Hasmonean society, see L. I. Levine, *Jerusalem*, 91–148.

26. Bickerman, *From Ezra to the Last of the Maccabees*, 148–65; Rappaport, "On the Hellenization of the Hasmoneans"; Rajak, "Hasmoneans and the Uses of Hellenism"; L. I. Levine, *Judaism and Hellenism*, 143–47. See also Tal, "Hellenism in Transition."

A dramatic and far-reaching change took place in the realm of art as well.[27] The main component of ancient art generally, and no less of earlier Israelite-Jewish art, had been the use of images, be they of animals, humans, or deities (as discussed above). However, after almost a millennium of the widespread use of figural art, the pendulum swung sharply in the opposite direction at the outset of the Hasmonean period and remained as such for some three hundred years.[28] Starting with the family tomb Simon erected in Modi'in circa 142 BCE (1 Macc. 13:25–30),[29] archaeological remains relating to subsequent generations reflect an almost universal aniconic policy.[30]

A number of questions should be considered in trying to explain this change: Why were figural images banned? Why did this change take place precisely at this time? Was there an ideological underpinning to this policy? And, finally, what can account for Judaean society's immediate and almost universal acceptance of this prohibition? In response to the last-noted question, it may be suggested that the force behind these changes was the Hasmonean dynasty itself, just as it was undoubtedly instrumental in creating the other religious markers described above.[31]

We would further suggest that the book of Deuteronomy played an important role in shaping Hasmonean attitudes and policy regarding figural art.[32] Being in a situation analogous to that which the Deuteronomist describes (i.e., on the threshold of [re]conquering the Promised Land), the Hasmoneans seem to have identified with many Deuteronomic attitudes and incorporated them into their own practices—hostility toward the local pagan population, the destruction of all traces of idolatry (shrines and temples),[33] and the removal of the idolaters themselves (through conversion, execution, or exile). By instituting this rigorous antipagan

27. L. I. Levine, *Judaism and Hellenism*, 119–43.

28. On the other hand, a few scholars have claimed that figural art continued to appear throughout this period. For example, Gutmann ("'Second Commandment,'" 8–14) states that figural art never disappeared from the Jewish scene in the Second Temple period and that literary sources such as Josephus and Philo intentionally misrepresented Jewish religious practice for political reasons (having the Romans in mind). Besides the problematic treatment of certain sources (and ignoring others that contradict this theory), Gutmann disregards the archaeological data that, almost without exception, point to a virtually universal aniconism in Late Second Temple Judaea.

29. See below.

30. For a discussion of this phenomenon in greater detail, see L. I. Levine, "Figural Art in Ancient Judaism," 11–16.

31. L. I. Levine, *Jerusalem*, 91–99, 114–48.

32. On other echoes of Deuteronomy in Hasmonean literature, see L. I. Levine, "Figural Art in Ancient Judaism," 15–16.

33. On the strong anti-idolatrous polemic in Deuteronomy, see, e.g., 12:2–3, 13:2–19, 17:2–7, as well as Weinfeld, *Deuteronomy and the Deuteronomic School*, 320–24, 366–70; Rofé, *Introduction to Deuteronomy*, 60–65. See also Josephus (*Against Apion* 1.22.193), who undoubtedly is referring here to the Hasmonean era.

policy for the purpose of preserving the holiness and distinctiveness of the Chosen People,[34] the Hasmoneans were, in effect, striving to Judaize their realm.

Indeed, Deuteronomy's anthropomorphic aversion seems to have gone far beyond the worship of pagan cultic images, as the Israelites were apparently warned against all forms of image-making:

> The Lord spoke to you out of the fire; you heard the sound of words but perceived no shape—nothing but a voice. . . . For your own sake, therefore, be most careful—since you saw no shape when the Lord your God spoke to you at Horeb out of the fire—*not to act wickedly and make for yourselves a sculptured image [or] any likeness whatever having the form of a man or a woman, the form of any beast on earth, the form of any winged bird that flies in the sky, the form of anything that creeps on the ground, the form of any fish that is in the waters below the earth.* (4:12, 15–18; emphasis mine)[35]

While it is generally agreed that these injunctions against imagery were aimed first and foremost at idolatrous representations, the elaboration of specific types of images constitutes an emphatic series of prohibitions that seem to include not only the image of the deity but also other, noncultic representations.[36]

Whatever the original intention of the Deuteronomist(s), it is evident that the repeated emphasis on the avoidance of images easily could have led later interpreters, in Hasmonean times as well as today, to understand this injunction as covering a wide variety of visual representations, thereby creating the context for a far more comprehensive ban of figural images. It is this Deuteronomic emphasis, as interpreted by the Hasmoneans, that most likely provided the basis and justification for their dramatic move to (re)invent nonfigural art as a boundary marker between Jews and non-Jews.[37]

Because this prohibition of figural art was dictated and enforced by the political power of the Hasmoneans, the ban was adhered to quickly and almost universally

34. For the Deuteronomic basis of this injunction, applying the concept of holiness to all Israelites and not just the priestly caste, while excluding other peoples, see Deut. 7:6; 14:2, 21; and Weinfeld, *Deuteronomy and the Deuteronomic School*, 225–32.

35. See Schmidt, "Aniconic Tradition," 83–88; see also Mettinger, "Veto on Images," 26–27.

36. See Garr, *In His Own Image and Likeness*, 6–7. For the interpretation of these terms as synonyms in a construct state, see Weinfeld, *Deuteronomy 1–11*, 205; Tigay, *Deuteronomy*, 49. It is worth noting in this regard that the Decalogue formulation of Exod. 20:4 (פסל וכל תמונה) is far more inclusive than that of Deut. 5:8 (פסל כל תמונה), the last two words of which seem to be in apposition to the first. On the basis of the principle of *lectio difficilior*, the latter may thus be earlier, which would mean that the former formulation is, in fact, more comprehensive.

37. In this regard, see the following comment by P. D. Miller, *Religion of Ancient Israel*, 16: "Indeed, the comprehensiveness of these formulations (with reference to Deut. 4:16–19) tended to make any kind of image, whether for purposes of worship or not, questionable."

throughout Judaean society. It not only became normative under their rule but also continued to be widely observed, at least until the second century CE.

The elimination of figural art constitutes the Hasmoneans' most radical divergence from contemporary Hellenistic (as well as earlier Jewish) practice At the same time, however, they (and others as well) were heavily influenced by Hellenistic models with regard to nonfigural artistic motifs. Thus an interesting balance, already in evidence in Persian-Hellenistic times, emerged between the acceptance and rejection of outside culture, one that is apparent in the two main types of artistic remains from this era—funerary monuments and coins.

Funerary Monuments

Three funerary monuments from this period are known, the first via a literary source and the other two via archaeological evidence. Chronologically, the earliest example is the Maccabean tomb-monument in Modi'in built by Simon over an already existing family tomb:

> He erected seven pyramids, one in front of the other, for his father, mother and four brothers. For the pyramids he devised an elaborate setting, surrounding them with massive columns on which he placed full suits of armor for a perpetual memorial. Besides the suits of armor were carved ships that could be seen by all who sailed the sea. (1 Macc. 13:27–29)

It has been plausibly argued that the Hasmonean structure was an imitation of similar types of Hellenistic funerary monuments found in Asia Minor[38] and that the above description bears resemblance to the earlier tombs of King Mausolus in Harlicarnassus and the Belevi tomb in Ephesus (fig. 12). Each had a pyramidal top of polished stone and beneath it surrounding columns and decorations. Clearly, Simon went to great lengths to build an impressive monument in memory of his family, having adopted what seems to have become a widely known Hellenistic model.[39]

A generation or so later a wealthy Jerusalem family, probably of priestly lineage, erected a tomb west of the city, in today's Rehavia neighborhood (fig. 13).[40] Known

38. Berlin, "Power and Its Afterlife," 143–47; Berlin, "Between Large Forces," 32–33; Fine, *Art and Identity*, 3–8; Fine, *Art and Judaism*, 60–65; Magness, "Ossuaries and the Burials of Jesus and James," 124–25.

39. See Waywell and Berlin, "Monumental Tombs"; and especially Waywell, "Mausoleum at Halicarnassus." See, however, Tal, "Hellenism in Transition," 69–70 and n. 54. Similar funerary monuments were found in southern Syria (the tomb of Hamrath in Suweida) and Lebanon (Hermel and Kalat Fakra); see Fedak, *Monumental Tombs of the Hellenistic Age*, 148–50.

40. Rahmani, "Jason's Tomb," 61–100; Fitzmyer and Harrington, *Manual of Palestinian Aramaic Texts*, no. 89; Foerster, "Architectural Fragments from 'Jason's Tomb' Reconsidered"; Barag, "Tomb of Jason Reconsidered"; Puech, "Inscriptions funéraires palestiniennes," 481–99; Avigad, "Jerusalem," 751; Berlin, "Power and Its Afterlife," 142–43; Hachlili, *Jewish Funerary Customs*, 34–36, 163–66; Magness, *Stone and Dung*, 149–50.

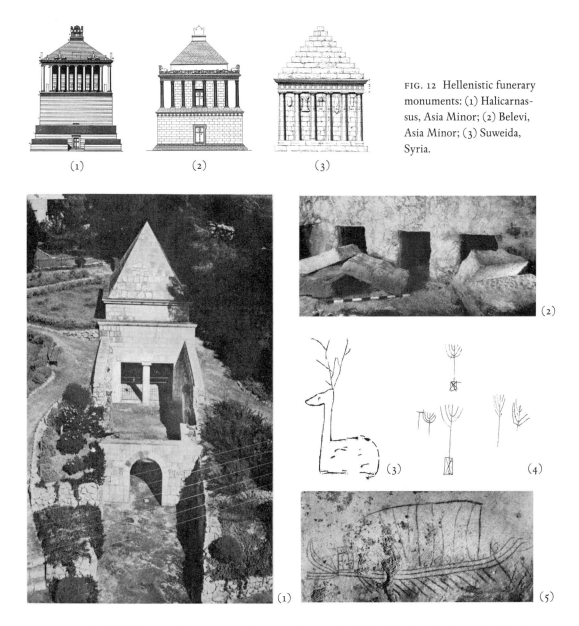

FIG. 12 Hellenistic funerary monuments: (1) Halicarnassus, Asia Minor; (2) Belevi, Asia Minor; (3) Suweida, Syria.

(1) (2) (3)

(1) (2) (3) (4) (5)

FIG. 13 Jason's Tomb: (1) View of reconstructed courts and pyramid; (2) *loculi* for burial in Room A; (3) etching of a stag; (4) graffiti of *menorot*; (5) graffiti of a warship.

as Jason's Tomb, it is crowned by a large pyramid, includes several courtyards in its entrance, and has a facade with an architrave and a single Doric column flanked by two pilasters. The tomb's ashlar blocks are well cut and fitted;[41] the entrance room or porch on the facade's interior is decorated with several graffiti and two inscriptions, one in Greek and another in Aramaic. One burial room contains a series of *loculi* (Heb. *kokhim*) along its walls, and another served as a bone repository for secondary burials. The appearance of *loculi* is a clear example of foreign influence, as this sort of burial arrangement, which originated either in Alexandria or Phoenicia, had reached Judaea only in the course of the Hellenistic period, perhaps via Maresha in the coastal region.[42]

Of particular interest in this tomb are the graffiti depicting three ships, a stag, a palm branch, and five *menorot*. Although the tomb is dated to the early first century BCE, there is no way of dating the graffiti, which could have been introduced anytime during the tomb's usage in the early first century CE. The appearance of *menorot* is unusual, as no other Jerusalem funerary remains display this motif. Moreover, what is the significance of the ships? Did those interred come from abroad? Were they merchants, seafarers, pirates?[43] And how does one explain the appearance of a stag, especially at a time when figural representations were frowned upon? The answers to these questions remain moot, but given the small repertoire preserved, the diversity of themes is indeed remarkable.

The third tomb from the Hasmonean era—that of Bnei Hezir—is located in the Qidron Valley, east of Jerusalem (fig. 14).[44] Its facade, too, is of the Doric order, but includes two columns flanked by two pilasters. The architrave bears a Hebrew inscription listing eight members of the priestly Hezir family (1 Chron. 24:15; Neh. 10:21) who were interred there. The inscription also mentions an accompanying *nefesh,* or funerary monument. Whether this edifice was destroyed or whether the term refers to the adjacent Tomb of Zechariah is unclear. Beyond the entrance porch are four chambers with *loculi* and an *arcosolium.*

The decorations in this tomb are negligible when compared to the other Hasmonean tombs discussed above. Only metopes and triglyphs on the frieze have been preserved, along with several geometric designs. The Hebrew inscription here, listing the names and genealogy of those interred, is likewise demonstrably conservative.

41. Regarding other Hellenistic influences on Jason's Tomb, see Foerster, "Architectural Fragments from 'Jason's Tomb' Reconsidered."

42. The Alexandrian connection has traditionally been claimed in this regard, although some scholars have argued for a Phoenician origin; see Tal, "On the Origin and Concept of the Loculi Tombs." But see now Erlich, *Art of Hellenistic Palestine*, 61–85, and esp. 80–81.

43. Rahmani, "Jason's Tomb," 69–73.

44. Avigad, *Ancient Monuments*, 37–78; Avigad, "Jerusalem," 750; Barag, "2000–2001 Exploration of the Tombs"; Hachlili, *Jewish Funerary Customs*, 262–63; Knauf, "Nabataean Connection of the Benei Hezir."

FIG. 14 Tomb of Bnei Hezir in the Qidron Valley: (1) Reconstruction of a tomb and *nefesh* according to Avigad; (2) reconstruction of tomb according to Barag; (3) inscription on the tomb's facade.

Coins

Throughout most of the Hasmonean era, from John Hyrcanus (134–104 BCE) through Alexander Jannaeus (103–76 BCE), and culminating with Mattathias Antigonus (40–37 BCE), the Hasmoneans minted their own coins.[45] Such evidence is particularly valuable, as it emanates from the ruling authorities and was intended to circulate among the masses. The very use of this particular medium reflects first and foremost a degree of Hellenization. The reappearance of coinage under the Hasmoneans, after a hiatus of over a century, was in line with other contemporary second-century ethnic and urban political groups that were likewise asserting their independence at this time, inter alia, by minting their own coinage.[46]

The motifs on these coins were drawn from the contemporary Hellenistic repertoire—the cornucopia, anchor, palm branch, wheel or star, lily, and helmet

45. The literature on Hasmonean coinage is quite extensive. See, inter alia, Meshorer, *Treasury*, 23–59; Hendin, *Guide to Biblical Coins*, 67–99; Kaufman, *Unrecorded Hasmonean Coins*.

46. See references in Schürer, *History*, 3/2:918–19.

(1) (2) (3) (4)

FIG. 15 Hasmonean coins: (1) Double cornucopia; (2) anchor with Greek inscription: "King Alexander"; (3) palm branch; (4) eight-pointed star with palaeo-Hebrew inscription: "King Yehonatan," between rays.

(fig. 15).[47] Moreover, the language, names, and titles appearing on these coins are often Greek. Many coins of Alexander Jannaeus have Greek inscriptions (later on, all of those minted by Antigonus were in Greek) and also bear the Hasmonean regal title (*basileus*) as well as the rulers' Greek names. Taken together, these various components reflect the desire to promote the rulers' Hellenistic profile.

This having been said, these same coins also reflect a strong desire to assert Jewish uniqueness and a strong ethnic/national identity. Significantly, the inscriptions appearing alongside those in Greek on most coins from this period are not merely in Hebrew but are written in the palaeo-Hebrew script reminiscent of First Temple times. They also bear the Hebrew names of the rulers (Yehoḥanan, Yehudah, Yehonatan) and their high priestly titles. Finally, the most distinctive "non-Hellenistic" marker on these coins is the total absence of images.[48] In this regard, the numismatic evidence is most dramatic, for the use of images, and particularly those of the ruling family, was ubiquitous throughout the Hellenistic world. The absence of such depictions was a bold statement that Jewish coins, and perhaps by implication Judaean society as a whole, remained unabashedly different.

This mélange of Hellenistic and Jewish components on coins was far from coincidental. For all the differences that undoubtedly existed from one Hasmonean ruler to the next, the common thread running through all of them was precisely their commitment to forge an integration of sorts between the Jewish and Hellenistic worlds. The Hasmoneans were comfortable with many aspects of Hellenistic culture yet were determined to erect barriers that would distinguish Judaean society from its surroundings. This proclivity found expression elsewhere as well. In Jericho, for instance, the Hasmoneans built a palace with a large swimming pool and

47. See Erlich, *Art of Hellenistic Palestine*, 96–97. Meshorer (*Treasury*, 34–35), however, views the lily as being essentially Jewish.

48. It is noteworthy that a uniquely Jewish component among the artistic motifs on Hasmonean coins is entirely absent until the dynasty's last king, Mattathias Antigonus (40–37 BCE). Only then do Jewish objects such as the menorah and the showbread table appear; see below.

pavilion, as was customary among other rulers at the time. Nevertheless, adjacent to this swimming complex were *miqva'ot,* a reminder of the purity concerns that related to their priestly status and its demands.[49]

Thus, in viewing artistic expression during the century of Hasmonean leadership, we can begin to appreciate the cultural and religious complexity of this society (or, at least, within its leading circles). Following the traumatic circumstances of 167 BCE (Antiochus's edict of persecution) and the achievement of independence, forging a renewed Jewish identity was a formidable task. The response of the Hasmonean state was to engage the outside world while asserting internally based norms, be it in the political, religious, or cultural realms. Doors were opened yet at the same time identity markers were set in place. Separatist Jewish practices and beliefs were actively cultivated together with an eye toward incorporating outside elements, at times significantly.[50]

Despite its quantitative limitations, contemporary art attests to these dynamic processes. Styles, architectural designs, and specific motifs were freely borrowed but always selectively and often with certain changes, such as omitting details, altering the composition, or combining designs. Rarely did anything appear that might be construed as religiously or culturally offensive. However, selectivity had little place in figural art; Hasmonean aniconic policy dictated a rejection not only of prior Israelite-Judaean practice but also of a universal Hellenistic convention. The elimination of figural representations, even if only decorative, was a major statement of Jewish otherness, creating a visible and visual separation between Jewish and contemporary norms.

UNDER HERODIAN AND EARLY ROMAN RULE
(63 BCE–70 CE)

Roman presence in Judaea, commencing with Pompey's conquest in 63 BCE, was met with mixed reactions by the inhabitants of Judaea.[51] For some it signaled the end of independence coupled with subjugation to a foreign power, with all its unsavory implications (greater fiscal exploitation; the danger of blatant offenses against Jewish religious practices; avaricious and insensitive, if not cruel, governors, etc.). For others, becoming an integral part of the Roman Empire had distinct advantages, affording peace and security (which were particularly welcome to a society that had suffered decades of civil strife), economic opportunities, and easy access to the wider world and an emerging far-flung Diaspora. These conflicting attitudes found expression on many levels—political, military, religious, and cultural. Jewish

49. Netzer, *Hasmonean and Herodian Palaces at Jericho,* 1:50–139. See also Erlich, *Art of Hellenistic Palestine,* 90–91.

50. See n. 32.

51. Rome was not new on the Eastern scene in the first century BCE and had made myriad contacts beforehand; see Osterloh, "Judea, Rome and the Hellenistic *Oikoumenê.*"

identities throughout this era were forged in large part by these apprehensions and hopes, and Jewish art, to which we will now turn, attests to this ongoing tension.

As noted earlier, the artistic remains from the Herodian era until the destruction of Jerusalem are far more abundant than those of earlier periods. While the two main categories discussed above for the Hasmonean era—funerary material and coins—continue to provide much of the evidence, Herodian domestic buildings discovered over the past generation add significantly to our knowledge. We will address each of these categories in turn.

Funerary Remains

While a relatively small cemetery was found in Jericho, the most important Judaean necropolis was in Jerusalem,[52] where more than one thousand burial caves have been identified, some nine hundred near the city and another hundred within a radius of two to three miles (3 to 5 km).[53] Doric, Ionic, and Corinthian architectural styles, either alone or in some combination, were predominant on capitals and friezes. A number of tombs have a portico, an ornamental facade, and a pyramidal or *tholos*-shaped monument; decorations often appear on friezes or on the pediment while the entranceway might be crowned by a gable containing floral motifs (foliage, acanthus leaves, and fruit). The most impressive exteriors are located in the Qidron Valley east of the city (Absalom's Tomb, the Cave of Jehoshaphat, and Zechariah's Tomb;[54] fig. 16, from left to right), and farther north were many others, some with striking facades, such as the Tomb of the Kings (fig. 17).[55]

On occasion, the interior of these tombs had decorated ceilings (as in Absalom's Tomb) and wall paintings. An unusually elaborate example of the former is Goliath's Tomb in Jericho, where grapevines, grape leaves, tendrils, and bunches of grapes dominate, although depictions of birds, a wreath, and possibly a structure (only its three courses of ashlar stones or brick masonry remain) also existed (fig. 18).[56]

The most abundant type of funerary remains in and around Jerusalem are the more than two thousand ossuaries[57] that held the bones of the decomposed bodies

52. The literature on these finds is voluminous. We have drawn heavily on the very useful and up-to-date volumes of Hachlili (*Jewish Funerary Customs*) and Kloner and Zissu (*Necropolis of Jerusalem*). See also Avigad "Jerusalem"; Goodenough, *Jewish Symbols*, 1:61–178; Geva and Avigad, "Jerusalem—Tombs."

53. Kloner and Zissu, *Necropolis of Jerusalem*, 1.

54. All of these names are biblical and were given to these monuments only in the Middle Ages. We have no idea how they were referred to in antiquity; see Avigad, *Ancient Monuments*, 3–8.

55. Far fewer tombs were to found to the west, of which the best known, other than Jason's Tomb, is the one commonly referred to as the Herodian family tomb.

56. Hachlili, "Jewish Funerary Wall-Painting."

57. Magness, *Stone and Dung*, 151–55. Contrast these ossuaries with the approximately twenty sarcophagi from this era (Hachlili, *Jewish Funerary Customs*, 115–26) whose decorative patterns closely resemble those on the ossuaries and the tombs discussed above.

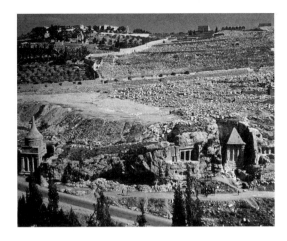

FIG. 16 Tombs in the Qidron Valley.

FIG. 17 Facade of the Tomb of the Kings (Queen Helena's tomb).

FIG. 18 Goliath's tomb in Jericho: Frescoed walls with representations of grapevines, grape leaves, and bunches of grapes.

of the deceased, placed there perhaps a year or so after death (fig. 19). The practice began during Herod's reign (37–4 BCE) and remained popular until the destruction of Jerusalem.

The rosette, with anywhere between three and twenty-four petals, appears on most decorated ossuaries.[58] Other geometric designs are also in evidence and include wreaths, flowers, palm trees, acanthus leaves, tendrils, lotus flowers, pomegranates, vines, grapes, and garlands.[59] Finally, a wide range of architectural elements, such as the tomb facade, wall, door, lintel, column, and *nefesh,* as well as trees and amphorae, is also represented.[60]

58. On ossuary decorations, see Goodenough, *Jewish Symbols,* 1:110–33, and vol. 3, nos. 105–231; Hachlili, *Jewish Funerary Customs,* 96–111; Figueras, *Decorated Jewish Ossuaries,* 37; Rahmani, *Catalogue,* 25–52.

59. Avi-Yonah, *Art in Ancient Palestine,* 13–27.

60. Rahmani, *Catalogue,* 28–34.

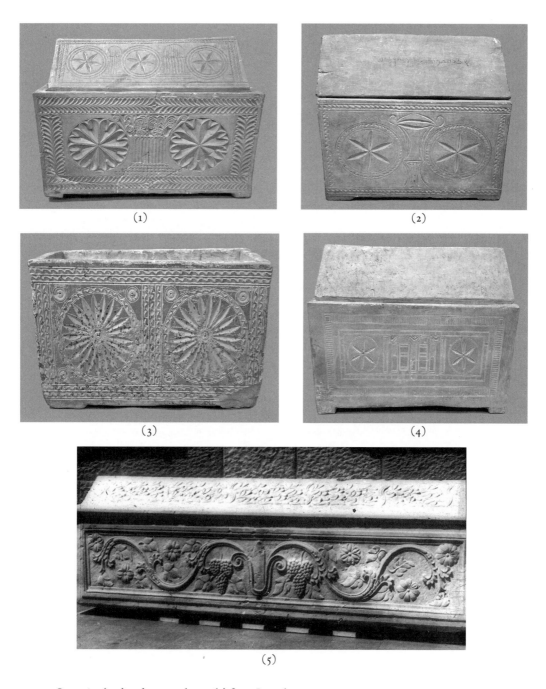

(1)

(2)

(3)

(4)

(5)

FIG. 19 Ossuaries (1–4) and a sarcophagus (5) from Jerusalem.

Coins

There are two main series of coins from this era, those of Herod and his dynasty during the last century of the Second Temple period, and those minted by the revolutionaries during the revolts against Rome in 66–70 CE and in 132–135 CE.[61]

Herod's coinage has been the source of much scholarly discussion and dispute.[62] Its chronology, motifs, and cultural significance, as well as the locations of his mints, have been variously interpreted. Yaakov Meshorer posits two sets of minted coins — those struck in Samaria during the first years of his reign, dated, and bearing Roman motifs, and those minted in Jerusalem, undated, and usually featuring more neutral depictions.[63]

Neutral images on Herodian coinage include the pomegranate,[64] diadem or wreath (enclosing a cross or the Greek letter *chi*), palm branch(es), anchor, galley, cornucopia, helmet,[65] vine, and table (fig. 20). Roman motifs include the apex (a ceremonial cap worn by Roman augurs), tripod and bowl, caduceus, and *aphlaston*,[66] but even these distinctions are far from clear. Some objects, such as the pomegranate (which looks like the head of a poppy plant and therefore could be associated with pagan cults), are not easily categorized, while opinions differ as to whether other motifs have Roman or Jewish significance.

61. Mention should also be made of the coins minted by the Roman governors of Judaea from 6–66 CE, which accommodated Jewish religious sensibilities by displaying only aniconic designs; see Meshorer, *Treasury*, 167–76. The major exception to this policy of accommodation was during the tenure of Pontius Pilate; see Bond, "'Standards, Shields and Coins."

62. See, for example, Meyshan, *Essays in Jewish Numismatics*, 85–97; Kanael, "Ancient Jewish Coins," 48–50; Richardson, *Herod*, 211–15; Meshorer, *Treasury*, 61–72; Ariel, "Jerusalem Mint." See also Fontanille and Ariel, "Large Dated Coin of Herod the Great."

63. See Ariel ("Coins of Herod the Great," 114–15), who notes that the motifs on the dated coins include a tripod, helmet, shield, winged caduceus, pomegranate (?), *aphlaston* (rear part of ship for measuring wind strength), and palm branch. On the nondated coins, see below. However, such a rigid distinction, for all its neatness, is not entirely persuasive. It is doubtful whether the Roman connection before 37 or the Jewish one thereafter can be conclusively demarcated. Earlier motifs are not exclusively Roman (e.g., the palm branch and helmet appear on the earlier Hasmonean coins), nor are later types necessarily strictly Jewish (e.g., table [?], eagle). See Richardson, *Herod*, 212. Nevertheless, most scholars generally accept the differentiation between earlier and later coin types, although other locales and time frames for the earlier mint have been suggested — Trachonitis, Tyre, Ashkelon, and Jerusalem itself; see Ariel, "Jerusalem Mint," 100, 101 n. 9; Ariel, "Coins of Herod," 121–23; Magness, "Cults of Isis and Kore," 168–69.

64. Meshorer (*Treasury*, 64) interprets this image as a poppy head, symbolizing the cult of Demeter in Samaria (Sebaste), where this coin was supposedly minted.

65. See, however, Hendin, "New Discovery," 32.

66. See Goodenough, *Jewish Symbols*, 1:274. The pagan orientation of Herod's coinage motifs is emphasized by Jacobson, "New Interpretation of the Reverse"; Kokkinos, *Herodian Dynasty*, 122.

FIG. 20 Herodian coins: (1) Anchor; (2) table; (3) double cornucopia and galley; (4) poppy pod on a stem with leaves and winged caduceus; (5) tripod and helmet with cheek pieces.

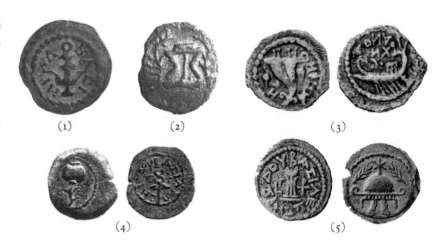

(1) (2) (3)

(4) (5)

One such example is the table (or tripod) motif. Meshorer maintains that it was a well-known Jewish artifact in the Temple and domestic settings, with several examples having been discovered in the Jewish Quarter excavations in Jerusalem.[67] David M. Jacobson, however, interprets this motif as a tripod with clear pagan associations.[68] The palm branch is similarly ambiguous and could easily be regarded as either Jewish or pagan.[69] It is quite possible that both interpretations are valid and that certain motifs may have been chosen precisely for their ambiguity. If this is the case, we may have here an example of Herod's political astuteness in depicting an object to which both his Jewish and pagan subjects could relate, each in their own way, without taking umbrage.[70]

The distinction noted above between earlier dated coins and later undated ones is engagingly suggestive. The more blatant Roman/pagan symbols appear on the earlier issues, a policy that would make sense since, while fighting the Hasmonean King Antigonus and his Parthian backers, Herod was heavily dependent on Roman support. His use of such motifs at this stage may have been intended not only as a gesture of loyalty to Rome but also to facilitate monetary transactions in larger denominations for both his and the allied Roman troops. The fact that the motifs used by Herod were particularly ubiquitous on Republican coinage of the late 40s BCE would seem to strengthen this argument.[71]

Following his war of accession (40–37 BCE) and having secured his sovereignty over Judaea, Herod now shifted gears, and in the nineteen denominations we know of from the remainder of his reign, he used, almost without exception, motifs that

67. Meshorer, *Treasury*, 66–67. See also Avigad, *Discovering Jerusalem*, 167–73.

68. Jacobson, "Herod the Great Shows His True Colors," 102–3. For a tripod on a contemporary Augustan coin, see Sutherland and Carson, *Roman Imperial Coinage*, 69. See also Meyshan, *Essays in Jewish Numismatics*, 87–88.

69. Kanael, "Ancient Jewish Coins," 48; Ariel, "Jerusalem Mint," 103–5.

70. Kanael, "Ancient Jewish Coins," 48–50.

71. Meshorer, *Treasury*, 61–63; Ariel, "Jerusalem Mint," 107.

would have been unassailable to the wider Jewish populace.[72] Thus Herod demonstrated through his coins a loyalty to and identification with the artistic orientation that had held sway in Judaea over the previous century.

FIG. 21 Eagle coin with cornucopiae.

The one major exception to this politically prudent policy is the appearance of the eagle in a series of Herod's coins, an act that seems to have blatantly defied current Jewish practice and contradicted his own policy of eschewing figural art in both the public and private realms (fig. 21).[73] From their large number, second only to the diadem motif, it appears that the eagle coins were issued over a number of years. Added to this conundrum is another, perhaps related, one—Herod's blatant defiance of Jewish norms in erecting an eagle over a gate in the Temple precincts (Josephus, *War* 1.647–65; *Ant.* 17.149–63). Such an innovation could not have been introduced without arousing Jewish opposition.

Before addressing the issue of Herod's motives here, it is worth noting the different reactions of the Jews in the two instances. The people seem to have accepted the eagle motif on coins, for we read of no public agitation or dissent.[74] In contrast, Jewish reactions to the golden eagle appear to have been swift and severe. This difference may be due to the form of the eagle (an image on coins versus a statue) or where it was placed (on a small everyday object versus the Temple precincts). The eagle on the coins was two-dimensional and could have been considered a Jewish symbol,[75] and given the other coins with eagle motifs circulating in Judaea, first and foremost those from Tyre widely used for payments due to the Temple itself, Jews might not have considered this motif particularly offensive. However, placing a three-dimensional statue of a golden eagle in a very prominent and public location within the Temple precincts would easily have been construed as an act of a different color, reflecting a gross disregard for Jewish religious sensibilities.[76]

72. L. I. Levine, *Jerusalem*, 181–83.

73. True enough, heads of the god Selinus were found carved on the handles of a marble water basin at Herodium; see Netzer, *Architecture of Herod*, 194—but this is an exception to the rule that was adhered to rather strictly in all of Herod's palaces.

74. Nevertheless, even here we must bear in mind that the absence of evidence is not always evidence of its absence; there may have been unrest, but Josephus, for whatever reason, chose not to report it.

75. See Goodenough, *Jewish Symbols*, 8:121–29; Grant, *Herod the Great*, 207–8; Meshorer, *Treasury*, 67–69.

76. Many reasons have been suggested for the resultant Jewish agitation—transgression of the Second Commandment, opposition to its symbolic meaning (an affirmation of Roman or Herodian rule), its placement in the Temple precincts, etc.; see van Henten, "Ruler or God?" 271–85.

It would seem that in the production and placement of the eagle Herod first and foremost had Rome in mind, given his increasingly precarious political position and questionable mental state toward the end of his life. He seems to have wanted to appease and accommodate Rome by symbolically reaffirming his loyalty and identification, perhaps even with an eye toward the imminent succession to his rule, which was in Rome's hands.

Having made similar gestures toward Rome for some years via his coins, Herod now decided to do something even bolder, more public, and more dramatic. This was so provocative an act that it is simply inconceivable for Herod to have done this in his earlier, more stable, days, when his political savvy would have prevented such an extreme and ill-advised gesture. But times were different by the last years of his reign,[77] and Herod faced growing hostility not only at home, in his court and among certain elements in Jewish society,[78] but also vis-à-vis Augustus and other Roman allies. Only in this light, and without speculating about the liberal and tolerant nature of his Jewish values—speculations that only serve to distort the religious and political reality of the Late Second Temple era—can we perhaps begin to understand such uncharacteristic behavior.[79]

77. Most scholars rightly date the golden eagle episode to the very last years of Herod's reign (e.g., Schürer, *History*, 1:312–13; A. H. M. Jones, *Herods of Judaea*, 147–48; Otto, *Herodes*, 112; Hengel, *Zealots*, 207). The main argument for this dating is twofold: (1) The narrative of the eagle's destruction appears in the *Antiquities* account of these last years, and, given the book's chronological format, it would appear to have occurred then; (2) it is difficult to separate the violent reaction to the eagle from when it was first erected. It seems most improbable that the eagle might have been in the Temple precincts for ten or fifteen years, as has been suggested (Richardson, *Herod*, 16–17), and only much later did a group of zealots attempt to demolish it.

78. So, for example, the activities of some Pharisees against him (*Ant.* 17.41–45) as well as the refusal of some six thousand subjects to swear loyalty to him. Van Henten has recently suggested that the eagle reflects Herod's own claim to power and authority, and it was this issue that was at the root of the clash between him and "a radical group of Jews" ("Ruler or God," 273, 285).

79. We encounter rather diverse behavior with regard to the coins of the later Herodian dynasty. On the one hand, both Archelaus and Herod Antipas (the former ruled Judaea for ten years and the latter the Galilee for forty-three years) adhered to the accepted Jewish policy of the time and never depicted any figure or symbol on their coins that might have been considered offensive. It should be noted, however, that in his palace in Tiberias, Antipas did what his father never allowed himself to do, namely, display images of animals for decorative purposes; see Josephus, *Life* 12.65.

On the other hand, Philip, who controlled the northeastern regions of Trachonitis, Auranitis, Batanaea, and the territory of Zenodorus, all of which were overwhelmingly pagan, had no compunctions about using a variety of figural and even pagan images (perhaps because this was expected by his subjects). Herod's grandson, Herod Agrippa, adopted a fascinating dual policy. In Jerusalem he fully adhered to the regnant norms of Second Temple Jewish society, but in Caesarea his policy was very much in line with Roman practice, including images of the emperor and even of himself. Agrippa's "Caesarea" policy is also reflected in his

Domestic Settings (Palaces and Villas)[80]

We are relatively well informed about domestic art owing to the extensive excavation of many of the king's palaces and fortresses in the Judaean Desert (such as Masada, Herodium, Jericho, and Cypros), where climatic conditions are conducive to their preservation, and also to the large-scale excavations in the Upper City of Jerusalem, home to many of the city's priestly and lay aristocracy.[81]

Decorative motifs appear on column shafts and flutings, column bases, pedestals, capitals, friezes, architraves, and ceilings.[82] In addition, decorative schemes also found expression on wall paintings, which were either plain or bore various types of floral and geometric motifs, although most ubiquitous was a widely used architectural pattern—square or rectangular panels with variations of imitation marble; in most places, the color scheme was an important component of the overall design.[83] Remains of both fresco and secco paintings were discovered in many Herodian palaces, as well as clusters of apples, pomegranates, and leaves (the garland motif), the latter depicting three-dimensional dentils (fig. 22).

dramatic appearances at the theater there, causing the crowds to call him a godlike figure, as well as in his decision to erect statues of his daughters in the city (*Ant.* 19.343-57).

Agrippa II became governor, and later king, over the regions once controlled by Philip, and by 55 CE his territories also included the Galilee and Peraea. Agrippa's policy regarding the art used on his coins fluctuated in response to the ethnic and religious orientation of his subjects. He observed the aniconic line in his coinage at Sepphoris, Tiberias, and Paneas, but after 70, given the overwhelmingly non-Jewish population of his realm, issued coins with blatantly pagan motifs, the most ubiquitous of which were portraits of the Flavian emperors on the obverse of all his coins. See Schürer, *History*, 1:471-83; Kushnir-Stein, "Coins of Agrippa II"; Meshorer, *Treasury*, 78-114; M. H. Jensen, *Herod Antipas in Galilee*, 187-217; D. R. Schwartz, *Agrippa I*, 107-11, 203-7.

80. For this section on domestic art and decoration, which includes finds from excavations in Jerusalem, Jericho, and Masada, I am indebted to: Rozenberg, "Wall Paintings"; Fittschen, "Wall Decorations"; A. Ovadiah, "Mosaic Pavements of the Herodian Period"; four appendices appearing in Netzer, *Architecture of Herod*: Peleg, "Herodian Architectural Decoration," Rozenberg, "Herodian Stuccowork Ceilings," Rozenberg, "Herodian Wall Paintings," and Talgam and Peleg, "Herodian Mosaic Pavements"; Barag and Hershkovitz, *Masada*, vol. 4, *Lamps*, 1-105; Bar-Nathan, *Masada*, vol. 7, *Pottery*, 245-78; Rozenberg, "Wall Painting Fragments from Area A"; Geva and Rosenthal-Heginbottom, "Local Pottery from Area A"; Rosenthal-Heginbottom, "Hellenistic and Early Roman Fine Ward from Area A"; Japp, "Public and Private Decorative Art"; and Rozenberg, *Hasmonean and Herodian Palaces*, vol. 4. Finally, in the recent volume edited by Jacobson and Kokkinos (*Herod and Augustus*) we find several relevant articles by Rozenberg ("Wall Paintings") and Hershkovitz ("Herodian Pottery"). See also Corbo, *Herodion*, vol. 1, colored plates I-X.

81. L. I. Levine, *Jerusalem*, 326-35.

82. See Rozenberg, "Herodian Stuccowork Ceilings."

83. Rozenberg, "Herodian Wall Paintings," 365-68; Rozenberg, *Hasmonean and Herodian Palaces*, 425-73.

FIG. 22 Fresco fragments from the Jewish Quarter in Jerusalem: (1) A column and an entablature; (2) apples and foliage.

FIG. 23 Herodian mosaic floors: (1) Masada; (2) Herodium; (3) Jerusalem.

However, the most striking artistic displays from the domestic setting are the mosaic floors (fig. 23).[84] Some twenty such floors have been found in Herodian buildings, half of which come from private bathing chambers (*balinea*), the remainder from various rooms and halls—and in three cases from triclinia. As noted, the most common motif is the rosette, often with multiple petals or appearing in a series of intersecting rosettes, sometimes enclosed in a square frame and a circle. Most panels were decorated with the standard floral or geometric designs. Alternatively, a floor might be paved with square and triangular stone tiles placed side by side, and in a number of instances, as in Cypros and Masada, with a repetitive carpet design. On occasion, *opus sectile* floors were laid; the large triclinium of Herod's third palace in Jericho used three different *opus sectile* patterns as well as a mosaic panel in the center.[85]

Thus, artistic decorations in Herodian domestic settings follow the patterns noted with respect to other facets of Judaea's material culture—the absence of figural art, the emphasis on floral and geometric patterns, and the use of architectural motifs. In all types of artistic remains, elements drawn from Hellenistic tradition appear side by side with styles current in Rome and throughout the empire, with the Roman component becoming more dominant in the course of Herod's reign.[86] Less prominent is the Nabataean influence, and what exists may not have been directly borrowed but derived from what had been embedded in earlier Hasmonean artistic activity.

The Menorah

In addition to its aniconic policy, the Late Second Temple period witnessed a second major innovation in the realm of Jewish art, one that later began to flourish and continues to this very day. For the first time, uniquely Jewish motifs made their appearance, and this was expressed primarily through the depiction of the menorah[87] and, to a lesser extent, the showbread table (on which the twelve loaves of showbread [לחם הפנים] were placed in the Temple). These depictions were found primarily (though not exclusively[88]) in Jerusalem in four distinct priestly con-

84. See Hachlili, *Ancient Mosaic Pavements*, 5–14.

85. Talgam and Peleg, "Herodian Mosaic Pavements," 381–82; Rozenberg, *Hasmonean and Herodian Palaces*, 523–35. Stonework fragments of stone tables also display floral and geometric patterns (and even a fish), especially along their sides, pottery bowls and a glass krater likewise display floral designs, and one sundial exhibits a rosette on its side.

86. See Japp, "Public and Private Decorative Art"; regarding Jerusalem specifically, see Avigad, *Discovering Jerusalem*, 95–120.

87. For a comprehensive review of the menorah in antiquity, see Hachlili, *Menorah*; L. I. Levine, "History and Significance of the Menorah," 134–37.

88. See generally Habas, "Incised Depiction of the Temple Menorah," 336–37. Most recently, a five-branched menorah incised on a stone vessel was found near the Temple Mount (personal communication, Ronny Reich), and the first appearance of a menorah in a synagogue setting was found carved on a large stone block found in the center of the hall of a

FIG. 24 *Menorot* from late Second Temple Jerusalem: (1) Coin of Antigonus with a menorah and showbread table; (2) plaster remains from Upper City of Jerusalem; (3) sundial from the Temple Mount; (4) Jason's Tomb; (5) stone block from the Migdal synagogue.

texts (fig. 24). First, a small bronze coin (of which forty specimens are known to date) was struck by the last Hasmonean ruler, Mattathias Antigonus (ca. 37 BCE). A seven-branched menorah with a triangular base appears on its reverse, a showbread table on its obverse (in several instances with two piles of bread).[89] Second, two plaster fragments depicting a menorah were found in the excavation of a house from the Herodian Upper City of Jerusalem. The menorah, standing some twenty centimeters high, originally had a triangular base and seven tall U-shaped branches with alternating ovals and two parallel lines, and flames on top.[90] To the right of the menorah were schematic designs of several objects, which Bezalel Narkiss suggests refer to the showbread table and the golden altar, both of which stood near the menorah in the *heikhal;* Dan Barag further opines that the tip of a three-stepped stone on which the priest stood when lighting the menorah is visible on the menorah's left side.[91] Third, a stone sundial dating to the Herodian period was discovered in

newly discovered first-century CE synagogue at Migdal, north of Tiberias (see fig. 24.5). A report of this excavation is as yet unpublished. In addition, three graffiti of *menorot* were found on the walls of an oil press at Bet Loya on the Judaean coastal plain, southeast of Maresha, and in all probability date to the first century BCE or CE. See Gutfeld and Haber, *Guide to Beit Loya,* 18–19.

89. Meshorer, *Treasury,* 54–57.

90. Avigad, *Discovering Jerusalem,* 147–49.

91. B. Narkiss, "Scheme of the Sanctuary," 6–15; Barag, "Temple Cult Objects Graffito"; Habas, "Incised Depiction of the Temple Menorah."

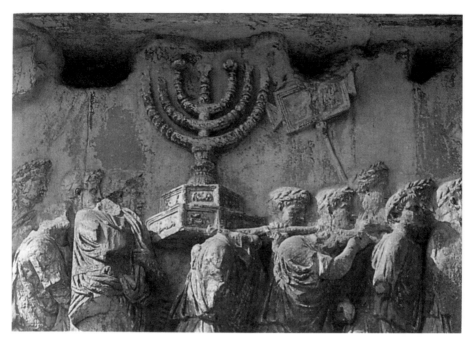

FIG. 25 Arch of Titus.

the Temple Mount excavations.[92] And finally, graffiti of five seven-branched *menorot* were found incised on the wall of the entrance to Jason's Tomb (see above).

The Arch of Titus in first-century CE Rome features the most famous representation of the menorah (fig. 25). Erected at the outset of Domitian's reign (81–96 CE), the arch depicts Titus's triumphal procession upon his return to Rome a decade earlier; Josephus's vivid account of this event emphasizes the prominence of the menorah (*War* 7.148–50). This artifact, crafted by Roman artisans who had the original representation at hand, constitutes the most important testimony for the form of the Temple menorah.[93]

Why the menorah, an object of clear religious significance, should make its first appearance at this time is difficult to ascertain. The need for such a representation (aside from the Antigonus coin, for which there seems to have been a clear-cut political-religious purpose) undoubtedly resulted from the heightened importance of the Temple generally, especially in light of Herod's massive expansion and rebuilding of the entire Temple Mount area, with the renewed and enlarged Temple edifice serving as its centerpiece. The menorah (and to a lesser extent the showbread

92. Hachlili, *Art and Archaeology — Israel*, 239, fig. 2a; Hachlili, *Menorah*, 24.

93. For a detailed architectural and artistic description and analysis of the Arch of Titus, see Pfanner, *Der Titusbogen*. On the disagreement among scholars with respect to the origins of this menorah's base (with its mythological motifs), see L. I. Levine, "History and Significance of the Menorah," 138–39, and the bibliography cited therein.

table) was selected expressly for representation because of its prominence in the Temple. Moreover, its unique features may have made it an especially appealing art object to reproduce.

The relative absence of the menorah in the post-70 era generally and on the coins of the two revolts would seem to indicate a reluctance to depict most Temple-related "sacred" objects. Such an aversion is reflected in a tannaitic tradition from the second or early third century, in which there is a general prohibition regarding the replication of Temple-related objects, especially the menorah, reflecting a clear proclivity among at least some second-century Jews to eschew such images.[94]

THE FIRST JEWISH REVOLT (66-70)

Silver and bronze coins were issued during the First Revolt[95] for both political and economic purposes—as propaganda for the revolt for independence (or redemption) and as a resource for economic activity. There also may have been several religious objectives, such as guaranteeing the requisite coinage for Temple donations with issues of exceptionally high silver content or providing visual confirmation of the Temple's importance. Religious motivation for this type of coinage might indeed explain the use of silver, a practice avoided over three hundred years earlier with the discontinuation of the Yehud coins.

The silver shekel and half shekel were minted throughout the entire revolt,[96] the two main motifs on these coins being the chalice on the obverse and a branch with three pomegranates on the reverse (fig. 26). The obverse is accompanied by the inscription "Shekel of Israel"[97] and the reverse by "Jerusalem the Holy." The chalice is large and has a wide brim decorated with pellets, but what it represents remains elusive; many scholars believe it is to be associated in some way with the Temple, as a cup either for libations of wine or water or for the *omer* offering.[98] The pomegranate appears in earlier and later Jewish art and may have been simply decorative or intended to represent one of the fruits of the Land of Israel.

In addition, small bronze coins (*perutot*) were struck from the second year of the revolt on, although in year 4 these were replaced by large bronze specimens minted in four denominations. Coins of years 2 and 3 bear an amphora and the inscription "Year Two" or "Year Three" on the obverse, and a grape leaf with the legend

94. B Menaḥot 28b; B Rosh Hashanah 24a; B 'Avodah Zarah 43a; Midrash Hagadol, Exodus 20:20, pp. 440–41. For the Bavli text, see chap. 20.

95. On the coins of the First Revolt, see, inter alia, Kadman, *Coins of the Jewish War*; Meshorer, *Treasury*, 115–34; Mildenberg, *Vestigia Leonis*, 168–69; McLaren, "Coinage of the First Year"; Goodman, "Coinage and Identity"; I. Goldstein and Fontanille, "New Study of the Coins"; Rappaport, "Who Minted the Jewish War's Coins?"

96. A quarter-shekel coin was minted in the first year only.

97. On the meaning of "Israel" on the coins of both revolts, see Goodblatt, *Elements of Ancient Jewish Nationalism*, 124–34.

98. Meshorer, *Treasury*, 106–7; Romanoff, *Jewish Symbols on Ancient Jewish Coins*, 21–25 (although he mistakenly dates these coins to Simon the Maccabee).

"Freedom of Zion" on the reverse. Other motifs introduced in year 4 include a date palm flanked by two baskets of fruit, two *lulavim* with an *ethrog* between them, a single *ethrog*, and a chalice. The inscription now reads "For the Redemption of Zion," which is perhaps indicative of an eschatological message.

Many motifs on these coins were new to the artistic repertoire of Second Temple Judaea, some rarely to be repeated. Indeed, this may well indicate the existence of a new minting authority then operating in Jerusalem. While the *lulav* and *ethrog* can be identified with the holiday of Sukkot (and were to reappear much more frequently on the coins of Bar-Kokhba), this is the first time that such motifs were used. The significance of the other depictions is far less certain. The tendency among many scholars has been to associate them with various Temple utensils or local agricultural produce, but most of these suggestions remain speculative.

(1) (2)

FIG. 26 Coins of the First Revolt: (1) Chalice and branch with three pomegranates; (2) palm tree with two baskets of dates and two bundles of *lulavim* flanking an *ethrog*.

The Bar-Kokhba Coins

Issued over a three-year period, the Bar-Kokhba coins,[99] made of both silver and bronze, are overstrikes of already existing Roman coins. They usually bear the inscription "Simon, Prince of Israel," leader of the revolt, although "Eleazar the Priest" also appears. The legends include "Jerusalem," "For the Redemption of Israel," "For the Freedom of Israel," and "For the Freedom of Jerusalem."[100] In general, there is some continuity between the coinage of the First Revolt and that of Bar-Kokhba, although the latter displays a greater repertoire. Motifs often focus on the Temple, its appurtenances, and the Sukkot holiday (fig. 27),[101] as demonstrated by the appearance of the Temple facade on the obverse and the Sukkot symbols (the *lulav* and *ethrog*) on the reverse. The importance of the proper observance of this holiday among Bar-Kokhba's forces finds expression in his letters as well.[102]

99. On the Bar-Kokhba coins, see, inter alia, Mildenberg, *Coinage of the Bar Kokhba War*; Mildenberg, *Vestigia Leonis*, 183–240; Meshorer, *Treasury*, 135–65; Kindler, "Coinage of the Bar-Kokhba War."

100. For a suggested context for the minting of the coin type "For the Freedom of Jerusalem," see Eshel, "Bar Kochba Revolt," 115.

101. On the appearance of a golden vine on the Temple facade appearing on the Bar-Kokhba coins, see Patrich, "Golden Vine."

102. See Y. Yadin et al., *Documents from the Bar Kokhba Period in the Cave of Letters*, 322–28, 351–62; Y. Yadin, *Bar-Kokhba*, 128–30; Meshorer, *Treasury*, 145–46.

FIG. 27 Coins of the Bar-Kokhba revolt: (1) Temple facade, *lulav*, and *ethrog*; (2) lyre and grape cluster; (3) palm tree; (4) amphora; (5) Temple facade with enigmatic object in the center.

Attempts have also been made to connect other motifs appearing on the Bar-Kokhba coins with either the Temple or Sukkot. For example, the jug (or flagon) has been identified as a vessel used for water libations on this holiday, the amphora for some similar ritual, the harp, lyre, and trumpets with the Temple service, and the palm tree and wreath with the booths (*sukkot*) themselves. Notably missing from this repertoire, as well as from the coinage of the First Revolt, is the menorah, and this may be connected, as noted in the rabbinic source cited above,[103] with opposition to depicting a central Temple object that was considered particularly holy.[104]

While the facade motif on these coins is clear, it is not certain to which Temple or to what part thereof they refer—the Temple destroyed in 586 BCE or in 70 CE, the Temple Bar-Kokhba may have intended to build, an outer facade or an inner entranceway.[105] The object in the middle of the facade, presumably standing inside the building, has also generated discussion: Is it the Tabernacle or the First Temple ark, the Torah shrine, the showbread table, or perhaps something else?[106]

103. See n. 94.

104. However, several *menorot* were drawn on the walls of a cave north of Jerusalem, where people sought refuge during or after this revolt; see Patrich, "Caves of Refuge and Jewish Inscriptions," 156.

105. Meshorer, *Treasury*, 144.

106. Ibid.; Barag, "Showbread Table and the Façade of the Temple" ("The Table of the Showbread," nos. 77–78). See also the suggestion that placing an object (a bust or statue of the emperor or god) in the entrance to a temple depicted on a coin was a well-known Roman practice. The Bar-Kokhba coins with a similar arrangement may have been a Jewish adaptation of this practice; see Fraade, "Temple as a Marker of Jewish Identity," 264 n. 85.

The coinage from the two revolts continues the rather conservative agenda of artistic representations in the Late Second Temple era. Moreover, the extent to which the Bar-Kokhba coins may have included Temple-related motifs and holidays would not be surprising. Not only may the reestablishment of the Temple have been a major goal of the latter revolt, but if a priestly ideology and leadership stood at its forefront, as has been argued,[107] then a highly visible Temple agenda becomes all the more explicable.

THE SECOND CENTURY: THE FIRST SIGNS OF CHANGE
VIS-À-VIS FIGURAL ART[108]

Although figural art, and certainly that of the pagan variety, was almost universally avoided in the Late Second Temple period, several sources relating to the second century suggest that some hints of change may have surfaced at this time.

The first is the mishnaic report of R. Gamaliel II's visit to the bathhouse of Aphrodite in Acco.[109] Not only did he bathe in what was considered a very Hellenistic, if not pagan, setting, but he responded to a surprised non-Jewish observer's questions with a series of justifications for such behavior. Since the absence of figural representation had heretofore constituted one of the cardinal distinctions between Jewish and non-Jewish societies,[110] Gamaliel's actions reflect how at least one sage, albeit a precursor of the Patriarchal dynasty,[111] may have grappled with this issue.[112]

A second hint of change in the art used by Jews relates to the second and early third centuries, when Tiberias and Sepphoris issued coins featuring representations of pagan gods and temples (fig. 28). The coinage of Tiberias depicts Tyche, Zeus, Poseidon, Hygeia, and Asclepius,[113] and that of Sepphoris, beginning with the reign of Antoninus Pius, displays the Capitoline Triad (Zeus, Hera, and Athena), Tyche, and various temples. The use of blatantly pagan motifs on the coins of these two Jewish cities is striking, constituting not only a radical departure from the numismatic practice of previous centuries but also a clear deviation from the types of coins that these very same cities had issued just a generation or two earlier, in the first century CE.[114]

We can only speculate as to the reason for the change in attitude toward figural art.[115] The destruction of Jerusalem and the termination of the Herodian dynasty

107. Goodblatt, "Priestly Ideologies"; Goodblatt, "Title 'Nasi'"; Ben-Haim-Trifon, "Some Aspects of Internal Politics"; Schäfer, "Bar Kokhba and the Rabbis."

108. For a more detailed presentation of this material, see L. I. Levine, "Figural Art in Ancient Judaism," 17–23.

109. M 'Avodah Zarah 3, 4. For the source itself, see chap. 21.

110. See, for example, Tacitus, *History* 5.5.4 (M. Stern, *GLAJJ*, 2:26, and comments on 43).

111. See chap. 1, n. 29.

112. On the historicity of this account (or the lack thereof), see chap. 21.

113. Meshorer, *City Coins*, 34–35.

114. Ibid., 36–37.

115. For a fuller presentation of this issue, see L. I. Levine, "Figural Art in Ancient Judaism," 19–21.

FIG. 28 Second-century coins, Tiberias: (1) Trajan and the goddess Hygeia sitting on a rock with gushing water; (2) Hadrian and a Temple of Zeus. Sepphoris: (3) Antoninus Pius and Tyche standing in a temple; (4) Antoninus Pius and temple with the Capitoline triad (Zeus, Hera, and Athena).

upon the death of Agrippa II (ca. 100 CE) may have signaled that the main factors inhibiting the accommodation of figural imagery (and perhaps other areas as well) were no longer present and that the Galilean Jewish aristocracy was now free to pursue alternative directions, especially in light of its changing circumstances.[116] Since second-century Galilee had now become part and parcel of the province of Syria, this new political reality, with its concomitant social and economic implications, forced the Jewish urban leadership to readjust past norms and issue coinage that would be accepted in other provincial locales.

Moreover, given what we know today of the extent of Hellenization among the Jews in antiquity generally, the Jewish aristocracy of these cities may not have viewed the use of pagan images on coins as particularly wayward.[117] Indeed, as noted above, pagan motifs on Jewish coins were not unheard of in earlier times. The Yehud coins issued by the Jewish authorities of Jerusalem in the late Persian and early Hellenistic periods bore such depictions, as did Herod's coins featuring an eagle[118] and some of the coins of his progeny. Moreover, Jews made widespread use of Tyrian shekels bearing images of Marduk and the eagle when engaged in Temple-related transactions.[119]

Such was the price of economic (and perhaps political and social) integration in the region; it was the local Jewish aristocracy that introduced figural images into the coinage of a largely, if not almost exclusively, Jewish urban population. Pagan motifs

116. This change was already anticipated by Agrippa II in his post-70 coinage; see above.

117. The Galilean urban aristocracy, as others in Syria at the time, functioned within a Roman context; see, e.g., Balty, "Apamea in Syria," 91–94.

118. It was not the representation of an eagle minted on coins over a period of years that disturbed segments of Jerusalem's populace, but rather the placement of a carved eagle over one of the Temple gates; see above.

119. Meshorer, *Treasury*, 1–21, 67–69; L. I. Levine, *Jerusalem*, 39, 180; Fine, *Art and Identity*, 23–25. On the widespread use of Tyrian silver coins in Late Second Temple Jerusalem, see M Bekhorot 8, 7; T Ketubot 12, 6, p. 99; and Lieberman, *Tosefta Ki-feshuṭah*, vols. 6–7, *Ketubot*, 392.

on Tiberian and Sepphorean coins, according to Martin Goodman, "may well have been chosen simply as inoffensive images by a Jewish aristocracy fearful of offending the Roman authorities after the bloody Bar Kokhba war and therefore choosing the safe types favored by neighboring cities."[120]

However explained, within a generation or two after the fall of Jerusalem, the winds of change were blowing away from the strictly aniconic posture that had heretofore reigned in Judaea—in one instance in connection with a newly emerging Jewish political, communal, and religious leadership (the Patriarchate), in another within the context of the Jewish urban setting of the Galilee. These two instances had much in common. Both involved leadership groups that had ongoing, if not intensive, contact with the wider world, be it the Roman government or other urban elites, and both easily could have served as models for others. The Patriarchal and urban aristocratic circles were among the most acculturated within Jewish society, and the change in practice might well have been perceived at best as a natural and unobjectionable shift in policy, and at worst as a necessary break with the past, a price they considered well worth paying.[121]

CONCLUSION

Despite the uneven spread of artistic remains during this long period, the important data they provide shed light on the complex reality faced by the Jews in navigating the fluctuating currents of history, not only in the realm of art but in other cultural and religious domains as well. In order to preserve continuity yet remain in touch with an evolving world, a measure of selectivity and accommodation as well as caution and creativity was required. As a result, changes in artistic expression over time were striking and significant. It is the historical context of each subperiod in this era that allows us to understand and appreciate these developments more fully.

Although remains are sparse for the first four hundred years of the Second Temple period (ca. 536–140 BCE), the Jews of Judaea seem to have continued earlier Israelite practice in the use of both figural images on coins and more conservative representations on stamped amphora handles. Moreover, they continued to borrow heavily from the artistic repertoires of the surrounding Persian, eastern Hellenistic, and Roman cultures. Thus, any Jewish artistic stamp in this period was expressed largely by the adoption and adaptation of a variety of foreign motifs and patterns.

120. Goodman, *State and Society*, 129. S. Schwartz endorses this view, although he regards these coins not merely as evidence of accommodation but also as a blatant statement of identification with paganism and Hellenistic culture by these Jewish urban aristocracies (*Imperialism and Jewish Society*, 139; "Political, Social, and Economic Life," 46–47). However, it would seem that the decisive factors here were primarily political and economic, and not cultural or religious-ideological.

121. On the importance of these two leadership groups for the later introduction of changes in Jewish art in cemeteries and synagogues, see chaps. 16 and 21.

The major turning point in artistic expression occurred in the Hasmonean dynasty, when figural art was eschewed in favor of floral, geometric, and neutral motifs. We have addressed possible reasons for this dramatic change, which clearly took hold throughout Judaean society in the second century BCE and lasted for a period of almost three hundred years. Depictions of birds, fish, and the eagle are so infrequent that the few exceptions to this rule must be considered inconsequential.[122]

The importance of the Jews' aniconic posture cannot be underestimated. Together with the sanctity and uniqueness of the Temple in Jerusalem and other elements of a common Judaism at the time (e.g., monotheism, Sabbath and holiday observance, circumcision, dietary restrictions, synagogue worship, etc.),[123] the avoidance of figural art in public and private spaces constituted a clear-cut and unique Jewish practice. The ban was total; it applied not only to idolatrous representations but to all human and animal figures.[124] Given the centrality and impor-

122. See Japp, "Public and Private Decorative Art," 242–44. Of interest in this regard are three gems found in the Jewish Quarter excavations dating from the end of the Second Temple era and displaying Hermes, Fortuna, and a scorpion; see Hershkovitz, "Gemstones." For recent attempts to maximize such tendencies, see n. 124.

123. Sanders, *Judaism*, 45–314; Sanders, "Dead Sea Sect and other Jews," esp. 8–9. See also S. J. D. Cohen, *Beginnings of Jewishness*, 69–139; L. I. Levine, "Common Judaism"; E. M. Meyers, "Sanders's 'Common Judaism'"; Zangenberg, "Common Judaism."

124. This goes counter to the thesis presented by Fine, who claims that the ban was essentially anti-idolatrous (or what he refers to as anti-idolic—*Art and Judaism*, 69–81), and the remarks of van Henten that such exceptions imply "that Judean Jews in the first century C.E. were divided about the tolerance of images of living beings" ("Ruler or God," 277). See also E. M. Meyers, "Were the Hasmoneans Really Aniconic?" Perhaps, in describing Jewish opposition to figural art, many of our literary sources tend to focus on the idolatrous dimension, but the many thousands of archaeological artifacts throughout the country, noted above, attest to the fact that the ban was far more comprehensive than the mere avoidance of idolatrous images. Even the attempt to marshal known examples of figural art among Jews at this time is unconvincing (Fine, *Art and Judaism*, 77–79). The number presented is minuscule: several concern inconspicuously depicted birds, fish, or other animals; a few instances of Herodian rulers (in one case the Hasmonean Alexandra; *Ant.* 15.26–27) who ignore this ban; the wholly gratuitous assumption that the mythological figural decorations on the base of the menorah on the Arch of Titus originated in Jerusalem, a view held by very few scholars. After thirty years of intensive excavation in Jerusalem and at other Herodian sites, it has become abundantly clear that both Herod and Jewish society at large were rather punctilious in eschewing figural representations. This having been said, there is no reason to believe that all Jews studiously avoided this prohibition all the time; no society is ever that monolithic. Nevertheless, noting some exceptions only reinforces the overriding impression that the normative and accepted behavior was otherwise.

Recently, several engaging studies have argued in favor of Josephus's sophisticated rhetoric regarding Jewish policy toward images, often borrowing Roman arguments in this regard. However, apologetics aside, literary and archaeological evidence from Late Second Temple Judaea point, with very few and usually marginal exceptions, to a normative aniconic practice among Jews. Chances are that this held true by and large for the contemporary Diaspora

tance of figural depictions throughout the Greco-Roman world, such a ban sharply distinguished the Jews from the surrounding cultures, a fact of which they and others were very conscious and one that was a source of fascination, curiosity, and scorn to Greek and Latin authors. However, by the end of the second century CE the first signs of change could be detected. The ensuing centuries would witness an unprecedented use of art in a variety of ways; figural representations, Jewish symbols, biblical scenes, and pagan motifs would now become widespread.

Thus, while the aniconic mode and the first usage of distinctive Jewish motifs rightly reflect a uniquely Jewish self-identity in the Late Second Temple period, the adoption of many other artistic motifs within Jewish society signify the absorption of techniques and patterns drawn from the wider Greco-Roman world. The art on coins, tombs, and ossuaries and in domestic settings points to a significant exposure to such influences and the willingness of many Jews to incorporate external motifs as their own. This Janus-like posture, looking inward and outward at one and the same time, has been a characteristic of Jewish culture and society throughout history;[125] it becomes even more pronounced in Late Antiquity.

as well, although the evidence in this regard is too fragmentary to draw any firm conclusions; see Barclay, "Snarling Sweetly"; von Ehrenkrook, *Sculpting Idolatry*.

125. On the contrast between the wealthy acculturated urban dwellers of Jerusalem and the conservative rural population of the Galilee and Golan in the first century CE, see the illuminating comments of Berlin, "Jewish Life before the Revolt."

II

NEW EXPRESSIONS OF JEWISH ART
IN THE LATE ROMAN ERA

4. THE EMERGENCE OF JEWISH ART IN THE THIRD CENTURY

WE HAVE ALREADY noted on several occasions that Jewish art in the pre-70 era, whatever its variety and level of sophistication, was severely limited owing in part to its popularly based and scattered contexts in the First Temple era and in part to the prevailing aniconic policy toward the end of the Second Temple period.[1] By Late Antiquity, however, the nature and content of Jewish art had changed dramatically as Jews began to use figural representations of animals, humans, and pagan mythological characters as well as biblical scenes and a variety of religious symbols in their synagogues and cemeteries.

In explaining this development, scholars have often assumed that this new type of Jewish art was related to the triumph of Christianity. Since the overwhelming majority of sites with Jewish artistic remains date from the fourth century onward, it was presumed that the challenges and threats presented by the new *Verus Israel* stimulated Jewish artistic creativity, which then found expression in their public and private spheres. Indeed, modern scholars' efforts to compare and contrast various aspects of Jewish and Christian art from this era have often yielded interesting and illuminating insights.[2]

But what about the earlier instances of this more developed Jewish art from the century *before* the ascendance of Christianity? The well-known Dura Europos synagogue and the impressive necropoleis of Bet She'arim and Rome all date to the third century, the latter two continuing to function into the fourth and fifth centuries as well. These three sites offer a remarkable display of artistic expression unknown in earlier Israelite-Jewish history. What factors pre-dating the rise of Christianity might have led to this significant spurt of Jewish artistic creativity that stretched from Rome, through Palestine, to the eastern frontiers of the Roman Empire?

The answer lies perhaps in a series of religious and cultural developments occurring throughout the empire, though primarily in the East, during the first three

1. See chaps. 2 and 3.

2. Vitto, "Interior Decoration"; Hachlili, "Aspects of Similarity and Diversity"; Talgam, "Similarities and Differences."

centuries CE. Each of the above-mentioned locales was influenced by a distinct cultural context and responded to it in different ways.

THE DURA EUROPOS SYNAGOGUE IN ITS RELIGIOUS URBAN CONTEXT

The religious ferment originating in the eastern provinces swept through the Roman Empire in the first three centuries CE; wave after wave of cults, many often referred to in modern scholarship as mystery religions, succeeded in capturing the hearts and minds of countless individuals.[3] Dura provides a rare look into the forces at play in this city that found expression, inter alia, in the local synagogue.

Ironically, while Rome was pushing eastward, seeking to expand the empire's territories in eastern Syria, Mesopotamia, and Babylonia, and while attempts were being made to simultaneously spread the imperial cult and thus unite the provinces religiously,[4] a large number of Eastern cults were moving westward, eventually penetrating virtually all regions of the empire as far as Spain, Germany, and Britain.[5] Thus, while the imperial cult was creating a veneer of homogeneity throughout the Roman Empire,[6] this was counterbalanced by the rapid diffusion of a wide range of Eastern religious groups along with the transformation of older local ones.[7]

3. These three centuries CE indeed witnessed the greatest penetration of Eastern cults into the empire, although Greek and Egyptian deities, as well as those from Asia Minor, appeared in Rome and Italy much earlier; see Turcan, *Gods of Ancient Rome*, 105–54; Metzger, "Considerations of Methodology"; and the comments of J. Z. Smith, *Drudgery Divine*, passim, and esp. 99–115. A corollary of this development is the decline of the civic model of religion that had held sway for centuries and with it the steady disappearance of social and political control over religion. For an enlightening example of this process with regard to Carthage, see Rives, *Religion and Authority*.

4. On the imperial cult in Asia Minor, see S. R. F. Price, *Rituals and Power*, passim, and esp. 234–48.

5. Adherents of these cults were soldiers returning from military duty, slaves who brought their local cults with them, and free laborers, merchants, and artisans from the East. Although Augustus and Tiberius attempted to repress these new cults, later emperors were often attracted to one or more of them — Caligula and Titus to Isis, Claudius to Phrygianism, Nero to Syrian gods and the doctrines of the magi, Vespasian to Serapis; see Turcan, *Cults of the Roman Empire*, 14; C. Edwards and Woolf, "Cosmopolis," 9. On earlier appropriations of foreign cults by Republican leaders, see Momigliano, *On Pagans, Jews, and Christians*, 180–81.

6. The imperial cult was the exception, since no other Roman cult successfully implanted itself in the East; see Gordon, "Mithraism and Roman Society," 111.

7. Much like Rome's early contacts with the Hellenistic world, when its political and military feats were countered by a significant degree of infiltration and the adoption of Greek culture, so too a new wave of Eastern influences permeated Roman society under the Roman Empire, as evidenced by Horace's statement (*Epistles* 2.1.156), written in the time of Augustus, that conquered Greece had taken Rome captive by educating the Romans in her arts. Had such a statement been made in the second or third century CE, it would have included other Eastern religions, to wit, Juvenal's comment that "the Syrian Orontes now flows into the Tiber" (*Satires* 3.62).

The second and early third centuries were a time of religious vitality. It has been noted that "the interest of many educated men in secret learning from the East, from Egypt, India, Babylonia, Israel, Persia . . . seems to have become increasingly fashionable in the second and third centuries A.D."[8] With the ascendance of the African and Syrian emperors (and empresses) of the Severan dynasty, Dionysios, Mithras, Helios, the Syrian gods, and Christianity in all its early forms made significant inroads into Rome and other parts of the empire. Both Septimius Severus and his son Caracalla, for example, were devoted to Egyptian deities, especially the cult of Serapis; the emperor Elagabalus imported to Rome the Syrian god Elagabal of Emesa, depicted as a conical black stone that presumably represented the sun;[9] and Alexander Severus reportedly had a room with busts of gods and heroes, including Apollonius of Tyana, Orpheus, Abraham, and Jesus. The success of the Eastern cults reached new heights and the "Orientalization" of the Roman Empire reached its culmination when Aurelian made Sol Invictus the supreme god of the empire and Constantine declared Christianity the official religion in the fourth century.

Several scholars assert that these centuries were indeed characterized by tremendous religious and cultural ferment. Shirley Jackson Case noted some eighty years ago: "At no period before or since in the history of civilization as known to us have so many separate religious movements flourished at one time within a single area so thoroughly unified culturally and politically as was the Roman Empire."[10] James B. Rives described this phenomenon as follows: "The period from Augustus to Constantine was in terms of religious developments one of the richest, perhaps the richest, in the history of Europe and the Mediterranean world."[11] Focusing on the iconographic dimension, André Grabar has commented: "In the early third century the Roman East and Persian Upper Mesopotamia were experiencing a time of exceptional iconographic fermentation, which extended to the art of several different faiths. On the Roman side, we have just mentioned the Christian and the Jewish activity. On the Persian side, between about 240 and 270, a new religion, that of Manes, was spreading its propaganda with the aid of images."[12] Indeed, Jewish communities at this time were not, and indeed could not be, immune to such developments.

The synagogue in Dura is unusually well preserved, as is the city generally, since it was never resettled after its destruction in 256 CE (fig. 29).[13] Located on the Euphrates River at the eastern extremity of Syria, it boasted fifteen religious build-

8. Gordon, "Mithraism and Roman Society," 110.

9. Herodian describes this cult as having a large temple and attracting many pilgrims, satraps, and barbarian princes from a wide area in Syria (5.3.4–5).

10. Case, "Popular Competitors," 55.

11. Rives, *Religion and Authority*, 2.

12. Grabar, *Christian Iconography*, 27–28.

13. MacMullen (*Second Church*, 9) estimates Dura's population to have been between 6,000 and 8,000.

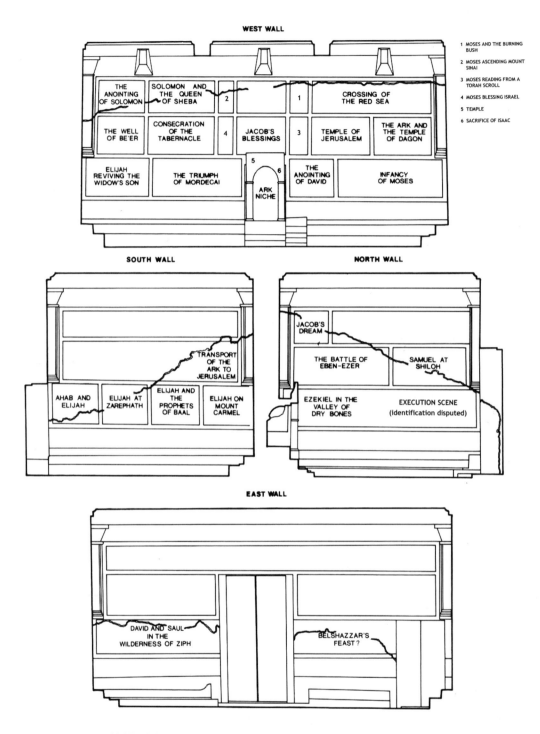

WEST WALL

THE ANOINTING OF SOLOMON	SOLOMON AND THE QUEEN OF SHEBA	2		1	CROSSING OF THE RED SEA	
THE WELL OF BE'ER	CONSECRATION OF THE TABERNACLE	4	JACOB'S BLESSINGS	3	TEMPLE OF JERUSALEM	THE ARK AND THE TEMPLE OF DAGON
ELIJAH REVIVING THE WIDOW'S SON	THE TRIUMPH OF MORDECAI	5 / 6 / ARK NICHE		THE ANOINTING OF DAVID	INFANCY OF MOSES	

1 MOSES AND THE BURNING BUSH
2 MOSES ASCENDING MOUNT SINAI
3 MOSES READING FROM A TORAH SCROLL
4 MOSES BLESSING ISRAEL
5 TEMPLE
6 SACRIFICE OF ISAAC

SOUTH WALL

TRANSPORT OF THE ARK TO JERUSALEM

| AHAB AND ELIJAH | ELIJAH AT ZAREPHATH | ELIJAH AND THE PROPHETS OF BAAL | ELIJAH ON MOUNT CARMEL |

NORTH WALL

JACOB'S DREAM

| THE BATTLE OF EBEN-EZER | SAMUEL AT SHILOH |
| EZEKIEL IN THE VALLEY OF DRY BONES | EXECUTION SCENE (identification disputed) |

EAST WALL

DAVID AND SAUL IN THE WILDERNESS OF ZIPH

BELSHAZZAR'S FEAST?

FIG. 29 Layout of biblical themes in Dura Europos synagogue.

ings, but the synagogue has by far the most impressive remains; all four walls were covered from floor to ceiling with frescoes depicting biblical scenes and figures, and those remaining intact constitute about half the synagogue's original paintings. The western wall, which is the best preserved, was also the focus of the sanctuary, having a Torah shrine in its center. The fresco scenes span the entire biblical period, from the book of Genesis, through the exodus from Egypt and the wilderness sojourn, and down to the story of Esther in the Persian era. Attempts to decode this art and reveal its overriding theme(s) have engaged scholars for some eighty years, but no consensus has yet been reached. Until recently, it was universally assumed that this art could not have been produced by a small and remote community such as the one in Dura; it was thus surmised that what was found there was but the tip of the iceberg and that any artistic creativity of the Jews at this time must have originated in one or more of the large urban centers of the empire.[14] However, with the passing of eight decades and the discovery of many more synagogues, none even begins to compare with the rich display in Dura; consequently, the unique setting of this city and its Mesopotamian provenance have become increasingly focal in attempting to decipher this art.

Indeed, recent studies have argued that virtually all aspects of the synagogue building, its architecture, art, and inscriptions, can best be explained as an outgrowth of the regnant styles and practices in Mesopotamia in general and Dura in particular.[15] To date, however, most of these comparisons address only the externalities of the buildings in question. Of interest to us is the art itself, the pièce de résistance of the synagogue and of Dura generally. Remnants of artistic creations in most Duran temples are generally fragmentary. What is clear, however, is that religious art in this region was being mobilized in the service of the traditional cults (for instance, Zeus Theos and the Palmyrene deities) and those newly revitalized ones (such as Isis). It is in Dura that we can catch a glimpse of how art was harnessed to promote a cult, first and foremost for its adherents but perhaps for others as well. As Michael I. Rostovtzeff described this phenomenon, "The excavations of Dura have shown for the first time that the revival of Semitic religions in the Near East, the creation there of a Semitic religious κοινή, the concentration of the religious thought and feeling on one leading god and one leading goddess, found among other modes of expression that of a new religious art."[16]

14. See, e.g., Kraeling, *The Synagogue*, 382–84, 391–93; Brilliant, "Painting at Dura-Europos"; Thompson, "Hypothetical Models"; Weitzmann, "Individual Panels and Their Christian Parallels," 143–50; H. L. Kessler, "Program and Structure," 181–83.

15. Rostovtzeff, *Dura-Europos and Its Art*, 57–134; Perkins, *Art of Dura-Europos*, 55–65, 114–26; Gates, "Dura-Europos"; and chap. 5. On the shared characteristics of Mesopotamian temples and the unique aspects of those in Dura, see Downey, *Mesopotamian Religious Architecture*, 124–29, 175–80.

16. Rostovtzeff, *Dura-Europos and Its Art*, 67.

What makes this geographical context so fascinating and crucial is that very few places in the Roman world other than Dura have preserved so much material evidence of religious diversity at one specific time.[17] Indeed, Rostovtzeff suggested over seventy years ago that this art be called Mesopotamian art, "though we might as well call it the artistic κοινή of the Parthian Empire."[18] While Dura's temple art is overwhelmingly pagan, in the traditional sense, three relative latecomers to the city—the synagogue, church, and Mithraeum—deviated from this norm.[19]

Perhaps a key to the enigmatic uniqueness of Dura's Jewish art may be found in the timing of its appearance (fig. 30). Earlier, in Stage 1 (before 244/45), the synagogue's decoration was limited to imitation marble incrustation such as dados and moldings, multicolored geometric patterns such as diamonds and triangles, fruits and pomegranates, and some floral designs.[20] Kraeling summarized the art of this stage as follows:

> The decorations of the Dura Synagogue's earlier building are therefore entirely conventional and traditional. Certainly there is nothing in these decorations that could be called specifically Jewish, or that would suggest they were eventually to be followed by the pictorial compositions that covered the walls of the later structure. All they reveal is that by their use the Jewish community of Dura sought to adorn certain rooms of its Synagogue building in a manner becoming to the significance of their religious usage, and that in seeking to accomplish this purpose they chose their designs tastefully and well from the limited repertoire of the local artists.[21]

Only in Stage 2 (244/45–256) do we have the stunning display of biblical scenes, unrivaled in any other ancient synagogue. What is significant is that this artwork was executed at the same time that two nearby houses of worship, the church and Mithraeum, were likewise being decorated (sometime in the 240s), the former for the first time, the latter with an expanded decorative scheme largely replacing what had existed in previous decades.[22] Was this development merely coincidental, or were there common stimuli affecting these three religious communities that found expression in the respective art forms in their buildings?[23] Indeed, a number of

17. See, most recently, Brody and Hoffman, *Dura Europos: Crossroads of Antiquity*.

18. Rostovtzeff, *Dura Europos and Its Art*, 90.

19. On the pagan gods of Dura, see Welles, "Gods of Dura-Europos."

20. Kraeling, *The Synagogue*, 26–38.

21. Ibid., 38.

22. Church: Kraeling, *The Christian Building*, 34–39; Mithraeum: Rostovtzeff et al., *Excavations at Dura-Europos*, 64–80, and esp. 76–80; see also Perkins, *Art of Dura-Europos*, 49–55; Edwell, *Between Rome and Persia*, 125–28.

23. Gates ("Dura-Europos," 169) cites mudbrick construction, the overall plan of the sanctuary, the presence of a cult niche or *aedicula* at times accompanied by programs of painted decorations, the focus along the back wall with the figure (or statue) of a deity, frontal depictions, a series of registers along the wall featuring cultic ceremonies, and more,

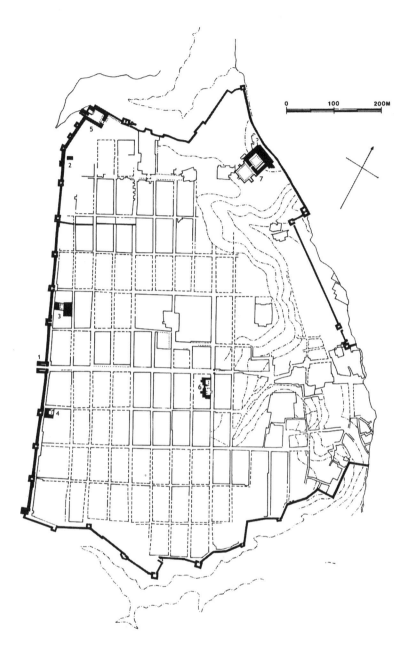

FIG. 30 City plan of Dura, noting major third-century structures: (1) Western
gate; (2) Mithraeum; (3) synagogue; (4) Christian building; (5) Temple of Bel;
(6) Temple of Gaddé; (7) Palace of the Dux.

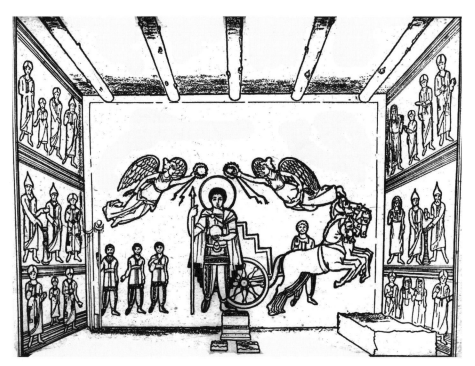

FIG. 31 Temple of Zeus Theos.

scholars have pointed to similar stylistic elements in each of the buildings, strongly suggesting a common artisan or workshop.[24]

The decorative schemes of these three institutions differ from anything else found in Dura. In other local sanctuaries, the art invariably depicts worshippers bringing gifts to the god or priests in the act of sacrificing or offering incense (*supplicatio*).[25] The most extensive remains of this type were found in the temples of Bel, Zeus Theos (fig. 31), and Adonis. In contrast, the synagogue, church, and

as was characteristic of earlier Mesopotamian art having roots as much as a millennium earlier. Perkins (*Art of Dura-Europos*, 55–65) had already noted some of these points, but did not reach conclusions comparable to those of Gates regarding the synagogue's overall provenance. Also of interest is the fact that the religious orientation of all three sanctuaries was to the west. In the synagogue, the *aedicula* with its Torah shrine faced in that direction, as did the primary depictions relating to Mithras in the Mithraeum and the baptismal font and its decorations in the church.

24. R. M. Jensen, "Dura Europos Synagogue," 180–87, and esp. 184: "In any case, it seems likely that both Jews and Christians availed themselves of the same atelier to decorate their houses of worship, a workshop that had already produced murals for pagan temples and other public buildings in the area." In the same vein, see also Wharton, *Refiguring the Post Classical City*, 60–61; Elsner, "Archaeologies and Agendas," 119.

25. Perkins, *Art of Dura-Europos*, 33–49; Downey, *Mesopotamian Religious Architecture*, 88–130; Wharton, *Refiguring the Post Classical City*, 33–38.

FIG. 32 Christian building: (1) Overall plan; (2) baptistery; (3) scenes from baptistery font (above: the Good Shepherd; below: Adam and Eve); (4) Jesus healing the paralytic.

Mithraeum each emphasize something of the adherents' own unique historical or mythological heritage.

The art of the church, for example, featuring scenes from the Hebrew Bible and New Testament, was concentrated in its baptistery; depictions of Adam and Eve along with David and Goliath appear beside representations of the Good Shepherd, the Samaritan woman at the well, two miracles of Jesus (walking on the water and healing the paralytic), and women approaching the empty tomb (fig. 32).[26] In the Mithraeum, numerous scenes from the life of the god appear alongside episodes of the Mithraic cosmogony on the arch of the niche at the western end of the room (fig. 33). Flanking this arch are two large figures of Mithraic prophets or magi, and on the side walls are hunting scenes, one of which depicts Mithras with a flowing cloak and bow in hand astride a galloping horse. The sacred banquet of Mithras and his ally Sol, as well as various symbols, including the zodiac signs, are also displayed here. The focus in the Mithraeum is the central cult relief or statue, the Mithras tauroctony, where the divinity is depicted slaying the bull.

Thus, these three religious communities—all relative newcomers to Dura emerging under Roman rule—built or refurbished their buildings at the same time, each using a decorative scheme that highlighted its particular *Heilsgeschichte*, its sacred icons or symbols (the synagogue and Mithraeum), its god and his *aretai*. It is thus difficult to avoid the conclusion that there must have been significant connections between these contemporary communities and their initiatives.[27]

Some scholars have posited that a competitive atmosphere pervaded Dura, especially among the Jews,[28] although no compelling case has been made for a milieu of conflict or competition among these three religions or vis-à-vis the other cults in the city.[29] On the contrary, in a number of instances several gods were recognized in the same temple, and priests of different cults were represented in the same place.[30] Dura was apparently a city of many commonalities and interactions, resulting in mutual influences among these three communities. It is impossible to assess which of the above-mentioned religious buildings influenced the others or whether the emergence of religious art was a simultaneous response to other stimuli. Thus, in the absence of hard evidence, and preconceptions aside, there is little justifica-

26. For a suggestion regarding the role of this art, at least in part, in the liturgy of the baptistery, see Mathews, *Clash of Gods*, 152–53. Interestingly, the New Testament scenes outnumber those of the Hebrew Bible by four to one (Grabar, *Christian Iconography*, 20)—just the opposite proportion of that in the Christian catacombs in Rome (see below).

27. See Kraeling, *The Christian Building*, 218–20.

28. See Weitzmann and Kessler, *Frescoes of the Dura Synagogue*; Elsner, "Cultural Resistance"; Rajak, "Dura-Europos Synagogue."

29. See the well-argued case presented by Dirven, "Religious Competition"; Flesher, "Conflict or Co-operation?"; Deleeuw, "A Peaceful Pluralism." See, however, North, "Development of Religious Pluralism."

30. Dirven, "Religious Competition," 13; Flesher, "Conflict or Co-operation?"

FIG. 33 Art in the Mithraeum: (1) Altar with scenes from the life of Mithras; (2) one of the two magi on the arch of the niche; (3) Mithras the hunter.

tion for positing a hypothetical struggle or polemic. Self-assertion and communal-religious pride, as well as the creation of institutional (and artistic) boundary markers, are not necessarily intertwined with an atmosphere of tension, conflict, and confrontation.

Whatever the case, we may conclude that the unique configuration of religious cults in Dura and their resultant artistic expression must have provided its Jewish community with enough of a stimulus to create what has become, and remains to this day, the quintessential example of synagogue art in antiquity, distinguishing the Dura synagogue from anything that preceded or followed it.[31]

31. See in this regard Grabar, *Christian Iconography*, 19–30, esp. 30.

FIG. 34 View of Bet She'arim necropolis, featuring the two main catacombs cut into the base of the hill: Catacomb 20 to the left, and Catacomb 14 to the right.

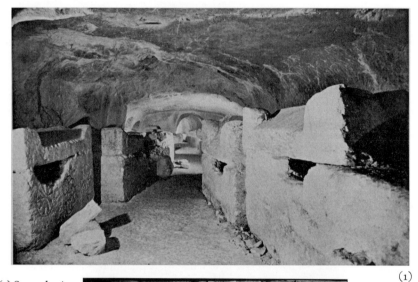

(1)

FIG. 35 (1) Sarcophagi from Catacomb 20; (2) lion relief on sarcophagus from Catacomb 20.

(2)

BET SHE'ARIM IN ITS GRECO-ROMAN SETTING

A second instance of third-century CE Jewish art comes from a very different cultural, social, and religious milieu. Many of those interred in the Bet She'arim necropolis, aside from the Patriarchal dynasty, were members of the Jewish urban elites, synagogue officials, and others who functioned under Patriarchal auspices, as well as those who chose this cemetery out of identification with and respect for that office.

Two developments impacted upon these circles in early third-century Palestine, especially, though not exclusively, through the agency of the Patriarch, R. Judah I, a most extraordinary individual whose wealth, political stature, and religious-intellectual achievements distinguished him from others in his generation.[32] The first of these developments was the political and cultural rapprochement between many Jews and the Severan government; the second was the Second Sophistic, the renaissance of Greek culture in the East from the first to the third century.[33] Their impact on the above-noted circles and other parts of Jewish society was considerable and found expression, inter alia, in the Patriarchal necropolis of Bet She'arim.

The Roman architectural features of Bet She'arim are pronounced (fig. 34). The facades of the two main catacombs (14 and 20), where many generations of the Patriarchal family were interred, are typically Roman, with small side arches flanking a larger middle one. In addition, bases, pilasters, capitals, architraves, cornices, and friezes are all influenced by the regnant styles of Roman Syria.[34] The mausoleum of Catacomb 11 is likewise typical of Roman funerary monuments, and the widespread use of sarcophagi, especially in Catacomb 20, follows the current practice of primary burials recently introduced in second-century Rome. Of the two hundred burials in Catacomb 20, one hundred and twenty-five are in sarcophagi (fig. 35).[35]

Another indication of the cultural orientation of those buried in Bet She'arim is the language of the approximately three hundred inscriptions; over 80 percent are in Greek, and this number approaches about 90 percent if we exclude Patriarchal catacombs 14 and 20, where Hebrew was dominant.[36]

The art found in the Bet She'arim necropolis combines a Hellenistic dimension, including many mythological depictions, with a heretofore unattested emphasis on

32. Foremost among R. Judah I's achievements was the compilation of the Mishnah, which quickly became a standard sacred text among the rabbis.

33. On the ofttimes close relationship between Severan culture and the culture of the East, particularly with reference to art, see Newby, "Art at the Crossroads?" 249: "In many ways we can see the Severan period as the culmination of the cultural philhellenism which had dominated the second century." On the term *Second Sophistic*, see below.

34. Avigad, *Beth She'arim*, 3:86–93.

35. Ibid., 136–83.

36. In addition to the inscriptions reported in the Bet She'arim volumes (see chap. 6), Jonathan Price informs me (personal communication) that another twenty or so inscriptions from Bet She'arim (almost all in Greek) will be published in a forthcoming volume of *Corpus Inscriptionum Iudaeae/Palaestinae* (*CIIP*), under the direction of W. Ameling et al.

(1)

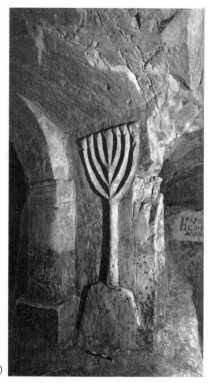

FIG. 36 Catacomb art: (1) Sarcophagus fragment with relief of Leda and the swan, Catacomb 20; (2) relief of menorah, Catacomb 3.

(2)

Jewish symbols. Thus, a representation of Leda and the swan and scenes featuring Amazons[37] are found together with depictions of the menorah, the Torah shrine, and other Jewish symbols (fig. 36). The appearance of blatantly pagan motifs alongside uniquely Jewish symbols characterizes Jewish artistic representations at later sites, and this combination may well have been due to Patriarchal influence.[38]

The art, architecture, and inscriptions in the Bet She'arim necropolis differ from those at other Jewish burial sites in Second Temple Jerusalem, the contemporary Galilee, and the Diaspora. The use of sarcophagi was extremely scarce in Jerusalem, and only about 37 percent of the inscriptions found there are in Greek. Moreover, Jerusalem's art is almost entirely aniconic, and there certainly is no evidence of pagan mythological representations. Similarly, the use of Greek or any kind of figural art at contemporary Galilean burial sites was marginal, and while symbols and Greek were common in the Diaspora at this time, figural representations were studiously avoided (see below).

37. On the popularity of mythological scenes in Roman art at this time, see Newby, "Art at the Crossroads?" 233–40.

38. See chap. 16.

What, then, made Bet She'arim so unique? The answer lies in the Severan historical context in Palestine generally, and in the Patriarchal house and Jewish aristocratic circles in particular.

The Severan Political Dimension

The era of Judah I witnessed a major shift in Jewish-Roman relations following the three disastrous revolts of the first and second centuries. Jewish affinities to Rome were expressed in a number of ways at this time:[39]

1. Jewish political support of Severus in his early wars of accession.
2. R. Judah's attempt (eventually foiled by other sages) to abolish the fasts of the Seventeenth of Tammuz and the Ninth of Av, commemorating, inter alia, Rome's destruction of the Second Temple.
3. The purportedly close relationship between R. Judah and a Roman emperor named Antoninus mentioned in a number of rabbinic traditions, most of which are blatantly legendary.[40] The earlier, tannaitic ones are somewhat more plausible, as they speak of conversations and consultations involving R. Judah and the emperor, a not unusual occurrence between Rome and Eastern leaders.[41]
4. R. Judah's encouragement of Jews to move to the large non-Jewish cities of Palestine by exempting them from halakhic agricultural laws binding in the Holy Land, such as tithes and sabbatical year laws, while at the same time declaring many such cities "pure" as if they were part of the "Jewish" Land of Israel. Such decrees conformed with Rome's policy of urbanization in Palestine and were clearly intended

39. The issues that follow, as well as references to the relevant primary sources, are discussed by Alon, *Jews in Their Land*, 2:681–737; Avi-Yonah, *Jews of Palestine*, 54–88; Büchler, *Studies in Jewish History*, 179–244; Tropper, *Wisdom, Politics, and Historiography*, passim; L. I. Levine, "Age of R. Judah I"; Oppenheimer, "Severan Emperors"; Oppenheimer, *Rabbi Judah ha-Nasi*, 41–57.

40. On the R. Judah-Antoninus traditions in Palestinian and Babylonian traditions, see Meir, *Rabbi Judah the Patriarch*, 263–99; regarding the later Babylonians' reworking of earlier Palestinian traditions for their own, perhaps polemical, purposes, see A. M. Gray, "Power Conferred by Distance from Power," esp. 30–54. With specific reference to the tradition regarding Antoninus's conversion, noted in the Palestinian sources but ignored in the Bavli, see S. J. D. Cohen, "Conversion of Antoninus." Despite the Bavli's problematic treatment of this material, we nevertheless should assume some degree of historicity, owing not only to the evidence of Palestinian sources but also to the historical contexts of Severan Palestine on the one hand, and the dynamics of the Second Sophistic on the other. On contact between sophists and Rome, see Bowersock, *Greek Sophists*, passim, and esp. 43–58.

41. Even if these rabbinic traditions do not reflect much of the historical reality, the Jews' (or rabbis') invention of such images is an indication of their desire to gain cultural-social-political recognition (perhaps given their political inferiority), an attitude that permeated other parts of the Greek world as well; see Swain, *Hellenism and Empire*, 196–97.

to promote Jewish economic prosperity while fostering the increased integration of Jews within wider society.[42]

5. R. Judah's move from Bet She'arim to Sepphoris, one of the two major Jewish cities of the Galilee. Such a move reflects, inter alia, his desire to be more closely involved in the larger political and social decisions of the day. Residence in Sepphoris would offer R. Judah a greater opportunity to shape public policy and facilitate his contact with the Roman authorities and the non-Jewish population of the region.

The desire for rapprochement with Rome was not confined to Patriarchal circles alone, but also had a wider resonance among the Jews of Palestine. Two examples, both sui generis in Jewish life of the Greco-Roman era and thus indicative of a radically new attitude, highlight this reality:

1. An inscription dating to 197 CE discovered at Qatzion, a village in the Upper Galilee, reads: "For the welfare of our lords, the ruling emperors Lucius Septimius Severus the pious, Pertinex, Caesar, and Marcus Aurelius Antoninus (that is, Caracalla) and Lucius Septimius Geta, his sons, on the basis of a vow, the Jews [dedicated this]."[43] In a wreath to the side we read: "and Julia Domna the empress."[44] While the reason for this particular dedication remains unknown (as does the type of building being dedicated), the evidence makes it patently clear that a pro-Roman posture was not limited to urban or Patriarchal circles.

2. In the early third century, during the reign of the emperor Caracalla, Sepphoris issued coins acknowledging its special relationship with Rome (fig. 37). The legends on these coins read, "Diocaesarea the Holy, City of Shelter, Autonomous, Loyal (a treaty of) friendship and alliance with the Romans" or "Diocaesarea the Holy, City of Shelter, Autonomous, Loyal (a treaty of) friendship and alliance between the Holy Council and the people of Rome." How this Sepphorean evidence relates to R. Judah, then a resident of the city, remains unknown, but the city's pro-Roman proclivity was clearly shared by him.

Evidence for rapprochement is no less striking on the Roman side as well. One law (either a new one or a reaffirmation of an already existing privilege) from the early third century allowed Jews to participate in municipal councils while protect-

42. In addition to Büchler, *Studies*, 179–244 ("The Patriarch Judah I and the Graeco-Roman Cities of Palestine"), see also Oppenheimer, "Severan Emperors"; and, most recently, D. Levine, "Rabbi Judah the Patriarch."

43. Roth-Gerson, *Greek Inscriptions*, 125–29. See also L. I. Levine, *Ancient Synagogue*, 84 n. 16.

44. For a suggestion that the depiction of Esther in the Dura Europos synagogue was influenced by iconography associated with Julia Domna, see Levit-Tawil, "Queen Esther at Dura," esp. 287–97.

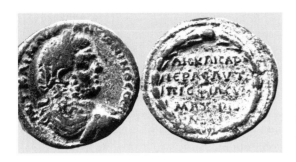

FIG. 37 Sepphorean coin
issued under Caracalla, noting
a treaty of friendship between
Rome and Sepphoris.

ing them from liturgies that might disrupt their religious practices: "The Divine
Severus and Antoninus permitted those that follow the Jewish religion to enter
office (probably a reference to the municipal rather than imperial government) but
also imposed upon them liturgies such as should not [cause them to] transgress their
religion."[45]

Furthermore, the *Scriptores Historiae Augustae*, although a historically problem-
atic source dating to the late fourth century, notes ongoing imperial contacts with
Jews and Judaism from Caracalla through Alexander Severus, the latter emperor
being unflatteringly referred to on one occasion as a "Syrian *archisynagogos*" by an
Antiochan mob.[46] This same emperor reputedly included busts of Abraham, Apol-
lonius of Tyana, Jesus, and Orpheus in his palace shrine.[47]

Origen refers to the status of the Patriarch (here referred to as an ethnarch)
around the year 240 CE as follows: "Now that the Romans rule and the Jews pay
them two drachmae, we, who have experience in this, know how much authority
the ethnarch among them has, and that he differs only slightly from being a king
of the people. He conducts legal proceedings secretly and some are even sentenced
to death. And even though there is not total recognition for this, nevertheless these
things are done with the knowledge of the ruler."[48] Origen clearly indicates that
such a status was recognized by Rome, de facto if not de jure, and it can be safely
surmised that it had already been extended to the Patriarch in the time of R. Judah I.

45. Linder, *Jews in Roman Imperial Legislation*, no. 2. While the Constitutio Antoniniana
of 212 upgraded Jewish status in the empire, it of course was not directed specifically toward
Jews, but rather to virtually all inhabitants in the realm.

46. *SHA, Alexander Severus* 28.7.

47. Ibid., 29.2. In addition, this emperor reputedly followed a Jewish and Christian prac-
tice of announcing the names of candidates for public office prior to their appointment
(ibid., 45.7), and he once cited the golden rule, which he supposedly heard from Jews and
Christians (ibid., 51.6–8). For evidence of positive Jewish attitudes toward the Severans in
Hungary, Ostia, and Rome, see L. I. Levine, *Ancient Synagogue*, 297.

48. *Letter to Africanus* 14. See M. Jacobs, *Die Institution*, 248–51; Goodblatt, "Political and
Social History," 418–22.

In sum, the above-cited Jewish and Roman sources offer persuasive evidence of a Jewish-Roman rapport. Indeed, much had changed politically and socially in Jewish life in Palestine by the turn of the third century.

THE GREEK CULTURAL DIMENSION

Integration into the Severan East included a cultural element generally referred to as the Second Sophistic,[49] a term often used as a shorthand for the cultural ethos of the period as a whole[50] — including philosophy, music, sculpture, literature, art, architecture, and athletics. Sophists served as prominent cultural representatives, civic leaders (at times actively involved in resolving crises), participants in urban society and beyond, major benefactors, and public entertainers,[51] and came to represent the most visible element in the revival of Hellenic culture in the Roman East.[52]

Second Sophistic culture found expression in Palestine as well, having produced a number of local sophists as well as others who hailed from the province but lived elsewhere in the empire. The cities of Gadara and Ashkelon were especially prominent in nurturing such intellectuals, and twenty-eight local figures from the second and third centuries CE alone have been identified with this movement.[53]

A number of cultural foci of the Second Sophistic have a bearing on our subject: (1) their embrace of Atticism and return to the classical Greek world, using classical Greek and addressing subjects connected with the Greek past, especially the period

49. The term *Second Sophistic* stems from the third-century sophist Philostratus, who describes several score intellectuals living from the late first through mid-third centuries in his book *Lives of the Sophists (Vitae Sophistarum)*. On Philostratus, see Anderson, *Philostratus*; C. P. Jones, "Reliability of Philostratus." Philostratus called these intellectuals the Second Sophistic (and not the New Sophistic) to emphasize the continuity with earlier generations in Greece; indeed, one of their priorities was to reinstate Greek Atticism as the favored language of discourse; see Anderson, *Second Sophistic*, 86–100; Swain, *Hellenism and Empire*, 17–64; Whitmarsh, *Second Sophistic*, 41–56.

50. According to Bowie ("Greeks and Their Past," 4): "The most characteristic and influential figures of the age, not least in their own eyes, were the sophists." See also Swain, *Hellenism and Empire*, passim; Whitmarsh, *Second Sophistic*, 3–22; Tropper, *Wisdom, Politics, and Historiography*, 136–46.

51. On the benefits accruing from the presence and activities of a successful sophist, see Philostratus, *Vitae Sophistarum* 613.

52. See especially Anderson, "*Pepaideumenos*." Such an assertion usually involves the inclusion in the Sophistic movement of second-century figures such as Galen, Plutarch, Pausanias, Sextus Empiricus, and others. See Swain, *Hellenism and Empire*, passim, esp. pp. 1–13, 409–22; Reardon, "Second Sophistic and the Novel." For a more reserved evaluation of the scope and significance of the Second Sophistic phenomenon, see Brunt, "Bubble of the Second Sophistic."

53. Geiger has written extensively on this subject; see "Athens in Syria," "Greek Intellectuals of Ascalon," "Notes on the Second Sophistic," and "Local Patriotism." All in all, it appears that Palestine had an abundance of Greek intellectuals, especially in the second and third centuries CE.

before Alexander;[54] (2) their allegiance to Roman imperial domination and desire to become integrated into that world and its civic order (contacts with Roman officialdom on the municipal, provincial, and imperial levels—not to speak of the imperial family itself—were considered desirable, and for many receiving imperial honors was the quintessence of recognition);[55] (3) a deep commitment to Hellenism as a universal culture;[56] and (4) the inculcation of their values and skills as a desideratum of prime importance; as sophists, they were first and foremost teachers, and nurturing students and creating educational frameworks were part and parcel of this tradition.[57]

In light of these features, many of the activities and religio-cultural innovations of R. Judah and his circle gain an extra dimension of significance. While R. Judah I was by no means a sophist, many traditions associated with him reflect concerns and behavior similar to those of these intellectuals:

1. Just as Attic Greek was of supreme importance for sophists,[58] Hebrew enjoyed a golden age among second- and third-century rabbis, as reflected in R. Judah's Mishnah, in the Tosefta, and in tannaitic midrashim; the use of Hebrew in these works contrasts with the predominance of Aramaic in the Yerushalmi and early postamoraic aggadic midrashim, all of which were edited in subsequent centuries.[59] In fact, R. Judah is quoted (albeit in the Bavli and thus of problematic historical value) as preferring either Greek or Hebrew and considering Aramaic to be of secondary importance.[60]

2. R. Judah embraced the Jewish past wholeheartedly, much as the sophists viewed the era of classical Greece. In R. Judah's case, however, it was the Second Temple and its rituals, and indirectly Jerusalem, that occupied a large part of his Mishnah's agenda; together with related traditions, such topics constitute almost half of the material therein.[61]

3. R. Judah compiled the Mishnah at about the same time that Ulpian of Tyre undertook the compilation, organization, and systematization of Roman law. Whether there may be some connection, either direct or indirect (for example, as part of an imperial zeitgeist regarding standardization of law), between these two occurrences merits further consideration.[62]

54. Anderson, *Second Sophistic*, 86–132; Swain, *Hellenism and Empire*, 17–100.

55. See Bowersock, *Greek Sophists*, passim.

56. Anderson, *Second Sophistic*, 69–85, 234–46.

57. Ibid., 13–46.

58. Bowie, "Greeks and Their Past."

59. See de Lange, "Revival of the Hebrew Language."

60. B Bava Qama 82b–83a.

61. See Geiger, "Sophists and Rabbis."

62. See the comments of Tropper, *Wisdom, Politics, and Historiography*, 196; as well as Neusner, "Mishnah in Roman and Christian Contexts," 121–34; Stertz, "Roman Legal Codification."

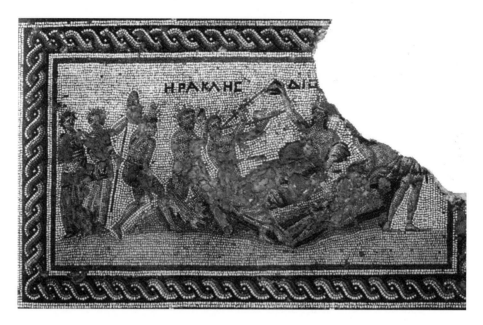

FIG. 38 Depiction of drinking contest between Dionysus and Herakles in the center of the mosaic floor in Sepphoris.

4. The fourth section of the Mishnah contains *Pirqei Avot* (Ethics of the Fathers), a tractate that commences with a validation of tradition by tracing the lines of succession and authority from Moses through the early third century CE. This succession list parallels similar lines of tradition created by philosophers and church fathers in the second and third centuries.[63]

5. R. Judah's Mishnah records the earliest known Passover seder ritual in the post-70 era, which in some respects bears an intriguing resemblance to the contemporary Roman symposium.[64]

6. Three "foreign" practices singled out in rabbinic literature are associated with R. Judah—the use of mirrors, elaborate hairdos, and Greek.[65]

7. R. Judah made a point of including in his Mishnah an account of a visit made by his grandfather, R. Gamaliel II, to the bath of Aphrodite in Acco, where he defended his actions to a non-Jewish philosopher who

63. See in this regard the important study of Tropper, *Wisdom, Politics, and Historiography*, passim.

64. See especially the seminal study of S. Stein, "Influence of Symposia Literature"; L. I. Levine, *Judaism and Hellenism*, 119–24. See, however, the comments of Bokser (*Origins of the Seder*, 50–66), who emphasizes the diachronic dimension of this ritual.

65. Y Shabbat 6, 1, 7d.

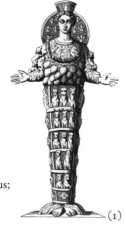

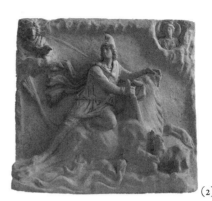

FIG. 39 (1) Drawing of a statue of Artemis of Ephesus; (2) marble relief of the Mithras tauroctony.

(1)

(2)

questioned his presence there.[66] R. Judah clearly deemed the quintessential Greco-Roman practice of visiting a bathhouse legitimate and in line with his own cultural proclivities, and therefore found it appropriate for inclusion in his Mishnah.

8. It has recently been suggested that the lavish House of Dionysus on Sepphoris's acropolis, containing a remarkable mosaic of Dionysiac mythology, may have belonged to R. Judah—indeed a stunning though still speculative theory (fig. 38). If in fact this were his residence, then the degree of his Hellenization would have been far more extensive than previously thought.[67]

Having established R. Judah's predilection for many aspects of Hellenistic culture, we may now conclude that the art at Bet She'arim fits comfortably into the wider Severan/sophistic world. It would account for the use of Hellenistic motifs as well as for the fact that over 80 percent of the inscriptions were in Greek. Moreover, the wider context of the Roman East would also help to explain this early appearance of uniquely Jewish symbols, particularly the menorah. In the second and third centuries, the use of symbols and icons (such as statues, statuettes, coins, and gems depicting Artemis of Ephesus and the Mithras tauroctony) became ubiquitous throughout the contemporary Greek world (fig. 39).[68] Yet another instance of the prominence of symbolic representation at this time is the sacred stone the emperor Elagabalus brought to Rome.[69]

66. See M 'Avodah Zarah 3, 4, as well as chaps. 3 and 21.

67. This suggestion was raised by Weiss ("Between Paganism and Judaism"); see also Talgam and Weiss, *Mosaics of the House of Dionysos*, 125–31.

68. Elsner, "Origins of the Icon."

69. Herodian, *Roman History* 5.3.4–5, and above, n. 9.

FIG. 40 Reconstructed entrance facade of a tomb in Palmyra.

Indeed, the appearance of Hellenistic artistic motifs beside Jewish ones in Bet She'arim was far from uncommon at this time. A combination of Roman and local Eastern motifs appears on sarcophagi from Palmyra; in one case, the lid depicts the person interred as an Eastern caravaneer, while the chest itself shows the same person in Roman dress. In the architectural sphere, the upper part of the facade of one Palmyrene tomb bears an Eastern appearance—a flat roof, deep wall niches, and several stories—while the lower part exhibits typically Roman features (fig. 40).[70]

Perhaps, then, one important stimulus for the representation of Jewish objects as symbols, presumably for the first time in Judaea/Palestine, was the increased tendency to use comparable symbols throughout the East.[71] Such a change does not seem to have emerged from internal Jewish developments. There is virtually no precedent for displaying the menorah alone, although it had been done beforehand on rare occasion, but only then primarily in a Temple/priestly context at the end of the Second Temple period.[72] The widespread use of icons in the Roman East, however, makes the emergence of the menorah and other religious artifacts as symbols more readily explicable.

The remarkable finds from the Bet She'arim necropolis offer a fascinating instance of Romanization, when some or many Jews, citizens of the empire since 212, responded favorably to regnant cultural trends and practices.[73] They have allowed

70. Schmidt-Colinet, "Aspects of 'Romanisation.'" For aspects of Romanization and its limits in the burial practices of Asia Minor, see S. Cormack, "Funerary Monuments." For a comparison and description of the integration of Roman, Hellenic, and local components in the art of second- and early-third-century Asia Minor, see Newby, "Art and Identity in Asia Minor."

71. See Elsner, "Origins of the Icon," 196: "The icons of pagan polytheism in the east were used during and after the second century AD . . . as a prime means for ethnic and religious self-assertion. . . . The particular feature of this use of sacred art for eastern self-assertion was that it never denied the logic of empire: it never argued for nationalism or separatism."

72. See chap. 3.

73. See Hecataeus on the proclivity of the Jews to adopt foreign burial and marital practices (M. Stern, GLAJJ, 1:29). Nevertheless, Bet She'arim may likewise attest to the continuation of an older Second Temple practice; it has been recently claimed that a number of

us to examine a context intimately associated with the Patriarchal dynasty and its circles—elements of the urban elite, synagogue officials, Diaspora leadership, and others. Nevertheless, as important as these groups may have been, they do not necessarily reflect the whole of third-century Jewish Palestine. Indeed, the extensive use of both pagan and Jewish artistic motifs remains, for the present, largely unattested elsewhere in contemporary Galilee.

THE ROMAN CATACOMBS: BETWEEN JUDAISM AND CHRISTIANITY

A third factor behind the artistic renaissance of the third century may well have been the expansion of Christianity, which by the third century was beginning to constitute a noticeable, if not formidable, religious and communal presence in many places throughout the Roman world.

While our historical information regarding the Jews in third-century CE Rome is virtually nil, we are considerably better informed about the Christian community.[74] The Severan era was reportedly a favorable time for Christians, when the church was beginning to acquire land and Callistus (awarded the title *pontifex maximus* when he became bishop of Rome[75]) was appointed to create a Christian cemetery on the Via Appia. By the middle of that century, the bishop of Rome, Cornelius, noted that his church included forty-two presbyters, seven deacons, seven subdeacons, forty-two acolytes, and fifty-two exorcists, readers, and doorkeepers, and assisted more than fifteen hundred widows and poor through its charity.[76]

Nevertheless, as late as the turn of the fourth century the Christians remained a relatively small minority of the Roman population, perhaps 10 percent of the city's inhabitants, who are estimated to have numbered 800,000.[77] The physical, demographic, and institutional Christianization of the city was a gradual process, even after the "conversion" of Constantine, and it is only around the turn of the fifth century that one can speak of *Roma cristiana*.[78]

stepped water installations at this cemetery may have in fact served as *miqva'ot*. See Amit and Adler, "*Miqwa'ot* in the Necropolis of Beth She'arim."

74. See Lampe, *From Paul to Valentinus*, 35–41; Curran, *Pagan City and Christian Capital*, 35–41; Elsner, "Inventing Christian Rome," 73–74. See also MacMullen, *Second Church*, 69–76.

75. This is the interpretation often given to a comment of Tertullian, *On Modesty* 1.

76. *Eccles. Hist.* 6.43.11.

77. These are speculative figures; see Drake, "Models of Christian Expansion"; Stark, *Rise of Christianity*, 3–27, and comments thereon by Wilson, *Darwin's Cathedral*, 147–57.

78. Throughout almost the entire fourth century, a traditional pagan urban body politic maintained the temples, priesthoods, festivals, rites, and games. As formulated by Krautheimer (*Rome: Profile of a City*, 33): "The Church, though backed by the imperial court and by the urban masses inside the city, had a hard time asserting her position. The struggle, at times bitter, ended early in the fifth century with the triumph of the Church, no longer contested. Only from then on does the map of Rome increasingly reflect the city's Christian character, and this remains so until 1870."

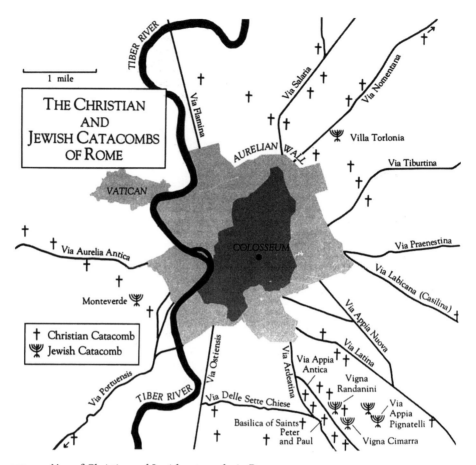

FIG. 41 Map of Christian and Jewish catacombs in Rome.

Given the fact that Jews and Christians of the third century on shared a common text and a number of similar rituals (especially when compared to their pagan neighbors), and that their catacombs (and perhaps areas of residence as well) were found in close proximity (fig. 41), it is not surprising that their burial practices display many similarities as well. Either a Christian or Jewish component played a role in determining the nature of the other, or perhaps both communities were shaped by the larger Roman setting, including elements of their epigraphy and art. The Jewish, Christian, and pagan catacombs in Rome consist of extensive passageways and galleries (fig. 42) lined with layers of horizontal burial niches (*loculi*) and painted burial chambers (*cubicula*) containing *arcosolia*, *loculi*, and sarcophagi.[79]

The artistic remains in the Roman Jewish catacombs are far more plentiful than at other Jewish burial sites in Late Antiquity. While Hellenistic motifs (such as Fortuna or the seasons of the year) were only rarely used, most depictions are either

79. On this and what follows, see chap. 7.

(1)

(2)

FIG. 42 Catacomb passage-
way with burial niches.

FIG. 43 Painted *cubicula*: (1) Domitilla (Christian); (2) Vigna Randanini
(Jewish).

neutral (floral and geometric designs with some fish and animals) or contain Jew-
ish symbols. The latter appear primarily on two types of objects—on the plaster of
slabs and bricks sealing the *loculi* along the galleries, where most of the burials are
found, and on fragments of gold glass.[80] The artistic evidence from the catacombs is
surpassed only by the treasure trove of some six hundred inscriptions found there,
mostly in Greek.[81]

The Jewish and Christian catacombs resemble each other in many ways; they
are all underground burial places (hypogea) with similar chronologies, plans, and
artistic designs, and both have painted rooms (*cubicula*), gold glass, sarcophagi,
and inscriptions (fig. 43). Moreover, it appears that in many cases Christians and
Jews employed the same workshops.[82] There was also geographical propinquity be-
tween their catacombs even though both communities seem to have been scattered
throughout the city and were organizationally fragmented during the first centuries
CE. Finally, the use of art as a vehicle for symbolic expression surfaces at this time
in both Jewish and Christian (as well as contemporary pagan) contexts.[83]

Yet there are also significant differences between them. The plaques used for
sealing the *loculi* in Christian settings are usually plain, with almost no decoration
or artistic representation, while more elaborate ornamentation was reserved for the
individual *cubicula* of the wealthy. Christian inscriptions are frequently personal in
content, while Jewish ones often note the synagogue affiliation or communal titles
of the interred. The use of gold-glass cups is far from uncommon in the pagan and
Christian world, but when the Jews adopted this widespread practice they decorated
these objects with an array of Jewish motifs (fig. 44). Artistically, the Christians

80. On gold glass, see chap. 7.
81. Noy, *Foreigners at Rome*, 264, and chap. 7.
82. Rutgers, "Archaeological Evidence."
83. See Newby, "Art at the Crossroads?" 233–49.

(1) (2)

FIG. 44 Gold-glass fragments: (1) Christian—
above: Saint Peter, Saint Paul, Saint Laurence,
and another in a tunic and pallium; below: Saint
Hippolytus and Saint Timothy flanking Jesus;
(2) Jewish—lions flanking a Torah ark; *lulav, ethrog,*
and shofar flanked by two *menorot* and amphorae.

were far freer in their use of pagan motifs and biblical scenes, and, interestingly, they used four times as many scenes from the Hebrew Bible than from the New Testament.[84] In striking contrast, the Jews used neither human figural art nor biblical scenes in the decoration of their catacombs.

While the language and names appearing in Jewish inscriptions seem to indicate a high degree of acculturation,[85] the inscriptions entirely ignore the civic dimension (if one even existed) of their life in Rome and focus solely on Jewish institutional involvement, clearly pointing to a more insular setting among Jews residing in the imperial capital.[86]

The Roman material may also be relevant to a wider issue—the relationship between Jews and Christians before the triumph of Christianity. Or, to phrase the issue in more current terms, had Judaism and Christianity "parted ways" in Rome by the third century?[87]

The implications of the catacomb material in this regard are far from clear. On the one hand, the many similarities between Christian and Jewish burials at this time would lead us to assume a great deal of communication, parallel developments, and perhaps even cooperation between these groups. There is no way of assessing whether other groups in the city shared these practices—and, if so, to what degree. For example, no catacomb has been discovered that might relate to a well-defined pagan community, as those in existence during the second to fourth centuries had been taken over sooner or later by Christians.[88] However we might define the nature and extent of this parallel activity, Jews and Christians clearly acted in tandem. On the basis of this evidence, then, it would be difficult to conclude that the communities at this time were going their separate ways.

84. R. M. Jensen, *Understanding Early Christian Art*, 68–69; see also the series of articles by M. Charles-Murray, R. M. Jensen, J. Deckers, and H. L. Kessler in Spier, *Picturing the Bible.*

85. Jewish onomastic practices followed those of Roman society; see Rutgers, *Jews in Late Ancient Rome*, 163.

86. For more on the above, see chap. 7.

87. Recent studies of the issues relating to a late date for the "parting of the ways" can be found in Becker and Reed, *The Ways That Never Parted.* For a claim that Judaism and Christianity had "parted ways" in Rome well before the third century, see R. E. Brown, "Further Reflections"; Spence, *Parting of the Ways.*

88. The presence of some pagan motifs in Jewish and Christian contexts (referred to above) is irrelevant. Such art now appears in a plethora of nonpagan contexts and clearly appears to have been accepted by at least some Jews and Christians.

On the other hand, the archaeological remains preclude any assumption that the boundary lines between the two groups were blurred or nonexistent. As noted, many aspects of Jewish remains reflect an exclusivity and insularity that bespeaks the *mentalité* of a very distinct ethnic-religious group seeking to preserve its unique identity and culture. Jewish art differed strikingly from that of the local Christians both in what it emphasized (Jewish symbols) and in what it ignored or perhaps rejected (such as figural scenes, biblical and otherwise). Moreover, the exclusive focus of many inscriptions on the synagogue and its officials further highlights the insular world of the local community.

Indeed, the ways do seem to have parted in Rome, at least to some extent; differences between Jewish and Christian burials are many and seemingly of primary importance to each group. Yet even with the apparent parting, a significant degree of similarity and commonality remain. Hostility does not seem to have been the order of the day between Jew and Christian, although admittedly it would be rather unusual for archaeological material to reflect such tensions. Perhaps within the larger pagan surroundings of Rome's sprawling metropolis (sometimes referred to as a cosmopolis[89]) of the third and early fourth centuries both groups were regarded by the "mainstream" as the "other" (and undoubtedly even saw themselves as outsiders), thereby minimizing, if not neutralizing, whatever tensions might have otherwise surfaced between them.[90]

CONCLUSION

We have examined the various causes that stimulated a renewed and revitalized artistic expression among Jews in the third century. Although surfacing in geographically disparate locales across the Roman Empire and thus reacting to the stimuli of vastly different historical contexts, Jews turned to a heretofore untapped repertoire of symbols and images to give voice to their religious beliefs and cultural proclivities, all the while reinforcing their identity both as part of a group and as individuals. In addition to being part of the Roman Empire, each of these locales was associated with a place in which the interaction between Jew and non-Jew constituted a significant factor in this process. Ultimately, however, there was no single all-embracing cause for the emergence of this art among Jews, but rather a series of cultural and religious developments in the Roman world that impacted upon various Jewish communities in different ways.[91] As a result, the art in each place was

89. C. Edwards and Woolf, "Cosmopolis."

90. It was only in the late fourth and fifth centuries that anti-Jewish and anti-Judaic sentiment became far more public and ubiquitous in both imperial and ecclesiastical circles, as well as on the street; see Parkes, *Conflict*, 151–95; and chap. 9.

91. The same holds true for early Christianity. On the differences in Christian art between Dura and Rome, see Grabar, *Christian Iconography*, 19–30; Perkins, *Art of Dura-Europos*, 55. The art produced in the Severan era was likewise multifaceted: "It is impossible to characterize Severan art as having any one style or theme. Instead, each object or monument forms part of a bigger picture showing the crucial role that art continued to play in expressing

unique: that in Rome was characterized by the large-scale use of symbols and very limited figural art; that in Bet She'arim, by the use of Jewish symbols and figural art (though no biblical scenes), including a series of pagan images; and that in Dura, by the broad use of figural and biblical art with little "pagan" imagery (except for destroyed Philistine idols) but only minimal use of Jewish symbols per se.[92]

Having said this, two caveats are in order. First, we should bear in mind that there is a difference between a public display of art in a synagogue such as Dura (being a public venue) and the type of art appearing in the necropoleis of Rome and Bet She'arim, be they more communally organized, as the former, or more individually (or familially) oriented, as the latter. In other words, are we running the risk of mixing the proverbial apples and oranges? Thus, the richness of Dura stands in striking contrast to the far more modest representations in the burial areas, where few people entered and the lighting was minimal. Nevertheless, the art emerging at this time, whatever its particular setting (synagogue or funerary), was new to the Jewish scene; never before had such motifs been featured in Israelite-Jewish contexts. Moreover, whatever the differences between these third-century settings, this art expanded and developed in the subsequent Byzantine-Christian period.

Second, despite our above claim regarding the immediate wider contextual setting, it is not absolutely certain that these new artistic expressions were the result of solely synchronic factors. To what degree might these communities have been influenced by one another or, alternatively, by some as yet unidentifiable and untapped reservoir of Jewish artistic traditions that existed before the third century? Put differently, might a common Judaism in the second and third centuries have contributed, actively or passively, to the emergence of these artistic expressions?[93] In considering the two necropoleis, we note the following artistic similarities: the use of the menorah as a symbol, with only occasional reference to its original historical setting as part of the Tabernacle or Temple (Dura); the introduction of other symbols such as the shofar, *lulav*, and *ethrog*; and the appearance of some pagan themes, especially on sarcophagi but also in several *cubicula* paintings (Rome). Among the commonalities at all three sites discussed above, we should mention the motif of the Temple facade or the Torah shrine flanked by one or two *menorot*. Such simultaneous appearances at very distant sites, especially at such an early stage of Jewish artistic development in Late Antiquity, may have been a product of a common Judaism, but such an assertion cannot be substantiated at present owing to a dearth of evidence.

the identities of, and relationships between, people, emperors, and gods across the Roman world" (Newby, "Art at the Crossroads?" 249).

92. The menorah at Dura appears on several occasions, but not as a symbol. It is presented as a central and easily recognized object that once stood in the Tabernacle and Temple, and is always related to one of these settings; it never stands alone, as in Bet She'arim and Rome.

93. See L. I. Levine, "Common Judaism."

5 ♦ DURA EUROPOS IN ITS EASTERN RELIGIOUS SETTING

BY ALL ACCOUNTS, the most sensational of ancient synagogues is that of Dura Europos. The building's external appearance was rather modest, as it was originally a private house located in a largely residential area at the western extremity of the city. The synagogue's uniqueness lies in its interior, in the elaborate wall decorations that remain unparalleled. Consequently, this synagogue has drawn more scholarly interest than any other Jewish find from antiquity, opening up new vistas in our understanding of ancient Jewish art. Before its discovery scholars had doubted the existence of a developed Jewish artistic tradition in antiquity; afterwards, Dura was regularly seized upon as proving that it did, and in a striking fashion.[1]

Located in eastern Syria, on the west bank of the Euphrates River, Dura Europos was a Hellenistic urban center founded by Seleucus I around 300 BCE (fig. 45).[2] Built in typical Greek fashion, with a grid pattern, walled defenses, a central agora, and temples dedicated to traditional Greek deities, the city was one of many that this Hellenistic monarch founded in his realm. Dura remained in the Seleucid orbit until 113 BCE, when it was captured by the Parthians. During the next three centuries, Parthian Dura flourished as a center on the east-west trade route along the Euphrates, and in the second century CE, after a brief period of Roman rule under Trajan in 115, the city was recaptured by the Romans in 165 and remained under their control for almost a century.[3] It was destroyed by the Sasanians in 256 or soon thereafter and was never resettled.[4]

1. For more on the Dura synagogue, see chap. 4.

2. On the history of Dura, see Rostovtzeff, *Caravan Cities*; Rostovtzeff, *Dura Europos and Its Art*, 1–31; Downey, "Transformation of Seleucid Dura"; Welles, "Population of Roman Dura."

3. See Edwell, *Between Rome and Persia*, 115–48.

4. Although 256 has been generally accepted as the date of Dura's final destruction, this dating remains contested by some; see C. Hopkins, "Siege of Dura" (256 CE); S. James, "Dura Europos and the Chronology of Syria" (255 or 256, but possibly even early 257 or late 254); and D. MacDonald, "Dating the Fall of Dura" (257 CE); see also Edwell, *Between Rome and Persia*, 87–91, 143–46.

FIG. 45 Map indicating Dura Europos on the banks of the Euphrates River.

The remarkable preservation of a sizable portion of the Dura synagogue is indeed fortuitous. Paradoxically, this preservation was due to the synagogue's location on a street running parallel to the city's western wall, precisely the direction from which the Sasanian attack on Dura came. Anticipating this assault, the Romans fortified the western wall with a ramp that buried some of the adjacent buildings, including a large part of the synagogue. When the city eventually fell, those parts of the synagogue that had been covered remained virtually unscathed. Several other religious buildings along this western street, such as the Christian church, the Mithraeum, and the Temple of Bel (or Temple of the Palmyrene Gods), were also relatively well preserved.

While 256 is generally accepted as the date of the synagogue's destruction, there is no way of determining when it was first built. It clearly had two distinct stages; the later one, to which practically all the extant remains belong, can be dated with precision. Several inscriptions note two different eras that correspond precisely with each other — 556 of the Seleucid era and the second year of the emperor Philip's reign; both date the synagogue's second stage to 244/45 CE. Thus, the ornate later stage lasted little over a decade. However, no evidence exists for the founding of the earlier, more modest, synagogue building of Stage 1. If, as seems likely, the Jewish community was linked to the presence of the Roman garrison in the city after 165, perhaps serving primarily as merchants and traders, then the first stage of this synagogue should be dated to the latter part of the second century CE or, at the latest, to the beginning of the third.[5]

5. Rostovtzeff, *Dura-Europos and Its Art*, 104; Kraeling, *The Synagogue*, 7–33.

The first stage of the synagogue consisted of a series of rooms surrounding a central courtyard measuring 6.55 by 6.05 meters (fig. 46). Entering from the northwest via a narrow corridor, one comes to a peristyle courtyard (1) paved with tiles. A series of rooms (nos. 4–6) appears to have been used for many of the nonliturgical functions often associated with a synagogue: schoolroom, court, communal dining room, a room for the synagogue custodian, lodging for wayfarers, and more.[6] Room 7, whose precise function remains elusive, was located south of the courtyard. The benches built along three of its walls might have accommodated overflow attendees, provided a separate meeting place with access to the main sanctuary, or served some other religious, educational, or social purpose.[7]

Room 2, west of the courtyard, clearly served as the sanctuary proper. It was generally rectangular in shape, measuring roughly 10.65–10.85 by 4.6–5.3 meters, and had two entrances, one near the center of the eastern wall and a second at its southernmost extremity. Benches lined all four walls of the room, and in a few places an additional low pedestal might have served as a footrest to compensate for the greater height of the benches there. A patch of white plaster in the middle of the room may have covered cavities that once supported the base of a platform or table. The focal point of the room, located in the western wall opposite the main entrance, was an *aedicula* that served as a Torah shrine.

The later (Stage 2) building was much larger and more ornate than its predecessor, indicating a sizable increase in the Jewish community and its degree of prosperity (fig. 47). The seating capacity grew from approximately sixty-five in Stage 1 to double that later on, based on the length of the stone benches only (and not the possible use of mats or wooden benches). The sanctuary and its adjacent courtyard were now ex-

FIG. 46 Dura synagogue, Stage 1 (before 244/45 CE).

FIG. 47 Dura synagogue, Stage 2 (244/45–256 CE).

6. See L. I. Levine, *Ancient Synagogue*, 380–411.

7. If, however, one assumes that there were special quarters for women in ancient synagogues, an assumption that has been generally rejected of late, then this room would be a logical candidate; see ibid., 500–5.

panded to include the entire width of the former building (Room 7 of the first stage was incorporated into the enlarged courtyard), and benches were added along the walls of the enlarged assembly hall. The later building followed the pattern of its predecessor in several of its features—a broadhouse-type building where worship was oriented toward the long, western wall, which accommodated an *aedicula* for the Torah scrolls in its center. Next to the sanctuary's *aedicula* was an elevated seat, clearly intended for a distinguished personage such as Samuel, who—as attested by the epigraphic evidence—was the leader of the community.[8] Two entrances from the east led into the main hall.

Major changes also included the acquisition of an adjacent dwelling (House H, 26 by 18 meters) to the east, which was transformed into an integral part of the synagogue complex and virtually doubled its size. Nine rooms (H 1–8), which undoubtedly housed various synagogue functions similar to those in the earlier stage, were added. As a result, the entrance to this newly expanded complex was relocated on its eastern side.

The Dura synagogue preserves a large corpus of inscriptions, second only to those from Sardis. The exact numbers are disputed, depending on the language identified (Hebrew vs. Aramaic, Middle Persian vs. Parthian), how the samples are counted (Kraeling counts three Aramaic dedicatory inscriptions as one), and how a number of virtually illegible graffiti are categorized. According to Kraeling, there are fifty-eight inscriptions—twenty-four in Aramaic, nineteen in Greek (six of which are questionable), and fifteen in Iranian (one of which is uncertain). David Noy and Hanswulf Bloedhorn list a total of fifty-two inscriptions—eighteen in Aramaic, two in Hebrew/Aramaic, twelve in Greek, two in both Greek and Aramaic, thirteen in Middle Persian, three in Parthian, and two uncertain.[9] While no Hebrew inscriptions were found, several parchment fragments containing Hebrew text were discovered outside the synagogue building.[10]

Several Greek and Aramaic inscriptions found on ceiling tiles furnish not only the date of Stage 2 but also names and titles of the synagogue's leadership. The epigraphic evidence is typical of a Syrian setting, where bilingualism was ubiquitous.[11] Most of the inscriptions in these two languages appear on the wall frescoes and were intended to identify a particular personage or scene.

The Iranian inscriptions, usually associated with Sasanian visitors, are the most enigmatic,[12] since it is not clear whether these people were Jews or Persian officials

8. Kraeling, *The Synagogue*, 263–68; 277–78.

9. Ibid., 261–317; Noy and Bloedhorn, *Inscriptiones Judaicae Orientis*, 3:133–212, summary, 268–69. For a broader view of the intersection of religion and language in Dura, see Kaiser, "Religion and Language in Dura-Europos."

10. See chap. 18; Fine "Jewish Identity."

11. Drijvers, "Syrian Christianity and Judaism," 125.

12. Kraeling, *The Synagogue*, 283–300; Noy and Bloedhorn, *Inscriptiones Judaicae Orientis*, 3:178–81.

FIG. 48 Ceiling tiles: (1) Female bust (personification of vegetation?); (2) Capricorn; (3) birds eating fruit within a wreath; (4) clusters of grapes; (5) sheaves of grain; (6) apotropaic eye.

or why they would have recorded their visit by leaving inscriptions on the frescoes. Most of these inscriptions appear on two panels in the lowest register—the Purim story and a scene from the life of Elijah. Interestingly, these panels were found with some of the figures' eyes damaged and occasionally gouged out, and it is debatable whether there is some connection between these visitors and this defacement.

The ceiling tiles were one of the few components used in both stages of the synagogue.[13] They bore a variety of motifs, some appearing frequently and some only two or three times (fig. 48): (1) vegetation; (2) astrological symbols (Pisces, Capricorn, and a centaur), the first two of which were often found elsewhere as part of the zodiac; (3) animals (including deer, dolphins, serpents, gazelles, and birds); (4) flowers; (5) fruits; (6) grains; (7) several eyes as an apotropaic sign; (8) busts of young women; (9) the sun; and (10) six dedicatory inscriptions, three in Greek and three in Aramaic.

The pièce de résistance of the Dura synagogue was not its architecture but its art. Although both literary sources and inscriptions relating to the entire Diaspora mention that synagogues were sometimes decorated with painted walls, archaeological

13. Kraeling, *The Synagogue*, 41–54; K. B. Stern, "Mapping Devotion in Roman Dura Europos."

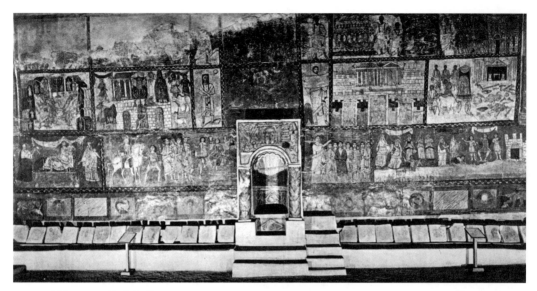

FIG. 49 Western wall of the Dura synagogue.

excavations to date have uncovered only fragments of them. Only in this provincial town, far from the empire's urban centers, was the local synagogue decorated from floor to ceiling and on all four walls with an astounding display of biblical scenes, divided into three primary registers (fig. 49).[14]

The only exception to the narrative character of these biblical scenes is in the area above the Torah shrine, where the representations are of a more symbolic nature (fig. 50). On the arch of the *aedicula*, immediately above the Torah niche, are a series of depictions associated with the Jerusalem Temple, which, not coincidentally, is located west of Dura, in the direction of this wall. The facade in the center undoubtedly represents that of the Temple itself; to the left is a large menorah flanked by a *lulav* and *ethrog*, while to its right is an unusual depiction of the sacrifice of Isaac (the *'Aqedah*). This scene is somewhat crowded and depicts Isaac lying on a large altar, Abraham holding a knife in his right hand, a ram next to a tree or bush, and an unidentified figure standing in a tent. All three human figures have their backs to the viewer, an arrangement that has given rise to a number of interpretations.[15]

Above this area is an enormous panel that was reworked on several occasions during the short span of Stage 2. It initially consisted of a large tree (often interpreted

14. In addition to the three main registers, there are also two narrow areas, one at the bottom and one at the top of the walls, "the former consisting of a continuous dado in imitation of marble incrustation work, and the latter in all probability a painted imitation of moulded architraves" (Kraeling, *The Synagogue*, 67).

15. Ibid., 54–62; Gutmann, "Early Synagogue and Jewish Catacomb Art," 1315–16; St. Clair, "Torah Shrine"; Kühnel, "Jewish Art in Its Pagan-Christian Context," 53–64; Goodenough, *Jewish Symbols*, 9, 68–77; H. L. Kessler, "Program and Structure," 156–57.

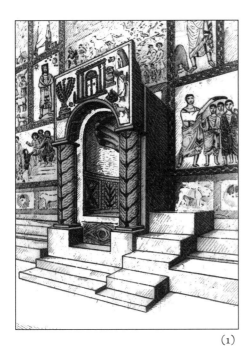

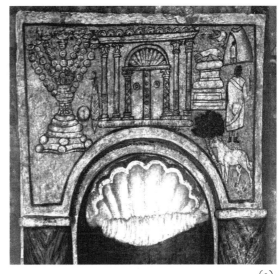

(2)

FIG. 50 Dura synagogue:
(1) Torah shrine in western wall
(2) area above Torah shrine.

(1)

as the Tree of Life or a tree symbolic of the Torah) with two somewhat enigmatic representations on either side of its base—a table with a cushion on top and a round object beneath it, and some sort of stand featuring two lions in a heraldic position. This area was later divided in half. The lower portion bears multiple scenes: Jacob blessing Joseph's two sons, Ephraim and Menasseh (lower right); Jacob blessing his twelve sons (lower left); and David, in the garb of Orpheus, spellbinding an audience of animals with his music (fig. 51).[16] The upper portion features a seated dignitary surrounded by his court. Various identifications have been suggested for this scene (fig. 52): Jacob and his sons; the blessing of Moses; David as king; and, most frequently, the Messiah surrounded by representatives of the House of Israel.[17]

The central panel is flanked by four large figures (fig. 53):[18]

> *Upper right:* Moses and the burning bush (clearly identified as such by an inscription).
> *Upper left:* Moses on Mount Sinai; or, alternatively, Joshua encountering an angel near Jericho.

16. See, however, the reservations Flesher has about this identification, in "Rereading the Reredos."

17. See, for example, Kraeling, *The Synagogue*, 225–27; Gutmann, "Early Synagogue and Jewish Catacomb Art," 1317.

18. Gutmann, "Early Synagogue and Jewish Catacomb Art," 1317.

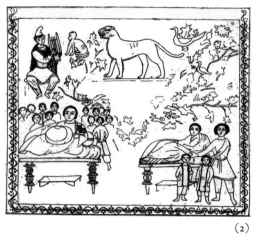

(2)

(1)

FIG. 51 Dura synagogue, lower middle panel: (1) Stage 1, Tree (of Life?); (2) Stage 2, Jacob blessing his sons and grandsons and David playing for animals.

FIG. 52 Dura synagogue, upper middle panel: Messianic court?

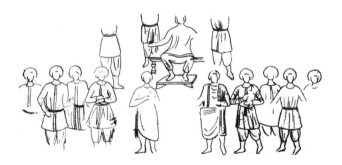

Lower right: Moses reading from a scroll (other suggested identifications: Ezra, Josiah, Jeremiah).

Lower left: A figure praying: Moses at the end of his life (the blessing of Moses); other interpretations include Joshua at Gibeon, Abraham receiving God's blessing, or Isaiah.

There can be little question that the scenes above the ark were laden with meaning for the worshippers and that the potential historical and symbolic associations are multifaceted. The four wing panels with their large, looming figures are crucial components in and of themselves but also served to heighten the importance of the entire area above the Torah shrine.[19] Moreover, the fact that almost all of the nar-

19. For further discussion of the identities of these figures, see below.

ratives appearing on the three main registers seem to flow toward this central area further emphasizes its importance.

There is a general consensus among scholars regarding the identification of at least a dozen panels, which comprise almost half of those that have been preserved. The remaining panels were either totally demolished with the city's destruction in 256 CE or are very poorly preserved.

Let us survey the panels and their contents:[20]

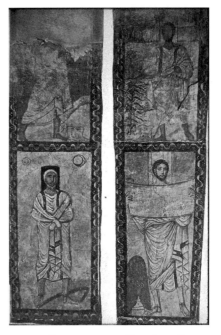

FIG. 53 Dura synagogue: Four large figures (of Moses?) flanking middle panels.

WEST WALL (fig. 49)[21]

Register A (upper):
North—Exodus.
South—Solomon and the Queen of Sheba; extreme left-hand panel is unidentifiable.

Register B (middle):
North—The return of the ark from the land of the Philistines; Jerusalem and the Temple of Solomon.
South—Dedication of the Tabernacle with Aaron and his sons; Israelite desert camp and the miracle of the well.

Register C (lower):
North—Infancy of Moses; Samuel anointing David.
South—Scenes from the scroll of Esther; Elijah resuscitates the widow's child.

SOUTH WALL[22]

Register A : Obliterated.

Register B : Dedication of the Temple; left-hand side obliterated.

Register C : Prophets of Baal on Mount Carmel; Elijah and the widow of Sarepta; extreme left-hand panel unidentifiable.

NORTH WALL[23]

Register A: Jacob at Bethel; right-hand side obliterated.

20. For a more detailed summary of the various suggestions made in this regard, see Gutmann, "Early Synagogue and Jewish Catacomb Art," 1315–22; Gutmann, "Synagogue of Dura Europos"; and, of course, the discussions of Kraeling (*The Synagogue*) and Goodenough (*Jewish Symbols*, vols. 9–11), passim.

21. The description moves from right to left when facing the Torah shrine, looking west.

22. When facing the south wall, moving from right to left (west to east).

23. When facing the north wall, moving from left to right (west to east).

Register B: Hannah and Samuel at Shiloh (partially destroyed); the battle at Evenezer.

Register C: Ezekiel's vision of the dry bones; the execution of an important personage on the altar (identification disputed).

EAST WALL

Registers A and B: Obliterated.

Register C:
North—David and Saul in the Wilderness of Zin.
South—Belshazzar's feast (?).

The copious scholarly literature on the Dura synagogue has been devoted, with rare exception, to the meaning of one or more of these scenes. There is general agreement that they represent, in one form or another, high points in biblical history, when God's intervention was in evidence as He guided the destiny of the Israelites. Since this is the major theme in biblical literature generally, the question arises as to why these specific episodes were chosen for this synagogue. What were the criteria for the selection of these scenes and not others, or were they chosen randomly?

Scholarly opinion is divided on this question.[24] Rostovtzeff, Sukenik, and Kraeling assume that no overriding theme or comprehensive program dictated the selection other than a desire to celebrate important events, a kind of artistic *Heilsgeschichte* paralleled in numerous literary sources that likewise recount these and other events.[25] Others have suggested that each register focuses on a different, perhaps related theme. Thus, Robert du Mesnil de Buisson considers the subject matter of one register to be historical, another liturgical, and a third moralizing.[26] Isaiah Sonne interprets the three registers as reflecting the rabbinic dictum regarding the three crowns—Torah, priesthood, and royalty.[27] Still others posit that one overall theme pervades all the frescoes—Rachel Wischnitzer and Jonathan A. Goldstein a messianic one,[28] and Goodenough a mystical one.[29] In addition, several scholars have suggested that these panels reflect one or more aspects of Jewish liturgy, from

24. See Gutmann, "Early Synagogue and Jewish Catacomb Art," 1322–24. See also Gutmann, *No Graven Images*, xxxvii–xliv; Wharton, "Good and Bad Images."; Hachlili, "Dura-Europos Synagogue Wall Paintings."

25. Rostovtzeff, *Dura-Europos and Its Art*, 100–34; Sukenik, *Synagogue of Dura Europos*, 164–70; Kraeling, *The Synagogue*, 346ff.

26. Du Mesnil du Buisson, *Les peintures de la synagogue de Doura-Europos*, 13–17.

27. Sonne, "Paintings of the Dura Synagogue." Working horizontally rather than vertically, Grabar has suggested that the western wall, at least, is decorated symmetrically with parallel themes that balance one another, e.g., a Temple scene, a kingship scene, and the saving of a child scene; see Grabar, "La thème religieux."

28. Wischnitzer, *Messianic Theme*; J. A. Goldstein, "Judaism of the Synagogues."

29. Goodenough, *Jewish Symbols*, vols. 9–11, and esp. 10:197–210.

the centrality of the Torah-reading, its translation and explication, and the rab-binic *'Amidah* to the recitation of religious poetry (*piyyut*) centuries later within the framework of the prayer service.[30] Others have interpreted the scene from the scroll of Esther as reflecting contemporary political events, specifically the rise and impending threat of the Sasanian Empire.[31]

Another approach maintains that this synagogue's art embodied polemical as-sertions directed at Christianity. Although such a view has been particularly in evi-dence with regard to the Sepphoris synagogue,[32] it in fact first surfaced with respect to Dura. Marcel Simon had already raised this possibility in the mid-twentieth cen-tury, and the Jewish-Christian polemic is the main thrust of Herbert L. Kessler's theory regarding the frescoes of Dura.[33] No one today questions that such a polemic flourished in the writings of church fathers in the second and third centuries (and beyond),[34] yet these authors lived far from Dura and there is no way of knowing whether such polemics reached or affected the local Duran Christian community, much less its Jewish counterpart.[35] The suggestion that a polemic lies behind the synagogue paintings would undoubtedly gain plausibility were there unequivocal evidence that such issues were known in Dura or were of importance in Mesopo-tamia as far back as the early third century. However, neither of these desiderata is in evidence.[36]

The enormous range of scholarly opinion on the meaning and significance of the Dura frescoes is in large part the result of the sheer number of panels and their many interpretations, especially in conjunction with nearby depictions. Another factor is the relative isolation of this community, which was far from the known centers of Jewish life, is not mentioned in any literary source,[37] and has no literary tradition of its own. Attempting to give meaning to this art, scholars have turned to Jewish literary sources from other times and places. Goodenough, for example, relied heavily on Philonic writings (and even the thirteenth-century Zohar!) under the (mistaken) assumption that this first-century Alexandrian Jewish philosopher

30. Gutmann, "Early Synagogue and Jewish Catacomb Art," 1324–28; Moon, "Nudity and Narrative"; Laderman, "New Look"; Fine, "Liturgy and the Art of the Dura Europos Syna-gogue"; Fine, *Art and Judaism*, 172–83.

31. Sabar, "Purim Panel at Dura" (a pro-Roman interpretation); Levit-Tawil, "Purim Panel in Dura"; and Levit-Tawil, "Queen Esther at Dura" (a pro-Sasanian interpretation).

32. See chap. 18.

33. Simon, *Recherches d'histoire judéo-chrétienne*, 188–98; Weitzmann and H. L. Kessler, *Frescoes of the Dura Synagogue*, 2:153–83. See also Goranson, "Battle Over the Holy Day."

34. See Fredriksen and Irshai, "Christian Anti-Judaism."

35. On the extent and nature of the Jewish-Christian polemic in antiquity, see chap. 18.

36. On the rather speculative if not fanciful suggestion that this synagogue was actually a Jewish-Christian building, see Teicher, "Ancient Eucharistic Prayers"; Mancini, *Archaeologi-cal Discoveries*, 138–47; Jaffé, "Les synagogues des *amei-ha-aretz*."

37. Only the name Dura de-Ra'awata appears in the Bavli, but this is a different place; see Oppenheimer, *Babylonia Judaica*, 117–19.

espoused a mystical Judaism that became normative throughout the Jewish world, at least until the end of antiquity.[38]

Until now, the source most often invoked to explain Dura's art has been rabbinic literature. This massive corpus, including scores of books of varying lengths and spanning almost a millennium,[39] has been considered a logical reference, not only because of its sheer volume but also owing to the assumption that the rabbis were the main proponents and regulators of Jewish religious practice in antiquity.[40] Kraeling's masterful report of the finds was the pièce de résistance of such efforts and set the tone for much of the subsequent research; he utilized virtually all the literature generally associated with the rabbis—Talmud, midrash, and *targum*—to explain the myriad details appearing on the synagogue's walls.[41] Others have continued to explore this literature, beginning with the more or less contemporary tannaitic sources, but primarily concentrating on later compositions, some of which were edited many hundreds of years after the synagogue disappeared, and not infrequently using sources that originated in Palestine.[42]

Finally, Kurt Weitzmann suggested that this synagogue's artistic tradition originated in illustrated biblical manuscripts of Alexandrian provenance that had circulated throughout the Diaspora.[43] This suggestion has foundered, however, owing to the lack of evidence that such manuscripts ever existed at this early date.

One assumption, noted in chapter 4, seems to have united almost all of the past century's scholarly attempts to make sense of Dura's art—that the Dura paintings

38. Goodenough, *Jewish Symbols*, passim.

39. See Strack and Stemberger, *Introduction to the Talmud and Midrash*.

40. Alon's formulation is only one of many articulating such a view: "It is a known fact that from the days of the Hasmoneans and onwards the Pharisees constituted the vast majority of the nation, and hence, generally speaking, we have to regard the history of Jewry in our period, in all spheres, as also reflecting the history of the Pharisees. . . . At all events, 'the Sages of Israel' gave expression to the spirit and life of the nation, whose history mirrored the thoughts and deeds of the majority of the Pharisees" (*Jews, Judaism and the Classical World*, 22 and n. 11). See also Kraeling, *The Synagogue*, 356; Moon, "Nudity and Narrative," 588.

41. Kraeling summarized his approach thusly: "These conclusions, if they are correct, provide an important witness to the religious life and to the status of the Jewish community at Dura. The congregation subscribed sincerely to the beliefs and value judgments that are traditional in Judaism (i.e., rabbinic Judaism) and endeavored by the decoration of its House of Assembly to memorialize and inculcate reverence for the historic tradition to which it adhered" (*The Synagogue*, 358).

42. See the brief overview of Laderman, "New Look," 5–6. For a recent attempt to revive this rabbinic connection, see chap. 18.

43. Weitzmann, "Illustration of the Septuagint," esp. 227–30; Weitzmann, "Question of the Influence"; and, most recently, in Weitzmann and H. L. Kessler, *Frescoes of the Dura Synagogue*, 5–13. For criticism of this theory, see Gutmann, "Illustrated Jewish Manuscript"; Gutmann, "Dura Synagogue Paintings," 66–69; Wharton, *Refiguring the Post-Classical City*, 21–23.

could not have been the product of this small, short-lived community alone[44] but that a well-developed Jewish artistic tradition must have already existed in many large Diaspora communities. However, in the years following the discovery of the Dura synagogue and numerous other Diaspora synagogues, nothing even remotely resembling the Dura paintings has ever come to light. As a result, a number of scholars have begun of late to consider the heretofore unthinkable—that the art in Dura was not part of a "Jewish" Diaspora phenomenon per se, but rather the product of local artists in this particular community.[45]

Four recent attempts have addressed this hypothesis, each from a different perspective. Marie-Henriette Gates approaches this issue from an archaeological-artistic dimension. In her estimation, "The local tradition of Dura-Europos was all-pervasive: It remained oblivious to outward forms imposed by Hellenistic Greeks, by oriental Parthians, or by imperial Rome."[46] She then elaborates on this unique Duran tradition: "This so-called oriental, or Syro-Mesopotamian quality, is in fact precisely the essence of Durene culture. One cannot correctly interpret the religious structures, whether pagan, Jewish, or Christian, from any perspective other than within the context of a typical, provincial Syro-Mesopotamian community that is part of a long conservative history of religious and secular building."[47] Gates concludes that "there is no need . . . to postulate that the Durene synagogue artists were copying programs from other synagogues or illustrated manuals. . . . It is far more reasonable to credit the synagogue artists with an original program adapted from local practices than to search for outside sources for which there is no supporting evidence."[48]

Gates's analysis, however, for all its cogency and appeal, focuses mainly on the external aspects of the Dura synagogue. Even assuming that the synagogue was built in Duran style both architecturally and artistically, what were the significance and meaning of the frescoes themselves? Do they reflect ideas and beliefs that were widespread among the Jews at that time?

Paul V. M. Flesher, too, emphasizes the local character of the Dura paintings, maintaining that the scenes address one of two overriding contemporary themes:

44. See, for example, the statement of Simon, *Verus Israel*, 18: "It would be difficult to argue that the technical facility that produced the Dura frescoes had sprung to such perfection in an instant, on the bare soil of the Syrian desert."

45. Indeed, this idea is not entirely new but has accompanied the study of Duran art since its earliest stages with the publication of Rostovtzeff's monographic article, "Dura and the Problem of Parthian Art," and his subsequent *Dura-Europos and Its Art* (1938). These have been followed by other studies that also note the Palmyrene connection: Brilliant, "Painting at Dura Europos," passim; Dirven, *Palmyrenes of Dura Europos*; Levit-Tawil, "Enthroned King Ahasuerus at Dura"; Levit-Tawil, "Purim Panel in Dura."

46. Gates, "Dura Europos" (quote on 168). See also Perkins, *Art of Dura-Europos*, 55–65, 114–26.

47. Gates, "Dura Europos," 169.

48. Ibid., 176; and chap. 4.

(1) the reinforcement of Jewish identity and commitment; and (2) cooperation between Jew and gentile in the biblical narrative.[49] Claiming that a number of scenes highlight such cooperation (for example, the Esther and Mordecai narrative, the saving of Moses by Pharaoh's daughter, and Elijah's resuscitation of the non-Jewish son of the widow of Zarephath), Flesher argues that such depictions served the community's desire to become integrated into larger Duran society. He also rejects an assortment of theories that emphasize the messianic orientation of this synagogue's art.

Annabel J. Wharton likewise calls attention to the local provenance of the Dura synagogue paintings, comparing them to a technique used in rabbinic midrash.[50] Just as a midrashic text offers several interpretations alongside each other, so do the Dura frescoes. In a postmodern vein, she asserts that the frescoes conveyed a pastiche of messages that the local viewer(s) would imbue with his or her own meaning(s). Almost as an aside, Wharton also introduces the concepts of resistance and subversiveness as potential meanings of this multivocality. As she summarizes her position: "Too often in the past, art historians (or theologians) have sought a single, identifiable meaning in the paintings of Dura rather than allowing a free play of possible, even contradictory, significations. For mid-third century viewers, it seems more likely that these images figured in a variety of ways in their daily experience of the divine."[51]

Finally, Jaś Elsner attempts to read several panels of the Dura synagogue as polemical statements directed against local Duran pagan cults,[52] asserting that the concept of cultural resistance is the key to many aspects of local art, not only in the Dura synagogue but in the church and Mithraeum as well. All the more so, Elsner asserts, this theory holds true when viewed as a deliberate imperial policy to foster competition (referred to as "segmentary opposition") and thus facilitate political domination by the principle of "divide and rule."[53] Elsner offers several examples from this synagogue's art—the statues of Dagon lying strewn on the ground in the presence of the Israelite holy ark and Elijah's victory over the prophets of Baal—to demonstrate that it is suffused with "actively anti-pagan imagery."[54] He maintains that these two scenes represent the triumph of Judaism over paganism per the biblical contexts, referring not only to the Philistines and Canaanites but, by extension, to the local Duran cults and even to the Romans themselves.[55] In summing up his ar-

49. Flesher, "Conflict or Cooperation?"

50. Wharton, *Refiguring the Post Classical City*, 38–51; Wharton, "Good and Bad Images," 15–22.

51. Wharton, *Refiguring the Post Classical City*, 63.

52. Elsner, "Cultural Resistance," esp. 281–99.

53. Ibid., 270–71.

54. For his argument regarding the synagogue, see ibid., 281–83.

55. As a third example, defined "as an internal affirmation of Jewish identity" (ibid., 283), the author interprets the *'Aqedah* scene as a rejection of human sacrifice in favor of ani-

gument, Elsner asserts: "There is no doubt that the Synagogue frescoes actively promulgate Judaism by denigrating other religions. These are specifically the religions of the local Syrian environment—the worship of Baal and Dagon, as represented in Scripture, and their contemporary Durene successors such as Bel and Adonis."[56]

Elsner's interpretation of these two panels, while theoretically possible, is somewhat speculative, to say the least. There is a great difference here between the possible and the probable. Focusing on but two of some thirty preserved panels does not make for a compelling case of cultural resistance, even if we assume that such polemics might often be subtle (a hidden transcript!) and thus not readily identifiable. In the instances noted, such "evidence" is virtually useless: since the Bible is already replete with antipagan stories, diatribes, and polemics, why should anyone resort to contemporary realities to explain such themes, unless driven, a priori, by certain preconceptions? Nevertheless, Elsner and others have rightly noted that this art was used for self-definition and self-affirmation;[57] an underlying quest to strengthen and enhance Jewish identity (without necessarily denigrating the other) is more than likely in a setting that was relatively isolated from other Jewish communities and that boasted other cults and temples.

I have selected these recent contributions since their underlying assumption seems plausible, focusing as they do on the local context of Dura.[58] Some eighty years have passed since the discovery of this imposing art, and although many other synagogues have been excavated since then, including some of considerable wealth (such as Sardis), nothing even begins to compare artistically to what was found in this Roman frontier town. Moreover, one of our greatest assets in understanding these frescoes is precisely the local Duran setting: we know exactly when they were created, as well as something about the synagogue's religious, cultural, and social contexts.

Dura seems to provide a stellar example of the religious ferment that characterized much of the second- and third-century Roman Empire, particularly in its

mal offerings. While this explanation might be relevant when trying to explain the background of Genesis 22, it is quite doubtful that it was a factor in a third-century CE synagogue representation.

56. Ibid., 299.

57. From a different slant, it has been claimed that in the "Purim" panel on Dura's western wall, the artist, in depicting the "Jewish community as a peculiarly Romanized group . . . subjected to forced Greco-Roman enculturation . . . offers a subtle protest to the suppression of Parthian culture, preserving memory of the Jews' traditional allegiance to the Persian monarchy" (Burns, "Special Purim," 23).

58. A recently published article argues that the Dura synagogue was closely linked to the Roman garrison stationed in the city, with many of its members also serving in the army. The synagogue, it is claimed, reflects these ties in some of its artistic motifs. As fascinating and creative as this suggestion is, it is based, unfortunately, on a series of assumptions and assertions that find little support in the available evidence. See Rosenfeld and Potchebutzky, "Civilian-Military Community."

eastern regions.[59] The diverse religious institutions preserved there, including unusual displays of religious art, offer a glimpse into a particularly rich and exuberant religious milieu.

In making use of the artistic medium of wall painting, the Jews of Dura followed local or perhaps wider Mesopotamian practice. Temples, along with other private and public buildings, were decorated with frescoes, reliefs, and statues honoring a local deity.[60] Moreover, as noted above, just as the nearby church and Mithraeum depicted sacred scenes from the lives of their respective deities and sacred traditions, so too did the Jews draw from the Hebrew Bible.[61] The Duran Jews did not invent or import a new genre of artistic expression into the city. Rather, in the course of expanding and renovating their synagogue in 244–45 (continuing in subsequent years as well) they adopted a current Duran fashion, carrying out this task more ambitiously, it seems, than anywhere else in Dura or in any other Jewish community in the Diaspora or Palestine.

Given this perspective, we suggest an interpretation of this synagogue's art that focuses first and foremost on the frescoes themselves, invoking literary sources only secondarily. Although it is far more modest than those previously offered, perhaps this interpretation will offer some insight into several main components of this community's Judaism. We will focus on the frescoes of the western wall, the most important of the synagogue's four walls, because these are largely intact. As the focus of the synagogue's liturgy, this wall contained the Torah shrine and faced Jerusalem, and it was also the wall that greeted all who entered the hall. Those themes appearing repeatedly on this wall, we can assume, would have represented core ideas and beliefs of the Duran Jewish community as a religious and ethnic group. This art, then, would have projected and articulated the self-identity of the Jewish community and perhaps benefited others as well (if, indeed, non-Jews also visited the synagogue). The following themes, listed in no particular hierarchical order, seem most vividly represented on Dura's western wall:

The centrality and sanctity of the Torah. This concept is expressed in two very prominent ways. First and foremost, the Torah shrine is positioned in the middle of the western wall, oriented toward Jerusalem and directly opposite the main entrance to the sanctuary. The Torah shrine is located in an *aedicula*, the same setting in which pagan deities, whether statues, reliefs, or painted images, were placed in their respective temples.[62]

59. See Kraeling, *The Synagogue*, 381–84; Brilliant, "Painting at Dura-Europos."

60. In fact, certain aspects of synagogue art may have been borrowed directly from Duran models via common workshops; see chap. 4, n. 24.

61. On the relationship between the Jewish, Christian, and Mithraic buildings, see chapter 4.

62. Indeed, several episodes from previous centuries indicate that both Jews and non-Jews perceived the Torah scroll as the Jewish equivalent of a pagan deity; see L. I. Levine, *Ancient Synagogue*, 146–48; Magness, "Arch of Titus," 204–9.

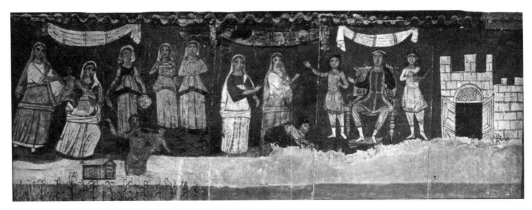

FIG. 54 Dura synagogue: Moses' infancy.

Moreover, the importance accorded the Torah scroll (and by extension the entire Bible generally) is underscored by the dozens of panels on all sides of the synagogue hall depicting scenes from the Scriptures, clearly the text that had come to represent two main components of Jewish identity—past history and future hopes. Indeed, well before the construction of the Dura synagogue, the reading of Scriptures constituted the heart of Jewish liturgy throughout the Roman Empire. Already in the Second Temple period the reading of the Torah, followed by a selection from the Prophets (and supplemented and elucidated by a sermon and perhaps a *targum*), formed the warp and woof of synagogue religious ritual.[63]

The prominence of Moses. Inextricably intertwined with the sacrality and centrality of the Torah is the image of Moses, leader, prophet, and teacher. His importance is articulated in the two most extensive scenes portrayed on the western wall. Moses's infancy appears on the right side of the lower register, with Pharaoh ordering the two midwives to kill all Israelite male infants, followed by Moses's mother placing the infant in a basket on the river and Pharaoh's daughter finding him and handing him over to his mother and sister for care (fig. 54). If Goodenough is correct and the use of the Anahita image for Pharaoh's daughter is intentional,[64] then the scene may have been intended to represent Moses in a quasi-divine status, establishing his glorified prominence and unsurpassed uniqueness. However, even if the artist and community did not actually have in mind the associations that the image of Anahita might have conjured up in a pagan setting, this series of vignettes around the figure of baby Moses clearly highlights his importance to those present in the synagogue.

Two registers above the infancy panel comprise the longest composition on the western wall—the exodus from Egypt (fig. 55). The towering figure of Moses fea-

63. L. I. Levine, *Ancient Synagogue*, 145–69. On the importance of the Torah to the Greek-speaking Diaspora, see A. I. Baumgarten, "Bilingual Jews"; Rajak, "'Torah shall go forth from Zion'"; see also L. I. Levine, *Ancient Synagogue*, 530–92.

64. Goodenough, *Jewish Symbols*, 9:200–3.

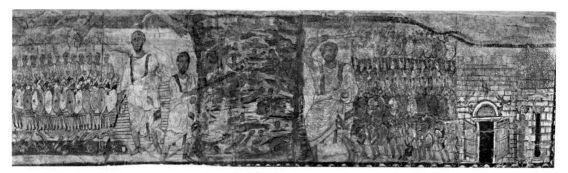

FIG. 55 Dura synagogue: Moses and the exodus from Egypt.

tures prominently; not only is he depicted three times, but in each case he is iden-
tified by an Aramaic inscription and displayed larger than life, dwarfing all other
figures. In each instance he wears a Greek himation and chiton, and carries a staff; in
the largest depiction (what Kraeling labels of "unusual stature"[65]), located farthest
to the right, he holds a staff over his head and is identified by an inscription as "Mo-
ses, when he went out of Egypt and split the sea."[66] The next two figures, to the left,
are identified as simply "Moses" and "Moses, when he split the sea."[67] In the latter
cases, the hand (and partial arm) of God appears above Moses.

We have already noted the prominence of the four large figures above the To-
rah niche and the fact that a number of suggestions have been offered as to their
identification. Only the upper right-hand figure can be identified unequivocally as
Moses before the burning bush, per the Aramaic inscription appearing between
the figure's legs. The figure on the upper left-hand side, also barefoot with shoes
placed on the side, is almost certainly Moses ascending Mount Sinai. This is a far
more likely identification for a synagogue setting than the only other instance men-
tioned in the Bible of a man standing barefoot, that of Joshua conversing with an
angel before the gates of Jericho. Less certain, but in my opinion most likely, is the
identification of the two lower figures as Moses as well, one reading from a To-

65. Kraeling, *The Synagogue*, 82. In a similar vein, Moon ("Nudity and Narrative," 592)
writes the following with regard to the Burning Bush scene:

> Whether or not Moses' gesture toward the burning bush would have suggested to
> the faithful the authority of the Roman *adlocutio* . . . is less important, at this junc-
> ture in our narrative, than our recognition of the artist's presentation of Moses as
> a Classical hero. . . . In Roman art as well this is a stock indicator that the hero is on
> sacred ground; Moses is in the holiest of places (Exodus 3:5). Heroic contrapposto,
> ideal body type, and other motives functioned in the paintings as moral qualifiers
> and determinatives. In Graeco-Roman terms 'Moses near the Burning Bush' is the
> epitome, for the congregation, of masculine beauty and legendary strength; Moses
> is a leader, heroic and pure.

66. Kraeling, *The Synagogue*, 81, 269–70, no. 3; Moon, "Nudity and Narrative," 592.

67. Kraeling, *The Synagogue*, 270–1, nos. 4–5.

rah scroll and the other offering a final prayer for his people before his death. The identification of these four figures towering above the Torah shrine in the center of the western wall is pivotal in understanding an important component of the *Weltanschauung* of this congregation. If they are all portrayals of Moses, as has been suggested by Goodenough,[68] then they provide important insight into this community's outlook and beliefs. Moreover, this suggested prominence of Moses would place Dura's Jewish community much more in sync with its pagan and Christian surroundings.[69]

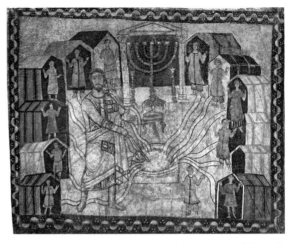

FIG. 56 Dura synagogue: Moses and the miracle of the well.

Finally, Moses appears, once again, on the left (or southern) side of the western wall (fig. 56). In the scene depicting the well supplying water to the twelve tribes (represented by twelve small tents with a figure standing at the entrance to each), the Tabernacle and its associated ritual objects are depicted at the top, above the tents and the well. A large figure of Moses, executed with unusual care, stands by the well, pointing at it with his staff as the well's water flows toward the tents of the Israelites.[70] In summary, then, Moses is represented nine times on Dura's western wall, eight times as a "heroic" figure,[71] undoubtedly indicating his prominence in the historical memory of the local community.[72]

Dura was not alone in according such an important role to Moses. Indeed, Moses played a prominent role both in ancient Judaism generally[73] and among pagan authors who wrote about the Jews, their history, and their traditions.[74] As a political and military leader, statesman, miracle worker, and lawgiver, perceived both posi-

68. Goodenough, *Jewish Symbols*, 9:110–23.

69. It has also been opined that the seated figure holding court in the upper central panel, between the two sets of large figures just discussed, was also Moses, blessing Israel at the end of his life; see Sonne, "Review of Wischnitzer's *Messianic Theme*," 232.

70. See Kraeling, *The Synagogue*, 118–25.

71. Of the nine appearances, six are universally agreed upon. Only the three large portraits accompanying that of Moses in the center of the western wall are disputed, as noted above.

72. As noted in chap. 4, Moses' prominence may also have been influenced by the central role of Mithras and Jesus in the nearby sanctuary and church.

73. On Moses' prominence in late Second Temple Judaism, see, e.g., Horbury, *Herodian Judaism and New Testament Study*, 34–46; and as an eschatological prophet, see Teeple, *Mosaic Eschatological Prophet*; Meeks, *Prophet-King*; Allison, *New Moses*.

74. M. Stern, *GLAJJ*, 3:136–37 (s.v. Moses).

tively and negatively by various Greco-Roman authors,[75] Moses came to represent the epitome of Jewish tradition. In the second century CE, Numenius of Apamea is reputed to have asked, "For what else is Plato than Moses speaking Attic Greek?"[76] To Philo and the Samaritans, the prominence of Moses was most pronounced,[77] and even among the rabbis, usually considered to have been restrained in this matter,[78] the degree to which Moses might legitimately be extolled was openly debated.[79] Given this widespread esteem for Moses, at times expressed in cosmic and messianic terms, it is not surprising to find that the Jewish community in Dura might have expressed this reverence in the artistic realm.

The centrality of the Tabernacle-Temple. The holiest institutions in Judaism throughout the first millennium BCE and beyond were the Wilderness Tabernacle and the two Jerusalem Temples that followed. These are depicted on the synagogue's western wall on four occasions. Three appear in the middle register (B): one shows the Tabernacle with Aaron, other priests, sacrificial animals, holy vessels, and altar(s); a second places the Tabernacle and its appurtenances above Moses in the miracle of the well; and a third features Solomon's Temple (with perhaps hints of its later adaptations). Even more prominent is the fourth example, located on the arch immediately above the Torah shrine. The central depiction of the Temple facade is flanked by a menorah, *lulav*, and *ethrog* on one side, and the *'Aqedah* scene on the other—the latter event being associated with the Temple Mount at least since the time of 1 Chronicles 3:1.

Until the year 70 CE, the Jerusalem Temple had commanded the attention and loyalty of all Jews, in Judaea, the Galilee, and the Diaspora.[80] Interestingly, the region of ancient Mesopotamia in which Dura was located featured prominently in Temple-related activities before 70. A number of sites to the south and north of Dura, Nehardea and Nisibis, served as depositories for monies intended for Jerusalem and its Temple (Josephus, *Ant.* 18.310–13). So large were the sums involved that Herod made special arrangements to guarantee their safe transport by hiring

75. Positive attitudes are to be found in the writings of Hecataeus, Diodorus, and Strabo, negative ones in those of Quintilian, Tacitus, and Juvenal; see Gager, *Moses in Greco-Roman Paganism.*

76. M. Stern, *GLAJJ,* 2:209–11, no. 363a–e. See also the comment of the first-century author of *De Sublimitate* who wrote: "A similar effect was achieved by the lawgiver of the Jews—no mean genius, for he both understood and gave expression to the power of the divinity as it deserved. . . ."; see ibid., 1:364, no. 148.

77. Samaritans: J. Macdonald, *Theology of the Samaritans,* 147–222, 420–46. Philo: Wolfson, *Philo,* 2:16–20; Goodenough, *Introduction to Philo Judaeus,* 145–52; Goodenough, *Jewish Symbols,* index (s.v. Moses); Winston, "Sage and Super-sage in Philo"; Winston, "Judaism and Hellenism"; Clifford, "Moses as Philosopher-Sage in Philo."

78. Often cited in this regard is the Passover Haggadah, which mentions Moses just once, and even then in a verse quoted for other reasons.

79. See Fraade, "Moses and the Commandments."

80. See L. I. Levine, *Jerusalem,* 219–53.

one Zamaris and his five hundred horsemen to settle in Trachonitis in order to provide the necessary security (*Ant.* 17.23–31). To Dura's northeast lay the kingdom of Adiabene, whose royal family converted to Judaism in the first century CE (*Ant.* 20.17–96). Queen Helena of Adiabene was especially active in expressing her newly discovered Judaism, visiting Jerusalem on many occasions, building palaces and a monumental burial complex for her family there, donating gifts to the Temple, aiding the Jerusalem populace in times of famine, and taking Nazirite vows.[81]

Thus, loyalty to the Jerusalem Temple had deep roots in Mesopotamia, and such homage also found expression on the western wall of the Dura synagogue. However, there is no way of determining how this third-century community related to the Temple, which was destroyed over 150 years earlier—as a historical memory, a religious symbol, a future hope, or some combination thereof.[82]

Messianic/eschatological themes. Finally, hopes for redemption seem to have been a notable component of the Duran Jewish community's makeup. The area above the Torah niche, between the four large figures, is devoted to this theme. Jacob blessing his sons and grandsons clearly reflects it, as does the upper panel depicting a royal figure and his entourage—possibly a reference to David or more likely the Messiah. Although located in the lower register of the northern wall, the long and detailed depiction of Ezekiel's vision of the dry bones symbolizing national restoration clearly underscores this idea as well.[83]

CONCLUSION

In assessing the thoughts and beliefs of the Jewish community in Dura as reflected in the synagogue paintings—without imposing outside agendas of the past (as do ancient literary sources) or the present (modern scholarly notions)—the assertion that in this case art itself should take the lead seems reasonable and compelling. We have discussed four themes that appear central to the community's consciousness and set the Jews apart from their pagan and Christian neighbors. These themes assert Jewish uniqueness, highlight their self-esteem, and emphasize their sense of chosenness.

However, one cannot fully understand the Duran Jews' art or its creation without taking into account the synchronic dimension. The local community utilized local architectural and artistic styles extensively in fashioning its synagogue's interior, using, it seems, local workshop(s) to execute the work.[84] Moreover, it is probably not coincidental that the same type of historically and mythologically oriented art was used in the church and Mithraeum as well, both in the same decade of the third

81. Schiffman, "Conversion of the Royal House of Adiabene."

82. Shenk has recently emphasized this dimension in his "Temple, Community, and Sacred Narrative."

83. See Riesenfeld, "Resurrection in Ezekiel XXXVII"; Garte, "Theme of Resurrection"; and Magness, "Third Century Jews and Judaism."

84. See chap. 4, n. 24..

century.[85] Each community designed or embellished its communal setting more or less at the same time, and a comparison of their similarities and differences is most suggestive.[86] As noted, the prominence of Moses might usefully be compared with the centrality of Jesus and Mithras, and that of the Torah shrine with the Christian baptistery and Mithraic *aedicula*. However, while these other religious settings were markedly focused on offering their congregants personal salvation, the synagogue's art vividly expressed the common ethnic and religious background of this Jewish community and of the Jewish people as a whole. Any vision of future salvation was articulated through past blessings and promises.

Equipped with such beliefs, comfortably ensconced in the Dura landscape, and fortified by a growing and prosperous community, the Jews might well have looked forward to a stable and promising future—but for the Sasanian attack on the city in 256.

85. On the transformation of a private home into a church in Dura in the 40s of the third century, see Kraeling, *The Christian Building*, 38–39.

86. Wharton, *Refiguring the Post Classical City*, 61–62; Dirven, *Palmyrenes of Dura Europos*; and chap. 4.

6. BET SHE'ARIM IN ITS PATRIARCHAL CONTEXT

THE NECROPOLIS OF Bet She'arim was first discovered in 1936; it was subsequently explored by Benjamin Mazar in a series of excavations from 1936 to 1940 and again in 1956, and by Nahman Avigad from 1953 to 1958. Each produced a volume presenting most of the finds, while a third, by Moshe Schwabe and Baruch Lifshitz, is devoted to the Greek inscriptions found at the site.[1] The cemetery in Bet She'arim, a relatively small town by any standard, is quite extensive, containing many hundreds of burials. Alongside the cemeteries of Second Temple Jerusalem and the catacombs of Rome, it ranks as one of the major Jewish necropoleis in antiquity. While Jews had a general preference to be buried close to home, Bet She'arim was apparently considered an especially attractive site for many, since it involved bringing the deceased from afar for interment.[2]

Literary sources tell us little about Bet She'arim.[3] It can probably be identified with Besara, which Josephus described as a place "on the borders of Ptolemais," on the southwestern edge of the Galilee, where a large quantity of corn was collected and stored (*Life* 24.118–19). This area apparently belonged to the Herodian family, as it is specifically associated with Berenice, wife of Agrippa II. In the early second century, R. Yoḥanan b. Nuri lived there (T Terumah 7, 14, p. 147; T Sukkah 2, 2, p. 260), and in a tradition attributed to the third-century R. Yoḥanan, Bet She'arim appears as one of a series of rabbinic centers in second- and third-century Galilee (Genesis Rabbah 97, pp. 1220–21; B Rosh Hashanah 31a–b). According to the accepted narrative, Bet She'arim's prominence around the turn of the third century

1. B. Mazar, *Beth She'arim*, vol. 1; Schwabe and Lifshitz, *Beth She'arim*, vol. 2; Avigad, *Beth She'arim*, vol. 3; and see chap. 4.

2. Relatively few subsequent studies regarding Bet She'arim have been published (see, e.g., n. 10), but see a recent attempt to fill this gap in Tepper and Tepper, *Beth She'arim*, and Z. Safrai, "Beit Shearim."

3. For brief surveys on the history of the town, see B. Mazar, *Beth She'arim*, 1:3–7; Avigad, *Beth She'arim*, 3:1–4. On the archaeological finds, see Avigad and B. Mazar, "Beth She'arim."

was due to the presence of R. Judah I, editor of the Mishnah (B Sanhedrin 32b).[4] These years were presumably the town's heyday, serving as an important center of Patriarchal and rabbinic activity. R. Judah reportedly moved to Sepphoris only in the latter years of his life, at the beginning of the third century CE, and his subsequent burial in Bet She'arim—described in some detail in rabbinic literature (Y Ketubot 12, 3, 35a; Y Kil'aim 9, 4, 32c; Tanḥuma, Vayeḥi 3; Tanḥuma, Vayeḥi 6, ed. Buber, p. 107b; see also B Ketubot 103b)[5]—transformed the town into the site of a major necropolis for Jews living in Roman-Byzantine Palestine and the eastern Diaspora, especially Syria.[6] Although rarely noted in rabbinic literature following R. Judah's death (e.g., Y Mo'ed Qatan 3, 5, 82c; B Niddah 27a),[7] Bet She'arim continued to play a significant role in Late Antiquity for many Jews, not only as a place of interment but also for visitation. At first it was assumed that Bet She'arim flourished only until the mid-fourth century, when it fell victim to the upheavals of the Gallus revolt of 351–52,[8] but modern historical scholarship has challenged the extent and severity of this "revolt"[9] and recent archaeological finds have clearly demonstrated that the town and its cemetery continued to function as late as the fifth and even sixth centuries.[10]

THE FINDS

The remains from the Bet She'arim necropolis can be divided into four categories:

Catacombs. More than two dozen burial complexes (catacombs) have been discovered, differing from one another in size, plan, and style. Most consist of networks of interconnecting caves or halls with burial places cut into the walls. Several catacombs (nos. 14 and 20) are particularly monumental and include a spacious outer courtyard surrounded by benches, a facade of well-cut ashlar stones featuring

4. R. Judah is usually viewed as a scion of the Gamaliel dynasty (according to some traditions even stretching back to Hillel); see Mantel, *Studies,* 18–41. For a recent view that R. Judah was a member of an aristocratic Galilean family newly associated with the rabbinic class and that he, in fact, was the one who created the Patriarchate *de novo,* see S. Stern, "Rabbi and the Origins of the Patriarchate."

5. For an analysis of the traditions, see Meir, *Rabbi Judah the Patriarch,* 300–37.

6. See Noy and Bloedhorn, *Inscriptiones Judaicae Orientis,* 3:269 (s.v. "Beth She'arim"); Roth-Gerson, *Jews of Syria,* 372 (s.v. "Bet She'arim").

7. For a survey of rabbinic traditions relating to the site, see S. Safrai, "Bet She'arim in Talmudic Literature" (*Eretz-Israel and Her Sages*).

8. B. Mazar, *Beth She'arim,* 1:6–7; Avi-Yonah, *Jews of Palestine,* 176–81; Avigad and B. Mazar, "Beth She'arim," 248.

9. See, e.g., Stemberger, *Jews and Christians in the Holy Land,* 161–84.

10. Vitto, "Byzantine Mosaics at Bet She'arim," esp. 136–41; Weiss, "Social Aspects of Burial," 371; Weiss, "Burial Practices in Beth She'arim," 225–31. Avigad (*Beth She'arim,* 3:190–92) had already pointed out that Byzantine lamps, some dating to the sixth–seventh centuries, were found in Catacomb 20. One lamp from Catacomb 17 also bore a Christian monogram on its handle (ibid., 74).

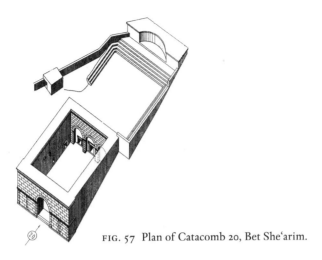

FIG. 57 Plan of Catacomb 20, Bet She'arim.

(1)

(2)

(3)

FIG. 58 Types of burials in
Bet She'arim:
(1) Trough; (2) *arcosolium*;
(3) sarcophagus.

three arches—a large central one and two smaller side arches, each with a decorated lintel or gable, and semicircular benches carved into the side of the hill above the burial chambers, undoubtedly intended as an assembly place for those who came to memorialize the deceased buried beneath them (fig. 57).[11]

Types of burial. Some forms of burial are a continuation of earlier Jewish practices—the use of the *loculus* or *kokh* as well as the *arcosolium* in which the corpse was placed (fig. 58). Other forms, either unknown or used only sparingly beforehand, now became prevalent. Trough-shaped burial arrangements were now ubiq-

11. See also B. Mazar, "'Those Who Buried Their Dead.'"

FIG. 59 Reconstruction of the mausoleum adjoining Catacomb 11.

uitous, and there was a far more extensive use of sarcophagi, particularly in Catacomb 20.[12] Ossuaries, so prominent in the Second Temple Jerusalem necropolis,[13] are hardly in evidence here.[14]

Indeed, many aspects of the Bet She'arim burial practices derive from Greco-Roman models, including those adopted by the nearby pagan population.[15] The appearance of a mausoleum above Catacomb 11 (fig. 59), the impressive facades of Catacombs 14 and 20, and the above-noted use of sarcophagi (of marble, lead, or stone)—to cite three salient examples— all attest to the significant influence of non-Jewish burial practices in Bet She'arim.

Inscriptions. The overwhelming dominance of Greek inscriptions is at first glance surprising. Of the approximately three hundred inscriptions from the site,[16] over 80 percent are in Greek, about 16 percent in Hebrew, and the remainder in either Aramaic or Palmyrene.[17] By comparison, Greek synagogue inscriptions throughout Roman-Byzantine Palestine amount to only some 35 percent, roughly the same percentage as the Greek epigraphic evidence from Second Temple Jerusalem.[18] Given that the overall percentage of Jewish inscriptions in Greek from Greco-Roman and Byzantine Palestine (from both synagogal and

12. Remains of about 125 sarcophagi (out of a total of some 200 burials) were found in this catacomb, more than six times as many as those found in the entire Jerusalem necropolis; see Kloner and Zissu, *Necropolis of Jerusalem*, 53.

13. Rahmani, *Catalogue*; L. I. Levine, *Jerusalem*, 261–65; Magness, "Ossuaries and the Burials of Jesus and James."

14. On the use of ossuaries in the Galilee in the first century CE, see Aviam and Syon, "Jewish Ossilegium in Galilee."

15. Weiss, "Hellenistic Influences."

16. There are 279 published inscriptions, but according to Jonathan Price (personal correspondence) approximately twenty additional inscriptions from the site, almost all in Greek, have yet to be published. See a forthcoming corpus of inscriptions from Greco-Roman Palestine (*Corpus Inscriptionum Iudaeae/Palestinae* [*CIIP*], under the direction of W. Ameling et al.).

17. Avigad, *Beth She'arim*, 3:230. It is not clear on what van der Horst based his assumption that there were only 246 inscriptions at Bet She'arim. By his count, the percentage of Greek inscriptions would rise to 88 percent; see van der Horst, "Greek in Jewish Palestine," 156 (*Japheth in the Tents of Shem*, 12).

18. See L. I. Levine *Ancient Synagogue*, 9; L. I. Levine, *Jerusalem*, 272–74. Greek inscriptions appear on 37 percent of the ossuaries published in Rahmani, *Catalogue*, 12–13; see also L. I. Levine, *Judaism and Hellenism*, 76; Hengel, *"Hellenization" of Judaea*, 10.

funerary contexts) is about 55 percent,[19] the predominance of Greek in Bet She'arim is indeed remarkable and calls for an explanation (see below).[20]

The inscriptions provide a rich trove of information about the interred. Of especial interest is the title "rabbi" (רבי), appearing some twenty-seven times—thirteen times in Catacomb 20 alone and three times in Catacomb 14. Besides the Patriarchal family, the names of only two interred in the necropolis can be identified with a talmudic rabbinic figure, both of whom are known to have been intimately connected with the Patriarchate (see below).[21] Synagogue and communal officials, such as the head of a synagogue (*archisynagogue,* ἀρχισυνάγωγος) or the head of a council of elders (gerousiarch, γερουσιάρχης), are also recorded (see below). Relatively little is known about the professions of the interred, although a goldsmith, physician, banker, perfume and cloth merchants, and a dyer are noted. Inscriptions from the nearby synagogue indicate that several of its members were involved in the operation and maintenance of the cemetery.[22]

Most of the Diaspora inscriptions indicate that the deceased came from Syria and the Phoenician coast.[23] More distant places, such as Mesha in Babylonia, Asia Minor (possibly identified with Etzion Gever near Eilat), and Ḥimyar in the Arabian

19. Van der Horst, *Japheth in the Tents of Shem*, 12 and n. 12; L. I. Levine, *Judaism and Hellenism*, 180. All the above-noted percentages must be regarded as provisional pending the full publication of the *CIIP*.

20. Only the necropolis of Joppa reflects a greater predominance of Greek inscriptions (about 90 percent); of the sixty-nine inscriptions cited by Frey, seven are in Hebrew or Aramaic, two are bilingual (Hebrew and Greek), and sixty are in Greek; see Frey, *CIJ*, vol. 2, nos. 892–960.

21. S. J. D. Cohen, "Epigraphical Rabbis," especially 3–5, nos. 14–41; Lapin, "Epigraphical Rabbis: A Reconsideration" (offering a revised and updated listing of these inscriptions); as well as the comments of Hezser, *Social Structure*, 119–223. On thirteen recently published inscriptions from Sepphoris referring to eleven rabbis, see Aviam and Amitai, "Cemeteries of Sepphoris." Nine of the above-mentioned inscriptions were published earlier and bear the names of five rabbis, while four newly discovered inscriptions appearing for the first time (ibid., 23) include the name of one additional rabbi. For reservations regarding the validity of this dichotomy between epigraphic and talmudic rabbis, see S. S. Miller, "'Epigraphical' Rabbis, Helios, and Psalm 19"; Rosenfeld, "Rabbi Joshua ben Levi," 26–27; and, most recently, Rosenfeld, "Title 'Rabbi': Revisited"; Millar, "Inscriptions, Synagogues and Rabbis." The concentration of "rabbis" in Bet She'arim generally, and in Catacombs 14 and 20 specifically (out of a total of almost sixty instances throughout Palestine), seems to indicate that this term was used in many cases with regard to those having some sort of close association with the Patriarchate; this conclusion is strengthened by the addinal names from Sepphoris, a city which served as the seat of this office for several generations in the third century before its transfer to Tiberias. In contrast, Lapin suggests that this term should be linked to particular families and has no connection with rank or office ("Epigraphical Rabbis: A Reconsideration," 327–29).

22. Schwabe and Lifshitz, *Beth She'arim*, 2:215.

23. B. Mazar, *Beth She'arim*, 1:197–207; Schwabe and Lifshitz, *Beth She'arim*, 2:217–22; see also above, n. 6.

FIG. 60 Origins of Diaspora Jews buried in the Bet She'arim catacombs.

Peninsula, are also mentioned (fig. 60). Several inscriptions note specific Palestinian sites (e.g., Caesarea, Bet She'arim, and Araba), but one may assume that the overwhelming majority of the interred hailed from the Galilee and the immediate vicinity of Bet She'arim.[24]

Most inscriptions list the name of the deceased and at times other bits of information. However, several contain extensive and lavish epithets whose formulation exhibits an impressive mastery of Greek language and culture. The following, for example, was found in Catacomb 11: "I, the son of Leontios, lie dead, Justus, the son of Sappho, / Who, having plucked the fruit of all wisdom, / Left the light, my poor parents in endless mourning, / And my brothers too, alas, in my Bet She'arim. / And having gone to Hades, I, Justus, lie here / With many of my own kindred, since mighty Fate so willed. / Be of good courage, Justus, no one is immortal."[25] In addition to the Greek and Latin names, the above epithet takes note of Hades and Moira (Fate), and is written in Homeric hexameter while using Homeric phraseology. As with Greek epithets generally, this one is cast in the first person and refers to "all [kinds of] wisdom," possibly a reference to the varieties of Greek and Jewish culture. As Pieter W. van der Horst has commented: "It is therefore not accidental that

24. Schwabe and Lifshitz, *Beth She'arim*, 2:217–22.

25. Ibid., 97–110, no. 127. See also van der Horst, *Japheth in the Tents of Shem*, 9, 23–25; van der Horst, "Jewish Poetical Tomb Inscriptions," 135–38. A similarly lavish epithet appears in Catacomb 18. See van der Horst, *Ancient Jewish Epitaphs*, 152–53; Schwabe and Lifshitz, *Beth She'arim*, 2:157–67, no. 183. For similar epithets from Leontopolis, see Horbury and Noy, *Jewish Inscriptions of Graeco-Roman Egypt*, nos. 30–36.

FIG. 61 Artistic depictions in the Bet She'arim catacombs: (1) Horseman;
(2) Torah ark with scrolls flanked by *menorot*; (3) *menorot*; (4) bearded figure.

it is in the concept of *sophia* that we see the two worlds of Judaism and Hellenism
reaching out to each other here."[26]

Art. The Bet She'arim catacombs are rich in artistic ornamentation (fig. 61). The
many reliefs, carvings, and paintings on stone throughout the necropolis comprise
one of the richest repositories of Jewish art in Late Antiquity.[27] Floral and geomet-

26. Van der Horst, *Japheth in the Tents of Shem*, 24.

27. For a short summary of the finds, see Avigad and B. Mazar, "Beth She'arim." For the
excavation reports, see above, n. 1. See also Avi-Yonah, *Oriental Art*, 36–41.

FIG. 62 Catacomb 20, Bet She'arim: *Nikae* sarcophagus.

ric designs abound, as do representations of animals (lions, bulls, eagles, birds, horses) and an occasional human figure. Depictions of ritual objects are ubiquitous and include the Torah shrine, *lulav, ethrog,* shofar, and incense shovel. The most prominent motif is the menorah, which appears some thirty-seven times in a variety of shapes and styles.[28] Several other depictions are particularly noteworthy. In Catacomb 20, there is a series of animal figures as well as a hunting scene of a lion chasing a gazelle. A bearded figure appears in relief on one side of a coffin and has been interpreted as either a representation of a Greek god or a theater mask.[29]

Motifs of especial interest appear in Catacombs 11 and 20. Of the thirty-five decorated stone sarcophagi in Catacomb 20, eleven display figures, mostly animals (some fifty-five altogether) but also humans and mythological characters (fig. 62).[30] Although most of the sarcophagi (125) are plain, the appearance of those bearing figural representations is revolutionary in ancient Jewish art. Nothing even remotely similar appeared in previous centuries, with the possible exception of images of a limited number of deities on the coins of Sepphoris and Tiberias from the second and early third centuries CE;[31] such artistic representations do not appear in any other contemporary Galilean Jewish cemetery.

Of major import are the several score fragments from as many as twenty marble sarcophagi, all from Catacomb 20.[32] While some fragments preserve floral and geometric designs, others attest to depictions of animals and about twenty human figures.[33] A number of mythological representations have been identified (fig. 63), such as Aphrodite writing on a shield, Nike, a winged Eros, and a number of Amazons engaging the Greeks in battle. The latter are depicted as either holding an ax, wounded, or riding a horse, and one Amazon is being helped to sit, perhaps referring to the dying Amazon queen Penthesilea. A monstrous head may represent one of the two snakes harnessed to Demeter's chariot, and several large figures with long cloaks perhaps once belonged to the Sidamara sarcophagi (i.e., those depicting columns and arches). The marble for these coffins was imported from Greece and Asia Minor and may have been produced in nearby workshops operating in Caesarea and Tyre.

28. Hachlili, *Menorah,* 515–16.

29. Avigad and B. Mazar, "Beth She'arim," 241–48.

30. Ibid.; Avigad, *Beth She'arim,* 3:136–64.

31. See chap. 3.

32. Avigad, *Beth She'arim,* 3:164–73.

33. The following summary is based on Avi-Yonah, *Art in Ancient Palestine,* 257–69.

FIG. 63 Marble fragments of mythological figures in the Bet She'arim catacombs.

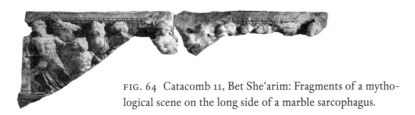

FIG. 64 Catacomb 11, Bet She'arim: Fragments of a mythological scene on the long side of a marble sarcophagus.

The mausoleum adjoining Catacomb 11, built of ashlars where the above-noted Justus inscription was found, has four sides, one of which displays elaborate architectural designs, including a prominent animal frieze. Architectural remains found in the debris of the mausoleum bear decorations on two long sides and one short side of a marble sarcophagus (fig. 64). The better-preserved long side features an assembly of people standing in a courtyard in front of a palace facade. These figures include a naked youth holding a sword in his right hand while extending his left hand toward a horse, a seated figure wearing a crown, a standing bearded man, three women, a man blowing a trumpet, another wearing a helmet, and several horses. In the center, a young man with long hair holds a shield and stands frontally; he has been identified as Achilles while the entire scene is regarded as describing events on Scyros, an island off the coast of Euboea. If this identification is correct, then the other figures would be the daughters of the seated King Lycomedes and Odysseus.

The other, less well preserved side of the sarcophagus depicts a huntress accompanied by a male figure and another male riding a horse with his spear pointing downward. It has been suggested that this scene may portray the Calydonian hunt, and thus the two central figures should be identified as Atalanta and Meleagros.

The short side of the sarcophagus presents a scene from the Greek myth of Leda and Zeus embodying the figure of a swan. The swan, with raised wings, advances to rape Leda while she attempts to push him away. A similar depiction was discovered on a sarcophagus from Caesarea.[34]

In summary, the salient characteristics of the Bet She'arim material remains suggest four significant historical ramifications: (1) the close connection between these remains and the Patriarchate, beginning with R. Judah I; (2) the prevalence of Greek, as attested by the high percentage of inscriptions in that language, the remains of several rather sophisticated literary epithets, and the predominance of Greek personal names; (3) the use of a far more extensive range of artistic motifs than known heretofore in Jewish circles, including animal and human depictions, as well as figures and scenes drawn from Greek mythology;[35] and (4) the earliest display in Palestine of uniquely Jewish artifacts that clearly served as symbols and identity markers.[36]

HISTORY OF THE RESEARCH

Soon after Mazar's initial excavations in Bet She'arim, an acute awareness of the potential significance of these finds quickly surfaced. The location of this site in Jewish Galilee, its association with a major rabbinic figure, and its extensive remains all emphasize the site's key role in reconstructing Jewish and rabbinic identity in Late Antiquity. Its distinct Hellenistic dimension was appreciated immediately, and its relationship to what was assumed to have been a rabbinic setting became an intriguing issue with multiple cultural ramifications. Saul Lieberman's pathbreaking *Greek in Jewish Palestine*, published in 1942, was one of the earliest responses to this historical context. Having been kept abreast of these discoveries owing to his friendship with Mazar, the timing of his publication was influenced, at least in part, by the Bet She'arim finds and by his desire to demonstrate the degree to which the sages, too, knew Greek.[37] Owing to Lieberman's unparalleled mastery of rabbinic sources

34. Ibid., 258–62. See above, chap. 4, fig. 36.

35. Varying degrees of Hellenization among those buried in Bet She'arim are evident in the significant difference between the epigraphic and artistic evidence. While the use of Greek is indeed ubiquitous in most catacombs, the appearance of figural images is more limited, especially with regard to the use of mythological motifs. See Weiss, "Hellenistic Influences."

36. See chaps. 17 and 21, as well as S. Schwartz, *Imperialism and Jewish Society*, 154–58.

37. Lieberman personally shared with me the connection between the Bet She'arim finds and the subsequent publication of his *Greek in Jewish Palestine*. He completed this task by demonstrating the degree to which the rabbis were aware of Hellenistic culture generally; Lieberman, *Hellenism in Jewish Palestine*.

and Greco-Roman language and literature, his view that there is no contradiction between Bet She'arim's Hellenistic remains and the world of the sages eventually became the *communis opinio* and, with few exceptions, has remained so until recently.

Goodenough was the first to question the connection between this site and the rabbis. In light of his basic thesis, that Jewish art reflects a popular form of mysticism that was inherently non- (indeed anti-) rabbinic, the remains at Bet She'arim indicated common Jewish usage having nothing whatsoever to do with the talmudic rabbis:

> It seems to me dangerous to assume that the title "rabbi" here indicates a rabbi in the technical rabbinical sense, if that is what Maisler [Mazar] means by "scholars." We know that the word was very casually used in early Christian circles, with no reference to "scholarship" of any kind, and that its technical application in rabbinical circles was only slowly established, a process for which finally conflicting accounts were given. That the appearance of the term at Sheikh Ibreiq [Bet She'arim] established the connection of the cemetery with either the Palestinian or Babylonian amoraim can accordingly by no means be assumed.[38]

As already noted, Goodenough's overall revolutionary approach to the religious meaning and social implications of all Jewish art invited a wave of critical response,[39] and with regard to the question of Bet She'arim and the role of the rabbis in Jewish society at the time, Ephraim E. Urbach took the lead.[40]

Urbach's categorical rejection of Goodenough's thesis, together with the assumed rabbinic presence in Bet She'arim and Lieberman's assessment of the Hellenistic proclivities among some rabbis, carried the day. For more than four decades, scholars of every persuasion and inclination have agreed on this point—a feat not often paralleled in academic circles, then or now. As a result, Bet She'arim has been routinely referred to as a rabbinic center and those interred there as either rabbis or those who identified with them.[41]

38. Goodenough, *Jewish Symbols*, 1:90.

39. See M. Smith, "Goodenough's 'Jewish Symbols' in Retrospect."

40. Urbach, "Rabbinical Laws of Idolatry," 149–54 (English): "This is not the place to discuss Goodenough's exegetical method nor his treatment of the literary sources. Nor, indeed, is it necessary to dwell at length on the inner contradiction in a theory which asserts that, in the days of the later Hasmoneans, of Herod and Herod Agrippa, the Pharisees and Sages wielded an almost absolute spiritual domination over the people; and, on the other hand, that, in the period when Yavneh and Usha were the centers of Jewish life, the Patriarchs and Sages had no authority at all; and that even in the time of Rabbi Judah the Patriarch and his sons they were devoid of spiritual influence. Such a theory flies in the face of all that we know about the social status and spiritual authority of the Sages in both these periods" (150–51).

41. To cite but one example from the pen of an esteemed scholar: "The city was a rabbinic

This consensus has been challenged by Tessa Rajak, who suggests that the site should be dissociated from both the Patriarchs and the rabbis, and instead was merely used by Jews from the nearby Galilee and Diaspora.[42] Her main argument is twofold, divorcing the rabbis from Bet She'arim (and here she, as others, includes the Patriarchs) and denying a significant Diaspora presence there.

Rajak's thesis is engaging and somewhat revolutionary. On the one hand, her rejection of Diaspora Jewry's presence as the determining factor in shaping the necropolis seems correct; on the other, her dismissal of rabbinic testimony for the centrality of R. Judah I in serving as a catalyst for the growth of Bet She'arim into a major burial site appears unwarranted, particularly if one considers the epigraphic evidence from Catacomb 14 (see below), which, surprisingly, is never once mentioned in her article.

Despite the above reservation, I would like to pursue Rajak's reassessment from a different perspective and with appreciably different results. I will argue that: (1) the importance of Bet She'arim stems precisely from the presence of the Patriarchal family; (2) the role of those whom we usually refer to as rabbis (the "talmudic rabbis") in Bet She'arim was virtually nil, but other circles close to the Patriarch were indeed well represented; and (3) the unique remains from the site, including its overwhelming number of Greek inscriptions and the rather bold artwork, can be best explained as reflecting the interests and cultural proclivities of Patriarchal circles and their allied urban aristocracies.[43]

Patriarchal Context

The fact remains that Bet She'arim and the Patriarchate had been intricately intertwined since the days of R. Judah I.[44] Both rabbinic sources and archaeological remains make this point quite poignantly: (1) Bet She'arim was identified in rabbinic circles as the site of R. Judah's court, just as other sites were associated with various sages, such as R. 'Aqiva in Bnei Beraq and R. Gamaliel in Yavneh (B Sanhedrin 32b; Yalqut Shim'oni, Leviticus, 611, p. 594;[45] (2) at a certain point, R. Judah moved to

center of great renown and several famous rabbis were buried there" (van der Horst, "Greek in Jewish Palestine," 163).

42. Rajak, "Rabbinic Dead."

43. It is certainly not coincidental that all sixteen inscriptions found in the Bet She'arim synagogue are in Greek; Schwabe and Lifshitz, *Beth She'arim*, 2:189–98. See chap. 4.

44. See L. I. Levine, "Finds from Beth-She'arim."

45. Although this tradition derives primarily from the Bavli, it is hard to imagine why later Babylonian sages would have invented R. Judah's association with Bet She'arim if none had been known. Such a connection certainly fits chronologically and geographically with what we know about other sages in the mid to late second century. Indeed, as we will see below, the Bavli indeed preserved accurate traditions regarding Judah's immediate circle. Several other, more doubtful instances of connections between Rabbi and Bet She'arim have been suggested by S. Safrai ("Bet She'arim in Talmudic Literature," 209–11 [*Eretz Israel and Her Sages*, 79–83]).

Sepphoris, where, according to the Yerushalmi, he spent seventeen years;[46] (3) following R. Judah's death, an elaborate cortège brought his remains from Sepphoris for interment in Bet She'arim (Y Kil'aim 9, 4, 32a–b; Y Ketubot 12, 3, 35a; B Ketubot 103a–104a);[47] and, finally (4) another Palestinian tradition speaks of R. Judah granting permission to carry on Shabbat in an exedra (a porch?) located in Bet She'arim (Y 'Eruvin 1, 1, 18c).[48]

Other traditions place R. Judah in a Bet She'arim context; these derive mainly from the Bavli and are thus more problematic[49] but, nonetheless, are of some historical value.[50] These include: R. Judah taught in the *bet midrash* in Bet She'arim for an entire day upon the death of his daughter (*Diqduqei Soferim* to B Mo'ed Qatan 21a);[51]

46. For a literary analysis of these traditions regarding R. Judah I and Sepphoris, see Meir, *Rabbi Judah the Patriarch*, 300–37. See also below, nn. 49–50.

47. It has been suggested that R. Judah was brought back to Bet She'arim for burial because it was part of his private domain; having once belonged to the Herodian family, it was taken over by the Romans and subsequently transferred to R. Judah and his successors along with other regions of Roman Palestine (B. Mazar, *Beth She'arim*, 1:5). This sequence of events, however intriguing, is rather speculative.

48. See comments of Pnei Moshe, ad loc., and Lieberman, *Hayerushalmi Kiphshuto*, 220.

49. On the problematics of utilizing the Bavli for establishing a historical context for Roman Palestine, see Weiss-Halivni, *Midrash, Mishnah, and Gemara*, 76–104; S. Friedman, "Critical Study of *Yevamot*," 283–321; Friedman, "Literary Developments and Historicity" and, in an expanded form, "On the Historical Aggadah"; L. Jacobs, *Structure and Form in the Babylonian Talmud*; Rubenstein, *Culture of the Babylonian Talmud*, 1–15; Rubenstein, "Introduction"; Rubenstein, "Criteria of Stammaitic Intervention"; Rubenstein, *Talmudic Stories*, 1–33. See also Goodblatt, "Babylonian Talmud," 314–18.

50. Kalmin has posited that not all of the Bavli was fundamentally reworked by the latest stammaitic layers, but rather it is a thickly layered compilation preserving earlier strata as well; thus, some relatively credible traditions reflecting Palestinian historical reality and not only cultural history may be found in the Bavli; see Kalmin, *Sages, Stories, Authors, and Editors*, passim, and esp. 87–110; Kalmin, "Formation and Character," 843–52, 862–67; and Kalmin, "Problems in the Use of the Babylonian Talmud," wherein he claims, inter alia, "for the Bavli contains much material which derives from Palestine and may sometimes (as this study of the example of attitudes to astrology will demonstrate) preserve Palestinian rabbinic material in a form closer to the original than is found in Palestinian compilations" (165). Most recently, D. Levine has bolstered this line of argument by invoking a number of compelling methodological considerations ("Rabbis, Preachers, and Aggadists"). Bet She'arim itself seems to provide an example of the Bavli's accuracy in noting the marriage of R. Joshua b. Levi's son into the Patriarchal family (Qiddushin 33b). Interestingly, the only identifiable non-Patriarchal rabbinic name in the catacombs is that of Joshua b. Levi (see below).

51. Rabbinic places of study were initially informal settings, in a teacher's house or in some other private quarters. The term "academy" (*bet midrash*) implies a more formal and permanent setting and may have evolved under Patriarchal auspices, possibly under R. Gamaliel but more likely only in third-century Palestine under R. Judah (and even later in Babylonia). R. Judah was apparently also responsible for other developments in rabbinic circles; see L. I. Levine, *Rabbinic Class*, 25–42); given his wealth and status, R. Judah may

Rav Dimi attests to a halakhic issue brought before R. Judah in Bet She'arim (B Ketubot 107b); and R. Judah himself refers to a case that took place in Bet She'arim (B Niddah 32a).

Not very often do we find so many sources, albeit of varying historical value, connecting a particular sage to a specific place both in his lifetime and after his death. Thus, it may be assumed, contra Rajak, that Bet She'arim is often associated with R. Judah because he indeed lived and was buried there.

Moreover, archaeological remains confirm not only the centrality of the burial places of R. Judah I's immediate circle in the Bet She'arim cemetery but also, to a lesser degree, that of the Patriarchal house in the ensuing generations. A mere glance at the layout of the necropolis excavated by Avigad demonstrates that the most prominent catacombs, virtually twins, are nos. 14 and 20, both geographically central and both constituting the most monumental structures in the immediate area.[52] As noted above, no other catacombs have as impressive facades as these, each featuring three portals, a large courtyard with benches, and semicircular benches cut into the hillside above, apparently used as a place of assembly for those visiting these graves. Catacombs 14 and 20 are also distinguished from the others by their epigraphic remains: while Greek is overwhelmingly dominant throughout the rest of the necropolis (reaching some 90 percent there), Hebrew inscriptions constitute the majority in these two catacombs. Catacomb 14 contained two inscriptions in Hebrew and two in Hebrew and Greek, while Catacomb 20 had eighteen in Hebrew and only six in Greek.

The evidence of the names recorded in both these catacombs indicates that they are closely associated with the Patriarchal dynasty. The male names appearing in the Hebrew inscriptions in Catacomb 20 are as follows:[53] R. Joshua b. R. Hillel; R. Aniana; R. Gamaliel b. Nehemiah; R. Judah b. R. Gamaliel; R. Jonathan; R. Hillel b. Levi; R. Joshua b. Levi; R. Judan b. R. Miasha; [R.] Gamaliel b. R. Eliezer; and R. Aniana.[54] It is notable that in almost every case at least one member of the family (either father or son) bore a name typical of, if not exclusively associated with,

well have provided public quarters for his study sessions. Thus, reference in his case to an institutionalized academy, and not merely to a private informal study house, may be justified. See in general Rubenstein, "Social and Institutional Settings."

52. The mausoleum of Catacomb 11, located on the other side of the hill, was undoubtedly also impressive.

53. Avigad, *Beth She'arim*, 3:100–9. Only two male names appear in Greek—Agrippas and Alupis (Schwabe and Lifshitz, *Beth She'arim*, 2:181–82). A number of female names (in Hebrew and Greek) appear as well: Miriam, Domna, Domnika, Atio, and Ation (see Avigad, *Beth She'arim*, 3:102–5); however, there is no room for comparison here, since our literary sources do not mention the names of any female members of the Patriarchal family in the third and fourth centuries.

54. Regarding the last-named person, Aniana, see the reference to one R. Gamaliel b. Aniana in Y Peah 1, 1, 15b.

(1) (2) (3)

FIG. 65 Catacomb 14, Bet She'arim: Inscriptions identifying the burial places of R. Judah's sons (1 and 3) and his student (2): (1) R. Gamaliel; (2) R. Aniana (Ḥanina); (3) R. Simeon.

the Patriarchal family—Gamaliel, Hillel, and Judah (or Judan).[55] Moreover, nearly every male held the title *rabbi* while the majority of women interred there bore the title *kyra* (lady) in Greek. Only R. Joshua b. Levi (mentioned three times—with regard to himself, his wife, and his daughter) was a recognized talmudic sage, and he was also reportedly related to the Patriarchal family through his son's marriage (see above; B Qiddushin 33b).[56] Thus, his family's burial in Catacomb 20 is readily explainable. Of the other names noted above, only that of Jonathan cannot be directly associated with the Patriarchate, at least on the basis of the extant literary sources. The above evidence thus clearly suggests that Catacomb 20 was overwhelmingly, if not exclusively, a Patriarchal catacomb.

However, the Patriarchal connection with Catacomb 14 is even stronger. All those interred there (Gamaliel, Simeon, and Ḥanina)[57] are clearly associated with R. Judah himself (fig. 65). According to the Bavli, the first two were R. Judah's sons and the third was his leading student. Before his death, R. Judah reputedly appointed these three to different positions: "My son Simeon [shall assume the post of] *ḥakham*, my son Gamaliel [shall be the] *Nasi* (Patriarch), and R. Ḥanina b. Ḥama shall preside" (יֵשֵׁב בָּרֹאשׁ, literally, shall occupy the first place in the academy; B Ketubot 103b). Focusing only on the relationships of those closest to R. Judah (and not the precise assignments noted in the Bavli tradition),[58] the archaeological material

55. See the interesting case of R. Gamaliel II, who named two sons Judah and Hillel (T Mo'ed Qatan, 2, 16, p. 372), and this may have served as a model for subsequent generations.

56. See the discussion about this sage and his family at Bet She'arim by Rosenfeld ("Rabbi Joshua ben Levi"), who also suggests additional reasons for R. Joshua's association with the Patriarchate, i.e., his wealth and ties to the Roman government.

57. Avigad, *Bet She'arim*, 3:238–40. The last-named sage is referred to on several occasions. One slab bears two inscriptions—one in Greek ("Of Rabbi Anianos the Little" [lit., "the dwarf"] and one in Hebrew ["This is Rabbi Aniana's tomb"]). Strangely, however, another inscription, in Hebrew (which has since disappeared), was found on the opposite wall of the same room and reads: "Anina the Little." Despite obvious difficulties (such as location and spelling), it seems conceivable that these inscriptions refer (for reasons unknown) to the same person; see ibid., 239–40.

58. On the particular Babylonian context of this and similar Bavli traditions, see Steinmetz, "Must the Patriarch Know *Uqtzin?*"; and above, n. 49.

FIG. 66　Catacomb 14, Bet She'arim: double-trough grave in the innermost room, probably that of R. Judah I and his wife.

fully substantiates the identity of Judah's most intimate confidants and successors in the Bavli narrative. Thus, Catacomb 14 clearly seems to have been not only a Patriarchal burial site in general but one intimately connected with R. Judah himself.

R. Judah's name does not appear in this catacomb, but it is noteworthy that the above-noted inscriptions were found in the entrance hall and in a passageway leading to a back room often designated in ancient burial caves as the final resting place for the head of a family or some other distinguished individual. Indeed, this back room contains an unusual arrangement—two burial troughs placed side by side in the center of the floor and set apart from the rest of the room by a low wall (fig. 66). Given the many parallels to other burial arrangements in antiquity, both Jewish and non-Jewish, it would seem logical to assume that these two troughs were reserved for R. Judah and his wife. This type of double burial, placed in the center of a room and set off by a barrier, is unattested elsewhere in all of Bet She'arim and would befit a person of his stature. Thus, while there is no explicit epigraphic attestation as to who, in fact, occupied the twin troughs, the circumstantial evidence seems quite persuasive.[59]

Although Catacombs 14 and 20 have much in common—a Patriarchal context, similar architectural plans, and a common linguistic orientation (Hebrew)—they differ considerably in one regard: figural art is ubiquitous in Catacomb 20 and entirely absent in Catacomb 14. It is not clear how to account for this difference. It may be a matter of personal preference (R. Judah I's otherwise unattested predilection for an aniconic burial setting) or, alternatively, a chronological differentiation (later generations of Patriarchs and their families were more comfortable embracing figural art in a funerary context).

Given the centrality of Catacombs 14 and 20 and their unequivocal ties to the Patriarchate, it seems clear that the Bet She'arim necropolis was originally and pri-

59. R. Judah's concern for his spouse is clearly indicated in the instructions he gave his sons on his deathbed, reported in both Talmuds: "Do not remove her from my house" (Y Kil'aim 9, 4, 32a and parallels); "Take care to show respect to your mother" (B Ketubot 103a). It therefore may not be unreasonable to assume that R. Judah would have made arrangements for his wife to be interred beside him. For a more skeptical approach to the identification of these two catacombs with the Patriarchal dynasty, see Lapin, "Epigraphical Rabbis: A Reconsideration," 322–29.

marily a Patriarchal cemetery that subsequently—owing to the prestige of the office in ensuing generations—became a choice burial site for other Jews as well.[60]

Aside from the Patriarchal family and several other closely associated sages, it appears that leaders of various Jewish communities who were undoubtedly allied with the Patriarch chose to be interred in the Patriarchal necropolis. The Bet She'arim inscriptions record the presence of a number of synagogue officials from both Syria and Palestine. The office of archisynagogue is particularly in evidence, as in the case of Eusebius, head of the synagogue of those hailing from Beirut;[61] Yosi of Sidon;[62] and Jacob of Caesarea, head of the synagogue of Pamphylians (this inscription was found in the nearby Bet She'arim synagogue).[63] Another inscription notes one Aidesius, a gerousiarch from Antioch,[64] and the Yerushalmi refers to the wealthy and powerful of Caesarea who were buried in Bet She'arim (Y Mo'ed Qatan 3, 5, 82c).[65]

The Absence of Talmudic Rabbis

While the case for Patriarchal prominence in Bet She'arim appears quite certain, the same cannot be said regarding the presence of talmudic rabbis. From the evidence at hand, it seems that this burial site did not attract these sages who, in fact, seem to have consciously and studiously avoided using it. Other than the Patriarchs themselves and, as noted, others explicitly connected to their circles,[66] no other rabbi known to us from rabbinic literature was interred there. The title *rabbi*, appearing some twenty-seven times in Bet She'arim, is by no means to be associated automatically with the talmudic sages.[67] Such a title appearing in the New Testament and some rabbinic sources refers to persons of honor, leadership, or religious stature.[68] The Tosefta discusses various definitions of the title (T Bava Metzia 2, 30, p. 72; T Horayot 2, 5, p. 476),[69] and several talmudic sources refer to a judge or a

60. On the prominence of the Patriarchate in the generations following R. Judah I, see L. I. Levine, "Emergence of the Office of the Patriarchate."

61. Noy and Bloedhorn, *Inscriptiones Judaicae Orientis*, 3:40–42; Schwabe and Lifshitz, *Beth She'arim*, vol. 2, no. 164; Roth-Gerson, *Jews of Syria*, no. 17.

62. Noy and Bloedhorn, *Inscriptiones Judaicae Orientis*, 3:29–30; Schwabe and Lifshitz, *Beth She'arim*, vol. 2, no. 221; Roth-Gerson, *Jews of Syria*, no. 43.

63. Schwabe and Lifshitz, *Beth She'arim*, vol. 2, no. 203.

64. Noy and Bloedhorn, *Inscriptiones Judaicae Orientis*, 3:118–19; Schwabe and Lifshitz, *Beth She'arim*, vol. 2, no. 141; Roth-Gerson, *Jews of Syria*, no. 1.

65. This follows the reading of Nahmanides and most early medieval commentators (Rishonim); see Ratner, *Ahavat Zion v'Yerushalayim, Mo'ed Qatan*, 114; *Pesaḥim*, 51; Lieberman, *Studies in Palestinian Talmudic Literature*, 167.

66. R. Ḥanina (= Aniana) b. Ḥama and R. Joshua b. Levi; see nn. 56 and 57.

67. See S. J. D. Cohen, "Epigraphical Rabbis"; Lapin, "Epigraphical Rabbis: A Reconsideration."

68. On the title *rabbi* generally, see L. I. Levine, *Rabbinic Class*, 15, and the literature cited there; Hezser, *Social Structure*, 55–62, 111–13.

69. In the course of sorting out various definitions, these sources ignore several options that would seem to have been in use at the time (e.g., a teacher of a craft or a teacher of

brigand-chief as *rabbi* or *rav* (Y Bikkurim 3, 3, 65d; B Bava Metzia 84a).[70] Even were we to assume that the title refers in many, if not most, cases to one learned in Torah, there is no reason to posit that such people were necessarily talmudic sages. The Patriarch himself was surrounded by his own circle of scholars.[71] Nor should we assume that the talmudic rabbis were ipso facto to be found anywhere throughout the Jewish world where this title appears (including many places in Palestine and the Diaspora for which there is no evidence of rabbinic presence) on the basis of the unwarranted assumption that the title necessarily refers to this one specific circle, whose numbers were quite limited.[72]

Moreover, not only are talmudic rabbis unattested in Bet She'arim, but the one rabbinic source relating explicitly to burials at this site (besides that of R. Judah I) refers to the wealthy and powerful Jewish residents of Caesarea interred there.[73] Finally, when rabbinic sources do, in fact, relate to burials, it is invariably in connection with Tiberias, as we learn from the instructive story of several third-century sages:

> R. bar Quraya and R. Lazar were sitting and studying Torah in the Ilsis[74] of Tiberias when they saw caskets coming from abroad. R. bar Quraya said to R. Lazar: "I would say about these, that in your life: 'and My possession (the land) you have made an abomination' (Jer. 2:7), while in your death: 'you have come and polluted My land' (ibid.)." He (R. Lazar) said to him: "Not so. Since they are coming to Eretz Israel, a clod of earth is put on them and atones for them. And what is the Scriptural reference? 'And His land atones for His people' (Deut. 32:43)." (Genesis Rabbah 96, 5, p. 1240; Y Kil'aim 9, 4, 32c–d, and parallels)

Whether the arrival of coffins in Tiberias from abroad was a common occurrence is not clear, nor is the question whether these were coffins of any Jew or only of sages.

Bible). See also the comments of Lieberman, *Tosefta Ki-Feshuṭah*, 9:168. Note also the amulet found at Ḥorvat Kanaf in the Golan, which records a prayer for the protection of one "R. Eleazar, the son of Esther, the servant of the God of Heaven" from any kind of pain, fever or shivering; see Naveh and Shaked, *Amulets and Magical Bowls*, 50–54.

70. On reservations regarding the dichotomy between the talmudic and "epigraphical" rabbis, see above, n. 21.

71. See Epiphanius, *Panarion* 30.4.2, as well as Y Bikkurim 3, 3, 65d. Indeed, given the fact that a large number of inscriptions bearing the title *rabbi* are attested in Bet She'arim specifically, it may well be, as noted, that the term was often (mainly?) used regarding individuals associated with the Patriarchate.

72. See Levine, *Rabbinic Class*, 66–69.

73. See Y Mo'ed Qaṭan 3, 5, 82c; and above, n. 65.

74. On the disputed meaning of this word (forest? plaza? hiding place? site of glass factories? courtyard? palatial building?), clearly referring to a well-known section of the city, see Eliav, *Sites, Institutions and Daily Life*, 11–15.

Another source, however, refers explicitly to the corpses of Babylonian sages being brought to Tiberias for burial:

> Rava said: "Is there anyone who claims that Reqet (Josh. 19:35) is not [to be identified with] Tiberias? For when someone dies here (in Babylonia), they mourn for him there (in Tiberias) thusly: 'Great is he in Sheshakh (Babylonia) and he has a name in Reqet.' And when the coffin arrives there, they mourn for him thusly: 'Lovers of remains [of the dead], residents of Reqet, go forth and receive those who have been murdered in the depths (in Babylonia).'"
> (B Megillah 6a)[75]

Although meager, the evidence from rabbinic literature may well indicate that Tiberias was the focal point for the burial of rabbis, particularly from Babylonia. While these two traditions are all we have on this topic, when taken together with the absence of any reference to rabbinic burials in Bet She'arim, and the absence of any "rabbinic" name in the inscriptions there (with the two exceptions noted above),[76] we can safely conclude that the sages in rabbinic literature were rarely, if ever, interred there.[77]

The dichotomy between the Patriarchs and the talmudic sages should not come as a surprise. The Patriarchate undoubtedly achieved new heights of prestige and authority in the days of R. Judah I and thereafter.[78] Under the supportive Severan dynasty (193–235 CE), R. Judah I garnered a great deal of economic wealth and political clout that, as mentioned above, when combined with his intellectual and religious stature, all but guaranteed him an undisputed position of leadership.[79] Given this enhanced status, and in line with the policy adopted by the Romans throughout the East, the Patriarch forged new alliances and strengthened existing ones, the most important being the urban aristocracies.[80] The need and desire of the Patriarchs to cultivate ties with persons in a position to further their interests and

75. The burial place of Rav Huna, exilarch and friend of R. Judah I (Y Kil'aim 9, 4, 32b; Y Ketubot 12, 3, 35a) is uncertain; Tiberias, Sepphoris, and even Bet She'arim have been suggested. On another such tradition involving one Rav Huna, see B Mo'ed Qatan 25a and the comments in my *Rabbinic Class*, 64–65.

76. See above, n. 66.

77. Traditions regarding the burial of sages (referred to as the "burial caves of rabbis") in the Galilee can be found, inter alia, in Y Kil'aim 9, 4, 32b and parallels; B Bava Metzia 84b, 85b. These sources usually do not mention a site by name, one exception being Meiron and Gush Ḥalav (Pesiqta de Rav Kahana 11, 23, pp. 198–99).

78. This is the *communis opinio* today; see chap. 4; L. I. Levine, *Rabbinic Class*, 33–38; L. I. Levine, "Emergence of the Patriarchate"; S. J. D. Cohen, "Place of the Rabbi," 169–73; Goodman, "Roman State and the Jewish Patriarch"; S. Stern, "Rabbi and the Origins of the Patriarchate"; Lightstone, "Mishnah's Rhetoric," 484–88.

79. On references to the *Nasi* in regal and messianic terms, see Goodblatt, *Monarchic Principle*, 141–75; Herr, "Synagogues and Theatres," 106 n. 11.

80. Millar, *Emperor in the Roman World*, 394–447.

help implement their policies are indeed natural. These ties, however, often came at the expense of the talmudic sages, who bitterly complained, for example, that the wealthy received judicial appointments in their stead (Y Bikkurim 3, 3, 65d) or that the Patriarchal taxation system affected them adversely (Y Sanhedrin 2, 6, 20d and parallels).

The rabbis, for the most part, kept their distance from the Patriarch, often criticizing his policies, judgments, and decisions throughout most of the third and fourth centuries. The number of references to the Patriarch in rabbinic sources drops precipitously over the course of the third century. Whereas R. Judah I is mentioned some thirteen hundred times, his grandson Judah II (ca. 250 CE) is noted only fifty times, and his great-grandson Judah III (ca. 300 CE) but twenty. Fourth-century Patriarchs rarely appear in rabbinic sources.[81] Thus, the dichotomy between the Patriarchs and the talmudic rabbis grew, each becoming increasingly peripheral to the other's agenda.[82]

The Patriarch, for his part, cultivated those rabbis belonging to his own circles (many of whom carried the title *rabbi*), whose counsel he sought and on whom he relied to formulate and implement policies.[83] Every Patriarch from R. Gamaliel II through R. Judah II in the mid-third century is noted as having functioned in conjunction with his own court, issuing enactments (*taqqanot*) and decrees (*gezerot*) in response to new circumstances.[84] The *apostoli* sent by the Patriarch to collect taxes and deal with administrative and religious affairs while visiting various communities are another group of confidants whom he undoubtedly consulted (though

81. Rosenfeld, "Crisis of the Patriarchate," 240–42. For comments on the split between the rabbis and Patriarchate, see Oppenheimer, *Rabbi Judah ha-Nasi*, 179–81.

82. Ironically, then, just when R. Judah I seems to have created new opportunities for the sages to be involved in communal positions, the office of the Patriarch developed politically and communally, creating the need to draw from other sectors of the Jewish population—much to the chagrin of the sages; see L. I. Levine, *Rabbinic Class*, 23–42, 134–91.

83. See, e.g., the references in rabbinic literature to the court of the Patriarch (B 'Avodah Zarah 36a; Y Sanhedrin 1, 2, 19a), and Epiphanius's comments on the Patriarch's councilors (*Panarion* 30.4.2): "Joseph was one of their men of rank. These are the ones who come after the Patriarch and are called 'apostles.' They attend the Patriarch and are often with him continuously by night and day in order to advise and report to him on matters of the law." S. Schwartz refers to these men as the Patriarch's *consistorium* (*Imperialism and Jewish Society*, 117–18). As noted (above, n. 21), it is quite possible that the newly published inscriptions from the Sepphoris necropoleis that name additional rabbis also refer mainly to those with close relations to the Patriarchal house. If this were the case, then almost sixty percent of all references to "epigraphical" rabbis would be found in either Bet She'arim or Sepphoris.

84. Mantel, *Studies*, 227–35. On perhaps a comparable arrangement of sages in the orbit of the Babylonian Exilarch, see B Bava Batra 65a; Seder Olam Zuta, 2, p. 72), and the comment of Beer, *Babylonian Exilarchate*, 115 n. 85.

there may have been some overlap with the former group).[85] In addition, the Patriarch would appoint or recommend members of his circle for communal posts in communities that sought his advice, as R. Judah I did for Levi b. Sisi (Y Yevamot 12, 7, 13a and parallels).[86] It can be surmised that those close to the Patriarch included rabbis from the above circles, some of whom may have been buried in Bet Shetarim.[87]

CONCLUSION

The Bet Shetarim necropolis has always been rightfully considered the single most important Jewish archaeological site in Late Antique Palestine. The extent and variety of the finds there and their connection to contemporary literary sources bestow on it a status perhaps surpassed only by the cemetery in Second Temple Jerusalem. However, as we have suggested above, the site's main contribution is somewhat different from that which has heretofore held sway. It was not a rabbinic site and therefore does not attest to rabbinic Hellenization, and the Patriarchate of the third and fourth centuries should not be considered a rabbinic dynasty.[88] Rather, the necropolis is to be identified with the Patriarchal family, which at this point in time was not rabbinic in the usual sense of the term.

The Patriarchate and its associated circles constituted an important factor in the social and religious life in the Jewish community and enjoyed the full backing of the Roman government along with the power and communal authority that resulted from this kind of support. The talmudic rabbis did not and could not compete with the Patriarch politically; they showed neither the desire nor ability to control existing communal institutions or to create alternative ones. Whatever institutionalized positions of influence and authority they gained at this time were often due to the goodwill and support of the Patriarchate, which was the main seat of power in the Jewish community beyond the local level.

85. Juster, *Les juifs dans l'empire romain*, 1:388–90; Mantel, *Studies*, 198–206. On the relationship, if any, between these emissaries and those sages identified as such in rabbinic literature, see Goodblatt, *Monarchic Principle*, 135–41. In this regard, there is one source that speaks of the Patriarch Judah II Nesiah sending R. Ḥiyya bar Abba to serve as an emissary (Y Ḥagigah 1, 8, 76d; Y Nedarim 1, 1, 42b).

86. It is perhaps indicative of the marginality of some talmudic rabbis vis-à-vis the Patriarch that the third-century R. Ḥiyya bar Ba, when planning to travel abroad, had to ask R. Elazar to intercede on his behalf (פייס לי, lit., persuade [him] for me) in order to obtain a letter of recommendation from R. Judah III Nesiah (Y Ḥagigah 1, 8, 76d).

87. An inscription (now missing) found in the early twentieth century in Bet Shetarim may indicate how some of these Patriarchal *rabbis* may have referred to themselves. The inscription reads בנימין בר יצחק רבן תורה ("Benjamin bar Isaac Rabban Torah"); see B. Mazar, *Beth Shetarim*, 1:26.

88. Per Millar, *Roman Near East*, 383.

Finally, as spelled out in some detail above,[89] the Bet She'arim necropolis pro-
vides solid evidence for the integration of those interred there into the contempo-
rary Roman world. Rapprochement with Rome, concretized most vividly by the
rise of the Patriarchate as a pivotal Jewish office in the empire, now became a model
and an option in other areas of Jewish life; as with Herod centuries earlier, cultural
and social areas did not lag far behind the political realm. The prominent revival of
Greek language and culture represented by the Second Sophistic played a signifi-
cant role in the religious, cultural, and social agendas of many Jews at this time, first
and foremost within Patriarchal circles.

89. See chap. 4.

7. THE JEWISH CATACOMBS OF ROME AND THEIR ROMAN AND CHRISTIAN PARALLELS

THE JEWISH CATACOMBS in Rome are a unique archaeological phenomenon on the Jewish landscape of Late Antiquity, perhaps no less so, *mutatis mutandis*, than the sites considered in the two previous chapters. Similar Jewish burial sites are known elsewhere in the Diaspora, for instance in Venusia (today's Venosa) in southern Italy, Malta, and Leontopolis and Alexandria in Egypt, as well as Carthage and elsewhere in North Africa. None, however, is as extensive in size or as rich in artistic and epigraphic remains—or has as massive a repertoire of local comparative pagan and Christian material—as the Roman catacombs. They comprise by far the largest corpus of material culture for any single Diaspora community in antiquity.[1]

Indeed, the catacombs in Rome dovetail with the burial practices of contemporary Roman society, particularly those of the Christian community. Hecataeus of Abdera's oft-quoted observation—that the Jews of his day (the late fourth century BCE), despite their particularistic ways, nevertheless adopted in certain areas many of the practices of their neighbors, including those relating to burial—is indeed an apt description of Roman Jewry's burial customs.[2] And while Rome's Jews shared many characteristics (such as neighborhoods, languages, professions, and forms of communal organization) with other immigrant groups in the city,[3] they still found numerous ways of leaving a unique Jewish stamp on their lives, including their catacombs.

1. Toynbee, *Death and Burial in the Roman World*, 234–44; see also below, n. 19.

2. This idea is articulated by Diodorus Siculus, *Bibliotheca Historica* 40.3, in M. Stern, *GLAJJ*, 1:29.

3. Regarding the Jewish community, MacMullen ("Unromanized in Rome," 54) has formulated this phenomenon thusly: "It is not surprising that an ethnic group well known for their poverty should seek out a life among their socioeconomic kind. It would bring them to the city's third ring, where the homeless settled, where the dead were disposed of, and where noxious industries were relegated."

THE CATACOMBS[4]

Roman Jewry's funerary practices can best be understood in light of contemporary pagan but primarily Christian practice in Rome.[5] While scholars from the seventeenth through much of the twentieth centuries had assumed that the city's Christian catacombs originated in the first century CE, the *communis opinio* today is that they date from the late second to fifth centuries CE.[6] Beforehand, Christians apparently buried their dead alongside pagans, or at least in similar types of tombs with no special Christian markings, and thus are unidentifiable archaeologically. Such early burial sites included funerary monuments for the wealthy, mass graves for the poor,[7] and simple individual graves marked by an altar or stone slab for those of modest means. By the first century CE, pagan Rome introduced burial societies (or *collegia*; see below) and *columbaria* (collective burial chambers with niches containing as many as three thousand urns of the cremated dead) to handle the increased demand for burial space and reduce soaring costs.[8]

4. "Catacomb" is derived from the Greek word meaning "near the gorge, hollows" and was Romanized to *ad catacumbas*, which originally designated a specific site on the Via Appia Antica, referring to hollows, cisterns, and white sandstone cavities created by earlier quarrying. Later on, these cavities retained this name but were used for burial, and only in the ninth–tenth centuries was it applied to all the catacombs in the city (and elsewhere). In Late Antiquity, burial places were called crypts and were referred to as such by Jerome (*In Ezek.* 12.40) and Prudentius (*Peristephanon* 11.1.154). Contrary to a once-prevailing opinion, catacombs were not intended to serve as places of refuge for Christians during persecutions or as places for regular communal worship.

5. Stevenson, *Catacombs*; Pergola, *Le catacombe romane*; Nicolai, Bisconti, and Mazzoleni, *Christian Catacombs of Rome*, 25–36; MacMullen, *Second Church*, 69–76. Previously, the opposite was the case, namely, that Christians followed earlier first-century CE Jewish practices that somehow originated in Jewish custom in Palestine (see, e.g., Leon, *Jews of Ancient Rome*, 54–55, 66). On Roman pagan influence on the Jews, again assuming an earlier first-century dating for these catacombs (though also acknowledging some Palestinian influence), see Margaret H. Williams, "Organisation of Jewish Burials," 177–82.

6. This dating derives from archaeological remains such as coins, dated inscriptions, and pottery, as well as bricks used in the construction of the catacombs. The earliest Christian catacombs, some ten in number, date from around 200; the oldest parts of the catacombs of Priscilla, Domitilla, and St. Callisto are all dated now to the turn of the third century; see Pergola, "Le catacombe romane, miti e realtà"; Nicolai, Bisconti, and Massoleni, *Christian Catacombs of Rome*, 13–20; Pergola, *Christian Rome*; M. J. Johnson, "Pagan-Christian Burial Practices," 41–42; Rutgers, *Subterranean Rome*, 53–67; B. Green, *Christianity in Ancient Rome*, 178–85. According to Finney, "The year 200 (plus or minus ten or fifteen years) should be identified as the likely *terminus a quo* for the creation of distinctively Christian forms of art" (*Invisible God*, 146–230; quote from p. 146). Moreover, a number of literary sources tell of third-century popes interred in catacombs, and several church fathers (e.g., Tertullian, Origen, and Hippolytus) note that there were special cemeteries for Christians.

7. See, e.g., Bodel, "Dealing with the Dead," 128–35.

8. K. Hopkins, *Death and Renewal*, 205–17; Toynbee, *Death and Burial*, 101–63; van Nijf, *Civic World of Professional Associations*, 44–49.

A number of factors in the late second century CE led to a massive change in Roman burial practices. The growing population of imperial Rome, together with the second-century CE transition from cremation to inhumation, led to an acute need for many more burial areas. In the past, scholars have posited that the continued growth of the local Christian community, which at least by the latter half of the third century had a significant presence in the city, contributed to the demand for an expanded catacomb network owing to the Christians' aversion to cremation.[9] This problem was solved by digging additional spaces underground, often by expanding existing hypogea that might have been originally for pagan or Christian use.[10] The resultant catacombs featured extensive subterranean complexes with myriad galleries or passageways arranged one above the other, in some instances with as many as five and six levels. *Loculi* likewise placed one above the other were carved along the walls of these galleries, from floor to ceiling. Altogether, some sixty Christian catacombs with an estimated 750,000 burials have been discovered in Rome.[11] Earlier Christian (as well as pagan) catacombs were often privately owned while later ones increasingly came under the ownership and supervision of the church.[12]

Christian use of catacombs as the primary burial setting lasted close to three centuries. While, as noted, the evidence for such an underground burial system in Rome stems from the late second and early third centuries, the development of such underground complexes expanded in the third century and peaked in the fourth.[13] Indications of a decline in this practice in the late fourth century presaged its dramatic diminution and eventual cessation in the fifth and sixth centuries, and

9. Other suggestions have also been made regarding the emergence of the catacomb burial practice in late-second century Rome, including the influence of Eastern Hellenistic customs; see Nock, *Conversion*, 66–137; Bowersock, *Greek Sophists*; Gruen, *Studies in Greek Culture*, 1–3. For an emphasis on the evolution of local Roman burial customs in the first three centuries CE as the crucial factor in the appearance of catacombs (including the role of *collegia* in this process), see Bodel, "From *Columbaria* to Catacombs," 177–242, esp. 233–35. A somewhat different perspective is offered by Morris, *Death-Ritual and Social Structure*, 42–69.

10. These hypogea were initially extensions of surface mausolea or were developed independently, and later on, in the third and fourth centuries, became integrated into large catacomb networks. See, e.g., Fasola, "Un tardo cimitero christiano."

11. Stevenson (*Catacombs*, 47) notes a claim by "ecclesiastical writers" that 14 popes and 170,000 martyrs were buried in the catacombs. This somewhat hypothetical number, of course, includes Christian burials in the fourth to sixth centuries, which clearly constituted the overwhelming majority.

12. On early church involvement in burials under Victor, the first bishop of Rome, see La Piana, "Roman Church at the End of the Second Century," 254–74.

13. On the increased usage of far more elaborate and monumental *cubicula* and private hypogea outside communal areas at this time, see Nicola, Bisconti, and Massoleni, *Christian Catacombs of Rome*, 37–49, based on the calculations of Guyon, *Le cimetière aux deux lauriers*, 288–303. It was Pope Damasus (366–384 CE) who accorded a renewed importance to the tombs of martyrs by identifying their places of burial, constructing monuments over these tombs, and facilitating the visits of large numbers of pilgrims who came to venerate these

originally may have been caused by a preference for being buried above ground, near churches associated with martyrs then being erected throughout the city.[14] The abandonment of catacomb burials in Late Antiquity should also be related to the larger sociopolitical crises in Rome arising from the conquests of the city in 410, 455, and 476, and continuing into the sixth century.[15] The numerous sieges of the city in this period forced Romans to find alternative places and methods of burial as the use of catacombs outside the city walls became a far less viable option. Finally, grave robbery was rampant under such circumstances and deterred this practice even further.[16]

As noted,[17] the Jewish catacombs of Rome are also large underground burial spaces featuring a network of galleries or passageways and *cubicula* (square or rectangular chambers) and incorporating earlier family tombs (hypogea) containing *arcosolia* (arcuated niches for individual burials) and sarcophagi; about thirty such chambers were discovered in the Vigna Randanini catacomb alone.[18] The first of these Jewish funerary complexes was discovered in Monteverde (southwest of the city on the Via Portuense) by Antonio Bosio in 1602, but it no longer exists, having been erased by residential building in the early twentieth century. Other catacombs were found in the nineteenth century, one beneath the Vigna Randanini on the Via Appia Antica south of ancient Rome (1859) and another (originally two separate catacombs that were later joined) on the grounds of the Villa Torlonia northeast of the city (1919). In addition, a number of much smaller hypogea were discovered in

holy persons. For an overview of these various stages, see Spera, *Il paesaggio suburbano di Roma*, 365–410. See also Trout, "Damasus"; B. Green, *Christianity in Ancient Rome*, 170–206.

14. This new trend was actively supported by a succession of popes; see Nicolai, Bisconti, and Massoleni, *Christian Catacombs of Rome*, 49–59. On the importance of the burial sites of martyrs and their cult in Late Antiquity, see P. R. L. Brown, *Cult of the Saints*; as well as Markus, *End of Ancient Christianity*, 139–55; Morris, *Death-Ritual and Social Structure*, 164–73; Christie, *From Constantine to Charlemagne*, 156–61.

15. See Marazzi, "Rome in Transition," 21–22. All told, Rome's population at this time was severely diminished, from some 800,000 residents in the early fifth century to somewhere between 100,000 and 300,000 in the sixth. However, on the problematics of demographic assessments for this period, see Purcell, "Populace of Rome"; Lançon, *Rome in Late Antiquity*, 14. For a lower estimate, see Mitchell, *History of the Later Roman Empire*, 311. See also Noy, "Immigrants in Late Imperial Rome," 15–16; Vallée, *Shaping of Christianity*, 106–7; and, most recently, MacMullen, "Christian Ancestor Worship in Rome," 607–8 n. 30.

16. On the dramatic decline in the number of Christian epitaphs in the fifth century, which is most certainly related to the decline in the use of catacombs, see Morris, *Death-Ritual and Social Structure*, 169–71.

17. See chap. 4.

18. Leon, *Jews of Ancient Rome*, 60. Hachlili has estimated that there were some 100,000 burial places in the Jewish catacombs, although the basis for such a claim is never substantiated (*Ancient Jewish Art—Diaspora*, 266).

the latter half of the nineteenth century (1866, 1882, 1885) northeast and southeast of the city.[19]

The Jewish and Christian catacombs are similar not only in their adoption of this form of burial but also in many of their features. The consensus regarding the Jewish catacombs, like the Christian ones, was once that such burials date to the first century CE and that the Christian burials were influenced by Jewish models.[20] However, as noted above, it is generally accepted today that this phenomenon dates from the late second to fifth centuries CE.[21] Heikki Solin adopted this date on epigraphic and palaeographical considerations, Adia Konikoff on the style and artwork of forty-odd sarcophagi (or fragments thereof), and Leonard Rutgers on many aspects of the material culture in the catacombs—plans, building methods, burial styles, artwork (wall paintings, gold glass), and lamps, as well as the various types of sarcophagi and inscriptions.[22]

While this later period makes it easier to explain the need for expanded burial arrangements in light of the growing Christian community, there is no evidence of a similar growth of the Jewish community at this time. Given this later dating, then, the Jewish practice seems best explained as a parallel to that of its neighbors.[23] Jew-

19. The literature on these Jewish catacombs and their remains is extensive: Müller, *Die jüdische Katakombe am Monteverde*; Müller and Bees, *Die Inschriften der judischen Katakombe am Monteverde*; La Piana, "Foreign Groups in Rome"; Beyer and Lietzmann, *Die jüdische Katakombe der Villa Torlonia*; Frey, *CIJ*, 1:liii–cxliv, 5–392; Goodenough, *Jewish Symbols*, 2:3–50; 3, nos. 702–844; Leon, *Jews of Ancient Rome*; Fasola, "Le due catacombe ebraiche di Villa Torlonia"; Vismara, "I cimiteri ebraici di Roma," 351–81; Rajak, "Inscription and Context"; Margaret H. Williams, "Structure of the Jewish Community"; Margaret H. Williams, "Organisation of Jewish Burials"; Margaret H. Williams, "Structure of Roman Jewry Re-Considered"; Finney, *Invisible God*, 247–74; Noy, *JIWE*, vol. 2; Noy, *Foreigners at Rome*, 255–67; Noy, "Jews in Italy," 51–56; Hachlili, *Ancient Jewish Art—Diaspora*, 263–310; Capelletti, *Jewish Community of Rome*, 143–91; and most prominently, the various studies of Rutgers: *Jews in Late Ancient Rome*; *Hidden Heritage of Diaspora Judaism*, 45–95; and *Subterranean Rome*, 146–53. See also Brilliant, "Jewish Art and Culture."

20. Leon, *Jews of Ancient Rome*, 66.

21. It remains moot as to how and where first-century Roman Jews buried their dead; see Rutgers, *Jews in Late Ancient Rome*, 96–99.

22. Solin, "Juden und Syrer," 654–721; Konikoff, *Sarcophagi*, 13–58; and Rutgers, "Überlegungen zu den jüdischen Katakomben"; Rutgers, "Archaeological Evidence"; Rutgers, *Jews in Late Ancient Rome*, 50–99. Of late, a number of scholars from Utrecht University have published a series of brief reports on radiocarbon dating, indicating that the Jewish catacomb in Villa Torlonia predates the earliest Christian catacomb by a century. This is indeed a revolutionary theory, which, if validated, would undercut the current general consensus; see, e.g., Rutgers, van der Borg, and de Jong, "Radiocarbon Dates from the Jewish Catacombs of Rome"; Rutgers, van der Borg, de Jong, and Poole, "Radiocarbon Dating," and the bibliography cited there. See also Rutgers, van der Borg, and de Jong, "Radiocarbon Dates from the Catacombs of St. Callixtus."

23. See Noy, "Where Were the Jews of the Diaspora Buried?" 87–88.

ish catacombs apparently developed in a similar fashion, as a series of connecting individual hypogea that were expanded over time. The Vigna Randanini catacomb appears to have developed in this way. Moreover, Jewish burial sites, like the Christian catacombs, were located outside the *pomerium* (the sacred boundary) of Rome, near the major highways leading out of the city.[24]

We will now examine the main components of these Jewish catacombs.

ART

As noted above, the artistic remains in the Roman catacombs are abundant compared to other Jewish burial sites from Late Antiquity. Harry J. Leon counted 144 representations of the menorah; 34 of the *lulav*, 27 of the *ethrog*, 27 of the flask, 14 of the shofar, and 6 of the Torah shrine.[25] Other motifs, ranging from seemingly neutral objects to some with pagan associations, appear as well. Although many burial places did not have any art, the extant artistic remains suffice to make a powerful statement of Jewish identity, especially when taken together with the related six hundred funerary inscriptions from these catacombs (see below).

Following is a description of the various forms and contexts of this art:[26]

Along the Galleries

Most artistic remains are to be found along the catacombs' passageways, either etched in the marble or terra-cotta plaques affixed to the *loculi* or painted on the plaster used to seal these tombs (see chap. 4, fig. 42). Virtually all of this art consists of Jewish symbols that are clearly ancillary to the funerary epitaphs and thus always placed above, below, or beside the text. The symbols appear individually or in clusters, and representations of a particular object vary considerably. *Menorot*, for example, might have different-shaped branches or legs, some quite simple, others ornate.[27]

A perennially controversial issue among scholars is whether these depictions have a specific symbolic meaning, are merely decorative, or both. Another alternative assumes that they give expression to Jewish identity but are devoid of any specific religious connotations. Goodenough and Franz V.-M. Cumont have adopted

24. Patterson, "On the Margins of the City of Rome," 90–95.

25. Leon, *Jews of Ancient Rome*, 196. It should be noted, however, that Leon's figures reflect the situation in 1960. Since then, archaeological work has been carried out and new material has been identified, but no new statistics regarding the number of religious symbols have been published.

26. Unlike other scholars, who prefer treating this art by catacomb or in some combination of place and genre. See, e.g., Goodenough, *Jewish Symbols*, 2:3–50; Leon, *Jews of Ancient Rome*, 195–228; Hachlili, *Ancient Jewish Art — Diaspora*, 266–304.

27. The illustrations in Goodenough, *Jewish Symbols*, 3:701–32, are representative of this variety.

a maximalist position on this matter,[28] whereas Leon and Rutgers have embraced a more minimalist one.[29] Those advocating an overarching interpretation often have clear-cut agendas (for example, a mystical or eschatological approach) that dictate their evaluation of these artistic remains. However, there is no way of corroborating such interpretations without invoking contemporary sources emanating from this Jewish community; since such sources do not exist, any and all interpretations are conjectural, arbitrary, and moot.

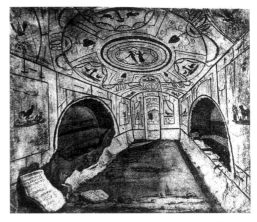

FIG. 67 Ceiling in Vigna Randanini catacombs.

In Cubicula

Although the number of such rooms in Jewish catacombs is limited, some of the artwork is noteworthy.[30] Decorations are often drawn from a repertoire of neutral motifs ubiquitous in pagan and Christian tombs (garlands, foliage, grapevines, birds, peacocks, dolphins, and so on), and Jewish symbols appear as well, albeit far less frequently than in the galleries. However, the ceilings in Cubicula I and II of the Vigna Randanini catacomb are most unique in that they contain two Greco-Roman scenes—one of a winged Victory (or Nike) holding a palm leaf in her left hand while crowning a naked youth with her right, the other of the same goddess, crowned, holding a cornucopia in one hand and pouring a libation from a dish with the other.

The Vigna Randanini *cubicula* motifs parallel similar depictions in contemporary Christian catacombs. Architecturally, Cubicula I and II are strikingly similar to those in the nearby Callistus catacomb.[31] Artistically, the paintings on the ceilings and walls of the Vigna Randanini catacomb have a central medallion, elliptical shapes, concentric circles, linear frames, and trapezoidal segments (fig. 67), while those in the Callistus catacomb feature red and green linear frames. Moreover, the iconography on both the ceilings and walls of the Jewish catacomb is almost identical to that of the Christian one—birds, vases with flowers, garlands, dentilations, and *hippocampi* (sea horses). Although the other two painted rooms in Vigna Randanini are poorly preserved, Cubiculum III shows remnants of a painted dado or lozenge, a large *kantharos* or vase with flowers on either side and plants or sprays emerging from its mouth, as well as date palms in the four corners of the room. When discovered, the ceiling reportedly exhibited flying birds, but this has never

28. Ibid., vol. 2, inter alia, 3–4, 28, 32–33; 114–19; Cumont, *Recherches sur le symbolisme funéraire.*

29. Leon, *Jews of Ancient Rome*, 225–27; Rutgers, *Jews in Late Ancient Rome*, 89–92.

30. Goodenough, *Jewish Symbols*, 2:14–35; Leon, *Jews of Ancient Rome*, 203–5.

31. Finney, *Invisible God*, 247–56.

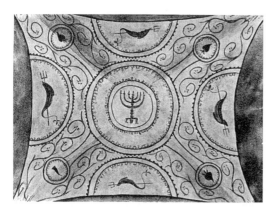

FIG. 68 Ceiling in Villa Torlonia *cubiculum,* featuring a menorah.

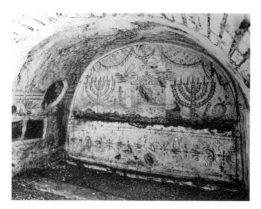

FIG. 69 Painted wall in Villa Torlonia catacombs, with a Torah shrine and flanking *menorot.*

been confirmed. Cubiculum IV features a menorah and *ethrogim* above an *arcosolium.* Paul Corby Finney described such art as "neutral-generic, the stock-in-trade of third- and fourth-century Romano-Campanian funerary painting."[32]

In contrast, the Jewish component plays a far more prominent role in the Villa Torlonia *cubicula,*[33] particularly in one painted room and with respect to two painted *arcosolia* with double graves. The ceiling of the former bears a series of concentric circles, as in the Vigna Randanini,[34] but a menorah, and not the goddess Fortuna, appears in the center (fig. 68). The four sides of this central depiction exhibit half circles, each containing a dolphin entwined around a trident. Between these four painted lunettes are four circles with representations of perhaps a shofar in one case and an *ethrog* in three others. Regarding the *arcosolia,* Jewish motifs include *menorot,* a scroll (of a Torah?), and the roof of a building (the Jerusalem Temple? a Torah shrine?[35]). Most impressive, however, is the back wall of Arcosolium IV depicting a Torah shrine with doors open to reveal a Torah scroll. The shrine is flanked by two *menorot,* a *lulav,* an *ethrog,* a knife, a vase, red fruit, and a palm branch (fig. 69).[36] The *cubiculum* also contains an array of neutral decorative motifs, including fruit, floral and geometric patterns, a jar, lunettes, and a peacock—again, quite similar in composition and iconography to the motifs in the Callistus catacomb.

32. Ibid., 254.

33. Beyer and Lietzmann, *Jüdische Katakombe der Villa Torlonia,* 15–27; Goodenough, *Jewish Symbols,* 2:35–44.

34. Given his emphasis on the mystical, Goodenough interprets these circles as the dome of heaven (*Jewish Symbols,* 2:36). On these geometric patterns in Christian catacombs and their pagan antecedents, see Finney, *Invisible God,* 160–92.

35. Beyer and Lietzmann, *Jüdische Katakombe der Villa Torlonia,* 21–22; Goodenough, *Jewish Symbols,* 2:38.

36. Beyer and Lietzmann, *Jüdische Katakombe der Villa Torlonia,* 21–24; Goodenough, *Jewish Symbols,* 2:39–40.

Scholars have addressed the issue of pagan motifs in the Vigna Randanini cata-comb, and attempted to account for this seemingly problematic phenomenon. Might there have been intrusive pagan remains in these Jewish burial places,[37] or might some Jewish catacombs have penetrated earlier pagan hypogea, incorporat-ing them in the course of their expansion, as was the case with Christian ones? In another vein, were all those interred indeed Jewish from birth, or might some have been recent converts who, at the time of burial, had not yet made the full transi-tion to the more accepted ways of the local community?[38] Finally, such finds may indicate that there were no iron-clad rules as to who was buried where, and just as mixed Christian and pagan burials occurred in some Roman catacombs, so too, albeit in rare cases, pagans and Jews might have been buried together at one site.[39]

As might be expected, the range of opinions on these matters is substantial. Jean-Baptiste Frey, for example, tended to dissociate all pagan symbolism and terminol-ogy from anything Jewish, assuming them to be intrusive, while Leon posited that everything in a Jewish catacomb was Jewish unless there was a specific reason not to think so.[40] Goodenough, for his part, asserted that virtually all the material discov-ered in the catacombs was Jewish, and that anything "pagan" should be viewed as a Jewish appropriation.

37. On the possibility of the intrusion of some pagan elements into the Jewish catacomb, see Rutgers, *Jews in Late Ancient Rome*, 77–79.

38. The basic issue here is whether such motifs reflect an actual pagan burial in a larger Jewish setting. While, in principle, such a situation is not out of the question, it seems quite unlikely. The overwhelming majority of the remains in these catacombs are identifiably Jewish while pagan motifs are rare. This does not mean that mixed burials did not exist, although no unequivocally pagan or Christian inscription has been found yet.

Christian burials are markedly different in this regard. The third and especially fourth centuries witnessed a rapid, if not at times headlong, conversion of pagans to Christianity, and it is more than likely that many families and friends were split over loyalties and affiliations. For relatives to remain united in burial despite differences in religious affiliation may not be so outlandish a thought, particularly in light of the fact that no explicit prohibitions of such practices have been found, much less followed, in either the Christian or Roman realm; see M. J. Johnson, "Pagan-Christian Burial Practices." The Via Latina remains appear to be a prime example of such a mixture, with depictions of Hercules, a partly nude Cleopatra (perhaps Tellus or Isis), a philosopher, Minerva, and other pagan figures depicted alongside clearly biblical ones. See Ferrua, *Unknown Catacomb*, 59–152, and esp. 122–39; Goodenough, "Catacomb Art," esp. 125–29; Berg, "Alcestis and Hercules." For a broader treatment of the presence of Hellenistic-pagan motifs in the Christian catacombs, see Nicolai, Bisconti, and Mazzoleni, *Christian Catacombs of Rome*, 100–30.

39. For varying assessments regarding separate or mixed Jewish burials in Late Antiquity, see Noy, "Where Were the Jews of the Diaspora Buried?"; T. Ilan, "New Jewish Inscriptions." Truth to tell, explicit evidence of the juxtaposition of Jewish and pagan burials in Rome is unattested and there are no reports of significant conversion to Judaism in Rome in Late Antiquity.

40. Frey, *CIJ*, 1:cxxiv–v; Leon, *Jews of Ancient Rome*, 60, 97 n. 1; Goodenough, *Jewish Symbols*, 2:21–33. See also R. S. Kraemer, "Jewish Tuna and Christian Fish," 152–54.

All the above options are indeed speculative, and thus a consensus regarding the meaning of the pagan motifs at Vigna Randanini remains elusive. Goodenough's basic approach (without, of course, his mystical interpretation), maintaining that these depictions are no more than instances of Jews feeling comfortable with such motifs (a case of low-key Hellenization, if one wishes), seems the most sensible, thus rendering their appropriation as neither unnatural nor problematic.

Indeed, with the rapid increase of data on Jewish artistic practice in antiquity, we have become well aware of the inclination in many synagogues, as well as of individual Jews, to make use of pagan images with seemingly little concern for issues of assimilation or crossing boundaries. The zodiac panel is probably the most striking case in this regard, but such Greco-Roman images refer primarily to Palestine; the Diaspora was quite different.[41] In Rome we encounter far more subtle examples of pagan motifs. Moreover, the most ubiquitous art in the catacombs is found on plaques used to seal burial niches, and in these cases Jewish symbols are all-pervasive. By way of comparison, the plaques used for sealing *loculi* in Christian settings are usually plain and devoid of artistic representation.[42] Art in Christian settings seems to have been reserved primarily for the walls of the more wealthy classes' *cubicula*.

On Sarcophagi

Sarcophagi[43] that may be identified with Jews or Jewish catacombs present a special challenge owing to their mobility. Very few complete examples have been found in situ, and thus we must deal by and large with fragments of varying sizes and shapes. Moreover, it is not always clear from existing reports whether a sarcophagus, complete or fragmentary, was found in or near a Jewish catacomb or was even related to one.[44] This issue is, of course, less acute when the fragment bears one or more Jewish symbols or an inscription identifying the interred as a Jew (either by name, communal title, synagogue affiliation, or some sort of Jewish descriptive phrase).[45]

Marble sarcophagi have been the target of grave robbers from time immemorial, and even the first Jewish catacomb discovered in 1602 showed signs that the finds there had already been disturbed. Several factors were at work here: the mobility of these remains and their aesthetic quality facilitated their appeal, in addition to the desire to acquire such artifacts for personal collections or, no less likely, for the

41. See also chap. 16.

42. Nicolai, Bisconti, and Mazzoleni, *Christian Catacombs of Rome*, 75–80.

43. Konikoff, *Sarcophagi*; as well as Leon, *Jews of Ancient Rome*, 210–18; Rutgers, *Jews in Late Ancient Rome*, 77–81; Rutgers, "Ein in situ erhaltenes Sarkophagfragment." See also Koch, "Jüdische Sarkophage," 190–200.

44. See Rutgers, *Jews in Late Ancient Rome*, 77–81.

45. Name: Sabbatus, Judas; communal title: gerousiarch; synagogue affiliation: *pater synagogae* of the Vernaculi; description: "Hebrew boy who loved his father."

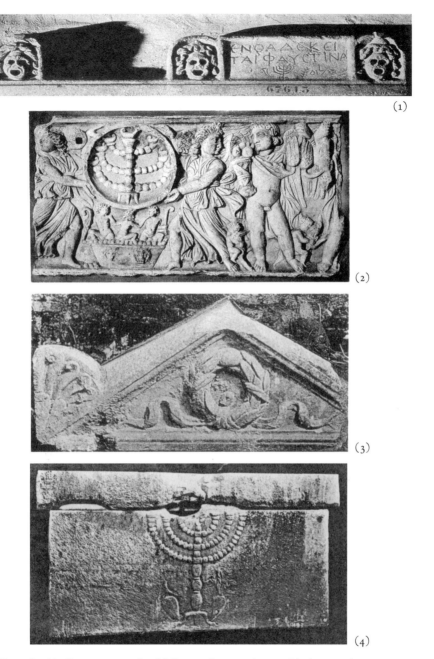

FIG. 70 Sarcophagi in Roman catacombs: (1) Cover of a sarcophagus with three masks; (2) richly figured side of a season sarcophagus with two winged Victories holding a menorah medallion; (3) one end of a sarcophagus lid featuring a gable and a wreath; (4) side of a sarcophagus depicting a menorah.

many museums in Rome and beyond. This last factor practically guaranteed that they would be pillaged and sold on the antiquities market. When added to the fact that the excavation reports of these catacombs—if they ever existed—were often inaccurate and almost always incomplete, one can readily understand the problems of identifying the catacombs' original contents.

Nevertheless, the range of motifs depicted in the forty or so sarcophagi fragments generally regarded as coming from Jewish contexts is limited though still varied, much the same as with other types of finds from the catacombs (fig. 70). Some motifs are neutral, featuring floral and other decorations (such as baskets of fruit or flowers), geometrical motifs (strigilated lines), or animal depictions (dolphins, frogs). Others are suggestive of modest Hellenistic motifs, including griffins, peacocks eating grapes, astral symbols, cupids or putti, seasons, masks, and fragments of human figures in a sitting or standing position. However, there are also depictions featuring the menorah and other symbols as well as Victory, Fortuna, Horae, perhaps the muse Urania, and the carved image of a child with a dog at his side lying atop a sarcophagus lid. In several instances, sarcophagi feature a striking combination of Jewish and Roman motifs, such as the representation of the seasons flanking a *clipeus* enclosing a menorah.

Gold Glass

Gold glass is made by applying gold leaf etched with a depiction and usually an inscription onto a round piece of clear or dark glass serving as the base of a cup, plate, or bowl, which was then covered with a thin layer of colorless glass.[46] Broken pieces of such vessels were mixed into mortar to seal the burial niches in Rome, although the reason for this practice is not clear. Perhaps these vessels were originally meant to decorate the tomb, were in some way associated with the deceased, or served as grave markers to identify where a particular person was interred. Goodenough asserted that these fragments had the eschatological purpose of invoking the hope of immortality, in light of the fact that the word *live* appears on a number of glass pieces.[47] Opinions differ as to how such decorated cups were used in one's lifetime—for decorative purposes at festive meals, in liturgical settings involving drink, as gifts on holidays, or some combination of the above.[48]

Before we discuss the art adorning this gold glass, several caveats are in order. First, although a few fragments were purportedly found in situ in the Monteverde catacomb,[49] the provenance of most of the fourteen remnants of gold glass display-

46. Barag, "Glass," 629.

47. Goodenough, *Jewish Symbols*, 2:114–19 contra a more accepted interpretation that links the term to the use of these cups for drinking wine at banquets.

48. Rutgers, *Jews in Late Ancient Rome*, 84–85.

49. Müller, *Die jüdische Katakombe am Monteverde*, 59–60.

ing Jewish symbols is unknown.[50] Thus, any association with a Jewish context rests squarely on the iconography, and at times on the inscriptions, appearing on these fragments. Secondly, no complete example of such a cup has ever been found. It would appear that these fragments were intended for use in Jewish catacombs (given their motifs and on the basis of Christian parallels; see below); since only a few specimens have survived, such objects were probably plundered in antiquity.

The use of gold glass was not only a Jewish practice; pagans as well as Christians in Rome likewise created such vessels. This craft flourished in the third and especially fourth centuries, particularly in the vicinity of Rome but perhaps in Cologne as well.[51] Altogether, some five hundred Christian gold-glass cups (or fragments thereof) have been found,[52] although Irmgard Schüler notes that slightly over half this number (279) displays motifs that cannot be readily associated with any specific religious group.[53] Most of the other remnants of gold glass indeed bear Christian symbols, although only thirty-two of them were actually found in Christian contexts.[54]

Gold-glass vessels are distinctive in that their Jewish symbols are more explicit and prominent than any other medium associated with the catacombs (fig. 71).[55] Most depictions have two tiers. The upper part almost always shows a Torah shrine with its doors open and a view of the Torah scrolls lying on shelves. The facade of the ark varies, as does the number of scrolls. The objects flanking the ark might also

50. Specimens of gold glass with Jewish symbols, housed in museums in Berlin and Cologne, are said to come from the Vigna Randanini and Villa Torlonia catacombs, respectively. Ironically, the several instances in which such glass has been found in situ are those specimens from Christian contexts—the catacomb of Peter and Marcellinus and that of Saint Ermete; see Leon, *Jews of Ancient Rome*, 220 n. 1; Barag, "Glass," 630; Hachlili, *Art and Archaeology—Diaspora*, 292–93; Elsner, "Archaeologies and Agendas," 115–18. Why this indeed happened is as unclear as it is intriguing, but to use isolated finds as a basis for arguing a case of religious fluidity among Jews and Christians in Rome, as Elsner does, seems exaggerated. The epigraphic evidence and artistic motifs found in situ in the Jewish catacombs point decidedly in the opposite direction (see below).

51. Schüler, "Note on Jewish Gold Glasses," 50–54.

52. This number is generally agreed upon by scholars; Beyer and Lietzmann (*Die jüdische Katakombe der Villa Torlonia*, 23) speak of more than 500 specimens, Barag ("Glass," 630) and Nicolai, Bisconti, and Mazzoleni (*Christian Catacombs of Rome*, 80–81) of about 500.

53. This last figure, offered by Schüler, is based on the 450 fragments of gold glass known in his day ("Note on Jewish Gold Glasses," 50).

54. Vopel, *Die altchristlichen Goldgläser*, 84ff.; Ferrari and Mordy, *Gold-Glass Collection*. That Jews themselves might have made these Jewish gold-glass cups, see Neuberg, *Glass in Antiquity*, 49. Hachlili, *Art and Archaeology—Diaspora*, 292–304.

55. For descriptions and illustrations of this material, see Ferrari and Mordy, *Gold-Glass Collection*, nos. 114–16, 173, 346, 359, 426, 433, 458; Goodenough, *Jewish Symbols*, 2:108–19; vol. 3, nos. 964–78; Hachlili, *Art and Archaeology—Diaspora*, 293–301. See also Gressmann, "Jewish Life in Ancient Rome."

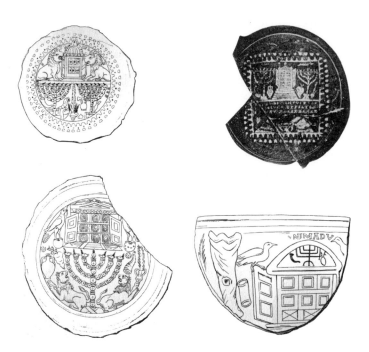

FIG. 71 Gold glass from the Roman catacombs.

differ—lions, birds, or a cluster of Jewish symbols. The bottom tier always displays the usual Jewish symbols, or lions when they do not appear on the upper part.

In one case, the menorah appears above the Torah shrine along with a shofar and *ethrog*, and in another, a structure perhaps intended to resemble the Jerusalem Temple stands inside a courtyard surrounded by palm trees and approached by four stairs. Beneath it are a *lulav*, an *ethrog*, amphorae, several other objects, and a menorah (fig. 72).[56] One glass specimen has no artwork but bears a funerary inscription in Greek along with the word *shalom* in Hebrew. Other than this instance, all the inscriptions are either in Greek or Latin[57] and often refer to drinking ("drink with Eulogia [?]" and more frequently "drink, live").[58]

Goodenough was certainly correct in remarking that these designs indicate "the consummate importance of the Torah."[59] The ark is crowned with impressive semicircular tympana in three very similar and relatively complete instances. Two of these arks (nos. 964 and 965)[60] have two shelves with three scrolls on each; the third

56. Noy (*JIWE*, 2:471–73) likewise notes other interpretations—a tomb, the interior of a synagogue, and a Torah shrine. For a rather fanciful interpretation of these fragments of gold glass as referring to the holiday of Sukkot and its messianic implications, see St. Clair, "God's House of Peace."

57. As for the inscriptions on these glass objects, see Noy, *JIWE*, vol. 2, nos. 588–600.

58. Ibid., vol. 3, nos. 590, 591, 594, 595.

59. Goodenough, *Jewish Symbols*, 2:110.

60. For this and the following references, see ibid., vol. 3, nos. 964–66.

(no. 966) has three shelves with two scrolls on each.[61]
In each of the three, lions flank the shrine in a heraldic
posture, and in one case (no. 966) a curtain appears on
both sides of the shrine.[62]

In viewing catacomb art generally, we note that the
overwhelming majority of examples are either neutral
or Jewish in content. Several instances, particularly in
the Vigna Randanini catacomb, are drawn from pagan
models with which the families of the interred presum-
ably felt comfortable. However, the art in the galler-
ies and on the gold glass appears to be almost entirely
Jewish in content. The sarcophagi combine neutral
motifs (which predominate) together with others of
a more pagan character. The Jewish dimension here is
relatively marginal, though on occasion rather striking.
The *cubicula* paintings combine all three components—
Jewish, neutral, and pagan.[63]

FIG. 72 Gold-glass representation of a
temple facade and entrance.

One might venture a suggestion that the art represented in the *cubicula* and on
the sarcophagi is more reflective of Roman influence and may indicate the tastes
of a wealthy stratum of the community that could afford more elaborate forms of
burial. Most families, however, sufficed with simpler burials in *loculi*. The distinc-
tion within the Christian community between the ecclesiastically sponsored cata-
combs and private ones is not applicable to the Jewish context. No such "umbrella"
infrastructure governed the local Jewish community of Rome (see below).

Moreover, Jewish catacomb art is strikingly different from that of the nearby
Christian catacombs, where the artistic remains constitute the primary repertoire
of pre-Constantinian Christian art. Robin M. Jensen has divided this Christian ico-
nography into four categories: (1) pagan motifs adapted to the Christian context
(the seated philosopher, Orpheus and Apollo/Helios as Jesus, the Good Shepherd,
the *orans* posture representing piety); (2) traditional images that were religiously
neutral but used here for Christian purposes (the dove, peacock, flowers, fruit,
vines and grapes, fish, olive or palm trees, cherubs [putti]); (3) biblical stories or fig-
ures (the *'Aqedah*, Jonah, Noah, Daniel, Moses); and (4) portraits of Jesus or saints

61. The number six, however, should not be considered of any special importance in
this respect. Other designs have varying numbers of scrolls; see ibid., no. 967 (nine), no.
978 (perhaps four), and no. 974 (as many as twenty, although the illustration is not entirely
clear).

62. No. 966 is also unique in that it has small objects standing to the side of the ark,
sometimes identified as scrolls.

63. The three smaller Jewish catacombs found in the nineteenth century add very little
to the artistic repertoire we have been reviewing; see Goodenough, *Jewish Symbols*, 2:33–35;
Leon, *Jews of Ancient Rome*, 65; Müller records seeing a pair of nude wingless cupids there
(*Die jüdische Katakombe am Monteverde*, 202).

(Jesus' baptism or healing the paralytic).[64] Jewish catacomb art is thus quite differ-
ent from its Christian counterpart, displaying pagan themes and figural art on rare
occasion and no biblical scenes at all. Only Jensen's second category, neutral geo-
metric and floral patterns, finds parallels in the Jewish catacombs. The cross—later
to become the Christian symbol par excellence—never appears in third-century
Christian art.

INSCRIPTIONS

The cultural-religious orientation attested in Jewish art is similar to that of the 600
inscriptions found in the catacombs.[65] Some 200 epitaphs come from the Monte-
verde catacomb, 120 from Villa Torlonia, 200 from Vigna Randanini, and 70 from
other sites. Greek appears in 74 percent of the inscriptions, Greek and Latin to-
gether in another 6 percent, Latin in 17 percent,[66] and Hebrew or Aramaic in 3
percent.[67]

This preference for Greek is typical of most foreign minorities living in Rome at
the time.[68] Greek appears in 73 percent of the inscriptions in Monteverde (includ-
ing another 4 percent appearing together with Latin), in almost 63 percent in Vigna
Randanini, and in 92 percent in the Villa Torlonia.[69] Of the few Semitic inscriptions,

64. R. M. Jensen, *Understanding Early Christian Art*, 15-20, 32-93. See also Finney,
"Art," 121-23; Snyder, *Ante-Pacem*, 13-29; Snyder, "Interaction," 78-86. See also B. Green,
Christianity in Ancient Rome, 195-99.

65. On the methodological issues in identifying inscriptions as Jewish, see Kant, "Jewish
Inscriptions," 671-713; R. S. Kraemer, "Jewish Tuna and Christian Fish," 141-62; van der
Horst, *Ancient Jewish Epitaphs*, 16-18. The figure 600 represents only a small percentage of
the total number of Jews buried in the city, as is the case regarding Christian catacombs; see
Nicolai, Bisconti, and Mazzoleni, *Christian Catacombs of Rome*, 148; and below.

66. Latin constitutes 26 percent of the inscriptions in Vigna Randanini, 18 percent in
Monteverde, but only 5 percent in Villa Torlonia.

67. Noy, *Foreigners at Rome*, 264. In another publication from the same year, Noy lists
slightly different numbers: Greek, 73 percent, and together with Latin, another 7 percent;
Latin, 17 percent; and Hebrew or Aramaic, 3 percent ("Jews in Italy," 56). See also Noy,
"Writing in Tongues"; Rutgers, *Jews in Late Ancient Rome*, 176; van der Horst, *Ancient Jewish
Epitaphs*, 22; Leon, *Jews of Ancient Rome* 75-92, and esp. 76-77; Solin, "Juden und Syrer," 701.

68. Noy, *Foreigners at Rome*, 169-78, 287; MacMullen, "Unromanized in Rome," 47-48.
On the use of Greek in all facets of life in imperial Rome, see Kajanto, "Study of the Greek
Epitaphs"; Kaimio, *Romans and the Greek Language*.

69. See Noy, "Writing in Tongues," 301. Rutgers (*Jews in Late Ancient Rome*, 177-78)
offers slightly different percentages for the use of Greek: Monteverde, 79 percent; Vigna
Randanini, 65 percent; and Villa Torlonia, 99 percent or higher. It is interesting to compare
these inscriptions to the 75 from Venosa in southern Italy, dating somewhat later than
those of Rome (fourth-fifth to sixth centuries, with one inscription dating explicitly to 521
CE). Reflecting a period of transition, we find the earliest inscriptions primarily in Greek,
followed by a shift to Latin later on. The Hebrew found throughout these catacombs is often

almost all come from Monteverde. It is not clear how, if at all, these percentages should be interpreted. Leon claims that they reflect the different cultural proclivities of those interred in the various catacombs, maintaining that those buried in Vigna Randanini were wealthier, more Romanized, and therefore used more Latin; those in the Villa Torlonia were more Hellenized; the Monteverde catacomb appears to have served a more conservative, Semitic-oriented population.[70] Rutgers, however, suggests that these inscriptions point to a more fluid and dynamic situation, with the use of Latin indicating a later development. If so, the Vigna Randanini catacomb would reflect a later stage in the history of Roman Jewish catacombs, when Latin became the language of choice for an increasing number of Jews.[71]

However, such sweeping conclusions are problematic. On the one hand, the statistics seem to indicate a far more dynamic situation than what Leon assumes, namely, that there was no significant cultural differentiation between catacombs over their two- to three-hundred-year existence. Rutgers's suggestion to fix chronological boundaries that would correspond to the use of language among Roman Jews is likewise somewhat speculative; indeed, no conclusive evidence can be adduced to support such a claim.[72]

The dominance of Greek is somewhat attenuated when examining the names in these inscriptions. Despite the overwhelming influence of a Greco-Roman onomasticon, Latin in this case has the upper hand, although once again there are some differences between the three catacombs.[73] In the Vigna Randanini catacomb we find that almost 64 percent of its names contain elements of Latin, as against 38 percent with some Greek and 11 percent with some Hebrew or Aramaic. The same applies to the other catacombs: in Monteverde, the above languages appear in the names of 55, 34, and 20 percent of the deceased, respectively, while in Villa Torlonia the percentages are 48, 45, and almost 11.[74]

limited to the word "Shalom." Together with a number of problematic, mostly illegible, epitaphs, the numbers are approximately: 38 in Greek, 32 in Hebrew (usually combined with Greek or Latin), and 23 in Latin; see Leon, "Jews of Venusia"; Noy, "Jewish Communities," 172–82; Noy, *JIWE*, 1:61–149; see also Rutgers, "Jews of Italy," 499–502.

70. Leon, *Jews of Ancient Rome*, 77–78, 240–44.

71. Rutgers, *Jews in Late Ancient Rome*, 176–81. Christians generally followed this same pattern through the third century (about half their inscriptions were in Greek), but thereafter Latin became predominant in their inscriptions, as it did in their liturgy; see Noy, "Writing in Tongues," 303.

72. Rutgers, *Jews in Late Ancient Rome*, 302–6.

73. Latin influence was felt not only in the preference for Latin names, a phenomenon of the contemporary Christian epigraphy generally, but also in the choice of certain *nomina gentilicia*, the most popular in Rome being Aurelius, Flavius, Iulius, and Aelius; Jews preferred such names as well (ibid., 161–62).

74. Leon, *Jews of Ancient Rome*, 110, followed by Rutgers, *Jews in Late Ancient Rome*, 140. The overlap of languages in some of the inscriptions accounts for the high percentages.

While the language and names used in the inscriptions seem to indicate a high degree of acculturation,[75] this is only part of the picture. Other aspects of the epigraphic material point in the opposite direction. Whereas inscriptions from several Diaspora communities, such as Sardis and Aphrodisias, highlight the involvement of members or affiliates in civic and imperial political institutions,[76] those from Rome ignore the civic dimension entirely (if it even existed) and focus solely on those linked to the synagogue, thereby accentuating Roman Jewry's insular framework.[77] Synagogue officials are noted in approximately 130 inscriptions, over 20 percent of the total.[78] Most frequently cited is the archon (in almost fifty cases), whose duties may have been primarily administrative, political, and fiscal. In addition, the archisynagogue, *pater* or *mater* (if indeed a professional title), scribe, gerousiarch, *prostates*, and several other officers are mentioned.[79] Ironically, this emphasis on internal synagogue officialdom may also be an expression of Romanization. Wittingly or not, Jews may have adopted the recognized Roman practice of using an office as an indication of status and prestige on their epitaphs.[80]

Thus, epigraphic evidence from the Jewish catacombs indicates that a strong Jewish orientation found expression alongside an equally prominent Greco-Roman one. The overwhelming presence of Greek and Latin together with Greco-Roman names is balanced by a striking Jewish institutional identification.[81]

75. On Jewish onomastic practices following those of Roman society, see Rutgers, *Jews in Late Ancient Rome*, 158–63.

76. See Ameling, *Inscriptiones Judaicae Orientis*, 2:70–123, 224–97.

77. The synagogues of Rome are mentioned in some 40 inscriptions (Noy, *JIWE*, 2:539–40; see also La Piana, "Foreign Groups," 347–61; L. I. Levine, *Ancient Synagogue*, 283–86), although the precise number of these synagogues is not clear and depends on the interpretation of several terms and the reconstruction of fragmentary references. The number 11 is cited most often, but estimates range between 10 and 16.

78. Noy, *JIWE*, 2:538–39; and in more detail, Leon, *Jews of Ancient Rome*, 167–94. See, also L. I. Levine, *Ancient Synagogue*, 412–53.

79. Margaret H. Williams, "Structure of Roman Jewry Re-Considered," 131.

80. Margaret H. Williams, "Shaping of the Identity," 45.

81. In addition, snippets of information in these inscriptions reflect concerns that are quite familiar, if not particular, to Jewish settings. One Eusebius is called "the teacher (*didaskalos*) and a student of the law (*nomo . . . mathos*)" (Noy, *JIWE*, vol. 2, no. 68); the latter designation appears in another three instances in these catacombs, while the title *nomodidaskalos* appears once. The title "priest" appears in a half dozen instances and the prominence of the title *grammateus*, noted in almost 25 cases, seems to reflect the importance of this office in Jewish communal settings. Whether this had religious or communal implications is unknown. See references to the above titles in ibid., 538. Interestingly, in the Jewish catacombs, as in the Christian ones, the number of "religious" inscriptions (containing blessings, prayers, and other devotional terms) is relatively small; see ibid., 540; Nicolai, Bisconti, and Mazzoleni, *Christian Catacombs of Rome*, 147.

The Roman Community in Light of Its Material Remains

Several interesting and perhaps unique features of Roman Jewry are reflected in the catacomb material. The first relates to the disparate locations of the Jewish catacombs and the numerous synagogues functioning in the city. It thus seems certain that Jews were scattered in different parts of Rome and organized themselves in what appear to have been autonomous synagogues. No inscription mentions a community-wide Jewish network such as that which once governed the affairs of Alexandrian Jewry or the *politeuma* of Berenice. In light of the large number of synagogues in the city, this absence is telling,[82] although it has been suggested that there is an allusion to an overseeing body in Acts 28:21, where Paul reputedly summoned "the leading men of the Jews."[83] Yet, as no central body is ever referred to elsewhere, it may well be that this was no more than a reference to leaders of various synagogues.[84]

The reality of scattered Jewish congregations, each functioning autonomously, conforms to the situation among other foreign groups in Rome. The best-attested expression of this decentralization may be found among the Christian communities in Rome, certainly in the first two centuries CE and very likely into the third as well. Christians, too, lived throughout the city, also in the marginal and poorer, primarily Greek-speaking immigrant quarters such as the Trastevere, Via Appia, and Campus Martius.[85]

Not only were Christian groups scattered throughout the city, but they also seem to have been independent entities in the first century CE.[86] Christians congregated in diverse residential settings (apartment buildings or *insulae*, or perhaps small mansions) on the outskirts of the city, called *tituli*, and had an autonomous clergy, cult, baptistery, and burial place.[87] Peter Lampe refers to this phenomenon as the "fractionation of Roman Christianity,"[88] which would have paralleled the decentraliza-

82. See Margaret H. Williams, "Structure of Roman Jewry Re-Considered"; Noy, *Foreigners at Rome*, 266.

83. The only other possible hint of such an umbrella framework appears in an inscription from the Torlonia catacombs noting an *archigerousiarch*, but the context there is unclear and the term might refer to the head of one of the local synagogues; see Noy, *JIWE*, vol. 2, no. 521 and comments.

84. Contra the argument that there was, in fact, some sort of centralized community framework in the city (La Piana, "Foreign Groups," 363–64). See also Margaret H. Williams, "Structure of the Jewish Community."

85. Lampe, *From Paul to Valentinus*, 19–66, esp. 48–66 and 138–44. See also Patterson, "On the Margins of the City of Rome," 86–97.

86. On the local context of the early church in Rome, see Pietri, *Roma Christiana*, 115–21.

87. Krautheimer, *Rome*, 16–18; Bowes, *Private Worship*, 65–71; Lampe, *From Paul to Valentinus*, 360.

88. Lampe, *From Paul to Valentinus*, 359–65, 381–96; see also La Piana ("Roman Church at the End of the Second Century"), who notes, inter alia, that in the days of the bishop

tion that also characterized the Jewish community. Only at the turn of the third century, or perhaps as late as midcentury, did a monarchical episcopate begin to assume control of various aspects of local church life,[89] a process that culminated only in the late third century and perhaps not even until the early fourth. This process and degree of centralization was a Christian phenomenon par excellence; the Jewish community appears to have retained its decentralized character throughout Late Antiquity.

A second feature of Rome's Jewish community attested by its funerary remains is the degree of intercongregational coordination regarding burial arrangements. Given that we know of three large catacombs and several considerably smaller ones serving a dozen or so congregations, some person or group must have been charged with organizing these burials, even though there is no evidence of a direct relationship between catacombs and congregations.[90] Despite the earlier-noted variations among the catacombs, there is a large measure of homogeneity in burial practices. How members of the various communities found their way to the different catacombs is an enigma, although in most cases geographical propinquity must have been a decisive factor. The question of who exactly organized these catacombs and oversaw the many details of the burial procedure, not to speak of maintaining and (when needed) expanding the facilities, has for the most part been noted only perfunctorily in scholarly literature, and then only on rare occasion.

Exceptional in this respect is Margaret H. Williams, who speculates that the Roman setting played a major role in the development of Jewish burial customs and that rival burial societies, or consortia, competed for Jewish business. This, in her opinion, would satisfactorily explain whatever differences existed between these catacombs, as well as their geographic dispersion.[91] Moreover, claiming that the Jews learned from contemporaneous local practice about the physical planning and organization of burial sites, Williams suggests that at some point there may have been commercial interests at work that were subsequently replaced by individuals or funerary societies.[92]

Such an approach to Roman burial practices in general has been developed in John P. Bodel's comprehensive and illuminating study, wherein he suggests that

Victor there were in Rome "some ten Christian bishops, or heads of independent groups and schools, all claiming to represent exclusively the true Christian tradition" (p. 250). Brent (*Hippolytus and the Roman Church*, 398–412) refers to this phenomenon of multiple and competing Roman churches as philosophical schools.

89. Lampe (*From Paul to Valentinus*, 397–408) argues for a late second-century setting in the time of Victor; Brent (*Hippolytus and the Roman Church*, 398–457) suggests a date a generation later.

90. See Margaret H. Williams, "Organisation of Jewish Burials," 165–71; Rajak, "Inscription and Context," 230–34.

91. See Margaret H. Williams, "Organisation of Jewish Burials," 179–82, esp. 181, although she mistakenly dates these burials as early as the first century BCE.

92. Ibid., 177–78.

many Roman *collegia*, perhaps created in large part by the diverse populations in Rome (slaves, immigrants, Christians), undertook the responsibility to provide adequate burial places from the first century on:

> Behind the *collegia* stand individual proprietors of funerary properties—purpose-built *columbaria* and catacombs—private patrons in some cases but also entrepreneurs and developers. Enterprising businessmen in the death trade, it seems, inspired the major developments in Roman burial architecture over the first three centuries of empire.[93]

A third and final feature of Rome's Jewish catacombs is the maintenance of a delicate balance between Jewish identity and the larger Roman context. In all that relates to these catacombs, we have noted the Roman Jewish community's proclivity to integrate the two worlds in which they lived. Rome's influence is present in the very use of catacombs (their overall plans and types of burial—*loculi, arcosolia,* hypogea, and so on), as well as sarcophagi, wall paintings, a variety of "neutral" motifs, decorated glass vessels, a number of pagan representations and designations (such as the abbreviation D.M. for the phrase *dis manibus*)[94] invoking institutional titles in epitaphs, decentralization, and community-wide burial arrangements. Yet at the same time the Jewish component—the use of the *kokh*-type burial (perhaps derived from its usage in Palestine), Jewish symbols, the centrality of the synagogue, and the association of many of those interred with this communal institution—was ubiquitous.[95]

A key component of this community's cultural and religious perspective is reflected not only in what it represented artistically but also in what it deliberately ignored. Given the emergence of a biblical and figural art in third-century Christian catacomb paintings (as well as at several Jewish sites, Dura and Khirbet Ḥamam; on the latter, see below), a trend that increased exponentially in the course of the fourth and early fifth centuries,[96] the question arises as to why the Jews of Rome did not follow suit. For example, while no biblical scenes appear on the Jewish goldglass fragments, a plethora of such motifs—the 'Aqedah, Adam and Eve, Noah, Mo-

93. Bodel, "From *Columbaria* to Catacombs," 226-35 (quote from p. 233). See also La Piana, "Foreign Groups," 271-75; van Nijf, *Civic World of Professional Associations*, 31-69.

94. This term refers to underworld divinities and/or divinized ancestors (hence the inscriptions DM [*dis manibus*] or DMS [*dis manibus sacrum*]) who were to protect the tomb. Several Christian and Jewish settings adopted it from pagan usage. For the suggestion that such references are most probably Jewish and not "syncretistic," see Goodenough, *Jewish Symbols*, 2:137-40; Rutgers, *Jews in Late Ancient Rome*, 269-72. Note also the more reserved position of Noy (*JIWE*, vol. 1, nos. 604-612) in the title of his Appendix 2—"*Dis Manibus* in Possibly Jewish Inscriptions," and comments of R. S. Kraemer ("Jewish Tuna and Christian Fish," 155-58). Finally, see Margaret H. Williams, "Image and Text in the Jewish Epitaphs."

95. Goodenough, *Jewish Symbols*, 2:26. See also Snyder, "Interaction of Jews."

96. Christian art: Snyder, *Ante-Pacem*, 45-65; Finney, *Invisible God*, 146-274; R. M. Jensen, *Understanding Early Christian Art*, 64-93. Jewish art: see below.

ses at the Burning Bush, Jonah—are used on near-contemporary Christian ones.[97] The question is even more poignant when we consider that almost all these early Christian representations were taken from the Hebrew Bible, and not the New Testament.[98] It was once assumed that early Christian art drew heavily from Jewish prototypes. However, such a claim is most unlikely, as Jewish biblical art was non-existent in the first two centuries CE. Given the realization over the past generation of the extent that Dura is best contextualized in its eastern Roman and Syrian-Mesopotamian worlds,[99] even that third-century site has become less relevant as a possible prototype or model for later Jewish and Christian artistic developments.

The absence of literary sources relating to the Roman Jewish community means we can only speculate about the reasons for this reticence. In light of the fact that the Christian catacombs were in close proximity to those of the Jews, it is most probable that the latter would have known what was being done among their Christian neighbors and would have followed suit if they so wished.[100]

As several scholars have pointed out, execution of artistic work in the Jewish catacombs could have been facilitated by the fact that Jews, pagans, and Christians often used the same workshops. This relates not only to the construction of the catacombs but also to their decoration and the production of sarcophagi.[101] Josef Engemann made the same point with regard to gold glass, remarking that while the artistic depictions themselves are different from those of the other groups, many of the technical and artistic aspects seem to have been shared.[102] The very use of gold glass, in daily life as in funerary settings, was undoubtedly expedited by having common workshops.

In this light, the only possible explanation for the Jewish aversion to figural art and biblical scenes in the catacombs is the overall conservatism of the local Jewish community. There is no question that many families could readily have afforded such decorations, especially the more modest designs, but virtually no one chose to do so. The answer thus seems to lie in the nature of this and other Diaspora communities that shied away from figural art, especially human representations. Isolated animal figures (such as fish and birds, and in the case of Sardis lions and eagles)

97. Ferrari and Morey, *Gold-Glass Collection*, 82.

98. R. M. Jensen estimates that Hebrew Bible depictions outnumber New Testament ones by about four to one (*Understanding Early Christian Art*, 68–69).

99. See chaps. 4 and 5.

100. The difference between Christians and Jews in this regard is further emphasized by the relatively sparse range of pagan motifs that were adopted by the former and their absence from the catacombs of the latter (ibid., 32–63); as noted by Finney (*Invisible God*, 230): "by contrast [to the Jewish catacombs], the Callistus Christians reflect considerably more liberal attitudes toward the Christian uses of pagan tradition in explicitly Christian contexts."

101. Rutgers, *Jews in Late Ancient Rome*, 65–88, and esp. 92–95; as well as Rutgers, *Hidden Heritage of Diaspora Judaism*, 73–95 (essentially a reprint of his article appearing in *AJA* 96 [1992]: 101–18). See also Schüler, "Note of Jewish Gold Glasses," 58.

102. Engemann, "Bemerkungen zu römischen Gläsern," 7–25.

were at times invoked, but there is nothing approximating a biblical scene. In short, excepting Dura and the figure of Daniel recently discovered in Sardis, no human figural or narrative art is known in any of the two dozen or so Diaspora synagogues and cemeteries excavated to date.[103]

Thus, when the Jews of Rome wished to express their Jewishness or articulate their *interpretatio judaica*, they did it through the display of their particular religious symbols. Inscriptions, the centrality of the synagogue, and the artistic content displayed in their catacombs formed the three pillars that gave expression to this Jewish community's unique identity.[104]

ROMAN JEWISH IDENTITY IN PERSPECTIVE

An important caveat applies to other chapters in this book, but most poignantly to this one, given the relative abundance of material evidence at our disposal. These catacombs, with their six hundred inscriptions and innumerable examples of Jewish art, are but a small percentage of what must have constituted the total number of Jewish burials in Rome during these several hundred years. We have no idea how many Jews lived in the city throughout Late Antiquity, but it was, conservatively speaking, in the tens if not hundreds of thousands. The Jewish population in first-century CE Rome has been estimated at twenty to sixty thousand,[105] and there is little reason to assume a dramatic or catastrophic decline in these numbers in the following centuries. In fact, the opposite may well hold true. One might suppose that some or many of the captives taken to Rome following the revolts of 70 and 135 were sooner or later incorporated into the local community.[106] Thus, in the course of the centuries we are addressing there were about seven to eight generations; if each comprised a minimal estimate of 20,000 persons, then something in the order of 150,000 Jews lived in the city from the third to fifth centuries.[107] However, there

103. Regarding Gerasa in Jordan and Mopsuestia in Asia Minor, see chaps. 11 and 17.

104. See Margaret H. Williams, "Shaping of the Identity," 43–46.

105. See La Piana, "Foreign Groups," 346; Solin, "Juden und Syrer," 698–701; Leon, *Jews of Ancient Rome*, 135 and n. 1; Noy, *Foreigners at Rome*, 257–58; Capelletti, *Jewish Community of Rome*, 86 n. 62.

106. Interestingly, the number of Jews and Christians in the third century may not have been all that disparate. Lampe notes that "modern guesses vary between 10,000–30,000 Roman Christians in the middle of the third century." ("Early Christians in the City of Rome," 26).

107. It is impossible to know how the Jews of Rome fared demographically after 70 CE. We do not hear of any reprisals, restrictions, or expulsions. If the ongoing influx of new immigrants to the city throughout the second and perhaps third centuries is any indication, then the Jewish population might even have grown. MacMullen, for his part, accepts the figure of 40,000–50,000 for the Jewish population at the time ("Unromanized in Rome," 54).

Of late, however, Rutgers ("Reflections," and esp. 358; see above, n. 22) has offered a drastically reduced estimate of the Jewish population in Rome. Utilizing modern demographic calculations reached on the basis of funerary remains, he concludes that there was a Jewish

are, at most, only about seven thousand identified burial places, admittedly a speculative number since the Monteverde catacomb has been erased by modern urban development.[108] We thus have evidence of about 5 percent, at most, of the Jewish population living (and dying) in Rome during these centuries.[109] In this light, we can only surmise as to the nature of the rest of the Jewish population in the city and whether its remains would have reflected the same types of burials, inscriptions, and art as those found in the existing catacombs. A somewhat similar disparity exists with regard to Roman burials in general. Bodel has recently calculated that only some 150,000 burials are known from 25 BCE to 325 CE, constituting roughly 1.5 percent of the total Roman population during these three centuries![110] Thus, we must be careful when attempting to draw conclusions on the basis of the severely limited available material, and bear in mind how provisional our conclusions should be.

Whatever the disparity between Jewish and Christian funerary remains, the discrepancy between these communities is far greater when it comes to the extant literary sources. We are far better informed about Christians in Rome from the second century on than about Jews. The names of bishops, the crystallization of a ruling bishopric, and many internal disputes within the community, not to speak of the plethora of sources for the post-Constantinian era, are a rich trove compared to the almost nonexistent literary references to or by Jews. For example, attempts have been made to identify various artistic remains from the third century by comparing the frescoes of the Callistus catacomb with the Hippolytus group and interpreting them as products of competing factions within the Roman church at the time.[111] No such comparisons or contextualizations are conceivable with respect to the Jewish community, whose archaeological remains stand alone and with nothing else at hand to help flesh them out or provide wider contexts.

Despite the above reservations, the picture that can be drawn about Roman Jewish identity is not inconsequential and certainly far greater than for any other Diaspora community in Late Antiquity. The categories often invoked with regard to these communities, such as assimilation versus acculturation or accommodation and integration versus resistance, or issues of Hellenization, orthodoxy, and deviation,[112] are only partially relevant to Roman Jewry, especially when cast in such dichoto-

population of only 600 or so individuals per generation throughout Late Antiquity, although he admits that his figures are tenuous.

108. Rutgers, "Reflections," 354 n. 49.

109. Even here we must exercise caution. In reality, much has been lost, even from the Jewish catacombs that have been identified and explored, due to haphazard exploration, the absence of reliable plans, sloppy recording, subsequent pillage, and the vicissitudes of man and nature over time.

110. Bodel, "From *Columbaria* to Catacombs," 236–42.

111. Elsner, "Inventing Christian Rome," 74. See also Brent, *Hippolytus and the Roman Church.*

112. Barclay, *Jews in the Mediterranean Diaspora,* 82–102.

mous terms.[113] Every aspect of material culture from the catacombs reflects an attempt to include the dimensions of integration and particularism. Jews adopted and adapted pagan and Christian practices and styles regnant in Roman society but, at the same time, carved out a range of particularistic practices that served to define and preserve their self-identity.

The perpetuation of communal institutions such as synagogues and cemeteries by the Jews of Rome, unlike most other immigrant groups in the city,[114] is an indication of their loyalty to and identification with their communities and their common heritage. The insular dimension of Roman Jewish life may be reflected in the relatively small numbers of proselytes (about six altogether) and perhaps another four "sympathizers" attracted to Judaism (*metuentes*) recorded in catacomb inscriptions.[115] Compared to the prominence of these two groups in Sardis and Aphrodisias, this number is indeed minuscule. Thus, adopting pagan and Christian burial patterns and other cultural practices in Rome while remaining strongly identified Jewishly is well demonstrated by virtually all aspects of catacomb culture, including its art, which—more than others—emphasizes the Jewish component.[116] Having created their own insular community, the Jewish community seems to have become quite comfortably ensconced in the Roman cosmopolis.

113. There are also some problems with the term *interaction*, used to describe Jewish practices vis-à-vis their surroundings; see Rutgers, *Jews in Late Ancient Rome*, 50–99, as well as his earlier "Archaeological Evidence." The fact that Jews had much the same material culture as their pagan and Christian neighbors, even including the use of the same workshops, is a far cry from positing a relationship of interaction between the various groups. The term *interaction* implies a dynamic give and take, mutual influences, and exchanges that result from direct and frequent contact. This, however, need not happen (although it might have) simply by the Jews' and others' use of the same styles, material, artistic forms, workshops, and even names and language. Adoption should not be equated with interaction, unless on a very superficial level. Thus, the term interaction seems to assume far more than the material culture warrants.

114. See Noy's comment regarding Egyptians in Rome ("Being an Egyptian in Rome," 54): "The inevitable conclusion is that Egyptians at Rome lacked any form of communal organization. Isis and Serapis worship could have united Alexandrians with other Egyptians, but only along with people from a variety of other backgrounds. There is no evidence of any other institution which provided a focus for Alexandrians or other Egyptians, and only the people from fifth-century Koprithis seem to have been anxious to preserve a form of local identity. As far as we can tell from the surviving evidence . . . people who came to Rome from Egypt were likely to experience fairly rapid assimilation rather than maintaining their own distinctive institutions in the way that the Jews did."

115. Noy, *JIWE*, 2:537; Leon, *Jews of Ancient Rome*, 250–56. See also La Piana, "Foreign Groups," 389–93.

116. The role of the rabbis in the life of the Jewish community at this time must remain moot. Although a number of traditions primarily from the first two centuries note that some Palestinian sages visited Rome and several others were associated with it (i.e., Todos and Mattiah b. Ḥeresh), information concerning their activities in the city is virtually nonexistent. Thus, we can only speculate as to the place and import of rabbinic traditions on this community; see Noy, "Rabbi Aqiba Comes to Rome"; Noy, *Foreigners at Rome*, 260–61.

8. THE THIRD CENTURY IN RETROSPECT

IN THE PREVIOUS chapters we have examined the diverse religious and cultural stimuli that played a major role in the creation of a new type of art among Jews in a number of locales in the third century CE. Those for which we have evidence span a broad geographical range—from Rome in the west, through Bet She'arim in Palestine, and continuing to Dura Europos on the eastern border of the Roman Empire—and boast a multifaceted content and style of artistic expression. This diversity is accounted for in large part by the different contexts in which this art was created, as each locale had its own unique configuration that determined policy, including the artistic dimension. In chapter 2 we noted the differences in artistic expression between the kingdoms of Israel and Judah, and even within each of these regions, during the Israelite era. In subsequent chapters we will examine the exuberant artistic diversity among various Jewish communities in the Byzantine-Christian period.[1]

Our study of the striking variety in third-century art and its historical implications began at the eastern end of the Roman Empire with the splendid biblical scenes and wealth of figural depictions in the Dura Europos synagogue; these remain unparalleled in any other known Jewish building in antiquity. Indeed, the sheer quantity of figural art in Dura alone, especially human representations and biblical topics, exceeds all the other excavated ancient synagogues combined. We have suggested that this phenomenon was a result of the vitality of eastern cults generally, and of those in Dura in particular. Beyond the wealth of figural depictions is the stunning content of this synagogue's art, which highlighted and illustrated biblical narratives, personages, and institutions. Jewish identity in this synagogue was thus expressed by focusing on the collective memories of Israel's early history.

At the other end of the geographical spectrum are the Jewish catacombs in Rome, where Hellenistic, biblical, and other figural representations of animals are virtually

1. This phenomenon will be discussed more fully in chap. 19.

nonexistent; instead we find a plethora of religious symbols, including the Torah ark, menorah, *lulav, ethrog,* and shofar. The extensive use of Jewish symbols in these catacombs may best be explained, as noted in the previous chapter, in terms of the community's need to establish its own boundaries and define its singular identity in the *Urbs,* surrounded as it was by flourishing pagan cults and an expanding Christian community. We have taken note of the marked insularity of the various Jewish congregations in Rome, which found expression, inter alia, in their art and institutional affiliations.

Between these geographical and artistic extremes lies the Bet She'arim necropolis, where Jewish symbols are likewise in evidence (though far less intensively than in Rome) but whose figural art, although well attested, is not equally represented in all the catacombs. Moreover, the figural art in Bet She'arim is not biblical, as in Dura, but ranges from neutral depictions of animals and human figures to very explicit pagan mythological scenes.[2] Such motifs may represent a Jewish adaptation of some of the main emphases of Second Sophistic culture that affected the Patriarchal family and upper classes, beginning in R. Judah I's generation under Severan rule.

The diversity of Jewish art around the turn of the fourth century is also evidenced in the recently excavated synagogue north of Tiberias, Khirbet Ḥamam.[3] The fragmentary remains of the mosaic floor there reveal three scenes with rich figural representations that may represent biblical events: the building of the Temple; Goliath or Samson in battle; and the crossing of the Red Sea (for a detailed description, see the appendix to this chapter). Unfortunately, we know nothing about the wider social, cultural, or religious context of this Galilean village, and thus the roots of such artistic proclivities elude us.

This creative and diversified Jewish art provides an important addition to our understanding of Jewish cultural activity in an age for which historical sources are sparse. Scholars who base their research largely, if not exclusively, on rabbinic sources (which, like most ancient literary sources, are tendentious, limited, and selective) are at a disadvantage in this regard. Their horizons are often dictated by the specific foci of these sources or by assumptions as to how the related biases should be redressed. Indeed, just as rabbinic activity in the third century flourished as

2. Mention should be made of two suggestions that identify certain shapes and lines in the Bet She'arim catacombs as perhaps representing biblical figures—Daniel (Mazar, *Bet She'arim,* 1:77–78) or Abraham (Revel-Neher, *L'Arche d'Alliance,* 91 n. 66).

3. The building is identified as a synagogue for the following reasons: (1) it is the only recognizable public structure in a village located in a heavily populated Jewish region of the Galilee; (2) its architecture is reminiscent of nearby Galilean-type synagogue buildings; its plan fits regional synagogue characteristics—an impressive façade facing south, three rows of internal columns, and benches on three sides of the main hall; (3) two fragmentary inscriptions were found, one dedicatory and the other mentioning Samuel the scribe (likely a synagogue functionary).

never before, with the creation or compilation of close to a dozen works,[4] so too did nonrabbinic expressions of Jewish culture emerge and thrive. Whatever the status of the rabbis within the Jewish body politic may have been at this juncture,[5] Jewish life in the third century was developing both religiously and culturally outside of rabbinic circles as well as within.

Jewish artistic creativity, and virtually all aspects of Jewish cultural life, cannot be fully understood or appreciated if measured solely within the parameters of Jewish society, independent of developments in the surrounding cultural settings. For example, the remains from Bet She'arim, when viewed within the context of the Severan dynasty and the Second Sophistic, afford insight into the forces at play in early third-century Palestine; these go a long way in defining the context of the Jewish cultural and artistic milieu at the time, particularly among the ruling elites and upper classes—the Patriarchate, heads of synagogues, the Palestinian urban aristocracy, as well as parts of nearby Diaspora communities. Not only are these circles ignored in varying degrees in third-century rabbinic writings, but they are rarely, if ever, addressed in any other source.[6] When such groups are indeed mentioned—for example, the Patriarchate in fourth-century Roman and Christian sources or the urban aristocracy in later archaeological finds—the results are often quite surprising, as will become apparent in subsequent chapters. Thus the openness to contemporary cultural models noted in connection with Dura and Bet She'arim continued in the fourth century and beyond, revealing a similar synchronic dimension, only now on a far more extensive scale. In short, the settings discussed above are of a different ilk than those of the sages, who feature so prominently and almost exclusively in rabbinic literature. The groups associated with the Patriarch in the third and fourth centuries were the elites that controlled and determined much of Jewish society at the time and therefore cannot be ignored.

In trying to determine who stood behind the innovations and developments at the three sites discussed above, our response can be only partial and qualified. The most certain response, of course, relates to Bet She'arim, where the Patriarchal dynasty appears to have been a determining factor, although allowing for a large degree of diversity. At Dura, the only information on who exercised control comes from several dedicatory inscriptions naming the heads of the congregation. Most prominent is one Samuel, referred to as a priest, son of Yeda'yah the archon and founder of the building, who is mentioned on several occasions.[7] The work on the synagogue was carried out when Samuel held office, and it has been suggested

4. Strack and Stemberger, *Introduction to the Talmud and Midrash*, 119–81, 269–99.

5. See L. I. Levine, *Rabbinic Class*, 23–42; Oppenheimer, *Rabbi Judah ha-Nasi*; and chap. 20.

6. L. I. Levine, *Rabbinic Class*, 167–81.

7. Kraeling, *The Synagogue*, 263, 267–68; Noy and Bloedhorn, *Inscriptiones Judaicae Orientis*, vol. 3, nos. 84–86.

that his seat may have been intentionally placed next to the Torah shrine, beneath the panel depicting Samuel the prophet anointing David as the next king of Israel. Clearly this synagogue official was a member of a local family of priestly extraction whose leadership role in the congregation was in all likelihood pivotal.

In Rome, however, no such prominence was accorded any of those interred there; the catacombs contain burials representing an amalgam of congregations, each with its own leadership and about which we have only snippets of information.

Some interesting art-related developments among Jews as well as between Jews and Christians at this time are noteworthy. For example, the first use of Jewish artifacts as symbols (and not merely representational depictions) took place more or less simultaneously at two very distant locales, Rome and Bet She'arim. At both sites we witness the widespread use of the menorah and, to a lesser extent, the shofar, *lulav, ethrog,* and Torah shrine.[8] Was this a mere coincidence, or did one site influence the other? If the latter, which preceded and why did this artistic development originate precisely where and when it did? Yet, given the paucity of sources, it is impossible to offer a definitive answer to such queries.

On the basis of the evidence at hand, it would seem that an art incorporating components of symbolism, figural expression, and biblical motifs (or some combination thereof) in varying degrees was a product of the contemporaneous Jewish and Christian communities in Dura and Rome, which in turn were stimulated by the larger religious contexts at each site.[9] Although there were significant differences between these communities, as, for example, a stronger emphasis on ethnic particularistic elements on the part of Jews as against individual/universal themes among the Christians, both found occasion to make extensive use of figural, symbolic, and mythological images, with variations from place to place and even within a specific burial setting.[10] It is quite possible that there may have been some interaction between Jewish and Christian communities on the local level, although its extent and nature are difficult to determine. The art from Dura and Rome suggests that their ways had parted by the third century, though perhaps not fully.

Finally, the *consensus universorum* stated at the outset of this section,[11] namely, that Christianity played a crucial role in the appearance of a new type of Jewish art in Late Antiquity, requires some refinement. Today, it is clear that the Byzantine era was not the first to generate this type of art, but that its beginnings can be traced back to the Late Roman Empire of the third century.

8. The possible existence of a common Judaism that may have played a role in these simultaneous appearances is discussed in chap. 4. For a later period, see chap. 19.

9. On the emergence of Christian art at the turn of the third century, see Murphy, *Rebirth and Afterlife,* 1–36; Finney, *Invisible God,* 8–31; Elsner, "Archaeologies and Agendas."

10. Grabar, *Christian Iconography,* 7–30, and esp. 27–30; Mathews, *Clash of Gods,* 3–10.

11. See chap. 4.

Nevertheless, Byzantine Christianity did play a pivotal role in the development of Jewish art, both geographically and thematically, as reflected in its substantially expanded inventory of artistic finds. Thus, the most flourishing era for Jewish visual expression in antiquity was the Byzantine-Christian orbit, and it is to this realm, with its rich remains and challenging context, that we now turn.

APPENDIX

The Khirbet Ḥamam Synagogue Mosaics[12]
Uzi Leibner and Shulamit Miller

Five seasons of excavation (2007–11) have been carried out thus far at Khirbet Ḥamam, located in the Lower Galilee. The interior layout of the prayer hall is typical of Galilean-type synagogues, but with some differences. It is generally rectangular, measuring 15.4 by 12.8 meters, and its southern wall is some 60 centimeters longer than the northern one, giving it a slightly trapezoidal shape. Three rows of columns divided the hall into a wide nave surrounded by three narrower aisles. Two rows of benches lined the interior of the hall along the western, northern, and eastern walls. The building faces south, toward Jerusalem, with a pronounced deviation eastward. The main entrance was apparently in the center of the southern wall.

The floor of the synagogue is decorated with a magnificent mosaic, one of the few known to date from Galilean-type synagogues. It was severely damaged in antiquity, and large portions of its northern and western aisles were replaced by a simple plaster floor. Some thirty fragments of the mosaic pavement have survived, including the remains of four Aramaic inscriptions, sections of geometric and floral decorations, and figurative scenes. The latest finds beneath the foundation of the mosaic floor are fragments of vessels commonly found in Galilean assemblages from about the mid-third century on. In contrast, no vessel fragments of types common in Galilean assemblages from about the mid-fourth century on were found in the soundings conducted beneath the floor. Thus the phase containing the mosaic floor can be dated to the late third or early fourth century, making it the earliest synagogue mosaic depicting figures known to date. The synagogue was built chiefly of basalt, but many architectural elements made of limestone were incorporated into it in secondary use. These apparently came from an even earlier synagogue that stood at the very same site.

Based on the preserved remains of four panels containing figurative scenes and many other fragments of frames and borderlines, it would seem that the original mosaic in the aisles contained a chain of ten or twelve panels depicting such scenes. To the best of our knowledge, this mosaic layout is unparalleled in any other known ancient synagogue. We will focus below on three figurative scenes with remains sufficient for interpretation—one in the eastern aisle depicting craftsmen at work and two in the western aisle, one depicting a battle and the other a maritime scene. All three scenes were badly damaged, and their reconstruction is thus difficult.

12. For a full description and analysis of this mosaic floor, see Leibner, "Excavations at Khirbet Wadi Hamam" (including Leibner and S. Miller, "Appendix: A Figural Mosaic").

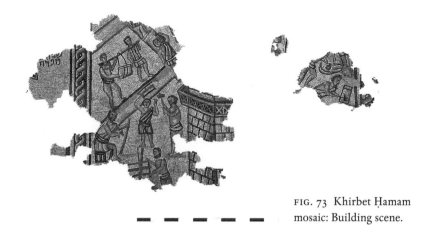

FIG. 73 Khirbet Ḥamam
mosaic: Building scene.

The Mosaic in the Eastern Aisle

Remains of two panels survived in the northern part of this aisle—the northern panel contains an inscription,[13] and three preserved fragments in the southern one depict builders and craftsmen. The focal point of the 194-by-130-centimeter section of the southern panel is a partially preserved scene depicting a large polygonal stone structure with an encompassing wooden parapet surrounded by craftsmen engaged in various trades (fig. 73).

The structure appears to be freestanding, unaccompanied by any other structures, and therefore is not part of the commonly portrayed cityscapes.[14] Seven of the thirteen craftsmen are preserved almost in their entirety, four are somewhat damaged, and two are almost completely destroyed. The workers represent carpenters, porters, builders mixing mortar, and a stonemason. Not enough is preserved of the remaining figures to identify their exact tasks. The craftsmen are barefoot and wear either a tunic (*tunica*) or loincloth (*subligar*).

While this scene represents a narrative, what remains does not facilitate a clear identification. Synagogue art usually exhibits religious symbols or biblical narratives; it is therefore unlikely that we are looking at a prosaic illustration of craftsmen in everyday life. For the same reason it does not seem plausible that the scene depicts a local event, such as the villagers building a fortification or even the synagogue itself. A "major" contemporaneous historical event or any postbiblical one does not seem to be the subject either, since the themes and narratives of Jewish figurative art in this period are largely biblical.[15]

13. The inscription is composed of black tesserae on a white background and reads: שמו[א]ל ספרה (Samuel the Scribe). The wording seems to indicate the end of a dedicatory inscription.

14. Architectural facades and city walls were a common motif in Roman and Byzantine mosaics; see Piccirillo, *Mosaics of Jordan*, 34. Among the best-known examples in the region are the Madaba map mosaic (ibid., 81–95) and the border of the nave mosaic in the church of St. Stephen at Umm al-Rasas (ibid., 238–39).

15. See chaps. 11, 16, and 17.

FIG. 74 Khirbet Ḥamam mosaic: Battle scene with giant.

Thus, our synagogue mosaic most likely portrays a biblical episode. The main accounts of building in biblical literature are Noah's Ark, the Tower of Babel, the Tabernacle, and Solomon's Temple. All these stories are illustrated primarily in Christian works, and some are fairly close in time to our mosaic. Another possible biblical account to consider is that of the Israelites' oppression in Egypt in the book of Exodus. This, however, would seem to be a strange choice for decorating a synagogue, and nothing in our scene alludes to the craftsmen being oppressed. The Temple and its memory are focal points in Jewish tradition, and therefore the construction of the Temple may indeed be the subject of our scene. Even though ancient synagogue art frequently features elements of the Temple and its cult, no depiction of the building of the Temple is known anywhere else. Thus, for the present at least, there is no conclusive identification of this scene.

The Mosaics in the Western Aisle

The Battle Scene

Several large fragments of the mosaic have been preserved in the western aisle of the synagogue.[16] Faded remains of what appears to be a large figure are visible in the western margin of the third panel from the south. The figure, wearing a red-belted tunic decorated around the collar and a multicolored cloak or sash, seems to be lying on the ground with his right arm raised. The scanty remains do not permit further interpretation. The discussion here will focus, therefore, on the two southernmost panels in the western aisle whose remains are sufficient for interpretation.

The second panel from the south (fig. 74) contains eight figures, one considerably larger than the others. The larger figure is badly damaged, with only his left arm and body preserved from the hips down. The remaining figures are warriors dressed in like attire and holding the same types of weapons. Two figures with blood spurting

16. A partial dedicatory inscription is preserved in the northeastern corner of the panel and reads: ברה דשימעונא אבדו הדה טבלה מנדידון ("The sons of Simon made [i.e., donated] this panel from their own [i.e., own means]").

from their heads lie dead between the legs of the larger figure, who holds the other three by their hair while blood likewise spurts from their heads; yet another figure flees the scene on horseback, glancing back at the carnage he's left behind.[17]

The clothes worn by the figures in this panel are typical garments of the third and fourth centuries (tunics decorated in a variety of patterns and colors), as were the *calcei*, or shoe-boots, worn by both civilians and soldiers.[18] The weapons depicted throughout the panel—swords, shields, and shafted weapons—lend a warlike character to the scene, as does a group of weapons at the bottom of the panel that are not associated with any particular figure.

This panel clearly presents a narrative; the supernatural aura of the scene strengthens the notion that it is a biblical story. Giants are mentioned briefly in the Pentateuch, and one account describes a battle in which the Israelites defeated Og, the giant king of the Bashan (Num. 21:33–35; Deut. 3:11). The giant in our scene, however, is clearly winning the battle, and nothing in the Og account alludes to such an outcome.

A more plausible interpretation is, of course, the famous biblical story of David's battle with the giant Goliath, popular in Jewish tradition and frequently depicted in both Jewish and Christian art. For example, the depiction of a warrior encompassed by gigantic combat arms in the synagogue mosaic at Merot has often been interpreted as David surrounded by Goliath's weapons.[19]

However, there are two main difficulties with this interpretation. First, the biblical account emphasizes that the battle was a duel, and second, the mosaic clearly shows the giant victorious. It is possible that the depiction reflects a local tradition or an unknown midrash, or that a continuation of the story appeared in an additional scene in this or another panel. Admittedly, however, we have no data to support these hypotheses.

Based on parallels, however, the most plausible interpretation of this scene is that it represents the story of Samson smiting the Philistines with the jawbone of an ass (Judg. 15:15–17). Although Samson in the Bible is not described explicitly as a giant, some rabbinic traditions present him as such (e.g., Leviticus Rabbah 8, 2, p. 168; B Sotah 10a). In Christian art as well, Samson is frequently depicted as a giant. The earliest known illustration of this story is a late fourth-century wall painting in one of the catacombs on the Via Latina in Rome,[20] where Samson, raising the jawbone in his right hand, is standing near a large building and at his feet lie the

17. The depiction of blood streaming from a lethal wound is common in hunting and amphitheater scenes, as in second-century mosaics from North Africa (Blanchard-Lemée and Mermet, *Mosaics of Roman Africa*, 201, figs. 149–50, 163b). Bleeding from a head wound is a specific type of injury that rarely appears, but may be found in the scene of Samson smiting the Philistines in a wall painting in the Via Latina catacombs (see below).

18. N. Goldman, "Roman Footwear," 116–22, figs. 6.1, 6.21, 6.22, 6.23.

19. Z. Ilan, "Synagogue—General Description," 55.

20. H. L. Kessler, "Christian Realm," 472–73.

FIG. 75 Khirbet Ḥamam mosaic: Egyptians fleeing the Sea of Reeds.

bodies of slaughtered Philistines. Most interesting, and reminiscent of our mosaic, is the depiction of a Philistine in flight whose blood is spurting from his head. The resemblance of our mosaic to some Middle Byzantine illuminated manuscripts is even more remarkable and suggests a common iconographic source.[21]

The Maritime Scene

A large fragment of the mosaic was found in the southern part of the synagogue, beneath a stone *bima* that was added in the late fourth century, directly on top of the mosaic without any sort of foundation. Most of this fragment (fig. 75) is located in the nave and contains geometric and floral patterns. The western part of the fragment includes a long narrow strip that belonged to the southernmost panel in the western aisle. The strip measures 210 by 60 centimeters and comprises the eastern (bottom) part of the panel. The western part was damaged in antiquity and replaced by a plain white plaster floor. The borders of the panel are preserved on the southern and eastern sides.

A chariot pulled by three horses (*triga*) fills the center of the preserved segment, and a shaded curved gray line appearing in front of them likely symbolizes a wave. The horses, harnessed side by side, are depicted in different colors to distinguish one from the other. The chariot, viewed from the side, looks like a platform with a low railing to which the horses are hitched by a triangular shaft. Two wheels are depicted deformed and detached from their axles; the chariot itself is tilted at an angle, as if it is about to flip over. The charioteer is preserved from the waist down, standing in the front of the chariot in a knee-length tunic. He holds the reins in his left hand and what seems to be a whip in his right. Part of a leg and the edge of an additional tunic are all that remain of a figure standing behind the charioteer. Behind the chariot is an armed soldier preserved from the chest down lying supine with outstretched legs. A huge fish with very detailed fins, scales, gills, and open mouth is swimming above the body of the soldier.

21. Compare the ninth-century copy of the *Homilies of Gregory of Nazianzus*, MS Paris gr. 510 (Der Nersessian, "Illustrations of the Homilies of Gregory," fig. 14), and the ninth-century *Sacra Parallela* (Weitzmann, *Miniatures of the Sacra Parallela*, fig. 96), as well as some twelfth- to thirteenth-century Octateuchs (Weitzmann and Bernabò, *Byzantine Octateuchs*, fig. 1514–16).

A city is portrayed in the far left corner of the panel. The main features preserved are a wall with a round tower and the facade of a monumental building with an Attic entrance, a sloping red-tiled roof, and a colonnade. Structures with a monumental facade and a gabled roof often indicate sanctuaries, similar to the churches appearing on the Madaba map.[22] The addition of a colonnade on the exterior is often an indication of a temple—as in the contemporaneous peripteral temples.

Although this panel is badly damaged, the narrative presented here is the easiest one to identify—Pharaoh's army drowning in the Red Sea (Exodus 14–15). The horses and chariot carried on the waves clearly recall the biblical narrative: "When Pharaoh's horses, chariots, and horsemen went into the sea, the Lord brought the waters of the sea back over them" (15:19). The wheels of the chariot, twisted and detached from its axles, illustrate the verse: "And He took off their chariot wheels, and made them drive heavily" (14:25). Most interesting is the city on the left side of the panel. The horses leading the chariot are heading toward the city located on the shore in the distance. Before the crossing of the sea, the Lord commanded Moses: "encamp . . . before Ba'al-Zephon, over against it shall you encamp by the sea" (14:2). Thus, this may be an attempt by the artist to depict Ba'al-Zephon on the opposite shore. Since Baal is the name of a Canaanite deity, the monumental gabled building may signify that it is the temple to this deity. Indeed, rabbinic homiletic interpretations mention that Ba'al-Zephon was a place of worship to Baal. According to these sources, a location opposite Ba'al-Zephon was chosen to lure the Egyptians to this site (Pesiqta Zutreta 14, 2, p. 82).[23]

Taken as a whole, the fragmentary state of the Ḥamam mosaic makes it impossible to conclude which biblical narratives or books are represented and whether a thematic thread runs through the different scenes. The identification of two adjacent scenes—Pharaoh's army in the Red Sea (Exodus) and Samson and the Philistines (Judges)—seems plausible; their common denominator is the theme of salvation. The identification of the construction scene as the Israelites in Egypt (or Noah's Ark) fits this theme as well. However, the more plausible interpretation, that it represents Solomon's Temple or the walls of Jerusalem, does not conform to this theme.

The meticulous layout of the Ḥamam mosaic—a series of panels depicting biblical scenes set around the aisles—is hitherto unattested in ancient synagogues. The basic decorative concept, however, resembles that of the third-century Dura Europos synagogue and may have also existed in another Galilean synagogue. Thus, the Ḥamam mosaic provides yet another window into an iconographic tradition that existed in Jewish art of the Late Roman period.

22. Avi-Yonah, *Madaba Mosaic Map*, 23.

23. This is probably based on earlier *midrashim*; cf. Mekhilta of R. Ishmael, Beshalaḥ, 1, p. 84; Mekhilta of R. Simeon b. Yoḥai 12, 29; 14, 2; 14, 9, pp. 28, 48, 53, respectively; Targum Pseudo-Jonathan, Exod. 14:2).

III

LATE ANTIQUITY IN JEWISH HISTORY
A Significantly Altered
Historical Perspective

9. THE BYZANTINE PERIOD
Old, New, and Recent Views

REASSESSING JEWISH SOCIETY IN LATE ANTIQUITY:
 POLITICAL, LEGAL, AND DEMOGRAPHIC DIMENSIONS
The flourishing of Jewish art in the Byzantine-Christian era in hitherto unprecedented dimensions was not fortuitous, but was facilitated by newly crystallizing political, economic, cultural, and religious circumstances. Moreover, both diachronic and synchronic considerations are crucial for understanding the specific timing, intensity, and scope of this phenomenon. What transpired in this era reflected the continuation of a process that had already surfaced in the third century, as discussed above, but also resulted from the stimulation and challenges posed by a newly evolving Christian society. Given the importance of this most unusual historical framework, the next two chapters will be devoted to mapping out the larger social and cultural contexts behind this development. We will then turn to the four major sites exhibiting this artistic ebullience and, finally, focus on specific issues concerning Late Antique Jewish art.

In this chapter we will examine three stages of modern scholarship concerning this period: the older, traditional perspective that prevailed until the mid-twentieth century; the new perspective, which has largely replaced it over the last few generations; and finally, several recent developments that suggest a need to rethink several aspects of the new consensus.

OLD PERSPECTIVES
The triumph of Christianity, trumpeted with regularity by church leaders and ancient historians, was assumed to have commenced already in Constantine's day. Churches were being built throughout the length and breadth of the empire, and judging by the ever-growing lists of attendees at the various church councils, the number of bishops and episcopal seats expanded as well. As a result, it was generally maintained that the Jews in the Byzantine period regularly encountered a wall of Christian hostility and that these centuries foreshadowed the persecutions and

tribulations that were to dominate much of Jewish life in the Middle Ages. What sort of evidence supports this long-held claim?

First and foremost, imperial legislation adopted a fairly consistent anti-Jewish posture. Although a number of edicts from the fourth and fifth centuries validate the status of Judaism and are supportive of Jewish institutions such as the Patriarchate, the synagogue, and Sabbath sanctity, the majority diminished and undermined the status of Jews by limiting their political, economic, social, and religious rights.[1] This diminished status is well reflected in the shift in terminology used during these centuries. At first the term *religio,* denoting a system of beliefs and practices, was used when referring to Judaism, but by the fifth century it was replaced with *superstitio* or *secta,* pejorative terms for something deemed hostile or base.[2]

In addition to imperial initiatives, contemporary ecclesiastical decisions likewise reflect sustained efforts to distance the Jews socially and religiously from their Christian neighbors. Beginning in the early fourth century, when Christian authorities were first allowed to meet and legislate on church affairs, these councils addressed a range of issues relating to Jews; in the East, such convocations took place primarily in the fourth and early fifth centuries.[3] The subsequent diminution of church council activity concerning Jews is probably due to the church's preoccupation in the fifth century and thereafter with a series of divisive theological controversies as well as to the fact that anti-Jewish legislation was now being issued and implemented by the imperial authorities.[4]

In addition, the cumulative effect of the Adversus Judaeos literature featuring a steady stream of polemical attacks by church fathers was to foment—at least among many of the church elite—a deep hostility and an unbridgeable chasm between Christian and Jew.[5] As a result, church leaders often gave vent publicly to extremely

1. These laws can be found in Linder, *Jews in Roman Imperial Legislation*; Linder, "Legal Status of the Jews," 144–73.

2. Linder, *Jews in Roman Imperial Legislation*, 55–58; Linder, "Legal Status of the Jews," 148–50. Other pejorative terms for Judaism that had been in use include: "pollution," "perversity," "contagion," a "nefarious" or "feral" sect, a "villainy," and a "turpitude." On attacks against pagans at this time, likewise invoking the terms *religio* and *superstitio,* see Kahlos, *Debate and Dialogue*, 93–112.

3. For a summary of the relevant church councils throughout the Byzantine period, see Noethlichs, *Die Juden*, 161–72; Linder, *Jews in the Legal Sources*, nos. 1, 63, 66. On fourth-century and later councils, see Rabello, *Giustiniano, ebrei e samaritani*, 2:495–599; Boddens Hosang, *Establishing Boundaries*, 23–165.

4. Nevertheless, church councils continued to impose their legislation on Jews in Merovingian France and Visigothic Spain; see Linder, *Jews in the Legal Sources*, nos. 810–34, 839–62; see Parkes, *Conflict*, 307–70.

5. See Juster, *Les juifs dans l'empire romain*, 1:43–76; A. L. Williams, *Adversus Judaeos*, 93–113; Parkes, *Conflict*, passim; Lieu, "Forging of Christian Identity"; Lieu, "History and Theology"; Lieu, *Image and Reality*, passim; Michael, "Antisemitism and the Church Fathers"; Fredriksen and Irshai, "Christian Anti-Judaism."

hostile comments. One of the most venomous series of tirades against the Jews and their synagogues was leveled by John Chrysostom of Antioch, who likened the synagogue to theaters, houses of prostitution, and idolatrous temples, where debauchery and drunkenness reigned (*Adv. Iud.* 1.3-4). Referring to the synagogue as a "hideout for thieves," a "den of wild animals," and a "dwelling place of demons" (*Adv. Iud.* 1.3-4.7), he concluded that the Jews were the embodiment of evil and "suited only for slaughter."[6] Soon after, Proclus, archbishop of Constantinople, reputedly declared: "Let therefore the pagans be killed! Let the Jews be destroyed! Let the Samaritans be ashamed! Let the Manicheans be dispersed! Let heretics be destroyed, and all enemies of the immaculate, catholic and apostolic church!"[7]

If the message of discrimination, exclusion, and delegitimization emanating from church and imperial circles was not enough, hostility and humiliation were at times brought home by recurring Christian violence against the Jews and their public space—the synagogue. From the fourth to sixth centuries, not a few of these Jewish communal buildings throughout the empire were either destroyed, converted into churches, or both.[8] Such attacks are documented in Rome (ca. 385), Callinicum (388), Tipasa (Mauretania), Dertona (Spain),[9] Antioch[10] (late fourth century),[11] Alexandria (414), Minorca (418), Apamea, Edessa, and Stobi (first part of the fifth century), as well as Daphne (ca. 490) and Gerasa (ca. 531). In the sixth century, additional synagogues were either destroyed or converted into churches—Tours and Clermont in France, Elche in Spain, Borion in North Africa, Saranda in Albania, Amida in northern Mesopotamia, and seven Asian synagogues.[12] Finally, in the seventh century, the synagogue in Palermo, Sicily, met a similar fate. In several cases (Terracina in Sicily as well as Sardinia), Pope Gregory ordered the local bishops to restore these buildings to the Jews. In Palestine, although the Samaritans were embroiled in a series of revolts against the empire in the fifth and sixth centuries,[13] the only report of such violence against Jews appears in a Syriac source noting a

6. Michael, "Antisemitism and the Church Fathers," 113-15.

7. *Homily* 15, as quoted in Barkhuizen, "Proclus of Constantinople," 193. For Chrysostom's well-known diatribes against the Jews, see below.

8. Parkes, *Conflict*, s.v. "Synagogues"; Simon, *Verus Israel*, 224-28; Bradbury, *Severus of Minorca*, 53; and, most recently, Rutgers, *Making Myths*, 79-115. See also Drake, "Lambs into Lions."

9. Niquet guardedly suggests that this incident happened in the early fourth century, around the time of the Council of Elvira ("Jews in the Iberian Peninsula," 167).

10. Rutgers, *Making Myths*, 19-48.

11. The widespread destruction of synagogues in the late fourth century, particularly in the East and in Illyricum, is reflected in the laws issued at that time for their protection (Linder, *Jews in Roman Imperial Legislation*, nos. 21 and 25).

12. Regarding the Asian synagogues, John of Ephesus claimed credit for this; see his *Lives of the Eastern Saints* (Brooks, 2/4:681).

13. On the Samaritan revolts, see Avi-Yonah, *Jews of Palestine*, 241-43; Crown, "Byzantine and Moslem Period"; Mor, *From Samaria to Shechem*, 208-34; Di Segni, "Samaritan Revolts."

destructive foray on synagogues (in Rabbat Moab, for instance) and pagan temples by the monk Barsauma and forty followers circa 420 CE.[14]

The precariousness of Jewish life under Christendom in the fifth century is nowhere more poignantly demonstrated than in the fate of the Jewish community of Magona in Minorca,[15] which presumably lived in relative peace and harmony with its Christian neighbors. The head of the community, one Theodorus, was a recognized leader of the town who functioned as a *defensor civitatis*,[16] enjoying exemptions from all curial obligations and also serving as the Jewish community's acknowledged patron. This same Theodorus bore the title *legis doctor,* apparently referring to someone knowledgeable in Torah.[17] However, as circumstances would have it, the combination of a zealous bishop named Severus, the religious enthusiasm generated by bringing Saint Stephen's bones to the island, and the lapse of imperial authority after 410 undermined whatever goodwill had previously existed, turning the local Christian community into a fanatical mob bent on violence and destruction. As a result, the local synagogue was burned to the ground and its holy books and other objects of value seized; soon thereafter the synagogue was replaced by a church while the local Jewish community, numbering some 540, was forced to convert to Christianity.

The pinnacle of this aggressive policy against Jews and Judaism found expression under Justinian (527-65 CE), who imposed a hostile and intrusive policy on Jews and other groups.[18] About half of the more than fifty laws in the earlier Theodosian

On the legal status of the Samaritans at the time of Justinian, see Rabello, *Jews in the Roman Empire*, chap. 11.

14. Nau, "Résumé de monographies syriaques"; Nau, "Deux épisodes," 184-99. The subject of violence in Late Antiquity has long been controversial. For a recent statement of its extent and impact, see Gaddis, *There is No Crime for Those Who Have Christ*. For a series of studies arguing that the violence associated with Late Antiquity has generally been exaggerated, see Drake (ed.), *Violence in Late Antiquity*, passim, and esp. the contributions of Drake ("Introduction") and M. Zimmermann ("Conclusion") therein.

15. For a similar assessment regarding the Jewish communities in Spain at the time, see Niquet, "Jews in the Iberian Peninsula," 175-78.

16. This office (lit., "protector of the city") was originally created to protect the people in general from abuse by municipal and imperial authorities. By the fifth century, however, its powers had greatly expanded to include civil and criminal jurisdiction, police activities, administrative responsibilities (in the absence of a local governor), and dealing with all sorts of heresies. Theodorus thus held a very prestigious and powerful position in his city. On what may have been a similar function fulfilled by several Jews in Venosa, that of "patron of the city" (πάτρων τῆς πόλεως), see Noy, *JIWE*, 1, nos. 114, 115.

17. Bradbury, *Severus of Minorca*, 6.2 (p. 85); Bradbury, "Jews of Spain, c. 235-638," 510-11; Hunt, "St. Stephen in Minorca," 109, 118-20; Millar, "Jews of the Graeco-Roman Diaspora," 119; S. Schwartz, *Imperialism and Jewish Society*, 196-99. For a recent study on the role of women in this constructed narrative, see R. S. Kraemer, "Jewish Women's Resistance to Christianity."

18. Rabello, *Giustiniano, ebrei e samaritani*, passim; Parkes, *Conflict*, 245-55. Regarding the inimical attitude and legislation toward "Hellenes" (including arrest), the banning of

Code dealing with privileges and benefits accorded the Jews were disregarded,[19] and of the twenty-five or so laws Justinian appropriated from this code, seven are cited unchanged while others were either altered (in terms of language or content) or reworked (always negatively) by his editors.[20] Only rarely do they accord the Jews recognition or consideration.[21]

The ultimate and sweeping degradation was a law from 527 that equated the political and social status of a person with his religious affiliation,[22] and one law from 534 that imposed a severe infringement on the Jews' right to adjudicate their own religious matters, thereby obliging Jews to appear in Roman courts for all civil and religious adjudication.[23] The authorities recognized arbitration within a Jewish setting, but only with respect to civil matters. This new requirement constituted a radical change in government policy when compared to a similar law issued by Arcadius and Honorius in 398, which explicitly left religious affairs in the hands of Jewish authorities.[24] By taking such jurisdiction out of Jewish hands, Justinian further infringed on the right of Jews to manage their own religious affairs.

Justinian's most egregious order encroaching on Jewish religious affairs, however, was his Novella 146, wherein for the first time an emperor directly interfered

the study of philosophy and law that led to the closure of the Academy of Athens, and the burning of books suspected of pagan proclivities, see Lemerle (*Byzantine Humanism*, 73–79). On attacks against the Montanists resulting in the burning of their churches and perhaps the destruction of their religious center in Pepuza, see Procopius, *Secret History* 11.23; and generally, Tabbernee, *Montanist Inscriptions and Testimonia*, 27–47, 474–76; Mitchell, "An Apostle to Ankara." See also Cameron, *Procopius*, 121–23. On Justinian's failed attempts to bring harmony to intra-church disputes, see Maas, *Exegesis and Empire*, 47–53; P. T. R. Gray, "Legacy of Chalcedon"; van Rompay, "Society and Community."

19. For a discussion of this phenomenon, see Juster, *Les juifs dans l'empire romain*, 1:424–56 see Rabello, *Jews in the Roman Empire*, chap. 12, 153–58; chap. 13, 51–66.

20. Rabello, *Jews in the Roman Empire*, chap. 13, 51–66.

21. Linder, *Jews in Roman Imperial Legislation*, nos. 57, 63. Justinian placed the following restrictions on the Jews: banning Jewish ownership of Christian slaves; restricting their right to acquire certain properties; limiting cases in which their testimony was valid; prohibiting their holding a municipal or imperial office (ibid., nos. 56, 57, 59, 60, 61, 62, 64, 65). Justinian also ordered that synagogues in North Africa that he had just conquered be confiscated (as he did regarding the Monophysitic churches in Alexandria) and converted into churches (Linder, *Jews in Roman Imperial Legislation*, no. 62). It is also reported that he compelled the Jews of Borion (Cyrene) to be baptized (Procopius, *Buildings* 6.2. See also Juster, *Les juifs dans l'empire romain*, 1:251 and notes; Cameron, *Procopius*, 124), and he reissued the prohibition against erecting new buildings or repairing old ones (Linder, *Jews in Roman Imperial Legislation*, no. 65).

22. Linder, *Jews in Roman Imperial Legislation*, no. 56 (Codex Justinianus 1.5.12).

23. The same applied, of course, to criminal cases; see ibid., no. 28 (*Codex Justinianus* 1.9.8). See also ibid., 204–7; and Rabello, "Civic Jewish Jurisdiction."

24. Linder, *Jews in Roman Imperial Legislation*, 108. The law of 398 followed a precedent legislated in 392 (ibid., no. 20).

with the conduct of Jewish worship.[25] Justinian took advantage of an internal Jewish squabble over which language should be used for synagogue scriptural readings, Hebrew or Greek (with some accommodation for Latin or other languages familiar to a given community). Justinian clearly preferred using the Septuagint translation and, as second best, that of Aquila,[26] and he went beyond that by forbidding any explanation or teaching (*deuterosis*) that might accompany the readings.[27]

The motivation behind Novella 146 has received much scholarly attention. Was the emperor simply adjudicating a local Jewish controversy, seeking only an ami-

25. Ibid., no. 66. On Justinian's efforts at the same time to establish "Orthodoxy" as normative throughout the Christian world, see Allen, "Definition and Enforcement of Orthodoxy," 822–28.

26. If those advocating Hebrew had indeed taken the initiative, was this an instance of some sort of Hebrew renaissance in the sixth century, as has sometimes been claimed? In that case, if those supporting the use of Greek had submitted the petition, they might have wished to preserve the status quo. For a range of opinions on the degree of Hebraization in the sixth–seventh centuries, see, e.g., Linder, *Jews in Roman Imperial Legislation,* 403–4; Simonsohn, "Hebrew Revival," 838–40; de Lange, "Hebrew Language in the European Diaspora," 134; S. Schwartz, "Rabbinization," 67. On the use of Hebrew in Italy in Late Antiquity, see Margaret H. Williams, "Jews of Early Byzantine Venusia," 50–52.

27. On this document, see Colorni, *L'uso del Greco*; Rabello, *Giustiniano, ebrei e samaritani,* 2:814–28; Linder, *Jews in Roman Imperial Legislation,* 402–11. Various interpretations of the term *deuterosis* include the following: (1) The term refers to *the Mishnah,* a Hebrew term with an identical meaning referring to the foundational halakhic text edited by R. Judah I at the beginning of the third century CE (Linder, *Jews in Roman Imperial Legislation,* 409; A. I. Baumgarten, "Justinian and the Jews"). However, the assumption that Justinian or anyone else in sixth-century Constantinople knew about the Mishnah and its contents, and thus banned it, is gratuitous. The prominence of the Mishnah outside of rabbinic circles, much less among most Christians, in Late Antiquity is virtually unattested. Moreover, it is difficult to fathom why the Mishnah would have been read in the synagogue in conjunction with the recitation of the Bible. Indeed, it has very little to do with the biblical text; the Mishnah is a halakhic composition that stands on its own, in contradistinction to midrash, which is directly linked to the Bible; (2) *deuterosis* does not refer specifically to the Mishnah but rather to the entire oral tradition of rabbinic culture, including the various midrashic texts, talmuds, *targumim,* and other rabbinic compilations (Juster, *Les juifs dans l'empire romain,* 1:374 n. 1; Grayzel, "Jews and Roman Law," 103; Avi-Yonah, *Jews of Palestine,* 250). This suggestion may make more sense than the former but, once again, assumes the dominance of rabbinic culture throughout the empire at this time, which is most questionable, as is the interpretation of this term as a catch-all phrase for all the corpora of rabbinic tradition; (3) The term *deuterosis* also appears in patristic literature and the *Didascalia,* and there it apparently refers to any post-biblical Jewish tradition, rabbinic or non-rabbinic; besides "second legislation" or "second teaching," the word might have had other meanings as well (Loehr, "Concept of *Deuterosis*"; see also Millar, "Jews of the Graeco-Roman Diaspora," 114–15; Fonrobert, "Jewish Christians," 244–45; Stemberger, "Die Verbindung von Juden mit Häretiker," 210; and chap. 20, n. 102). The probability that Justinian or his legal advisors would have picked up the term from Christian rather than rabbinic sources seems far more likely.

cable accommodation and peaceful solution, or was he attempting to abolish the use of Jewish interpretations that competed with Christian exegesis? Was Justinian forcing the Greek language on the Jews with an eye toward eliminating scriptural interpretations that differed from those considered true and legitimate by the church, and was the elimination of Hebrew and *deuterosis* from Jewish liturgy to be viewed as a first step in that direction?[28] He possibly may have been aiming to gain a measure of control over Jewish liturgy (particularly biblical interpretation), as speculated by some, so as to bring it in line as much as possible with Christian exegesis, possibly paving the way for increased Jewish conversions.[29] Regrettably, not only does the emperor's motivation remain a mystery, but a question has even been raised as to whether this entire episode was in fact a historic event.[30] Whatever the case, through this legislation (whether real or fictional), Justinian crossed a number of red lines heretofore respected by Christian emperors. Moreover, the gravity of his intent is reflected in the punishments to be meted out for ignoring the prescriptions of this novella, which included flagellation, exile, confiscation of property, expulsion from the synagogue, and execution.

Besides Justinian's measures, there were other forms of religious pressure in the sixth and seventh centuries. Under the Visigoths, the Jews (having been put under the supervision of a Christian priest) were not allowed to observe their customary Sabbath and holiday rituals and were forced to attend services in churches on those days, presumably in order to listen to lessons and sermons directed specifically at them (a practice that was to become widespread in the Middle Ages).[31] Christian intolerance also surfaced in the seventh century with active efforts to convert Jews en masse. Heraclius's decree of 632 advocated this, although nothing practical seems to have come of it.[32] At the same time, in Spain and Gaul to the west, where the Jews

28. See the engaging though somewhat speculative suggestion of A. I. Baumgarten that the Mishnah represents the oral tradition that, according to the rabbis, separated Jews from Christians and made them unique and holy in God's eyes; the Mishnah thus refers to God's mystery as having been given to the Jews only, and both the Jewish claim and the Christian response should be viewed in the context of the Jewish-Christian polemic at the time; see A. I. Baumgarten, "Justinian and the Jews," 37–44, followed by P. T. R. Gray, "Palestine and Justinian's Legislation," 266–68. Nevertheless, it is hard to imagine that the rabbinic traditions Baumgarten cites, both indeed late, stood behind Justinian's declaration.

29. It has been recently suggested that this novella is a literary construct relating to "hermeneutical" Jews but having no basis in reality; the true aim of the emperor was to eliminate Hebrew, thereby removing the Jews' access to this version of the Bible in their polemics with Christians and consequently eliminating one of their main claims to authenticity. See Rutgers, "Justinian's *Novella* 146," 385–407; as well as Rutgers, *Making Myths*, 49–77 and the extensive bibliography cited there.

30. This, in turn, many have been but one component in the emperor's vision of Christianizing the empire by integrating it with the church; see Justinian's Novella 131.

31. Linder, *Jews in the Legal Sources*, nos. 562–63.

32. Parkes, *Conflict*, 257–69; Dagron and Déroche, "Juifs et chrétiens," 28–32.

were apparently a small community, repeated legislation stripped them of their rights and ordered their conversion or, at the very least, vigorously advocated it.[33]

Thus, the impression gained from imperial, ecclesiastical, and patristic sources is that Christianity triumphed while the nonorthodox Christian population (Jews, heretics, and pagans) was at best tolerated but more often marginalized, demonized, and persecuted.[34] The dominant impression of Jewish life in much of twentieth-century Jewish historiography is one of increasing hardship and a painful awareness of suffering and despair, not infrequently reflected in the religious poetry (*piyyut*) of the times.

NEW PERSPECTIVES

The above historical perspective on the status of Jews in the Early Byzantine era has undergone a reassessment in the last half of the twentieth century, in large part due to a number of new critical perspectives that have mitigated the historical implications of this material and, consequently, the degree of Jewish degradation at the time.

Deconstructing the Literary Sources:
Reconsideration and Reevaluation

The social and religious implications of the Adversus Judaeos literature are far from clear. One approach, following Adolph von Harnack, maintains—under the assumption that the Jews had disappeared from the stage of history after 70 and 135—that these attacks were merely theoretical and rhetorical exercises on the part of church fathers that had nothing to do with the Jewish communities themselves. Thus, Christian sources were simply repeating the earlier denunciations and accusations of their predecessors.[35] If so, then who were these "Jews"? To whom were these attacks directed—the Christian community at large, or rival ideologies and leadership groups within the Christian elite? According to the first option, the term *Jew* in such sources served as a theological construct invoked by church fathers for the purpose of bolstering their flock in the face of internal and external challenges.[36] Alternatively, the latter option signifies attempts to vilify Christian opponents by labeling them as Jews, a well-worn tactic throughout the ages intended to dele-

33. Linder, *Jews in the Legal Sources*, nos. 541, 542, 556, 703. See Brennan, "Conversion of the Jews"; Bradbury, "Jews of Spain," 511–16; and, more generally, Blumenkranz, *Juifs et chrétiens*, 138–58. See also Fredriksen and Irshai, "Christian Anti-Judaism," 1020–24; as well as Newman, *Ma'asim*, 106–12.

34. For instances of violence and dispute among Christians groups throughout this era, see Gaddis, *There is No Crime*, passim.

35. See Harnack, *Die Altercatio*, 56–91; Harnack, *Mission and Expansion*, 57–70, 487; this approach was widely accepted among Christian scholars for some time.

36. For various nuances in understanding the "hermeneutical" Jew, see M. S. Taylor, *Anti-Judaism and Early Christian Identity*; Cameron, "Jews and Heretics"; Cameron, "Jews in Seventh-Century Palestine"; Fredriksen and Irshai, "Christian Anti-Judaism." For a recent

gitimize the opposition or distract one's own following from other pressing issues by denigrating the "other."

In reaction to Harnack's approach, a second theory posits that these polemics were meant to deal with real-life situations and perceived threats, namely, Jewish communities whose religious practices, biblical interpretations, and historical memories posed serious social, theological, and religious challenges to Christian communities.[37] Ever since the publication of Marcel Simon's *Verus Israel* in the mid-twentieth century, this last alternative, often referred to as the conflict theory or model, has attracted many scholars owing to the constant flow of new archaeological and epigraphic data (see below). This approach has been reaffirmed of late by Stephen Mitchell and Fergus Millar.[38]

As intriguing as each of the above perspectives may be, none alone provides a completely satisfactory explanation. Whether church fathers felt intimidated or threatened by the contemporary Jewish community is, with few exceptions (e.g., John Chrysostom), almost impossible to assess from their polemical writings alone, nor is the assumption of a "hermeneutical" Jew borne out by all local circumstances. Indeed, it is quite possible that both factors were at play, depending on local circumstances, the particular authors in question, and the sources at our disposal.[39]

Turning to the ecclesiastical legislation discussed above, these sources in fact convey a dual message. Although the main thrust of these promulgations was to denigrate the Jews and distance them from Christians, such laws in fact may be understood as evidence of just the opposite. The objectionable behavior lambasted in this genre may only serve to highlight the real relations that existed between Jew and Christian. The extent of this phenomenon is, of course, impossible to gauge, although the fifth-century Christian historians Socrates and Sozomen knew of in-

argument focusing on the seventh-century polemics and emphasizing the goal of constructing Christian identity, see Olster, *Roman Defeat*, 4–29. See also Parkes, *Conflict*, 257–69.

37. For the theoretical underpinnings of this concept, see Simmel, *Conflict*; Coser, *Functions of Social Conflict*. For an overview of this issue in contemporary scholarship, see Horbury, *Jews and Christians*, 20–25, 180–99.

38. Simon, *Verus Israel*, 135–78, followed, inter alia, by Wilken, *Judaism and the Early Christian Mind*, 9–68; Wilken, *John Chrysostom and the Jews*; Meeks and Wilken, *Jews and Christians in Antioch*; Gager, *Origins of Anti-Semitism*, 113–73; Millar, "Christian Emperors." Wilken assumes that the church was dealing with a Jewish community whose status and stability allowed it to engage the Christians on an equal footing, at least during these first centuries: "Throughout the history of the early Church, when Christian leaders were faced with attrition in Christian ranks due to the presence of strong Jewish communities in the cities in which they lived, they prohibited intercourse between Jews and Christians; others put Christian rites in direct competition with Jewish rites, calling for a fast when Jews feasted and a feast when Jews fasted, or insisting that Christians work on Saturday and attend church on Sunday. Others wrote treatises against the Jews" (*John Chrysostom and the Jews*, 94).

39. For an intriguing attempt to combine both factors into one overall explanation, see Fredriksen, "What 'Parting of the Ways'?"; Fredriksen and Irshai, "Christian Anti-Judaism," 985–98, 1007, 1027.

stances in which Jews and Christians intermingled,[40] and other sources note how Jewish practices influenced not only Christians in Antioch and Aphrodisias but also heretical groups in Asia Minor (Quartodecimans, Novatians, and Montanists).[41] Such cases include the observance of Easter on the fourteenth of Nissan, attending synagogue, and following the lunar calendar. Taken together with the Laodicea (Phrygia) council decisions, which, inter alia, forbade resting on the Jewish Sabbath and accepting a Passover meal from Jews, it is clear that at least some orthodox Christian authorities were concerned about Jewish influence.[42] In this light, then, ecclesiastical sources attest to cordial relations between Jews and Christians no less than to the clergy's determination to eliminate such relationships. What they do not tell us is how effective such pronouncements were in terminating or significantly curtailing such activity.

The same methodological caveat holds true, *mutatis mutandis,* with regard to imperial edicts. It is apparent that such legislation was responding to concrete historical situations, be they in the local, provincial, or wider imperial realm. Such edicts may afford a broader purview of the Jews' precarious situation in Late Antiquity than the above two genres of sources. However, imperial legislation must also be viewed critically. In the first place, such legislation was far from monolithic with regard to the fourth and even fifth centuries. Whatever forces may have been at play, and unfortunately we have little information in this regard, emperors issued both supportive and restrictive orders vis-à-vis the Jews at one and the same time, or issued contradictory edicts on the same matter within a span of but a few years. One striking instance of this shift involves the permission granted the Patriarch to collect taxes, a privilege rescinded in 399 but reinstated in 404.[43]

Secondly, and no less important, is the matter of enforcement. Was a law merely a rhetorical statement of what a ruler wished to see, or did it indeed effect change? Is the repetition of a particular law in successive codes a reflection of the conservative nature of such corpora, a determined policy of enforcement, or a sign of weakness and a failure of implementation? It has been shown that the edicts of the Theodosian Code regarding social mobility (involving the colonate, guilds, obligations of rank, and more) indeed demonstrate a significant gap between law and reality, or, as modern scholarship has oft reiterated, "Laws repeated are laws unenforced."[44] One

40. Socrates, *Ecclesiastical History* 4.28; 5.22; Sozomen, *Ecclesiastical History* 7.18.

41. See Tabbernee, *Montanist Inscriptions and Testimonia*, s.v. "Jews/Judaism," "Montanist-Novatian"; and below.

42. Noethlichs, *Die Juden*, 161–72.

43. This privilege is noted by Julian already in 363; see Linder, *Jews in Roman Imperial Legislation*, nos. 13, 30, 34. For examples of legislative attempts to protect synagogues and Jewish homes, see ibid., nos. 46, 47.

44. MacMullen, "Social Mobility": "The *Code* certainly reveals what the emperors intended, but it should be used with great caution by anyone seeking to describe the realities of the times" (p. 53). See also N. Q. King, "Theodosian Code"; Harries, *Law and Empire*, 95–98.

particular case regarding the Jews provides an excellent example of a very partial or a totally neglected piece of legislation. While the building or repairing of synagogues was repeatedly prohibited in a number of edicts, archaeological finds from both Byzantine Palestine and the Diaspora clearly attest that synagogues were being built, repaired, and maintained throughout Late Antiquity.[45]

Archaeology, Genizah Material, and Recent Surveys

Palestine

Our understanding of Jewish life in Byzantine Palestine has been revolutionized over the past several generations by two additional sources of information that focus on internal developments within the Jewish community. Both the large number of archaeological finds and the recovery of texts from the Cairo Genizah have illuminated many heretofore unknown facets of Jewish society, vastly enriching and significantly revamping our view of Jewish life in this era. The archaeological finds include the art and architecture of scores of synagogue buildings (to be discussed in subsequent chapters), several extensive necropoleis, and many hundreds of inscriptions. The Genizah documents tell us much about the cultural and religious spheres of the period, at least as far as Palestine, and to a far lesser extent Babylonia, are concerned. As a result of this new information, the earlier picture of Late Antiquity now requires substantial reassessment and revision.

The archaeological data are generally indicative of widespread Jewish settlement, economic prosperity, and what appears to have been a stable political and social environment. Sepphoris and Tiberias grew in size, along with other cities in the region, and well over one hundred synagogues were constructed throughout the country; the greatest concentration was in the Galilee and Golan, although such buildings have also been found in the Bet Shean region, on the southern periphery of Judaea, and in the coastal area.[46]

Indeed, the overwhelming majority of synagogues excavated in Palestine date from Late Antiquity (the late third to seventh centuries). As noted, despite the imperial restrictions, the Jews in Byzantine Palestine continued to build new communal institutions (Merot, Capernaum, Bet Alpha, southern Judaea), repair those already standing (Maʻoz Ḥayyim, Ḥammat Tiberias, Ḥammat Gader, ʻEn Gedi), and rebuild and refurbish others after a period of abandonment or neglect (Nevoraya). In fact, it was precisely at the end of this period, in the sixth and seventh centuries, that a number of synagogue buildings (Ḥammat Tiberias, ʻEn Gedi, Nevoraya, Horvat Rimmon, Maʻoz Ḥayyim) reached their largest dimensions.[47]

45. Linder, *Jews in Roman Imperial Legislation*, nos. 41, 47, and 54; as well as L. I. Levine, *Ancient Synagogue*, 210–380.

46. On this and the following, see L. I. Levine, *Ancient Synagogue*, chaps. 7 and 9.

47. See *NEAEHL*, passim.

In several regions, synagogues were erected where few, if any, had existed before. Most surprising are the discoveries in the Golan, where twenty-five synagogues were uncovered, all of which (Gamla excluded) were built in the Byzantine era.[48] Even on the periphery of Judaea (both to the east and west, but especially in the south), a dozen or so synagogues have been discovered to date. Given Hadrian's prohibition of Jewish settlement in and around Jerusalem, the extensive destruction in Judaea during and after the Bar-Kokhba revolt, and the strong Galilean focus on rabbinic literature, such a large number of Judaean synagogues was indeed unexpected.

Synagogue remains have been an important catalyst in reassessing Jewish life in this period. The monumental nature of many of these buildings, such as the Capernaum edifice dating to the latter part of the fifth, perhaps even the sixth, century—deep into the Byzantine era[49]—indicates a prosperous and politically confident community. The synagogue was considerably larger than the octagonal church there, despite the fact that Capernaum was a widely recognized and oft-visited Christian pilgrimage site.[50]

A Jewish "epigraphic habit" flourished at this time as well. More than two hundred Palestinian inscriptions in Greek, Aramaic, Hebrew relate to synagogues and their officials, and the number almost triples if we include those from important necropoleis of Late Antiquity such as Bet She'arim and Joppa.[51] Overall, Greek and Aramaic inscriptions predominate while Hebrew constitutes a minor, though not inconsequential, component.[52] In Palestine, only some 35 percent of the synagogue dedicatory inscriptions are in Greek, most in the cities and along the coast, with Aramaic and Hebrew being much more ubiquitous in the interior rural areas of the country.[53]

Synagogue inscriptions were usually meant to acknowledge individual donors or entire communities. Others, however, relate to the date of a building's foundation (Bet Alpha, Ashkelon, and Gaza), important communal decisions ('En Gedi), an extensive prayer formula (Jericho), memories of the past and present (such as the

48. Ma'oz, "Ancient Synagogues of the Golan"; Ch. Ben David (*Jewish Settlement on the Golan*) has concluded that Golan settlements from the Late Roman period bear no evidence of synagogue buildings.

49. See Loffreda, "Capernaum"; as well as Magness, "Question of the Synagogue," 18–38.

50. The building's prominence was enhanced by the artificially raised podium on which it stood, dwarfing the nearby Church of Saint Peter that was also built at this time.

51. Price and Misgav, "Jewish Inscriptions." At Bet She'arim and Joppa together, the number of Greek inscriptions reaches almost 85 percent of the total found.

52. Inscriptions were an integral part of the synagogue setting and were found in almost every part of the building—on its facade and throughout its interior, including the area around the Torah shrine. Columns and chancel screens were often used as well, but mosaic floors preserve most of this epigraphical material.

53. Hebrew appears to have occupied a central role at several sites in the Upper Galilee and southern Judaea.

lists of priestly courses), halakhic texts (Reḥov), or the identification of biblical and zodiac figures.[54]

Besides archaeology, a second catalyst in reevaluating Jewish life in this era is based on the extensive literary sources from the Cairo Genizah, some of which were formerly dated to the early Middle Ages but are now acknowledged to have been written in the Byzantine era. These include both known and new literary genres: synagogue poetry (*piyyut*); early aggadic midrashim; Hekhalot traditions; apocalyptic works; magical treaties and amulets; and targumic traditions.[55]

As a result of this new material, a far-reaching reassessment of Jewish life in Byzantine Palestine has taken place. Clearly, it was not a postclassical (or post-talmudic) era of decline, as once assumed, but rather one that generated new literary forms reflecting new cultural and spiritual foci, as well as enhanced activity in the creation and transmission of past traditions and practices. The earlier picture of Byzantine Palestine as a cultural wasteland characterized by political decline, economic decay, and cultural stagnation has now been replaced by a very different and far more nuanced appreciation of this era (see below).[56]

In addition to the new corpora of evidence (archaeological finds and Genizah material), archaeological surveys over the last few generations have pointed to the remarkable demographic growth and geographical expansion in this era. Byzantine remains are, for the most part, significantly greater than those of the preceding periods, and excavations at well-known sites (Jerusalem, Tiberias, Caesarea, Bet Shean, Sepphoris, and Gerasa, among others) have invariably shown a marked in-

54. For synagogue inscriptions, see Naveh, *On Stone and Mosaic*; Roth-Gerson, *Greek Inscriptions from the Synagogues*. On the Bet She'arim inscriptions, see Schwabe and Lifshitz, *Beth She'arim*, vol. 2; Avigad, *Beth She'arim*, 3:230–58. For general discussions of this evidence, see L. I. Levine, *Ancient Synagogue*, 371–75; Price and Misgav, "Jewish Inscriptions." On the Reḥov inscriptions, see chap. 20.

55. See chap. 10; on *targum*, see Hayward, "Date of Targum Pseudo-Jonathan"; Shinan, "Dating Targum Pseudo-Jonathan"; Shinan, *Embroidered Targum*, 11–15, 193–98.

56. As regards Babylonian Jewry from the third century onward, according to later sources, its development may have been disrupted by the alleged downturn in Jewish political and religious fortunes of the fifth century, which is said to have involved the closing of synagogues, the prohibition of Sabbath observance, and the abduction of children to serve in pagan temples; see Gafni, *Jews of Babylonia*, 46–51. These sources notwithstanding, it seems that the Jews of the Sasanian Empire generally lived in relative social and cultural harmony with their surroundings; see Brody, "Judaism in the Sasanian Empire," 59–62; Gafni, "Babylonian Rabbinic Culture." Kalmin, however, basing himself first and foremost on a literary analysis of the relevant sources, claims that these sources related to supposed persecutions are in essence reflective of various perceptions among the sages and editors of the Bavli regarding what, if anything, transpired, thus rendering the historical reality behind such "events" well-nigh impossible to ascertain; see his *Jewish Babylonia*, 121–47. For a similar attempt to minimize the nature and extent of Sasanian persecutions generally, see McDonough, "A Question of Faith?"

crease in populated areas.[57] The following chart, focusing on the more rural northern areas of the country (and thus relevant to the bulk of the Jewish population), indicates the extent of the increase in the number of settlements.[58]

Site	Roman	Byzantine
Northern Carmel	17	32
Central Carmel	31	70
Western Jezreel	53	51
Southeastern Lower Galilee	12	37
Lower Galilee (Tabor area)	30	49

Hayim Lapin's figures are as follows: for the northern region (sites in the Galilee, including the Bet Shean Valley and the coastal plain west of the Upper Galilee), Hellenistic: 167, Roman: 280, and Byzantine: 467; for the Golan, 16, 125, and 165, respectively.[59]

Opinions differ as to the causes for this growth and expansion. Over fifty years ago Avi-Yonah discussed the economic prosperity in Byzantine Palestine, offering several reasons for this phenomenon—a relatively peaceful era and, more importantly, the rise of Christianity and the transformation of Palestine into a Christian Holy Land. This, he claimed, involved huge investments in the building of churches and monasteries and, together with the presence of large numbers of pilgrims, bolstered all aspects of the local economy.[60] Recently, however, Doron Bar has suggested that the primary reason for this economic upswing was not so much the inroads made by Christianity but the general vitality of the East at the time.[61] He maintains that just as the developments in Palestine should be viewed primarily in

57. For all their importance, we should remember that the data culled from such surveys must be used with caution. See in this regard the comments of Lapin, *Economy, Geography, and Provincial History*, 39–44.

58. Tsafrir, "Some Notes on the Settlement and Demography," 273–74; Bar, "Geographical Implications"; Bar, "Settlement and Economy"; Bar, "Roman Legislation." On the demographics and economy of Palestine at this time, see the comments of Z. Safrai, *Economy of Roman Palestine*, 436–58. With regard to northern Jordan, 248 Byzantine sites as against 130 Roman ones have been identified (with several doubtful cases in each); see Mittmann, *Beiträge zur Siedlungs-und Territorialgeschichte*, 256–64.

59. Lapin, *Economy, Geography, and Provincial History*, 44–76.

60. Avi-Yonah, "Economics of Byzantine Palestine"; Wilken, *Land Called Holy*, 178–81; Patrich, "Church, State and the Transformation of Palestine," 470–73; Parker, "An Empire's New Holy Land."

61. Bar, "Was There a 3rd-c. Economic Crisis?"; Bar, "Christianisation of Rural Palestine"; Bar, *"Fill the Earth."* See also Groh, "Jews and Christians in Late Roman Palestine"; as well as Tsafrir, "Some Notes on the Settlement and Demography." In this regard, and on a wider scale, see Cameron, *Later Roman Empire*, 170–86; Cameron, *Mediterranean World*, 177–82; Walmsley, "Byzantine Palestine and Arabia"; Foss, "Syria in Transition"; and, most recently, F. Millar, "Palestinian Context of Rabbinic Judaism."

their wider Mediterranean matrix, so should the economic prosperity and religious creativity in Jewish Palestine be viewed against the backdrop of a generally dynamic and innovative Byzantine context. The growth of cities and their outlying villages, where many hundreds of churches and monasteries sprang up, attest to this provincial prosperity. Moreover, Bar claims, this economic resurgence is not to be dated to the fourth or fifth centuries but in fact began much earlier, in the second and third centuries CE.[62]

The reevaluation of Byzantine Palestine in general, and of the Jewish community in particular, dovetails neatly with Peter R. L. Brown's challenging reassessment of these centuries some four decades ago, when he popularized the term *Late Antiquity*.[63] Reconceptualization of this period resulted in the recognition that it was not an era of decline and fall, per Edward Gibbon and others, but rather one of cultural and religious creativity within a supportive social context, relative political stability, and economic prosperity. Whereas Gibbon marked the end of this era with the fall of Rome in 476,[64] Brown posited a very different scenario, in which a new era evolved in the second century CE and lasted until the eighth.[65] Clearly, there is more than just a chronological difference between these two approaches. One emphasizes the political climate that focused on the West, the other on the cultural and religious dimensions, primarily in the East. For Gibbon, the Greco-Roman world came to a close with the conquests of the Germanic tribes and the destruction of Roman civilization, which, in the West at least, was replaced by something entirely different. For Brown, there was no abrupt end to classical civilization; rather, its evolution into something quite distinctive, an intricate mixture of classical and postclassical cultural elements, was highlighted by the rise of Christianity and the resultant integration of these components into a new and reconfigured world scene.

62. On the role of climate as a possible factor in accounting for settlement expansion and economic prosperity, see Hirschfeld, "Climatic Change."

63. See P. R. L. Brown, *World of Late Antiquity*, and a retrospective on this work some 26 years later: Brown et al., "World of Late Antiquity Revisited"; as well as Vessey, "Demise of the Christian Writer"; Cameron, "Ideologies and Agendas"; E. James, "Rise and Function of the Concept 'Late Antiquity'" (and the many references in each of these articles).

64. Gibbon (*History of the Decline and Fall of the Roman Empire*) took his cue, inter alia, from the reactions of fifth-century writers such as Augustine and Eunapius of Sardis, who commented on the collapse in the West.

65. Although Brown's basic concept has captured the day, scholars are at odds over the precise nature, and thus the chronology, of Late Antiquity. Bowersock and Lee, for instance, prefer to date the onset of this era to the third or fourth century, while Cameron uses 395 as the divide between the Late Roman period and Late Antiquity; see Bowersock, *Hellenism in Late Antiquity*; Lee, *Pagans and Christians in Late Antiquity*; Cameron, *Mediterranean World*. The original edition of The Cambridge Ancient History series (1923–39) fixed its *terminus ad quem* at 324, when Constantine became sole emperor, although two additional volumes have been published that extend the history of Late Antiquity to 600 CE. A compromise of sorts was reached by a number of leading scholars, who set 250–800 as the time frame for this period; see Bowersock, P. R. L. Brown, and O. Grabar, *Late Antiquity*, vii–x.

The Roman Diaspora

The evidence for the Roman Diaspora in Late Antiquity attests to the existence of many vibrant Jewish communities, each with its own religious and social framework trying to balance a loyalty to the Jewish people and tradition with a desire to integrate into the surrounding culture and society. A combination of literary sources, epigraphic evidence, and archaeological finds provides information for these communities, although these data differ in quantity and quality from one locale to the next.[66] Despite the fulminations of church fathers against the Jews and the discriminatory legislation emanating from Constantinople, Christian sources also attest to amicable Jewish-Christian contacts, to Christians being exposed to Jewish biblical interpretations and magical practices, and to some Christians observing Jewish customs, including synagogue attendance. When one discovers intermediate groups between Jew and Christian, such as Judaeo-Christian sects or Christian Judaizers, significant variations in behavior come to the fore.[67] In what follows, we shall focus on the three major corpora of evidence in this regard—archaeology, epigraphy, and literary sources.

Archaeology. The many archaeological finds that have come to light over the past century are crucial ingredients for a change in perspective and reassessment of Diaspora Jewry's standing in Late Antiquity. While the realization of Diaspora Jewry's creativity had already surfaced in 1932 with the discovery of the Dura Europos synagogue,[68] it gained additional momentum with the new data from the Sardis synagogue excavations in 1961. A spate of other synagogue finds followed over the ensuing decades, and today we know of fifteen synagogue buildings and another nine whose identification remains uncertain.[69]

Indeed, it was the Dura and Sardis discoveries that alerted scholars to a very different Diaspora reality than heretofore assumed. Dura, as noted, was a stunning revelation (virtually ex nihilo) of the existence of a highly developed Jewish art featuring an extensive program of biblical scenes.[70] The impressiveness of the Sardis structure, by far the most monumental of all ancient synagogues, stems, inter alia, from its prominent location, large dimensions, and rich remains. Its eighty-six inscriptions attest to a prominent and acculturated community,[71] and the fact that this

66. A similar configuration of sources and their interrelationships holds for the late Second Temple-period Diaspora as well; see L. I. Levine, *Ancient Synagogue*, 81–134, and esp. 127.

67. See Simon, *Verus Israel*, 306–38; Gager, *Origins of Anti-Semitism*, 117–33. See also Gager, "Jews, Christians and the Dangerous Ones in Between"; Kinzig, "'Non-Separation.'"

68. See chap. 5.

69. See my *Ancient Synagogue*, 250–52. We may now add to this list the newly discovered fourth-century synagogue at Andriake in southern Turkey; see Çevik et al., "Unique Discovery in Lycia," 335–49; Çevik and Eshel, "Byzantine Synagogue at Andriake."

70. See chaps. 4 and 5.

71. See the description and discussion of the Sardis synagogue in chap. 15.

building continued to function as a synagogue down to the destruction of the city in 616, is indicative of this community's continued prosperity and stability.

Epigraphy. Over 1500 inscriptions known today from the Roman Diaspora have opened many doors to understanding Jewish life there.[72] Undoubtedly, the most sensational of these epigraphic remains comes from Aphrodisias in southwestern Asia Minor,[73] where two inscriptions incised on one marble pillar record the names of sixty-eight Jews, three proselytes, and fifty-four gentile God-fearers.[74] Side A of the stone pillar lists thirteen Jews, three proselytes, and two *theosebeis,* all members of a *dekany* who contributed to some sort of memorial. This memorial building (μνῆμα), or part of it, presumably served as a soup kitchen (*patella,* lit., dish) "for relief of suffering in the community," and the *dekany* seems to have functioned also as a society devoted to prayer and study.[75]

Side B of the pillar lists the names of fifty-five Jews and is followed by the names of fifty-two *theosebeis,* the first nine of whom are identified as city councillors (*bouleutai*). Thus, we have here conclusive evidence of a group of pagan (or possibly, in part, Christian) God-fearers of high rank and significant number who were publicly and actively associated with the local Jewish community.[76] What makes the Aphrodisias inscriptions even more important is the emerging consensus that they originated in the Byzantine era, i.e., the fourth (Side B) and fifth (Side A) centuries. Assuming the accuracy of this dating, this Jewish community attracted large numbers of non-Jewish sympathizers well into the Christian era.[77]

72. Based on inscriptions published in the following corpora: *Jewish Inscriptions of Graeco-Roman Egypt*; *JIWE* (2 vols.); *Inscriptiones Judaicae Orientis* (3 vols.).

73. On the close relations between Jews and Christians in Asia Minor, see Sheppard, "Jews, Christians and Heretics."

74. See Reynolds and Tannenbaum, *Jews and God-Fearers*; Figueras, "Epigraphic Evidence," 198–203; Chaniotis, "Jews of Aphrodisias"; Ameling, *Inscriptiones Judaicae Orientis*, 2:209–97.

75. Margaret H. Williams ("Jews and Godfearers," 304–10) suggests that the *dekany* was a burial society and that the memorial in question was a *triclinium.* A *dekany* is also mentioned in Rome; see Noy, *JIWE*, vol. 2, no. 440. On funerary activities as a component of religious associations in Asia Minor, see Harland, *Associations, Synagogues, and Congregations,* 84–87.

76. Until recently, it had been assumed that these inscriptions were written in the early third century. See Reynolds and Tannenbaum, *Jews and God-Fearers,* 19–23; Schürer, *History,* 3/1:25–26; White, *Building God's House,* 88–89; Rajak, "Jewish Community," 20–21; Feldman, *Jew and Gentile,* 367–69; J. J. Collins, "Feldman, *Jew and Gentile,*" 718; Mussies, "Jewish Personal Names," 255–76. However, a growing body of scholarly opinion now places these inscriptions squarely in the Byzantine period. A fourth-century date has been suggested by Botermann ("Griechisch-Jüdische Epigraphik"); Chaniotis ("Jews of Aphrodisias") separates the two, dating Side B to the fourth century and Side A to the fifth; Bonz ("Jewish Donor Inscriptions," 285–91) also divides the two, dating Side A to the turn of the third century and Side B to the fifth or sixth century. Gilbert ("Jews in Imperial Administration") prefers to date the latter to the fourth century. We follow Chaniotis's dating.

77. It may not be coincidental, then, that a law in the Theodosian Code dating to 409 seems to address situations quite similar to those in Aphrodisias: "A new crime of superstition

Similar instances of well-established Jewish communities in the Greco-Roman and Byzantine eras attracting Christians, which included at times the adoption of Jewish customs and practices, are attested in other inscriptions from Asia Minor.[78] Some note Christians observing the Sabbath on Saturday or celebrating Easter on the Jewish Passover.[79] Such practices were particularly widespread among groups considered heretical by the established church (for example, Montanists, Novatians [or Katharoi], and Quartodecimans), and these were particularly numerous in Asia Minor: Phrygia, Galatia, Bithynia, Paphlagonia, Caria, and Lydia (Philadelphia).[80] A recently published inscription from Ankara[81] has led Stephen Mitchell to claim that "a close alignment between the organisation of the Montanist church and Jewish institutions in the fifth or early sixth centuries illustrates the potential for positive rather than hostile interaction between the two monotheistic religions in the communities of Asia Minor."[82]

shall somehow obtain the unheard name of Heaven-Fearers (God-Fearers or *sebomenoi*, those attracted to Judaism without undergoing conversion). Let them know, that unless they return within a year to the cult of God and to the Christian veneration, they too shall be affected by those laws which we have ordered to be imposed on the heretics. For it is certain, that whatever differs from the faith of the Christians is contrary to the Christian Law" (Linder, *Jews in Roman Imperial Legislation*, no. 39). See Chaniotis, "Jews of Aphrodisias," 218; and Ameling, *Inscriptiones Judaicae Orientis*, 2:82 n. 49. Recently, Chaniotis has offered a more detailed description of other Jewish finds in the city, but, once again, he dates both of the above inscriptions to between 350 and 500 CE ("Godfearers in the City of Love").

78. For an overview of this evidence, see Trebilco, *Jewish Communities in Asia Minor*.

79. For possible evidence that some Christians observed Yom Kippur, see Stökl Ben Ezra, "'Christians' Observing 'Jewish' Festivals."

80. Mitchell, *Anatolia*, 96–108. The perceived threat of such heretical groups to the official church is reflected in Theodosius II's imperial letter of 428 (CT 16.5.65): "The madness of the heretics must be so suppressed that they shall know beyond doubt, before all else, that the churches which they have taken from the orthodox, wherever they are held, shall immediately be surrendered to the Catholic Church"; Pharr, *Theodosian Code*, 462.

81. See Mitchell, "An Apostle to Ankara," and the inscription on pp. 211–12. Mitchell goes on to spell out some of the connections between this inscription and what we know of Jewish communities in Late Antiquity, especially in Asia Minor: Severus the *prostates* and the *dekania*, institutions known from Aphrodisias (see above); noting the Jewish Sabbath and the term "apostle," as in a sixth century Jewish epitaph from Venusia in Italy; and, finally, the fact that Patriarchs headed the Montanist community, as did their counterparts in the Jewish community (ibid., 216–19).

82. Ibid., 219; as well as Millar, "Repentant Heretics." See also Mitchell's summary statement ("An Apostle to Ankara," 223): "The judaising Christianity of the Montanists, the Novatians and other groups, especially in Asia Minor, represented a serious alternative to mainstream doctrines favoured by the orthodox hierarchy. The religious expectations that were fostered by the Pepuza community, and nurtured by discussion with the Jews of Asia Minor, were stronger in the fifth and sixth centuries than they had ever been. The rhetoric of one-sided orthodox sources has been responsible for creating an impression of conformity in the

As noted above, the desire of the Jewish communities to preserve their particular traditions while striving for some sort of social integration and acculturation is reflected in virtually all Diaspora evidence, whether literary, architectural, artistic, or epigraphic. Three epitaphs, from Sicily, Hierapolis in Asia Minor, and Palmyra, illustrate the complexity of cultural identities experienced by Diaspora Jews and are indicative of how the above-noted desiderata were integrated.[83] In each of the three epitaphs, Diaspora families found some sort of middle ground between local customs and practices on the one hand, and an assertion of their Jewish identity on the other. The latter component is evidenced by the names, languages, holidays, or alternative dating systems and thus projects a strong Jewish identity component alongside a significant degree of acculturation.

Literary sources. Perhaps the most comprehensive and varied literary evidence regarding Diaspora Jewish life in Late Antiquity stems from the province of Syria and eastward to Mesopotamia, and is based on Syrian Christian sources written in both Greek and Syriac.[84] References to Jews and Judaism are diverse—from Ignatius, the Pseudo-Clementines (Recognitions, Homilies, and several epistles), the *Doctrina Addai,* and the *Didascalia* to the writings of Aphrahat, Ephrem, and Chrysostom.[85] To these should be added the declaration of the Syrian church council in Antioch advocating the excommunication of any clergyman who celebrates Easter with Jews. It has long been recognized that Syriac Christianity had incorporated many Jewish traditions into the Peshitta, the Syriac Christian translation of the Bible.[86] Each of the above-mentioned church fathers and documents refers to Jewish arguments against Christianity and presumably sought to bolster Christian beliefs and interpretations in the face of such polemics.

beliefs and organization of the Church which radically misrepresented the real situation to be found over much of late Roman Asia Minor."

83. Sicily: Millar, "Jews of the Graeco-Roman Diaspora," 97–99. Hierapolis: Harland, "Acculturation and Identity." Palmyra: Noy and Bloedhorn, *Inscriptiones Judaicae Orientis,* vol. 3, no. Syr49. On these inscriptions, see L. I. Levine, "Jewish Identities," 32–34; K. B. Stern, "Limitations of 'Jewish,'" 320–27.

84. Our discussion of Syrian Christianity is based largely on Neusner, *Aphrahat and Judaism,* 123–49; Gager, *Origins of Anti-Semitism,* 117–33; Hayman, "Image of the Jew"; Drijvers, "Syrian Christianity and Judaism"; Millar, *"Many Worlds of the Late Antique Diaspora,"* 127–38. On the Jews of Syria in Late Antiquity generally, see Roth-Gerson, *Jews of Syria;* McCollough, *Theodore of Cyrus,* 81–114. See also J. B. Segal, "Jews of Northern Mesopotamia."

85. See Birdsall, "Problems of the Clementine Literature." On the use of Greek and Syriac in this region at the time, see Brock, "Greek and Syriac in Late Antique Syria."

86. Drijvers, "Syrian Christianity and Judaism," 142: "All the evidence shows that Judaism appealed to pagans and Christians alike and that the Christians used and took over large parts of Jewish writing for their own use, which implies regular contacts on all levels." See also Kazan, "Isaac of Antioch's Homily." Regarding Ephrem specifically, see Kronholm, *Motifs from Genesis 1–11,* 215–24; and generally Brock, *Bible in the Syriac Tradition.* On the *Peshitta* and Jewish tradition, see Dirksen, "Old Testament Peshitta."

Moreover, these sources make recurrent reference to Christians who had adopted Jewish practices. For example, Ephrem speaks of those who visit the synagogue, pray with the Jews, eat *matzot* on Passover, and circumcise their sons.[87] The virulence of his attacks on the Jews and Judaism has often been related to the strength of the local Jewish communities and on Judaism's continued appeal to local Christians.[88] Finally, a number of the above-noted sources, especially those dating to the first half of the fourth century, such as Aphrahat, the Pseudo-Clementines, and the *Didascalia,* seem to display strong Jewish influences and may stem at least in part from Jewish-Christian communities.[89] Aphrahat makes repeated reference in his homilies to the correct way for his congregants to counter Jewish claims.[90] These sources reflect the lay Christians' rather positive stance toward certain Jewish practices, if not toward the Jews themselves. Thus, not only was there a change in the attitude of the church elite, which apparently became more hostile over time,[91] but an even greater difference is evident between the emerging doctrine of mainstream Syrian Christian leadership and many ordinary Christians.[92]

87. Drijvers, "Jews and Christians at Edessa," 99; Drijvers, "Syrian Christianity and Judaism," 141–42. In a similar vein, the author of the Epistle to Diognetus (written ca. 200 CE) castigates those who followed Jewish practice: "But, in truth, I do not think that you need to learn from me that, after all, their qualms concerning food and their superstition about the Sabbath, and the vaunting of circumcision and the cant of fasting and new moon, are utterly absurd and unworthy of any argument" (Meecham, *Epistle to Diognetus,* 79).

88. Kazan, "Isaac of Antioch's Homily," 47 (1963), 92; Hayman, "Image of the Jew," 433; J. B. Segal, "Jews of Northern Mesopotamia," 41*–48*; Shepardson, *Anti-Judaism and Christian Orthodoxy,* 19, 157–61. For some of Ephrem's veiled and not-so-veiled theological attacks on the Jews in his hymns, see McVey, *Ephrem the Syrian,* 297–309. Ephrem also took pains to discourage Christians from associating with Jews and following their practices; see Kazan, "Isaac of Antioch's Homily," 46 (1962), 98. The same kinds of concerns also seem to be reflected in a homily from the fifth century; ibid., 47 (1963), 93–97.

89. See Gavin, *Aphraates and the Jews.*

90. Kazan, "Isaac of Antioch's Homily," 46 (1962), 90–91.

91. Note also the much harsher response to Jews and Judaism by Edessa's bishop Rabbula (412–36 CE) in the early fifth century. Besides their being the butt of polemics, as before, it is reported — undoubtedly in an exaggerated fashion — that thousands of Jews were baptized and that their synagogue was converted into a church dedicated to St. Stephen; see *Chronicon Edessenum,* in Guidi, *Chronica Minora* 1:LI.

92. Consider the assessment of Hayman ("Image of the Jew," 440), who points out that as late as the eighth century, ordinary Syrian Christians could not clearly distinguish between Judaism and Christianity:

We can trace this uncertainty about the exact boundary between the two religions virtually from the emergence of the Syriac-speaking Church right down to its effective demise as a major cultural force in the Middle East. The intellectual elite, the theologians, clergy, and the shock troops of the Syriac church, the monks, knew where the boundaries lay. But the ordinary laypeople did not. They appear to have taken a more tolerant attitude to the differences between the two religions despite all the attempts of the Christian elite to create an image of the Jews that would frighten

Fourth-century Antioch produced what is generally regarded as the most explicit and powerful example of Jewish influence on a Christian community.[93] We have already noted the series of tirades delivered by Chrysostom against Judaism and the Christian Judaizers in his church.[94] The synagogue apparently had great appeal to these Christians, in large part because of their high regard for its sanctity owing to the presence of Torah scrolls.[95] Women especially seem to have been drawn to the synagogue on Jewish festivals, along with the accompanying customs,[96] particularly the holidays during the month of Tishri (Rosh Hashanah, Yom Kippur, and Sukkot; *Adv. Iud.* 2.3, 4.7);[97] Chrysostom likewise notes the circumcision of Christians and their use of Jewish ritual baths (*Adv. Iud.* 2.2; *Catech.* 1.2–3).[98]

Judaism's attraction was also related to Jewish healing procedures, which themselves were closely associated with magic in the ancient world.[99] In Daphne, near Antioch, many ailing Christians went to the synagogue to be cured by incubation (*Adv. Iud.* 1.6) and other means of treatment, such as incantations, amulets, and a variety of charms; to Chrysostom's consternation, Christians also preferred signing contracts and taking oaths in synagogues.[100] He tells the story of intercepting one Christian who was taking another to the synagogue for these purposes, remonstrating with the former for doing so. Chrysostom's version of the Christian's reply is

laypeople from having any contact with them. The layman, as quoted in Sergius' *Disputation*, says: If Christianity is good, behold, I am baptized as a Christian. But if Judaism is also useful, behold, I will associate partly with Judaism that I might hold on to the Sabbath (22, 15).

93. See Sandwell, *Religious Identity*, 39–47.

94. Simon, *Recherches d'histoire judéo-chrétienne*, 140–53; Meeks and Wilken, *Jews and Christians in Antioch*, 30–35; Wilken, *Chrysostom and the Jews*, 66–94; Brändle, "Christen und Juden"; Harkins, "Introduction," xxxviii–xlvii; Kinzig, "'Non-Separation,'" and esp. 35–41; Maxwell, *Christianization and Communication*, 83–84, 140–42.

95. Chrysostom attempts to refute this impression by denying any similarity between the synagogue ark and that of earlier Temples (*Adv. Iud.* 1.5, 6.7).

96. Chrysostom also notes that Christians came to the synagogue on the Sabbath year-round (*Adv. Iud.* 1.5, 8.8).

97. See Wilken, *John Chrysostom and the Jews*, 92–94; Simon, *Verus Israel*, 326–27. This phenomenon also occurred in first-century Damascus (Josephus, *War* 2.559–61).

98. See Wilken, *John Chrysostom and the Jews*, 75.

99. Simon, *Verus Israel*, 339–68; Wilken, *John Chrysostom and the Jews*, 83–88. See also Schürer, *History*, 3/1:342–79; Margalioth, *Sepher Ha-Razim*; Naveh and Shaked, *Amulets and Magic Bowls*; Naveh and Shaked, *Magic Spells and Formulae*; Bohak, *Ancient Jewish Magic*, passim. See also chap. 10, n. 53.

100. *Adv. Iud.* 1.3: "Three days ago (believe me, I am not lying) I saw a noble and free woman, who is modest and faithful, being forced into a synagogue by a coarse and senseless person who appeared to be a Christian (I would not say that someone who dared to do such things was really a Christian). He forced her into a synagogue to make an oath about certain business matters which were in litigation" (Meeks and Wilken, *Jews and Christians*, 90).

telling: "Many had told him that oaths taken there were more awesome" (*Adv. Iud.* 1.3).[101]

At about the same time that Chrysostom was delivering these tirades, the *Apostolic Constitutions* decreed that no Christian (clergy or laity) was to enter the synagogue to pray, no clergy was to feast with Jews or participate in their festivals, and no Christian was to light synagogue lamps on Jewish holidays.[102] The reality behind such declarations would seem to indicate that Christians in the East not infrequently expressed an interest in the synagogue and Jewish practices.[103]

There were few secrets, even in a city the size of Antioch, and people were well aware of the habits of their neighbors (*Adv. Iud.* 8.4.7–10). Robert L. Wilken's overall assessment of what was transpiring in Antioch may not be far off the mark:

> What happened in Antioch in the late fourth century was neither unique nor unprecedented in the early Church, though the intensity of the struggle there and the vehemence of John's response are singular. This was, no doubt, due to the size and prestige of the Jewish community, as well as its spiritual power. But the magnetism of the synagogue must be attributed not simply to the repute of the Jewish community or the numinous power of Jewish holy places or Jewish books; it was also due to the intimate relations that existed between Juda-

101. De Lange, *Origen and the Jews*, 36, 86; Simon, *Verus Israel*, 326. Evidence to substantiate Chrysostom's concern may be found in a Jewish prayer (similar to the *'Amidah*) embedded in a Christian liturgical text, as preserved in the *Apostolic Constitutions* (7.33–38), a work often assigned to fourth-century Syria. Wilken describes this broader Antiochan setting (and perhaps elsewhere as well) rather pointedly, thus accounting, at least in part, for Chrysostom's hostility:

> If Christians were going around the corner to attend the synagogue, this meant that the divine was more tangibly present in the synagogue than in churches. If churches were empty because the Jews were celebrating their high holy days, this suggested that the Jewish way was more authentic. If the Christians used the Jewish calendar to set the date of a Christian festival, this could only mean that the Jews had the true calendar. In such a setting there was no middle ground, no accommodation between Jews and Christians, because the claims of the two religions were being negotiated not in the tranquility of the scholar's study but in the din of the city's streets. When churches were empty and the synagogue filled, it was not a secret but public knowledge passed on in the shops and bazaars of the city (*John Chrysostom and the Jews*, 78).

102. *Apostolic Constitutions* 8.47, 65, 70, 71, in Roberts et al., *Ante-Nicene Fathers*, 504.

103. The fascination of Antiochan Christians with Judaism and Jewish practices may also be evidenced in the transformation of an Antioch synagogue honoring the Maccabean martyrs into a Christian martyrium. It seems that a synagogue had been built in or near the alleged burial site of these Jewish martyrs (see 2 Maccabees 6–7) and their veneration was subsequently adopted by Christians. Sometime in the fourth century, the Antioch synagogue was taken over by the local church, for by Chrysostom's time the relics therein were already in Christian hands; see *In Sanctos Maccabaeos Homilia* 1.1; Simon, *Recherches d'histoire judéo-chrétienne*, 158; Schatkin, "Maccabean Martyrs"; Wilken, *John Chrysostom and the Jews*, 88; Hahn, "Die jüdische Gemeinde."

ism and Christianity. The Christians who went to the synagogue and observed Jewish law believed that the Law given by Moses and recorded in Scriptures venerated and read by Christians placed an obligation on them.[104]

Thus, it is thus quite evident that the perception of a dormant and passive Diaspora life in Late Antiquity requires serious revision. Both literary sources and archaeological finds offer a strikingly different picture than heretofore known. Throughout Asia Minor, Syria, and beyond a new dimension of Diasporan reality has come into focus.[105] In many places, Jews and Christians continued to maintain friendly, if not cordial, relations with one another, and boundaries between them were often not firmly drawn, either in life or in death.[106] The synagogue continued to attract non-Jewish sympathizers until the fifth and sixth centuries as the institution maintained a vigorous communal life well into, if not throughout, the Early Byzantine era. Although some of the above evidence, such as Chrysostom's diatribes, has been known from time immemorial, it was only the more recent discoveries of archaeological and epigraphic data that have refocused attention beyond the obvious tensions between Jew and Christian, to the degree of coexistence and perhaps even cooperation between them in the Late Antique Diaspora.[107]

RECENT DEVELOPMENTS

The vitality of research on Late Antiquity over the past few generations is demonstrated by the continuous flow of new information coming to the fore. Just when a new consensus was crystallizing regarding the prosperity in the Byzantine East and Palestine, new facts and insights emerged to complicate somewhat the picture.

104. Wilken, *John Chrysostom and the Jews*, 94. On a similar evaluation regarding Jewish-Christian relations in Alexandria, see Haas, *Alexandria in Late Antiquity*, 121-27.

105. A fascinating Jewish community was located in the vicinity of Yemen in Late Antiquity; see Sedov, *Temples of Ancient Hadramawt*, 165-71. Emerging perhaps as early as the fourth century, with the conversion of the royal family to Judaism under Persian patronage, the community flourished over time and reportedly persecuted Christians until it was defeated by the Ethiopian kingdom, which had converted to Christianity and had the backing of the Byzantine authorities; see Bowersock, "Hadramawt between Persia and Byzantium"; Beaucamp, Briquel-Chatonnet, and Robin, "La persécution des chrétiens"; as well as Moberg, *Book of the Himyarites*; and, more comprehensively, Robin, "Himyar et Israël."

Jewish influence on its surroundings may also be evident in North Africa, where some Berbers are reported (albeit in later, medieval sources) to have adopted Jewish practices, even to the extent of converting to Judaism; see Sharf, *Byzantine Jewry*, 34-35; Hirschberg, *History of the Jews in North Africa*, 90-96.

106. T. Ilan, "New Jewish Inscriptions." For a Palestinian example of a mixed cemetery, see Magness and Avni, "Jews and Christians"; Avni, Dahari, and Kloner, *Necropolis of Bet Guvrin-Eleutheropolis*, 209-18.

107. Fredriksen and Irshai, "Christian Anti-Judaism," 985-98.

Three such developments reveal nuances recently introduced to our understanding of this era.

One such development, fueled in the main by new archaeological discoveries,[108] relates to the ongoing debate as to whether the prosperity under Byzantine rule was slowed, if not reversed, sometime in the mid-sixth century. Many factors have been cited to explain an apparent slump in economic growth in a number of places: the weakening of the eastern frontier defenses allowing, inter alia, for the Sasanian sack of Antioch in 540 and Apamea in 573; a series of natural disasters beginning with the pandemic of 541–42, which continued for decades in various locales; and, finally, repeated earthquakes (Procopius, *Wars* 2.22.1).[109] With respect to Palestine in particular, one might add the successive Samaritan revolts of the late fifth and sixth centuries.[110]

The extent and severity of these disruptions, however, are hard to gauge. One approach posits a crisis of major proportions that led to a discernible decline.[111] However, the evidence available has also been interpreted as indicating just the opposite, namely, that there was continuity in the prosperous Eastern cities—among the elites and in the hinterlands—throughout the fifth and sixth centuries, with major disruptions occurring only in the seventh, following the Persian and then Arab incursions and conquests.[112] More nuanced assessments have also been suggested, one claiming that prosperity and decline were coterminous,[113] and another that relates to these circumstances in terms of transformation rather than decline.[114]

A second recent development focuses specifically on the Galilee. A new study by Leibner has challenged the regnant assumption that this was an era of prosperity and growth throughout the Jewish communities of Palestine, and especially in the heart of Jewish Galilee, which was reputedly a flourishing rabbinic center at this time. Focusing on the eastern Lower Galilee and, more specifically, on the area west and north of Tiberias, Leibner's survey findings indicate a widespread abandonment of settlements from the mid-third to mid-fourth centuries. Twenty

108. For evidence of a sixth-century crisis in Scythopolis, see Tsafrir and Foerster, "Urbanism at Scythopolis-Beth Shean."

109. Parker, "An Empire's New Holy Land," 136–37. For a broader picture of the disturbances and crisis throughout the East in the fifth to seventh centuries, see Kennedy, "From *Polis* to *Madina*," esp. 17–27; Kennedy, "Last Century of Byzantine Syria."

110. See also above, n. 13. On the possible decline in southern Syria and northern Jordan, see Ma'oz, *Ghassānids and the Fall of the Golan Synagogues*.

111. Liebeschuetz, "End of the Ancient City"; Liebeschuetz, *Decline and Fall of the Roman City*, 249–317 (esp. 295–303), 400–16. Regarding the Jewish Golan, see Ma'oz, *Ghassanids and the Fall of the Golan Synagogue*, 48–88.

112. Foss, "Persians in Asia Minor," 721–43; Foss, "Syria in Transition." See also Whittow, "Decline and Fall?"

113. Kennedy, "From Polis to *Madina*"; Kennedy, "Last Century of Byzantine Syria"; Kennedy, "Antioch."

114. Ward-Perkins, "Continuists, Catastrophists." See also Haldon, *Byzantium*.

of the thirty-five settlements (cave dwellings and farmsteads as well as small and large villages and towns) disappeared, reaching a nadir of only thirteen settlements by the seventh century.[115] This conclusion is based on a study of pottery remains recovered in large enough samples (averaging over two hundred per site) that purportedly allow for a high degree of certitude.[116] Leibner has also drawn a number of sweeping conclusions, suggesting that this demographic crisis may be connected to several important events in contemporary rabbinic life—the disappearance of Palestinian sages after the fourth century, the hasty editing of the Yerushalmi, and the emergence of a written rabbinic tradition and a new aggadically oriented rabbinic agenda—phenomena that had been noted by others earlier but are now presumably supported by a demographic/settlement context.[117]

Leibner's findings have raised some far-reaching issues: assuming the accuracy of his data, how does one account for such a serious decline in settlement in light of the prevailing view that this was a prosperous and creative era? Was the decline limited to this specific rural area only, or did it reflect a wider region, including urban areas as well? Was this decline the result of economic, social, or religious pressures, or was it a matter of a redistribution of the population (to cities or elsewhere) owing to other forces?[118] Scholars have only now begun to grapple with the implications of these findings.[119]

A third surprising development, from the summer of 2007, is the discovery of what appears to be a large church in the very heart of Tiberias, dating to the turn of the fifth century. To date, only parts of its impressive polychrome mosaic floor decorated with geometric patterns and crosses have been uncovered, presumably part of a side aisle. The building was identified as a church by its excavators, Moshe Hartal and Edna Amos, on the basis of (1) a medallion containing a cross flanked by the Greek letters alpha and omega; and (2) a presumed reference to Jesus in one of the three Greek dedicatory inscriptions ("Our Lord, protect the soul of your servant"). Both the mosaic floor and inscriptions have been dated to the turn of the fifth century, the former on the basis of art-historical criteria, the latter on palaeographic grounds.[120] The fact that a bishop from Tiberias is noted for the first time

115. Leibner, "Settlement and Demography," and more comprehensively in Leibner, *Settlement and History.*

116. Leibner, *Settlement and History,* 61. Leibner has been excavating one of these sites, Khirbet Ḥamam north of Tiberias, whose finds seem to corroborate the results of his earlier survey. On the mosaics discovered there, see appendix to chap. 8.

117. Leibner, "Settlement Patterns," 277–92. On the editing of the Yerushalmi in the late fourth century in Palestine, see Sussmann, "Once Again Yerushalmi Neziqin," 132–33; Sussmann, "Oral Torah"; see, however, Strack and Stemberger, *Introduction,* 188–89.

118. As, for example, the consolidation or nucleation of lands by the wealthy urban aristocracy; see a recent discussion of this issue in Alston, "Settlement Dynamics."

119. See the critique of Magness ("Did Galilee Experience a Settlement Crisis?") and Leibner's response ("Settlement Crisis"). See also Magness, "Did Galilee Decline?"

120. R. Talgam was consulted on the artistic aspect, L. Di Segni regarding the epigraphy.

as participating in the Councils of Ephesus (449) and Chalcedon (451)[121] may lend some credence to this date, assuming that the construction of such a large building in the center of the city could be accomplished only by a vigorous local leadership together with, most probably, some sort of imperial backing.

This discovery is noteworthy not only because of its early date, but also because the building was large and located in the center of the city. It once had been assumed that Christianity's penetration into the heart of Jewish Galilee was a late phenomenon, dating to the latter fifth or, more probably, sixth century. This was based on the absence of archaeological data and the apparent success of the Jews in thwarting earlier efforts to build churches in this region, as reflected in the episode of Joseph the Comes in the early fourth century.[122] In light of this archaeological discovery, and owing to the lack of any contradictory evidence, it now seems that Christianity may have established a significant presence in Tiberias much earlier.[123] Interestingly, and perhaps ironically, this would have occurred at the height of the power and authority of the Jewish Patriarch then residing in Tiberias, and just when the Christians in Gaza were erecting a church in their city.

CONCLUSION

Our assessment of Jewish life under Byzantine Christianity in Late Antiquity has been radically altered owing to a more critical reading of the literary sources and the growing impact of the archaeological and epigraphic finds from the last half century. Notwithstanding the numerous instances of oppression, discrimination, and polemical attacks attested by Christian sources, these centuries also exhibit flourishing and stable local communities, as reflected primarily by the material remains and Genizah fragments.[124]

Palestine generally, and its Jewish communities in particular, seem to have flourished despite some evidence to the contrary regarding the extent and duration of this prosperity. There is no question, for example, that the disruptive events of the sixth and seventh centuries probably had an impact on political, economic, and social life, but it is impossible at present to measure its extent.

The dominant impression regarding Jewish Palestine in the Byzantine period, even taking into consideration Leibner's findings, is one of growth, prosperity, and stability. Synagogues were being erected throughout the province, and the Jews' proclivity for artistic expression was in evidence in varying degrees virtually every-

121. John I; see Le Quien, *Oriens Christianus*, 3:708; Fedalto, *Hierarchia ecclesiastica orientalis*, 2:1038.

122. Epiphanius, *Panarion* 30.11.1–4. On this source, see Rubin, "Joseph the Comes"; L. I. Levine, "Status of the Patriarch," 24–26; M. Jacobs, *Die Institution*, 308–12; Reiner, "Joseph the Comes."

123. As interesting as this discovery is, it is to be remembered that the excavation to date is only partial and that nothing has been published as yet.

124. For a fuller treatment of the Genizah materials, see the next chapter.

where, with highly visible architectural creations and artistic motifs in some sort of dialogue with the surrounding Byzantine-Christian motifs and models.

Matters were more complex in the Diaspora. Jews were more exposed to violence against their synagogue buildings and communities, as was the case in Magona. However, Jewish-Christian relations throughout the Roman Empire were also characterized by instances of mutual influence and, in not a few cases, even close relations. The diverse data from the Byzantine Diaspora reflect both the positive and negative dimensions of Jewish-Christian relations, and these varying and contrasting perspectives must be fully appreciated and weighed in our assessments of Late Antiquity.

With respect to the Jews themselves in Palestine and the Diaspora, evidence on both the individual and communal levels reveals a tenacity to preserve Jewish identity together with a willingness to accommodate and acculturate vis-à-vis the surrounding society. The balance between the two remained in the hands of the individual and the community, and this led to a fascinating mosaic of combinations and permutations.

The resultant picture thus seems somewhat untidy and ambiguous, offering different scenarios from place to place and from period to period. Indeed, such a reality would seem to reflect a very fluid situation during this era, one of transformation, readjustment, and realignment in all segments of Byzantine society, Jews included.

10. THE BYZANTINE-CHRISTIAN PERIOD AND ITS IMPACT ON JEWISH CULTURE

THE SEA CHANGE in our perception of Jewish life under Byzantine Christianity, from one of persecution and discrimination to that which also exhibits stability, creativity, and interaction with the surrounding culture, is sui generis in ancient Jewish history. Indeed, few time frames have undergone as radical a reconceptualization in modern Jewish historiography as have the last centuries of antiquity. Until the mid-twentieth century, this period was largely relegated to oblivion and accorded short shrift in surveys of Jewish history. At best, it was considered a mere addendum to the preceding talmudic age, which was thought to have ended, for all intents and purposes, in the late fourth or early fifth century in Palestine and somewhat later in Babylonia. These centuries were commonly viewed as marking the nadir of Jewish life in antiquity (indeed the Roman Diaspora was often entirely ignored), or, alternatively, as marking the onset of the Middle Ages.

THE POST-70 ERA IN JEWISH HISTORIOGRAPHY

The classic historiographical tradition among Jewish historians relating to the post-70 era was based entirely on rabbinic literature; given the regnant assumption of rabbinic dominance in Jewish society, the ensuing narrative virtually translated into a history of the talmudic rabbis themselves. Consequently, the entire period was at first divided into generations of sages from both Palestine and Babylonia (Graetz, *History of the Jews*), and even to this day the era is often referred to as the period of the Mishnah and the Talmud (70–500). However, breaking with this accepted historiography, Avi-Yonah set the boundaries of the period from the Bar-Kokhba revolt to the seventh century (135–640), but more importantly, he posited an alternative, nonrabbinic narrative for this era, entitling his book *In the Days of Rome and Byzantium* (Hebrew) and later, in English, *The Jews of Palestine: A Political History from the Bar Kokhba War to the Arab Conquest*.[1] This more inclusive approach was

1. Avi-Yonah's original Hebrew work appeared in 1946 and has gone through many reprints and subsequent editions; the English version was published in 1976. See Bowersock,

adopted in a series of historical volumes that appeared in Hebrew toward the end of the last century: *Eretz-Israel from the Destruction of the Second Temple to the Muslim Conquest* (2 vols.; 1982, 1984); *Sefer Yerushalayim: The Roman and Byzantine Periods, 70-638* (1999); and *The History of Eretz-Israel* (1981-85), in which the volume devoted to the era under discussion also adopts the 70-640 time frame with an internal subdivision set at 395.[2]

Several other publications covering this period opt for a second- or third-century watershed. Volume 3 of *The Cambridge History of Judaism*, devoted to the Early Roman period, marks the second century CE as its dividing point (p. xi), while the more recent volume 4, thoughtfully subtitled "The Late Roman-Rabbinic Period," deals with the entire 66-640 time frame, not infrequently breaking at 235.[3] Yet another collection of articles, *Christianity and Rabbinic Judaism*, begins its section on Late Antiquity around 220, presumably relating to the time the Mishnah was edited.[4]

Finally, a number of scholars from various disciplines designate the fourth century as the beginning of a new era. Dennis E. Groh, following Eric M. Meyers, suggests 363 as a watershed on the basis of archaeological data,[5] and several attempts were made to define rabbinic Judaism as having coalesced in this century in response to a triumphant Christianity—an idea first broached by Rosemary R. Reuther in the 70s of the twentieth century, followed by Jacob Neusner and, of late, Daniel Boyarin and Seth Schwartz.[6]

Despite these diverse attempts to define the six hundred or so years following 70 CE, none has yet gained a general consensus. For one, the events linked to a specific date (e.g., 70, 135, 220, 235, 324, 363, or 395) did not affect all Jews throughout the empire; nor did the fate of the Jews in Palestine necessarily overlap that of the Diaspora. Indeed, Babylonian Jewry was located in an entirely different political and cultural orbit than that of its coreligionists in the West. No less important is the fact that the above-noted suggestions were based on specific circumstances in Jewish life rather than on a comprehensive set of components at any single time. For example,

"Greek Moses," 34: "There is an unmistakable continuity in Palestine from the end of the Bar Kokhba war to the Persian invasion in the early seventh century. Avi-Yonah had it almost right."

2. Volume 5, entitled *The Period of the Mishnah and Talmud and Byzantine Rule*, thus combines two very different and somewhat contrasting terms—one internal and the other external. See Y. Dan, "Byzantine Period (395-640)," 234.

3. Horbury, Davies, and Sturdy, *Early Roman Period*; Katz, *Late Roman Period*.

4. Shanks, *Christianity and Rabbinic Judaism*.

5. E. M. Meyers, "Early Judaism and Christianity," 78-79; Groh, "Jews and Christians in Late Roman Palestine"; see also Magness, *Jerusalem Ceramic Chronology*.

6. Reuther, "Judaism and Christianity": "The classical form of both Judaism and Christianity was shaped by sages and theologians whose systems of thought found their fullest ripening in the fourth century after Christ" (p. 1); Neusner, *Death and Birth of Judaism*; Neusner, *Judaism and Christianity in the Age of Constantine*; Neusner, *Judaism in the Matrix of Christianity*; Boyarin, *Dying for God*, 1-21; S. Schwartz, *Imperialism and Jewish Society*, 179-289.

the dates suggested for a break in the third century focus primarily on internal events, and the criteria for selecting them seem to have been essentially religiously, literarily, and rabbinically based. The premise behind this selection—that the talmudic sages constituted a (if not *the*) decisive factor in Jewish life at this time—is controversial and often rejected today.[7]

One might legitimately ask whether there was indeed a historical watershed between 70 CE and the Arab conquest in the seventh century. Should this entire period be considered a single unit, as has often been done, or can we effectively make a case for a clear and justifiable break along the way?

THE METHODOLOGICAL CHALLENGE

The 70–640 era presents a complex historiographical quandary. From the middle of this era (fourth century CE), there is a radical change in the sources of information at our disposal. Until the fourth century, these are primarily rabbinic, while other literary material was decidedly marginal in quantity and importance. The archaeological material is likewise minimal, and for the second century it is almost nonexistent.[8]

However, this situation changes rather abruptly at the end of the fourth century; rabbinic sources (such as the Yerushalmi, which relates to specific people, places, and events) are no longer available to provide historical information, while new types of material from the later fourth through seventh centuries (such as mystical, magical, and apocalyptic literature, targumic sources, and *piyyutim*) now make their appearance. Moreover, non-Jewish sources relating to Jews and Judaism now surface in far greater numbers and diversity. The Theodosian Code, hagiographical literature, and writings of the church fathers and pagan authors such as Julian and Libanius all reveal a rich and variegated Jewish reality far different from that known in the preceding era. To this new literary pool one must add the very substantial archaeological data—from synagogues and cemeteries to extensive remains in the realm of art and epigraphy—almost totally unknown beforehand.[9]

Given the fact that different types of sources rarely address the same topics, and certainly not with the same emphasis or perspective, the question of continuity becomes most problematic. The implications of this shift in source material relating to Jewish society are enormous. For example, were certain hitherto unattested phenomena, surfacing for the first time at a later stage, a continuation of the past,

7. See, e.g., S. Schwartz, *Imperialism and Jewish Society*, 103–76, and Lapin, "Origins and Development of the Rabbinic Movement"; as well as chap. 20.

8. See E. M. Meyers, "Jewish Art and Architecture." Even the remains from the socalled third-century Bet She'arim necropolis can no longer be dated only to that century, as against the fourth, fifth, and perhaps even sixth centuries. See chap. 6.

9. The situation may be somewhat reminiscent of the dramatic change in the sources at our disposal from pre- and post-70 CE. See D. R. Schwartz and Weiss, *Was 70 CE a Watershed?*

or a break with it owing to new developments? Put differently, does new information appearing in later material reflect the emergence of something new, or simply something that may well have existed earlier but, for whatever reason, was not noted or was mentioned only peripherally?

What sort of evidence, then, do we need to posit that a late attestation indicates a late development, or that the lack of earlier evidence attests to its absence beforehand? Should the synagogues in the Byzantine period be viewed as an innovation simply because the overwhelming majority of archaeological finds date only from this later era?[10] The same may be asked regarding the flourishing of the Patriarchate in the fourth century.[11] Does such evidence indicate that the authority and prominence of the office crystallized only then?[12] It should be noted that the question at hand—continuity in Late Antiquity—does not address a situation in which the earlier period was a *tabula rasa* bereft of sources, as was the case with Jewish history in the late Persian and early Hellenistic eras; rather, it is one for which rabbinic literature provides a considerable amount of data no matter how biased or limited in scope it may be.

A corollary to the above is whether later information indeed corresponds to and supplements what was already known, even if only partially, thereby requiring us to assume that a later phenomenon had roots in an earlier stage. Inscriptions from the Byzantine period, for example, indicate that local communities wielded a great deal of authority and autonomy. May we assume that such autonomy existed earlier as well, even in the absence of similar epigraphic evidence, and that what does indeed exist is enough to be considered historically reliable? For example, the following two cases that preceded the Byzantine era seem to indicate a large degree of communal authority and religious identity: (1) the Tosefta notes that "members of a village (or town) can compel each other to build a synagogue or purchase a book (containing) the Torah and prophets" (Bava Metzia 11, 23, p. 396); (2) a Yerushalmi account relating to the third century tells of Simeon, a *sofer* (scribe, teacher, or translator) and student of R. Ḥanina, who was summarily dismissed by the local community for not following their instructions (Y Megillah 4, 5, 75b).[13]

Indeed, the appearance of large numbers of Jewish inscriptions in the Byzantine era complicates the situation. Both synagogues and cemeteries made extensive use of inscriptions to honor benefactors, preserve important texts, or indicate the names of those interred. Was this "epigraphic habit" a Byzantine phenomenon and,

10. See L. I. Levine, *Ancient Synagogue*, 174–209.

11. L. I. Levine, "Status of the Patriarch."

12. Nevertheless, there are some indications of a third-century prominence, i.e., the remains from Bet She'arim, the testimony of Origen, and the Stobi inscription (ibid., 13, 21–23), not to speak of a substantial number of suggestive rabbinic sources. See L. I. Levine, "Emergence of the Patriarchate."

13. See chap. 19.

if so, was it influenced by contemporary Christian practice?[14] However, it should be noted that inscriptions were used earlier as well, traces of which can be found in the cemeteries of Bet She'arim and Rome, in the Dura synagogue, and even in the necropolis of Second Temple Jerusalem. Thus, we should consider the possibility that such usage in a Jewish context was now only enhanced and was not a *creatio ex nihilo* of later centuries.

The above-noted issues clearly demand more than an a priori preference for either a diachronic or synchronic approach, or an assumption that the complexities of history can be reduced to an either/or choice.[15] A diachronic proclivity requires treating each instance individually in an effort to determine the extent to which there was something similar earlier on and whether a reasonable case can be made for a later phenomenon being a continuation of the past. A synchronic predisposition prioritizes the immediate historical context and assumes that it is the decisive factor in accounting for the appearance of a specific phenomenon; anything significant with no clearly attested predecessor must be attributed ipso facto to this new era and milieu. However, an intermediate position is also an option in certain cases, whereby a certain phenomenon existed earlier but was renewed, reshaped, or gained greater impetus owing to new circumstances, a situation that seems to hold true regarding artistic expression among Jews. Nevertheless, it would seem that any comprehensive account of the cultural expression in a given era requires some sort of amalgamation of these approaches.

THE BYZANTINE ERA AS A DISTINCT HISTORICAL
PERIOD IN JEWISH HISTORY

We will argue that the fourth to seventh centuries constitute a distinct era in Jewish history that finds ample expression in a wide variety of Jewish cultural endeavors. While the rise of Christianity was central to this era, deeply influencing many and diverse areas of Jewish life both directly and indirectly, not all of Jewish life was fundamentally transformed by Christianity, as has been suggested of late.[16] We will commence by noting the lines of diachronic continuity between the Late Roman

14. On the phrase "epigraphic habit," see MacMullen, "Epigraphic Habit." On the use of funerary inscriptions in the provinces as a reflection of Romanization and the desire for status in the Roman world, see Meyer, "Explaining the Epigraphic Habit."

15. See Bloch's comments on this issue: "Now, this real time is, in essence, a continuum. It is also perpetual change. The great problems of historical inquiry derive from the antitheses of these two attributes. There is one problem especially, which raises the very *raison d'être* of our studies. Let us assume two consecutive periods taken out of the uninterrupted sequence of the ages. To what extent does the connection which the flow of time sets between them predominate, or fail to predominate, over the differences born out of that same flow? Should the knowledge of the earlier period be considered indispensable or superfluous for the understanding of the later?" (*Historian's Craft*, 28–29).

16. S. Schwartz, *Imperialism and Jewish Society*, 15–16, 289–92.

and Byzantine eras and then address the more decisive synchronic dimension of the latter context.[17]

The Diachronic Dimension[18]

Some phenomena in the Byzantine era seem to have been a natural continuation of the preceding Late Roman period and thus do not require a synchronic rationale. In the economic realm, for example, it is generally acknowledged that the Byzantine era in Palestine benefited from an expanded Christian presence, which included the building of churches and the influx of pilgrims and monks. Yet, in the third century as well the local economy appears to have experienced prosperity, as reflected in the many building projects of cities and among a number of local ethnic and religious groups, Jews included.[19]

Continuity is likewise evident in Jewish settlement patterns. Remaining fairly constant from the late second century on, Jewish life centered in the Galilee (in particular its central and eastern regions) and, to a lesser extent, the Golan, with an additional concentration in and around Bet Shean, in the outlying areas of Judaea (to the south, east, and west), and along the coast. Tiberias and Sepphoris continued to function as the Galilee's major Jewish urban centers in the Byzantine era despite the fact that Christian communities were becoming more prominent in both places. The major languages used by Jews—Aramaic, Greek, and Hebrew—likewise remained constant,[20] and the model of local communal leadership carried over from the previous period (including the offices of the archisynagogue, archon, *parnas*, *ḥazzan*, and presbyter) and continued to operate throughout Late Antiquity.[21] Both rabbinic and epigraphic evidence from Palestine and the Diaspora attest to this continuity, and the former, as noted above, attests to a prevailing sense of community and communal autonomy from the earlier era.[22]

17. Our discussion regarding continuity will focus on Roman-Byzantine Palestine. The paucity of evidence for the Diaspora in the second and third centuries does not allow for any sort of meaningful comparison.

18. What follows may be viewed as an alternative approach to the issue of continuity in Jewish society of Roman Palestine or, as suggested by S. Schwartz (*Imperialism and Jewish Society*, Parts II and III), the lack thereof. Rather than posit a near-total collapse in communal and religious life following the disasters of 70 and 135, I would suggest a more nuanced appraisal of the Jewish component throughout these centuries: allowing for greater historical credibility of some rabbinic traditions; not overinterpreting the limited epigraphic evidence; and taking into account the implications of more recent archaeological finds (see below, n. 28).

19. For references, see pp. 192–93.

20. L. I. Levine, *Ancient Synagogue*, 371–75; Price and Misgav, "Jewish Inscriptions."

21. On these offices, see L. I. Levine, *Ancient Synagogue*, 412–53.

22. See above, as well as chap. 19.

The synagogue as a religious communal institution is a further instance of the diachronic dimension at play within Jewish communities in Late Antiquity,[23] and its activities are described in scores of literary, epigraphic, and archaeological sources for the first century CE.[24] Despite the reduced amount of archaeological and epigraphic material from the second and third centuries, contemporary rabbinic sources and remains from scattered archaeological sites attest to this institution's continued prominence, which would only grow in the coming centuries.[25] While many later Galilean structures were indeed of large proportions, the ongoing existence of the synagogue, its plethora of activities, and its ofttimes impressive size are duly recorded for the Late Roman period as well.[26]

The fact that much more is left of these buildings from the Byzantine period than from the preceding era requires an explanation. In the first place, impressive artifacts from later periods are inevitably more common, since the latest strata at a site are generally the best preserved; earlier ones have usually been destroyed by later construction. Indeed, every ancient city excavated in modern-day Israel (Caesarea, Bet Shean, and Sepphoris, for example) attests to this phenomenon, and this also holds true for Herodian Jerusalem as against its earlier Hasmonean, Hellenistic, Persian, and Judahite strata.

Moreover, it has been suggested that later Byzantine synagogues reused architectural elements from earlier buildings.[27] In most cases it is not clear from what sort of building these *spolia* were taken, although a public edifice seems to have been the most likely. Might this earlier structure have been a synagogue as well? Given the fact that our evidence comes primarily from village settings, and that the synagogue was indeed the communal institution par excellence, such *spolia* may well point to the existence of an earlier synagogue building.

23. L. I. Levine, *Ancient Synagogue*, 381–411.

24. See Runesson, Binder, and Olsson, *Ancient Synagogue*.

25. See, e.g., Y Megillah 3, 1, 73d, and, in general, L. I. Levine, *Ancient Synagogue*, 174–209.

26. See, e.g., ibid., 187–88, 206–8. The classic source in this regard is Y Sheqalim 5, 6, 49b (Y Peah 8, 9, 21b): "And R. Ḥama bar Ḥanina and R. Hoshaya were walking among the synagogues of Lydda. R. Ḥama bar Ḥanina said to R. Hoshaya: "How much money have my ancestors (lit., my fathers) invested here [in these buildings]?" The other responded: "How many souls have your ancestors lost here (lit., have they sunk here)? There are no people to study Torah!"

27. Over the last few years, Foerster, Aviam, and Ma'oz, inter alia, have noted that a number of later Byzantine synagogues used *spolia* from earlier buildings. This suggestion is confirmed by third-century rabbinic sources that discuss several cases in which residents wished to use stones from old synagogue buildings to build new ones (Y Megillah 3, 1, 73d). Moreover, such an approach would explain why late stratigraphic data exist alongside earlier art forms and styles. See Foerster, "Has There Indeed Been a Revolution?"; Aviam, "Ancient Synagogues at Bar'am"; Aviam, "Ancient Synagogue at Bar'am." On the proposed use of *spolia* at Capernaum, see Ma'oz, "Synagogue at Capernaum." See also Stemberger, "Jewish-Christian Contacts," 140 n. 38.

Indeed, the absence of archaeological evidence for synagogues in Roman Palestine between the late first and mid-third centuries now appears to be somewhat less severe than once assumed. Several recently excavated buildings from the first century CE (Qiryat Sefer and Modi'in) continued into the second, the early stage of the Nevoraya synagogue may stem from the second century, and at least one building (Khirbet Ḥamam) has been dated stratigraphically to the turn of the fourth century, with indications of a prior stage.[28] Added to these are several rabbinic traditions associated with third-century sages and synagogue buildings,[29] while a number of excavation reports note that the earliest stages of a number of later synagogue buildings (Bet She'arim, Sumaqa, Ḥorvat Rimmon, 'En Gedi, Ma'oz Ḥayyim, and possibly Ḥammat Tiberias) date to the third century, although in some cases the dating is not entirely certain.[30]

Finally, the presence of synagogues (however housed or wherever located) can likewise be safely inferred from the various communal functions that these buildings fulfilled (school, court, archive, place of meeting, and so on).[31] The Torah reading, sermon, *targum*, and communal prayer were central to the synagogue's religious agenda, and these components of Jewish liturgy had already begun to crystallize before the Byzantine era, some even prior to the destruction of the Second Temple.[32]

The Synchronic Dimension

Alongside these elements of continuity, there is no denying the fact that major changes took place in Jewish society of the Byzantine era. As noted, Jews now found themselves in an entirely new psychological, social, and religious environment as Byzantine rule moved toward greater homogeneity and the earlier multifaceted social and religious matrices of the Roman Empire were severely attenuated.[33]

This discontinuity between the Late Roman and Byzantine eras is likewise reflected in the leadership groups within Jewish society. The Patriarchate (de jure) and sages (de facto) were no longer functioning by the early fifth century, but how or whether they were replaced remains enigmatic. Was there a political and religious vacuum in Jewish leadership from the fifth to seventh centuries, or was the bulk of

28. On Modi'in and Qiryat Sefer, see L. I. Levine, *Ancient Synagogue*, 69–70; on Galilean Nevoraya, see E. M. Meyers and C. L. Meyers, *Excavations at Ancient Nabratein*, 35–44; and, finally, on the remains of two stages at Khirbet Ḥamam, see appendix to chap. 8.

29. Y Megillah 3, 1, 73d; Y Sheqalim 5, 6, 49b (Y Peah 8, 9, 21b).

30. However, one important result of Ben David's survey ("Late Antique Gaulanitis," 36–39) was that Late Roman settlements in the Golan that did not continue into the Byzantine era had no traces of a public building, i.e., a synagogue. Remains of the several dozen Golan synagogues, Gamla excepted, date only from the Byzantine era.

31. L. I. Levine, *Ancient Synagogue*, 381–411.

32. In chaps. 5–8 we suggested that a new kind of Jewish art first surfaced in the pre-Christian era (third century). These initial stages were to develop and expand further under Byzantine-Christian rule (see below).

33. This was particularly felt from the end of the fourth through the seventh centuries.

the decision-making process handled on the local, communal level throughout this period? Did some sages continue to function in this later period even though such activity remains unattested in any contemporary source? Were there other Jewish leaders, such as priests, who shaped or at least influenced parts of the religious, cultural, and spiritual landscape of Jewish society?[34]

The claim that the Byzantine period should be viewed as a separate historical era is significantly reinforced when one examines the changes and innovations in Jewish society that emerged at this time. It will be argued that almost all of these elements can best (and in many cases, only) be explained in terms of models and stimuli stemming from the wider Byzantine-Christian culture taking shape at this time. If this can be demonstrated, it would put to rest the counterclaim that all such developments were essentially diachronic, that is, rooted in the previous Jewish scene rather than related to the larger contemporary context.

Let us examine through the synchronic prism a range of phenomena emanating from the growing corpus of Jewish material and literary remains.

Burgeoning synagogue construction. Byzantine synagogues, as noted above, constitute the overwhelming majority of all synagogue remains in antiquity; they date from the fourth and fifth to seventh centuries and have generally been discovered in village settings. Perhaps not coincidentally, the construction of public buildings by both Christians and Jews took place almost simultaneously in rural areas. Thus there seems to have been a correlation between the erection of impressive synagogue buildings in the central and eastern parts of the Galilee and the building of churches in the western sector; the same holds true for the Golan, where all synagogues and churches date to the Byzantine era. What remains unclear is whether the building of synagogues at this time was a direct result of Christian activity, of a flourishing economic situation that encouraged such construction by both populations (and for a time the Samaritans as well), or a combination of both. The chronological and geographical propinquity, however, is too coincidental to ignore, and it therefore seems logical and compelling to link the intensive building of Galilean synagogues (many of which were monumental) with what was taking place in the nearby Christian sector.[35]

Synagogue architecture. Throughout Jewish history, synagogue buildings invariably reflect the prevalent styles and models of contemporary architecture. Most synagogues from the Byzantine period (for example, Bet Alpha) followed the basilica model used in the churches of that era, featuring a central nave, side aisles, an apse, a narthex, and a courtyard;[36] others appropriated variants of that model. Galilean-type synagogues such as the one in Capernaum may have been influenced

34. For a discussion of this topic, including a rich bibliography, see Irshai, "Priesthood in Jewish Society." See also Swartz, "Sage, Priest and Poet"; and chap. 13.

35. See, however, Runesson, "Architecture, Conflict, and Identity Formation," 245–57.

36. Tsafrir, "Byzantine Setting and Its Influence on Ancient Synagogues"; Milson, "Ecclesiastical Furniture."

by models once widespread in nearby Roman Syria in the second and third centuries, which later reappeared, *mutatis mutandis*, in churches of northern Syria and Egypt in the fifth and sixth centuries.[37]

Synagogue sanctity. The religious component of the synagogues in Palestine and the Diaspora became ubiquitous and prominent in the Byzantine era.[38] Rabbinic sources from the second and third centuries ascribe to the synagogue a degree of sanctity,[39] and this is already reflected in the material remains from mid-third-century Dura as well. How widespread this phenomenon was before the fourth century is impossible to determine for lack of evidence,[40] but from then on synagogues everywhere acquired a measure of sanctity, often to a significant degree, which was expressed in their orientation, art, and inscriptions.[41]

Whatever the role of the diachronic dimension in this regard, and it undoubtedly existed, we cannot ignore the fact that sanctity generally—of people, objects, and places—became paramount and universal only in Late Antiquity.[42] It is not difficult to imagine that Christian concern with holy places in the fourth century, the redefinition of Palestine as "the Holy Land," together with the sanctity attributed to churches affected the Jews[43] and that they were influenced by this widespread emphasis on the holy, introducing it into their synagogues as well.[44]

Piyyut. Religious poetry was a liturgical innovation in the Byzantine synagogue that flourished in the sixth and seventh centuries, although it may have already surfaced a century or two earlier.[45] Although the language and content of this literary genre drew heavily on earlier Jewish sources such as the Bible and midrash, the very appearance of this new form of liturgical poetry in Late Antiquity is significant. Extant sources offer no solid information as to why *piyyut* appeared at this time. While several medieval sources have attributed its creation to times of persecution and crisis, when communal prayers were supposedly forbidden,[46] modern scholars

37. Magness, "Question of the Synagogue," 33–37.

38. For a more detailed treatment of this phenomenon, see chap. 17.

39. L. I. Levine, *Ancient Synagogue*, 187–206; Fine, *This Holy Place*, 35–59.

40. The synagogue at Khirbet Ḥamam (see appendix to chap. 8) may well have acquired a measure of sanctity if the mosaic narrative fragments found there were indeed biblically inspired, as seems likely.

41. L. I. Levine, *Ancient Synagogue*, 236–42.

42. P. R. L. Brown, *Cult of the Saints*; P. R. L. Brown, *Society and the Holy*; P. R. L. Brown, "Rise and Function of the Holy Man"; Fowden, "Pagan Holy Man"; Markus, "How on Earth Could Places Become Holy?"

43. On the concept of the "Holy Land" in fourth-century Christianity, see Walker, *Holy City, Holy Places?*; Wilken, *Land Called Holy*.

44. L. I. Levine, *Ancient Synagogue*, 236–49; Kalmin, "Holy Men, Rabbis, and Demonic Sages"; Newman, *Ma'asim*, 53–57, 211–19; and chap. 17.

45. See L. I. Levine, *Ancient Synagogue*, 583–88.

46. See Bowman, "Jews in Byzantium," 1050.

have suggested that it evolved from prayer, earlier Hebrew poetry, or even the syna-
gogue sermon; nevertheless, all such suggestions are hypothetical, at best.[47]

However, the wider Byzantine setting must also be taken into account, as litur-
gical poetry flourished in contemporary Christian as well as Samaritan contexts.
Even the Hebrew words for this poetry (*piyyut*) and for its poet (*paytan*) are he-
braized Greek terms. Already in the mid-twentieth century, Hayyim Schirmann
and Eric Werner pointed out the many similarities between contemporary Jew-
ish and Christian poems, although the former assumed that it was *piyyut* that in-
fluenced Christian compositions.[48] Most recently, Ophir Münz-Manor has per-
suasively argued that the fourth and fifth centuries witnessed the simultaneous
emergence of Jewish, Samaritan, and Christian religious poetry (the latter in both
Syriac and Greek) that share many poetic, thematic, and conceptual characteristics.
The range of similarities clearly indicates that such parallels are part of a common
religious creativity in Late Antiquity that broke from all antecedents, be they bib-
lical, rabbinic, ancient Mesopotamian, or Greek.[49] Specifically, Romanos's poems
from the sixth century, especially his *kontakia*, have been compared to Yannai's *Qe-
dushta* that appeared at about this time.[50] Such parallels indeed suggest some sort of
indirect, if not more substantive, contact between these contemporary phenom-
ena.[51] One wonders if synagogue *piyyut* would have emerged expressly at this time
without the existence of a similar Christian or Samaritan genre. While a definitive
answer to this question is beyond the purview of our sources, I would suspect not.

Magic. The publication of documents on magic from the Cairo Genizah, together
with the relevant talmudic evidence and the discovery of related archaeological ma-
terial, have made it eminently clear that many Jews in Late Antiquity believed in
the efficacy of magical practices in solving their everyday problems.[52] What is strik-
ing is that similar practices—the use of amulets, incantation bowls, and literary

47. See the references in L. I. Levine, *Ancient Synagogue*, 584.

48. Schirmann, "Hebrew Liturgical Poetry"; Werner, *Sacred Bridge*, passim. Fleischer also
noticed a number of similarities but surmised that they were insignificant in determining
possible connections; see his "Early Hebrew Liturgical Poetry."

49. Münz-Manor, "Reflections"; van Bekkum, "New Liturgical Poetry of Byzantine Pal-
estine; idem, "Future of Ancient Piyyut."

50. Yahalom, *"Piyyût,* as Poetry," 122; Yahalom, *Poetry and Society*, 199–200.

51. Van Bekkum, "Anti-Christian Polemics"; de Lange, "A Thousand Years of Hebrew,"
149–50; Lieber, *Yannai on Genesis*, 205–25.

52. Alexander, "Incantations and Books of Magic"; Schäfer, "Jewish Magic Literature";
Schäfer, "Magic and Religion." See also Naveh and Shaked, *Magic Spells and Formulae*, 17–39;
Schiffman and Swartz, *Hebrew and Aramaic Incantation Texts*, 11–62; M. J. Geller, "Decon-
structing Talmudic Magic"; Harari, *Early Jewish Magic*, passim; Swartz, "Jewish Magic";
Bohak, *Ancient Jewish Magic*, 143–226; Bohak, "Jewish Magical Tradition," 324–42; Sperber,
Magic and Folklore; Veltri, "Magic and Healing"; Vilozny, "Figure and Image in Magic and
Popular Art"; and see chap. 9, n. 99. On the prominence of Jewish magicians at this time, see
Lacerenza, "Jewish Magicians and Christian Clients."

forms, as well as soliciting heavenly forces (usually angels) with similar ritual ceremonies (often accompanied by prayer or some other sort of incantation)—were also popular among pagans and Christians at this time.[53] Indeed, engaging in practical magic appears to have been universal in Late Antiquity, appealing to intellectual elites (rabbis, Christian clergy, and Neoplatonists) no less than the people at large.[54]

Astrology. Jewish interest in astrology from the Second Temple period through Late Antiquity has merited scholarly attention over the last several generations.[55] Both literary sources and archaeological material have contributed to this growing corpus of evidence, beginning with Qumran and including fragments of Late Antique astrological texts from the Cairo Genizah.[56] The Jews were indeed part of the astrological discourse of the age, making use of the Greco-Roman material then in circulation while adding certain elements having a distinct Jewish character, such as Hebrew words for identifying the zodiac signs.[57]

Apocalyptic literature. A number of Jewish apocalyptic compositions (for example, *Sefer Zerubbabel*) were written in the late sixth and early seventh centuries, very likely in response to the unsettling conditions of the time and especially the military confrontations between Persia and Byzantium.[58] Following Daniel, these wars were perceived as a struggle between two empires that would precede the end of days and usher in the messianic era (Daniel's fifth kingdom).[59] Similar eschatological responses to the Persian conquest of Jerusalem are to be found among Christians as well.[60] Thus, both Jewish and Christian writers reacted to similar contemporary political upheavals, each from his own religious perspective.

53. Goodenough, *Jewish Symbols*, 2:153-295; see Veltri, "Rabbis and Pliny the Elder." Regarding the influence of Mesopotamian magical practices on the Babylonian community, see Gafni, "Babylonian Rabbinic Culture," 238-53; BeDuhn, "Magical Bowls and Manichaeans." On the connection between Greco-Egyptian magic and the Palestinian material, see Margalioth, *Sepher Ha-Razim*, 1-22; Schiffman and Swartz, *Hebrew and Aramaic Incantation Texts*, 28; Lesses, *Ritual Practices*, 13-17, 362-65, 377-79; Stratton, "Mithras Liturgy and Sepher Ha-Razim."

54. See H. Maguire, *Byzantine Magic*, especially the first chapters that discuss the early Byzantine Empire.

55. See, e.g., Charlesworth, "Jewish Interest in Astrology"; Greenfield and Sokoloff, "Astrological and Related Omen Texts"; von Stuckrad, "Jewish and Christian Astrology."

56. For recent studies of the *locus classicus* in the Bavli dealing with astrology, see Rubenstein, "Talmudic Astrology"; Gardner, "Astrology in the Talmud"; Kalmin, "Late Antique Babylonian Rabbinic Treatise on Astrology." See also Kalmin, "Problems in the Use of the Babylonian Talmud."

57. See Epiphanius, *Panarion* 16.2.3-5.

58. See Reeves, *Trajectories in Near Eastern Apocalyptic.*

59. See Ibn-Shmuel, *Midreshei Geulah*, 1-liv; Silver, *History of Messianic Speculation*, 30-49; Baron, *Social and Religious History of the Jews*, 3:16-17.

60. Stemberger, "Jerusalem in the Early Seventh Century." See also Irshai, "Dating the Eschaton."

Hekhalot literature. Although there has been a general consensus of late that the traditions found in this literature were already crystallizing by Late Antiquity,[61] significant differences of opinion remain regarding the role of the Byzantine-Christian orbit in this development. Some scholars posit continuity from the Second Temple era, while others suggest a Late Antique context for this genre, yet it is the former view that has held sway until now,[62] namely, that the mystical lore and the mystical experience of Hekhalot literature is less a product of Late Antiquity and more a continuation of earlier Jewish traditions.[63]

Nevertheless, it has been noted, in fact, that the Hekhalot traditions offered another type of mystical orientation that involved a heretofore unknown religious experience.[64] This included, inter alia, an ascent to the highest reaches of the heavenly sphere owing to the mystic's active ritual technique; the extreme dangers of the ascent due to hostile angels, requiring a mastery of theurgic practices; highlighting a mythic "rabbinic" past (and not a biblical one); the importance of Israel's *Qedushah* (holiness) prayer to God even more than similar angelic prayers; God's love for Israel that exceeded His love for the angels; and the return of the mystic to this world in order to share these experiences with others and teach them how to attain them as well.[65] Raanan Boustan has recently argued that only Hekhalot-style motifs and shorter compositional units existed in Late Antiquity, but Hekhalot literature proper should be dated to the early Islamic era.[66]

Whatever the case, in attempting to balance continuity and innovation in the mystical traditions of Late Antiquity, it seems rather certain that this period witnessed a surge of activity in developing the theory and practice of mysticism, among both Jews and Christians.[67] In fact, some interesting parallels have been suggested

61. Swartz, *Mystical Prayer*, 211–23; Lesses, *Ritual Practices*, 13–17, 279–370; Lesses, "Speaking with Angels"; J. Dan, *Jewish Mysticism*, 1:ix–xxvii. See also Elior, *Three Temples*, 232–63; Elior, "Early Forms of Jewish Mysticism"; Stemberger, "Non-Rabbinic Literature," 30–36. For a fine overview of the issues involved in the study of Hekhalot literature, see Boustan, "Study of Heikhalot Literature."

62. For views in favor of continuity, see Scholem, *Major Trends in Jewish Mysticism*, 40–79; Gruenwald, *From Apocalypticism to Gnosticism*; Alexander, *Mystical Texts*, 128–38; Elior, "From Earthly Temple to Heavenly Shrines"; Elior, *Three Temples*, 232–63; Elior, "*Hekhalot* and *Merkavah* Literature"; Elior, "Early Forms of Jewish Mysticism."

63. On the question of the continuity as well as transformation of mystical traditions between Qumran and *Hekhalot* literature, see Swartz, "Dead Sea Scrolls."

64. See Schäfer, *Origins of Jewish Mysticism*, 243–330, 339–48; Himmelfarb, "Heavenly Ascent"; Stroumsa, "Religious Dynamics," 160–61; Stroumsa, "'To See or not to See.'"

65. See Hekhalot Rabbati, in Schäfer, *Synopse zur Hekhalot-Literatur*, nos. 169, 198–230.

66. Boustan, "Emergence of Pseudonymous Attribution," 26–27, especially with regard to the rabbinic attributions in this literature.

67. It is well known that mystical approaches in Christianity, existent almost from its very inception, were being articulated at this time. A series of third- and fourth-century writings have been preserved, and arguably the most important Christian mystical writer from the

regarding the role of the Byzantine-Christian context in the development of contemporary Jewish mysticism[68] as well as the role of Byzantine-Christian chronographers in the transmission of earlier Second Temple pseudepigraphic sources to the authors/editors of later mystical and midrashic works.[69]

Aggadic midrashim. The Byzantine period witnessed the appearance of a new rabbinic genre—aggadic *midrashim*—the earliest of which date to the fifth and sixth centuries: Genesis Rabbah, Leviticus Rabbah, Pesiqta d'Rav Kahana, Lamentations Rabbah, and perhaps others.[70] Virtually all we know about Palestinian rabbinic culture at this time comes from such *midrashim* (the only halakhic work being the *Ma'asim*, a collection of court decisions and responsa),[71] indeed a far cry in content and quantity from the mainly (though not exclusively) halakhic works of the third and fourth centuries.

How can the emergence of this important rabbinic literary genre at this time be explained?[72] Perhaps one should view these collections of commentaries and sermons focusing on the Bible as parallels to the commentaries and sermons (*catena*) of the contemporary church fathers. Was this type of Jewish creativity influenced by Christian practice? Alternatively, were these similar literary works by Jews and

Roman East in Late Antiquity is an unknown author referred to as Dionysius the Areopagite (after Paul's Athenean convert—Acts 17:34) who lived ca. 500 CE. See McGinn, *Foundations of Mysticism*, 157–82, and the bibliography cited therein; as well as Versluis, *TheoSophia*. See also Barasch, *Icon*, 158–82.

68. On Christian tradition's similarities and parallels to the Hekhalot literature, see Stroumsa, "Religious Dynamics," 160–61; Stroumsa, "'To See or not to See.'" The differences between these mystical traditions, however, are no less pronounced; for example, the Hekhalot's images of palaces (or temples), its emphasis on the inimical forces opposing the mystic, and the absence in the Christian context of an earthly institutional framework (e.g., the synagogue), enabled and enhanced the celestial experience. However, given the limited data at our disposal, the connections, if any, that existed between the Christian mystical world and Hekhalot traditions have yet to be adequately explored. See also Alexander, *Mystical Texts*, 142–43.

69. See the suggestive study of Reed, "From Asael and Šemihazah," esp. 132–36; Reed, *Fallen Angels*, 13–16, 233–77. For a similar avenue of transmission from a slightly later period, see Himmelfarb, "R. Moses the Preacher," 55–78. See also Adelman, *Return of the Repressed*, passim and esp. 132–35.

70. Strack and Stemberger, *Introduction to the Talmud and Midrash*, 300–22; Shinan, "Late Midrashic, Paytanic, and Targumic Literature," 678–91.

71. Bokser, "Annotated Bibliographical Guide," 222–23; Strack and Stemberger, *Introduction to the Talmud and Midrash*, 185; Newman, *Ma'asim*.

72. The intensive concern with aggadah in Palestinian rabbinic circles in contrast to Babylonian sages has sometimes been explained by the need of rabbis there to counter local Christians and polemicize with them, following the well-known story of R. Abbahu and R. Safra in B 'Avodah Zarah 4a. Whatever the merits of this explanation, it does not account for the creation of literary compositions focusing on this genre at this particular time.

Christians a product of a common zeitgeist that yielded similar responses in both religions?[73]

Turning to aggadah may have been a Jewish response (rabbinic, though perhaps also more general) to the changing circumstances of Jewish life in the fifth to seventh centuries. One midrash from this period, Pesiqta d'Rav Kahana, quotes third-century R. Isaac:

> R. Isaac said: "At first, when there was ample money, a person would desire to learn some Mishnah or Talmud; but now, when there is a paucity of money and, moreover, we suffer [oppression], from the kingdoms, a person desires to learn Bible or aggadah." (12, 3, p. 205)

Whatever third-century situation R. Isaac might have envisioned (assuming the authenticity of this attribution), his words were very apt for a fifth- to sixth-century composition. The pressures of Christian rule at the time might well have been an important catalyst in the rise of aggadic study and the production of aggadic compilations. If this line of reasoning be granted, then the change in the rabbinic agenda toward the end of Late Antiquity was very much tied not only to Jewish circumstances but also to the Byzantine context and the literary practices of many church fathers.

Jewish art. Finally, the phenomenon of a unique Jewish art is a significant innovation of Late Antiquity. Although this art had appeared already in the third century, a far wider range of art forms gained popularity under Byzantine Christianity, and many of the most common motifs in Jewish art found their parallels in the Byzantine-Christian world.[74] For example, the widespread use of the menorah throughout the Jewish world—in synagogues, cemeteries, and domestic settings—was in no small measure a reaction to Christianity. Most striking in this respect is the menorah's appearance on objects precisely where the cross appears in a Christian context.[75]

Given the revolution transpiring under Byzantium, when the territorial empire of Rome was becoming a religious realm centered in Constantinople, religious identity emerged as a primary factor in the art of Late Antiquity. Consequently, Jews began using symbols and creating artistic forms in sync with their neighbors to bolster their self-identity.[76]

The artistic dimension demonstrates that the surrounding society in large part stimulated Jewish creativity and innovation in Late Antiquity. While Jews were just beginning to develop these cultural expressions as part of the religious ferment in

73. See Stemberger, "Exegetical Contacts"; Stroumsa, "Religious Dynamics," 165–67.

74. See chaps. 11–17, as well as A. Ovadiah, "Mutual Influences"; Hachlili, "Aspects of Similarity and Diversity"; Vitto, "Interior Decoration"; Talgam, "Similarities and Differences."

75. On this and other examples, see L. I. Levine, "History and Significance of the Menorah," 149–51; and chap. 17.

76. See chap. 22.

the third century, under Byzantium—both in the face of a hostile Christianity and, perhaps ironically, stimulated by Christian artistic models—they nurtured them far more extensively.

CONCLUSION

The above discussion, which incorporates examples of continuity from an earlier period and change engendered by contact with the Byzantine world, may facilitate our understanding of the uniqueness of Late Antiquity in Jewish history. Consequently, it would seem that a strong case can be made for the decisiveness of the synchronic dimension in accounting for the appearance of a wide range of cultural and communal phenomena in Jewish society at this time.[77]

The rise of Christianity inaugurated a new era for Jews, which would continue for some three hundred years, until the Arab conquest. Throughout Late Antiquity Jews were actively engaged in a broad range of cultural areas, stimulated primarily by the triumph of Christianity and its penetration into all corners of the empire and areas of life.[78] Despite the church's drive for compliance and unity, the Byzantine Empire remained fairly heterogeneous, not only among orthodox Christians but with regard to others as well. J. Hillis Miller has aptly noted the complexity of each period in this light: "Periods differ from one another because there are different forms of heterogeneity, not because each period held a single coherent view of the world."[79] The unique diversity of this period accorded it a special character; it was a Roman milieu under Christian rule, but still less rigid and ideologically driven than what was to crystallize in the Middle Ages.

If the term *Late Antiquity* points to processes of renewal, vitality, and creativity in Late Antique society generally, then it is not difficult to identify similar developments within the Jewish sphere as well. Instances of Jewish innovation in the material and literary realms can be most fully appreciated only if viewed in the wider historical context in which they coalesced, namely, the Byzantine-Christian orbit. This multifaceted creativity and resilience, together with the vulnerability that now enveloped Jewish life, characterized this particular era in ancient Jewish history.

77. The reactions of Jews to external stimuli might take one of several forms (and often more than one form at any given time): an imitation of Christian models; a parallel development as part of the prevailing zeitgeist; a rejection of these influences; and not infrequently a combination of the above, such as borrowing ideas and patterns while adapting them—sometimes significantly—to a Jewish framework. See also chaps. 11, 16–17.

78. Morony, "Teleology."

79. J. H. Miller, "Deconstructing the Deconstructors," 31.

IV

THE FLOURISHING OF JEWISH ART
IN THE BYZANTINE-CHRISTIAN ERA

11. SYNAGOGUE ART IN LATE ANTIQUITY

An Overview

BYZANTINE PALESTINE

Jewish art, especially mosaics, flourished in Late Antiquity as never before, much in keeping with the artistic productivity throughout the Byzantine world.[1] We will now present an overview of this art, which will be followed by more detailed treatment of the most important sites and salient motifs. The range of artistic and architectural expression is quite varied. Indeed, despite geographical propinquity, Capernaum is worlds apart from Ḥammat Tiberias, as Reḥov is from Bet Alpha and Jericho from Naʿaran. The cluster of synagogues in sixth-century Bet Shean and its environs is a striking case in point, as they differ from each other in almost every conceivable category.[2] This heterogeneity is also exhibited in synagogue architecture generally. While scholars had once assumed that certain architectural styles of Palestinian synagogues were representative of different periods, positing that chronology and typology went hand-in-hand, today this theory has been largely eschewed and has been replaced by the realization that a variety of tastes and styles existed simultaneously throughout this era.[3] Synagogues featuring a Galilean-type basilical plan were constructed alongside those with apses and broadhouse-type plans, while pagan images in some synagogues existed concurrently with those whose representations exhibited a marked degree of reservation, if not opposition, to such figural displays.

We will divide the principal remains of Jewish art in Byzantine Palestine into three distinct types of ornamentation—architectural decorations, mosaic floors, and frescoes.[4]

1. Bowersock, *Mosaics as History*, 1–13.

2. See chap. 19.

3. See L. I. Levine, *Ancient Synagogue*, 319–26.

4. Previous overviews appear, inter alia, in Goodenough, *Jewish Symbols*, vols. 1–3; Maʿoz, "Art and Architecture"; Hachlili, *Ancient Jewish Art and Archaeology—Israel*, 199–224; Foerster, "Ancient Synagogues of the Galilee"; A. Ovadiah, "Art of the Ancient Synagogues."

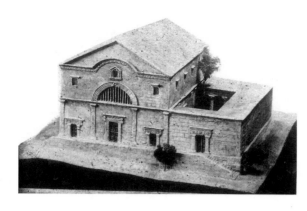

FIG. 76 Suggested recon-
struction of the Capernaum
synagogue.

Architectural Decorations

The most impressive architectural decorations, featuring ornate exteriors and frequently decorated interiors, were discovered mainly in the synagogues of the Upper Galilee (also known as the Galilean type) and Golan. The relief carvings of these buildings were featured on a number of architectural elements—facades (such as door and window jambs as well as gables), lintels, friezes, and capitals—and drew heavily on the regnant decorative style in Late Roman Syria, which continued to appear, though more modestly, in Syrian and Egyptian churches of Late Antiquity.[5]

Facades. Aside from the entrance's ornate doorposts and lintels, the facades of these synagogues were regularly decorated with aediculae, conches, or niches, often crowned with gables (fig. 76). As these were typical architectural motifs of Roman public buildings, such synagogue facades blended in with the eastern Roman scene. A fascinating talmudic discussion, found however only in the Bavli, revolves precisely around such a situation: Is a person who bows before a building that happens to be a pagan temple (thinking it is a synagogue) guilty of transgressing intentionally (since he did intend to bow) or unintentionally (not realizing it was a pagan temple)?[6] Clearly, the assumption here is that the two types of buildings looked so much alike that it was hard to distinguish between them.

Lintels. Among the motifs that often adorned the lintels of synagogue entrances were wreaths (possibly flanked by *nikae*), eagles, rosettes, or amphorae, and less frequently *menorot*. At times the wreaths enclosed a rosette or vines with clusters of fruit.

Friezes. Synagogue friezes usually displayed architectural motifs common in Hellenistic and Roman repertoires, and included rosettes, five-and six-pointed stars, egg-and-dart motifs, meanders, interlaces, dentils, Hercules knots, and shells. Floral motifs took the form of vines, wreaths, garlands, palm trees, and, especially in

5. Hachlili, *Ancient Jewish Art and Archaeology—Israel*, 205; Magness, "Question of the Synagogue," 33–34.

6. B Shabbat 72b. See also B Sanhedrin 61b, as well as L. I. Levine, *Ancient Synagogue*, 325–26.

Capernaum and Chorazin, "peopled" acanthus scrolls containing lions, fruits, rosettes, and putti (or *erotes*). There are also a number of unusual representations, such as a series of scenes depicting the wine harvest (Chorazin), once interpreted by Goodenough as the Jewish equivalent of the Dionysus ritual;[7] mythological figures such as Zeus-Serapis, Heracles, centaurs, Capricorn, and Medusa (Chorazin and Capernaum); and a wagon with end doors, a gable, and a conch displaying columns along its side (Capernaum), often interpreted as either a portable Torah shrine or the ark of the Wilderness Tabernacle.[8]

Capitals. Of the three orders of capitals, Doric, Ionic, and Corinthian, it is the last that appears most often in synagogues. Only on rare occasion did a Corinthian capital bear a menorah (sometimes with other ritual objects) or a wreath and branches. An unusual capital in Umm el-Qanatir in the Golan has the shape of a basket.

There are also a number of variations in these architectural motifs. For instance, the lavish decorations at Chorazin and Capernaum are unmatched in any other Galilean-type building, and there are also some interesting and significant differences between the Capernaum and Chorazin buildings themselves.[9]

Furthermore, although the Galilean and Golan synagogues share many similarities, there are also substantial differences between them.[10] For one, while Jewish religious symbols (especially the menorah) appear in some of these synagogues, notably in Capernaum and the Golan, their number and variety are limited.[11] In contrast, they are virtually nonexistent in all the other Galilean-type synagogues, perhaps because the rural communities in the Upper Galilee, being relatively isolated from the cosmopolitan cities and non-Jewish populations in the region, felt less of a need to adopt such symbols. An exception is a presumed Torah shrine in the synagogue of Nevoraya, with carvings of two lions climbing the sides of its gable.[12]

Figural representations appearing in these Galilean and Golan synagogues include lions, eagles, fish, birds, and griffins, as well as human and mythological figures such as a soldier, grape-harvest workers, centaurs, and *nikae*. Some figures on stone have been interpreted as vestiges of zodiac signs.[13] Finally, a figure often considered to be David appears in a mosaic floor in the Galilean synagogue of Merot.[14]

7. Goodenough, *Jewish Symbols*, 1:194.

8. Ibid., 1:187–88. On the ark generally, see Revel-Neher, *L'Arche d'Alliance*, 81–86, 115–31.

9. Hachlili, *Ancient Jewish Art and Archaeology—Israel*, 218–20; May, "Decor of the Korazim Synagogue Reliefs," esp. 155 (Hebrew; English summary); Amir, "Style as a Means of Periodization," 42–48.

10. Hachlili, *Ancient Jewish Art and Archaeology—Israel*, 230–31. See Ma'oz, "Art and Architecture"; Amir, "Style as a Means of Periodization," 32–42, 48–49.

11. Ma'oz, "Art and Architecture," 111–12.

12. E. M. Meyers, "Nabratein," 1078. Some motifs have been arguably understood as representing the seven species of grains and fruits associated with the Land of Israel per Deut. 8:8.

13. See Z. Ilan and Damati, *Meroth*, 47, and bibliography cited there.

14. See chap. 17.

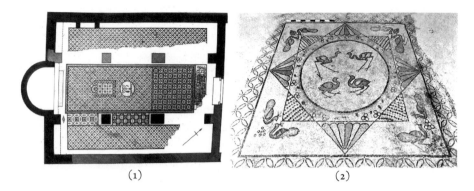

FIG. 77 Mosaic synagogue floors: (1) Jericho; (2) 'En Gedi.

Animal representations carved in stone are generally regarded as two-dimensional, although instances of three-dimensional figures, usually lions, have been found and interpreted as statues originally placed next to the Torah shrine.[15]

Mosaic Art

Beyond the bounds of the Upper Galilee and Golan, synagogues bore less imposing exteriors although their interiors tended to be quite ornate, primarily owing to the use of mosaics.[16] Such floors were found throughout Palestine—even from the Upper and Lower Galilee but especially southward, including the Sea of Galilee and Bet Shean areas, the Jordan Valley, the coastal region, and southern Judaea. These mosaics included a wide variety of motifs and designs, from relatively simple ones featuring geometric patterns (as in Jericho, 'En Gedi, and Reḥov) to more sophisticated motifs and figural scenes.[17] The earliest traces of mosaic floors in a synagogue context date to the late third century ('En Gedi, Khirbet Ḥamam, Ḥorvat 'Ammudim, and perhaps Stratum I of Ḥammat Tiberias), but it was only from the fourth century on that the use of figural representations became widespread. This development, as reflected in archaeological finds, dovetails neatly with one rabbinic

15. One such arrangement is attested in Sardis. See chap. 15. The most striking testimony we have of statuary in synagogues comes from the Bavli, where we read of two leading sages, Rav and Samuel, who had no compunction about praying in a Nehardea synagogue that contained a statue of a human figure (B Rosh Hashanah 24b). See also the same account regarding Samuel's father and one Levi in B 'Avodah Zarah 43b. On this synagogue, see Krauss, *Synagogale Altertümer*, 214–19; Oppenheimer, *Babylonian Judaica*, 290–91.

16. Bowersock has described this medium as "widespread in the late-antique Mediterranean world. The explosion in the popularity of this kind of interior design was by no means confined to the Near East"; see Bowersock, *Mosaics as History*, 113. See also R. and A. Ovadiah, *Hellenistic, Roman, and Early Byzantine Mosaic Pavements*; Hachlili, *Ancient Mosaic Pavements*.

17. See chaps. 12–14.

tradition: "In the days of R. Abun (fourth century) they began depicting [figural images] on mosaic floors, and he did not object."[18]

Beginning with the late fourth-century synagogue at Ḥammat Tiberias, most mosaic floors were divided into three panels. This pattern, though widespread in Palestinian synagogues, was nonetheless a unique arrangement when compared to local churches; however, a number of synagogue sites feature an overall carpet with no internal divisions. Jericho is one such example, depicting geometric and floral designs as well as a stylized Torah chest in the center, while 'En Gedi displays four birds in the center of the mosaic surrounded by a carpet of geometric designs (fig. 77). The floors of three synagogues—Gaza, nearby Ma'on, and Bet Shean B—are decorated with another kind of carpet containing an inhabited scroll pattern. This featured vine tendrils issuing from an amphora, creating a series of medallions enclosing, inter alia, baskets of bread and fruit, cornucopiae, clusters of grapes, flowers, animals, and birds, as well as a central row in the center of the mosaic depicting a variety of bowls, vases, and baskets containing fruit and cages holding birds.[19]

The most striking motifs on the mosaic floors of Palestinian synagogues are the depictions of Helios and the zodiac signs on the one hand, and the cluster of Jewish symbols on the other (see chap. 17, fig. 117).[20] This widespread display of religious symbols stands in sharp contrast to those in the above-noted Galilean-type buildings, where there is a relative dearth of such representations. Biblical scenes are less common than these symbols, although they appear nonetheless in disparate regions of the country and include the *'Aqedah* (Bet Alpha, Sepphoris), David (Gaza and probably Merot), Daniel (Susiya, Na'aran, and perhaps 'En Semsem in the Golan), Aaron and the Tabernacle-Temple appurtenances and offerings (Sepphoris), and possibly symbols of the tribes (Japhia).[21]

Mosaic art offers some fascinating instances of the artistic commonality between Jewish and Christian communities in Palestine and Provincia Arabia.[22] Similarities are evident in all types of representations, from geometric and floral patterns to depictions of birds, fish, animals, and humans, as well as inhabited scrolls.[23]

A remarkable instance of this similarity can be found in the mosaic floors of the Gaza and Ma'on synagogues on the one hand and the Shellal church on the other, all dating to the sixth century CE and located close to each other geographically

18. Y 'Avodah Zarah 3, 3, 42d; the Genizah fragment of this tradition is published by Epstein, "Yerushalmi Fragments," 20.

19. See Hachlili, *Art and Archaeology—Israel*, 347–69; Hachlili, *Ancient Mosaic Pavements*, 111–47.

20. For a more detailed discussion of these motifs, see chaps. 16 and 17.

21. See chap. 17, as well as A. Ovadiah, *Art and Archaeology*, 481–509. The identification of the Japhia depictions as tribal symbols was first suggested by Sukenik ("Ancient Synagogue at Yafa," 18–23; see also Barag, "Japhia") contra Goodenough (*Jewish Symbols*, 1:216–18), who views them as having been originally a zodiac motif.

22. Hachlili, *Ancient Mosaic Pavements*, 219–42.

23. See ibid., 111–47.

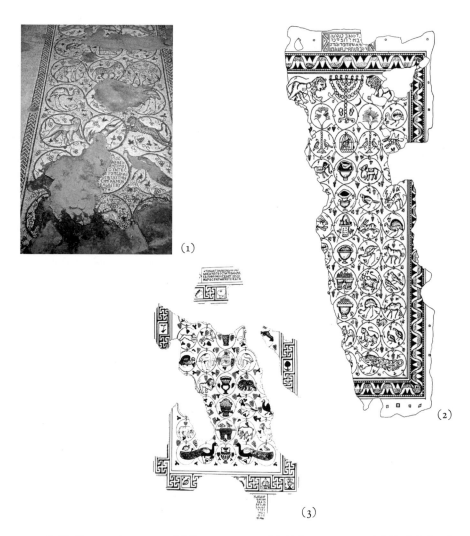

FIG. 78 Similar mosaic patterns: (1) Gaza synagogue; (2) Ma'on synagogue; (3) Shellal church.

(fig. 78). The patterns and motifs of these floors are so similar that Avi-Yonah once surmised that their art was executed in the same Gazan workshop. Although this particular suggestion has met with some criticism, there is little disagreement as to the unusual resemblance between them.[24]

A number of striking similarities in contemporary Jewish and Christian art are also found in scenes of religious import. One such instance involves the use of religious symbols on mosaic floors despite the official church ban of 427 concerning

24. Avi-Yonah, *Art in Ancient Palestine*, 389–95; Avi-Yonah, "Mosaic Pavement of the Ma'on Synagogue"; Hachlili, "On the Gaza School of Mosaicists"; Hachlili, *Ancient Jewish Art and Archaeology—Israel*, 310–16; Hachlili, *Menorah*, 251–62; N. Stone, "Notes on the Shellal Mosaic"; A. Ovadiah, "Mosaic Workshop of Gaza."

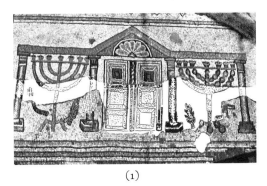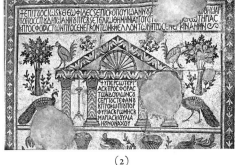

(1)　　　　　　　　　　　　(2)

FIG. 79 Similar depictions of facades: (1) Susiya synagogue; (2) Chapel of the Priest John, Mount Nebo.

such displays.[25] A second example is the Temple facade appearing both in a sixth-century church on Mount Nebo in Jordan and in the Susiya synagogue in southern Judaea (fig. 79); it has been suggested that the latter may have borrowed this motif from this church or possibly from a common pattern book.[26] In our discussion of Bet Alpha below, we note that Marc Bregman argues that the ram motif in the *'Aqedah* scene may have been borrowed from a Christian model; the "hanging" ram was probably originally intended as a prefiguration of Jesus on the cross.[27] Finally, the figure of Orpheus playing a harp and surrounded by an audience of animals appears in a sixth-century Gaza synagogue mosaic, where he is expressly identified as David, while an almost identical figure and setting appears in a Christian burial chapel in fifth-century Jerusalem.[28]

Nevertheless, as might be expected, many differences are also evident between Jewish and Christian mosaic floors. For example, while figural art was regularly used in fourth- to sixth-century synagogues (but significantly less so in the later sixth and seventh centuries), the opposite trend is discernible in the contemporaneous churches. Whereas aniconic designs were much more the rule in earlier churches, figural art flourished by the sixth and seventh centuries. Moreover, Jews seem to have gravitated toward literal and narrative depictions of biblical and religious motifs, while Christians were inclined toward more symbolic and allegorical

25. *Cod. Just.* 1.8.1; *Edict of Theodosius* 2. See C. A. Mango, *Art of the Byzantine Empire,* 36; Habas, "Byzantine Churches of *Provincia Arabia,*" 1:313–15; Hachlili, *Ancient Mosaic Pavements,* 224–26.

26. Foerster, "Allegorical and Symbolic Motifs." For other examples from Byzantine Palestine, see Rutgers, *Jews in Late Ancient Rome,* 89–92.

27. See chap. 14.

28. A. Ovadiah and Mucznik, "Orpheus from Jerusalem"; see also chap. 17. Another example of such a theme is the Isaiah vision of peace in the End of Days appearing in both the Merot synagogue and the Acropolis church at Ma'in (Hachlili, *Ancient Mosaic Pavements,* 227).

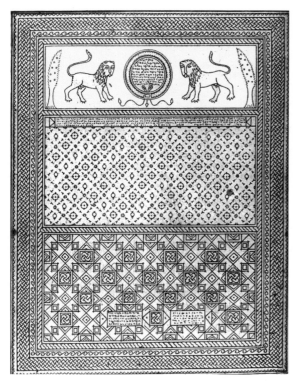

FIG. 80 Mosaic floor from Ḥammat Gader synagogue.

visual representations in line with their overall proclivity toward symbolic and typological hermeneutics of the biblical text.[29] Finally, churches might often display vintage, village, and hunting scenes from daily life as well as Nilotic and landscape themes, whereas such depictions are absent from synagogue contexts. Mythological scenes, in contrast, are used more often in Jewish settings, as in the appearance of the zodiac in a series of synagogues from the fourth through sixth centuries.[30] The widespread use of biblical themes in churches throughout the Byzantine world finds no comparable expression in local Palestinian and Jordanian churches, and in this respect Jewish usage of such themes is somewhat greater.[31]

In addition to the three Palestinian synagogues with the best-preserved and most striking mosaic floors (to be discussed in chaps. 12–14), several others merit comment with regard to their unique combinations of motifs:[32]

Ḥammat Gader.[33] Discovered in 1932 and located just southeast of the Sea of Galilee, the ruins of this synagogue (spanning the fourth to sixth centuries) sit atop a small hill overlooking the site. Surrounded by a series of small rooms to the east and west, the synagogue's main hall has an apse and *bima* facing south; the three rows of columns to the east, north, and west further accentuate this southerly orientation. The floors of the three aisles are decorated with geometric patterns, while the almost square nave is divided into three panels (fig. 80). The northernmost one contains a pattern of intersecting lines interspersed with large and small squares

29. Hachlili, *Art and Archaeology—Israel*, 370–75; Hachlili, "Aspects of Similarity and Diversity"; Talgam, "Similarities and Differences," 93–101. See also A. Ovadiah, *Art and Archaeology*, 459–80, 549–68. See, however, Posèq, "Toward a Semiotic Approach"; Elsner, *Art and the Roman Viewer*, 190–91.

30. See chap. 16. On the above comparisons in their wider context, see Merrony, "Reconciliation of Paganism and Christianity."

31. Hachlili, *Ancient Mosaic Pavements*, 226–28.

32. Other synagogue mosaic floors will be noted in subsequent chapters.

33. Goodenough, *Jewish Symbols*, 1:239–41; Avi-Yonah, "Ḥammat Gader"; Naveh, *On Stone and Mosaic*, nos. 32–35.

containing guilloches and checkerboard patterns. The central panel has a series of diagonal lines forming diamonds that enclose flowers and pomegranates. The third, southernmost panel, adjacent to the *bima*, displays two lions flanking a wreath containing an inscription. Four Aramaic inscriptions, a number of them quite extensive, bless donors and note their contributions. Since Ḥammat Gader was primarily a health spa, many of its visitors hailed from other locales, and in several inscriptions their hometowns are mentioned as well.

Na'aran.[34] In 1918, a Turkish artillery shell exploded near the British lines, exposing the mosaic floor of a sixth-century building complex in Na'aran (fig. 81), and subsequent excavations revealed several rooms and courtyards. One entered the main hall via three openings from the north and moved southward through a narthex (with a mosaic floor containing a stylized menorah and geometric patterns along with an inscription), reaching a nave flanked by two aisles. The richly decorated mosaic, largely destroyed by human hands, was divided into three panels. The first and largest panel (roughly half the floor) displays a series of hexagons bordered by guilloche bands interlaced with medallions containing birds. The second panel features a largely destroyed zodiac motif in which representations of the seasons and zodiac signs move in opposite directions and are thus not aligned. The third and southern panel is unusual: although a Torah shine and a pair of *menorot* appear here, as elsewhere, no other symbols are represented, while a pair of lamps is suspended from each menorah. Moreover, two lions flank what was

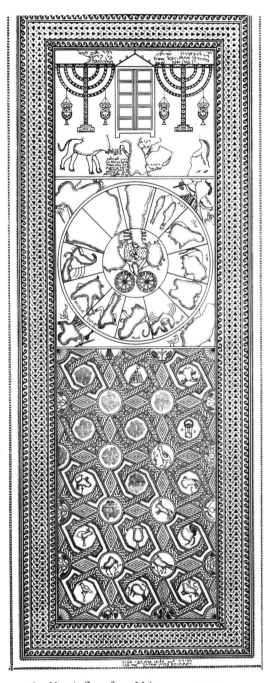

FIG. 81 Mosaic floor from Na'aran synagogue.

34. Vincent and Carrière, "La synagogue de Noarah"; Goodenough, *Jewish Symbols*, 1:253–57; Avi-Yonah, "Na'aran"; Naveh, *On Stone and Mosaic*, 58–67.

FIG. 82 Fragment of mosaic floor from Gerasa synagogue.

once a depiction of Daniel, whose presence is indicated by an inscription ("Danie[l] Shalom"); the remains of two hands raised in an *orans* position are discernible, as well as a number of Aramaic dedicatory inscriptions located at the top and bottom of the panel.

Gerasa, Jordan. Much of the art in this synagogue, which was converted into a church in 530–31, was obliterated. The best-preserved remains are from the narthex and display a scene revolving around the Noah and the flood narrative (fig. 82). While, technically speaking, Gerasa is part of the Diaspora and is often categorized as such in scholarly literature, the art of this synagogue appears to be much closer to that of contemporary Palestine. The combination of biblical scenes and Hebrew dedicatory inscriptions from Late Antiquity is known only from Palestine.[35] Considering the geographical propinquity of Gerasa to the Jewish communities of the Galilee, Golan, and Bet Shean region, a Palestinian cultural orbit appears far more appropriate in accounting for this fifth-century synagogue's distinctive features.[36]

Frescoes

Painted pieces of plaster, apparently remains of frescoes, were found among the debris at several sites in Byzantine Palestine. An inscription from Susiya makes specific reference to the plastering of the synagogue's walls: "May he be remembered for good, my holy teacher, my sage, Isi the priest, the honored one, son of a sage, who made this mosaic and plastered its walls."[37] Many pieces of painted plaster were also found in the Reḥov synagogue, some portraying a treelike menorah and several aediculae, while a number of columns preserve Aramaic inscriptions. No figural designs or representations were found here.[38]

Given the limited wall remains preserved in archaeological material, it is impossible to determine how synagogues with plastered walls were decorated, if at all. The only talmudic source relating to the plastering of walls is the first part of the tradition cited earlier referring to a phenomenon as yet unattested archaeologically:

35. For more on the contents of this mosaic, see chap. 17.

36. See Dvorjetski, "Synagogue-Church at Gerasa."

37. Naveh, *On Stone and Mosaic*, no. 75.

38. Hachlili, *Ancient Jewish Art and Archaeology—Israel*, 224. For a more detailed discussion of the Reḥov synagogue, see chap. 20, and for a discussion of the inscriptions there, see the forthcoming article of Misgav, "List of Fast Days."

"In the days of R. Yoḥanan (third century) they began depicting [figural images] on the walls, and he did not object."[39]

THE DIASPORA

Architectural Elements

Diaspora[40] synagogues generally followed a basilical plan, although the range of variation was wide "as a result of the social contexts of its diffusion and adaptation."[41] The synagogue building at Sardis was worlds apart from the converted private home at Dura Europos, even after the latter had been transformed into an enlarged synagogue complex. The architectural plan of the Ostia synagogue was radically different from that of Naro, as was that of Aegina from the one in Priene. Moreover, the location of synagogues varied, ranging from the center of a town (Stobi, Apamea) to its periphery (Ostia, Bova Marina, Dura); and variation was also evident in the plan of the sanctuary and the shape of the entire complex. For example, some synagogues had an atrium (Sardis) while some did not (Ostia). This is in part owing to the varying social and cultural contexts of these buildings and in part to the fact that they originated under different circumstances. Some were refurbished residential dwellings, such as Dura, Priene, Naro, and Stobi, and others were built *ab origine* as synagogues, as, for instance, Apamea, Elche, Andriake, and perhaps Ostia.

For all this diversity, however, there was also a great deal of uniformity and commonality among Diaspora synagogues. This was regularly expressed with regard to orientation toward Jerusalem, the presence of a Torah shrine (in an aedicula or a niche, or on a raised *bima*), the widespread use of Jewish symbols (particularly the menorah), and the presence of some sort of water installation.[42]

Mosaic Art

Mosaic pavements existed in most Diaspora synagogues of Late Antiquity discovered to date—Apamea, Sardis, Delos, Aegina, Plovdiv, Stobi, Saranda, Ostia, Bova Marina, Naro, and Elche. When compared to contemporary Palestinian art, and in light of earlier Duran art, it is quite surprising to find a relative absence of figural representation in these Diaspora settings, although the mosaic in the Naro synagogue in North Africa has a selection of animals, fish, and birds. Moreover, the Sardis building presents a fascinating study of contrasts—its extensive aniconic mosaic floor and wall revetments on the one hand, and its statues of lions and eagle

39. See above, n. 18.

40. See Goodenough, *Jewish Symbols*, 2:70–100; Hachlili, *Art and Architecture—Diaspora*, 198–236; L. I. Levine, *Ancient Synagogue*, 252–83, as well as the bibliographies and references in each.

41. White, *Building God's House*, 62.

42. See also chaps. 10 and 17, as well as L. I. Levine, *Ancient Synagogue*, 250–309.

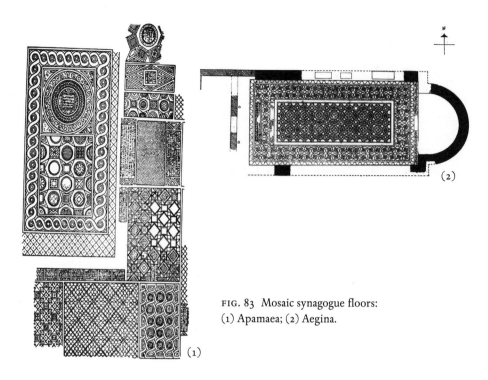

FIG. 83 Mosaic synagogue floors:
(1) Apamaea; (2) Aegina.

reliefs in the center of its nave, as well as a newly identified depiction of Daniel and lions on a marble revetment fragment on the other.[43]

Let us briefly review the salient artistic remains of the Diaspora synagogue buildings.[44]

Apamea, Syria, late fourth century. A lavish mosaic floor bears a series of impressive carpetlike geometric patterns and a menorah.

Aegina, Greece, fourth century. A mosaic floor with geometric designs (fig. 83).

Plovdiv, Bulgaria, third and fourth centuries. This tripartite mosaic floor has geometric designs; a large, highly ornate seven-branched menorah with a circular base is located in the middle of the central panel.

Andriake, Turkey, fifth to sixth centuries. A plaque with a menorah was found in a recently discovered synagogue, a small apsidal building located near the city's

43. See chap. 15. Though limited in quantity, a number of Sasanian stamped seals are associated with Jews (on the basis of Hebrew names and Jewish symbols), displaying motifs ranging from a star and crescent moon to animals (e.g., rams, lions, sheep), human figures, and busts, and finally to several representations of the 'Aqedah; see Shaked, "Jewish Sasanian Sigillography"; Friedenberg, *Sasanian Jewry and Its Culture.*

44. Excluding Dura and Sardis, which have been treated in chaps. 5 and 15. For a detailed examination of the Diaspora synagogues, see L. I. Levine, *Ancient Synagogue*, 252–83. On the recently discovered synagogues at Andriake and Saranda, see Çevik et al., "Unique Discovery in Lycia," 335–49; Çevik and Eshel, "Byzantine Synagogue at Andriake"; Netzer and Foerster, "Synagogue at Saranda."

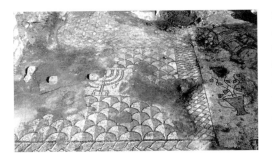

FIG. 84 *(left)* Mosaic from Saranda synagogue: Menorah together with a shofar and *ethrog* surrounded by geometric shapes; to the right, an adjacent panel displaying an amphora with branches and leaves.

FIG. 85 Mosaic from Saranda synagogue: The first of three panels depicting a facade, a gable, columns, curtains, and an unidentifiable object in the center.

FIG. 86 *(below, right)* Mosaic from Saranda synagogue: Several trees with animals and a fish.

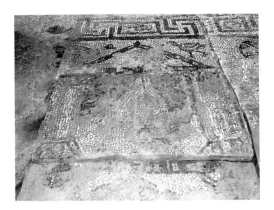

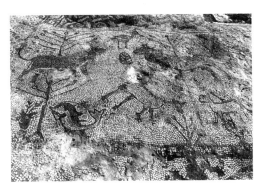

port and next to granaries built by Hadrian. Several chancel-screen posts were also found here, each displaying a menorah (with spirals beneath its branches) flanked by a shofar, *ethrog*, and *lulav* and accompanying inscriptions.

Stobi, Macedonia, late third to fourth centuries. The walls of the building seem to have had frescoes with geometric and floral motifs, and perhaps also decorative stucco moldings and several menorah graffiti. A mosaic floor pavement here also bears geometric motifs.

Saranda, Albania, fourth to sixth centuries. A complex of rooms adjacent to a fifth–sixth-century basilica-type building contained a room with an earlier mosaic floor divided into four panels. One panel depicted a seven-branched menorah flanked by a shofar and *ethrog* and at least one damaged unidentifiable object (a *lulav?*). Another included an amphora from which branches with either leaves or fruit emerged while an animal (a panther?) stood nearby (fig. 84). At a later stage, three consecutive panels were depicted in the nave of the basilica itself, each featuring a facade with columns and a gable (and in at least one case displaying two birds scurrying up its sides) representing either the Jerusalem Temple or the synagogue's Torah shrine, as in Bet Alpha (fig. 85). Other preserved panels include geometric patterns, one with a krater surrounded by animals (including an ox, fish, birds, and a peacock) and another featuring schematically portrayed trees with pairs of animals facing each other—an ox and a lion, a fish and a ram, and an ox and a sheep (fig. 86).

Ostia, Italy, third to sixth centuries. A large apsidal aedicula located at the eastern end of the synagogue sanctuary housed the Torah shrine and scrolls. Next to

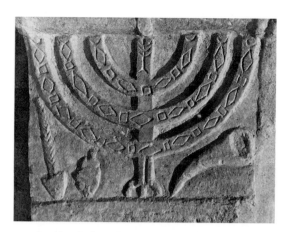

FIG. 87 Mosaic from Ostia synagogue: Jewish symbols on the corbel of an architrave.

this aedicula, four large columns formed a propylaeum for entry into the sanctuary. Two corbels (at the end of each architrave extending from the apse) are carved with a menorah, shofar, *lulav*, and *ethrog* (fig. 87). A small fragment of a stone lion was found on the floor of the main hall, although its original location is unknown. The floor itself was decorated in part with *opus sectile* marble slabs in secondary use (some of which bore inscriptions, presumably from other buildings) and in part with a black-and-white mosaic floor depicting a Solomon's knot.[45]

Bova Marina, southern Italy, fourth century (renovated in the sixth). The central mosaic floor in the main hall was decorated with geometric designs and plaited borders bearing wreathlike decorations. Rosettes and a Solomon's knot were also represented, along with the central design of a menorah, shofar, *lulav*, and *ethrog*.

Naro (Ḥammam Lif), Tunisia, perhaps as early as the fourth or fifth century but possibly as late as the sixth. The mosaic floors throughout this synagogue complex are generally plain, except for an elaborate horizontal pavement divided into three panels in the main hall (fig. 88). These panels have remarkable parallels with mosaics from contemporary Roman-Byzantine North Africa, particularly churches and baptisteries.[46] The outer two panels feature vines in the shape of acanthus leaves emanating in pairs from four vases. Animals (including a lion, ducks, pelicans, and other birds) as well as baskets of fruit and bread are depicted among the tendrils. The central panel was divided into two parts: the upper section depicts a partially preserved scene of fish, ducks, water, plants, and the head of a bull, and perhaps some land, as well as a wheel or star with a four-pronged object interpreted by some as the hand of God. The lower panel contains two peacocks standing at the edge of an amphora-shaped fountain with a shell-like decoration; below the fountain, flanked by trees, are flowers, vines, and two partridges. These depictions have been variously interpreted, for example, as portraying scenes of the Creation in the top panel and Paradise or the End of Days in the lower one.

Elche, Spain, fourth century. The mosaic floor here features geometric designs (especially braids, mazes, and diamonds) with rectangular, square, octagonal, and round frames interspersed throughout. One of its prominent motifs is a series of

45. White, "Synagogue and Society"; Runesson, "Synagogue at Ancient Ostia."

46. See also Biebel, "Mosaics of Hammam Lif"; Dunbabin, *Mosaics of Roman North Africa*, 194–95; Darmon, "Les mosaïques de la synagogue de Hammam Lif," 23–28; Bleiberg, *Tree of Paradise*.

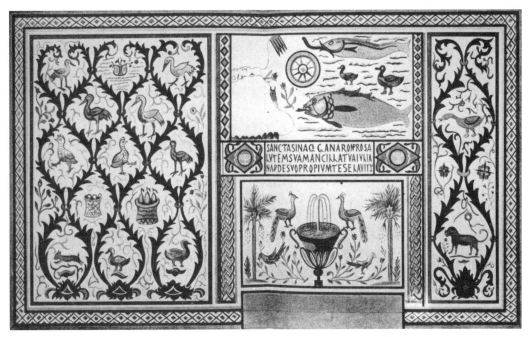

FIG. 88 Mosaic floor from Naro synagogue (Ḥammam Lif).

knots, including the Solomon's knot. The floor, arranged in three parallel panels stretching over the length of the hall on an east-west axis, as well as its dominant patterns, are reminiscent of other Spanish mosaics from the Late Roman era. A seven-branched object (and perhaps a second one) was recently discerned on the mosaic floor and identified as a menorah; overlooked in the past by scholars, these *menorot* have now provided incontrovertible evidence that this building was once a synagogue.[47]

While the attitude toward figural art varied from one Diaspora synagogue to the next, the general impression is one of marked conservatism relative to the art of both contemporary Christian buildings and Palestinian synagogues. Nevertheless, Diaspora synagogue art was often influenced by the regnant motifs and decorations in each particular locale.[48] Dura provides an striking example of this phenomenon, as its wall paintings reflect the technique and overall artistic conception, though not the content, of similar fresco decorations encountered in both religious and secular contexts elsewhere in the city.

47. The (re)discovery of this menorah was reported by Robin Faith Walsh at the SBL conference in Atlanta, 2010.

48. See L. I. Levine, *Ancient Synagogue*, 252–83. For a striking example of medieval manuscript art in various European Jewish communities, where the different cultural surroundings and social contexts of each were significant factors in the iconography and techniques displayed, see Kogman-Appel, "Jewish Art and Non-Jewish Culture."

Diaspora Jewish art from Late Antiquity discussed in this and the following chapters thus reflects a significant degree of diversity; no two synagogues were identical in their art, plans, architecture, or inscriptions. One community employed a full range of figural representations (Dura); another featured only animals, birds, and fish (Naro); still others were completely devoid of figural art (Apamea, Stobi, Elche, and Bova Marina). As noted, the synagogue at Sardis exhibits a great many geometric patterns but also lions, eagles, and a depiction of Daniel. Moreover, even when the same artistic motif was used, different regional settings may well have given rise to interpretations that might have been unknown or unacceptable in another. Needless to say, the same potential for diversity holds true for a Galilean setting in the north as against a Judaean one in the south, for a community in Palestine as against one in the Diaspora, or in a Greek-speaking environment as opposed to an Aramaic or Latin one. As we shall see below,[49] the depiction of Helios in fourth-century Tiberias in all probability reflects a set of beliefs and associations different from those prevailing in sixth-century rural Na'aran or Bet Alpha. Furthermore, it may also be assumed that the facade of the Temple or Torah shrine, or for that matter the various Jewish symbols, did not necessarily have the same meaning in third-century Dura as they did in fourth-century Tiberias, fifth-century Sepphoris, or sixth-century Bet Alpha.[50]

THE DECLINE OF JEWISH ART AT THE END OF ANTIQUITY

The flourishing of Jewish art became only a memory following the Muslim conquest of the East in the seventh century and beyond. Jewish communities in both Palestine and the Diaspora dwindled considerably, with many ceasing to exist in the ensuing centuries. More importantly, the vast majority of Jews now lived under Muslim rule, which over the course of the seventh and eighth centuries embraced increasingly strict aniconic patterns, particularly in their religious settings, and thus they perforce eschewed the use of figural art as well.

However, the first indication of the Jews' withdrawal from the fourth to sixth centuries' heyday of artistic creativity was evident perhaps even before the advent of Islam. Archaeological evidence from the late sixth century, and certainly from the seventh and eighth, indicates that such a change was already under way. First, many synagogues built at this time were demonstratively aniconic. The mosaic floors of Jericho, 'En Gedi, and Ma'oz Ḥayyim, and of course Reḥov, reflect this tendency. Second, a number of synagogues that underwent renovations now opted for aniconic patterns. Ḥammat Tiberias and Merot exemplify this change.

49. See chap. 16.
50. See chap. 17.

A most interesting phenomenon affecting Jewish art in Late Antiquity was the appearance of iconoclastic activity.[51] Since the earliest discoveries of synagogues, it was noted that in many instances figural images had been intentionally defaced, sometimes in a wholesale fashion, at other times selectively. Signs of this figural destruction were found on the architectural elements of buildings (Capernaum and Chorazin) and on mosaic floors (Na'aran and Susiya; fig. 89). Opinions are divided as to when this occurred, at once or in waves, who was responsible, and why.[52]

FIG. 89 Destruction of figures on mosaic floor from Na'aran synagogue.

Since this type of activity is almost impossible to date (for example, we do not know if it was carried out after the building ceased to function as a synagogue or while it was still in operation), positing the time of destruction and the perpetrators becomes a highly speculative exercise.[53] Some scholars have laid the blame on Christian authorities, others on Muslim policy, and still others on the Jews themselves.

Amit's preliminary study on the subject presents evidence primarily from Susiya, but also draws from Bar'am, Ashkelon, and Nevoraya, indicating that this defacement was selective in nature and done when these synagogues were still functioning.[54] He concludes that Jews opposed to figural representation were responsible for these acts, perhaps because it was viewed as a breach of the Second Commandment. Amit's more complete listing of these instances is intriguing. Half of the synagogues he mentions are in the Galilee, while nine others are located in the Golan. Thus, twenty-one of his twenty-four examples, about 88 percent, hail from these northern regions of Palestine. The three remaining examples are from Judaea proper — Na'aran, Susiya, and Ashkelon. With few exceptions, all the sites are not only rural but lie in areas relatively distant from urban centers; such places generally tend to be more conservative in orientation, as attested by their minimal use of Greek and the limited amount of figural representations. The latest excavations in Sepphoris bear out this distinction, as the remains from this major urban site in the central Galilee show no signs of iconoclasm.

51. For recent studies and relevant bibliography on this question, see L. I. Levine, *Ancient Synagogue*, 364–68; Yuval-Hacham, "'You Shall Not Make for Yourself Any Graven Image...'"

52. See Hachlili, *Ancient Mosaic Pavements*, 209–17; Fine, "Iconoclasm," 183–86.

53. See L. I. Levine, *Ancient Synagogue*, 365–66.

54. Amit, "Iconoclasm."

The pattern thus discerned seems to indicate that internal Jewish social and religious pressures rather than the decrees of a ruling power imposing its will were at the root of much of this conservatism and iconoclastic activity.[55] This, of course, does not preclude the possibility that these Jewish perpetrators were also influenced by external phenomena—whether Muslim or Christian.[56] Perhaps here, as elsewhere, it would be best not to fall into the trap of seeking one overriding explanation for all cases. The forces at play may well have been multiple, spread over generations, stemming from a number of sources, and expressing a varied agenda. Religious zealotry was not a monopoly of the Jews at this time, as the destructive forays of the monk Barsauma and the defacement of images at the Ḥammat Gader baths and on the Madaba map attest.[57] Given the limited and uncertain evidence at hand, settling for other-than-tentative suggestions might well be hazardous.[58]

By the very end of Late Antiquity Jewish artistic expression seems to have been shifting away from figural representation, as had happened centuries earlier in late Second Temple times. Whether the iconoclastic activity discussed above had something to do with this new tendency—as a cause, effect, or parallel development—must remain moot for the present.

55. In this regard, see also Avigad, *Beth She'arim*, 3:281–82.

56. See Vasiliev, "Iconoclastic Edict"; Kitzinger, "Cult of Images," 130 n. 204; Barber, "Truth in Painting," 1035; Schick, *Christian Communities*, 218–19; Fine, "Iconoclasm," 192–94; Fine, *Art and Judaism*, 123; Bowersock, *Mosaics as History*, 91–111. On the hostility of Christians, Jews, and Muslims to art in this period, see Grabar, *L'iconoclasme*, 93–122.

57. Tsafrir, *Archaeology and Art*, 113 and 427.

58. On a similarly nuanced explanation of the damage to churches in Palestine from the seventh to eighth centuries, see Schick, *Christian Communities*, 180–219.

12. HAMMAT TIBERIAS AND ITS PATRIARCHAL-ARISTOCRATIC SETTING

HISTORICAL OVERVIEW

Throughout the first centuries of the Common Era, Tiberias and Sepphoris vied for primacy in the Galilee. At the beginning of the first century CE, Sepphoris held this distinction by default as it was the only urban center in the region, but Tiberias, upon its foundation in 19–20 CE, seems to have quickly assumed this role.[1] In contrast to Josephus's rather detailed description of the city during the first stages of the revolt against Rome in 66–67, our knowledge of Tiberias in the years that follow is quite fragmentary. The city remained predominantly Jewish, and both Tiberias and Sepphoris undoubtedly expanded at this time, in part as a result of the failure of the Bar-Kokhba revolt (135 CE) and the subsequent population flow northward from Judaea.

We are probably on safe ground in assuming Sepphoris's brief primacy in the Galilee in the early third century, possibly owing to the presence of the Patriarch R. Judah I. However, in the course of the third century Tiberias gradually reassumed a position of leadership in the Galilee, housing the main rabbinic academy in Palestine under R. Yoḥanan[2] at about the same time the Patriarchate transferred its headquarters from Sepphoris to Tiberias. We have no way of gauging the extent of these institutions' influence on civic life in general, but it probably was far from negligible.

1. On first-century Tiberias, see Hoehner, *Herod Antipas*, 91–100; M. H. Jensen, *Herod Antipas in Galilee*, 135–46; L. I. Levine, *Ancient Synagogue*, 49–51. See also the many articles in Avissar, *Sefer Teveria*; Hirschfeld, *Tiberias*. On the city's archaeological remains from the first-century, particularly the monumental southern gate and remains of the stadium, see Weiss, "Tiberias and Sepphoris," 13–18; Weiss, "Josephus and Archaeology," 387–92.

2. Some mistakenly refer to this institution as the Sanhedrin. Despite the homiletic claims of several sources, no such institution existed during these centuries; see my *Rabbinic Class*, 76–83; Goodblatt, *Monarchic Principle*, 232–76; Hezser, *Social Structure*, 186–95.

By the fourth century, the city had become widely recognized as the center of Jewish activity in Palestine, and to some degree this held true for the Diaspora as well, most significantly because the Patriarchal court was located there. In a polemical and tendentious narrative suffused with degrading and hostile remarks, Epiphanius provides an account of Patriarchal activities in early fourth-century Tiberias (*Panarion* 30.4-12). Some details ring true and are corroborated by other sources: for example, maintaining contact with Diaspora communities, sending emissaries abroad, and conducting halakhic and communal-oriented deliberations within his own circle of advisers (rabbis?) were all part of this office's regular agenda.[3]

Rabbinic sources tell us that there were some twelve or thirteen synagogues in Tiberias (B Berakhot 8a), possibly including the one in the Ḥammat suburb to the south that was later incorporated into the city (Y Sotah 1, 4, 16d). Several synagogues are mentioned by name, such as those of the Tarsians and the Babylonians, as well as one referred to as the *Boule* (Y Sheqalim 2, 4, 47a; Y Ta'anit 1, 2, 64a; Y Yoma 7, 1, 44b). One late (and thus historically problematic) tradition speaks of a very large Tiberian synagogue, described as a *diplostoon* (literally, a double stoa), where children would study (Midrash on Psalms 93, 8, p. 416). One can only speculate whether this building may have been related to the large first-century synagogue mentioned by Josephus (*Life* 54.277).[4]

THE ḤAMMAT TIBERIAS SYNAGOGUE

Only three synagogues have been discovered in the city to date, the most impressive being the one in Ḥammat.[5] Excavated by Moshe Dothan in 1961, this fourth-century synagogue was but one of several stages ranging from the mid-third or fourth to eighth centuries; that the earlier stage also functioned as a synagogue is quite possible but uncertain.[6] The fourth-century synagogue (Stratum IIA) will be the focus of our discussion.[7] The sanctuary in this stratum was oriented southward,

3. Stemberger, *Jews and Christians in the Holy Land*, 71–75; Thornton, "Stories of Joseph of Tiberias"; Goranson, "Joseph of Tiberias Revisited"; Reiner, "Joseph the Comes." See also Mantel, *Studies*, 188–206.

4. See L. I. Levine, *Ancient Synagogue*, 52–54. For highlights in the history of Tiberias in Late Antiquity, see Irshai, "Jews of Tiberias."

5. See Weiss, "Ancient Synagogues in Tiberias and Hammat," 34–48; Roth-Gerson, *Greek Inscriptions*, 61–65. See also Z. Ilan, *Ancient Synagogues*, 139–47; Foerster, "Ancient Synagogues of the Galilee," 302–6.

6. However, it did function as such in the later phases of this building, at the very end of Late Antiquity; see Dothan, *Hammath Tiberias*, vol. 2.

7. While Dothan dated this stage to the late third–early fourth centuries (ibid., 1:27–70), it is now generally assumed that the date should be pushed forward several generations, to the second half of that century; see, e.g., Dunbabin, *Mosaics of the Greek and Roman World*, 189, n. 6; Talgam, "Similarities and Differences," 100–1; Talgam, "Mosaic Floors in Tiberias," 123–25; Magness, "Heaven on Earth," 10–13. See also Z. Weiss, "Stratum II Synagogue at Hammath Tiberias."

toward Jerusalem, but it featured a nave with one aisle on the west and two on the east. The room was thus asymmetrical, somewhat resembling a broadhouse building.[8] The mosaic floor of the eastern aisles bore geometric designs and three inscriptions (two in Greek and one in Aramaic), and three magnificent panels adorned the nave (fig. 90). In the order of one's progression through the hall from the north to the *bima* in the south,[9] these panels depicted: (1) eight dedicatory inscriptions in Greek filling nine squares flanked by two lions in a heraldic posture; (2) a zodiac design with the four seasons in the outer corners and a representation of the sun god Helios in the center;[10] and (3) a cluster of Jewish symbols, including a Torah shrine, pairs of *menorot*, *shofarot*, *lulavim*, *ethrogim*, and incense shovels.

The patrons of this building are readily identifiable in the inscriptions. Those written in Greek contain Greek and Latin names (Ioullos, Zoilos, Maximos) and specify some of the wealthy and acculturated residents of Tiberias responsible for financing the building's construction, several of whom apparently held official positions in the synagogue or community.[11] The use of Greek names, language, and titles (such as μιζότερος and προνοτής) was not uncommon in these circles[12] and is attested in inscriptions from Bet She'arim as well.[13]

FIG. 90 Mosaic floor from Ḥammat Tiberias synagogue.

8. On this type, see Goodenough, *Jewish Symbols*, 1:225–37.

9. For an alternative suggestion, namely, that the entrance to the synagogue was located in the east, see Weiss, "Synagogue at Hammat Tiberias."

10. See Goodenough, *Jewish Symbols*, 8:167–218; Hachlili, "Zodiac"; Foerster, "Representations of the Zodiac"; and chap. 16.

11. Dothan, *Hammath Tiberias*, 1:54–62; Roth-Gerson, *Greek Inscriptions*, 65–72. The names appearing in the synagogue inscriptions are well attested in fourth-century Roman prosopography; see A. H. M. Jones, Martindale, and Morris, *Prosopography*, vol. 1, passim.

12. Interestingly, the names of two Patriarchal *apostoli* known from other sources appear in Greek and Hebrew. Joseph was an early fourth-century aide of the Patriarch noted by Epiphanius (*Panarion* 30.4–12), and Theomnestus, mentioned by Libanius in his correspondence with the Patriarch in the latter part of the century, presumably held a similar office (see M. Stern, *GLAJJ*, vol. 2, no. 501).

13. See chap. 6.

Moreover, as with the Bet She'arim necropolis, the Ḥammat Tiberias synagogue is to be associated with Patriarchal circles, if not with the Patriarch himself. The main donor to this building, one Severus, is identified as "a disciple (or protégé, θρεπτός) of the Illustrious Patriarchs,"[14] once in an inscription in the eastern aisle and again in one of the eight dedicatory inscriptions located in the northern panel of the nave. In the latter setting, Severus is accorded unusual prominence: each of the other seven inscriptions occupies one square, while that of Severus fills two.[15] Thus, mention of the Patriarch was a significant feature in the epigraphic remains from this building.

From this comparatively rich trove of eleven dedicatory inscriptions (ten of which are in Greek),[16] it appears that the wealthy and Patriarchal circles in the city were intimately connected. Rabbinic sources have preserved a number of critical references, clearly tendentious, to the close working relationship between these two groups in the third and fourth centuries.[17]

The dominant role of Greek in this synagogue floor, together with its striking mosaic, discussed below, clearly indicate the cosmopolitan cultural orientation of its donors and probably of many, if not most, of this congregation. The acculturation within Patriarchal circles, from the very first (proto-) stage under R. Gamaliel II until that of R. Gamaliel VI, the last of this dynasty's line, was expressed by the liberal and tolerant attitude toward figural and even pagan art, which undoubtedly would have upset many contemporaries.[18]

This nexus of Patriarchal and urban aristocratic circles, the latter represented by wealthy synagogue benefactors, goes a long way in explaining the significant degree of acculturation and the strikingly high quality of the Tiberian synagogue mosaics, which are rightfully considered the most elegant and "Hellenized" of their kind in

14. The word θρεπτός has been variously translated: "disciple," "protégé," "apprentice," "pupil," "slave," "freedman," "adopted son," "one fed by or dependent upon" (in this case the Patriarch), or "someone brought up in the household of" (sometimes referring to abandoned children raised as slaves or foster children); see Lifshitz, *Donateurs et fondateurs*, 64; Dothan, *Hammath Tiberias*, 1:57; Roth-Gerson, *Greek Inscriptions*, 68; Millar, *Roman Near East*, 385; Stemberger, *Jews and Christians in the Holy Land*, 258–59. See also Frey, *CIJ*, 1:57; Cameron, "θρεπτός"; Nani, "ΘΡΕΠΤΟΙ"; Martin, "Construction of the Ancient Family," 46 n. 25; Lapin, "Palestinian Inscriptions," 47 n. 22; Di Segni, "Inscriptions of Tiberias," 92–94; Hezser, "Impact of Household Slaves," 397 n. 92; Sivertsev, *Private Households*, 128–31; Ricl, "Legal and Social Status." See also L. I. Levine, *Ancient Synagogue*, 434 n. 26.

15. Dothan, *Hammath Tiberias*, 1:55.

16. Fourteen preserved Hebrew words identify nine zodiac signs, four seasons, and the word *shalom*, in addition to an Aramaic inscription with a general blessing for all donors; see ibid., 53–54.

17. See, e.g., B 'Eruvin 86a; Y Bikkurim 3, 3, 65d; and chap. 21. See also Alon, *Jews, Judaism and the Classical World*, 385–98; L. I. Levine, *Rabbinic Class*, 167–80.

18. See chaps. 3, 6, and 21.

ancient Jewish art. The emphasis on naturalism, the depiction of nude figures, and the sophisticated play of light and shadow render a vivid three-dimensional quality that epitomizes the highest of artistic standards in the fourth century. An unusually fine collection of such floors was discovered in Antioch,[19] and it is quite possible that the artisans of the Ḥammat synagogue mosaics, or at least their sources of inspiration, may have hailed from this Syrian capital. The Patriarch's close association with Libanius of Antioch strengthens the Tiberian connection with that city.[20]

In light of the above, we will argue that this synagogue floor's stunning central panel of a zodiac design and Helios was a conscious choice of the building's patrons, who had close ties to the Patriarchate and quite possibly to the Patriarch himself. While this particular motif was to reappear in other Palestinian synagogues in subsequent centuries,[21] the Tiberias depiction remains the earliest such representation, and far and away the most artistically impressive. The figure of Helios, represented here in the guise of Sol Invictus with his array of attributes, had become a universal symbol by the fourth century, though heretofore unattested among Jews. Moreover, Josephus reports that the zodiac design was categorically prohibited in the Jerusalem Temple centuries earlier (*War* 5.213). Thus, the first appearance of such pagan motifs in the center of a mosaic floor in this important Tiberian synagogue requires an explanation.[22]

The Ḥammat Tiberias mosaic is a unique example of the importance of a historical (political, social, and cultural) context for determining the art forms appearing in a Jewish public space. First, the depictions of Helios and the zodiac motifs are indicative of the wider cultural and political ambience of this synagogue's leadership—the Patriarchal circle—in the latter part of the fourth century (see below). Second, the use of these motifs befits a Hellenized provincial elite with noteworthy ties to pagan and Christian imperial circles. And third, the importance of the calendar for the Patriarch at this time is crucial for understanding the meaning and significance of this mosaic.

Let us examine these dimensions in greater detail.

Helios and the cultural-religious ethos of the third and fourth centuries. By the Late Roman era, the figure of Helios, or in his guise as Sol Invictus, occupied a central role throughout the empire—from the imperial circles of Rome to the eastern provinces, and from Neoplatonic philosophers to the popular practitioners of magic across the empire. Indeed, throughout the Greco-Roman period, but especially in the third and fourth centuries CE, the cult of the sun god enjoyed enormous

19. Levi, *Antioch Mosaics Pavements*, vol. 1.

20. See the comments of M. Stern, *GLAJJ*, 2:580-99; Meeks and Wilken, *Jews and Christians in Antioch*, 59-66; Wilken, *John Chrysostom and the Jews*, 58-62.

21. On the origins of the Helios-zodiac-seasons motif, see Hanfmann, *Season Sarcophagus*, 1:246-53.

22. See chap. 16.

popularity.[23] Starting in 218 under Elagabalus, originally a priest of the sun god at Emesa, this particular cult attained high visibility.[24] Following a temporary eclipse induced by Elagabalus's behavioral excesses, which led to his *damnatio memoriae*, the cult reached a new plateau of official recognition under Aurelian (270–75 CE).[25] Although he had sacked Palmyra, Aurelian nevertheless ordered that the local temple to the sun be restored.[26] In Rome itself, he erected a statue to Sol Invictus and constructed a temple in his honor, allocated funds for maintenance and attendants' salaries, and founded a college of pontiffs.[27] Aurelian also introduced a new festival (the Heliaia) to acclaim the sun god and establish his worship as the official imperial cult.[28] Henceforth this was to become the state religion of Rome, and with his right hand raised in a gesture of triumph and holding a globe, Helios was now claimed to have been endowed with the attributes of the *cosmocrator*.

Not surprisingly, political considerations were as much at play here as religious ones. The sun cult provided a unifying focus for the empire in general: "A world state needed a world religion. . . . As Shapur had welded his diverse kingdom together with the Mazdaean religion, so Aurelian must now strive to center on a single god the patriotic devotion that the majority of this subjects could never feel toward the city of Rome."[29]

The popularity of Sol Invictus in the fourth century is reflected in inscriptions and on imperial coinage, as well as in the famous calendar of 354.[30] Even though Constantine terminated the appearance of this god on his coins in 323,[31] Helios's

23. See, e.g., Seyrig, "Le culte du Soleil"; Halsberghe, *Cult of Sol Invictus*; Teixidor, *Pantheon of Palmyra*, 29–52; MacMullen, *Paganism*, 84–88; Dothan, *Hammath Tiberias*, 1:41–42; Stoneman, *Palmyra and Its Empire*, 71–74, 143 46, 183–87; R. S. Kraemer, *When Aseneth Met Joseph*, 156–67; Berrens, *Sonnenkult und Kaisertum*; Friedheim, "Sol Invictus in the Severus Synagogue," 94–106.

24. See Halsberghe, *Cult of Sol Invictus*, 57–107.

25. On the fusion of Sol Invictus and the emperor on third-century coins, see L'Orange, *Likeness and Icon*, 325–35. On Gallienus's identification with the sun god, including the wearing of a radiate crown and the erection of "a statue of himself arrayed as the Sun and greater than Colossus," see *Scriptores Historiae Augustae*, *Gallienus* 16.4; 18.2–4.

26. Ibid., *Aurelian* 31.7–9.

27. Ibid., 35.3; see also 28.5.

28. See Halsberghe, *Cult of Sol Invictus*, passim.

29. Stoneman, *Palmyra and Its Empire*, 185. On the connection between the sun theology and the needs of imperial politics, see Štaerman, "Le culte impérial." On the concept of a cosmic kingdom in Late Antiquity and its association with the sun-Helios, see L'Orange, *Likeness and Icon*, 319–24.

30. Halsberghe, *Cult of Sol Invictus*, 162–71; Salzman, *On Roman Time*, 149–53. See also L'Orange, *Likeness and Icon*, 325–44.

31. On Constantine and Sol Invictus, see the comments of Liebeschuetz, *Continuity and Change*, 285: "Sol Invictus answered a need. Constantine required a symbol which would demonstrate the power which he wielded. He also wished to proclaim his confidence in the supreme God. At this stage, he did not feel free to employ controversial Christian imagery.

image is vividly recalled and prominently featured in Eusebius's panegyric to this emperor in 336, on the thirtieth anniversary of his rule:

> Constantine, like the light of the sun . . . illuminates those farthest from him with his rays . . . and harnessing the four Caesars like spirited coursers beneath the single yoke of his royal quadriga, he moulds them to harmony with the reins of reason and unity, guiding his team like a charioteer, controlling it from above and ranging over the whole surface of the earth illuminated by the sun, and at the same time present in the midst of all men and watching over their affairs. . . . God is the model of royal power and it is He who has determined a single authority for all mankind. (Eusebius, *Speech on Constantine's 30th Anniversary* 3.4–5, 5.1–4)[32]

The importance of Helios in the mid-fourth century was especially highlighted by Julian, who in his term as emperor (361–63) maintained close contacts with the Patriarch and the Jews (see below).

The association with Helios, "King of the All" (Julian 1.158b), was one of the pillars of the emperor Julian's philosophy.[33] Julian credited Helios with bestowing on humanity life and nourishment for the soul. As father of Dionysus and leader of the Muses, Helios was responsible for man's wisdom and for begetting Asclepius, who was to ensure health and safety for all. In short, all blessings devolve on the world owing to Helios's beneficence (1.152b–153d; 3.434c–d). Julian also perpetuated the ancient Roman tradition of celebrating Helios's return to earth on the New Year with a festival in his honor (1.155a–156b).

The supremacy of the sun god was a widespread belief throughout Roman society. The cult of Mithras and other Oriental cults identified the supreme deity with the sun,[34] and the many mosaic floors featuring the sun god or some other deity,

Sol Invictus provided an image acceptable to many Christians and many pagans. In the later years of his reign, Sol faded from the coinage, but elsewhere the use of the image to describe the function of the emperor in the world continued. It was still found under Constantine's successors." See also Bowder, *Age of Constantine and Julian*, 26–27; Bowersock, "Imperial Cult," esp. 177–82 (= Bowersock, *Studies on the Eastern Roman Empire*, 327–42); Fears, "Theology of Victory at Rome," 822–24; Drake, "Solar Power in Late Antiquity."

32. Quoted by Browning, *Emperor Julian*, 22. This passage strikingly resembles the prayer to Helios appearing in the fourth-century book of practical magic, *Sepher Ha-Razim* (ed. Margalioth). The book is divided into seven sections corresponding to the seven firmaments; the fourth features the sun, its sanctity, and power per Gen. 1:14–18. One of the prayers is directed specifically at Helios; see below.

33. See R. B. E. Smith, *Julian's Gods*, 114–78. All references to Julian's writings may be found in W. C. Wright, *Works of the Emperor Julian*. Even as a child, he noted that Zeus had entrusted him to the care of Helios who, with the help of Athena, was charged to cure the emperor of his malady, i.e., his Christian faith (2:.229c–d). Perhaps this account also served as an anti-Christian polemic for the author.

34. L. A. Campbell, *Mithraic Iconography*, 134–40, 211–46; R. B. E. Smith, *Julian's Gods*, 139–59. See also the classic study of Cumont, *Mysteries of Mithra*, 33–103, and the reserva-

along with either the zodiac signs or personifications of the months of the year, similarly attest to the centrality of the sun.[35] On an intellectual level, Neoplatonic thought also addressed the centrality of the sun, and Julian himself was heavily influenced in this regard by Neoplatonic philosophers such as Iamblichus and Porphyry.[36] Several Orphic hymns dating to the third century focus on the sun in its various manifestations,[37] as did Neoplatonists later on—Macrobius in his *Saturnalia* and Proclus in his hymn to the sun.[38] Closer to Palestine, sun worship is amply attested in Palmyra, earlier among the Essenes, and on a plethora of coins, statuettes, altars, busts, and inscriptions from Nabatea in the first centuries CE.[39]

Popular magical amulets and papyri regularly include prayers to the sun,[40] such as the fourth-century magical Jewish tractate *Sefer Ha-Razim* (*Book of the Secrets*), which features a series of prayers to the sun god. Not only do we read of prayers for approaching the sun (both during the day and night—*sic*!), seeing its essence beyond and behind its glow, and asking it questions, though what one could ask of Helios is of a very different nature than that requested of other angels. Whereas earthly concerns preoccupy the prayers to other angels, a person is instructed to solicit the help of the sun in order to access the secrets of the universe. The following accolade should precede one's entreaty to Helios:

tions of R. B. E. Smith, *Julian's Gods*, 163–78. Note also the earlier claim of Strabo (*Geography* 15.3.13, C732) that the Persians worship Helios, whom they call Mithras.

35. See chap. 16. In fact, the tendency in Late Antiquity to unify creeds allowed Helios to be identified in many circles as the highest deity ("One Zeus, one Hades, one Helios, one Dionysos"). See Macrobius, *Saturnalia* 1:18, quoting the third-century Cornelius Labeo (M. Stern, *GLAJJ*, vol. 2, no. 445). According to Proclus, the sun is also called Dionysos, Apollo, Attis, and Adonis. Julian spoke of "Zeus, Hades, Helios Serapis, three gods in one godhead" (W. C. Wright, *Works*, 1:136a).

36. Shaw, *Theurgy and the Soul*, 173–77, 223–28.

37. See Athanassakis, *Orphic Hymns*, 12–15, 46–49, 100–1, 115. See also West, *Orphic Poems*, 206.

38. Hanfmann, *Season Sarcophagus*, 1:151–54; R. S. Kraemer, *When Aseneth Met Joseph*, 161–63. On Proclus's Neoplatonism generally, see Lamberton, *Homer the Theologian*, 162–232.

39. Stoneman, *Palmyra and Its Empire*, 71–74, 143–46 (Palmyra); Strabo, *Geography* 16.4.26, C784 (Nabataeans); Josephus, *War* 2.128 (Essenes); and, in general, M. Smith, "Helios in Palestine." See also Glueck, "Zodiac"; MacMullen, *Paganism*, 84–89. On artistic representations of Helios in antiquity, see *Lexicon Iconographicum Mythologiae Classicae* (*LIMC*), 4/1:592 625; 4/2:366 86.

40. See, e.g., Bonner, *Studies in Magical Amulets*, 148–55, 291, no. 227 and plate 11, no. 227); Betz, *Greek Magical Papyri*, 6–9, 15–16, 30–34, 46, and 68: "I invoke you, the greatest god, eternal lord, world ruler, who are over the world and under the world, mighty ruler of the sea, rising at dawn, shining from the east for the whole world, setting in the west. Come to me, thou who risest from the four winds, joyous Agathos Daimon, for whom heaven has become the processional way. I call upon your holy and great and hidden names which you rejoice to hear." See also Frankfurter, *Religion in Roman Egypt*, 224–37.

> Holy Helios who rises in the east, good mariner, trustworthy leader of the
> sun's rays, reliable [witness], who of old didst establish the mighty wheel [of
> the Heavens], holy orderer, ruler of the axis [of the heavens], Lord, Brilliant
> Leader, King, Soldier. (*Sepher Ha-Razim* 4, ed. Morgan, p. 71)[41]

The very form of Helios in the Ḥammat Tiberias synagogue mosaic is a further
indication of the positive associations of Helios's image in certain Jewish circles.
Not wishing simply to depict the sun or a charioteer, the Patriarch or patrons of
this synagogue chose to have Helios represented in the form of Sol Invictus with
all his characteristic accoutrements — the globe, scepter, halo, and rays. No other
synagogue representation of Helios even begins to approximate this detailed depic-
tion. The image of the sun god elsewhere is either totally ignored (Sepphoris and
'En Gedi) or represented in a very general and stereotypical fashion (Bet Alpha).
Indeed, the uniqueness of the Tiberias depiction is far from coincidental.[42]

We have devoted considerable space to a discussion of the place of Helios in
third- and fourth-century Roman society with the intention of neither claiming
his centrality in Jewish life nor identifying his image in Ḥammat Tiberias with the
God of Israel.[43] Rather, in an attempt to understand the sun god's appearance in the
Ḥammat Tiberias mosaic floor (for the first time ever), we have chosen to map out
the pervasiveness of this cult and the preservation of his symbol among pagans,
Christians, and Jews at this time while factoring in two additional considerations:

Julian and the Patriarch. While Helios played a significant role in the general cul-
tural ambience of the brief Julian era, the emperor also demonstrated an affinity for
the Jews and Judaism generally, and for the Patriarch Hillel II in particular. These
ties find expression, inter alia, in the emperor's epistle to the Jewish community,
dating in all probability to early 363,[44] in which he addresses the problem of the
onerous tax the Patriarch levied on his community. Recounting how he put to death
the emperor Constantius's advisers, who had recommended imposing additional
taxes on the Jews, Julian continues:

> And since I wish that you should prosper yet more, I have admonished my
> brother Iulus (the Latin equivalent of Hillel), your most venerable Patriarch,
> that the levy which is said to exist among you should be prohibited, and that
> no one is any longer to have the power to oppress the masses of your people by
> such exaction.[45]

41. See also Morgan, *Sepher Ha-Razim*, 71.

42. See chap. 16.

43. See Goodman, "Jewish Image of God."

44. M. Stern, *GLAJJ*, 2:560, no. 486a. On the authenticity of this letter, despite not a few
criticisms, see Lewy, *Studies in Jewish Hellenism*, 248-54; M. Stern, *GLAJJ*, 2:508-10; Hoff-
mann, *Julian's "Against the Galileans,"* 177-83, and esp. 179-82. See also Linder, *Jews in Roman
Imperial Legislation*, no. 13.

45. M. Stern, *GLAJJ*, 2:560, no. 486a.

At first glance, this document appears to contain contradictory evidence. On the one hand, Julian admonishes the Patriarch for oppressing his people with heavy taxation,[46] and on the other, the emperor refers to Hillel as "my brother" and "your most venerable (αἰδεσιμώτατος) Patriarch," both clearly terms of respect and amicability. In fact, the Greek term αἰδεσιμώτατος may be equivalent to λαμπροτάτων, paralleling the Latin *illustrus* and *clarissimus* that, by the later fourth century, had become honorary titles as well as official designations of the Patriarch within the imperial bureaucracy.[47] Within decades, the Patriarch was also referred to as *spectabilus*, and while certainty is elusive, it may have been Julian who first conferred one or more of these titles on this office.[48]

How can the apparent incongruity of this document be explained? The simplest approach would seem to be that Julian's passionate commitment to reducing taxes constituted one of his highest domestic priorities. He gained much support and sympathy in Gaul by taking a strong stand on this issue, and he acted similarly when in Constantinople in 361–62, after becoming emperor.[49] In the above-quoted letter to the Jewish community, Julian notes that he abolished an imperial tax and destroyed tax records so that the people would not be held accountable for arrears. Therefore, the emperor's "admonition" of the Patriarch over the latter's taxation policy should be viewed in light of Julian's more general policy and not as an expression of personal disdain. Moreover, considerable significance should be accorded the term *brother*, which the emperor also used to denote his high esteem for Libanius, as well as for Theodorus, High Priest of Asia.[50]

Julian's dramatic proposal to rebuild the Temple in Jerusalem at about the same time was a sudden and unexpected gesture of support and respect for Judaism, although admittedly his virulent anti-Christian bias was also a major factor.[51] The realization of such a plan would have not only undermined a central plank in Christian theology (that the destroyed Jerusalem Temple bears witness to God's rejection of the Jewish people and recognition of Christianity as *Verus Israel*) but also en-

46. The word κωλυθῆναι has been interpreted to mean that Julian requested only a change in the taxation policy, not its abolition; see ibid., 2:567.

47. In Theodosian Code 16.8.8, dated to 396 (Linder, *Jews in Roman Imperial Legislation*, no. 20), the Patriarchs are called *viri clarissimi et illustres* and are ranked with the *praefectus praetorio*, the highest nonmilitary figure in the empire. See A. H. M. Jones, *Later Roman Empire*, 1:142ff., 378, 525–29; Di Segni, "Involvement of Local, Municipal and Provincial Authorities," 318.

48. Avi-Yonah, *Jews of Palestine*, 195, 206 n. 32; Syme ("Ipse ille Patriarcha," 124) opts for either Julian or Theodosius. Strobel, however, has suggested a third-century date for some of these titles on the basis of evidence from the East, especially Palmyra ("Jüdisches Patriarchat, Rabbinentum und Priesterdynastie," 74–75).

49. Ammianus Marcellinus 16.5.4; 17.3, 1–5. See also Browning, *Emperor Julian*, 91–93, 132–33; Bowersock, *Julian the Apostate*, 74–76; M. Stern, *GLAJJ*, 2:561.

50. See W. C. Wright, *Works*, 3:183, no. 52 (Libanius); 152, no. 89a (Theodorus).

51. See Lewy, "Julian the Apostate"; R. B. E. Smith, *Julian's Gods*, 179–218.

hanced the prestige of Jews everywhere and thus added further support for Julian's efforts to reinstate the sacrificial cult throughout the empire.[52]

There is no reason to believe, as has been asserted, that the rebuilding of the Jerusalem Temple would have served to reinstate priestly authority at the expense of either the Patriarch or the rabbis, and that the latter circles opposed the plan or at least were reserved regarding its implementation.[53] Even were the Temple to be rebuilt, there is every reason to believe that the priestly officiants would have been placed squarely under the aegis of the Patriarch, much as centuries earlier they were subject to Herod, his successors, and the procurators.[54] In Roman eyes, the Patriarchate at this time was too solidly entrenched as the central Jewish leadership position for its status to be undermined by priests officiating in the Temple.

Publication of the calendar (358-59 CE). Another component that may well have influenced the depiction of Helios and the zodiac on the Ḥammat Tiberias synagogue mosaic floor relates to the Patriarch Hillel II's publication of the calendar in 670 of the Seleucid era (358-59 CE),[55] an event first noted by the twelfth-century Jewish astronomer Abraham bar Ḥiyya (ca. 1065-ca. 1136) in his *Sefer HaʿIbbur,* written in 1122-23.[56] Bar Ḥiyya was ostensibly quoting a responsum of Hai Gaon composed a century or so earlier. However, a Genizah fragment published by Jacob Mann confirms that the responsum in question was written not by Hai but by his father Sherira Gaon, even earlier, in 992 or 994. At that time, Hai functioned as the *av bet din* of the academy, and this may explain how his name came to be associ-

52. Julian's extreme fixation on sacrifices is noted, perhaps somewhat critically, by Libanius; see his *Oration* 12.79-82 (ed. and trans. Norman, *Libanius,* 1:82-87).

53. The absence of this event from rabbinic writings should not be taken too seriously. Much transpired in Jewish life that did not find expression in these sources. Besides, Julian's proposed rebuilding of the Temple was short-lived and failed—all the more reason for subsequent editors to ignore it!

54. See M. Stern, "Social and Political Realignments," 49-55; L. I. Levine, *Jerusalem,* 352-61.

55. Sternberg (*Zodiac of Tiberias,* 72-103) first suggested the connection between the Tiberias mosaic and the Patriarch's publication of the calendar, but without going into any detailed argumentation. See also Dothan, *Hammath Tiberias,* 1:49. On the calendar in Judaism throughout Late Antiquity and the early Middle Ages generally, see Bornstein, "Latest Phases," esp. 361-68. Although Hillel II (in addition to a number of later Patriarchs) is never mentioned in rabbinic literature, he is noted by Epiphanius in connection with Joseph the Comes (*Panarion* 30.4.2, 5) as well as by Abraham b. Samuel Zacuto in his medieval Jewish chronicle, *Sefer Yuḥasin* (ed. Filipowski, 122, 129), where he is referred to as the son of Judah III and the tenth generation of the Hillelite dynasty.

56. *Sefer Ha-ʿIbbur,* 3:7, ed. Filipowski, 97. See, however, the reservations of Stemberger, *Jews and Christians in the Holy Land,* 249-58; S. Stern, *Calendar and Community,* 175-79. For a summary of the theories on the "crisis" background for a fourth-century calendar change, see ibid., 212-32. On Abraham b. Ḥiyya's interest in astronomy, see Langermann, *Jews and the Sciences,* sec. 1, 10-16.

ated with the document.[57] Of more importance, however, is whether a *gaon* wrote the passage, and while bar Ḥiyya's quote may be accurate, there is some question whether the particular section dating the Patriarch's publication of the calendar to 670 was indeed part of an earlier Babylonian version or whether it was added by bar Ḥiyya himself.[58]

Such explicit testimony would seem to constitute a powerful argument confirming that the Tiberias mosaic floor, laid in the latter part of the fourth century, was indeed related to this important event. This is especially compelling given the Patriarchal connection with both the calendrical affairs[59] and the synagogue mosaic. The validity of such a conclusion, however, is thrown into doubt by the enormous time gap between the alleged event of 358–59 and its attestation in the twelfth (or even tenth) century. A span of 600 or 750 years is, by any measure, an enormous block of time, and the trustworthiness of a tradition under such circumstances can legitimately be regarded with suspicion.

The following considerations, however, when taken cumulatively, would seem to justify accepting the historicity of Abraham bar Ḥiyya's testimony:

1. If the source of Bar Ḥiyya's statement is indeed the Babylonian Gaonate, then the presumption of authenticity increases; we know that the *geonim* had at their disposal reliable sources from an earlier period, as attested by Sherira's famous letter detailing rabbinic history throughout the entire talmudic era, replete with specific dates. This, then, might hold true in the case of Hillel II's publication of the calendar as well.[60]
2. There is no clear polemical tone in bar Ḥiyya's comment, and it is offered as a simple and definitive statement of fact.
3. It is hard to imagine why one would concoct such an event about an otherwise unknown Patriarch if in fact there were no basis for it.
4. The specific date, 670 of the Seleucid era, would seem to indicate accurate historical information.
5. The Yerushalmi ('Eruvin 3, 9, 21c) preserves a statement made by fourth-century R. Yosi that may also be pertinent to the issue at hand:

57. See J. Mann, "Gaonic Studies," 237–48.

58. The latter skeptical view is advocated by J. Mann (ibid., 238–39) and Stemberger (*Jews and Christians in the Holy Land*, 253). The former alternative, i.e., that b. Ḥiyya is indeed quoting a Babylonian document containing a 670 date, is maintained by M. M. Kasher (*Torah Shelemah*, 13:24) and Taubes (*Otzar Ha-Geonim leMassekhet Sanhedrin*, 92).

59. On the calendrical authority wielded by the Patriarchs, see L. I. Levine, "Jewish Patriarch," 669–71.

60. See the recent study by Brody affirming the accuracy of several geonic "histories" of the talmudic period and positing the existence of a chronicle of exilarchic origins behind these works ("On the Sources").

"R. Yosi sent the following letter: 'Even though they have written to you regarding the order of the festivals, do not alter the custom of your ancestors.'" Although this source is far from clear regarding its context and precise intent, it is possible that R. Yosi might have been defending the older custom of setting the calendar ad hoc and via messengers, thereby, in effect, opposing the Patriarch's initiative.[61]

6. Most significant for our argument, however, is a rabbinic tradition, though formulated enigmatically, indicating that there were problems with the transmission of calendrical information toward the middle of the fourth century; messengers sent by the Patriarch to announce the new moon were prevented from carrying out their mission:

> A message was sent to Rava: Several [messengers] came from Reqet (Tiberias) and they were apprehended by an eagle (Rome) and in their hands were goods made in Luz.[62] . . . And the descendants of Naḥshon [referring to the Patriarch] wanted to set (literally, establish) a *netziv* (an additional month determined by intercalation), but this Edomite (Rome) did not permit it. But the scholars met and set an additional month (*netziv*) in the month in which Aaron the priest died (Av). (B Sanhedrin 12a)[63]

There can be little question that some sort of disruption regarding the reporting of calendrical matters indeed occurred around this time; however, scholars are divided over the precise cause—a general persecution of the Jews at the time (Heinrich Graetz)[64] or, more likely, pressure brought to bear by the church in order to prevent Quartodeciman Christians in the eastern part of the empire from following the Jewish calendar when setting the date for celebrating Easter, a prac-

61. This step may also have been due to the fact that the continued existence of a far-flung Diaspora dependent on Patriarchal authority rendered the old calendrical system antiquated and ineffective (Mantel, *Studies*, 187). The Patriarch may have considered his position of leadership so secure that he had no need to continue the time-honored practice of making such determinations on an ad hoc monthly and yearly basis.

62. The talmudic commentaries explain this as a reference to a purple-blue dye used for fringes; it may also be an oblique reference to the city of Lydda, where the calendar was at times intercalated.

63. A similar tradition, preserved by Maimonides (*Mishneh Torah*, Laws of Sanctifying the Month 5, 3), though likewise garbled, indicates a disruption of the calendrical process and the need to calculate in a different way: "And when did Israel begin to calculate according to this calculation? Since the end of the sages of the Gemara, in the time when Israel was laid waste and no fixed court remained there. But in the days of the sages of the Mishnah and also in the days of the sages of the Gemara, down to the days of Abaye and Rava (ca. 350), people relied on the determination [of the calendar] in the land of Israel."

64. Graetz, *Geschichte der Juden*, 4:316–18; see also Jaffe, *History of Calendar Computation*, 3–10.

tice considered anathema by the orthodox establishment (Lieberman).[65] Whatever
the explanation, the date that Abraham bar Ḥiyya mentions dovetails quite neatly
with the above tradition. According to Lieberman, the government tried to disrupt
calendrical communication between Palestine and the Diaspora, and the Patriarch
was forced to find another way to ensure the observance of Jewish festivals at their
appointed times. Consequently, he resorted to the publication of the calendar so
that Diaspora Jewish communities would not be dependent on oral communication.

Thus, given the above considerations, there seems to be a plausible basis for con-
sidering Abraham bar Ḥiyya's report as fundamentally reliable, and that the Patri-
arch in Tiberias was indeed involved in a calendrical innovation in the mid-fourth
century.[66] This event, then, might have been a key factor in the decoration of the
Tiberias synagogue associated with the Patriarch's protégé Severus, in which well-
known calendrical motifs (the zodiac, Helios, and the four seasons) were adopted
from pagan models to mark the occasion. I see no inherent difficulty in the fact that
the borrowed Roman visual motif reflects a solar calendar, with the sun featured
in the center, while the regnant Jewish calendar, certainly in Patriarchal and rab-
binic circles, was primarily a lunar one (albeit with solar-related adjustments). It
seems that those responsible for the mosaic decoration in Ḥammat Tiberias simply
borrowed a well-known calendar motif and felt no need to make any major adapta-
tions, such as adding an image of the moon beside Helios.[67]

The claim that the Ḥammat Tiberias mosaic reflects calendrical concerns may
find support when compared iconographically to a similar depiction in a third-
century mosaic from Münster-Sarmsheim, Germany. In the latter, the proportions
between Helios and the zodiac are very different: Helios dominates the panel com-
pletely, and the zodiac signs are much smaller and clearly secondary (fig. 91).[68] At
Ḥammat Tiberias, however, as in other later synagogue zodiac representations, a
greater balance was struck between these components, thereby placing more em-

65. Lieberman, "Palestine in the Third and Fourth Centuries," 36:329–34. See also Avi-
Yonah, *Jews of Palestine*, 166.

66. One reason sometimes offered for doubting this report is that calendrical contro-
versies constantly resurfaced in subsequent centuries. Therefore, it might be assumed that
Patriarchal innovation had never been attempted. However, later controversies, the most fa-
mous of which involved Saʿadia and ben Meir in 921, were invariably about particular details;
they by no means preclude the fact that the fourth-century Patriarch might well have taken
the steps outlined above to resolve an immediate and critical problem for the Diaspora. See
A. A. Lasker and D. J. Lasker, "642 Parts." For skeptical positions regarding the historicity of
this tradition, see Stemberger, *Jews and Christians in the Holy Land*, 249–58; S. Stern, *Calendar
and Community*, 175–81; Jacobs, *Die Institution*, 202–5; and above, n. 58.

67. See chap. 16.

68. Gundel, *Zodiakos*, 114, cat. no. 84, plate 3. Kühnel, "Synagogue Floor Mosaic in Sep-
phoris," 37–39. For a somewhat similar design from Sens, see de Villefosse, "Le soleil mai-
trisant ses chevaux."

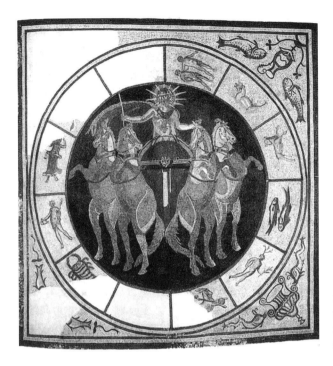

FIG. 91 Helios on a
third-century mosaic floor
from Münster-Sarmsheim,
Germany.

phasis on depictions of the months and seasons at the expense of the image of
Helios.[69] Thus it appears that the Ḥammat Tiberias mosaic was not intended to fo-
cus exclusively on Helios, but rather on broader calendrical considerations—days,
months, and seasons—which, we suggest, constituted a prime reason for the selec-
tion of this motif.[70]

Moreover, given the cosmopolitan cultural proclivities of the Patriarch, it is hard
to imagine that the appearance of Helios in the form of Sol Invictus in the Ḥammat
Tiberias synagogue was not related to the prominence of this image in many circles
of mid-fourth-century Roman society.[71] Use of such a depiction would have served
to emphasize the Patriarch's association with the wider Roman culture. Even if the
floor had been laid sometime after Julian's death, following the return to power
of Christian rulers, such a statement of affiliation might not necessarily have been

69. In one mosaic remnant from Antioch, however, the depictions of the months seem to
be far more dominant than the almost completely destroyed central figure, possibly Helios;
see Hanfmann, *Season Sarcophagus*, 2:148, no. 134, and plate 111. On the zodiac in Byzantine
synagogues of Palestine, see chap. 16.

70. On the centrality of calendrical motifs as well as the zodiac in the fourth century, see
Salzman, *On Roman Time*, 63–189.

71. On the continued use of pagan symbols during and after Constantine's reign, see
Toynbee, "Roma and Constantinopolis," and especially the evidence of the codex-calendar
of 354. See H. Stern, *Le calendrier de 354.*

deemed politically inappropriate, as the Patriarchate and Judaism generally contin-
ued to be regarded with respect and honor by subsequent Christian emperors until
the fifth century.[72] In short, besides its calendrical significance, this zodiac panel
may also have served as a personal statement of the Patriarch and his circle regard-
ing their ties to and identification with the empire, and not primarily as a statement
of an assumed Jewish belief at the time (astrology, the power of the God of Israel,
and so on), as has often been suggested.[73]

CONCLUDING REMARKS

The historical context of this mid-fourth century mosaic goes a long way in explain-
ing the motifs selected and presented in this synagogue. We have focused above on
the Patriarchal context, taking our cue from the Tiberian milieu, the quality of
the artistic work, the themes highlighted, the participation of the local urban aris-
tocracy, the predominance of Greek and Latin names, and the close association of
the major donor in the community, Severus, with the Patriarch. All these elements
point to a Patriarchal initiative (either by the Patriarch himself or by those close to
him) supported by a wealthy and acculturated group of Tiberians with the aim of
commemorating an event that they deemed important.[74]

However, the wider context must not be ignored. The fourth century is acknowl-
edged as a time of transition between the older pagan order and the newly emerging
Christian one.[75] Paganism still flourished throughout the empire, and Christianity
was only beginning to gain a foothold among the many and various sectors of so-
ciety. Its final triumph, in the East and the West as well as among rural and urban
populations, was a process that would take time to complete. As with similar pe-
riods of transition, a large degree of fluidity and diversity reigned at first, and the
levels of tolerance and acceptance were still relatively high among the populace
and even among many in church leadership. Michele R. Salzman has described the
situation in Rome as one of "accommodation and assimilation" between pagan and
Christian, characterized by "an ambience of compromise."[76] Such an atmosphere
may have allowed some segments of Jewish society as well, foremost among whom
were the wealthy aristocracy and the Patriarch, to continue to identify with Roman

72. See, e.g., imperial edicts dating from the last third of the fourth century in Linder,
Jews in Roman Imperial Legislation, nos. 14, 20 21, 24, 27, and 28; and above, chap. 9.

73. See chap. 16.

74. This is not to say that there may have been some sort of influence from other groups
of the population as well, such as priests or rabbis (although see chap. 20). Such possibilities
remain only theoretical; the principal factors at Ḥammat Tiberias were, as argued above, the
Patriarch and his circle.

75. See chap. 9.

76. Salzman (*On Roman Time*, 193–231) summarizes her position as follows: "In sum, the
mid fourth century was a period of accommodation and assimilation in Rome. Pagans and
Christians coexisted more or less peacefully. This climate, fostered in part by the policies

culture as they had in the past. The display of Helios and the zodiac was therefore not offensive to these Jewish circles; indeed, it was part of the general Hellenistic milieu with which they had no trouble identifying.

Finally, the zodiac panel appears alongside a mosaic depicting a cluster of Jewish symbols that was also now making its debut in the public Jewish sphere.[77] Is this merely coincidental, or were these symbols of especial importance to the Patriarch? Unfortunately, we have no solid data that might help resolve this question.

Nevertheless, this juxtaposition of motifs at Ḥammat Tiberias may well reflect an ideological statement of the Patriarchate, via Severus and the allied urban aristocracy, presenting a balance of sorts between Jewish and Hellenistic motifs, thereby visually affirming that the Jewish and Greco-Roman worlds were culturally compatible.[78] Jewish objects of veneration could indeed coexist alongside explicitly Hellenistic forms, and the Patriarchate itself, certainly in its own eyes, was a supreme example of this confluence.[79] In this regard, then, the artistic selection of the Ḥammat Tiberias synagogue was a way of asserting the religious and cultural identity of its patrons, those whose social context closely mirrored the nature and content of these motifs.

of Constantius II, greatly facilitated the incorporation of aristocratic pagan traditions into a Christian present. Christianity, too, was altered in the process, as can be seen in the emergence of a respectable aristocratic Christianity at this time. Among the elite strata of society especially, shared cultural values, class interests, and political considerations cut across religious categories and defused potential conflicts" (p. 231). For a more general assessment of the fourth century, see P. R. L. Brown, "Aspects of the Christianization of the Roman Aristocracy"; P. R. L. Brown, "Christianization and Religious Conflict"; Bowder, *Age of Constantine and Julian*, 65–96, 129–93; Kahlos, *Debate and Dialogue*, 3–4.

77. Such symbols were used (perhaps) beforehand (the relative dating here is not certain), individually and on occasion in clusters, in funerary frameworks such as Bet She'arim and the Roman catacombs. See chaps. 6 and 7.

78. It is interesting to note, however, that despite the many variations in the zodiac motif that were introduced by different communities over the next few centuries, these two themes remained inextricably intertwined. Whenever the zodiac was portrayed, so, too, was this particular cluster of Jewish symbols, although its details constantly fluctuated (see chap. 16).

79. This line of argument also forms the basis of Salzman's persuasive presentation of the 354 calendar (*On Roman Time*, passim). She argues that this calendar must be understood within the immediate context of the city of Rome in the 350s and relates to contemporary attitudes and policies of the imperial government, the local urban aristocracy, and the Christian church. In its integration of pagan and Christian themes, the calendar conveys a message of accommodation and assimilation between pagan and Christian elements of the local population that shared the same set of values and lifestyles (ibid., 193–231).

13. SEPPHORIS IN ITS PRIESTLY CONTEXT

HISTORICAL OVERVIEW

In contrast to Tiberias, Sepphoris's origins are shrouded in mystery. First noted by Josephus (*Ant.* 13.338), the city was firmly in Hasmonean hands in Alexander Jannaeus's day and was considered the main urban center (or town) in the Galilee at the time. As noted in the previous chapter, Tiberias surpassed Sepphoris as the political center of the Galilee soon after its foundation (19–20 CE) and seems to have functioned as the capital of the region for several decades. However, with the transfer of Tiberias to Agrippa II ca. 55–60 CE, Sepphoris regained its primacy as the central Galilean city, now boasting a royal bank and archives (*Life* 9.38).

The pro-Roman policy of Sepphoris's inhabitants during the first revolt (*War* 3.30) brought peace to the city and is reflected in the legend "Eirenopolis (City of Peace) Neronias Sepphoris" on its coins.[1] Numismatic evidence also attests to the continuation of this pro-Roman stance in the next century and a half. Hadrian renamed the city Diocaesarea, and its alliance with Rome was proudly proclaimed on its coins from the Severan era.[2] Sepphoris's political and social prominence was undoubtedly a major factor in R. Judah I's move there, and his presence at the height of his career would have undoubtedly further enhanced the city's reputation and status, at least among Jews.

1. Meshorer, "Sepphoris and Rome," 159–63.

2. Ibid., 163–71; and above, chap. 4. On the pagan images appearing on Sepphoris's coins, see chap. 3.

THE SYNAGOGUE

We read of eighteen synagogues associated with Greater Sepphoris.[3] Until recently, only a handful of epigraphic fragments had been discovered,[4] but in 1993 an exceptional synagogue was unearthed on the northern slopes of the city. It is unusually narrow (20.7 by 8 meters) and asymmetrical, its main hall or nave measuring 16.5 by 5.6 meters, and it has only one side aisle, not the standard two.[5] The building was entered from the southeast, while its *bima* was oriented to the northwest, away from Jerusalem. Only one other ancient synagogue, just north of Bet Shean, faces this direction.[6] Such an orientation not only flies in the face of the generally accepted contemporary practice, according to which synagogues were oriented toward Jerusalem,[7] but also runs counter to specific rabbinic directives in this regard (T Berakhot 3, 15–16, pp. 15–16; Sifre Deuteronomy 29, p. 47).

The most engaging and important feature of this Sepphorean synagogue, however, is its unusual mosaic floor. Unlike other decorated synagogue floors, which are usually divided into three bands or registers, this one has seven. Moreover, single registers elsewhere usually extend the breadth of the nave, but in Sepphoris many are subdivided, thus creating a total of fourteen panels.

The epigraphic evidence is likewise most unusual. The synagogue had thirteen Greek inscriptions (nine dedicatory and four captions identifying the seasons in the zodiac panel)[8] and eleven dedicatory inscriptions in Aramaic (with room for

3. Hüttenmeister and Reeg, *Die antiken Synagogen in Israel*, 1:400–18; S. S. Miller, "On the Number of Synagogues." The number 18 is noted in Y Kil'aim 9, 4, 32b. In addition, rabbinic literature mentions specific synagogues associated with groups from various locations: Babylonia (Genesis Rabbah 33, 3, p. 305); Gofna in Judaea (Y Berakhot 3, 1, 6a), and Cappadocia (Y Shevi'it 9, 5, 39a), in addition to the Great Synagogue in Sepphoris (Pesiqta de Rav Kahana 18, 5, p. 297).

4. Naveh, *On Stone and Mosaic*, no. 29; Roth-Gerson, *Greek Inscriptions from the Synagogues*, no. 29; Hüttenmeister and Reeg, *Die antiken Synagogen in Israel*, 1:402–7; Weiss, *Sepphoris Synagogue*, 2–3.

5. Interestingly, the other well-known example in this regard is the Tiberias synagogue discussed above. There, however, it was not a matter of the absence of an aisle, but rather the addition of a second one on the eastern side.

6. Chiat, "Synagogues and Churches," 22–24; Z. Ilan, *Ancient Synagogues*, 180–82. On the question as to whether this was a Jewish or Samaritan building, see L. I. Levine, *Ancient Synagogue*, 215–16, 216 n. 21.

7. L. I. Levine, *Ancient Synagogue*, 302–6. While the interior arrangement of the Sumaqa synagogue on the Carmel range faces east and the interior orientation of the synagogues in the Golan faces either west or south, one might claim that all of them are located on the periphery of the country and are positioned in the general direction of Palestine (as was the practice in the Diaspora). In contrast, those of Sepphoris and Bet Shean are quite different, since they basically face in almost the opposite direction from Jerusalem. It is this feature that makes these buildings so unusual.

8. Di Segni notes the number fourteen ("Greek Inscriptions"), but only thirteen are documented.

FIG. 92 Mosaic floor from Sepphoris synagogue.

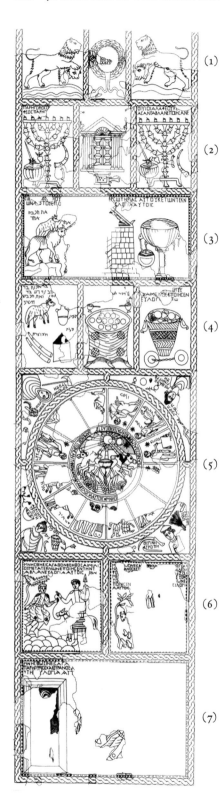

(1)

(2)

(3)

(4)

(5)

(6)

(7)

possibly an additional eleven that have not been preserved).[9] All the dedicatory inscriptions in Greek were incorporated into the lavishly decorated central panels, a practice unknown in other synagogues, while the Aramaic inscriptions, with but two exceptions, were located in the side aisle or between the columns; it is also noteworthy that the mosaics in the nave are almost all figural, while those on the side are geometric. It would seem, therefore, that the wealthy Greek-speaking patrons donated the more elaborate and expensive mosaic panels, while the Aramaic-speaking members sponsored simpler aniconic ones. No Hebrew dedicatory inscriptions were discovered, although some twenty-two Hebrew captions were found identifying a person (for example, Aaron), the Tabernacle items, sacrifices, and seasons.

The pièce de résistance of this synagogue is the art in the nave (fig. 92).[10] Upon entering the hall from the southeast, one encountered the following motifs in a southeast-northwest sequence:[11] the first two registers (7 and 6), the most poorly preserved mosaics of the floor, depict scenes from the life of Abraham—presumably the visit of the angels who promised Abraham a son (Genesis 18), and the 'Aqedah scene (Genesis 22). In the first register (7), where only the top of the head of a woman standing in a doorway is visible, Zeev Weiss has plausibly suggested, on the basis of a similar combination of scenes from the sixth-century San Vitale church in Ravenna, that this panel depicts the visit of the three angels to Abraham, with Sarah standing at the entrance to her tent (fig. 93).[12] The 'Aqedah register (6) is

9. See Weiss, *Sepphoris Synagogue*, 199–223.

10. For an exhaustive description of these panels, see ibid., 55–197.

11. The numbering of the panels follows that of the excavators, though I have chosen to describe the floor from the opposite direction.

12. For reactions to this interpretation, see S. Schwartz, "On the Program and Reception," 169–70; Newman, "Bishops of Sepphoris," 98 n. 49.

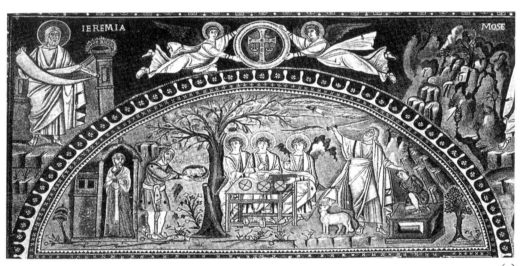

FIG. 93 Mosaics: (1) Fragmentary scene of the visit of the three angels to Abraham,
Register 7, Sepphoris synagogue; to left, Sarah standing in the doorway; (2) illustration
of Genesis 18 and 22, San Vitale church, Ravenna.

divided into two: the left side is well preserved and shows the two servants and an
ass; the right panel is almost totally obliterated, preserving only the head of a ram
tied to a tree as well as two pairs of shoes.

Beyond these two registers lies the largest one (5), featuring the zodiac signs,
the four seasons, and the sun above a chariot (fig. 94). Besides its larger size, this
register's impressiveness is further reflected by the fact that it is one of two registers
that are not subdivided. Moreover, this register is strikingly unique in that Helios
is replaced here by a depiction of the sun with ten rays, one of which descends into

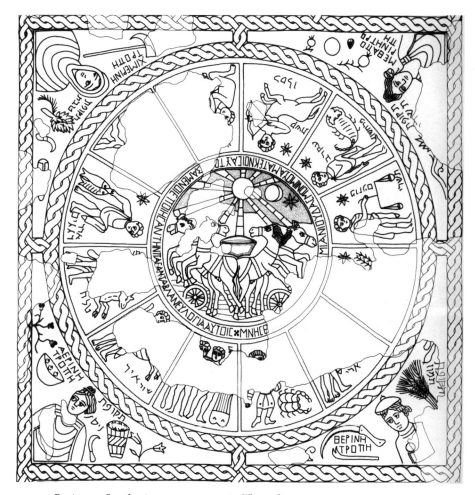

FIG. 94 Register 5, Sepphoris synagogue mosaic: The zodiac.

the chariot, giving the impression that the sun is riding in it. Beneath the galloping horses and chariot are horizontal wavy blue lines, perhaps representing the sea over which the chariot is set. The zodiac signs, which are to be read in a counterclockwise direction, also have a number of unique features: most of the figures are young men, either naked or wearing simple cloaks covering only part of their bodies; all except one are barefoot; the Hebrew name of the month and a star accompany each sign; the four seasons, identified by Greek and Hebrew captions, are accorded more attributes than similar depictions found elsewhere.

Registers 4 and 3 revolve around the theme of the Wilderness Tabernacle and feature Aaron officiating at the altar with cultic objects and ritual provisions represented nearby (fig. 95).[13] Some of these components are drawn from Exodus 29,

13. For a similar depiction from Dura, see Kraeling, *The Synagogue*, 125–33.

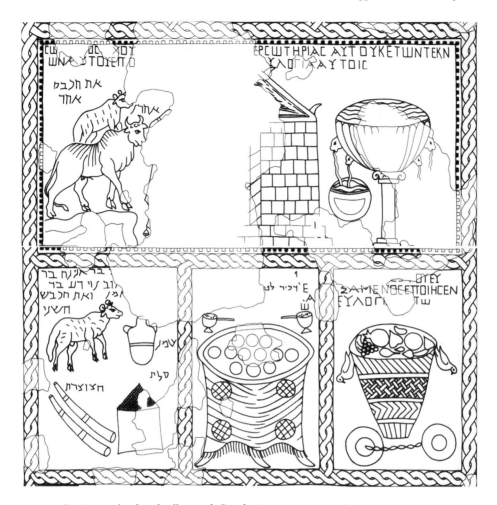

FIG. 95 Registers 3 (top) and 4 (bottom), Sepphoris synagogue mosaic: The Wilderness Tabernacle, Aaron, the altar, and various cultic items, including the showbread table and basket of first fruits.

where items associated with the Tabernacle's consecration (the daily sacrifice, oil, and flour) are specified. Moreover, other objects, such as the water basin (Exod. 30:17–21), trumpets (Num. 10:1–10), showbread table (Exod. 25:23–30; Lev. 24:5–9), and basket of first fruits (Deut. 26:1–11), are also depicted.[14] While the Abraham scenes located near the synagogue entrance move sequentially toward the zodiac, these two registers also move toward the zodiac in the opposite direction. We will therefore reverse the order here and describe the northernmost one first (3) and then the one below, nearest the zodiac (4).

14. Thus, it would seem that the theme of these registers is not specifically the consecration of Aaron (contra Weiss, *Sepphoris Synagogue*, 77–94), but rather his overall officiating role as the central figure in the holy cult; see below.

Register 3 depicts an elaborate water basin on the right. According to Exod. 30:18, the laver, used regularly for washing hands and feet, stood between the Tabernacle and altar, as it did later on in the Temple; in the consecration ceremony described in Exodus 29 it is not mentioned, perhaps because purification of the entire body was required (29:4).

In the center of the register, left of the laver, stands a partially preserved altar with a horn-shaped corner together with the almost totally obliterated figure of Aaron, identifiable by an inscription and a single bell attached to the fringes of his cloak (Exod. 28:33–35). To the left of Aaron are two animals—a bull and a lamb— the latter accompanied by the biblical phrase "one lamb" (Exod. 29:39; Num. 28:4). Directly below these animal depictions, in Register 4, are four other objects, each labeled by a Hebrew word: "a lamb" ("and the second lamb"—Exod. 29:41; Num. 28:4); a black jug or amphora with the word "oil"; a container or sack with the word "flour"; and two trumpets identified as such.[15] To the right of these is a showbread table (similarly depicted in the fourth-century Samaritan synagogue at el-Khirbe; see chap. 17, fig. 119) with twelve loaves of bread, and next to it, on the far right, a wicker basket containing fruit probably representing the offering of the first fruits (*bikkurim*).

Register 2, above the Tabernacle objects, contains a familiar depiction, although it is formatted in an unusual way. The register itself is divided into three panels. The two side panels show a menorah flanked on the right by a large shofar and presumably tongs[16] and on the left by a *lulav* and *ethrog* in a large bowl. The central panel contains a facade with a gabled roof and six columns, three on either side of a double door. Some have interpreted this type of facade in a synagogue context as representing the Temple (past or future), others a Torah shrine as it might have been seen in this and other synagogues.[17] Such representations are never identical; some seem to resemble the facade of a building, others an *aedicula* more suitable for housing Torah scrolls. Indeed, both interpretations may well be correct, as each community (or its artisan[s] and patron[s]) decided which object it preferred to depict.[18]

In Sepphoris, however, it is clear that a Temple facade was intended. The architectural components indicate that this was the front of a building and not a Torah shrine or ark, and the object placed beneath the facade—an incense shovel—seems to clinch this identification; as elsewhere, this item always appears next to the me-

15. The trumpets, although associated primarily with festivals in Num. 10:10, were also used on other special occasions as well as on a regular basis; see 2 Chron. 29:27; Ben Sira 50, 16; and later rabbinic literature (M Tamid 7, 3; M Sukkah 5, 5).

16. This is the first time such an implement is depicted in synagogue art. It appears in the Samaritan el-Khirbe synagogue and possibly in a Jewish catacomb in Rome (Goodenough, *Jewish Symbols*, vol. 3, no. 771).

17. See L. I. Levine, *Ancient Synagogue*, 215–19.

18. See chap. 17.

norah or alongside the shofar, *lulav*, and *ethrog*.[19] The incense shovel is the symbol par excellence of the Temple setting but plays no role whatsoever in synagogue liturgy. Thus, shifting the shovel from an ancillary position among a cluster of other symbols to center stage, and displaying it alone, constitutes rather conclusive evidence that this facade represents a cultic center, possibly the Wilderness Tabernacle but more likely the Jerusalem Temple.

Ironically, Register 1, nearest the *bima*, appears to be the least laden with religious significance. It too is divided into three panels, with the central one depicting a stylized wreath enclosing a Greek dedicatory inscription. The two flanking panels display lions facing the central wreath, each clutching the head of a bull or ox in its paw. An inscription flanked by lions is not uncommon, also appearing in Ḥammat Gader and Ḥammat Tiberias, although there the lions do not hold the head of another animal. The Ḥammat Gader motif, like the one in Sepphoris, is located near the *bima*, while the one in Ḥammat Tiberias appears in the register farthest from the *bima*.[20]

INTERPRETATIONS

Since its discovery and publication, the Sepphoris synagogue has attracted more attention than any other ancient synagogue, with the exception of the perennially fascinating Dura. Although the synagogue was discovered only two decades ago, a number of intriguing explanations have been proffered regarding its significance and *Sitz im Leben*. Many of these interpretations will be addressed in detail elsewhere,[21] and therefore we will discuss them here only briefly. Much of the credit for this interest belongs to Weiss, who excavated the site together with Ehud Netzer and has presented a detailed and in-depth analysis of these remains. His fundamental lines of interpretation have since been adopted and adapted by others.

Weiss's interpretation divides the mosaic floor's message into three themes—promise (the *'Aqedah* scene), redemption (represented by the Tabernacle, Temple, and associated elements), and the eternity of God's providence and His guarantee that all promises will be fulfilled in the end of days (represented by the zodiac, sun, moon, and stars). A second layer of this interpretation maintains that the entire mosaic floor represents a polemic against Christianity's claim to have superseded Judaism. Bianca Kühnel has added a geographical dimension: although Byzantine Jerusalem seemingly bears witness to the truth and triumph of Christianity, with the Temple Mount, the former focus of Jewish pride and identity, now lying waste,

19. Hachlili, *Art and Archaeology—Land of Israel*, 256–68.

20. At Ma'on (Nirim) lions flank a menorah, while at Bet Alpha they flank the Torah shrine; see *NEAEHL*, loc. cit. In the synagogue at Ḥuseifa, on the Carmel mountain range, an inscription within a wreath and flanked by two *menorot* is located near the entrance of the synagogue hall.

21. See chaps. 18 and 20.

God's assurances to fulfill His promise and restore the Temple and city to Israel will surely be realized.[22]

Nevertheless, as attractive as this programmatic reading might be, it is not without its problems.[23] The themes associated with each section of the tripartite division of the floor are far from apparent.[24] Many possible ideas and values are (and have been) associated with the 'Aqedah, not least of which is Abraham's unfaltering faith and loyalty to God.[25] Furthermore, it is not clear if the Tabernacle-Temple depictions are indicative of the future messianic Temple and an era of redemption. Enlisting a series of rabbinic traditions, some of which were either articulated much earlier or edited much later, is fraught with difficulties; given the lack of any contemporary literary or archaeological sources, such explanations become quite tenuous. Problematic argumentation is likewise evident in the interpretation of the sun and zodiac as an expression of God's control over the universe, indicating His ability to carry through with the promises made in Genesis.[26] Not only does the plethora of competing interpretations of the zodiac motif render any particular suggestion hypothetical,[27] but the rabbinic source invoked to clinch this particular argument of divine providence does not quite say what is claimed.[28]

Moreover, the claim that the overall purpose of the mosaic was to serve as a polemic against a triumphant Christianity is likewise questionable. The assumption that such a polemic was widespread in the Galilee when this synagogue was being planned and built (early fifth century) is well nigh impossible to prove. No one doubts that serious tensions between Christians and Jews existed in Late Antiquity, but it remains unclear when and where this occurred.

As mentioned in an earlier chapter, much of the fourth century was essentially a transitional era; on the one hand the church was aspiring to solidify and consolidate its hold on the empire while, on the other, pagans, Samaritans, and Jews, for the

22. Weiss and Netzer, *Promise and Redemption*, 34–39; and especially Weiss, *Sepphoris Synagogue*, 225–62; Kühnel, "Synagogue Floor Mosaic in Sepphoris." These ideas have been picked up in various ways by, inter alia, H. L. Kessler ("Sepphoris Mosaic and Christian Art") and England ("Eschatological Significance of the Zodiac"). On the newly established Christian Jerusalem in contemporary church ideology, see A. S. Jacobs, *Remains of the Jews*, 139–96.

23. See a more specific critique of this approach in chaps. 18 and 20.

24. See, e.g., the comments of Fine, "Art and the Liturgical Context," 228–29; S. Schwartz, "On the Program and Reception"; S. Schwartz, *Imperialism and Jewish Society*, 248–52.

25. For a range of ideas associated with this account in both early Jewish and Christian sources, see Vermes, "Redemption and Genesis XXII."

26. Weiss and Netzer, *Promise and Redemption*, 35–36; Weiss, *Sepphoris Synagogue*, 231–35. In a similar vein, it has been suggested that the representations of the eagle in later Jewish art were symbolic representations of God, which, as articulated in a series of rabbinic sources, were intended to express His power and might; see Yuval-Hacham, "'Like an Eagle Who Rouses His Nestlings.'"

27. See chap. 16.

28. For a more detailed critique of this theory, see chap. 20.

most part, still continued to function relatively unencumbered. True enough, the turn of the fifth century witnessed a slew of restrictive edicts and attacks on some temples and synagogues, but these seem to have been relatively isolated incidents. Thus, the assumption of a vigorous Jewish-Christian polemic in Sepphoris and the Galilee at this time is far from evident. In general, Christian polemics are well documented for this era, but very little evidence is available about active and explicit Jewish activity in this regard.[29]

Another competing but nonetheless problematic interpretation of the Sepphoris mosaic floor links it to some *piyyutim* originating in the Byzantine era. Steven Fine, for example, invokes a Rosh Hashanah *piyyut* of Yannai containing the themes of the '*Aqedah*, the shofar, the sun, and the moon to forge such a tie. However, there is no end to the themes that can be culled from *piyyutim* and applied to one or more of the many motifs represented in this or any other mosaic floor. In addition, there are serious chronological problems in making such comparisons, as the *piyyutim* most often cited postdate the synagogue floor by over a century.[30]

THE PRIESTLY CONTEXT

A very different approach—one based first and foremost on the synagogue's art— maintains that the Sepphoris mosaic reflects a noticeable priestly agenda. While this floor contains motifs that are not sui generis, many of its unique features can best be explained by positing a significant degree of priestly influence.[31] This proposal does not mean that priests were necessarily the leaders of this institution or even among its major donors. Nevertheless, their influence, whether direct or indirect, appears palpable, as priestly related interests are unusually prominent in this mosaic.

Priestly emphasis is most blatant in Registers 2–4, where the focus is on the Tabernacle and the Temple—two institutions indisputably run by priests. As noted above, the building facade in Register 2 is clearly that of the Temple, and the location of the incense shovel beneath the facade, conspicuously set apart from the other religious items on either side, further underlines the priestly emphasis. The incense shovel is closely associated with priests and is mentioned several times in the construction of the Tabernacle, once as a utensil with which priests cleaned the altar and again in connection with the removal of ashes from the menorah (Exod. 25:37–38, 27:3). A shovel filled with incense and coals also served Aaron in the ritual of atonement on Yom Kippur (Lev. 16:12–13) and is featured in the biblical description of the Korah rebellion against the leadership of Moses and Aaron (the episode ends with the reminder that only priests, descendants of Aaron, should burn

29. For a more detailed critique of this suggestion, see chap. 18.

30. Ibid. For a very different understanding of the relationship between *piyyut* and synagogue decoration, see S. Schwartz, "On the Program and Reception," 176–81; and below, chap. 18.

31. This association has been noted by Yahalom, "Story of Mosaic Stones." See also Yahalom, "Sepphoris Synagogue Mosaic," 89–91; Yahalom, *Poetry and Society*, 107–10.

incense before the Lord; Num. 17:1–5). The depiction of tongs, used to clean the menorah (Exod. 25:38, 37:23), is likewise an unusual priestly addition to the cluster of symbols in Register 2.

The elaborate rendering of the Tabernacle in Registers 3 and 4, replete with Aaron, the daily sacrifices, and other offerings, also vividly highlights this priestly focus.[32] This is likewise emphasized by the arrangement in each register: Aaron and the altar stand in the center of the third register, and right below, in the center of the fourth, is the showbread table. The twelve loaves, arranged in two rows of six each, follow the biblical prescription (Lev. 24:5–9);[33] once removed, the bread was consumed by priests in the area of the sanctuary: "They should belong to Aaron and his sons, who shall eat them in the sacred precinct; for they are his, as most holy things from the Lord's offerings by fire, a due for all time" (Lev. 24:9). The preparation of these loaves was the task of the Kohathite clan of Levites, and in the late Second Temple period the family of Garmu was charged with this responsibility (M Sheqalim 5, 1). Left of the showbread table were depictions of a jar labeled "oil" and a receptacle labeled "flour," two indispensable ingredients of the meal offering that were likewise used by the priests in their daily offerings (Lev. 2:1–10). Finally, the appearance of a basket of first fruits is also directly related to priests, who were officially designated to receive such ceremonial offerings (Deut. 26:1–11; M Bikkurim 3).

The appearance of trumpets in the fourth register, beside the oil and flour, once again highlights the role of priests, as they are the ones who were instructed to sound the trumpets (Num. 10:8); in contrast to blowing the shofar, sounding the trumpets was exclusively a priestly prerogative.[34] Moreover, the use of trumpets by priests became a daily feature on the Sukkot holiday in the later Second Temple period (Ben Sira 50:16; M Tamid 7, 3; M Sukkah 5, 4–5).

Many of the above-mentioned objects (the Temple facade, menorah, showbread table, tongs, trumpets, and incense shovel) are similarly featured in the fourth-century Samaritan synagogue mosaic from el-Khirbe, located west of Shechem. Since priestly domination of the Samaritan religious scene is well attested, such depictions may best be understood as a reflection of the interests and agenda of this sacerdotal class among Jews as well.[35]

32. By way of comparison, see the depiction of Aaron and the Tabernacle at Dura Europos in Kraeling, *The Synagogue*, 130–31. In a somewhat different vein, see Branham ("Mapping Sacrifice on Bodies and Spaces," 214–24), who focuses on the sacrificial theme in Registers 4 and 3.

33. Similarly in Mesopotamia, twelve loaves of bread were placed on the sacrificial table before Ishtar; see Sarna, *JPS Torah Commentary—Exodus*, 256 n. 68.

34. Milgrom, *JPS Commentary—Numbers*, 372–73.

35. Montgomery, *Samaritans*, 230; MacDonald, *Theology of the Samaritans*, 310–13; Gaster, *Samaritans*, 47–48; Magen, "Samaritan Synagogues" (1993), 194–204; and below, appendix to chap. 17.

Other elements in the Sepphoris mosaic floor may serve to strengthen our claim for the prominence of priestly concerns and traditions:

1. The frequency with which the persons depicted in this mosaic appear barefoot may indicate a priestly practice. The priestly blessing offered in the Temple and later in the synagogue was performed without sandals (B Sotah 40a; B Rosh Hashanah 31b).[36] All but one of the zodiac figures appear barefoot, and this is especially apparent in the fragmentary remains of the *'Aqedah* scene, where we find two pairs of shoes, presumably left behind by Abraham and Isaac before ascending the mountain. The removal of sandals is not mentioned in either the biblical narrative or rabbinic tradition. In fact, the rabbis themselves appear to have taken a dim view of their removal in a liturgical context and protested against anyone leading services barefoot (M Megillah 4, 8); such a remark may have been directed primarily at priests.[37]

2. The zodiac register must be considered central, not only because it is the largest one but also because, as noted above, the four adjacent registers (3 and 4 as well as 6 and 7) are oriented toward it. This arrangement does not seem coincidental, for it breaks the usual sequence of synagogue mosaics that "flow" in one direction, from the entrance toward the *bima*.

 The symmetry between the registers depicting Aaron and the Tabernacle on one side of the zodiac and Abraham on the other may have been intended to highlight a priestly focus. Abraham demonstrated this priestly dimension when he built altars and sacrificed to God; the anticipated "sacrifice of Isaac" thus would have constituted the pièce de résistance of his priestly activity. This image resurfaces not infre-

36. This practice is also associated with the tribe of Levi in a later midrash; it is claimed that, in contrast to other Israelites who wore sandals, members of this tribe walked barefoot in the desert (Numbers Rabbah 5, 8).

37. Nevertheless, one Genizah fragment indicates that such a practice seems to have been well known perhaps in Late Antiquity and more certainly in the early Muslim period: One should remove his shoe or sandal from his foot outside and enter barefoot, for thus slaves go barefoot in the presence of their master(s). . . . And if [one acts thusly] before an ordinary mortal (lit., an ill-smelling secretion; see Jastrow, *Dictionary*, 702), how much more so before the King, King of Kings, Blessed be He. And thus the sages have said: "One should not enter the Temple Mount with his staff and shoe. And if because of our sins the Temple Mount is no longer ours, we still have a diminished sanctuary (i.e., the synagogue), and we are obligated to conduct ourselves in purity and awe. . . . Therefore, our ancestors have decreed that basins of fresh water should be placed in the courtyards of synagogues for washing hands and feet. And if a person is sickly or cannot remove his shoes and has to be careful how he walks, we do not insist that he remove them" (following Margoliot, *Palestinian Halakhah from the Genizah*, 131–32; Kister, "'Do Not Assimilate Yourselves'").

quently in postbiblical Jewish sources as well. The book of Jubilees, for instance, rehearses Abraham's building of altars and sacrificing (chaps. 15–18), instituting the giving of tithes (15:25–27) and first fruits (15:1), and celebrating the Sukkot festival with daily sacrifices while surrounding the altar with the four species (16:21–31). Moreover, Abraham's final testimony to Isaac in Jubilees 21:7–16 includes detailed instructions of sacrificial procedures, as if the latter were assuming the role of a priest. Centuries later, rabbinic sources refer to Abraham as a priest, most prominently in connection with the command to sacrifice Isaac (Genesis Rabbah 55, 6–7, pp. 589, 592; Leviticus Rabbah 25, 6, pp. 580–81); Tanḥuma, Vayera, 44, ed. Buber, p. 56a; Pirqei de Rabbi Eliezer 8 and 31).[38]

From the mosaic's other direction, Aaron's proximity to the zodiac, together with the Temple-related appurtenances, may reflect a tradition harking back to Second Temple days that bespeaks the priestly role in preserving the knowledge of the solar calendar and guarding sacred times. Aaron received this wisdom from Moses, served as its guardian, and then passed it on to his priestly descendants. Traces of such a tradition can be found in the Enoch literature, Jubilees, and several Qumran scrolls.[39]

Thus, from both directions of the mosaic floor, via the Abraham narrative on the one hand and the representations of Aaron and the priestly cult on the other, the viewers' attention is directed toward the sun and zodiac, which—at least here in Sepphoris—clearly represent the solar-lunar calendar, which was the basis of Jewish life generally and of priestly wisdom and concern in particular.[40]

3. The calendrical dimension of the zodiac panel is highlighted by the labeling of the months of the year appearing beside the zodiac signs, a practice unknown in any other synagogue context. It is possible, though difficult to substantiate, that the Sepphorean coupling of calendar concerns with the sun may represent a continuation of the priestly practice attested earlier at Qumran, which also addressed astrological matters (including the zodiac signs) in relation to the calendar.[41]

4. The very number of registers in the Sepphoris mosaic—seven—calls for an explanation. While this number had become well entrenched

38. For a suggested link between Abraham's priestly image and Melchizedek, see Siker, *Disinheriting the Jews*, 87–97; Irshai, "Priesthood in Jewish Society," 92–94 n. 66. See also Revel-Neher, "Offerings of the King-Priest."

39. Elior, *Three Temples*, 88–110.

40. See Magness, "Heaven on Earth," 21–28.

41. E.g., 4Q Aramaic Brontologion (4Q318); 4Q186; 4Q561; VanderKam, *Calendars in the Dead Sea Scrolls*, 71–90; Albani, "Der Zodiakos in 4Q318"; Elior, *Three Temples*, passim. See also *Jubilees* 6, 23–37; Enoch 72–82.

in Jewish tradition by the fifth century CE, there is little question that its roots were clearly associated with earlier priestly tradition. Starting with the priestly accounts in Leviticus (seven days a week, seven years in a sabbatical cycle, seven cycles in a jubilee, and so on), this number remained prominent in the priestly calendar of the Second Temple period.[42] If this mosaic indeed had a priestly provenance, then the unusual number of registers would fit nicely.[43]

At first glance, one might well argue that many of the above-noted features reflect Jewish thinking in general and have no particular connection with priestly circles.[44] The memory of the Temple and its appurtenances may have been considered sacred and important to the ordinary Jew and not just to those of priestly lineage. However, what makes the possibility of an especially strong priestly component in Sepphoris compelling is the fact that these themes are emphasized here to a far greater degree than in any other synagogue, where they are either entirely absent (for instance, the depiction of Aaron and the number of Tabernacle-Temple ritual appurtenances, such as the trumpets and oil) or given minimal emphasis (the incense shovel, barefoot figures). Thus, the high concentration of these unique elements in Sepphoris, when compared to other synagogue mosaic floors, leads us to assume priestly presence and influence as the most viable explanation.

To reiterate: we do not mean to imply that priests were the leaders of this community or synagogue, but only that their traditions were recognized and accepted by this particular congregation and found expression in the mosaic's artistic details. However, the Sepphoris building's uniqueness may also be attributed, at least in part, to the significant and unusual priestly presence in the city throughout the post-70 era.[45]

PRIESTLY PRESENCE IN LATE ANTIQUE SEPPHORIS

The notion of a significant priestly presence in Sepphoris might not have been seriously entertained a generation or two ago. Lately, however, a considerable amount of scholarly literature has been devoted to the role of priests in Jewish society of Late Antiquity.[46] Dalia Ben-Haim Trifon's doctorate from 1985 on the subject notes, inter alia, that mostly non-Jewish sources from the Byzantine period (fourth to

42. On the number seven in priestly traditions of antiquity, see Elior, *Three Temples*, 29–62, and subsequent chapters there (pp. 63–200).

43. For numerical symbolism in early Jewish and Christian apocalypticism, particularly with regard to the number seven, see A. Y. Collins, *Cosmology and Eschatology*, 55–138.

44. Weiss, *Sepphoris Synagogue*, 247–49.

45. Thus, I have serious reservations regarding any attempt to apply this priestly phenomenon to all ancient synagogues featuring the Helios and zodiac motifs per Elior, *Three Temples*, 13–14; Elior, "*Hekhalot* and *Merkavah* Literature," 115–16; Magness, "Heaven on Earth," passim.

46. See already Büchler, *Priests and Their Cult*, 29–37.

sixth centuries) often single out priests as leaders and spokesmen of the Jewish community.[47] Aside from scattered literary references, epigraphic evidence attests that priests took up residence throughout the eastern and central Galilee at some point following the destruction of the Temple, and presumably constituted a recognizable presence in these regions.[48] A half dozen or more synagogues (in Nazareth, Reḥov, Caesarea, Ashkelon, Yemen, and possibly Kissufim) graced their walls with plaques of the twenty-four priestly courses, listing not only the names of the courses, but also the specific settlement in the Galilee in which each of them resided.[49]

In examining the wider context of the material relating to the Galilee, it is also important to note a heightened priestly role in several realms of religious creativity in the Byzantine period. *Piyyut* and mysticism have been singled out as having been particularly influenced by priests and priestly traditions.[50] If, indeed, priestly influence in these areas is acknowledged, then the chances that other aspects of synagogue life were affected by priestly traditions becomes substantially greater — especially in a city such as Sepphoris. And indeed it is this unique priestly context that we encounter in a series of sources noting the presence of priests or priestly traditions in Sepphoris and its environs in the post-70 era and throughout Late Antiquity:

1. An intriguing incident took place in the early second century involving two rabbis, one from Sepphoris and the other from nearby Sikhnin, who instituted a fast-day ritual in their hometowns. Identified as having once taken place in the Temple, this ritual featured the participation of priests who periodically sounded the shofar. Other sages are reported to have frowned upon this practice, claiming that it should be reserved for the Temple only (T Taʿanit 1, 10–13, pp. 326–28).[51]

2. The resettlement of priests throughout the Galilee is evident in a number of literary and archaeological sources, and there is specific reference to the Yedaʿyah course that settled in Sepphoris (Y Taʿanit

47. Trifon, "Priests from the Destruction of the Temple," passim. More recently, Irshai has addressed this subject, focusing on Late Antiquity; see his "Priesthood in Jewish Society"; and Fraade, *From Tradition to Commentary*, 73–74.

48. One of the fascinating phenomena of the post-70 era was the resettlement in the Galilee of the priestly courses hitherto concentrated in Judaea. The dating of this transition is unclear, with suggestions ranging from the late first to third centuries. See, e.g., Klein, *Galilee*, 64–70; T. Kahana, "Priestly Courses"; Z. Safrai, *Pirqei Galil*, 261–74; Trifon, "Did the Priestly Courses?"

49. See L. I. Levine, *Rabbinic Class*, 171–72 (and the map of priestly settlements in the Galilee on p. 174); Oppenheimer, *Galilee*, 53–57; S. S. Miller, *Studies*, 123–27; Magness, "Heaven on Earth," 23–24.

50. See appendix at the end of this chapter.

51. On varying assessments of this tradition, see S. S. Miller, *Studies*, 103–15; D. Levine, *Communal Fasts and Rabbinic Sermons*, 107–19.

4, 6, 68d). This is the only priestly course to have resided in an urban setting, the other twenty-three purportedly having taken up residence in the villages and towns of the region. Tiberias, for instance, did not attract a priestly presence, perhaps owing to the lingering issue of impurity that plagued this city for generations[52] (even though several courses settled in the immediate vicinity). It may very well be that the Yeda'yah priests' decision to live in Sepphoris was linked to the earlier tradition of a prominent priestly presence associated with the city, but we cannot be sure of this.[53]

3. One late midrash mentions a tradition regarding the members of the Yeda'yah course, referring to them as "the Sepphoreans," who ostensibly played a prominent role in the events surrounding the death of R. Judah I: "Rabbi (Judah I) was dying in Sepphoris and the Sepphoreans said, 'We will kill whoever comes and says that Rabbi has died.' Bar Kappara came and went to the window . . . he said, 'My brothers, sons of Yeda'yah, listen to me, listen to me'" (Ecclesiastes Rabbah 7, 11).[54]

4. In events related to the death of R. Judah's grandson, Judah II Nesiah (ca. 270 CE),[55] which most likely occurred in Sepphoris,[56] an announcement was made that "there is no priesthood today" (Y Berakhot 3, 1, 6a).[57] This would have allowed the local priests to participate in the funeral out of respect for the Patriarch, even though it might have meant defiling themselves. The remark assumes that the priestly community in the city and surrounding area was significant and important, or at least closely associated with the Patriarch.[58]

5. Several generations later, when Judah III Nesiah (Judah II Nesiah's grandson) died, it is reported that R. Ḥiyya bar Abba pushed R. Ze'ira

52. See L. I. Levine, "R. Simeon b. Yoḥai."

53. Another possible instance of a Jerusalemite (priest?) in Sepphoris in the mid-second century may be attested in B Ketubot 77b, especially when taken in conjunction with T Ketubot 7, 11, p. 82. This was suggested by Büchler, *Priests and Their Cult*, 29–30. Other Judaeans who resettled in Sepphoris might include a significant number of residents from Gofna, who founded a synagogue there by that name; see Y Berakhot 3, 1, 6a; Y Nazir 7, 1, 56a.

54. In the earlier Yerushalmi report (Kil'aim 9, 4, 32b; Ketubot 12, 3, 35a), the reference to the Yeda'yah clan is absent.

55. See L. I. Levine, "Jewish Patriarch (Nasi)," 685–88.

56. See the tradition in Y Shabbat 12, 3, 13c and Y Horayot 3, 8, 48c (and below), which speaks of the daily visits of Sepphoreans to this Patriarch's home.

57. See Ginzberg, *Commentary*, 2:95–96.

58. Something similar may have happened several generations earlier in Sepphoris following the death of R. Judah I. B Ketubot 103b reports: "On the day that Rabbi (Judah I) died, holiness was suspended (קדושה בטלה)." However, even if accurate, the announcement may have had a more general meaning.

into the Gofna synagogue in Sepphoris where the Patriarch's corpse was lying, causing this priest to become unclean (Y Berakhot 3, 1, 6a; Y Nazir 7, 1, 56a).[59]

Reuven Kimelman has suggested a far-reaching though somewhat speculative interpretation of one tradition that, if correct, would place the Sepphorean priesthood at the very center of the city's political scene (Y Shabbat 12, 3, 13a; Y Horayot 3, 8, 48c).[60] In discussing the daily visits (*salutatio*) to the Patriarch in the third century, it is noted that the members of the city council (*bouleutai*) of Sepphoris were recognized as a privileged group that would enter and leave first. When others who studied Torah challenged this primacy, R. Yoḥanan responded in a public sermon that they should be duly rewarded by according them preference in this morning ritual. Quoting a mishnah (Horayot 3, 8; see also T Horayot 2, 10, pp. 476–77), R. Yoḥanan declared: "Even if a sage is a *mamzer* (the product of a forbidden marriage) and a high priest is an *'am ha-aretz*, the sage who is a *mamzer* takes precedence over the high priest who is an *'am ha-aretz*."

It would seem that R. Yoḥanan's analogy assumes that the competing group, although of a lesser pedigree, should be accorded primacy owing to their knowledge of Torah, and that the priests, although of superior descent, are to be relegated to a secondary position. The question is whether this analogy was merely a rhetorical flourish utilizing a mishnaic quote asserting the precedence of a sage, or whether R. Yoḥanan was consciously pointing his finger at the priestly members of the *boule*. If Kimelman is correct and the reference is indeed to priests, then this source might provide decisive proof of priestly political and social centrality in mid-third-century Sepphorean life. Such an interpretation, though most intriguing, remains questionable.

Archaeological material from these centuries also may be indicative of priestly centrality in Sepphoris. Excavations on the western slope of the city's acropolis yielded a residential quarter with twenty stepped pools (probably *miqva'ot*) and the remains of what has been interpreted as incense shovels.[61] Since neither of these types of finds is common throughout the Galilee during Late Antiquity, they have been understood, rightly in our opinion, as pointing to the presence of a local

59. S. S. Miller, *Studies*, 116–17.

60. Kimelman, "Conflict."

61. *Miqva'ot*: Hoglund and Meyers, "Residential Quarter"; Eshel, "Note on 'Miqvaot' at Sepphoris"; Galor, "Stepped Water Installations." For an exchange of views as to whether the Sepphoris pools should be regarded as *miqva'ot*, see Eshel and E. M. Meyers, "Pools of Sepphoris"; S. S. Miller, "Stepped Pools." One should note that there was a relative decline in the number of *miqva'ot* during Late Antiquity as compared to the pre-70 era; see Reich, "Synagogue and the *Miqweh*," 292–97. On a series of methodological considerations regarding the identification of *miqva'ot* relating particularly to Second Temple times, see B. G. Wright, "Jewish Ritual Baths." Regarding incense shovels, see Rutgers, "Incense Shovels at Sepphoris?"

priestly community.⁶² If such an assumption is to be granted, then the location of these priestly dwellings on the city's acropolis, and perhaps elsewhere in the city, would be an important indication of their social, religious, and political prestige and prominence in city life.⁶³

In summary, a fully satisfactory solution to the meaning and significance of the Sepphoris synagogue mosaic may be out of reach at present, given the limitations of the sources at our disposal. Nevertheless, it would seem that the accumulation of evidence noted above, some direct and some circumstantial, more than justifies the assumption that a priestly context in Sepphoris provides the best explanation for understanding this mosaic floor, its various components, and its wider historical context.⁶⁴

62. The fact that similar pools have been found elsewhere in Sepphoris does not diminish the uniqueness of this discovery. Such pools either belonged to priestly families as well or had been adopted by others owing to priestly influence. It is important to bear in mind that other than Susiya in the south, no similar concentration of pools has been found in Late Antique Palestine. On *miqva'ot* in Late Roman and Byzantine Palestine, see Amit and Adler, "Observance of Ritual Purity"; and below, chap. 20. For a suggestion to remove *miqva'ot* from a priestly context in Sepphoris and elsewhere, see S. S. Miller, "Some Observations on Stone Vessel Finds," 417-18.

63. This appears to be well attested until the earthquake of the mid-fourth century, when most of the *miqva'ot*, at least on the acropolis, went out of use; see Galor, "Stepped Water Installations." In general, the extent of the damage to Sepphoris from the 363 CE earthquake varied in different parts of the city. Besides the area of the *miqva'ot*, the western acropolis seems to have been seriously affected, both its residential quarter (Hoglund and E. M. Meyers, "Residential Quarter," 41-42) and the House of Dionysos (Talgam and Weiss, *Mosaics of the House of Dionysos*, 27-29). Nevertheless, the city center to the east continued to develop in the following generations, apparently having suffered very little long-term damage; see Weiss and Netzer, "Sepphoris during the Byzantine Period," 81-82; Weiss, "Sepphoris," 2032-34.

64. While other influences also may have been at play in Sepphoris, our analysis assumes that the priestly component was of decisive importance. For a different view, see Fine, "Between Liturgy and Social History." For a recent overview of the priestly role in Late Antique Judaism, with special attention to *piyyut*, *targum*, and Hekhalot mysticism, see Alexander, "What Happened to the Jewish Priesthood after 70?"

APPENDIX

The Role of Priests in the Jewish Religious
Life of Late Antiquity

The creation of *piyyut* in Byzantine Palestine has been attributed in part to a number of *paytanim* who have been identified as priests—Yose b. Yose (the first-known *paytan* who referred to himself as a "high priest"), Shim'on Megas, Yoḥanan HaCohen b. Joshua HaCohen, Pinḥas HaCohen of Kafra, and Haduta. Moreover, a connection with priestly concerns may be reflected in *piyyut*'s intense interest in Temple-related issues: the twenty-four priestly courses; sacrificial worship, especially on Yom Kippur; Sukkot celebrations; and the effects of the Temple's destruction (in compositions commemorating the Ninth of Av).[65] Finally, priestly participation in the creation of *piyyut* is probably the best explanation for the decidedly positive portrayal of priests and Temple cultic functions in many *piyyutim*, especially when compared to their image in rabbinic literature.[66]

The mystical traditions in the Hekhalot literature and related magical texts such as *Sefer Ha-Razim* comprise a second area of religious creativity during this period. Both Ithamar Gruenwald and Ira Chernus have noted the impact of Second Temple priestly traditions on the formation of this literature, and Rachel Elior has revisited this thesis of late with even greater emphasis. Given the earlier priestly preoccupation with mystical speculation, the loss of the Temple created a vacuum in their circles. This was filled in part by the shift in focus from the earthly Temple to the heavenly spheres that housed temples or shrines (*hekhalot*), where Metatron offered sacrifices on an altar while revealing the order of these spheres. The angels not only praised God in song but celebrated His majesty with trumpets, timbrels, and cymbals.[67]

The existence of some sort of relationship between these mystical circles and the synagogue and its prayers (or parts thereof) has also merited attention.[68] Note,

65. See, e.g., Mirsky, *Yosse ben Yosse*, 10; Fleischer, "Early Paytanim of Tiberias"; Yahalom, *Priestly Palestinian Poetry*, 56–57; Rubenstein, "Cultic Themes in Sukkot Piyyutim."

66. Swartz, "Ritual about Myth about Ritual"; Swartz, "Sage, Priest and Poet." See also Yahalom, *Poetry and Society*, 107–36.

67. Gruenwald, "Impact of Priestly Traditions"; Chernus, "Pilgrimage to the Merkavah"; Elior, "From Earthly Temple to Heavenly Shrines"; Elior, "*Merkavah* Tradition"; Elior, "*Hekhalot* and *Merkavah* Literature"; and, most recently, Elior, *Three Temples*, 232–65.

68. On the relationship between Hekhalot hymns and the *paytan* Yannai, see Gruenwald, "Yannai and Hekhalot Literature." See also Elior, "*Hekhalot* and *Merkavah* Literature," 115–18.

for instance, the *'Aleinu* prayer, which is paralleled by the *'Alay* (singular) hymn in *Ma'aseh Merkavah*.[69] However, while the claim has been made that the synagogue was influenced by such mystical prayers and hymns,[70] we note that the opposite may be no less likely, namely, that the mystics incorporated synagogue prayers into their own ritual program.[71]

69. Swartz, "'Alay Le-Shabbeah."

70. Bar-Ilan, *Mysteries of Jewish Prayer and Hekhalot.*

71. Swartz, *Mystical Prayer,* 107–25. For recent studies on the priestly provenance of targumic literature, see Flesher, "Literary Legacy of the Priests?"; Mortensen, *Priesthood in Targum Pseudo-Jonathan.*

14. BET ALPHA IN ITS SIXTH-CENTURY CHRISTIAN MILIEU

THE ANCIENT SYNAGOGUE at Bet Alpha in the Jezreel Valley was discovered in the winter of 1928-29. This find is of particular interest owing to its plan, inscriptions, and art. It was built according to the typical Byzantine basilical plan (10.75 by 12.40 meters), with a courtyard, a narthex, a hall divided into a nave and two side aisles by two rows of pillars, and stone benches along its walls (fig. 96).[1] A projection on the southeastern side of the hall, next to the second pillar, has been interpreted as a secondary *bima* or *ambo*. Along the southern wall, opposite the main, northern, entrance stood an apse with a raised platform, or *bima*, oriented toward Jerusalem.[2] A cavity in the middle of this *bima* has been interpreted as a *genizah*, but it was more likely a treasury, given the discovery of some thirty-six Byzantine coins there. An adjacent room west of the hall seems to have had stairs leading to a second story.

Two inscriptions, one in Aramaic and the other in Greek, were found one above the other on the northern entrance of the central nave. The former is heavily damaged on its right side, but what remains is fascinating:

> [This mosa]ic was laid in the year
> [in] the reign of Justin the emperor (literally, king)
> [at the] sale [price of] wheat, 100
> [*seah* (?)] contributed by the entire
> v[illage/community] Birribi
> . . . [May they be remembered] for good.[3]

1. For a detailed description of the synagogue finds, see Sukenik, *Ancient Synagogue of Beth Alpha*; Avigad, "Beth Alpha."

2. In front of this *bima* were several steps flanked by two cavities, which Sukenik rather speculatively interpreted as having held poles for a curtain covering the Torah shrine (*Ancient Synagogue of Beth Alpha*, 19-21, 52).

3. Naveh, *On Stone and Mosaic*, no. 43; Sukenik, *Ancient Synagogue of Beth Alpha*, 43-46.

This inscription attests that the mosaic was laid in the sixth century and paid for by the entire community.[4] Since two emperors by the name of Justin reigned during this century, Justin I (518–27) and Justin II (565–78), there is no way to be certain which is referred to in the inscription. Coins found during the excavations seem to point to the earlier date,[5] while an iconographic comparison of the mosaic with late sixth-century Christian artistic works may well argue for the later date.[6]

FIG. 96 Basilical plan of the Bet Alpha synagogue.

The Greek inscription commends the artisans: "May they be remembered (for good), the artists who executed this work, Marianos and his son, Ḥanina."[7] The Aramaic inscription was undoubtedly written in the spoken language of the community that funded the building, while the Greek inscription was intended to acknowledge the artisans in their native tongue. The likelihood of the latter assumption is supported by the fact that these same two artisans are also mentioned in a Greek inscription found in a Bet Shean synagogue;[8] it is quite plausible that the two hailed from this city, and thus Greek was more familiar to them. It is also possible that they were Jewish, as both names appear frequently in Jewish epigraphic and literary sources,[9] but this is far from certain. Acknowledging artisans was a known practice in Jewish society; similar inscriptions were found in the Galilee (Alma [twice], Barʿam, and Dabbura) and southern Judaea (Susiya).[10]

The Bet Alpha inscriptions are flanked by two animals facing the interior of the hall, a lion to the left of the entrance and an ox to the right. Interpretations here, as elsewhere, range from simple and minimalistic to complex and ideological. Sukenik, for example, assumes that these animals, known for their strength, were

4. It is generally accepted that the building itself was constructed earlier, perhaps sometime in the fifth century.

5. Sukenik, *Ancient Synagogue of Beth Alpha*, 13, 52.

6. Gutmann, "Revisiting the 'Binding of Isaac' Mosaic," 82. Others who have dated the mosaic to the latter part of the sixth century include Kitzinger, *Israeli Mosaics of the Byzantine Period*, 15; and H. Stern, "Le zodiaque de Bet-Alpha," 17. Some scholars have asked how such a synagogue and mosaic could have been created so close to the reign of Justinian, who is known for his harsh attitude toward Jews and Judaism (see chap. 9). Whether his policies had any impact on the provinces (and especially on northern Palestine) is a moot issue, and it is thus far from clear whether a post-Justinian date should be considered problematic.

7. Roth-Gerson, *Greek Inscriptions*, no. 4; Sukenik, *Ancient Synagogue of Beth Alpha*, 47.

8. Roth-Gerson, *Greek Inscriptions*, no. 5.

9. Ibid., 2 n. 1.

10. Naveh, *On Stone and Mosaic*, nos. 1, 3, 4, 6, 80.

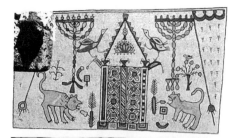

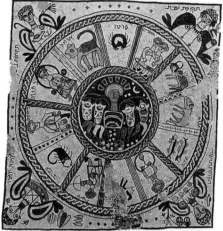

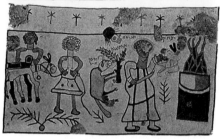

FIG. 97 Mosaic floor from Bet Alpha synagogue.

chosen to guard the entrance to the hall.[11] Others assume that they bore eschatological significance and were meant to reinforce the theme of the entire mosaic floor.[12]

THE MOSAIC FLOOR

The pièce de résistance of this synagogue is its well-preserved mosaic floor (fig. 97). It is divided into three panels, and we will discuss each in the order of its appearance, starting from the entrance to the synagogue from the north.

The 'Aqedah

This panel depicts the two servants and to their left a saddled donkey with a bell around his neck;[13] on the right Abraham stands before a flaming altar, holding Isaac with one hand (in fact, it appears that he is flinging him; see below) and holding a knife in the other. Both Abraham and Isaac are identified by Hebrew inscriptions, as is the hand of God that emerges from above (in a cloud?) accompanied by the Hebrew words from Genesis 22:12: "Do not raise [your hand]." Breaking with the biblical account, the ram is depicted tied to a tree (not caught in the thicket) in the middle of the panel, instead of on the far right, which the chronological sequence would dictate. Moreover, the ram appears to be standing upright (and not on his hind legs).

The artistic quality of this scene is far from impressive (*primitive* may be too severe a term); it is a simple and naive ("childish" according to one opinion[14]) two-dimensional rendering with no attention paid to naturalism or realism.[15] Each figure is depicted frontally and statically, and no at-

11. Sukenik, *Ancient Synagogue of Beth Alpha*, 42.

12. Friedman, "More on the Mosaic Floor"; Talgam, "Similarities and Differences," 107–9; Weiss, *Sepphoris Synagogue*, 65, 244–45.

13. The fact that these young men are not identified in some way may be a clear indication of their ancillary role in the episode.

14. Avigad, "Mosaic Pavement," 66. See also Milburn (*Early Christian Art and Architecture*), who refers to the mosaic as "childishly crude to the point of caricature" (p. 85).

15. See Posèq ("'Aqedah' of Bet Alpha"), who suggests that Jewish art of the sixth century, in Bet Alpha and elsewhere, was intentionally cast in a mythical (i.e., unrealistic and unnatu-

tempt is made to represent realistic body proportions. This disregard for perspective and naturalism is reflected in the Abraham-Isaac depiction; the artist may have intended to show Abraham placing Isaac on the altar, but owing to the simplistic execution, it appears as if Isaac is being flung through the air. Abraham is shown with a graying beard (perhaps an indication of his advanced years) and a halo, or aureole, around his head.

The most intriguing aspect of this scene, however, is the upright ram located in the center of the panel.[16] Theories abound as to its significance. Sukenik offers the simplest explanation, namely, that the artist ran out of room and somehow had to squeeze the ram into the open space in the middle.[17] Shmuel Yeivin draws a parallel from a third-millennium BCE Sumerian statue of a ram standing on its hind legs and nibbling on a bush as well as a representation from a mid-first-millennium BCE Babylonian barrel-shaped seal depicting (from right to left) an altar, a man offering a sacrifice, and, again, a ram on its hind legs nibbling on a bush. He suggests that this motif has been used for millennia, resurfacing once again in Bet Alpha.[18] Finally, Bregman has raised an engaging suggestion that the ram is, in fact, depicted hanging from a tree; this was originally a Christian motif, in which the ram represented the prefiguration of Jesus.[19]

Some of the similarities between Christian and Jewish artistic traditions are of particular interest.[20] Joseph Gutmann notes that in both, in contrast to rabbinic sources,[21] Abraham is the key figure while Isaac is portrayed as a young boy.[22] Another feature of later Christian representations is the tendency to expand this scene

ral) mode, as compared, for example, to the art of the San Vitale church in Ravenna; he then compares this difference to the various literary styles of Genesis 22 and Homer's *Odyssey*, as presented by Auerbach (*Mimesis*).

16. In Sepphoris, the ram is tied to a tree and positioned on the left, in the direction of the servants, while the scene of the *'Aqedah* itself (of which nothing remains) appears on the right. See chap. 13.

17. Sukenik, *Ancient Synagogue of Beth Alpha*, 40, a view ascribed to by Gutmann as well ("Revisiting the 'Binding of Isaac' Mosaic," 79).

18. S. Yeivin, "Sacrifice of Isaac," 20–23; Avigad, "Mosaic Pavement," 66.

19. Bregman, "Riddle of the Ram."

20. A. Ovadiah, "Mutual Influences." Some scholars have claimed that the very representation of Isaac in rabbinic literature as a symbol of sacrificial atonement was influenced by the image of Jesus in Christian tradition; see Davies and Chilton, "Aqedah." This view stands in sharp contrast to that of many others who regard such motifs as early Jewish traditions dating from the Second Temple period and having in some way influenced the Christian conceptualization of Jesus; see, inter alia, Swetnam, *Jesus and Isaac*; Vermes, *Scripture and Tradition*, 193–227; Le Déaut, *La nuit pascale*, 110–15, 131–218; Daly, "Soteriological Significance"; Hayward, "Sacrifice of Isaac." See also the persuasive critique of both views and a reasonably argued compromise in A. F. Segal, *Other Judaisms*, 109–30.

21. See chap. 20.

22. See chap. 20 and Namenyi, *Essence of Jewish Art*, 33–41. In at least one Christian depiction Isaac appears as a grown man; see, e.g., R. M. Jensen, "Offering of Isaac," 88–89.

to include other phases of the narrative. This is strikingly demonstrated in the Vatican Codex of Cosmos Indicopleustes, where the two servants and donkey are fully depicted, followed by Isaac carrying the wood, Abraham about to slay his son, the intervention of the Lord, a symbolic altar, and the ram tied to the tree.[23]

The Zodiac and Helios

The middle and largest panel depicts the zodiac signs and the sun god Helios. The twelve signs, along with their Hebrew captions, appear in a circle, in the center of which Helios and his chariot rise out of the night against a background of the moon and stars. Two pairs of galloping horses, with only their heads and forelegs visible, draw the chariot. The four corners of the outer square depict the four seasons, each in the garb and with the accoutrements befitting its time of year. The seasons are likewise identified by Hebrew captions. Here too, as throughout the mosaic, little attempt was made to create realistic portrayals.

There is an enigmatic discrepancy at Bet Alpha between the sequence of the months and the seasons. In earlier synagogues, such as Ḥammat Tiberias and Sepphoris, the arrangement of the months and their corresponding seasons is coordinated, both moving counter-clockwise. However, at Bet Alpha, both the months and seasons move counterclockwise with a ninety-degree misalignment between the two; thus, spring is lined up with the summer months, summer with the autumn months, and so on.[24] Another unusual feature in the Bet Alpha zodiac shows each of the last two months preceded by the conjunctive *vav*, ודלי ודגים, while the rules of Hebrew grammar would dictate that only the last name in the list should be so designated.[25]

Religious Symbols

The southernmost panel, located nearest the *bima*, contains the usual cluster of religious objects. A double-doored Torah shrine stands in the middle with hornlike projections at its upper corners (in imitation of the biblical altar?), three vases on

23. This tendency first surfaces in the fourth-century Via Latina catacombs, where a depiction of one servant with the donkey appears, in addition to Abraham, Isaac, the altar, and the ram. See Grabar, *Beginnings of Christian Art*, 229, no. 252; Ferrua, *Unknown Catacomb*, 91–93.

24. An even greater lack of coordination can be found in the Naʿaran synagogue, likewise dating from the sixth century, where the months revolve in one direction and the seasons in the other.

25. These two zodiac signs are presented in an unusual way in other synagogues as well. In Ḥammat Tiberias, the inscription דלי (= bucket) associated with Aquarius is written in mirror image, while in the ʿEn Gedi inscription, which only names the zodiac signs, Aquarius appears with the conjunctive *vav* and the last sign, Pisces, does not. Mirsky (*Piyut*, 93–101) has suggested that these three instances are not a sign of sloppiness or ignorance but indicate that the order of these zodiac signs had not yet been standardized. He cites a number of *piyyutim* that list the last two zodiac signs in a different order.

its lintel, a gabled roof with a hanging lamp (an eternal light?), and a conch beneath it. The rest of the panel—like similar ones elsewhere—is filled with a duplicate set of objects on both sides of the shrine. The overall impression is one of symmetry, although each object is rendered somewhat differently from its counterpart.

Most unusual are the two birds atop the gabled roof that have been identified either as ostriches (Sukenik), storks (Wischnitzer), or simply "'birds' in general" (Goodenough), but have also been associated with the biblical cherubs (Exod. 25:18–22). What makes this last suggestion unlikely is that not only it is hard to imagine such birds representing cherubs, but what are clearly intended to be birds flanking the ark's gable in Saranda and a pair of doves on a gold-glass fragment from Rome are also portrayed in this position.[26] Moreover, the setting beneath these birds is neither the Wilderness Tabernacle nor the Jerusalem Temple, but rather a Torah shrine, which appears in many other synagogue and funerary representations; depicting biblical cherubs in such a setting would be strange indeed.[27]

Two *menorot* and two lions flank the shrine. The smaller objects on either side include *lulavim*, *ethrogim*, *shofarot*, and incense shovels. The curtains adorning the sides of the panel may have been intended to frame these symbols or could have been intentionally pulled back in order to view them.[28]

A series of very simple geometric and figural designs surrounds this mosaic floor. Several intertwining vine tendrils on the eastern side of the nave create a circular space in which animals, one human bust, and several baskets or other kinds of containers are interspersed. The southern and western sides feature connecting rhomboids containing mostly geometric patterns. The space between the pillars on the west is likewise filled with a series of carpets having geometric patterns.

INTERPRETATIONS

Given this floor's excellent state of preservation, scholars have suggested a range of programmatic compositions, all of which, unfortunately, must be viewed as speculative. Wischnitzer interprets the mosaic as representing the Sukkot holiday and the related themes of harvest, fertility, rainfall, abundance, and even messianic expectations.[29] Wilkinson views the panels as representing the various sacred areas of

26. See chap. 11, and Goodenough, *Jewish Symbols*, vol. 3, nos. 967–68.

27. See also Sukenik, *Ancient Synagogue of Beth Alpha*, 25. If one assumes that some communities wished to depict a fusion of Temple and synagogue symbols (see chap. 17), then a number of details of the Bet Alpha mosaic fall into place. The birds may have been intended to represent the biblical cherubs, the horns atop the Torah shrine—the altar, and the separated curtains—the Tabernacle *parokhet*. One might be led to believe that this Torah shrine was meant to depict the ark containing the two stone tablets from Mount Sinai. Everything, then, would be an allusion to the Tabernacle/First Temple. However, such a line of argument, for all its cleverness, appears somewhat speculative.

28. For more on these symbols and their various interpretations in contemporary Jewish art, see chap. 17.

29. Wischnitzer, "Beth Alpha Mosaic."

the Jerusalem Temple, with the 'Aqedah symbolizing the altar in the outer courtyard and the other two panels the *heikhal* and *dvir* (Holy of Holies), respectively; thus, the idea behind this composition is that moving forward within the synagogue hall brought the worshipper into ever-greater Temple-related holiness.[30]

On a very different plane, Goodenough posits that the various panels represent the mystical ascent of the soul from a state of earthly purification to the heavenly and then mystical worlds beyond. The 'Aqedah scene thus symbolizes atonement and forgiveness; the zodiac represents the great ascent, including the heavenly causation of all things (divine sovereignty), the hope for immortality, and the ladder to the world beyond; the final panel epitomizes the true heaven, with the Torah shrine and symbols serving as a Jewish passage into this realm.[31] Bernard Goldman and Benedict T. Viviano follow Goodenough's overall mystical thrust, albeit with some variations. Goldman understands the sequence of panels to be symbolic of the mortal-earthly tradition of sacrifice (the 'Aqedah), of movement to the heavenly astronomical-astrological sphere "where the destinies of nations and men were ordered" (the zodiac), and finally, regarding the Temple facade in the third panel, the sacred heavenly portal, "the ubiquitous symbol of transformation."[32] Viviano interprets the mosaic as representing three aspects of the religious experience: the need for forgiveness, the process of growth through *imitatio Dei*, and union with the Divine through faith and love.[33]

More recently, Kühnel has posited an evolving iconographic tradition in which Bet Alpha represents "a fully articulated" representation. Accordingly, the Tabernacle-Temple at one end of the mosaic and the 'Aqedah at the other affirm and complement each other, with both components emphasizing an eschatological theme and the promise of redemption. The zodiac, she maintains, represents God behind the powers of nature and Helios as nothing but "a lifeless emblem of the sun."[34]

In addition to the above thematic approaches, some more recent articles link almost every detail in this mosaic floor to rabbinic sources, particularly in the midrashic realm. At times the association is intriguing (as the suggested cloud over Abraham and the reference to such a cloud in these midrashic works), while at

30. Wilkinson, "Beit Alpha Synagogue Mosaic," esp. 26–28.

31. Goodenough, *Jewish Symbols*, 1:241–53. See also p. 253: "Mystics who follow the Perennial Philosophy have always tended to see three stages in mystical ascent, stages which have most generally been called purgation, illumination, and unification. The three stages here might well be given the names purgation, ascent, and arrival."

32. B. M. Goldman, *Sacred Portal*, 21, 56–68. Goldman also notes approvingly the three-part mosaic as representing priesthood, kingdom, and Torah (p. 67).

33. Viviano, "Synagogues and Spirituality."

34. Kühnel, "Synagogue Floor Mosaic in Sepphoris," esp. 34, 41. Sed-Rajna ("Missing Link," 49) suggests that the tripartite division in synagogue mosaic floors reflects the metaphysical, cosmic, and terrestrial realms of the universe, the first represented by the Torah shrine, the second by Helios and the zodiac, and the third by the 'Aqedah.

others the connection seems rather implausible.[35] Only on occasion is any deference given to non-Jewish material in such presentations,[36] while art that seems to contradict rabbinic sources is not always given due attention. This latter type of approach is based on a series of questionable assumptions, especially the degree to which rabbinic culture was normative and widespread throughout Byzantine Palestine or the degree to which, if at all, the sages influenced synagogue practice, and in what areas.[37]

Israel S. Renov, followed by Ephraim Zoref, has suggested that a messianic theme is the common thread binding the various panels.[38] The *'Aqedah* scene, it is claimed, is frequently interpreted in this vein in rabbinic sources, while in the zodiac panel the sun represents Israel's glory, the glory of the God of Israel, and redemption under the restored Davidic kingdom. The apparent misalignment between the seasons and months, according to this line of thinking, was intentional so as to emphasize the placement of Tammuz and Av above the others and in close proximity to the religious symbols panel, since the two commemorative days marking the destruction of the Temple (the Seventeenth of Tammuz and the Ninth of Av) occurred in these months. Renov maintains that they are arranged in this way so as to be close to the facade in the third panel, which represents the Temple and its Holy of Holies as well as Israel's future redemption, and he denies any contemporary influences on the art of this mosaic floor, suggesting that the various designs and themes stem directly from Jewish sources and traditions.

A diametrically different approach assumes that the Bet Alpha mosaic can best be explained within the context of contemporary Christian art. It is based, inter alia, on the fact that the *'Aqedah* was a narrative shared by Jews and Christians alike and that both religions cultivated their respective interpretations via literary and artistic channels.[39] Gutmann has been a main proponent of this approach,[40] noting a

35. See, e.g., Rozensohn, "Beth Alpha"; Bitner, "Illustrated Midrashim" (2003); this article also appeared in a more preliminary form (1999).

36. Truth be told, Rozensohn exhibits an awareness and openness to non-Jewish data, especially in the archaeological realm. Moreover, he is much more deliberate, and even willing, to question the certainty of some midrashic connections. Nevertheless, when push comes to shove, he maintains, rabbinic material takes precedence. For another attempt in this direction, this time emphasizing the central theme of the Creation, which includes the Temple, deliverance, and a historical dimension, all assumed to be in tandem with midrashic literature and *piyyut*, see Berliner (Landau), "Interpretation of the Presence of Daniel and the Lions."

37. For a detailed discussion of the problems in using rabbinic literature to explain public Jewish art of Late Antiquity, see chap. 20.

38. Renov, "Relation of Helios and the Quadriga"; Zoref, "Note."

39. A. M. Smith, "Iconography of the Sacrifice of Isaac"; van Woerden, "Iconography of the Sacrifice of Abraham"; E. Kessler, *Bound by the Bible*. See also Westenholz, *Images of Inspiration*, 48–63.

40. See n. 6, as well as Gutmann, *Sacred Images*, 115–22.

number of commonalities between Bet Alpha and Christian parallels: the ram tied
to a tree; Abraham with an aureole; the hand of God extending downward; a flam-
ing altar; protagonists identified by captions; Isaac suspended or flung in midair;
and a bearded Abraham in frontal position wearing slippers. Gutmann identifies
two separate Christian artistic traditions that influenced this mosaic, possibly via
pattern books based on Coptic East Byzantine and North African traditions. He
concludes his argument with the following declaration:

> In sum, it can be stated that the Binding of Isaac mosaic at the Beth-Alpha
> synagogue is solidly rooted in well-known Christian motifs dating from the
> fourth to the thirteenth centuries, that the mosaic may stem from the third
> quarter of the sixth century, and that the models the provincial artists had may
> have been pictorial guides which served artists in widely scattered places and in
> diverse media over a long period of time.[41]

Unfortunately, here too, as with several other opinions discussed above, Gut-
mann's apparent certitude may blur a number of assumptions and selective citations
of precedents in his arguments. First of all, many of the above-noted characteristics
were not the monopoly of Christian art but appeared in earlier Jewish art as well.
A ram tied to a tree and the appearance of the hand of God are found in Dura and
Sepphoris, the latter site having been excavated only after Gutmann published his
article. Secondly, Gutmann makes the same mistake as those advocating rabbinic
connections, in that he refers at times to Christian illustrations postdating the Bet
Alpha floor by hundreds of years, such as the *Carmen Paschale*, and assumes the ex-
istence of an earlier, now-lost model. Although some fascinating parallels do in fact
exist—the suspended Isaac or the unusual appearance of Abraham—it is not clear
whether these parallels point to direct borrowing or only to generic similarities.
As noted above, the emphasis on Christian parallels suggests a later sixth-century
date, in contrast to the numismatic evidence found in the synagogue that dates more
than a half century earlier. Few of the above explanations, however, tell us anything
about the meaning or intended message of the Bet Alpha depictions.

THE QUEST FOR CONTEXT

The pavement at Bet Alpha, perhaps more than any other site we have examined
until now, highlights the many issues involved in interpreting artistic remains that
stand in splendid isolation. We know nothing of the Bet Alpha context—its lead-
ers and members, the challenges they confronted, the traditions they preserved,
the nature of their religious beliefs and practices, and the influences to which they
(or the artisans) might have been exposed. Even the ancient name of the village is
unknown (the name Bet Alpha is taken from the modern-day kibbutz).[42] Thus the

41. Gutmann, "Revisiting the 'Binding of Isaac,'" 82.

42. Ironically, the problem of identification continues even today. As it turns out, the
synagogue is located on Kibbutz Ḥefzibah, adjacent to Kibbutz Bet Alpha!

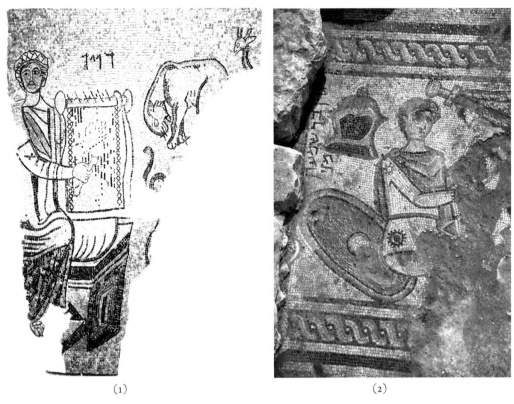

FIG. 98 Depiction of David in synagogue mosaics of Byzantine Palestine: (1) Gaza; (2) Merot.

door is wide open for competing interpretations; everything depends on which detail(s) one emphasizes, which source(s) or model(s) one invokes, and, as is often the case, one's own personal penchant and agenda.

However, two related contexts may help to explain the Bet Alpha mosaic, at least partially—one is internal (the Jewish) and the other external (the Byzantine). It is noteworthy that biblical scenes and figures depicted in the synagogues of Palestine, excluding the early fifth-century Sepphoris synagogue, are all found in sixth-century structures, more or less contemporary to that of Bet Alpha.[43] Seven synagogues throughout the country (including the Gerasa synagogue in Transjordan)[44] contain biblical depictions in their mosaics. Besides the *'Aqedah* scene in Bet Alpha, we know of David in Gaza and probably Merot in the Upper Galilee (fig. 98); of

43. For a survey of these mosaic floors, see Hachlili, *Ancient Mosaic Pavements*, 57–83. In some cases this phenomenon may have begun somewhat earlier, i.e., the late fifth century.

44. As noted in chap. 11, the art of the Gerasa building, which was converted into a church in 531 CE, does indeed belong to the cultural sphere of Byzantine Jewish Palestine, as this type of depiction was limited to Palestine; furthermore, no other Diaspora synagogue from Late Antiquity featured biblical scenes.

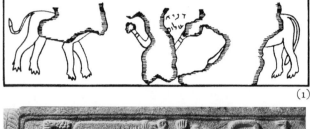

(1)

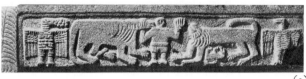

(2)

FIG. 99 Depiction of Daniel in synagogue mosaics of Byzantine Palestine: (1) Naʿaran (fragmentary); (2) ʿEn Semsem (?).

Daniel in Naʿaran, Susiya in the southern Hebron hills, and possibly ʿEn Semsem in the Golan (fig. 99); and of Noah's sons Shem and Japhet along with animals disembarking the ark adorning the Gerasa synagogue vestibule.[45] The fact that synagogues displaying biblical motifs derive from the sixth century (seven out of eight, or almost 90 percent, including Sepphoris) calls for an explanation.[46] In this light, then, Bet Alpha is not to be viewed as an isolated phenomenon, but rather as part of a wider trend affecting many Jewish communities from the Galilee to the Hebron hills and from the coastal region to east of the Jordan River.

Admittedly, lacking concrete corroborating data, we can only speculate as to the reasons for this rather widespread phenomenon. Such a query requires an examination of the external forces at work in the sixth century generally and in Palestine in particular. The wider Byzantine world at that time, particularly under the reign of Justinian, witnessed a dramatic increase in the appearance of Christian art and architecture.[47] Hundreds of churches were being built throughout the empire; in Constantinople itself, Justinian reputedly erected some thirty buildings, including the pièce de résistance of his efforts—the Hagia Sophia.[48] Art likewise flourished not only in cathedrals and churches such as San Vitale in Ravenna, but also on small artifacts such as pilgrim tokens and flasks, reliquary boxes, trinkets, mementos, amulets, and pendants, many of which bore scenes from the life of Jesus and the Old

45. For the dating of these structures, see *NEAEHL*, passim. For several identifications of obscure graffiti in Bet Sheʿarim as also depicting biblical figures, see chap. 8, n. 2.

46. Besides fifth-century Sepphoris, I have also excluded the newly excavated synagogue at Khirbet Ḥamam, which dates to the turn of the fourth century. The mosaic floor there displays a number of scenes that may be biblical (see appendix to chap. 8).

47. See Alchermes, "Art and Architecture"; as well as Cormack, "Visual Arts"; and M. M. Mango, "Building and Architecture."

48. See Procopius, *Buildings*, bk. 1, as well as the cautionary remarks of Cameron, *Procopius*, chap. 6. See also Mainstone, *Hagia Sophia*.

Testament.[49] Moreover, a new mode of religious artistic expression emerged with the use of icons.[50]

Palestine took part in these developments, in its monumental buildings such as the Nea church in Jerusalem and the Saint Catherine monastery complex in Sinai, and in the production of *ampullae* and other souvenirs intended for the growing pilgrim trade during this century.[51] Particularly significant is the fact that the sixth century witnessed a dramatic expansion in the number of churches in rural areas.[52] On the basis of dated inscriptions from churches, monasteries, and chapels in Byzantine Palestine, as well as restorations and new buildings, Leah Di Segni has listed some ten buildings that were erected throughout the country in the fourth and fifth centuries, no less than thirty-two in the sixth century itself, and an additional twelve in the seventh century.[53] The increase in village churches at this time is even more pronounced in Arabia.[54]

Thus, Christianity made its most significant inroads into rural areas precisely when Jewish art flourished in rural synagogues, essentially those named above — Bet Alpha, Na'aran, Merot, Susiya, 'En Semsem — as well as Gaza and Gerasa. Whether the construction of scores of churches in the Holy Land at this time constituted a threat or catalyst to the Jews cannot be determined; both reactions may well have existed simultaneously. That Jewish biblical motifs flourished in the sixth century is undeniable, and the presence of an invigorated Christianity in all parts of the country may not have been coincidental.

Indeed, there seems to have been a great deal of imitation and appropriation, especially with regard to the synagogue. For one, the model of the Christian basilica now made inroads into many Jewish communities, and it is precisely the Bet Alpha synagogue that displays the best example of this architectural model. Although other synagogues boast variations of this type of architectural plan, Bet Alpha offers the most compelling model.[55]

The apse at the far end of the nave, opposite the entrance (which is typical of church architecture), appears for the first time in a Jewish setting in the sixth century, as does the balustrade, a significant feature in the church separating the clergy from the congregation that had no comparable or ostensible purpose in the syna-

49. See, e.g., Vikan, *Byzantine Pilgrimage Art.*

50. Cameron, "Language of Images"; Krueger, "Christian Piety and Practice," 310–11.

51. Grabar, *Ampoules de Terre Sainte.*

52. See chaps. 9–10.

53. Di Segni, "Epigraphic Documentation," esp. 166–70; Bar, "Christianisation of Rural Palestine"; Bar, "Rural Monasticism."

54. Di Segni, "Epigraphic Documentation," 165, 171–78 (almost fifty different types of religious buildings in the sixth century); Di Segni, "Greek Inscriptions in Transiton," 363–64. A. Ovadiah's corpus of Byzantine churches built in Palestine (1970) also points to the fifth and sixth centuries for the construction of the overwhelming majority of churches — 115 out of 145, more than 88 percent (not including some 52 undated buildings); see his *Corpus*, 193.

55. See Tsafrir, "Byzantine Setting."

8

gogue.[56] The balustrade provides a striking example of the synagogue's acquisition of non-Jewish elements, even though there does not seem to have been any particular need for them. It is, of course, possible that in the course of time such a partition may have assumed a raison d'être in the synagogue, perhaps to enclose a more sacred area close to the Torah shrine, but there is no concrete evidence to confirm this.[57]

Thus, the artistic domain of sixth-century synagogues seems to reveal several complementary responses to the sixth-century historical context—adding a dimension of borrowing and adapting while also exhibiting a creative innovation nurtured in part by internal Jewish factors.[58] Indeed, the artistic productivity of the Jews at this time can be divided into three categories: (1) the adoption of outside models with minimal change (Nilotic scenes, chancel screens, and inhabited vine scrolls), including the amphora flanked by peacocks, baskets with bread, fruit or birds, and animals attacking prey; (2) the continuation of certain patterns that had been inherited from past Jewish usage, including the zodiac motif and the cluster of Jewish symbols; and (3) the creation of relatively new kinds of depictions. With regard to the last-noted element, the introduction of biblical figures and narrative themes into the Jewish scene was neither inspired from precedents (to wit, Khirbet Ḥamam no longer existed and the fifth-century Sepphoris synagogue was considerably different in content) nor connected in any way to the sixth-century Christian art then flourishing in Palestine and Jordan (which was almost completely devoid of biblical themes).[59]

THE SIXTH CENTURY IN PERSPECTIVE

In sum, Christianity was indeed a factor in the cultural development of sixth-century Palestine. On the one hand, increasing pressures were being placed on Jews and Judaism by imperial and ecclesiastical authorities, beginning with the emperor

56. Foerster, "Dating Synagogues"; Foerster, "Decorated Marble Chancel Screens."

56. Foerster, "Dating Synagogues"; Foerster, "Decorated Marble Chancel Screens."

57. L. I. Levine, *Ancient Synagogue*, 341–42. See, however, Branham, "Vicarious Sacrality." Similarly, the flourishing of *piyyut* in the sixth century, particularly that of Yannai, may be related to the increased prestige of religious poetry in the church at this time, especially in light of the impressive productivity of Romanos the Melodist in sixth-century Constantinople. See L. I. Levine, *Ancient Synagogue*, 628–29; de Lange, "Jews in the Age of Justinian," 404. On Romanos, see, inter alia, Lash, *St. Romanos the Melodist, Kontakia*; Schork, *Sacred Song*. See also de Matons, "Liturgie et hymnographie"; Lingas, "Liturgical Use of the Kontakion"; Krueger, "Christian Piety and Practice," 297–300; and above, chap. 10.

58. Important publications relating to Christian and Jewish mosaics from this period include R. and A. Ovadiah, *Hellenistic, Roman, and Early Byzantine Mosaic Pavements*; Piccirillo, *Mosaics of Jordan*; Hachlili, *Ancient Mosaic Pavements*; Talgam, *Mosaics of Faith*.

59. The only exceptions are the depictions of Jonah in a Bet Guvrin church and the lamb and wolf scene per the vision of Isaiah in Christian Maʻin. See Baramki, "Byzantine Church"; R. Ovadiah, "Jonah in a Mosaic Pavement"; Hachlili, *Ancient Mosaic Pavements*, 227–28. It should be noted, however, that some Christian communities, especially in Jordan, might have named a church after a biblical figure; see Piccirillo, *Mosaics of Jordan*, 357–65.

Justinian himself and continuing on the regional and local levels by the myriad clerical figures and ever-growing ranks of monks and pilgrims.[60]

But besides their immediate and intended deleterious effects, religious and political pressures also seem to have strengthened resistance and promoted increased communal and cultural cohesion among those targeted for persecution or discrimination.[61] Cultural productivity in Jewish society, both in the literary sphere (*piyyut* as well as midrashic and aggadic compositions) and the material realm, seems to have been an attempt, at least in part, to counter the pressures of a triumphant Christianity by reasserting Jewish identity and, in terms of art, through the depiction of a variety of biblical themes.[62] Interestingly, the anti-Chalcedonian churches in the East were being revitalized and fortified at this very time, despite the imperial pressures against them.[63] In this light, therefore, to view Jewish biblical motifs as a reassertion of Jewish identity intended to buttress self-confidence is not unlikely.

Thus, we may assume with confidence that the increased presence of Christian art and architecture in Palestine served to stimulate Jewish communities to develop their artistic expression, much as was the case several centuries earlier, when the widespread use of the cross motivated Jews to expand their use of the menorah.[64] Needless to say, the reasons offered above for Jewish artistic activity in the sixth century are not mutually exclusive, and both components—a reaction to political and religious hostility and a response to cultural stimuli—were almost certainly contemporary influential factors, although undoubtedly of varying proportions among the different communities.

60. For a discussion of these factors, see chap. 9.

61. See, e.g., Exod. 1:8–12.

62. Some have been tempted to carry this line of argument even further, pointing out that most of these depictions of biblical figures and stories are related to the theme of salvation and hope. The *'Aqedah*, Daniel, and Noah all represent this dimension very well, as do the depictions of David, who had become a symbol of hope, redemption, and restoration in many contemporary Jewish sources (see Urbach, *Sages*, 1:678–87). This is the interpretation usually given to the early Christian representations of these figures in the catacombs of Rome; see R. M. Jensen, *Understanding Early Christian Art*.

63. See Gray, "Legacy of Chalcedon"; and van Rompay, "Society and Community." Van Rompay states: "Throughout his long reign, Justinian attempted to bridge the rift by winning the anti-Chalcedonians over to some sort of acceptance of the council (i.e., the Council of Chalcedon held in 451 CE), which since 518 had become the cornerstone of imperial religious policy. He failed, however, to achieve his goal. The opposition between the imperial church and the anti-Chalcedonians that existed at the beginning of Justinian's—indeed, from the beginning of Justin's—reign, was still there at this death. By that later date (565), not only had the opposition become much more articulate, the anti-Chalcdonians also had started building up their own ecclesiastical structure and had laid the foundations for the material and spiritual survival of their communities, which still exist today" (p. 239).

64. See chap. 17.

15. SARDIS
Prominence and Stability in the Jewish Diaspora

THE SARDIS SYNAGOGUE was discovered in 1962 and has deservedly drawn a great deal of scholarly attention.[1] Besides its monumentality, the uniqueness of this synagogue stems from its prominent location in a major western Asia Minor city, its rich architectural, artistic, and epigraphic remains, and a longevity spanning some three centuries under Christian rule. Located on the main street of the city (referred to as Marble Road or Main Avenue), at an important intersection boasting a grand *tetrapylon*, the synagogue was housed in the southern wing of the *palaestra*, Sardis's bath-gymnasium complex (fig. 100). Between the main street to the south and the synagogue building was a row of shops, some of which were owned by members of the Jewish community; a separate entrance connected the shops to the synagogue's atrium.[2]

No other ancient synagogue can match the sheer physical size of this building, which measured almost 85 meters long and 20 meters wide, and was divided into two by a sanctuary 65 meters long and an atrium 20 meters long. Compared to the largest synagogues known to date in ancient Palestine—Capernaum (24 meters long), Meiron (27 meters long), and Gaza (roughly 30 meters long)—the Sardis synagogue's dimensions are indeed extraordinary.

The building in which the synagogue was eventually housed boasts a long history (fig. 101). In the early first century CE, following a devastating earthquake,[3] the city began erecting a *palaestra*, which remained under construction throughout the first

1. Seager, "Building History"; Seager and Kraabel, "Synagogue and the Jewish Community," 171–73. Additional articles by Kraabel appear in Overman and MacLennan, *Diaspora Jews and Judaism*. See also Bonz, "Jewish Community of Ancient Sardis"; Bonz, "Differing Approaches to Religious Benefaction"; Botermann, "Die Synagoge von Sardes"; Trebilco, *Jewish Communities*, 37–54; White, *Building God's House*, 98–101; White, *Social Origins*, 2:310–23; Hachlili, *Ancient Jewish Art—Diaspora*, 58–63, 218–31, 410–12; Magness, "Date of the Sardis Synagogue."

2. Crawford, *Byzantine Shops at Sardis*, 17–18.

3. Tacitus, *Annals* 2.47; see Pedley, *Ancient Literary Sources on Sardis*, no. 220, for text and bibliography.

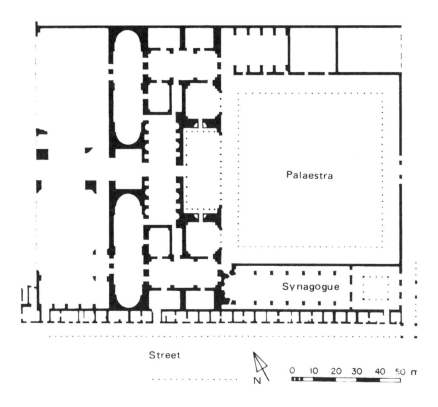

Palaestra

Synagogue

Street

N

0 10 20 30 40 50 m

FIG. 100 Sardis synagogue as part of the city *palaestra* complex.

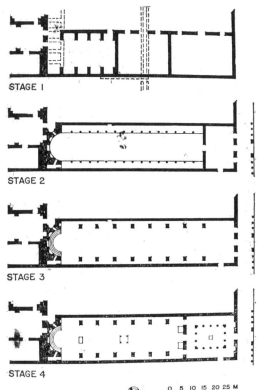

STAGE 1

STAGE 2

STAGE 3

STAGE 4

0 5 10 15 20 25 M

FIG. 101 Four stages of the Sardis synagogue building: (1) An integral part of the gymnasium (*palaestra*) complex (first–second centuries CE); (2) a civic basilica (second–third centuries CE); (3) early stage of the synagogue? (late third–early fourth centuries CE); (4) synagogue as excavated (fourth–seventh centuries CE).

and into the second centuries CE but was never completed as originally conceived.[4] The complex's southeastern wing, as its northeastern counterpart, was divided into several rooms that appear to have functioned for a time either as *apodyteria* (dressing rooms), exercise rooms, or both, each opening onto the *palaestra.* Sometime in the late second or early third century, this wing was converted into a basilica, with an apse at its western end containing niches for statues, two rows of columns forming a nave and two side aisles, and a forecourt to the east with entrances from several adjacent streets. While it was once suggested that the building at this stage was already being used by the Jewish community, it seems much more likely that it served as a civic basilica.[5]

Dating the third stage of the building is more problematic. It has often been assumed that it was taken over by the Jewish community around 270 CE. Only at this time, when the building's basilical plan was modified—the wall between the hall and vestibule was removed, pillars replaced the earlier columns, and three-tiered semicircular benches were built in the apse to transform it into a sitting area—did it perhaps begin to function as a synagogue. It should be acknowledged, however, that the evidence for dating the synagogue to the late third century is negligible, and thus the assumption that the building functioned as a synagogue at this time is largely unsubstantiated.

THE SYNAGOGUE BUILDING OF LATE ANTIQUITY

The synagogue revealed in the excavations and partially reconstructed on site is primarily from the fourth century (fig. 102): the atrium was completed around 360–80 CE; the main hall, with its piers and elaborate mosaic floor, dates to the second quarter of the fourth century, and the wall inscriptions, along with the plaques and marble revetment on which they appear, date from the mid-fourth to early fifth centuries. Later additions and renovations can be dated to the fifth and sixth centuries.[6]

Those entering the synagogue would have accessed the atrium from either the east or south (fig. 103). The atrium itself was large and attractive, with porticoes containing fourteen columns surrounding an open courtyard lavishly decorated with a mosaic pavement of multicolored geometric patterns and donor inscriptions in Greek. One such inscription reads: "Aurelios Eulogios, Godfearer [*theosebes*], I fulfilled a vow," while another reads: "Aurelios Olympios of the tribe of Leontii,

4. The history of the synagogue building presented here is based on Seager, "Building History," and his contribution in Seager and Kraabel, "Synagogue and the Jewish Community," 171–73.

5. For the former opinion, see, e.g., Kraabel's contribution in Seager and Kraabel, "Synagogue and the Jewish Community," 179; Hanfmann, *From Croesus to Constantine,* 89 n. 61. For the latter, see Seager and Kraabel, "Synagogue and the Jewish Community," 173.

6. See the appendix to this chapter for a discussion of Magness's recent suggestion to redate the synagogue to the sixth century CE.

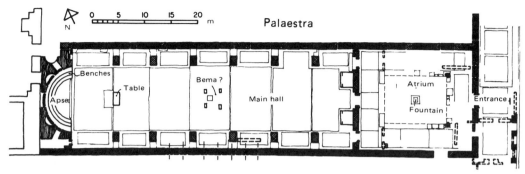

FIG. 102 Reconstructed plan of the Sardis synagogue.

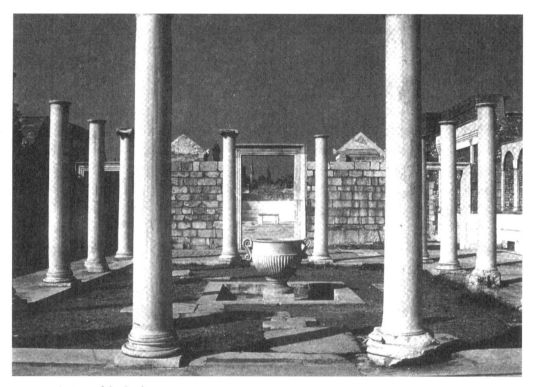

FIG. 103 Atrium of the Sardis synagogue.

with my wife and my children, I fulfilled a vow."[7] The walls of the atrium were covered with white plaster, and a chancel screen or balustrade ran between the some of the columns, in part separating the portico-covered area from that of the fountain. A large marble krater with volute handles for washing and perhaps drinking was located in the center of the atrium, while a series of pipes supplied it with water. Next to the southern wall of the atrium was a basin that might have been used for ablution.

7. Kroll, "Greek Inscriptions," nos. 9–10; Trebilco, *Jewish Communities*, 44–45; Ameling, *Inscriptiones Judaicae Orientis*, vol. 2, no. 69.

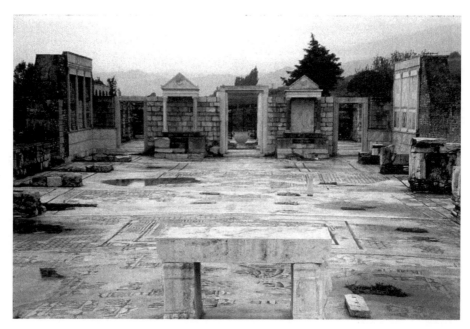

FIG. 104 Main sanctuary of the Sardis synagogue, facing east toward the entrances and two *aediculae.*

Three portals—a large central door flanked by smaller ones on either side—led from the atrium into the main sanctuary (fig. 104). Immediately inside the sanctuary, on either side of the main entrance, stood two *aediculae* on masonry platforms; the southern one was of a better quality and probably once held the Torah scrolls.[8] It was here that six fragments of Hebrew inscriptions were found,[9] in addition to a marble plaque depicting a menorah, *lulav,* shofar, and two spirals, identified by some as Torah scrolls.[10] The function of the second *aedicula* remains obscure; it might have held additional scrolls or possibly a menorah. Alternatively, it may have served as a seat for an elder or some other official, although this seems unlikely given the size of the hall and the fact that there were benches along the far western wall of the apse (possibly for the elders of the congregation) and some sort of installation in

8. These *aediculae*, which faced Jerusalem and were located in the eastern wall of the synagogue, determined the congregation's orientation. The corresponding entrances on the east are somewhat problematic since congregants would have had to pass the *aediculae* in order to take their seats. It was a far less elegant way to enter than accessing the hall from the rear. But given the configuration of the immediate vicinity—the bath-gymnasium complex to the west and north, and the intersection of two streets with its *tetrapylon* (see Yegül, *Bath-Gymnasium Complex at Sardis*, 21 and fig. 7)—and, most importantly, the fact that the two previous stages of the building also had the same triportal entrance, it seems that these were the determining factors for the synagogue's entrances.

9. Of the six fragmentary Hebrew inscriptions, only one word survives in each (*Severus, Shalom, Yoḥanan,* and *vow* [twice]). One reads: "I, Shemaryah son of [E]lijah—I wrote [this]"; see Cross, "Hebrew Inscriptions from Sardis."

10. First suggested by Shiloh, "Torah Scrolls."

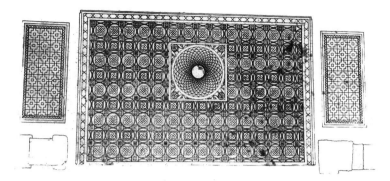

FIG. 105 Mosaic floor panel from the Sardis synagogue.

the middle, perhaps for a teacher. As was the case with a number of architectural elements in the hall, the stones used for these *aediculae* were *spolia*, materials reused from other buildings in the city.[11]

Two rows of six pillars each divided the hall into a central nave and two side aisles. As there were no traces of a balcony or stone benches, the congregation—which by an oft-quoted estimate might have numbered up to one thousand people—probably sat on mats or wooden benches, although it is also possible that some might have stood. The mosaic floor was divided into seven panels (fig. 105) corresponding to the seven architectural bays formed by the two rows of pillars. The mosaics featured geometric patterns, and four panels (Bays 2–4 and 7) included dedicatory inscriptions, such as: "Aurelios Alexandros, also called Anatolios, citizen of Sardis, Councillor, mosaicked the third bay."[12] Bay 4, in the center of the hall, had four marble slabs, and a nearby inscription named one Samoe who served in some sort of religious capacity.[13] This inscrip-tion led to the suggestion that the four marble slabs supported either a platform or, more likely, a canopy or baldachin, so as not to hide the inscription.

The lower parts of the walls, built of brick and rubble, were covered with brilliantly colored marble revetments secured with metal hooks and decorated with *skoutlosis*, similar to those adorning the mosaic patterns (fig. 106). These marble and colored stone tiles also bore floral and animal

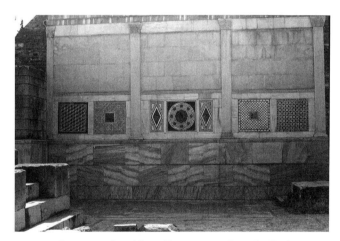

FIG. 106 Remains of marble wall revetments from the Sardis synagogue.

11. On the use of *spolia* more generally, see nn. 40–43.

12. Kroll, "Greek Inscriptions," no. 3.

13. For more on Samoe, see below.

(1)

FIG. 107 Western end of sanctuary in the Sardis synagogue: (1) Table flanked by two pairs of addorsed lions with semicircular benches in rear; (2) table support displaying an eagle.

(2)

designs. No human forms are represented in the synagogue itself,[14] but here and throughout the hall are depictions of fish, birds (doves, peacocks), and heads of sheep and a camel, as well as lions and dolphins.[15] The largest group of inscriptions in the synagogue appears on marble plaques affixed to the marble revetments.[16] One inscription informs us that there were also painted decorations on the ceiling or upper parts of the walls, but only fragmentary remains of brightly colored glass mosaics were found in the debris below.[17]

An imposing stone table (2.43 by 1.23 meters) at the western end of the hall, known as the "eagle table" because of two large Roman eagles carved in relief on each of its two supporting stones, stood aligned with the main entrance to the east (fig. 107). The table was flanked by two pairs of addorsed marble lions, and it was here that the Torah was probably read; a marble slab embedded in the floor indicates that the reader may have stood here, facing the Torah shrine to the east.

According to the excavators' estimates, the semicircular benches at the western end of the sanctuary might have accommodated about seventy people, presumably

14. On the recently discovered Daniel fragment, see below.

15. Seager and Kraabel, "Synagogue and the Jewish Community," 175.

16. Kroll, "Greek Inscriptions," 11–12.

17. "[.]s with my wife Regina and our children, in fulfillment of a vow, I gave out of the gifts of Almighty God all the *skoutlosis* of the [bay?] and the painting"; ibid., no. 29, and comments on pp. 30–31; Ameling, *Inscriptiones Judaicae Orientis*, vol. 2, no. 90.

the community's elders.[18] Directly in front of the apse, at the western end of the hall, is a finely executed semicircular mosaic floor featuring vine tendrils emerging from a krater; these were originally flanked by two peacocks that were later removed. A colored wreath above the krater incorporates the names of donors: "The Flavians Stratoneikianos and Synphoros in fulfillment of a vow."[19] A stone parapet (perhaps a chancel screen) separated the mosaic and apse from the rest of the main hall.

INSCRIPTIONS

The Sardis excavations yielded a rich harvest of epigraphic material; a total of eighty-five inscriptions (or fragments thereof) were found, seventy-nine in Greek and six in Hebrew.[20] Of the thirty or so donors listed, only two names are Hebrew derivatives. The Sardis donors are identified either by profession or public office, which was a fairly common practice in ancient Jewish and non-Jewish epigraphy. Among the synagogue members were a number of provincial and city officials—a procurator, nine city councillors, a *comes*, an assistant in the archives, and members of the decurionate. Altogether, the synagogue boasted affluent and apparently in-fluential members of the city, a fact that undoubtedly had something to do with the building's central location, size, and monumental proportions, as well as the ability of the Jewish community to maintain such an imposing facility for centuries.[21]

An inscription located in the very center of the mosaic floor noted above is of particular interest for understanding a religious component of the synagogue, men-tioning one "Samoe, *hiereus* (priest) and *sophodidaskalos*" (wise teacher or teacher of wisdom).[22] Both Sardis and Dura Europos offer striking examples of priestly leadership within the ancient Diaspora synagogue; Samoe's role here seems to have focused on the religious-cultural realm, while Samuel the priest, in Dura, referred to as a presbyter or elder (and archon?), appears to have been the overall leader of the community, something akin to an archisynagogue.[23] Given the prominent loca-tion of this inscription, it is clear that Samoe occupied a central religious role; he may have preached or taught from the very spot where the inscription was found, where, it will be remembered, four marble slabs that might have once supported

18. This number is similar to the number of leaders in the large Alexandrian synagogue described in T Sukkah 4, 6, p. 273. See also my *Ancient Synagogue*, 91–96.

19. Kroll, "Greek Inscriptions," no. 1.

20. Ibid., 1–127; Cross, "Hebrew Inscriptions from Sardis," 3–19; Ameling, *Inscriptiones Judaicae Orientis*, vol. 2, nos. 60–145.

21. For a somewhat different reconstruction of the community's history, see Bonz, "Jewish Community of Ancient Sardis."

22. Kroll, "Greek Inscriptions," no. 4; Ameling, *Inscriptiones Judaicae Orientis*, vol. 2, no. 63.

23. Kraeling, *The Synagogue*, 263–68; Noy and Bloedhorn, *Inscriptiones Judaicae Orientis*, vol. 3, nos. Syr84–86; on the role of the *archisynagogue*, see L. I. Levine, *Ancient Synagogue*, 415–27.

a platform or baldachin were found.[24] Owing to the fact that the panel with this inscription appears to be an addition to the larger mosaic floor, it probably dates to the fifth or even sixth century CE.

Other inscriptions tell us something about the nature of the Judaism as understood and practiced in this synagogue. One refers to the Torah shrine as a *nomophylakion* ("that which protects the Law") while another bears the cryptic sentence "Having found, having broken,[25] read! observe!" These inscriptions were carefully executed and probably displayed near the eastern end of the synagogue hall, adjacent the Torah shrine.[26]

Ten inscriptions, mostly fragmentary, mention the Greek term *pronoia* ("Divine Providence")[27] and include: "Aurelios Euphrosynos II, citizen of Sardis, Councillor, from the gifts of Providence, I gave the *skoutlosis* of the *perimaschalon* (a basin or corner)"[28]; "Leontios, Godfearer, from the gifts of Providence, in fulfillment of a vow. I gave the *skoutlosis* of the bay."[29] That the term *pronoia* refers not only to Providence generally, as an abstract term, but perhaps to the God of Israel as well may be inferred by another synagogue inscription (mentioning a menorah) found in the southwestern corner of the main hall.[30] In addition, earlier Jewish writers such as Philo and Josephus, and several earlier works, use *pronoia* in reference to God; indeed, Philo wrote an entire treatise (*De Providentia*) on the subject.[31] Thus, to assume that *pronoia* can refer to the acknowledgment and praise of God seems reasonable.

Two scholars who have addressed this term in the context of the Sardis synagogue each emphasized a different dimension. A. Thomas Kraabel calls attention to its use in the Greco-Roman world and to the fact that the appropriation of such a cosmopolitan Greek philosophical-religious concept by the community reflects a significant degree of acculturation.[32] Rajak emphasizes the Jewish dimension, point-

24. Hanfmann and Bloom, "Samoe."

25. The term may refer to the "breaking open" of a text (i.e., to decipher its meaning) or to breaking a seal in order to open a scroll; see Kraabel, "Impact," 289; Ameling, *Inscriptiones Judaicae Orientis*, vol. 2, no. 131.

26. Kroll, "Greek Inscriptions," nos. 63, 65; Ameling, *Inscriptiones Judaicae Orientis*, vol. 2, nos. 129, 131.

27. Ameling, *Inscriptiones Judaicae Orientis*, 2:622 (s.v. πρόνοια).

28. Kroll, "Greek Inscriptions, 25.

29. Ibid., nos. 17, 22.

30. Ibid., no. 66.

31. Rajak, "Gifts of God at Sardis," 234–35.

32. Kraabel, "*Pronoia* at Sardis," 75–96. A similar instance of Greek influence relates to the *nomen sacrum* (the contraction of certain sacred names) often found in Christian contexts. One Sardis inscription (Kroll, "Greek Inscriptions," 30–31, no. 29) may reflect such an abbreviation (J. R. Edwards, "*Nomen Sacrum*") and "that on occasion Jews dealt with the problem of the *nomen ineffabilis* by employing Greek *nomina sacra* of the divine name as a counterpart to the Hebrew tetragrammaton" (ibid., 821).

ing out the use of this term in earlier literary sources as well as in more contemporary epigraphic evidence.[33] Pagan inscriptions (and on occasion Jewish ones) use the term *pronoia* when commending individuals for donating from their own possessions. What exactly was meant by the term is unclear—fulfilling a vow, indicating some sort of Diaspora synagogue taxation, or perhaps acknowledging God as the source of all material possessions.[34] It would seem that these *pronoia* inscriptions are a significant Jewish marker of this highly acculturated community.[35] Paul R. Trebilco sums up these contrasting approaches by suggesting that they are, in fact, complementary and not mutually exclusive: "The Jews recognized *pronoia* as a part of their tradition that was also understood by their contemporaries and which was thus a possible vehicle for communication."[36]

Another piece of evidence, or we should say the absence thereof, tells us something about the religious and communal orientation of this congregation with respect to gender. Just as no remains of benches were found in the main hall, so there is no indication of an internal partition or a second story that might be construed as a women's section. Owing to its excellent state of preservation, the Sardis synagogue clearly points to a social reality that has become more and more apparent elsewhere on the basis of archaeological and epigraphic evidence, namely, that both women and men assembled together in the main hall during synagogue activities, be they of a liturgical or communal nature. However, the degree of female participation in the former realm, in whatever manner, is another issue for which there is almost no evidence.[37]

ART IN THE SARDIS SYNAGOGUE

The artistic evidence of the Sardis building offers rich yet seemingly contradictory data. On the one hand, most remains are of a simple, conservative bent. The mosaic floors that stretch like a carpet for scores of meters in both the peristyle of the atrium and the main hall are strictly aniconic. Nevertheless, they are quite sophisticated, featuring a series of complex geometric patterns of squares, rhombi, interlocking circles, circles within squares, triangles, hexagons, octagons, trapezoids, polygons, crosses, single and double meanders, guilloches, step and leaf motifs, arcs, four-pointed stars, intertwining loops, and scale patterns. The tesserae used in these patterns are red, yellow, pink, violet, blue-gray, black, and white.[38] On the other hand, some of the synagogue wall decorations, in addition to geometric designs, attest to

33. Rajak, "Gifts of God at Sardis," 232–36; and, more generally, Harrison, "Benefaction Ideology," 109–16.

34. Rajak, "Gifts of God at Sardis," 236–38.

35. Another example of Jewish appropriation of a Greek term becoming firmly embedded in Jewish usage is *Theos Hypsistos*; see Mitchell, "Cult of Theos Hypsisto," esp. 110–21.

36. Treblico, *Jewish Communities*, 49–50.

37. See L. I. Levine, *Ancient Synagogue*, 499–518.

38. Majewski, "Evidence for the Interior Decoration."

FIG. 108 Recently discovered incised revetment panel of Daniel and lions, found in the debris from the Sardis synagogue's atrium.

the depiction of fish, birds, and other animals. Recently, however, Marcus Rautman has published a fragmentary plaque, once attached to the revetment wall and originally found in the debris of the atrium, depicting a standing draped figure with raised arms, holding a scroll and confronted on one side by four lions (fig. 108).[39] This, then, constitutes the first human figure to appear in Sardis as well as a rare instance of a Diaspora synagogue (Dura aside) displaying a biblical one.

However, none of the above prepares us for the striking appearance of the two-and three-dimensional figural images in the center of the synagogue hall. Statues of two pairs of addorsed Lydian lions flank a large stone table from which the Torah was read; these have been identified as originally having been associated with the goddess Cybele and date to the sixth or fifth century BCE. Furthermore, two majestic eagles in high relief, with their wings outspread and talons gripping thunderbolts, are carved on two large stone supports of the same stone table and were visible to all present in the hall. Where were these representations beforehand, why were they given such a prominent location, and what do they tell us about the religious or cultural proclivities of the congregation?

There seems to be a general consensus that these figural pieces were, in fact, *spolia*—architectural and sculptural elements originating in a pagan setting and reused in the synagogue.[40] While the use

39. See Rautman, "Daniel at Sardis." For a similar depiction from Tunisia, see Bejaoui, "Christian Mosaics in Tunisia," 96–98.

40. The use of *spolia* has been addressed often in scholarly literature. See the recent discussions of Ward-Perkins, "Re-Using the Architectural Legacy"; Elsner, "From the Culture of *Spolia*"; Wohl, "Constantine's Use of Spolia." Hansen's monograph (*Eloquence of Appropriation*) focusing on Rome and the Middle Ages is most comprehensive, having important implications for the eastern empire in Late Antiquity as well. The use of *spolia* became a widespread phenomenon in the Byzantine era, beginning with Constantine; public buildings and monuments, such as the Arch of Constantine, were recycled architectural elements. See Elsner, "From the Culture of *Spolia*; Wohl, "Constantine's Use of Spolia." On the use of *spolia* in cities throughout western Asia Minor in the Byzantine era, see Parrish, *Urbanism in Western Asia Minor*, 31–32, 52, 55, 79–80, 112–14, 145–47; and Coates-Stephens, "Attitudes to *Spolia*."

of eagle reliefs, lion statues, and the marble table are the most blatant examples of *spolia* in the Sardis synagogue, other less dramatic instances exist as well,[41] including fragments of ancient capitals, statues, sepulchral stelae, a small marble shrine, a marble lion, and a relief depicting Artemis and Cybele.[42] Some of these elements were found in the synagogue debris or a masonry collapse, while others were built into the walls or piers.[43]

What was the purpose of using such *spolia?* Was it merely a utilitarian practice, using older material for the sake of convenience or economy? Was the use of different styles an assertion of the value of heterogeneity in the face of the strict homogeneity that characterized the former Greco-Roman orders? Might the use of certain materials, while deliberately hiding them from view, have been done for polemical reasons?[44] In some cases, the reuse of earlier materials was probably for propagandist purposes. Constantine's recycling of the statues of second-century emperors (Trajan, Hadrian, and Marcus Aurelius) and decapitating them in order to fit them with his own head may have been done to establish continuity between the glorious reigns of the past and his own.[45] There was also the motivation of triumphalism — the appropriation of older materials by a new regime for its own (and often quite different) agenda, to signify that a new order had taken over. Such was certainly the approach of Christianity during these centuries in its appropriation and interpretation of the Hebrew Bible and, later, in its use of Hellenistic and even pagan models to establish its own presence and legitimacy in the Byzantine era.[46]

What, then, are we to make of the Sardis eagles and lions? We might simply call them decorative motifs but for the fact that these figures were quite exceptional compared to the other artistic representations in the synagogue. Not only are they different in kind, but their prominent location in the center of the hall and their close proximity to the table where the sacred Torah was read — the main focus of the worship service — are indeed baffling. A triumphalist explanation is difficult to maintain and might have been appropriate in an earlier period, when Jewish writers declared Judaism's superiority over the pagan cults, but this would not have been the case in the fourth century and later, when paganism and Judaism were under attack by Christianity.

In this light, it would seem more reasonable to assume that the use of such figures should be construed as an appropriation of Hellenistic models that, however unusual they may be, could be made to fit into a Jewish framework.[47] Of all the

41. For a recent survey of such finds, see Mitten and Scorziello, "Reappropriating Antiquity."

42. Magness, "Date of the Sardis Synagogue," 459.

43. The use of *spolia* was also widespread at this time in the shops and bath-gymnasium complex adjacent to the synagogue.

44. Hansen, *Eloquence of Appropriation*, 24.

45. Elsner, "From the Culture of *Spolia*."

46. See Bowersock, *Hellenism in Late Antiquity*, passim.

47. See chap. 16.

(1)

(2)

FIG. 109 *Menorot* from the Sardis synagogue: (1) *Menorot* incised on plaques; (2) three-dimensional "Socrates" marble menorah.

possible animal representations, the eagle and lion are probably the most ubiquitous depictions in Jewish art.[48] Eagles in relief and a number of three-dimensional representations of lions have been found in several synagogues of ancient Palestine. What is unusual, however, is the appearance of such figures in a Diaspora setting. It would seem that the community's inclusion of such representations can best be explained by its extensive acculturation and entrenchment in the wider community, which is also reflected in the epigraphic remains and reinforced by the setting, size, and duration of the building.[49]

Finally, fragments of thirteen *menorot* were discovered in or near to the synagogue Most were found in the main hall and the remainder in the forecourt and adjacent shops (fig. 109).[50] One such fragment is of an impressive three-dimensional

48. Goodenough, *Jewish Symbols*, 7:29–86; 8:121–42.

49. It has been suggested that the congregation may have perceived these lions as representing the Lion of Judah or, alternatively, as symbols of the power and strength of the Torah or the God of the Torah. But all this is speculative. See, respectively, Hanfmann, *Letters from Sardis*, 134–35 and fig. 98 with caption; Trebilco, *Jewish Communities*, 42. It is quite clear that these figures had lost any pagan associations that they once had, having been defaced and then used as *spolia* in both the synagogue and the adjacent shops (Crawford, "Multiculturalism," 42–44).

50. Seager and Kraabel, "Synagogue and the Jewish Community," 176; Hachlili, *Menorah*, 532. Seager and Kraabel list the widely quoted number of nineteen *menorot*. However, a closer look at their list shows that five instances are not from the synagogue, one of the shop representations is questionable, and another is merely a reference in an inscription. By their count, we are thus left with seven *menorot* found in the main hall, two in the forecourt, and three in or near the shops; however, Rautman has now published a second freestanding marble menorah from Sardis ("Two Menorahs from the Synagogue at Sardis"), which would then bring the total number found to thirteen. See also Waldbaum, *Metalwork from Sardis*, 103, nos. 610–11. Another menorah, questionably from Sardis (now in the British Museum), appears on a bronze stamp along with a palm branch (*lulav*) and a cluster of grapes on either

white marble menorah (probable dimensions 50 by 100 meters) with lozenge and acanthus patterns incised between its branches and the name Socrates inscribed on the left side, facing the crossbar.[51] Given the location of these remains, it would seem that the menorah stood in the southern *aedicula.* Since both sides of the cross-bar were inscribed and decorated, it might have been positioned in the hall so as to be viewed from both sides.[52] Apart from fragments of the aforementioned recently discovered marble menorah published by Rautman, this is the only three-dimensional menorah found to date in the Diaspora, although seven such *menorot* have been discovered at sites in Byzantine Palestine.[53]

THE PROMINENCE OF THE SARDIS JEWISH COMMUNITY THROUGHOUT ANTIQUITY

The Sardian Jewish community of Late Antiquity had its roots in earlier times. Two testimonies, as fascinating as they are elusive, offer us a glimpse into the history of this community in the pre-Roman era. One is the reference to Sepharad in Ovadiah v. 20, which has often been identified with Sardis, especially on the basis of a Persian-era inscription found in the city that reads: בספרד בירתא.[54] The second is a report by Josephus that Antiochus III settled some two thousand Jews in Lydia and Phrygia toward the end of the third century BCE (*Ant.* 12.147-53).[55] Although Sardis is not specifically mentioned here, the fact that it was the main city in Lydia throughout antiquity probably indicates that Jews were settled here and perhaps elsewhere. Other colonists, from Hyrcania in the East, were also settled near Sardis in the Persian era.[56]

Josephus has preserved three Roman decrees relating to the existence of a Jewish community in Sardis—in 49 BCE, around 47 BCE, and around 12 BCE (*Ant.* 14.235, 259-61; 16.171). These decrees point to the extensive privileges enjoyed by Sardian Jewry, such as the right to live according to their own laws, to have a place of their own in which to conduct their communal life, and to collect funds intended for Jerusalem.[57] Noteworthy also is a reference to the sizable Jewish community then residing in Sardis.[58]

side of its base, and bears the name "Leontios." See Reifenberg, "Ancient Jewish Stamps and Seals," 194 and plate 33, no. 2; Goodenough, *Jewish Symbols,* 2:218, 3:1015.

51. Seager and Kraabel, "Synagogue and the Jewish Community," 176; Ameling, *Inscriptiones Judaicae Orientis,* vol. 2, no. 135.

52. Hachlili, *Menorah,* 56.

53. Ibid., 51-55.

54. Donner and Röllig, *Kanaanäische und Aramäische Inschriften,* no. 260 (1:50; 2:306); Wineland, "Sepharad," 1090; van der Horst, *Jews and Christians,* 44.

55. See also Schalit, "Letter of Antiochus III."

56. Schürer, *History,* 3:17 n. 33.

57. Pucci Ben Zeev, *Jewish Rights in the Roman World,* 176-81, 217-25, 281-83. See also Pedley, *Ancient Literary Sources on Sardis,* no. 275; Trebilco, *Jewish Communities,* 38-39.

58. Following Pucci Ben Zeev's translation (*Jewish Rights in the Roman World,* 282), which was influenced by an edict appearing in *Ant.* 16.166: "The Jews, however numerous they may

A very different type of source from the second century CE, whose relevance to the Jewish community of Sardis has been debated, was discovered only in the first half of the twentieth century. A virulent anti-Jewish homily known as *Peri Pascha* (*On the Passion*) has been attributed to Melito of Sardis, who lived in the latter half of the second century.[59] His hostility toward the Jews is reflected in the following words from this harsh polemic (§§73–74, lines 519–31, ed. Hall, p. 41):[60]

> What strange crime, Israel, have you committed?
>> You dishonoured him that honoured you;
>> you disgraced him that glorified you;
>> you denied him that acknowledged you;
>> you disclaimed him that proclaimed you;
>> you killed him that made you live.
> What have you done, Israel? Or is it not written for you,
>> "You shall not shed innocent blood,"
>> So that you may not die an evil death?
> "I did," says Israel, "kill the Lord.
>> Why? Because he had to die."
> You are mistaken, Israel, to use such subtle evasions
>> about the slaying of the Lord.[61]

In recent decades, opinions have differed sharply over the possible connection between Melito's diatribe and the Sardis Jewish community. The fact that we know so little about Melito himself, about the second-century Christian community in Sardis, or about the Jews there at that time casts doubts on our ability to pinpoint the motives behind his sermon; other possible reasons for his vindictiveness have been suggested, not the least of which might stem from purely ideological and internal Christian considerations.[62]

be. . . ." The Loeb edition understands this phrase as referring to the large sums of money collected.

59. Allegedly one of the first pilgrims to visit the Holy Land, Melito's literary output was reputedly extensive (Eusebius, *Eccles. Hist.* 4.26; 5.24.5 [identified here as a eunuch, perhaps meaning an ascetic or celibate]; 5.28.5). See also the comments of Hall, *Melito of Sardis*, xi–xvii; Kraabel, "Melito the Bishop." Eusebius cites a letter of Polycrates of Ephesus, noting that Melito was bishop of Sardis and was also buried there.

60. See also http://www.bc.edu/dam/files/research_sites/cjl/sites/partners/cbaa_seminar/melito.htm.

61. In what follows, Melito contrasts the Passover celebration in the time of Jesus with the latter's suffering, perhaps reflecting a similar disjuncture between the Christian fast and the Passover festivities in his own day (§80, lines 565–81).

62. See, e.g., Cohick, "Melito's *Peri Pascha*"; Satran, "Anti-Jewish Polemic." On Christianity in Asia Minor in the early centuries CE, see S. E. Johnson, "Asia Minor and Early Christianity."

Whether a socially and politically powerful and threatening Jewish community existed in second-century Sardis, or even in the first or fourth century for that matter, we may, at the very least, speak of a well-rooted Jewish community that had been a staple in Sardis for centuries and whose continued existence, whatever the degree of its prominence, might well have contributed to the heated polemic that Melito incorporated into his homily. Not only would Melito's extreme antipathy be hard to explain otherwise (unless, as noted, it was purely ideological), but many of his references and formulations become clearer and assume a more poignant meaning if we assume that, inter alia, the contemporary scene in Sardis, and especially that of the local Jewish community, were being referred to, at least in part.[63]

Turning now to Late Antiquity, it is little wonder that the findings from the Sardis synagogue excavations have challenged any sweeping negative assumptions concerning Diaspora Jewish life.[64] Taken together, and as clearly attested by the Aphrodisias inscriptions, it has been demonstrated beyond all doubt that at least some Diaspora communities, particularly those in Asia Minor, had achieved a high degree of recognition and status within their respective cities.[65] In the case of Sardis, this privileged position is reflected by the fact that many members of the Jewish community identified themselves as citizens of Sardis (Σαρδιανόι) and held numerous public offices, particularly the nine who bore the title Βουλευτής and others who also had imperial titles. The prominence of this synagogue's members continued for about three centuries after the Christianization of the empire, up to the Persian destruction of the city in 616 or soon after.[66]

One aspect of the excavations touched upon only tangentially underscores this point quite well. The social acceptance of Sardian Jews and their amiable relations with their neighbors throughout Late Antiquity is reflected in the remains of the Byzantine shops adjacent to the synagogue. Of the twenty-seven shops (some of

63. On the prominence of Jews in other Asia Minor locales at this time, see Lane Fox, *Pagans and Christians*, 460–92; Trebilco, *Jewish Communities*, 29–31; Gibson, "Jewish Antagonism or Christian Polemic"; Gibson, "Jews and Christians in the *Martyrdom of Polycarp*"; and above, chap. 9.

64. Kroll, "Greek Inscriptions," 9. Furthermore, an early third-century inscription, reused in the later synagogue building, notes a "Fountain of the Synagogue" and may well point to the existence of an earlier synagogue on whose premises such an installation, accessible to all the citizens of Sardis, was located (as with the later building). See Buckler and Robinson, *Greek and Latin Inscriptions*, no. 17; Ameling, *Inscriptiones Judaicae Orientis*, vol. 2, no. 53. A fragment found among the synagogue remains, possibly a dedicatory inscription honoring the mid-second-century emperor Lucius Verus, might constitute a significant piece of evidence for the Jewish community's prominence, however the fragment is too partial, its original context uncertain, and its latest interpretation reads "Severus." See Cross, "Hebrew Inscriptions from Sardis," no. 1; Ameling, *Inscriptiones Judaicae Orientis*, vol. 2, no. 105.

65. See chap. 9.

66. The date of destruction is usually set at 616 CE, following Seager and Kraabel ("Synagogue and the Jewish Community," 174) and Kraabel ("Impact," 180).

which were also dwellings), ten have been identified as belonging to Christians and six to Jews;[67] these premises were not segregated, and Jew and Christian seem to have worked side by side. The identification of these shops as either Jewish or Christian rests primarily on symbols such as the cross or menorah used in them, on the names of the shop owners, and on the nature of the small finds (ampullae, pig bones, or remains of shellfish).[68]

Beyond the issue of Jewish prominence and acceptance by the non-Jewish world, the Sardis remains tell us much about the Jewish community itself. On the one hand, these finds reveal a community well ensconced in its environs, as demonstrated by the almost exclusive use of Greek language and Greek names, and, as mentioned above, by the numerous references to city and imperial officials. At the same time, uniquely Jewish elements of the synagogue are also in evidence. The building is clearly oriented eastward, toward Jerusalem, and the placement of the two *aedicu-lae* further emphasizes this orientation. The fragments of thirteen *menorot*, noted above, indicate the importance of this symbol for the congregation, as does the central location of the inscription mentioning Samoe, a local teacher and priest.

This comfortable integration of Sardian Jews in their milieu was not only a matter of combining a variety of Greek and Jewish elements. Almost every facet of the synagogue displays an integrative blend of these traditions. Architecturally, the synagogue has a classic basilical plan, yet its orientation is uniquely Jewish. The inscriptions are fundamentally Greek in form and content, but a number of them deal with Jewish themes or are grouped with Jewish objects such as the menorah. Moreover, as noted, the use of the term *pronoia* is also instructive, having roots both in Roman thought and Jewish tradition and thus perhaps reflecting a compatible syncretism between the two worlds.

The synagogue's art displays a similar proclivity toward integration. The geometric and floral designs reflect a conservative approach to art that was characteristic of Diaspora Judaism generally (Dura excepted). Yet the congregation had little compunction about introducing what may have been considered pagan symbols, such as the three-dimensional lions and eagles in high relief located in the liturgical focus of the main hall. We will never know whether the Jews accepted these animal figures as an integral part of the Sardian cultural landscape, reinterpreted them in a distinctly Jewish fashion, or both; the fact remains that this congregation seems to have lived in harmony with these artistic elements, clearly and eloquently expressing the Jewish community's adaptation to and integration into the local scene.

67. Ten more were unidentifiable, and one was left unexcavated.

68. Crawford, *Byzantine Shops*; Crawford, "Multiculturalism;" Crawford, "Jews, Christians, and Polytheists"; Ameling, *Inscriptiones Judaicae Orientis*, vol. 2, nos. 57–59. For diverse opinions on the relationship between Jews and Christians in Sardis, their rivalry and coexistence, see Ascough, *Religious Rivalries*.

APPENDIX

Dating the Sardis Synagogue

Since the excavations, it has been generally accepted that the Sardis synagogue remains date from the fourth to seventh centuries. Recently, however, Jodi Magness has suggested a radical revision of this chronology.[69] On the basis of late fifth- and sixth-century coins found in the main hall and atrium, she concludes that the synagogue dates to the mid-sixth century. For students of Sardis, such a dating is indeed revolutionary; for Magness, it is but another example of a methodology that focuses strongly on the archaeological evidence and dates a building strictly on the basis of its latest datable finds. Her argument is essentially twofold: first, a small but not inconsequential number of coins found beneath the mosaic floor or its mortar bedding are dated to the fifth or sixth century and cannot be explained as products of later renovations, since they were recovered from what appear to be undisturbed sections;[70] and second, the large number of fourth-century coins found throughout the building, used by the excavators and others as evidence that the synagogue as we know it was first built at this time, are not in and of themselves reliable for determining the building's chronology. Given the history of numismatic issues in these centuries, large numbers of fourth-century coins continued to be used throughout the fifth century and even into the sixth. In Magness's words: "I believe the large numbers of bronze coins dating to the fourth century have given the incorrect impression that the synagogue was built at that time."[71]

Assessing the structure's foundation or later stages (usually resulting from repairs) on the basis of these numismatic remains is a fundamental though much debated methodological issue. Magness's suggestion to redate a number of Palestinian synagogues by using a similar approach has not gone unchallenged.[72] What can be-

69. Magness, "Date of the Sardis Synagogue."

70. At best, the number of coins clearly found in undisturbed places is relatively small—19 of the 300 legible ones discovered in the atrium or forecourt, and 9 out of 65 in the main hall. Moreover, the terms "undisturbed" or "intact" are not always clear; do they refer to the original floor or to a restored section? Finally, the existing excavation notes do not always correspond to the exact context of the coins (ibid., 468–73).

71. Ibid., 451.

72. See the illuminating exchange between Magness ("The Question of the Synagogue"; "Response") on the one hand, and E. M. Meyers ("Dating of the Gush Halav Synagogue") and Strange ("Synagogue Typology and Khirbet Shema' ") on the other. See also Magness ("Synagogues in Ancient Palestine") and the responses of Foerster ("Has There Indeed Been a Revolution?"), Strange ("Some Remarks"), and Aviam ("Ancient Synagogues at Bar'am").

considered stratigraphically foolproof evidence?[73] No one denies that renovations and repairs were made in the synagogue,[74] but it is not always possible to formulate a clear and convincing distinction between an original foundation and later renovations. Moreover, the chronology of the Sardis synagogue is especially complicated owing to the fact that even today, some fifty years after the excavations, there is still no final report on which to base firm conclusions.[75] Thus, it remains to be seen whether Magness's reading and interpretation of the numismatic evidence are valid. The final report (as well as a response to her findings and interpretation by the excavators themselves) may help clarify the issues at hand.

Examination of the fifth- to sixth-century numismatic evidence from the synagogue's excavations also confirms that the picture is far from clear. Of the twenty-eight late coins found in a stratigraphic context, only a handful can be identified conclusively as coming from a sealed area. The certitude of all the remaining coins is compromised by one or more of the following factors: (1) the mosaic floor was damaged at the spot beneath which the coins were found, and therefore they have no stratigraphic value vis-à-vis the original construction; (2) the excavators described the coins as being beneath the surface of the mosaic floor (rather than the mosaic having been, in fact, intact here); (3) some coins were found at the edges of the mosaic floor (and not clearly underneath an intact surface); and (4) there are contradictions and discrepancies between the various field notebooks from the excavations and even among the interpretations of the excavators themselves.[76]

In short, a rigorous and maximalist assessment of these late coins would leave us with less than half a dozen that could be assigned confidently to a post-fourth-century date. Whether such a number is significant (constituting about 1 or 2 per-

73. Magness often employs such terms as "appear," "apparently," or "seems," which in scholarly jargon indicates less than total certainty. Perhaps this is so, since she did not excavate Sardis but examined the material afresh some four decades later!

74. Seager and Kraabel, "Synagogue and the Jewish Community," 174.

75. Moreover, even when one might expect evidence that would help solve this problem, information is either not forthcoming or ambiguous. Decisive dating of the Byzantine shops next to the synagogue that would shed light on the synagogue's chronology would have been a desideratum. Alas, this subject is generally ignored in the final report, and even when addressed four different assessments are offered; one opinion dates the shops to the fifth–seventh centuries, another to the fourth–sixth centuries, yet another places the latest phase of the shops in the early fifth century, and the last one dates the shops and adjacent colonnade to the fifth century; see Crawford, *Byzantine Shops at Sardis*, 2, 5, 108, 124–25. Clearly, such data are of little use regarding the synagogue. In subsequent articles published after the appearance of the final report, Crawford repeatedly dates the shops to ca. 400 CE, which would seem to confirm the accepted dating of the synagogue to the fourth century ("Multiculturalism," 49; Crawford, "Jews, Christians, and Polytheists," 192).

76. At one point in her presentation, Magness quotes from a field notebook that a certain part of the mosaic floor was undisturbed, yet she also cites a letter from Seager stating that "portions of the [same] mosaic had been disrupted" (Magness, "Date of the Sardis Synagogue," 454 n. 59). Whom does one believe—the archaeologist-architect charged with the excavation and its field reports or the person who recorded the data in the field notebook?

cent of the finds) is a judgment call. What is clear, however, is that the field reports and interpretations leave much to be desired. They are often confusing and inconsistent, giving rise to various interpretations. The original excavation record seems to have been something less than meticulous, and the correlation between the state of the mosaic pavement and the presence of coins found beneath it is faulty. At the very least, Magness has raised serious methodological issues regarding these late coins and the accuracy of the excavation record. Therefore, barring a final report that would convincingly put everything into place, it may be that this chronological numismatic conundrum will never be resolved.

Setting aside these archaeological and numismatic issues for the moment, it should be mentioned that, owing to the uncertainty of the finds' context, the historical and epigraphic evidence discussed by Magness also poses serious obstacles for claiming a late date for the building's foundation.[77] While letter forms and personal names at Sardis may be acceptable in a sixth-century setting and earlier, the use of titles such as *comes* and *palatinus* is far more problematic. All the available evidence, primarily from imperial sources, attests to the fact that Jews were excluded from such offices already in the fifth century. To claim that because a prohibition of this sort was often repeated, it must have been ignored, in Sardis and presumably elsewhere, may be theoretically true, but it is not a particularly compelling argument. Repetition does not always mean failure; it might well reflect a conservative bent in the legal tradition or a strong desire to reinforce the status quo. Moreover, Magness's attempt to make use of a chronologically disputed Ḥammat Gader inscription (preferring Avi-Yonah's sixth-century date to the fifth-century one suggested by Sukenik, both interpretations based on rather impressionistic, subjective "readings") with respect to Sardis can be considered nothing more than special pleading.

Furthermore, several extensive arguments appear to be irrelevant to the suggested sixth-century date. The claim that public construction continued throughout the fifth and sixth centuries in Sardis and other cities of Asia Minor may be accurate[78] but has no direct bearing on the date of this particular synagogue. Public building was no less a phenomenon of the fourth century than it was later on. The same holds true with respect to the use of *spolia*.[79] Since such use was widely practiced throughout the Byzantine era, the fact that the synagogue made extensive use of *spolia* has little bearing on determining a fourth- or sixth-century date.[80]

77. On Magness's discussion of the proposed sixth-century dating from a historical perspective, see ibid., 460–67.

78. See, e.g., Yegül, *Bath-Gymnasium Complex*, 16, 171–72.

79. The use of pagan *spolia*, discussed above, might well point to a fourth- rather than sixth-century context for the construction of the synagogue. While some pagan temples may have continued to exist in Asia Minor as late as the sixth century, they were far less frequent then, and the chances that a Jewish community could utilize such *spolia* would be even more unlikely.

80. See nn. 40–43.

The generally accepted prominence of "Godfearer" (by Magness as well) as referring to sympathetic gentiles, as noted above, is very problematic if dated to the sixth century. It is hard to imagine that local Christians would be attracted to Judaism, given the concerted efforts of church and imperial authorities to limit Jewish rights and given the threat posed by Christian Judaizers, especially among heretical groups in the region of Asia Minor.[81] It is highly unlikely that the sixth-century Byzantine authorities, having witnessed Justinian's determined efforts to establish a Catholic orthodoxy at the expense of Christian heretics, pagans, Jews, and Samaritans, would allow a large Jewish community to emerge and flourish in the very center of one of Asia Minor's most prominent cities, located not all that far from the imperial capital in Constantinople. Such a possibility is even more inconceivable in light of the fact that quite a few synagogues throughout the Diaspora at this time were being destroyed or converted into churches by local authorities. Such was the case in Apamea (Syria), Gerasa (Jordan), Stobi (Macedonia), Saranda (Albania), and Elche (Spain). Justinian himself was reputed to have destroyed the synagogue at Borion (North Africa), which was subsequently converted into a church.[82] Thus, it is indeed hard to imagine that a synagogue building such as the one in Sardis—monumental, prominently located, and lavishly decorated—could emerge in such unfavorable circumstances and then attract so many prominent non-Jewish Sardian citizens.

Having said this, caution is always called for in accepting or rejecting new theories. Archaeological finds have often yielded revolutionary conclusions, and this is especially true of the Sardis synagogue; its initial dating to the fourth century contributed mightily to the beginnings of a thorough reevaluation of Diaspora Jewry's presence in Late Antiquity.[83] Each instance must be judged on its own merits, taking into account all possible facets of a building, be they archaeological, epigraphic, artistic, or historical. When we examine Magness's proposed sixth-century date of the Sardis synagogue, archaeological or, more specifically, numismatic considerations—as important as they are—should not be the sole factor, especially when invoked decades after the excavation itself and by someone who was not part of the original excavation team. Excavation records certainly provide crucial data but often can be interpreted properly (and responsibly) only in the wider context of the excavation, not to speak of the wider urban historical context of Sardis and the rest of the Diaspora. Magness has raised an interesting and revolutionary suggestion; it deserves consideration but, at this stage at least, seems somewhat less than compelling.

81. The attraction of some heretical Christian sects to Jewish practices as late as the sixth century in the more remote areas of Asia Minor (i.e., Phrygia), as noted in chap. 9, is a very different phenomenon.

82. See chap. 9.

83. Ibid.

V

ART-HISTORICAL ISSUES

16. THE ZODIAC AND OTHER GRECO-ROMAN MOTIFS IN JEWISH ART

JEWISH ART IN Late Antiquity included an unparalleled variety of patterns, designs, and motifs of non-Jewish content compared to earlier periods. Communities at times borrowed heavily from the art of the Roman-Byzantine world, and while the use of neutral motifs is understandable, the presence of blatantly pagan motifs in synagogues is indeed surprising.[1] Some of these are individual representations, such as the stone-carved images of centaurs, Victories, sea goats or Capricorns, and Medusas appearing in several Galilean-type synagogues, especially Capernaum and Chorazin. Besides the display of flowers, fruit, grain, birds, and animals on the Dura synagogue's ceiling, there are representations of the zodiac (Pisces, Capricorn), a centaur, and female busts, perhaps personifications of Demeter-Persephone. Most scholars, Goodenough excepted, perceive these figures as a mild form of Hellenization among Jews.[2] Far bolder, however, are the pagan mythological themes appearing in the Bet She'arim necropolis—Amazons, the Amazon queen Penthesileia, Leda and the swan, and possibly King Lycomedes, Odysseus, and Achilles, as well as Atalanta and Meleagros.[3]

While the Bet She'arim remains indeed reflect the personal preferences of the families of the interred, the appearance of an Orpheus-like figure in several synagogues may be of more consequence. The depiction of such a figure, wearing a Phrygian hat and playing a lyre before an audience of assorted animals (a lion, a bird, monkeys, ducks, and perhaps more), already appears above the Torah shrine

1. Goodenough, *Jewish Symbols*, vols. 7 and 8; M. Friedman, "Pagan Images"; S. Stern, "Pagan Images."

2. Such innocuous usage may be in evidence elsewhere in Dura, on the facades of the Tabernacle and Temple; these seem to imitate the entranceways of pagan temples, some even bearing tiny pagan images.

3. See chap. 6.

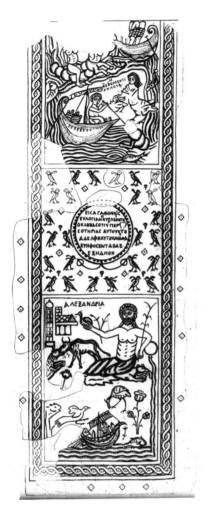

FIG. 110 Mosaic floor from the Leontis synagogue/prayer room in Bet Shean.

in Dura.[4] Ever since the excavation of this synagogue, it has been assumed that this figure represented David, whose musical talents were known in Jewish tradition; all doubt was removed when a similar depiction with the name David clearly written next to it was found in the Gaza synagogue (see chap. 11, fig. 98). As might be expected, views differ as to the significance of the association between David and Orpheus. Was it merely an innocent and logical tie owing to their ascribed musical proclivities, or was some deeper religious or otherworldly association of Orpheus as a symbol of heavenly peace perhaps now being linked to David?

In Byzantine art, pagan mythological themes are widely represented in private settings (such as villas) but are virtually nonexistent in public ecclesiastical buildings, a distinction followed by the Moslems later on as well.[5] A striking example of this dichotomy within the Jewish sphere may be found in a building complex in Bet Shean that housed both a prayer chapel and another room with a mosaic floor dedicated by one Leontis.[6] While the prayer room's mosaic features inhabited scrolls, animals (a peacock, other birds, a bear, an elephant, a fox, a hare, a dog, a deer, and a hen), and three inscriptions, two in Aramaic and one in Greek, the Leontis floor exhibits two striking Greco-Roman motifs along with three Greek inscriptions (fig. 110).[7] The floor is divided into three panels: (1) several scenes from Homer's *Odyssey*: above, Odysseus tied to the mast of a boat with a naked Nereid riding an ichthyocentaur or

4. Kraeling, *The Synagogue*, 223–35.

5. H. Maguire, "Good Life." The art in domestic quarters could include pagan gods, mythological motifs, scenes of nature and its cycles, Nilotic and marine representations, and more. According to Maguire, such depictions were not in conflict with Christian dogma but were probably understood as being subject to Jesus and were to be interpreted symbolically. Their main message was to convey a sense of well-being and prosperity (ibid., 252–53). See also Merrony, "Reconciliation of Paganism and Christianity"; as well as Bowersock, *Mosaics as History*, 31–63.

6. Foerster, "Beth-Shean," 233; Bahat, "Synagogue at Beth-Shean"; Zori, "House of Kyrios Leontis." See also Roussin, "Bet Leontis Mosaic"; Z. Safrai, "House of Leontis 'Kaloubas'"; Jentel, "Une Scylla méconnue." My thanks to Z. Weiss for calling my attention to this last article.

7. Roth-Gerson, *Greek Inscriptions*, nos. 6–9; Naveh, *On Stone and Mosaic*, nos. 46–47.

the sea monster Scylla, and below, a siren playing a flute and a half-naked young man seated in a ship while fighting a sea monster; (2) a panel filled with twenty-six birds, each sporting a red ribbon around its neck, a Greek dedicatory inscription naming Leontis as benefactor, and the fragmentary remains of a menorah found alongside an inscription; and (3) a Nilotic scene dominated by the figure of the Nile god, naked to the waist and leaning on a jug from which water pours into the river below; animals and a boat appear in the river, while to the left of the god is a building identified as "Alexandria," a Nilometer, and a tiger (?) attacking a bull.

The exact function of these rooms is unclear. Were they all part of Leontis's house, which included an adjacent prayer room,[8] or was the Leontis floor part of a larger communal building?[9] What is patently clear is that the Leontis floor, whether a private or public space, was not part of a prayer setting but a neutral room in which themes from Greek literature and mythology were openly embraced. Thus a sharp distinction was made in this Bet Shean building, as in Byzantine-Christian society generally, between a room used for religious purposes and one meant for secular activities.

THE ZODIAC

By far the most stunning Hellenistic-Roman depiction to appear in Jewish art of Late Antiquity is that of the zodiac signs, the figure of the sun god Helios, and the four seasons (all hereafter referred to as the zodiac motif). Indeed, no single motif in all of ancient Jewish art has aroused more surprise and scholarly attention than that of the zodiac appearing in a number of synagogues from Byzantine Palestine; indeed, this interest is reflected in scores of books and articles on the subject.[10]

8. Perhaps this is what the Talmud refers to as "the synagogue of an individual"; see Y Megillah 3, 4, 74a.

9. See Jentel, "Une Scylla méconnue," 248.

10. Among the most important contributions are: Avigad, "Mosaic Pavement of the Beth-Alpha Synagogue"; Sternberg, *Zodiac of Tiberias*; Stemberger, "Die Bedeutung des Tierkreises"; Dothan, *Hammath Tiberias*, 1:39–49; M. Smith, "Helios in Palestine"; Foerster, "Representations of the Zodiac"; Foerster, "Zodiac in Ancient Synagogues"; Yahalom, "Zodiac Signs"; Ness, *Astrology and Judaism*; Ness, "Astrology and Judaism"; Ness, "Zodiac in the Synagogue"; Berliner (Landau), "Circle of the Zodiac"; Roussin, "Zodiac in Synagogue Decoration"; Mack, "Unique Character of the Zippori Synagogue Mosaic"; Kühnel, "Synagogue Floor Mosaic in Sepphoris"; England, "Mosaics as Midrash"; Jacoby, "Four Seasons in Zodiac Mosaics"; Hachlili, "Zodiac in Ancient Synagogal Art"; L. I. Levine, *Ancient Synagogue*, 593–612; S. S. Miller, "'Epigraphical' Rabbis, Helios, and Psalm 19"; Weiss, *Sepphoris Synagogue*, 104–41, 231–35; Zohar, "Iconography of the Zodiac"; Fine, *Art and Judaism*, 196–205; M. Friedman, "Meaning of the Zodiac"; Magness, "Heaven on Earth"; Hachlili, *Ancient Mosaic Pavements*, 35–56; Friedheim, "Sol Invictus"; Talgam, "Zodiac and Helios in the Synagogue." See also Greenfield, "Names of the Zodiacal Signs."

Six synagogues display the zodiac motif:[11]

Na'aran/Na'arah. Although this synagogue near Jericho was the first to be discovered (1918) with this mosaic motif, the floor had been largely overlooked because of its very poor state of preservation following iconoclastic activity in Late Antiquity (see chap. 11, fig. 89). The Na'aran mosaic is unique in that the largest panel features geometric designs and not the zodiac. This panel is followed by the largely destroyed zodiac design, while that nearest the ark combines a cluster of Jewish symbols with a representation of the biblical figure Daniel.

Bet Alpha. This zodiac motif was the first to be highly publicized owing to its excellent state of preservation and its discovery by kibbutz farmers. Bet Alpha is located in the Jezreel Valley, west of Bet Shean (see chap. 14, fig. 98); the synagogue floor, found at the very end of 1928 and excavated in early 1929, also made headlines because it was the most detailed example of figurative art in a Jewish context at the time. Its zodiac motif appeared together with a biblical scene (the *'Aqedah*), and it was one of the earliest displays of a rich cluster of Jewish symbols.

Ḥuseifa. The mosaic floor in this synagogue, discovered on the Carmel range in 1930 and excavated in 1933, is very poorly preserved. The depiction of only one of the four seasons has survived, as have parts of several zodiac signs, a few *menorot*, a *lulav*, *ethrog*, shofar, and incense shovel, and a wreath bearing an inscription. In addition, a number of bands containing geometric mosaics were found along the sides of the hall.

Ḥammat Tiberias. Built just south of modern-day Tiberias, in a suburb once known as Ḥammat, owing to its hot springs, this synagogue, excavated from 1961 to 1963, boasts a well-preserved mosaic floor dating to the late fourth century (see chap. 12, fig. 90). All its panels are exceptionally well executed, the only damage having been caused by a later synagogue wall that destroyed part of the earlier mosaic floor.[12]

Susiya. Although identified as a public building already in the nineteenth and early twentieth centuries, this synagogue, excavated between 1969 and 1972, contains the least preserved zodiac representation, with only part of its original outer circle visible on the edges of the later floor.[13] Besides its circular shape, two other motifs found on the same floor seem to corroborate the fact that a full zodiac design was once displayed here. One was a depiction of Daniel and the lions on one side

11. For a fuller review of these zodiac representations, see Hachlili, "Zodiac in Ancient Synagogal Art." On two other synagogues at times included in this list ('En Gedi and Japhia), see below. The following list is organized by the years of their discovery; their chronological appearance in Late Antiquity is as follows: fourth century: Ḥammat Tiberias; fifth century: Sepphoris and Susiya; sixth century: Bet Alpha, Na'aran, and Ḥuseifa.

12. See chap. 12.

13. Of the four stages of the Susiya synagogue—all dated ca. 400–800 (see Z. Yeivin, "Susiya, Khirbet"), the zodiac appears in Stage 2. No date has been offered for this stage, but it seems most likely to have occurred by the mid-fifth century (personal communication, David Amit, December 9, 2009).

of the hall and the Temple facade with flanking *menorot* and other Jewish symbols on the other.

Sepphoris. This synagogue, excavated between 1993 and 1998, is most unusual in its orientation, size, shape, number of mosaic panels, and inscriptions,[14] as well as in the features of its zodiac motif (see chap. 13, fig. 94): the astrological signs are accompanied by the names of their respective months; young men and stars appear in each; there is a significant degree of nudity or partial nudity; and the figure of Helios is replaced by the sun riding in the chariot.

Two other synagogues are sometimes included in such an overview, although they are less relevant to our discussion. The 'En Gedi synagogue floor eschews any sort of figural representation and instead lists the zodiac signs as part of a long inscription.[15] The synagogue of Japhia, southwest of Nazareth, is sometimes included, since it displays a fragment of the familiar radially divided circle associated with the zodiac.[16] However, the only figures visible there are a buffalo and an ox, which have nothing to do with the zodiac. Thus, despite a similar format, it would seem that the intention here was to display symbols of the twelve tribes, and not the zodiac.[17]

Six factors come to mind in trying to account why the zodiac has become such a fascinating motif, thus prompting an infinite series of attempts to interpret its meaning and significance:[18]

1. The zodiac is represented in six synagogues — more than any other motif, except for the various clusters of Jewish symbols.
2. With rare exceptions, the zodiac constitutes the central panel of the mosaic floor and is almost always the largest one.
3. The motif appears in synagogues throughout the entire Byzantine period (fourth through seventh centuries).

14. See chap. 13.

15. The inscription reads as follows: "Adam, Seth, Enosh, Kenan, Mahalalel, Jared / Enoch, Methuselah, Lamech, Noah, Shem, Ham and Japheth / Aries, Taurus, Gemini, Cancer, Leo, Virgo / Libra, Scorpio, Sagittarius, Capricorn, and Aquarius, Pisces / Nisan, Iyar, Sivan, Tammuz, Av, Elul / Tishri, Marheshvan, Kislev, Tevet, Shevat / and Adar. Abraham, Isaac, Jacob. Peace / Hananiah, Mishael, and 'Azariah. Peace unto Israel."

16. See Barag, "Japhia."

17. Several Hebrew letters in one caption might represent part of the name "Ephraim," which gives some basis to the suggestion that this is a tribal designation. See chap. 11, n. 21.

18. The zodiac signs are mentioned in a number of literary texts from roughly this period: scattered references in rabbinic literature (e.g., Tanḥuma, Vayeḥi, 16, ed. Buber, p. 111a; *piyyut* (see Yahalom, *Poetry and Society*, 20–24; Yahalom, "Zodiac Signs"); *Sefer Yetzirah* 5; the somewhat later *Baraita de-Mazzalot*, ed. Wertheimer, 2:7–37; Sarfatti, "Introduction to 'Barayta De-Mazzalot'"; and especially Epiphanius, *Panarion* 16.2.4–5. See generally Charlesworth, "Jewish Interest in Astrology"; Greenfield and Sokoloff, "Astrological and Related Omen Texts"; von Stuckrad, "Jewish and Christian Astrology." The relationship between these texts and the artistic evidence remains a central issue (see below). What is clear, however, is that the art preceded the edited form of these sources.

4. The zodiac is not limited to any one region of Palestine, but appears throughout the country, from the Galilee to southern Judaea, and from the Jordan River Valley to the Carmel range.

5. The zodiac motif is not restricted to either an urban or rural setting but appears in both large cities (Tiberias, Sepphoris) and small villages (Bet Alpha, Na'aran, Susiya, Ḥuseifa).

6. Above all, and as noted, it is the pagan, "non-Jewish" aspect of this motif that has piqued scholarly interest and stimulated attempts to fathom its meaning for those communities, and perhaps also for the wider Jewish society at the time.

There is no question that these Late Antique Jewish communities were utilizing an artistic motif that had once been identified with the Greco-Roman world. While references to zodiac signs appear in certain earlier Jewish writings,[19] its artistic expression is never displayed; in fact, Josephus makes a point of emphasizing that while other heavenly designs decorated the curtains of the Jerusalem Temple, the zodiac was pointedly excluded.[20]

THE ZODIAC AND ITS VARIANTS IN THE HELLENISTIC-ROMAN WORLD

Throughout the Hellenistic-Roman period, this popular motif appears in numerous settings, from temples and villas to burial settings, as well as on statues of deities, gems, rings, and frescoes.[21] By the second and third centuries, its format and composition became more firmly crystallized, as did its widespread use on mosaic floors, all the while leaving a significant degree of flexibility in its content.[22] For instance, the running zodiac design changed over time into one divided into individual radial units with a different sign in each, and the relative sizes of the figures in the zodiac's center and outer circle also differ from one mosaic to the next.

To appreciate fully the complexity of the Roman context, it should be noted that the zodiac motif itself (Helios, the zodiac signs, and the seasons) was but one of many competing motifs in a varied Hellenistic-Roman repertoire. The basic format of concentric circles within an encompassing rectangular frame had become ubiq-

19. The zodiac signs already appear in the Qumran writings; see, e.g., 4Q138 (Brontologion); 4Q186 (4QHoroscope). See also Josephus, *War* 5.217; 2 Enoch (Slavonic Apocalypse) 30, in Charlesworth, *Old Testament Pseudepigrapha*, 1:150; Foerster, "Zodiac in Ancient Synagogues," 225–27.

20. Josephus, *War* 5.214: "On this tapestry (in the Temple) was portrayed a panorama of the heavens, the signs of the Zodiac excepted."

21. See generally Gleadow, *Origin of the Zodiac*, esp. 27–33. The zodiac motif, inter alia, was prominent in Mithraic iconography; see, e.g., R. Beck, *Planetary Gods and Planetary Orders*, 19–42, 52–55, 91–100; R. Beck, *Religion of the Mithras Cult*, 107–16, 206–56.

22. Gundel, *Zodiakos*, 101–31.

uitous, but no specific combination of motifs seems to have become normative, and each component of the threefold composition included many variations. While Helios was often the god depicted in the central circle, one might also find Jupiter, Mithras, Hercules, Tyche, Dionysos, or even the seven planets and the seven days of the week. Even the combination of Helios and Selene is attested at a later stage in Sparta and Bet Shean.[23]

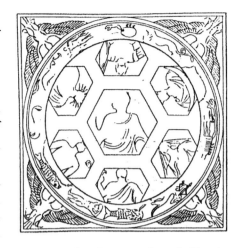

FIG. 111 Ceiling decoration from the Temple of Bel in Palmyra.

The same holds true with regard to the second outer circle. While zodiac signs are quite common, representations of the months—and in at least one instance the planets—are also prevalent.[24] The seasons found in the design's four corners, or spandrels, are likewise but one alternative in a wider repertoire that might include the four winds, amphorae, eagles, Egyptian goddesses, and other winged figures. To gain a sense of this variety, let us review a number of representative examples from the Roman period, in addition to two Byzantine adaptations.[25]

Dendera, Egypt. An early (ca. 30 BCE) sculptured relief decorating the ceiling of the Temple of Hathor portrays the zodiac signs. The celestial dome, supported by diagonal corner figures of Egyptian goddesses of the heavens, also portrays planets and *decans* (stars marking the celestial clock of ancient Egypt).[26]

Palmyra, Syria. A ceiling decoration in the form of a circular dome from the southern *adytum* of the first-century Temple of Bel (fig. 111) displays the seven planets personified by busts of the gods with whom they are identified. The bust of Bel-Jupiter dominates the center of the composition and is surrounded by six other planets; a square design encases several concentric circles within which the zodiac signs run in a continuous pattern; and the four corners of the heavenly circle are supported by winged creatures (sirens?).[27]

Antioch, Syria. A second-century mosaic floor in a triclinium located in the House of the Calendar (fig. 112) displays four preserved depictions of the months of the year in a circle, with two of the four seasons in the corners.[28] The figure in the

23. Zohar, "Iconography of the Zodiac," 4.

24. See Levi, "Allegories of the Months."

25. See Lehmann, "Dome of Heaven," 1–12; Gundel, *Zodiakos*; Foerster, "Representations of the Zodiac"; Hachlili, "Zodiac in Ancient Synagogal Art."

26. Gundel, *Zodiakos*, 82; Cauville, *Le zodiaque d'Osiris*, esp. 7–14; Gleadow, *Origin of the Zodiac*, 180–82.

27. Gundel, *Zodiakos*, no. 44; Lehmann, "Dome of Heaven," 3.

28. Levi, *Antioch Mosaic Pavements*, 1:36–38; H. Stern, *Le calendrier de 354*, 224–27; S. Campbell, *Mosaics of Antioch*, 61–62, plates 183–85.

FIG. 113 Ninth-century miniature in Ptolemy MS Vaticanus graecus 1291, based on third-century depiction.

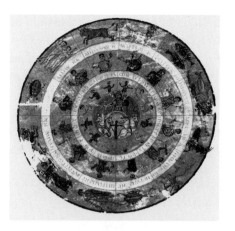

FIG. 112 Part of the mosaic floor from the House of the Calendar in Antioch.

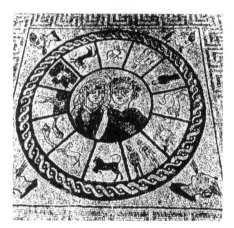

FIG. 114 Mosaic from a triclinium in Sparta.

central circle is largely destroyed; James C. Webster suggests a bearded man, George M. A. Hanfmann the sun god.[29]

La Chebba, Tunisia. A square-panel mosaic in a second-century CE villa features a half-clad Neptune emerging from the sea, riding a chariot led by four sea horses. In the central medallion, he holds a trident in one hand and a small dolphin in the other. The spandrels contain representations of the four seasons, with animals and people engaged in seasonal tasks between them.[30] No zodiac signs appear here.

Zaghouan, Tunisia. Found in this region and dating to the imperial era is a large hexagram containing images of the twelve zodiac signs encasing the seven days of

29. J. C. Webster, *Labors of the Months,* 26; Hanfmann, *Season Sarcophagus,* 1:248.

30. Parrish, *Season Mosaics,* 201–4. See also Ben Abed, *Tunisian Mosaics,* 101, fig. 5.13. Photo at http://commons.wikimedia.org/wiki/File:Neptune_Roman_mosaic_Bardo_Museum_Tunis.jpg, accessed November 2011.

the week.[31] The central figure, Kronos or Saturn, is surrounded by portraits personifying the days.[32]

Münster-Sarmsheim, Germany. Helios depicted as Sol Invictus in a quadriga dominates the center of the third-century mosaic design (see chap. 12, fig. 91). Much smaller zodiac signs appear in individual units, while the corners display amphorae flanked by fish.[33]

MS Vatican Ptolemy, gr. 1291. Based on a third-century original, this miniature (fig. 113) appears in an astronomical table of a

FIG. 115 Mosaic from the Tallaras baths.

ninth-century manuscript.[34] The central medallion depicting Helios riding in a chariot is surrounded by three circles: the inner circle contains personifications of the twelve hours; the middle, figures representing the twelve months of the year; and the outer, the twelve zodiac signs.

Sparta, Greece. A fourth-century triclinium mosaic depicts Selene and Helios in the inner circle, the zodiac in the outer circle, and the Four Winds in its corners (fig. 114).

Carthage, North Africa. A fourth- to fifth-century mosaic presents personifications of the twelve months, identified by namc, surrounding an inner circle containing two seated figures, one (identified as Tellus or Abundantia) holding a cornucopia, and the other a reclining figure of uncertain identity. The four seasons, likewise identified by name, appear in the corners.[35]

The Tallaras baths, Astypalaea, Greece. This fifth-century mosaic (fig. 115) is a close parallel to contemporary synagogue mosaics. It portrays Helios with rays, but no chariot, holding a globe in his left hand and raising his right in a blessing gesture.

31. For photo, see http://www.theoi.com/Gallery/Z50.2.html, accessed November 2011.

32. Mention should be made of a scene purportedly from the ceiling of Hadrian's villa in Tivoli reproduced in an eighteenth-century engraving from N. Ponce's *Arabesques antiques.* In the center is Jupiter or Helios representing the Pantokrator in a quadriga. The circle is surrounded by a square containing four female figures standing on globes and blowing on trumpets, as well as the zodiac signs grouped in threes in each corner. See Lehmann, "Dome of Heaven," 7, as well as a critique of this evidence by Joyce, "Hadrian's Villa," 361–66, 372–75; Mathews, *Clash of Gods,* 144–48.

33. Parlasca, *Die römischen Mosaiken,* 86–87, Taf. 84–87; Gundel, *Zodiakos,* no. 84.

34. Spatharakis ("Some Observations on the Ptolemy Ms.,"46–47) assumes that the original zodiac representation reflects a ca. 250 CE date and that the model of the ms. miniature should be dated to the third or fourth century; see also J. C. Webster, *Labors of the Months,* 22, plate IX.

35. Parrish, *Season Mosaics,* 116–20; J. C. Webster, *Labors of the Months,* 22–24; Åkerström-Hougen, *Calendar and Hunting Mosaics,* 143, fig. 80.

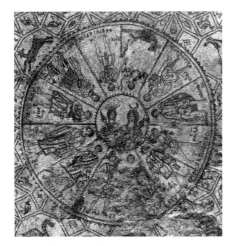

FIG. 116 Mosaic floor from the Monastery of Lady Mary, Bet Shean.

Around this central portrayal are representations of the zodiac signs and the four seasons.[36]

Bet Shean, Israel. This sixth-century monastery features a mosaic floor depicting Helios and Selene in the center surrounded by the months (fig. 116).[37]

The above examples indicate the wide range of alternatives used in depicting these celestial motifs. Nevertheless, the zodiac itself, along with Helios, seem to have been a popular theme whose appearance from the time of Hadrian in the second century increased in tandem with the solar deity's rising fortunes in Roman paganism.[38]

JEWISH ADOPTION OF THE ZODIAC MOTIF IN THE BYZANTINE ERA

Given the widespread use of the zodiac in pagan circles for centuries, its appearance in Byzantine synagogue settings is indeed surprising. As noted above, from the fourth through seventh centuries, only the Jews in Palestine made repeated use of this motif. The full zodiac never appears in any other religious building, pagan or Christian, in the Byzantine era, and the nearest parallel comes from the small Tallaras baths in fifth-century Greece.[39] Indeed, the composition depicting Helios, the zodiac signs, and the seasons is fixed in all the Jewish representations.[40] Its format also remains constant—two concentric circles within an encompassing square. Hebrew is regularly used to identify the different zodiac signs and seasons, although in Sepphoris, at least, the inscriptions accompanying the seasons appear in Greek as well.

36. Jacoby, "Four Seasons in Zodiac Mosaics." In the summer of 2009, a full zodiac motif similar to Palestinian models was found in Bursa, Turkey, in a purportedly third- to fourth-century building that has not yet been identified (my thanks to Zeev Weiss for calling my attention to this find).

37. On the famous Codex-Calendar of 354, which featured, inter alia, depictions of the months, planets, and probably also the zodiac (that has not survived), see Salzman, *On Roman Time*, 23–115.

38. Murray, "Christian Zodiac," 89. See chap. 12.

39. Murray, "Christian Zodiac," 90–93. On the very minimal use of allegorization of the zodiac in early Christian writings and its absence from Christian art until the Middle Ages, see ibid. The only use of the figure of Helios, in this case Sol Invictus, in a Christian funerary setting comes from the late third-century tomb of the Julii in Rome; see Toynbee and Ward-Perkins, *Shrine of St. Peter*, 72–74; Snyder, *Ante-Pacem*, 62–63; R. M. Jensen, *Understanding Early Christian Art*, 41–44. On the Tallaras baths, see above.

40. The major exceptions being Sepphoris, where the sun replaces Helios, and 'En Gedi, where there are no visual depictions at all.

Myriad attempts have been made to explain the significance of this motif, although most revolve around a limited number of suggestions relating to the entire composition: (1) it is essentially decorative, with no particular religious significance;[41] (2) it represents the sun;[42] (3) it expresses the importance of astrology in Jewish life;[43] (4) it reflects the centrality of the calendar in Jewish tradition;[44] (5) it symbolizes the eternal covenant between God and Israel;[45] (6) it conveys a messianic message;[46] and (7) it serves as a visual accompaniment to the recitation of *piyyutim* in synagogue liturgy.[47] Several scholars have related only, or primarily, to the image of Helios in their attempts to explain the zodiac motif. Some view it as an expression of: (8) the power of God over the heavenly order in nature and the world;[48] or (9) the power of God in history;[49] (10) an actual visual representation, symbolic or otherwise, of the God of Israel;[50] (11) Helios as the superangel (described in the third- or fourth-century *Sefer Ha-Razim*;[51] and (12) Helios as Elijah.[52] Recent theories linking Helios to the zodiac stress the dominance of the priests in Jewish society (Magness),[53] a biblically rooted polemic against sun worship (Stuart S. Miller),[54] or a theme closely related to the zodiac that finds expression in *piyyut* (Joseph Yahalom, Fine).[55]

41. Urbach, "Rabbinical Laws of Idolatry," 236–37; Strauss, *Die Kunst der Juden*, 27; A. Ovadiah, *Art and Archeology*, 481–509; Tsafrir, *Archaeology and Art*, 407–9.

42. Kühnel, "Synagogue Floor Mosaic in Sepphoris," 39.

43. Avigad, "Mosaic Pavement"; Avigad, *Beth She'arim*, 3:282; Sternberg, *Zodiac of Tiberias*, 72–84; Ness, "Zodiac in the Synagogue"; M. Friedman, "Meaning of the Zodiac"; and the interesting, wide-ranging, yet sometimes speculative presentation of von Stuckrad, "Jewish and Christian Astrology." On the association of Jews, and particularly Abraham, with astrology, by both Jews and non-Jews, see Josephus, *Ant.* 1.167–68; Artapanus (quoted by Eusebius, *Praeparatio Evangelica* 9.17–18); Vettius Valens and Firmicus Maternus, in Stern, *GLAJJ*, vol. 2, nos. 338–40, 473–76.

44. Avi Yonah, "Caesarea Inscription," 56–57; Hachlili, "Zodiac in Ancient Synagogal Art," 234–35 (with a liturgical emphasis).

45. England, "Mosaics as Midrash."

46. With respect to Bet Alpha, see Sonne, "Zodiac Theme"; Renov, "Relation of Helios and the Quadriga." Regarding other applications of the messianic theme, see chap. 18.

47. Yahalom, "Zodiac Signs"; Foerster, "Zodiac in Ancient Synagogues," 231; Fine, "Art and the Liturgical Context"; Fine, *Art and Judaism*, 186–89, 204–5.

48. Foerster, "Representations of the Zodiac," 388; Foerster, "Zodiac in Ancient Synagogues," 225. See also B. Narkiss, "Pagan, Christian and Jewish Elements," 186.

49. Weiss, *Sepphoris Synagogue*, 231–35, 242; Weiss, "Between Rome and Byzantium," 369–77.

50. Goodenough, *Jewish Symbols*, 8:215–18; Goodman, "Jewish Image of God"; Ness, "Astrology ad Judaism," 131.

51. M. Smith, "Helios in Palestine," 209*–10*; Roussin, "Zodiac in Synagogue Decoration."

52. Wadeson, "Chariots of Fire."

53. Magness, "Heaven on Earth."

54. S. S. Miller, "'Epigraphical' Rabbis, Helios, and Psalm 19," 48–76.

55. Yahalom, "Zodiac Signs"; Fine, *Art and Judaism*, 204–5.

Common to virtually all scholars is the assumption that their suggested interpretation is valid for all synagogues exhibiting the zodiac motif, even though, as noted, these depictions stretch over centuries and appear in disparate geographical and urban/rural settlement contexts. Is there no difference, for example, between how an artist or patrons who financed a structure might have interpreted the motif, or how ordinary members of the congregation might have reacted? Not only do most scholars ignore the possibility that a variety of understandings may have coexisted at any given time, but few, if any, entertain the possibility that different interpretations might have continued to emerge over time as well.

Faced with this variety of approaches, which bears witness at best to the eternal creativity of the human mind and at worst to the lack of any methodological controls by which to evaluate this phenomenon, we might ask why some sort of consensus has never been reached. Several reasons for this might be offered. In the first place, assuming that the local context is the decisive factor in what a synagogue mosaic displayed and how it did so,[56] we know practically nothing about the communal contexts of the zodiac's appearance. For example, we know precious little about fifth-century Sepphoris and nothing whatsoever about the other communities (Ḥuseifa, Bet Alpha, Naʿaran, and Susiya). In fact, the only zodiac representation with a relatively clear historical context is that from Ḥammat Tiberias.[57]

Secondly, scholars have invoked a wide range of literary sources to help explain this motif. These sources range over several millennia—from biblical literature of the first millennium BCE, through Philo and Josephus in the first century CE, to the latest rabbinic *midrashim* at the end of the first millennium CE (and even certain rabbinic compendia several centuries beyond). Rabbinic literature produced from the third to the twelfth and thirteenth centuries is the most frequently utilized source of information, but even here the choice of sources from which to draw varies, from tannaitic to amoraic sources and from those of Palestinian provenance to the Bavli. There has also been recourse to Roman beliefs (astrology), church fathers such as Epiphanius, and, on the Jewish side, to *piyyut*, *Sefer Ha-Razim*, and the Hekhalot mystical literature.[58]

A third issue frequently disputed in contemporary scholarship is whether any specific group in Jewish society was responsible for this art. Does it reflect the rabbis, the Patriarchs, the priests, mystical/magical circles, the local community, or a combination of the above?

Furthermore, it remains unresolved whether this motif should be interpreted on its own or in the context of the overall program of a mosaic floor, for example,

56. See chap. 19.
57. See chap. 12.
58. On the problems in invoking such diverse literary associations, see my comments in chaps. 18 and 20.

as part of a messianic message, as an accompaniment to the synagogue liturgy, or as articulating an anti-Christian polemic.[59]

Finally, and perhaps in reaction to the quest for a single interpretation, a recent approach raises the possibility that any of the components of the zodiac motif could have borne multiple meanings.[60]

Before suggesting an alternative approach based on a perspective quite different from any offered heretofore, it might be well to review several of the major methodological pitfalls regarding the above suggestions. First, and as noted above, they generally assume that the zodiac motif had one, and only one, meaning. Unless one grants a significant degree of unity among Jewish communities, this is a patently problematic supposition. Since synagogue buildings differed substantially from one another in almost every aspect—their architecture, inscriptions, liturgy, and art— such a blanket consensus on the meaning of the zodiac seems most unlikely.

Secondly, a corollary of the assumption of only one meaning implies that this art reflects the artistic expression of a normative Judaism with which all these congregations identified. Only in this light might one feel justified in utilizing sources from different times and places to corroborate a particular suggestion. For example, if we were to posit an all-pervasive rabbinic milieu, then such a view would become understandable and perhaps even credible. However, lacking such a premise, the basis for this approach disappears.[61]

A NEW PERSPECTIVE: THE ḤAMMAT TIBERIAS ZODIAC AS A PROTOTYPE

In contrast, I would suggest that the popularity of the zodiac motif stemmed first and foremost from its most impressive appearance in Tiberias, which by the third and fourth centuries had become the leading city of Jewish Palestine, housing some of the Galilee's major institutions—the seat of the Patriarchate and the home of a main rabbinic academy. The Ḥammat Tiberias synagogue, in which the zodiac motif appeared for the first time in a Jewish setting, was built by members of Tiberias's urban aristocracy; it bore Greek and Latin names and used Greek for their dedicatory inscriptions; it will be recalled that the leading contributor, Severus, twice identified himself in these inscriptions as having been closely associated with the "Illustrious Patriarch." The high profile of these patrons would explain not only

59. See chap. 18.

60. Examples of such multilayered interpretations can be found in Revel-Neher, "An Additional Key," 74; Talgam, "Comments of the Judean-Christian Dialogue," 78; Weiss, *Sepphoris Synagogue*, 231; see also Fine, *Art and Judaism*, 204–5. Such an approach, however, runs the risk of countering Hirsch's wise cautionary remark: "To dream that all expert interpretations are ultimately members of one happy family is to abandon critical thinking altogether" (*Validity in Interpretation*, 167).

61. See chap. 20.

the fine quality of the depictions (for instance, the use of naturalism and light-shade contrasts to render the impression of three-dimensional figures) but also the willingness to appropriate a motif so closely associated with Hellenistic-Roman culture.[62]

Given the status and social prominence of this synagogue's founders, their liaisons with the Patriarchate, and the distinction of the city in which it was located, other communities might have found the zodiac motif to be attractive and intriguing as well.[63] The Ḥammat Tiberias mosaic design thus may well have served as a model for emulation among the Jews of Palestine. While the specific application of the motif differed from one synagogue to the next (through additions, omissions, and changes),[64] this variety should not blur the very strong commonalities noted above. Ultimately, they were all following, directly or indirectly, the same model.[65] The striking similarities between them are thus best explained by a common prototype (the tripartite division of Helios, the zodiac signs, and the seasons of the year), which would account for the uniformity of this Jewish practice over several hundred years, especially when compared to the enormous variety of depictions in earlier Roman settings. This uniformity is even more pronounced by the fact that at each of the six sites the panel nearest the entrance to the hall, though still next to the zodiac, was always unique.[66]

Not only did the display of the zodiac motif remain constant, but its format also maintained an almost identical structure. Following the already established Roman pattern, each zodiac motif included two concentric circles, an inner one containing Helios (or the sun, in the case of Sepphoris) and an outer one, with a radius about twice the size of the former, containing the twelve signs of the zodiac in twelve radial units. The larger square frame enclosing these circles depicts the four seasons in its corners. In contrast to some pagan representations, in which the figure of Helios (or another deity) is often dominant and the zodiac signs are comparatively small, the division in the Jewish presentations is more balanced.[67] Moreover, the

62. See above, chap. 12. On the centrality and importance of solar theology in third- and fourth-century pagan circles, appropriated by Christians and Jews as well, see Liebeschuetz, "Significance of the Speech of Praetextatus," 187–92.

63. Thus, the importance of the Ḥammat Tiberias mosaic is due not only to the chronological factor (i.e., its being the first such mosaic to have appeared in a Jewish context); subsequence does not necessarily mean consequence.

64. Hachlili, "Zodiac," 220–28; Zohar, "Iconography of the Zodiac." Sepphoris is exceptional in a number of ways (see below).

65. An interesting, more contemporary parallel to this phenomenon may be found in the United States, where state capitals invariably imitate architecturally the national capitol in Washington DC, i.e., a neoclassical building featuring two wings, a cupola, and especially a circular dome. See Hauck, *American Capitols*.

66. This is true even for Sepphoris and Bet Alpha, where both depictions of the ʿAqedah exhibit significant differences.

67. Kühnel, "Synagogue Floor Mosaic," 37–39.

iconography of the zodiac signs themselves likewise remains constant; while the figures become more stylized by the sixth century, they almost always follow classical associations—the ram for Aries, scales for Libra, the archer for Sagittarius, and so on.[68]

The Ḥammat Tiberias model appears to have influenced later replications in other ways as well. The zodiac, usually the largest of the panels, is always located in the center of the mosaic floor. The fact that the seasons and zodiac signs were accompanied by identifying inscriptions in Hebrew may be a further sign of a shared heritage, as it, too, was markedly different from the surrounding culture.[69]

Two further elements of commonality in these synagogues are noteworthy. Despite the variety noted in the panel nearest the entrance, the panel adjacent to the zodiac motif, closest to the *bima* and Torah shrine at the front of the hall, always displays a cluster of Jewish symbols and regularly includes a pair of *menorot*, *shofarot*, *lulavim*, *ethrogim*, and incense shovels, all flanking a representation of the Torah shrine or Temple facade.[70] Indeed, it may be suggested that this cluster, also first appearing in Patriarchal contexts (Bet She'arim and Ḥammat Tiberias, and then in other synagogue settings, even those without a zodiac), was introduced into Palestine via Patriarchal circles, although specific evidence to corroborate such an assumption is lacking. Finally, it is worth noting that this motif appears throughout ancient Palestine only; nothing even remotely resembling this tripartite design is evidenced in a Diaspora context.[71]

The above suggestion implies that the continued popularity of this zodiac motif in Palestine was attributable more to social, cultural, and communal circumstances than to any ideological and religious rationale. All attempts to anchor this motif in one or another literary source are doomed to be speculative. There is simply no

68. For some of the exceptions, see Roussin, "Zodiac," 88; Hachlili, "Zodiac," 222–25. The differences between representations from the fourth and fifth centuries (i.e., Ḥammat Tiberias and Sepphoris) and those of the sixth (Bet Alpha, Na'aran, and Ḥuseifa) may not be only chronological but also geographical; the former are urban sites, the latter rural. On the differences between these two types of settings with regard to the Byzantine synagogues of Palestine, see L. I. Levine, *Ancient Synagogue*, 220–22, 230, 366, 596–97, 632, and elsewhere; and in contemporary Syria, see Brown, *Society and the Holy*, 153–65 ("Town, Village and Holy Man: The Case of Syria").

69. Whether these inscriptions appeared in Hebrew owing to general religious-ethnic boundary markers signifying Jewish space or some deeper symbolism is difficult to assess. Emphasizing the latter has led some to view such usage as a reflection of the sanctity in which the Hebrew alphabet was held at this time (statements in the Bavli bespeak the symbolic meaning of each letter [Shabbat 104a], that the Tabernacle was created out of letters [Berakhot 55a], or, alternatively, that every stroke of a letter in Scriptures is significant [Pirqei de Rabbi Eliezer 21]). However, such associations and connections appear quite far afield.

70. See chap. 17.

71. Except for several signs on the Dura ceiling also associated with the zodiac; see Kraeling, *The Synagogue*, 51, and above.

solid evidence for any sort of theological or religious component behind the use of the zodiac, as has often been assumed.

One further issue is whether the Tiberias mosaic was actually known to the builders, patrons, or congregants of the later synagogue communities that adopted this motif. It would seem that Stratum IIa of the Ḥammat Tiberias synagogue, that of Severus which first featured the zodiac, functioned at least until the second half of the fifth century, and perhaps even into the sixth.[72] Thus it is entirely conceivable that some of the builders of the later structures might have known about it first-hand. The fifth-century Sepphoris and Susiya synagogues almost certainly would have been familiar with the Ḥammat Tiberias zodiac model. The dating of at least two of the other three buildings to the sixth century is only an educated guess. The stratigraphic evidence for Naʿaran and Ḥuseifa is practically nonexistent, and Bet Alpha's dating to the reign of Justin would place it either in 518–27 (Justin I) or 565–78 (Justin II).

Moreover, the existence of a Tiberian model for creating later zodiac depictions may account for the overall conservatism over the centuries in the presentation of this motif together with the panel of accompanying symbols. Having gained respect with its first appearance in Tiberias under Patriarchal auspices, this pattern was then copied and adapted thereafter by other communities. No other mosaic program can boast such longevity and centrality in Late Antique Jewish art.

The phenomenon of an unusual artistic motif or object serving as a source of imitation is not new.[73] Examples of such models from antiquity include: the Piraeus lighthouse in Alexandria that Herod, among others, copied when building the Phasael tower in Jerusalem; the many funerary monuments of Etruscan, Hellenistic, and Roman vintage that served as models for the circular, rectangular, or polygonal varieties that became widespread throughout the Roman Empire; and, finally, the Roman basilica that was later used and adapted by the Christians for their churches.[74] Moreover, the phenomenon of imitating and adapting artistic models

72. Although the *terminus ad quem* of the Severus stratum is far from clear, given the fact that the subsequent stage of this synagogue dates only from the late sixth century, about a century later, the previous Stratum IIa of the building might well have remained in use into the sixth century. See Magness, "Heaven on Earth," 8–10: "the evidence suggests that the Stratum IIa synagogue was occupied *at least until the third quarter* of the fifth century" (p. 10; emphasis mine); Dothan offers very different dates for the building and abandonment of Stratum IIa (*Hammath Tiberias*, 1:66–67; *Hammath Tiberias*, 2:12).

73. Others have already hinted at the possibility of such a model. Hachlili suggests a prototype inspired by the Antiochan school, which had its roots "in the art of the preceding period with the two major schemes, which are part of the Jewish calendar: the astronomical zodiac and the agricultural calendar. The Jewish model unified both of these into the distinctive design of the seasons, zodiac signs, and sun god, signifying a liturgical calendar" ("Zodiac in Ancient Synagogal Art," 236). Weiss, too, raises this question, although he rejects the possibility of a model (*Sepphoris Synagogue*, 141).

74. On the use of models in funerary architecture, see Toynbee, *Death and Burial*, 118ff.

was well known in the ancient and medieval worlds generally. Byzantine Christianity borrowed pagan models wholesale from the third century onward[75] and even drew inspiration from distant classical Greek depictions.[76] Later on, Byzantine works of art influenced an array of medieval representations.[77]

Assuming a fourth-century Tiberian origin for the zodiac motif might help to explain the appearance of the zodiac signs and Helios in a Jewish context in several sources composed around this time. One such source is the *Panarion* of Epiphanius from circa 375, roughly when the Ḥammat Tiberias synagogue was being constructed. In describing the Pharisees, he notes that they used Hebrew words not only for astronomical terms (sun, moon, and planets) but also for the astrological signs.[78] Clearly, this description has nothing to do with the pre-70 Pharisees, as there is no other attestation for such beliefs in Pharisaic circles or among any Jews at the time. Epiphanius possibly had current (synagogue?) practice in mind; on the basis of the evidence presently available, he may even have been referring to the Ḥammat Tiberias floor.

Sefer Ha-Razim (*Book of the Secrets*), a handbook of practical magic, has been dated by Mordecai Margalioth to the third century, although Eliezer S. Rosenthal, whose comments are included in Margalioth's text, suggests a mid-fourth-century or later date.[79] One of the book's most poignant passages is the reference to Helios as a superarchangel knowledgeable in the mysteries of the universe.[80] Since this composition also may have been more or less contemporaneous with the Ḥammat Tiberias synagogue, some sort of link between this literary reference and the mosaic depiction of Helios may be warranted, and the image may have taken on added meaning owing to this particular mosaic floor (or vice versa). However, any such connection between these texts and the Tiberian synagogue is, admittedly, speculative.

Our explanation has attempted to account for the reappearance of the zodiac pattern in synagogues throughout Byzantine Palestine. We have not attempted to discuss either the changes and renovations made by each community in the pro-

On continuity and change in the monuments of Rome and Constantinople from the fourth century on, including the Arch of Constantine, see Elsner, *Imperial Rome and Christian Triumph*, 63–87.

75. Grabar, *Christian Iconography*; Gough, *Origins of Christian Art*, 18–48; Brenk, "Imperial Heritage"; Hanfmann, "Continuity of Classical Art"; Kitzinger, *Byzantine Art in the Making*, 19–44; Bowersock, *Hellenism*. Regarding earlier Roman influences on Christian book illumination, see Weitzmann, *Ancient Book Illumination*.

76. See Weitzmann, *Classical Heritage in Byzantine and Near Eastern Art*; Weitzmann, *Greek Mythology in Byzantine Art*.

77. Weitzmann, "Various Aspects of Byzantine Influence." For a particular theme that found expression throughout the last millennium and a half, see Barasch, "Job," 95–110.

78. Epiphanius, *Panarion* 16.2.1–5.

79. Margalioth, *Sepher Ha-Razim*, 23–28.

80. Ibid., 99; Morgan, *Sepher Ha-Razim*, 71.

cess of adoption and adaptation or the possible reasons for them. There are indeed many differences—some significant, others less so—in the portrayal of Helios, the zodiac signs, and the seasons.[81] The better-preserved examples from Ḥammat Tiberias, Sepphoris, and Bet Alpha, for example, have been addressed at length,[82] but definitive evidence for the process of adoption and implementation is simply not available for the latter two synagogues, and certainly not for the other sixth-century buildings.

What is clear, however, is that each community (and artisan) made choices and decisions regarding what to borrow, what to omit, what and how much to change, and finally, how to present the pattern in its own unique setting. Sepphoris and ʿEn Gedi are two clear-cut cases in point. The degree to which such changes were guided by aesthetic or ideological considerations is of great interest, but once again, it is beyond the scope of our sources to provide definitive answers. In short, the conservatism of these communities in their adoption of a central composition was balanced by the flexibility and creativity that characterized their respective zodiac iconographies.

While we are in an excellent position to account for the selection of the zodiac form in the first-attested mosaic at Ḥammat Tiberias, namely that considerations of culture, calendar, and politics were foremost,[83] one may assume that calendrical concerns were very much at play in Sepphoris and ʿEn Gedi as well. In each, it will be recalled, the zodiac signs are accompanied by the names of the months. However, given the lack of coordination between zodiac signs and seasons at Bet Alpha, Ḥuseifa, and Naʿaran, it would seem that there was less concern or interest for such a correspondence in these places.[84]

81. Besides the oft-noted alternating positions of the zodiac signs, some figures were directed inward, with their heads facing the center (Ḥammat Tiberias, Sepphoris, and Ḥuseifa) while others had their heads turned outward and their feet pointing toward the central circle (Bet Alpha and Naʿaran); many other unique features are also apparent from one mosaic floor to the next; see Hachlili, "Zodiac," 220–28; Weiss, *Sepphoris Synagogue*, 104–41; Mack, "Unique Character of the Zippori Synagogue Mosaic"; Zohar, "Iconography of the Zodiac," 5–7: "It thus seems that the creator of each zodiac mosaic used a different artistic model. At times, the single depictions are unique, with no other parallels. In contrast with the conservatism in the choice of composition and subject matter, the iconography of the signs themselves is rich and diverse. This might be a matter of chance, as we are only familiar with those representations that have survived, but it may also indicate the flexibility and creativity in which each mosaicist treated the artistic models at his disposal" (p. 7). On the suggested identification of the portrayal of Helios on amulets as Jewish, see Goodenough, *Jewish Symbols*, 2:258–61.

82. See chaps. 12, 13, 14.

83. See chap. 12.

84. It is interesting that the first two urban synagogues displaying the zodiac motif follow the topical design, with its emphasis on the cyclical and seasonal dimensions, as demarcated by equinoxes and solstices; the other three sixth-century rural examples ignore this and may

If our supposition is correct, then the Patriarchal dynasty played a central role in the display of the zodiac motif, first by conceiving and displaying such art and then by the fact that others eventually followed suit. It is interesting to note that while the zodiac motif first appears in the Patriarch-associated Ḥammat Tiberias synagogue, the earliest display of Jewish symbols, including a cluster of them, as in synagogue mosaics, first surfaced in the Patriarchal necropolis of Bet She'arim. The menorah is depicted in almost forty cases there, and at times together with the shofar, *lulav, ethrog,* and incense shovel.[85]

Whether or not Patriarchal influence was in and of itself sufficient to bring about this revolution in Jewish artistic practice of Late Antiquity, it is clear that this office, allied as it was with the wealthy aristocratic class, was quite instrumental in promoting it.[86]

CONCLUSION

The zodiac motif is generally regarded as the most intriguing aspect of Jewish art in Late Antiquity. The Jews in Palestine appropriated this popular motif in the fourth century and used it for several hundred years.

Although virtually all scholars until now had assumed that this motif bore the same meaning(s) for each and every community in which it appeared, and therefore that one explanation, be it of a religious, theological, or cultural nature, would suffice, there is no compelling reason to do so. Besides the inherent problems of such an assumption, both in view of the fact that interpretations of the zodiac in ancient literary sources (contemporary or near contemporary) are nonexistent and owing to the well-documented cultural and communal diversity evidenced among ancient synagogues,[87] the very notion of a symbol assumes that multiple meanings were always associated with it.

Nevertheless, the appropriation of the zodiac, whatever its significance, by a number of Jewish communities is a striking example of their willingness and ability to adopt, adapt, and sustain over a significant period of time an artistic tradition whose roots lay deep in the rapidly disappearing pagan world. Most Jews in the fifth to seventh centuries undoubtedly viewed the zodiac motif as Jewish; only they—and not their Christian, Samaritan, or pagan neighbors—were using it then and, what's more, placing it in a central and prominent location in their synagogues. When the fourth-century Tiberian community at Ḥammat Tiberias, dominated by Patriarchal circles and the local aristocracy, decided to introduce this motif into its synagogue, it constituted a fascinating example of the ability of certain Jewish

have derived their inspiration from sources influenced by astronomical charts that emphasized the stars and constellations and disregarded other considerations.

85. Hachlili, *Menorah*, 515–16; Avigad, *Beth She'arim*, 3:269, nos. 2, 4, 5, and plates LXII–LXIII, as well as above, chap. 6.

86. See J. Baumgarten, "Art in the Synagogue"; and below, chap. 21.

87. See chap. 19.

circles to utilize contemporary cultural elements to enhance and enrich their own local synagogue frameworks. Little did they know the long-range impact of this move, which would affect other Jewish communities for several centuries as they transformed this motif into the central design of their synagogues as well.[88]

Thus, the zodiac motif offers a profound example of Jewish resilience under Byzantine Christianity and of a recognized cultural expression resulting from a symbiosis with a larger cultural matrix. When choosing this motif for implementation in their religious communal settings, the Jews adopted what the wider Christian society rejected. Once again, we see that the heretofore traditional narrative, which construed Christianity as essentially a coercive and discriminatory societal framework, is only part of the story of the Jews in Late Antiquity; in truth, this matrix also provided a milieu of stimulation and creativity.[89]

88. Similarly, long after the disappearance of the Patriarchate, Bet She'arim continued to attract Jews in the fifth and sixth centuries as a place for burial; see Weiss, "Burial Practices in Beth She'arim," 225–31.

89. See chaps. 9–10.

17. RELIGIOUS COMPONENTS OF JEWISH ART AND SYNAGOGUE SANCTITY
Diachronic and Synchronic Factors

BEFORE LATE ANTIQUITY, Jewish art had consisted mainly of motifs drawn from the repertoire of the surrounding cultures and was characterized by selective borrowing from these cultures. In Late Antiquity, however, we witness an increased proclivity to absorb a wide range of "foreign" motifs while amalgamating them with elements rooted in Jewish tradition. Whether using Jewish symbols or biblical themes, Late Antique Jewish art was anchored to a far greater extent in the Jewish past.[1]

JEWISH SYMBOLS

Motifs of an exclusively Jewish nature were virtually nonexistent in the first millennium BCE. None is attested in the First or most of the Second Temple period. The first such visual evidence is the menorah (and in at least one instance, the showbread table)[2] in Late Second Temple Jerusalem, Bet Loya (in the Judaean Shephelah), and Migdal in the Galilee. It is represented on only a few occasions in the first century, although it would later become the symbol par excellence of the Jewish people.[3]

1. See Hachlili, *Ancient Mosaic Pavements*, 17–33, 57–96. On Christian efforts to reclaim, reinvent, and remake their past, see A. Cameron ("Remaking the Past," 16), who concludes her overview with the following comment: "The sheer energy of late antiquity is breathtaking. Every inch of the past received attention, and many topics and many texts were the subject of volumes of exegesis and comment. Nor were texts enough: the story was told, and thus its truth fixed, in pictures and other forms of visual art. It was this very exuberance and invention which the reforming iconoclasts attempted unsuccessfully to curb."

2. For a discussion of this Jewish symbol, see my "History and Significance of the Menorah."

3. Excluding the representation of the menorah on the Arch of Titus, for which, of course, the Jews were not responsible, other known examples from Jerusalem include the coinage

However, since most of these early examples were found in priestly contexts in Jerusalem, it would seem that the menorah, at times together with the showbread table, may originally have been intended primarily to represent the Temple, bearing no particular symbolic dimension.[4] Although appearing on a few post-70 "Darom" lamps from southern Judaea,[5] the menorah is conspicuously absent from the coins of the two revolts, and one *baraita* clearly stipulates that the menorah and other Temple implements should not be replicated.[6] The third century seems to have been a transition period, the earlier use of the menorah emphasizing its role as representative of the Temple appearing in Dura,[7] and its new symbolic role first surfacing in the contemporaneous Bet She'arim necropolis and Roman catacombs.[8]

It was only in the Byzantine era that this symbol emerged on a large scale, as did the shofar, *lulav*, *ethrog*, and incense shovel (the last appearing only in Roman-Byzantine Palestine). These objects are frequently depicted as a recognized cluster against the backdrop of a facade, but they often appear individually as well.[9]

The meaning of this cluster of symbols has been long debated. One theory maintains that they were intended primarily to recall the Jerusalem Temple (or possibly the Wilderness Tabernacle), with the facade representing the Temple and the menorah, shofar, *lulav*, *ethrog*, and incense shovel symbolizing the Temple vessels used in the cultic rituals once performed there. Ever since the discovery of the Dura synagogue in 1932, where the Temple facade is clearly depicted above the Torah shrine, this interpretation has been applied to other sites as well. It assumes that the Temple's memory was of paramount importance to many Jewish communities[10] and that the appearance of this motif in a synagogue setting can be construed as triggering this memory, perhaps together with hopes for its restoration or possibly reflecting the synagogue's religious significance as a continuation of the Temple (see below).

of Antigonus, the last Hasmonean king; the walls of Jason's tomb in Jerusalem's Rehavia neighborhood; a plastered wall from the excavations of the Upper City in today's Jewish Quarter; and a sundial from the Temple Mount excavations. On the finds from Jerusalem as well as from Bet Loya and Migdal in the Galilee, see chap. 3.

4. L. I. Levine, "History and Signficance of the Menorah," 134–39. The situation appears to have been different with regard to Bet Loya and Migdal.

5. Sussman, *Ornamented Jewish Oil-Lamps*, 16–17.

6. B Menahot 28b; B Rosh Hashanah 24a; B 'Avodah Zarah 43a; Midrash Hagadol, Exodus 20:20, pp. 440–41; and chap. 3.

7. Although even in one instance the menorah here is accompanied by the *lulav* and *ethrog*, which already may have had some symbolic meaning, perhaps representing the Sukkot holiday.

8. See chaps. 4–7.

9. Hachlili, *Menorah*, 211–49. On a series of facades positioned vertically and without accompanying symbols, see the Saranda synagogue in chap. 11.

10. See chap. 5.

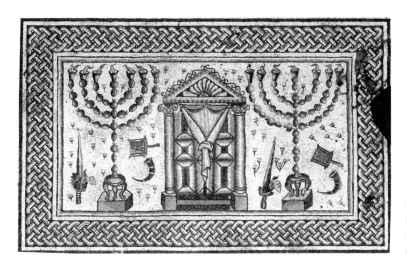

FIG. 117 Torah shrine flanked by Jewish symbols from Ḥammat Tiberias synagogue.

Another approach regards this cluster of symbols as representing the synagogue and its associated rituals. The facade is thus interpreted as depicting a Torah shrine while the other symbols represent the various ritual objects used in synagogue liturgy (fig. 117).[11] By Late Antiquity, the shofar and *lulav* had become integral parts of synagogue worship, and the depiction of a facade on gold-glass remains from Rome, with doors wide open and shelves containing scrolls, incontrovertibly indicates that a Torah shrine was intended.[12]

However, each of the above interpretations has its drawbacks. To interpret every facade as a depiction of the Temple's exterior is problematic. Most representations rarely resemble what we know about the Temple facade from the literary sources (Josephus or Mishnah Middot) or earlier second- and third-century Jewish art (for instance, the Bar-Kokhba coins and Dura frescoes). It has been suggested, albeit speculatively, that such depictions may refer to an inner portal of the Temple and not its outer facade. The incense shovel and menorah are certainly appropriate for the Temple context, though one wonders why two *menorot* (and not just one) are displayed and why the shofar, *lulav*, and *ethrog* are emphasized, since they seem to have been quite peripheral to official Temple worship. Only in the synagogue setting of the post-70 era did these symbols begin to occupy a central place in Jewish religious practice. Finally, if the intended focus was indeed the Temple, one might wonder why other objects more closely identified with its ritual were not chosen, such as the altar, the showbread table, sacrifices or other offerings, or even certain priestly vestments.

11. On representations of the Torah shrine, see E. M. Meyers, "Torah Shrine"; Hachlili, "Torah Shrine and Ark." On the incense shovel in a synagogue setting, see below.

12. Goodenough, *Jewish Symbols*, 2:108–19; Leon, *Jews of Ancient Rome*, 218–24; and above, chap. 7.

While this cluster of symbols (including the appearance of two *menorot*) seems to fit a synagogue context rather nicely,[13] there are two major problems with this identification. One is that a number of facades seem to be connected with the Temple edifice, and not the Torah shrine. Secondly, the incense shovel patently does not apply to the synagogue or its liturgy, as no written source ever relates to its use in such a setting.[14]

A less sweeping yet perhaps more compelling argument maintains that the above alternatives were not mutually exclusive and that either the Temple or the synagogue might have been intended, with each community choosing the representation most meaningful to its members. When all is said and done, some depictions (Bet She'arim, Bet Alpha, Ḥammat Tiberias, and Roman gold glass) are clearly Torah shrines, while others (Dura, Sepphoris, and Bet Shean) seem to resemble facades of buildings and presumably were intended to be symbolic of the Temple.[15]

However, if one were to focus solely on the smaller symbols accompanying the facade and *menorot*, it would be quite logical to interpret them as referring to the three major Jewish holidays in the month of Tishri—Rosh Hashanah (the New Year), Yom Kippur (the Day of Atonement), and Sukkot (the Feast of Booths).[16] In this light, these symbols can easily be associated with one or another of these holidays: the shofar—Rosh Hashanah; the incense shovel—Yom Kippur;[17] the *lulav* and *ethrog*—Sukkot. This suggestion may be borne out by John Chrysostom's homilies directed against the Judaizing Christians of his congregation in Antioch in 386–87 CE, when he chose to inveigh against these particular holidays (and in one case, their symbols): "What is this sickness? The festivals of the wretched and miserable Jews which follow one after another in succession—Trumpets, Booths,

13. Two *menorot* were found flanking Torah shrines in wall depictions from Bet She'arim and Rome, on gold-glass fragments found in the latter and on mosaic floors, and thus have been suggested in the restoration of a number of synagogues.

14. Some Jews seem to have used incense in tombs, as reported by the sixth-century Christian pilgrim Antoninus Martyr regarding the Cave of Machpelah in Hebron; see Tobler and Molinier, *Itinera hierosolymitana*, vol. 1, part 2:374; A. Stewart, *Of the Holy Places*, 24. See also Freund, who argues for the use of incense, even in the synagogues of Late Antiquity ("Incense Shovel of Bethsaida," esp. 445–49).

15. Another approach views these symbols as representations of two basic concepts in Judaism—Temple and Torah. As these two dimensions are often interrelated in Jewish tradition—starting with placing the two tablets of stone bearing the Ten Commandments together with Moses' Torah in the Wilderness Tabernacle (Deut. 31:9, 26), and later on in the First Temple—this combination conceivably may have found expression in Late Antique Jewish art as well.

16. This suggestion was first raised by Braslawski ("Symbols and Mythological Figures," 115–18) and later espoused by others.

17. On the importance of the incense shovel for the Yom Kippur ceremony, see Lauterbach, *Rabbinic Essays*, 51–83; Freund, "Incense Shovel of Bethsaida."

the Fasts—are about to take place. And many who belong to us and say that they believe in our teaching, attend their festivals, and even share in their celebrations and join their fasts. It is this evil practice I now wish to drive from the church."[18] Elsewhere Chrysostom rails against those Christians who are drawn to the sound of the shofar (Rosh Hashanah), dancing (*sic*!), fasting (Yom Kippur), and building booths (Sukkot).[19] Given the high profile of these holidays (in this case in Antioch, but probably elsewhere as well), it may not be far off the mark to imagine that many synagogues depicted symbols associated with these holidays.

Whichever of the above alternatives is preferred, it is quite clear that ritual objects were mobilized to serve the cultural, religious, and psychological needs of Jewish communities throughout the empire.[20] The use of art for such purposes, already surfacing in the third century,[21] became even more universal and intensive from the fourth century on owing to Christianity's newfound status and the hostile attitude of its spokespersons toward Jews and Judaism. Furthermore, Christianity's development of a symbolic art of its own undoubtedly served as a crucial factor in stimulating the appearance of a parallel feature among Jews. To illustrate this phenomenon more fully, we will examine the use of the menorah in this later period.

THE POPULARITY OF THE MENORAH
IN LATE ANTIQUITY

While the menorah's appearance in certain contexts may be interpreted as Temple- or synagogue-related, the overwhelming majority of instances display it as a symbol with no specific institutional context.

This symbolic dimension surfaced more or less simultaneously in third-century Rome and Bet She'arim.[22] It had once been assumed that the symbolic meaning of the menorah originated in the Diaspora on the presumption that its earliest appearance in large numbers was in the Roman catacombs of the first centuries CE. This assumption has since been discredited owing to the redating of these Jewish catacombs, which are now dated from the third to fifth centuries CE.[23]

The menorah's unrivaled popularity among the Jews of Late Antiquity in both the Diaspora and Palestine[24] is evidenced in a wide variety of contexts—mosaic floors, wall paintings, capitals, columns, ashlar stones, marble blocks, basins, house-

18. *Adv. Jud.* 1.1.844 (see also Meeks and Wilken, *Jews and Christians in Antioch*, 86).

19. See *Adv. Jud.* 1.5.851, 1.2.846, and 7.1.915; Wilken, *John Chrysostom and the Jews*, 75.

20. On Samaritan art in this regard, see the appendix below.

21. See chaps. 4–8.

22. See chap. 4.

23. See chap. 7; and Rutgers, *Jews in Late Ancient Rome*, 50–99.

24. See L. I. Levine, "History and Significance of the Menorah," 145–53; Elche, Saranda, and Andriake should now be added to the list of Diaspora sites featuring the menorah (see chap. 11).

hold objects, gold glass, lamps, sarcophagi, and tomb plaques. On occasion, it is represented as a three-dimensional and freestanding object, as in the synagogues of Sardis, Sidé, Tiberias, 'En Gedi, Ma'on, Susiya, and Eshtemoa.[25]

Moreover, the menorah is depicted in a broad range of styles. While the base is usually tripodal (although square and conical ones are also known), the legs are at times straight, rounded, or in the shape of animal paws. The branches are either simple or ornate, the latter presumably attempting to replicate the "flowers and knobs" mentioned in Exodus 25:33. They are usually rounded, although diagonal ones are also known; in some instances the branches extend horizontally from the main shaft, then either curve upward or take a sharp ninety-degree vertical turn. The branches usually terminate in a straight line, often connected by a bar. Lamps, at times depicted with flames, sometimes crown the tops of the branches.

As noted, the menorah might appear by itself or accompanied by other symbols. In Palestine, the frequency of its appearance alone is much greater (139 instances, as against 77 with other objects) than in the Diaspora, where the two numbers are almost on a par (126 versus 143, respectively).[26] Of the accompanying symbols, the shofar has the most frequent appearance in Palestine (69 times), followed by the *lulav* (52), *ethrog* (42), and incense shovel (25). By contrast, the *lulav* is by far the most recurrent accompanying symbol (84) in the Diaspora, followed by the *ethrog* (58) and shofar (41).[27] The incense shovel is never represented outside of Palestine.[28]

The widespread symbolic significance of the menorah (and to a lesser degree the other religious objects) at this time is a new development; there is no solid evidence prior to the third century that the menorah was so construed. If it were considered symbolic, then one would have expected to find its far greater usage in previous centuries. Its absence on coins from the two revolts, along with the rabbinic prohibition against its replication, seem to reflect a regard for the menorah's sanctity and its clear-cut Temple associations. The fact that such avoidance was subsequently almost totally eschewed throughout the Jewish world indicates that, despite earlier

25. We can only speculate as to why it was specifically the menorah that emerged as the central Jewish symbol. Its association with the Temple was undoubtedly a major factor, although other Temple-related objects (e.g., the altar and showbread table) were ignored. Choosing the menorah may also have been due to its unusual and attractive appearance, one that had already gained attention in Rome, as evidenced by its prominent appearance on the Arch of Titus. Finally, the menorah's association with the Tree of Life, and, above all, lights—for all its obvious symbolism on the Sabbath and festivals, as well as on Hanukkah—was certainly an appealing element as well. S. Sabar has suggested (personal communication) that the menorah's visual dimension, which was easy to depict graphically and was easily identifiable, may have been an additional factor in this object's popularity.

26. Hachlili, *Ancient Jewish Art and Archaeology—Diaspora*, 355. These numbers do not include the results of recent studies on the finds from Elche, Saranda, and Andriake.

27. The recent finds from Elche, Saranda, and Andriake include five *menorot*, two *shofarot*, two *ethrogim*, and a *lulav*.

28. See also M. Narkiss, "Snuff-Shovel."

reservations, forces had come into play from the third century on that dramatically altered this practice.

Most scholars attribute the ubiquity of the menorah in Jewish art at the time either to central Jewish ideas or beliefs that it presumably symbolized, or to the sociopsychological need for asserting the identity of either individual Jews (in a burial context) or entire Jewish communities (in a synagogue context). A sampling of scholarly opinions ascribes the following ideas or themes to the menorah: (1) messianism;[29] (2) God, the source of Torah and light;[30] (3) God and derivatively the tree of life, light, the saint, and the cosmos;[31] (4) the cosmos;[32] (5) eschatological associations (resurrection, immortality), heaven and the afterworld;[33] (6) redemption;[34] (7) messianic salvation, light, Jewish political and religious independence;[35] (8) affiliation and identification with the Jewish people;[36] (9) messianism, resurrection, a reminder of the Temple, a response to the emergence of Christian symbols;[37] (10) minority status;[38] (11) divine light, spirit of God, light of the Torah;[39] and (12) symbol of the Jewish people and its faith, distinguishing Jews from Christians, a reminder of the glory of the Temple and the hope for its renewal.[40]

In the absence of explicit contemporary literary sources relating to this issue, an attempt to pinpoint any one reason for the emergence of this symbol seems rather futile. Besides, the very essence of a symbol is that it is capable of eliciting a host of meanings—and this certainly seems no less true of the menorah. Its widespread appearance attests to a rich variety of associations that led Jews to invoke this object in their synagogues, cemeteries, and households. Therefore, instead of trying to posit one or more reasons for the menorah's popularity, it may be the better part of wisdom to try and elucidate the wider Byzantine context that provided the setting, opportunity, and, most importantly, need for the widespread use in Late Antiquity of Jewish symbols in general, and the menorah in particular.

Two contextual factors must be taken into consideration in trying to explain this phenomenon. Much has been written about the transition from Roman to Byzan-

29. Roth, "Messianic Symbols"; Barag, "*Menorah.*"

30. Goodenough, *Jewish Symbols*, 4:94–96.

31. M. Smith, "Image of God," 500–12.

32. Yarden, *Tree of Light*, 51–55.

33. Wirgin, "Menorah as Symbol of After Life"; Wirgin, "Menorah as Symbol of Judaism."

34. Namenyi, *Essence of Jewish Art*, 42–73.

35. Sperber, "History of the Menorah," 155.

36. Avigad, *Beth She'arim*, 3:268.

37. Barag, "*Menorah,*" 46.

38. Fine and Zuckerman, "Menorah as Symbol of Jewish Minority Status," 27; see also Strauss, "Jewish Art as a Minority Problem."

39. Klagsbald, "Menorah as Symbol," 130; see also Klagsbald, "La symbolique dans l'art juif," 424–38.

40. Hachlili, *Ancient Jewish Art and Archaeology—Israel*, 254–55; Hachlili, *Ancient Jewish Art and Archaeology—Diaspora*, 344.

tine art; some scholars point to a decline, others to continuity, and still others to a complex picture of evolution that defies any simple definition or categorization.[41] Elsner persuasively argues that the late empire witnessed a transition from a basically representational art to one featuring symbols with multiple meanings:[42]

> In essence, the imagery of official Roman religion has a literal and imitative relationship with its subject-matter and with religious practice, whereas the images of a mystery cult (such as Mithraism or pre-Constantinian Christianity) have a symbolic or exegetic relationship with what they represent. This difference between the art of official religion on the one hand and that of initiate cults on the other . . . is a fundamental conceptual breach, which has important consequences for post-Constantinian Christian art. This is because Christianity, an initiate cult *par excellence*, always produced a symbolic art (the art of the mystery cult) even when it replaced civic religion as the official cult of the empire.[43]

To phrase the matter in a more Platonic ("mimetic") mode, art generally had been intended to imitate sensory objects; descriptive scenes in pagan contexts were rarely meant to transmit religious truths.

Early traces of this transition are evidenced in Late Antique mystery cults such as third-century Mithraism (the ritual sacrifice of the bull), and in the images of Hercules in the Via Latina catacomb, possibly meant to symbolize man's striving for salvation.[44] Plotinus (205–270) was indeed reflecting his era (and perhaps influencing it as well) when he advocated downplaying physical reality (life in the "flesh" as a lower form of existence), and viewing reality with an introspective and metaphysical "inner eye."[45]

This process of freeing a representation from a particular historical context evolved even further in Byzantine Christianity. Biblical scenes were widely used to transmit Christian truths, often for their typological-symbolic meaning. Thus, Late Roman-Byzantine art can be characterized by an emerging emphasis on religious meaning.[46] With respect to iconography, however, the major change involved view-

41. Kitzinger, *Byzantine Art in the Making*, 7ff., 17; Mathews, *Clash of Gods*, passim. See also the seminal articles in Weitzmann, *Age of Spirituality: A Symposium*, which address this issue from a variety of perspectives.

42. Elsner, *Art and the Roman Viewer*, 190–245. See also Zanker (*Power of Images*, 335–39), who speaks of the art of the early empire as focusing on "pictoral vocabulary" (pp. 115–16) or "pictoral imagery" (p. 338).

43. Elsner, *Art and the Roman Viewer*, 190–91.

44. Ferrua, *Unknown Catacomb*, 130–41; Grabar, *Beginnings of Christian Art*, 228.

45. See, e.g., *Ennead* 5, 9; Wagner, "Plotinus"; O'Meara, *Plotinus*, 33–43. See also Panofsky, *Idea*, 25–32. On Plotinus and later Plotinian Neoplatonism, see Lamberton, *Homer the Theologian*, 83–143.

46. For other similarities or "analogous processes" among religions of Late Antiquity, Christianity, and the mystery cults in particular, see J. Z. Smith, *Drudgery Divine*, 85–143.

ing an image as a means rather than as an end. Christian images, thus, were intended to evoke an idea or a historical memory imbued with religious meaning. Whether the image was an insignificant object or a monumental and impressive piece of art, it was in truth geared to convey a message.[47]

The use of the menorah as a universal Jewish symbol must therefore be understood within the larger Late Roman and Byzantine-Christian contexts then coalescing. By the fourth century, the use of symbols was becoming more ubiquitous than ever before, and while Christianity spearheaded this development with all the imperial and ecclesiastical means at its disposal, Jews could hardly remain unaffected. It was in such a setting that the menorah became the most unique and impressive example of a Jewish religious object.

A second factor to be considered in trying to explain the popularity of the menorah among Jews is the dramatic emergence of the cross in the fourth century as the main symbol of Christianity. The introduction of the Chi-Rho monogram by Constantine in the early fourth century was indicative of the way Christian symbolism was to operate in the Byzantine setting. Having disassociated himself from his pagan roots, the emperor appropriated a symbol of the new religion with which he now identified, one that was intimately connected with its founder. Form now became subordinate to content, while doctrinal and didactic purposes reigned supreme. Iconography had become the handmaiden of theology, or, as formulated by Grabar: "Iconography rises here to the level of theological commentary."[48] If the relatively modest Christian art of the third century had already become inherently symbolic, by the fourth century and beyond this phenomenon—specifically the cross—had assumed grandiose and universal proportions.[49]

47. Grabar, *Christian Iconography*, xlvi, as well as the following passage—albeit from the eighth century but perhaps reflecting an earlier era as well—describing a church building and attributed to the Patriarch Germanus I:

> The church is heaven on earth. . . . It typifies the Crucifixion, the Burial and the Resurrection of Christ. . . . The conch is after the matter of the cave of Bethlehem.
> . . . The holy table is the place where Christ was buried, and on which is set forth the true bread from heaven, the mystic and bloodless sacrifice, i.e., Christ. . . . It is also the throne upon which God, who is borne up by the cherubim, has rested . . . The *ciborium* stands for the place where Christ was crucified. . . . The place of sacrifice is after the manner of Christ's tomb. . . . The *bema* is a place like a footstool and like a throne in which Christ, the universal King, presides together with His apostles. . . . The cornice denotes the holy order of the world. . . . (C. A. Mango, *Art of the Byzantine Empire*, 141–43)

48. Grabar, *Christian Iconography*, 144.

49. See also L'Orange, *Art Forms and Civic Life*, 21–33. This is not to say, of course, that symbolism was unknown in earlier pagan art—the Egyptian sundial, Athenian owl, and Roman eagle. Now, however, the move in this direction was to become much more pervasive and was made in the name of abstract religious concepts. See also Henig, *Handbook of Roman Art*, 234–48.

By the end of the fourth century the cross appeared everywhere—in Christian buildings, at burial sites, and in homes—and was worn by individuals as well. Its purpose was to serve as a reminder of Jesus, his message of redemption generally and his eschatological presence in particular; it also served an apotropaic purpose.[50] Witness John Chrysostom's late fourth-century paean to the cross:

> No imperial crown can adorn a head in such a manner as the cross, which is in all the world more prized. This thing had lately been the cause of horror to all, but now its image is so much sought after by all, that it is found everywhere, among virgins and matrons, among slaves and freemen. . . . One can see [the cross] celebrated everywhere, in houses, in marketplaces, in deserts, in streets, on mountains, in valleys, in hills, on the sea, in boats, on islands, on beds, on clothes, on weapons, in chambers, at banquets on silverware, on objects in gold, in pearls, in wall paintings, on the bodies of much-burdened animals, on bodies besieged by demons, in war, in peace, by day, by night, in parties of luxurious lovers, in brotherhoods of ascetics; so much do all now seek after this miraculous gift, this ineffable grave. (*Contra Judaeos et Gentiles* 9)

Not surprisingly, at about this time the cross was also becoming a central symbol in the Good Friday liturgy, first described by Egeria in her vivid account of the liturgical setting in Jerusalem.[51]

The widespread use of the menorah, in part as a Jewish response to the cross, is not simply a theoretical possibility. On a number of archaeological finds, we find that the menorah appears precisely where a cross would be depicted in a Christian context. For example, a menorah was incised on a chancel screen at Ḥammat Gader, as was a cross on a chancel screen at Masu'ot Yitzḥaq, and lamps were suspended from *menorot* in Na'aran, just as they were from a cross in North Africa (fig. 118). Crosses decorate Late Byzantine oil lamps, as well as glass jugs and jars from Jerusalem and elsewhere, in precisely the same place that *menorot* appear on these same objects.[52]

The Byzantine context thus looms large in accounting for the use of the menorah as a central Jewish symbol. Only in the fourth century, when Rome's territorial imperium was transformed into Constantinople's religious imperium, did religious identity become a paramount feature in contemporary art.[53] Within this ferment of

50. E. D. Maguire, *Art and Holy Powers*, 18–22. See also Lowrie, *Art in the Early Church*, 110–12.

51. Regan, "Veneration of the Cross," 2–7.

52. Israeli, *By the Light of the Menorah*, 139, 143; Barag, "Glass Pilgrim Vessels," 12 (1970): 35–63; 13 (1971): 45–63. See also Hachlili, "Aspects of Similarity and Diversity," 95. On the use of the menorah within a Christian setting in Late Antiquity, see Dulaey, "Le chandelier à sept branches."

53. Elsner, *Art and the Roman Viewer*, 244: "The incalculable importance of religion in this context is that it defines and frames the self-identity, the subjectivity, of its adherents. The

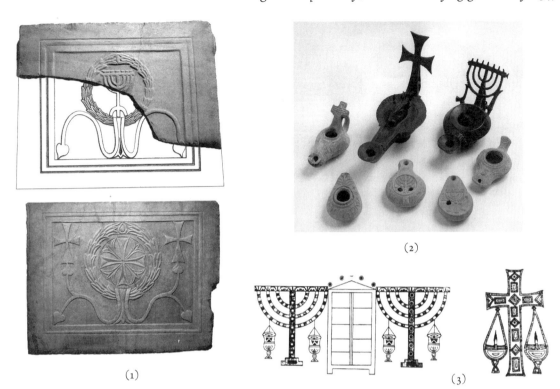

FIG. 118 Similar use of symbols: (1) Chancel screens
from Ḥammat Gader and Masu'ot Yitzḥaq; (2) lamps from Jerusalem;
(3) lamps suspended from a menorah and a cross.

changing perceptions, Jews throughout the empire made the transition from a local-
ized and occasional usage of symbols to a far more intensive and extensive one; in
the process, they also created other artistic expressions that served to bolster their
self-identity.

BIBLICAL DEPICTIONS

In addition to the widespread use of Jewish symbols, Jewish art in Late Antiq-
uity also focused on the past through images and scenes drawn from the Hebrew
Bible. The central role of Scriptures in shaping and consolidating Jewish ethnic,
cultural, and religious identity is reflected in a variety of literary genres from the
Persian through Greco-Roman eras: the retelling of biblical stories (Josephus, Ju-
bilees, *Liber Antiquitatum Biblicarum*); the interpretation of biblical narratives, laws,

advent of Christianity as the state cult brought with it a nigh-inconceivable transformation
in the self-identity of the subjects of the Roman state." On the wider pagan and Christian
contexts for the increased usage of religious symbols in Late Antiquity, see Fraade, "Temple
as a Marker of Jewish Identity," 257–65.

and prophesies (Philo, Qumran *pesharim*); the composition of plays, poems, and novels based on biblical accounts (Eupolemus, Artapanus, Ezekiel the Tragedian, and others); the regular recitation of scriptural readings and their exposition in synagogue liturgy; and more.[54] A myriad of talmudic discussions in the Yerushalmi and especially the Bavli address biblical stories, and more than a score of aggadic *midrashim* produced in Palestine and elsewhere from the fifth century CE on revolve almost exclusively around the Bible. While most *piyyutim* addressed the weekly Torah readings and the holidays, the foundations of the mystical Hekhalot experience were based on the visions of Isaiah and Ezekiel and apocalyptic compositions (such as the Apocalypse of Zerubbabel) drew their inspiration from eschatologically oriented biblical sources.

Artistic representations of the Jewish past focused exclusively on biblical themes, either via representations of individual figures or depictions of biblical episodes.

Biblical Figures

In a number of instances, primarily from Byzantine Palestine, we find the depiction of biblical figures in no specific narrative context. David appears on three occasions in synagogues of Palestine and the Diaspora. In one such depiction, in the western section of the nave in the Gaza synagogue dating to 508–9 CE, the figure is clearly identified by the Hebrew caption "David" (דויד) and exhibits the combined traits of a royal personage and musician (see chap. 14, fig. 98). On the one hand, he sits on a throne with accompanying footstool and cushion, dons what appears to be a crown, and wears imperial Byzantine robes; on the other, he plays a harp and is portrayed *en face* before a group of animals, including a lion cub with a bowed head, a coiled snake, and a giraffe.[55] Given the garb, the animals, and the lyre, David is clearly likened to Orpheus, who tamed beasts with his mesmerizing music.[56] This mosaic depiction thus synthesizes two iconographic traditions, of King David and Orpheus;[57] the crown-halo would fit both. In chapter 11 we raised the intriguing question of whether the identification of David with Orpheus in the Gaza synagogue is a superficial association (both were poets and singers) or represents a deeper messianic-eschatological tie. Our severely limited knowledge of the Jew-

54. See, inter alia, the following collections of sources, studies, and summaries: Charlesworth, *Old Testament Pseudepigrapha*; M. Stone, *Jewish Writings of the Second Temple Period*; Kraft and Nickelsburg, *Early Judaism and Its Modern Interpreters*; Mulder, *Mikra*; L. I. Levine, *Ancient Synagogue*, 146–62, 536–40, 577–83.

55. A. Ovadiah, "Excavations in the Area of the Ancient Synagogue at Gaza"; A. Ovadiah, "Synagogue at Gaza"; Hachlili, *Ancient Jewish Art and Archaeology — Israel*, 297.

56. Goodenough, *Jewish Symbols*, 9:89–104; Barasch, *Imago Hominis*, 169–71. On the depictions of Orpheus from the Byzantine era (including Palestine), see the articles of A. Ovadiah, "Orpheus from Jerusalem" and "Orpheus Mosaics"; as well as Strzygowski, "Das neugefundene Orpheus-Mosaik."

57. Barasch, "David Mosaic of Gaza."

ish community and its surroundings in sixth-century Gaza cautions us from being overly speculative.[58]

A similar depiction of David was discovered decades earlier in the lower central panel above the Torah shrine in the Dura synagogue (see chap. 5, fig. 50).[59] In contrast to Gaza, the figure is unidentified and depicted as a musician wearing a Phrygian cap and Persian royal garb while playing a lyre. Before him are a lion and several other animals (possibly birds, ducks, and monkeys). There is little question that here, too, the figure of Orpheus was used to represent David.[60] Unlike Gaza, however, the Dura representation bears no trace of an imperial motif.

A third figure often identified as David was discovered in the Merot synagogue in the Upper Galilee, about four miles northeast of Safed (see chap. 14, fig. 98). Appearing on a fragmentary panel of a mosaic floor measuring 1.70 by 2.15 meters and dating to the mid-fifth century,[61] the mosaic depicts a young redheaded man wearing a short white tunic with long sleeves; a red cloak (*sagum*) covers his left shoulder and is fastened above his right shoulder with a pin (*fibula*). He is surrounded by several large objects, including an elliptical shield, a helmet, and a long sword (*spatha*). To the left of the figure is a short Aramaic inscription reading: "Yudan bar Shimon *mny*."

The inscription is enigmatic on a number of counts. First and foremost, who was Yudan—the artist, the donor, or the figure represented? Secondly, what does the word *mny* mean? Was it an abbreviation of a personal name (Menaḥem?), a family name, or perhaps the title of a functionary? Does it simply mean "appointee," or might it refer to a sum of money presumably contributed to the synagogue?

The general consensus identifies the figure as that of David, owing to his red hair, his arguable military garb, and the oversized weapons surrounding him (purportedly those of Goliath after their encounter—1 Sam. 17:4-7, 45-54). It has been further suggested that the remains of an elliptical design in front of the figure be identified as a lyre or some other stringed instrument, which would strengthen the identification of the figure with David—as would the fact that, according to one in-

58. See, however, Barasch's attempt to map out such a context (ibid.). On Gaza as a religious and cultural center in the fourth to sixth centuries, see the illuminating collection of studies in Bitton-Ashkelony and Kofsky, *Christian Gaza in Late Antiquity*.

59. Kraeling, *The Synagogue*, 223-25; see also H. Stern, "Orpheus in the Synagogue of Dura-Europos." Kraeling (*The Synagogue*, n. 885), and in greater detail Goodenough (*Jewish Symbols*, 2:19-20 and vol. 3, no. 752), note, inter alia, R. Eisler's claim to have seen the depiction of a man, a lyre, and an animal in the Roman catacomb on the Via Appia (also referred to as Vigna Randanini). Whether or not this is related to our discussion is unclear, as the depiction has since disappeared.

60. On the appearance of Orpheus in earlier Jewish writings from the Diaspora, see Goodenough, *Jewish Symbols*, 9:89-104; Barasch, "David Mosaic of Gaza," 14-15.

61. Z. Ilan, "Synagogue and Study House at Meroth." See also Hachlili, *Ancient Jewish Art and Archaeology—Israel*, 299.

terpretation, he is wearing a crown. A connection with Orpheus may also be drawn from the figure's seated posture.[62]

Depictions of another biblical figure, Daniel, appear in perhaps three Palestinian synagogues, two of which are in an extremely fragmentary state (see chap. 14, fig. 99), and in Sardis. He is clearly represented in the sixth-century synagogue of Na'aran and most probably in the Susiya synagogue as well.[63] In the former, the figure of Daniel is depicted in the panel nearest the *bima* and next to the zodiac, devoted basically to a display of religious objects; his arms are raised in an *orans* position as he stands between two animals (probably lions). An accompanying inscription, "Daniel Shalom," clinches this identification.[64] In the western panel of the Susiya synagogue, only the last two letters of the name "[Dani]el" have been preserved, together with very partial remains of a hand and two animals (lions?). This depiction, too, has been generally accepted as representing biblical Daniel in the lions' den. The third instance, however, is more problematic. A well-preserved stone relief from 'En Semsem in the Golan (identified as one of the bases of a Torah shrine) depicts a figure with raised hands of exaggerated size standing frontally between two lions (sometimes interpreted as a lion and lioness suckling her cub) and beside two eagles.[65] This, too, may be a rendition of Daniel in the lions' den, although some of the details (the suckling lioness and the eagles) do not fit the usual Daniel scheme.[66]

The Daniel depictions resemble those found in Christian art from the third through sixth centuries. Often portrayed as nude and beardless, the Christian Daniel stands in a similar *orans* pose with his arms raised in prayer. Lions, usually in a heraldic posture, flank him on either side. Daniel was significant to Christians for a number of reasons: his prophetic-messianic predictions of the coming of Jesus or the end of the Roman Empire; his brave defiance of the social order demanding that he reject his faith, in which he is a prototype of the Christian martyr; his

62. Other suggestions identify this figure as an ordinary soldier or a person of high status displaying his weaponry. Although somewhat implausible, it has also been suggested that the scene be understood in light of the messianic message of Isa. 65:25 appearing in another room of the synagogue complex. The Davidic scene, then, might be explained as an expression of messianic hope for redemption; see Mucznik, Ovadiah, and Gomez de Silva, "Meroth Mosaic Reconsidered," 286–90; and comments in chap. 18.

63. Hachlili, *Ancient Jewish Art and Archaeology—Israel*, 294–95; Z. Yeivin, "Susiya, Khirbet," 1419.

64. Fine interprets the figure of Daniel in the *orans* posture before the ark as reflecting a Jewish prayer posture that was assumed by a prayer leader who may have stood near the depiction in the synagogue's nave (*Art and Judaism*, 193).

65. Ibid., 95, figs. 37–38. This suggestion was made several decades earlier by Z. Ma'oz, though with some reservations; see his "Art and Architecture," 111–12.

66. Hachlili, *Ancient Jewish Art and Archaeology—Israel*, 321–23. On the depiction of Daniel recently discovered at Sardis, see chap. 15.

escape from death in order to be resurrected, in which he is a prototype of a newly baptized Christian or even of Jesus himself.[67] The implications of the Daniel depiction in a Jewish context are less certain, but have been interpreted as a prayer for salvation, perhaps in light of the more difficult circumstances facing Jews in sixth-century Byzantium.

Biblical Scenes

Scenes from the Hebrew Bible[68] are considered the more impressive type of artistic expression referring to the Jewish past. Dura, of course, stands alone in the richness and variety of its depictions.[69] As noted above, no other Diaspora synagogue—with the exception of the recently discovered Daniel and the lions depiction in Sardis[70]—bears any sort of biblical representation, much less a repertoire even remotely resembling the extraordinary Duran example.[71]

The earliest discovery of a biblical scene in Byzantine Palestine was at Bet Alpha in the Jezreel Valley (see chap. 14, fig. 97);[72] the richest concentration of biblical scenes from a Palestinian synagogue was found in Sepphoris (see chap. 13, figs. 93

67. R. M. Jensen, *Understanding Early Christian Art*, 174–75, 177–78. On the *orans* figure in early Christian art, see ibid., 35–37.

68. In addition to the representation of biblical themes in synagogues, many amulets of alleged Jewish origin also display biblical themes, such as Daniel, the 'Aqedah, Jonah, and Solomon. See Goodenough, *Jewish Symbols*, 2:222–35.

69. See chap. 5.

70. See chap. 15.

71. On the Gerasa synagogue as belonging to the Palestinian orbit, see chap. 11. It is doubtful whether the Ḥammam Lif (Naro) mosaic from North Africa was meant to portray the Creation, as has been suggested; see Biebel, "Mosaics of Hammam Lif"; Goodenough, *Jewish Symbols*, 2:89–100; Hachlili, *Ancient Jewish Art and Archaeology—Diaspora*, 207–9; Bleiberg, *Tree of Paradise*, 24–35. Similar marine scenes were a familiar phenomenon in North African mosaics at the time; see Dunbabin, *Mosaics of Roman North Africa*, s.v. "marine scenes," and comment on p. 195: "Here too there is an adaptation of the stock current motifs, with the addition only of the indispensable sacred symbols, rather than the invention of something new."

Mention must be made of the intriguing appearance of Noah and his wife on early third-century coins from Apamea in Phrygia; see Schürer, *History*, 3/1:28–30; Ramsay, *Cities and Bishoprics of Phrygia*, 2:667–72; Grabar, "Images bibliques." However, these coins have no known connection with a Jewish community.

A fourth- to fifth-century mosaic floor discovered in Mopsuestia (Asia Minor) depicts Noah's ark surrounded by two rows of animals. Nearby, the story of Samson is portrayed in nine sequential scenes. Whether this mosaic derives from a Jewish or Christian context remains unresolved; see Kitzinger, "Observations on the Samson Floor"; Avi-Yonah, "Mosaics of Mopsuestia." In June 2012, a mosaic depiction of Samson was found in a fifth-century (?) synagogue in Ḥuqoq (Galilee) (Jodi Magness, personal communication).

72. See chap. 14.

and 95),[73] which has preserved two very distinct and different types of such scenes.[74] The first focuses on Abraham and features the visit of the angels promising him a son and then the *'Aqedah* narrative, the latter having been largely obliterated.[75] The second depicts the Wilderness Tabernacle, featuring Aaron officiating at the altar surrounded by a series of cultic objects associated with the Tabernacle's consecration.

The remains from Gerasa were found in the vestibule at the eastern end of the sanctuary, which was originally covered with a mosaic pavement containing the familiar cluster of Jewish symbols (menorah, *lulav*, *ethrog*, shofar, and incense shovel), a Greek inscription surrounded by animals (probably lions), and a scene from the Noah story. The last includes a depiction of animals exiting the ark; to its left are the heads of two young men—Noah's sons Shem and Japhet (whose names appear in Greek)—as well as a dove carrying an olive branch in its beak. The Greek inscription flanking the menorah reads: "To the most holy place, Amen, Selah. Peace upon the congregation."

The identification of the above-noted biblical scenes is generally not a problem, as each scene is readily recognizable either by the depictions themselves (the *'Aqedah*) or by an identifying inscription. The greater challenge, however, is trying to understand what the artisan/donors/congregation intended to convey by displaying a particular scene or scenes. Many scholars assumed at first that such scenes were for decorative purposes only and simply reflected the tastes of those who determined their inclusion.[76] Others posited that such representations convey a religious message but differ as to their precise content. The many attempts noted in earlier chapters to decipher the Dura paintings, the Sepphoris and Bet Alpha mosaics, and the zodiac motif all attest to the tenuousness of such an exercise.

The immediate stimulus that gave rise to the widespread visual display of biblical motifs in Jewish art at this time is undoubtedly related to a synchronic factor, which in this case refers to Christian art generally and its biblical component in particular. As with the introduction of Jewish symbols, the earliest evidence of receptivity to this type of art among some Jewish communities was already apparent in third-century Dura Europos and third- to fourth-century Khirbet Ḥamam. Only in the fifth and sixth centuries, however, long after their widespread adoption in Christian circles, was there a far greater use of biblical motifs among Jews.

It is important to note that while biblical motifs in Christian settings were ubiquitous throughout the Byzantine world, their appearance in the immediate area of Palestine and Jordan is extremely limited. On the one hand, there are more Jewish

73. See chap. 13.

74. For a detailed discussion of these registers, see Weiss, *Sepphoris Synagogue*, and above, chap. 13.

75. Another *'Aqedah* depiction, though quite different, is found in a Dura fresco (Kraeling, *The Synagogue*, 125–33). See chap. 5.

76. So, e.g., H. Strauss, "Jüdische Quellen frühchristlicher Kunst"; A. Ovadiah, "Art of the Ancient Synagogues."

than Christian instances of such art (even though there are almost six times more churches than synagogues in the region, including Jordan).[77] However, this should be understood in light of the fact that we are dealing here primarily with mosaic floors and that Christians in the region, as elsewhere in the empire, may have made greater use of wall mosaics and frescoes for biblical themes than the Jews. Whatever the case, the very fact that biblically related art was a new direction in which a number of Jewish communities chose to express themselves merits attention, and the Christian factor here cannot be ignored.

Thus, there can be little question as to the role of Christian art in shaping Jewish art, whether in the use of symbols or the depiction of biblical motifs (both narrative scenes and individual figures). Given the overall nature of Christian society in which the above Jewish themes flourished, one may inquire as to the actual dynamics that took place between Christian and Jewish art at this time. A minimalist position would suggest that Jews were merely copying motifs from their surroundings, whether for aesthetic or religious purposes. A maximalist approach would claim that this art, at least from the Jewish perspective, bears witness to an ongoing anti-Christian polemic—an approach that allegedly finds expression in the literary realm as well.[78]

Nevertheless, each of the above positions seems rather extreme. On the one hand, to label Jewish art as being largely in imitation of Christian art, whether with regard to biblical motifs or religious symbols, ignores the unique religious content and significance of these depictions for Jews, as well as the fact that these themes are also asserted and affirmed by literary sources. On the other hand, the sweeping assumption that the art facilitated Jewish claims in the context of a vibrant Jewish-Christian polemic at the time lacks any serious documentation. The incessant attack of church fathers and others on the Jews throughout these centuries is well documented,[79] but we have precious little evidence for such polemics on the Jewish side.[80] Nevertheless, this approach has found not a few adherents over the last generation or so, and we will address this issue more fully in the next chapter.

Another, more moderate approach regarding the significance of Jewish art at this time seems preferable. The Jews' main motivation in their art was neither decorative nor polemical. Rather, by adopting biblical artistic expressions from the wider

77. Piccirillo, *Mosaics of Jordan*, 15–40; Tsafrir, Di Segni, and Green, *Tabula Imperii Romani: Judaea Palaestina*, 19; Hachlili, *Ancient Mosaic Pavements*, 226–28; Habas, "Byzantine Churches of *Provincia Arabia*," 1.

78. See chap. 18.

79. See chap. 9.

80. I am defining *polemics* as some sort of systematic and sustained Jewish attack on or response to Christianity, in contradistinction to a brief derogatory statement of a random Christian belief, most often noted en passant. Behind these claims of a Jewish polemic, whether via the literary or material channel, is the assumption that the Jews were neither passive nor compliant during the stressful circumstances of Late Antiquity, but were actively engaged in attacking their opponents or justifying their claims regarding controversial issues.

Christian society, Jews were able to express feelings and hopes arising from their radically new circumstances. In the face of the growing presence and pressures of Christianity and the concomitant hostility, Jewish feelings of pride and fear, hope and despair, memory of the past and thoughts of a better future were bound to surface. Moreover, such art also afforded them a means to bolster their self-esteem and reassert their unique self-identity. Jewish art was not necessarily bound to an external or polemical intent; stemming for the most part from rural settings (at least what has been discovered to date), it is likely that the community was more concerned with its own internal Jewish agenda, whether for educational purposes or as a means to foster pride in its religious-historical heritage.

We should remember that Jewish art changed dramatically over the course of the Hasmonean and Herodian eras, when it adopted a range of foreign motifs while distancing itself from figural art. When the Jews embraced a rigorous aniconic policy in the second century BCE, there is no reason to assume that it was for polemical purposes; rather, it was a way to reassert Jewish distinctiveness. At that time, a balance of sorts was struck between the absorption of Hellenistic norms and the expressions of Jewish self-identity. This, we are suggesting, was most likely the case in Late Antiquity as well.

SYNAGOGUE SANCTITY

The two developments discussed in some detail up to now—the widespread use of a small but diverse repertoire of Jewish symbols throughout the Jewish world of Late Antiquity, together with the appearance of biblical scenes—are among the most compelling testimonies for the newly emerging religious status of the ancient synagogue. While earlier Second Temple synagogues (Masada, Herodium, Gamla, Qiryat Sefer, Delos, Cyrene, Ostia [?], and the Egyptian *proseuche*) bore very few indications of sacrality, either in their artistic, epigraphic, or architectural dimensions,[81] matters were quite different by Late Antiquity. Beginning with Dura and continuing in subsequent centuries with remarkable gusto, the sacred dimension of the synagogue found a variety of expressions. Explicit statements of this new status are especially evident in epigraphic and Roman sources.

Inscriptions.[82] A considerable number of inscriptions from this period refer to the synagogue as a "holy place" (אתרה קדישה or *hagios topos*) and to the community as a "holy congregation" (קהילה קדישה or *ḥavurah*, "holy association" (חבורתה קדישה). References to a "holy place" appear in synagogues throughout Byzantine Palestine in Ḥammat Tiberias (twice), Naʿaran (four times), Kefar Ḥananiah, Ashkelon, and Gaza, and references to "the most holy [place]" in Gaza and Gerasa. Inscriptions

81. For some evidence of Diaspora synagogue sacrality in the first century CE, see L. I. Levine, *Ancient Synagogue*, 169–73; Goodman, "Sacred Space," 2–6: Fine, *This Holy Place*, 25–33.

82. References to what follows can be found in L. I. Levine, *Ancient Synagogue*, 238–39; as well as in Naveh, *On Stone and Mosaic*, passim; and Roth-Gerson, *Greek Inscriptions*, passim.

from Bet Shean, Jericho, and Susiya mention "a holy congregation (or community)." The term "the language of the holy house" (לישן בית קודשא) occurs frequently in Targum Pseudo-Jonathan and may refer to the language used in the synagogue setting, while in the same *targum* on Leviticus 26:1 it is the synagogue that almost assuredly is referred to as a sanctuary.

Roman law. The synagogue's religious status is first articulated in the fourth century, in Byzantine imperial legislation. Valentinian I (ca. 370 CE) refers to the synagogue as a *religionum loca* when prohibiting soldiers from seizing quarters there,[83] and another seven edicts issued over the next half century were intended to protect synagogues from violence, arson, spoliation, seizure, and conversion into churches.[84]

Additional evidence attesting to synagogue sacrality has been suggested, including some factors that may have contributed to this status (and not merely reflect it). The following phenomena should be considered:

Orientation.[85] The practice of orienting a synagogue toward Jerusalem held true for both the Diaspora and Palestine. The Dura Europos and Gerasa synagogues faced west; Apamea south; Delos, Priene, Aegina, Stobi, Sardis, Ostia, and Naro east or southeast. Such was the norm in Roman Palestine as well: Galilean synagogues faced south; those in the southern part of the country north; and those in the southern coastal plain (Shephelah) northeast.[86]

There can be no better example of the assertion of Jewish particularism vis-à-vis other religious groups than orientation. Religious buildings in antiquity generally faced eastward, toward the rising sun, and this was as true of pagan temples and of Christian churches.[87] In fact, early Jewish tradition adopted this practice for both the Wilderness Tabernacle and the two Jerusalem Temples. However, sometime in the Second Temple era such obvious parallels with pagan worship were deemed problematic, and a ceremony was allegedly introduced into the Temple ritual on the festival of Sukkot to distinguish between the pagan and Jewish practice regarding orientation.[88]

Thus, a synagogue's orientation toward Jerusalem was a powerful statement of its religious and ethnic distinctiveness, and reflects profound changes transpiring within the Jewish community and its synagogues in the Late Roman and Early Byzantine periods. No longer was this main Jewish communal institution a neutral

83. CT 7.8.2 (Linder, *Jews in Roman Imperial Legislation*, 161–63).

84. See Linder, "Legal Status of the Jews," 156.

85. Regarding the proper understanding of the term *orientation* in connection with the ancient synagogue, see L. I. Levine, *Ancient Synagogue*, 326–28.

86. Nevertheless, there are some interesting cases of deviation among the many scores of Palestinian synagogues; see ibid., 327–29.

87. Stillwell, "Siting of Classical Greek Temples"; Vogel, "*Sol aequinoctialis*"; Vogel, "L'orientation vers l'est"; and the *Apostolic Constitutions* 2.57. Regarding Greek temples, cf. the remarks in Herbert, "Orientation of Greek Temples."

88. M Sukkah 5, 4.

gathering place, as were the earlier first-century Judaean synagogue buildings; it was now imbued with religious overtones and symbolism. Orientation expressed an attachment to Jerusalem and the Temple, a sentiment that flowed primarily from internal ethnic and historical considerations that apparently had assumed greater importance and urgency among Jews in Late Antiquity.[89]

Interior design and the Torah ark. The appearance of *bimot*, apses, and niches as fixtures in most later synagogues was probably not merely an architectural addition copied from Byzantine models[90] but seems to have reflected the more significant change that accorded the Torah ark a permanent and prominent status within the synagogue hall. Although the custom of reading Scriptures had been the central liturgical element of Sabbath services in both Judaea and the Diaspora in the Second Temple era, the Torah scrolls, to the best of our knowledge, were kept elsewhere and introduced into the assembly hall only at an appointed time. This arrangement, however, began to change in the latter part of the Roman period (for example, in Dura), and by the Byzantine era the presence of a permanent Torah shrine in synagogues had become the norm; the ubiquitous appearance of *bimot*, apses, and niches from the third and fourth centuries on clearly indicates this new reality. Located along the Jerusalem-oriented wall, the Torah shrine shared in the emerging emphasis on orientation and undoubtedly even enhanced it.[91]

The permanent presence of Torah scrolls played an important role in according the synagogue a heightened sanctity, and this is dramatically attested in one of John Chrysostom's diatribes against the Judaizing Christians in his church in Antioch:

> But since there are some who consider the synagogue to be a holy place, we must say a few things to them as well. Why do you revere this place when you should disdain it, despise it and avoid it? "The Law and the books of the prophets can be found there," you say. What of it? You say, "Is it not the case that the books make the place holy?" Certainly not! This is the reason I especially hate the synagogue and avoid it, that they have the prophets but do not believe

89. Alternatively, the change in synagogue orientation may have stemmed from the introduction of communal prayer, and especially the *'Amidah*, which required facing Jerusalem. While it is not difficult to determine when communal prayer first crystallized within rabbinic circles (i.e., the late first to third centuries; see L. I. Levine, *Ancient Synagogue*, 540–58, 570–77), it is impossible to gauge when local synagogues in Palestine and the Diaspora adopted this liturgy and its prescriptions.

90. Hachlili, *Ancient Jewish Art and Archaeology—Israel*, 166–95; Hachlili, *Ancient Jewish Art and Archaeology—Diaspora*, 67–84; Hachlili, *Ancient Mosaic Pavements*, 22–33; L. I. Levine, *Ancient Synagogue*, 343–60.

91. See E. M. Meyers, "Torah Shrine." Amoraic literature's preference for *'aron*, and not the earlier *tevah*, when referring to the Torah chest may be indicative of this change. The term *'aron* carries with it very clear associations with the biblical ark containing the tablets with the Ten Commandments that was placed in the holiest precinct inside the Tabernacle and then in the First Temple. Later on, in the eighth century CE, the Karaites attacked the Rabbanites precisely because of this association; see Lieberman, *Midreshei Teiman*, 25.

in them, that they read these books but do not accept their testimonies. . . . Therefore stay away from their gatherings and from their synagogues and do not praise the synagogue on account of its books.[92]

Despite the poignant evidence of this late fourth-century text, it nevertheless remains unclear just how pivotal a factor the presence of scrolls was in creating synagogue sanctity.

The Temple model. Another component of synagogue sanctity may have resulted from an increased association of the institution with the Jerusalem Temple. The artistic evidence in this regard is mixed: as noted, some symbols clearly refer to the Temple, while others can easily, and perhaps more compellingly, be interpreted as reflecting the local synagogue setting.

Other evidence in this regard is more questionable. For instance, were the chancel screens that appear in a number of synagogues intended to be a replica of the Jerusalem Temple barrier and thus point to synagogue sanctity?[93] Are the half dozen synagogue inscriptions listing the priestly courses intended to highlight an earlier Temple reality or, perhaps, the growing importance of the priestly class in Late Antique Galilee? The same issues hold true regarding amulets found buried on synagogue premises;[94] did the use of such objects contribute to the emerging sacrality of the building, or were they a result of this new status? The rabbis, for their part, incorporated Temple-related prayers and Torah readings into their liturgy,[95] and *piyyutim* centering on the Ninth of Av bemoan the Temple's loss. But once again, whether these liturgical innovations effected synagogue sanctity or merely reflected an already crystallized reality is difficult to determine. Or, as is often the case, perhaps both these factors played a role.

The role of the rabbis in the emerging sacrality of the synagogue is equally unclear, as the evidence is not of one hue. On the one hand, a number of rabbinic traditions, beginning with the Mishnah, promote the notion that the synagogue had a distinct and holy dimension, often contrary to popular views that advocated a more distinctly communal and neutral conception of the institution.[96] On the other, not all sages were comfortable with the idea that the synagogue and its practices should resemble those of the Temple too closely.[97]

92. John Chrysostom, *Homily* 1.5, trans. in Meeks and Wilken, *Jews and Christians in Antioch*, 94–96. In the town of Mago in Minorca, the local synagogue purportedly possessed "silver" vessels and "sacred books," as reported by Severus, bishop of Minorca, in his *Epistula Severi* 9–10 (PL 41, 924–25).

93. As suggested by Branham, "Sacred Space"; Branham, "Vicarious Sacrality."

94. See Naveh and Shaked, *Amulets and Magical Bowls*; Naveh and Shaked, *Magic Spells and Formulae*; Schiffman and Swartz, *Hebrew and Aramaic Incantation Texts*.

95. L. I. Levine, *Ancient Synagogue*, 198–200.

96. See, e.g., M Megillah 3, 1–3; T Megillah 2, 16, p. 352; 3, 21–22, pp. 359–60. See L. I. Levine, *Ancient Synagogue*, 192–206; Fine, *This Holy Place*, 35–59.

97. See n. 6.

Thus, while there was a general consensus within rabbinic circles regarding the synagogue's sanctity, there was less agreement as to the precise nature of this sanctity expressed, inter alia, by the extent of its identification with the Temple. In what appears to be a quintessentially elegant formulation reflecting the ambiguity of the synagogue's status, as well as the ambivalence in identifying it with the Temple, at least one rabbi, third-century R. Samuel b. R. Isaac, defined the synagogue as a מקדש מעט, a diminished or small sanctuary.[98] The synagogue was indeed something sacred, "Temple-like," but it was only a replica whose status was not to be confused with that of the Jerusalem Temple itself. In reality, it was diminished (מעט), something less than the Temple, not quite as sacred, not quite as special.

The issue of holiness engaged many Jewish communities of Late Antiquity. Steps were being taken in a number of locales to steer the synagogue toward what appears to be an unreserved status of sanctification, and it is in third-century Dura that we witness the first indications of this process as manifested in the building's orientation, presence of sacred objects (first and foremost the Torah scrolls), and plethora of biblical scenes. Thus, from the elements enumerated above—orientation, permanent presence of Torah scroll in the synagogue hall, and suggested connection between the synagogue and the Temple— taken together with the artistic data discussed earlier in this chapter (religious symbols and biblical scenes), it would appear that matters of sanctity were becoming widespread, if not universal.

Despite the various engaging suggestions offered heretofore in trying to explain this transformation of the synagogue from a neutral communal institution into one with an increasingly distinct religious stamp (expressed in its external physical aspects and its internal liturgical components, which now included the institutionalization of public prayer), little consensus has been reached. On the basis of the available sources, it is well nigh impossible to ascertain which factor or combination of factors was pivotal in the synagogue's transformation in status.[99]

However, all the above explanations have been primarily internal diachronic considerations. In other words, what in Jewish life and tradition might have led to this change? As suggested elsewhere,[100] what appears no less crucial, and perhaps even decisive in this regard, is the synchronic dimension. Sanctity was becoming a key value in Late Roman and Christian society that found expression in persons, objects, and places, and was often ascribed to churches through their identification with the Jerusalem Temple. Eusebius refers to the Church of the Holy Sepulchre as a "New Jerusalem" and a "temple" (ναός), and he applied the latter designation

98. B Megillah 29a, citing Ezek. 11:16. This is the correct reading following MS Munich and other manuscripts (e.g., British Library—Harley 5508 [400]; Columbia X893—T 141; Göttingen 3), and not the Vilna printed edition; see Rabinowitz, *Diqduqei Soferim*, loc. cit.

99. See also Newman, *Ma'asim*, 52–57, 211–19.

100. L. I. Levine, *Ancient Synagogue*, 242–49.

to the church built in Tyre ("a temple of God").[101] It is reported that upon completion of his magnificent Hagia Sophia edifice in Constantinople in the sixth century, Justinian declared: "Solomon, I have outdone you!"[102]

In light of these developments, especially within Christendom during the Byzantine era, it seems quite clear that this sociopolitical context may well have been at least as significant a factor in the creation of "diminished sanctuaries" as any. The degree of the synagogue's association with Jerusalem and its Temple[103] parallels similar Christian assertions. Thus, the association of the synagogue with the Temple, Jerusalem, and the idea of holiness was a process that commenced even before Constantine (as evidenced in rabbinic sources) but, in fact, gained enormous impetus during the Byzantine era, particularly under Christianity's stimulus.[104]

This chapter has focused on two related phenomena of Late Antiquity—the religious artistic dimension (that is, the widespread use of Jewish symbols and biblical motifs) on the one hand, and the transformation of the synagogue into a religious institution par excellence on the other. Just as the use of architectural models, symbols, and biblical motifs by the Jews of Late Antiquity reflects Byzantine practices,[105] so too the attribution of holiness to the synagogue cannot be divorced from the regnant Christian milieu. Both art and institutional sanctity served as a means to strengthen group identity and became hallmarks of this period for both Christians and Jews.

We have come to appreciate the extensive degree of Jewish-Christian interaction in all walks of life during this period, whether hostile or supportive, destructive or fructifying. Within the synagogue context, especially its artistic expression, the synchronic dimension was clearly a crucial factor in accounting for these developments.

101. Eusebius, *Vita Constan.* 3.33, 36, 45; Eusebius, *Eccles. Hist.* 10.4.1–3, 25, 69. Regarding the use of ναός for other churches, see Eusebius, *Vita Constan.* 3.45; and for references to "holy place" with regard to the church on Mount Nebo and twenty or so other sites in Byzantine Palestine, see Piccirillo and Alliata, *Mount Nebo*, 1:36, 51.

102. See also Wilken, *Land Called Holy*, 93; as well as C. A. Mango, *Art of the Byzantine Empire*, 72–78. A Syriac hymn notes that the cathedral of Edessa was compared to the Wilderness Tabernacle built by Bezalel; see C. A. Mango, *Art of the Byzantine Empire*, 57.

103. B. Narkiss, "Image of Jerusalem in Art."

104. It should be emphasized that we are speaking of *increased* usage; all of the themes that became prominent in the Byzantine period (sanctity of the synagogue, representation of the Temple-related motifs, use of religious symbolism, etc.) had already surfaced earlier in one form or another. In this respect, then, S. Schwartz may have overemphasized the extent of Christianity's impact on the Byzantine synagogue, not to speak of its influence on the community and its religious life; see his *Imperialism and Jewish Society*, 179–202. See also Goodman, "Sacred Space," 9–16.

105. See, e.g., Foerster, "Art and Architecture"; Foerster, "Synagogue Inscriptions"; Tsafrir, "Byzantine Setting."

APPENDIX

Commonalities and Differences
in Samaritan and Jewish Art

The material culture of the Samaritans is far from abundant, yet the remains of several impressively decorated synagogues have been discovered, as well as many amulets, sarcophagi, and decorated lamps.[106] Emerging in Late Antiquity, precisely at the same time that Jewish art began flourishing (this is especially true of the synagogue mosaic floors dating from the late fourth and early fifth centuries), these Samaritan remains have many affinities to their Jewish counterparts but, nonetheless, a number of quite notable differences as well.[107]

Much of Samaritan art was devoted to neutral themes—geometrical and floral motifs as well as agricultural and everyday objects (grain, pomegranates, a wine press, cups, amphorae, and so on). On several occasions, however (and especially in the two relatively well-preserved synagogues at el-Khirbe and Khirbet Samara—see below), the facade of a building is depicted in an exquisite and detailed fashion.

What makes Samaritan art so unique in comparison to its Jewish counterpart is its strict avoidance of figural art of any kind—no biblical scenes, no biblical figures, no animals (with the exception of a few sarcophagi), and certainly no zodiac motifs. One might add to this distinctiveness the fact that Samaritans eschewed the basilical model that was so popular among Jews and others; columns rarely appear in the main hall of the Samaritan synagogue. Besides use of the Samaritan script, including biblical citations, Samaritan art reflects other aspects of tradition. For example, the widespread and often exclusive use of Temple themes may well underscore its dominant priestly leadership, and the absence of the *lulav* and *ethrog* symbols clearly reflects the Samaritan biblical interpretation that the four species (which the Jews interpreted as referring to these two symbols) were to be used as components for the building of the *sukkah*.[108]

106. The most recent and fullest presentation of this material can be found in a series of articles in E. Stern and Eshel, *The Samaritans*: Reich, "Samaritan Amulets"; Barkay, "Samaritan Sarcophagi"; Sussman, "Samaritan Oil Lamps"; and Magen, "Samaritan Synagogues" (2002). For earlier English versions of these articles and other studies, see Magen, "Samaritan Synagogues" (1993); Sussman, "Samaritan Lamps"; Sussman, "Binding of Isaac; Sussman, "Samaritan Oil Lamps from Apollonia-Arsuf"; and Rosenthal-Heginbottom, "Jewish Lamp."

107. Samaritans, too, included a variety of Temple-related images and symbols on the mosaic floors of their synagogues; see Magen, "Samaritan Synagogues" (1993).

108. Jacoby, "Four Species."

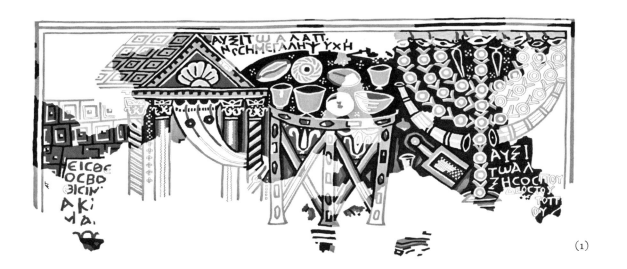

(1)

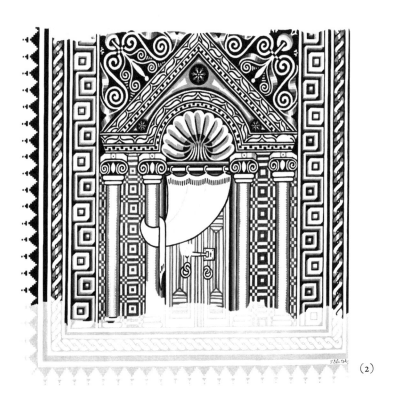

(2)

FIG. 119 Samaritan synagogue mosaics: (1) el-Khirbe; (2) Khirbet Samara.

Nevertheless, Samaritan artistic expressions in many ways paralleled Jewish ones, not only chronologically but also in content—the prominence of a Temple/ Torah shrine facade and the frequent presentation of religious symbols, especially the menorah, almost all of which are anchored in the biblical text held sacred by both peoples and their religious traditions. Other parallels between Samaritans and Jews include the emergence of *piyyut* (as among Christians as well) at approximately this time, and the fact that both groups underwent political and religious revivals in the third and fourth centuries, among the Samaritans under the leadership of Baba Rabba and among the Jews under Patriarchal, rabbinic, local, and perhaps priestly leadership.[109]

The pièces de résistance of Samaritan art to date are several very impressive mosaics discovered in two synagogues northwest of Shechem/Nablus near Sebaste dating to the fourth century (fig. 119).[110] The first synagogue, at el-Khirbe, has a tripartite mosaic floor containing intricate geometric patterns in one panel and several very poorly preserved concentric circles in another. Three objects in the central rectangular area—on the right, a menorah with flanking tongs and trumpets, and one incense shovel to its left; in the middle, a table on which assorted bowls, cups, and loaves of bread rest; and on the left, a facade (probably of the Temple but also identified as a holy ark) with columns, a gable, a conch, and a partially drawn curtain—were all executed with great care and expertise.

The second synagogue, at Khirbet Samara, also has a beautiful mosaic floor featuring intricate geometric designs and a large number of medallions with floral patterns and other depictions (birdcages, palm and other trees, cornucopiae, cups, amphorae, and so on). A Temple/ark facade, along with a gable, conch, columns, and a partially drawn curtain, appear in one poorly preserved panel. A second, far better preserved representation of a facade with a similar overall design was found off to the side of the hall (fig. 119, no. 2).

In examining Jewish and Samaritan art in their historical contexts, questions of precedence and sources of influence between the two understandably emerge, but the dearth of material and literary sources bars drawing any firm conclusions. A third alternative should be considered, namely, that the impulse toward this institutional artistic and religious creativity came from outside Palestine, perhaps reflecting a renewed interest in the religious dimension resulting from developments in the Late Roman and Byzantine world generally. Not the least of such factors was the dramatic rise of Christianity in the early fourth century.

109. L. I. Levine, *Ancient Synagogue*, 187–93; L. I. Levine, "Status of the Patriarch"; Stemberger, *Jews and Christians in the Holy Land*, 217–29. See also Crown, "Samaritans in the Byzantine Orbit"; Crown, "Samaritan Religion"; and especially Münz-Manor, "Liturgical Poetry."

110. See Magen, "Samaritan Synagogues" (2002).

18. MODERN METATHEORIES IN THE INTERPRETATION OF JEWISH ART

JEWISH ART HAS been studied on a number of levels. The simplest one involves the identification of specific motifs or panels; for the most part, a scene is recognizable from the depictions themselves (as in the *'Aqedah*) or by an identifying inscription. A more ambitious challenge, however, is attempting to understand what was intended by using a particular scene. Were these depictions chosen arbitrarily for aesthetic or other reasons, reflecting the personal tastes of those who determined their inclusion and placement,[1] or did they have specific didactic or religious goals? A third level of interpretation involves conveying a metamessage: Did a given composition, whether an entire mosaic floor or a series of frescoes from Dura, have one overall theme or message?[2] The latter, more ambitious type of analysis inevitably requires referencing one or more literary sources, and the manifold attempts to decode the Dura paintings or a particular mosaic floor are cases in point.[3]

In this chapter, we will discuss a number of frequently encountered metatheories regarding Jewish art as they relate to one or more sites. These topics include, in the order of their presentation below, messianism, mysticism, the decisive influence of rabbinic literature, polemics, and liturgy. These five categories are not mutually exclusive, and often two or more of them—such as the polemical and messianic emphases—come into play in a single presentation.

1. So, e.g., Strauss, "Jüdische Quellen"; A. Ovadiah, "Art of the Ancient Synagogues in Israel."

2. Another category that relates only to Dura assumes that each of the three registers has it own theme, and some have contended that there was a common thread based on rabbinic traditions; see chap. 5.

3. See, for example, the summaries of various approaches: Gutmann, "Programmatic Painting"; Gutmann, "Early Synagogue and Jewish Catacomb Art," 1313–28; and above, chaps. 5, 13, and 14.

MESSIANISM

The synagogue of Dura Europos has merited much attention since its discovery in 1932, and all the above-noted categories have been invoked in connection with its art. Wischnitzer's 1948 monograph *The Messianic Theme in the Paintings of the Dura Synagogue* is one of the first extensive studies of this synagogue, and her thesis is clearly set forth in its title: (1) the thirty or so preserved panels convey one overall theme; and (2) it is the messianic idea that constitutes the ideational substratum pervading the wall paintings.[4] Wischnitzer identifies the three registers of biblical panels as follows: the bottom register—the salvation cycle; the middle register—the trials of salvation; and the top register—the witnesses of salvation.[5]

There can be little question that several depictions on these walls clearly point to a messianic theme, the most blatant and compelling instance being the representation of Ezekiel's vision of the dry bones (Ezek. 37) along the bottom register of the northern wall.[6] With almost the same degree of certitude, it has been assumed that the seated figure in the upper central panel over the Torah shrine is to be identified as a messianic David or the Messiah (and on rarer occasion, Moses). This figure is flanked by two people, with others standing on a somewhat lower level. Given its position above the lower panel, which contains scenes of Jacob blessing his sons and grandsons, as well as a representation of David, the above assumption has been generally agreed upon.

However, discerning a messianic theme elsewhere in Dura becomes a far more speculative exercise: Should the crossing of the Red Sea or Samuel anointing David be considered messianic?[7] Wischnitzer hypothesizes that the scene of Elijah resurrecting the child parallels the Ezekiel panel, serving as a prefiguration of the ultimate messianic resurrection.[8] Indeed, such interpretations have led one reviewer to describe her as having an "exuberant artistic imagination,"[9] perhaps most evident in her assertion that the belief in the tradition of the ten tribes (though never displayed as such) was of paramount importance in Duran art. Moreover, this notion, she believes, is demonstrated in the seated figure appearing in the upper panel, whom she identifies as Joseph, and the two accompanying figures as Ephraim and Menasseh, the most important northern tribes;[10] few, however, have supported this suggestion.

4. Wischnitzer, *Messianic Theme*, passim, and esp. 11–15.

5. Ibid., 100.

6. See Garte, "Theme of Resurrection." For an emphasis on the Ezekiel panel as the key to Dura's paintings, see Revel-Neher, "An Additional Key."

7. Wischnitzer dismisses the former but supports the latter (*Messianic Theme*, 77–78 and 50–52, respectively).

8. Ibid., 44.

9. Sonne, "Review of Wischnitzer's *Messianic Theme*," 230.

10. Wischnitzer (*Messianic Theme*, 96–99) writes the following in this regard: "Moving from the aedicule panel upward across the center area of the triptych, we have seen displayed Abraham, Isaac, and Jacob; the twelve sons of Jacob, fathers of the twelve tribes; David, father

Wischnitzer also adopted an approach that has characterized much of art-historical studies until today; namely, relying heavily on the extensive corpora of rabbinic material. While the idea of messianism can certainly be found in these sources, stretching over a millennium, how, if at all, this literature relates to the Dura synagogue and its scenes is far from clear. At all events, there is little justification for Wischnitzer's assertion that "the messianic concept which pervades the rabbinical literature of Palestine and Mesopotamia has been found to be the organizing, formative factor in the iconography of the synagogue decoration."[11] Just because this idea may surface at times in rabbinic literature or in the *piyyutim* of the sixth and seventh centuries does not mean that it necessarily reflects the thinking and beliefs of all rabbis or of Jewish communities everywhere at any given time, including those places where we have no reason to assume that rabbis (or composers of *piyyut*) resided, whether temporarily or permanently.[12]

Toward the end of the twentieth century, some forty years after Wischnitzer's book appeared, this approach was revisited by Herbert L. Kessler, but from an entirely different perspective—not that of the rabbis but of later Christian art and the Jewish-Christian polemic.[13] Kessler views much of the Dura paintings, and especially the central panels above the Torah shrine, as a strong declaration of messianic hopes.[14] Beginning with the early stage of these decorations, he associates the large and imposing vine as possibly representing the Tree of Life, which is reminiscent of the prophecies of Isaiah (4:2) and Zechariah (8:12) that speak of a vine coming to fruition with the coming of the Messiah. Accordingly, the fruitless vine depicted at Dura emphasizes that this divine promise remained unfulfilled when this synagogue stood. The large trunk of the vine is likened to the Messiah as the "righteous branch," for he is destined to rebuild the Temple (Zech. 6:12). Kessler goes on to interpret the two objects at the foot of the tree in this light: the empty throne to the left, ostensibly awaiting the Messiah; and the table to the right, presumably representing the place reserved for his new Torah.[15]

The pièce de résistance of Kessler's claim for a messianic focus appears in the final stage of this area. Of the four large and dominating portraits on either side of the central composition, he identifies the two top figures as Moses, the one on the lower left as Isaiah, and that on the lower right as Jeremiah. The latter identifica-

of the Messiah; and Joseph, father of the two leading Israelite tribes and of the Ephraimite Messiah. It is to be noted that Joseph, not David, presides, enthroned, over the array of ancestors" (p. 99).

11. Ibid., 100.

12. For a fuller discussion of the problematics in positing a rabbinic influence on ancient Jewish art, see below and chap. 20.

13. We have already commented on this aspect in Kessler's analysis of Dura; see chap. 5.

14. H. L. Kessler, "Program and Structure."

15. Ibid., 157–64. For the idea that the messiah will bring a new Torah, see the late midrash, *The Alphabet of Rabbi Akiba*, p. 163.

tions rest on two considerations: (1) both prophets offer vivid descriptions of the coming of the Messiah (Isa. 60:19–21; Jer. 32:37); and (2) they appear in much the same way on the wall mosaics of the sixth-century church of San Vitale in Ravenna, some three hundred years later, long after Dura was destroyed; in the church, too, these prophets appear near two depictions of Moses, one at the burning bush and the other holding a scroll.[16]

For Kessler, the heart of the messianic theme lies in the two central panels; the lower one depicts Jacob blessing his children, which would become the source of later messianic speculation (Gen. 49), and David, ancestor of the Messiah; the upper panel depicts a seated figure representing the Messiah, either David or the Messiah-king surrounded by the people of Israel. Opting for the second, Messiah-king, possibility, Kessler identifies the accompanying two figures as Zerubbabel, governor of Judaea, and Joshua the high priest, both commanded by God to build the Second Temple.[17]

Gabrielle Sed-Rajna, generally adopting Kessler's approach, also asserts the existence of a total programmatic statement at Dura emphasizing the messianic theme in the center of the synagogue's western wall. To the right of the arch, above the *aedicula* of the Torah shrine, is the *'Aqedah* (God's covenant with Abraham on Mount Moriah); the focus then moves leftward, to the fulfillment of God's promise in the Temple of the End of Days located in the center of the Torah niche's arch; just above it, this promise is crowned by the messianic blessings of Jacob and the enthronement of the Messiah-king.[18]

Certain representations in the art of Byzantine Palestine have likewise been interpreted as reflecting a messianic or eschatological message resulting from historical exigencies. Since it was only in the fifth and especially sixth centuries that the full impact of Christian rule was felt by Jews in the empire, it is often assumed that the artistic remains of this era reflect the pressures then being brought to bear on the Jews and Judaism. This was the age of Justinian, whose aggressive and intolerant attitude toward the Jews (and Samaritans) is well documented.[19] Thus it has been suggested that the figure of Daniel in an *orans* posture in the Na'aran synagogue is praying for salvation in the wake of the distress of the Jewish community at this time, and the figure of David in the fifth- and sixth-century Gaza and Merot synagogues expresses hope for the messianic restoration of Jewish life.[20]

16. H. L. Kessler, "Program and Structure," 170–73.

17. Ibid., 164–66.

18. Sed-Rajna, *Jewish Art*, 120–25, and esp. 123. For an eschatological interpretation of the Esther in the Purim panel, see Levit-Tawil, "Queen Esther at Dura."

19. See chap. 9.

20. In contrast, Barasch, focusing on the similarities between the David depiction in Gaza and that of Orpheus, has ventured an explanation that this identification stemmed from the vibrant Hellenized culture in that city in Late Antiquity and from the fact that "the

A similar explanation has been accorded the zodiac arrangement in the sixth-century Bet Alpha synagogue. In order to express this community's messianic longings and expectations, it has been claimed that the zodiac signs were shifted (and therefore appear unaligned with the seasons) so that Scorpio (a symbol of Israel) would appear at the top of the circle, nearest the *bima* and Torah shrine, while the lion (a personification of Rome) would be next to, but somewhat below, it.[21]

The discovery of the Sepphoris synagogue has given rise to the theory that one of the several programmatic messages of its mosaic floor is messianic-eschatological. This assertion, according to Kühnel, rests on the association of the Temple facade, menorah, and other religious symbols (along with the Tabernacle registers) not only with the past Temple but also with the Temple of the End of Days.[22] Moreover, it is claimed that this fusion of Tabernacle, Jerusalem Temples, and messianic Temple is relevant to other synagogues as well.[23] In every case, borders and time frames are erased and the future commingles with the past.[24] Unfortunately, the only piece of hard evidence cited for such an interpretation appears in a *piyyut* composed centuries later in medieval Germany. Besides the chronological and geographical disparity, however, only this source identifies the ass in the 'Aqedah story with the Messiah; nothing is said about a future Temple.

Weiss makes the same connection between the Temple facade on the Sepphoris mosaic floor and the eschatological Temple, but from a very different perspective. He finds the key to interpreting the Tabernacle-Temple depictions in the three registers near the *bima* in a relatively late midrash (Tanḥuma, Tetzaveh 10, ed. Buber, p. 103).[25] In this source, second-century R. Simeon b. Gamaliel links the daily offerings, showbread table, and first fruits—all of which are depicted on the mosaic floor (though not everything displayed there is noted in the midrash and vice versa)—to the prosperity and blessing in First Temple times. Yet with the First Temple's destruction, this abundance ceased and would be restored only in the world to come (לעולם הבא), when the Temple would be rebuilt. On the basis of this interpretation, Weiss claims that the Temple facade in Sepphoris points to the past building and its future restoration, and that the sacrifices, showbread table, and first fruits reflect

thoroughly Hellenized Jews of Gaza were particularly deeply influenced by the beliefs of their neighbors . . ." ("David Mosaic of Gaza," 29).

21. Sonne, "Zodiac Theme," 11.

22. Kühnel, "Synagogue Floor Mosaic in Sepphoris," 31–35. This assertion is often coupled by the interpretation that the floor also conveys an anti-Christian polemic (see below).

23. Ibid., 33: "Thus, at both Hammat Tiberias and Sepphoris, the upper part of the composition above the zodiac is occupied by a joint representation of the Tabernacle and Temple, the unity of the two being expressed by reference to continuity of the cult."

24. Ibid., 34.

25. I am ignoring the two parallel sources cited by Weiss (*Sepphoris Synagogue*, 258 n. 76) since they are less specific.

the envisioned abundance in the messianic Temple.[26] Whether the Tabernacle and Temple representations indeed convey this dual meaning (past and present), and whether the use of a late midrash invoking a second-century sage is justified in pulling all of these elements together to explain a fifth-century mosaic, remain open questions.

An interesting though somewhat curious suggestion in the messianic vein has been made with regard to the Upper Galilean synagogue of Merot, where a large side room contains an inscription citing Isaiah 65:25—"A wolf and lamb will graze together"—with both animals depicted beneath it.[27] While this scene has often been recognized as messianic in nature, Asher Ovadiah and Sonia Mucznik have connected it with the depiction of a soldier generally identified as David found in another part of the synagogue building.[28] Viewing the figure as a soldier resting, with his instruments of war laid aside, they suggest that this depiction, too, points to messianic hope.[29] Despite the citing of several alleged parallels in biblical literature and contemporary Christian art, this suggestion has several drawbacks. First, the two depictions are located far from each other, in two different rooms of the synagogue complex. Secondly, these rooms are separated in time by almost three centuries, with the soldier appearing in a fifth-century floor and the messianic inscription and representation in an eighth-century one.[30]

The above comments should not be construed as claiming that messianism was decidedly marginal among Jews; as noted, it is a theme not infrequently invoked in *piyyutim,* rabbinic sources, and later apocalyptic works, and is also reflected in several reported messianic "movements" from Late Antiquity.[31] Nevertheless, such evidence is limited and does not indicate to what extent such a phenomenon was reflective of Jewish society as a whole at this time (in contrast to the Middle Ages). It is likewise unclear what sort of messianism is attested—an active and central concern or a latent, relatively passive attitude. Thus, not only is it impossible to generalize on the basis of the available data, but the archaeological-artistic data regularly marshaled are far from being persuasive and unequivocal.

MYSTICISM

Goodenough introduced an all-encompassing mystical interpretation of Jewish art in his comprehensive and monumental thirteen-volume *Jewish Symbols in the Greco-Roman Period.* He claimed that a mystical orientation permeated all aspects of Jewish art—from Hasmonean times through Late Antiquity, in synagogues, cemeteries,

26. Weiss and Netzer, *Promise and Redemption*, 36–39, and somewhat more developed in Weiss, *Sepphoris Synagogue*, 235–39.

27. A. Ovadiah and Mucznik, "End of Days."

28. See chaps. 11 and 17.

29. A. Ovadiah and Mucznik, "End of Days," 218.

30. This fact is also acknowledged by the authors, who explain it away as evidence of the hope that was alive in every generation (ibid., 219).

31. Irshai, "Dating the Eschaton," 139–53.

and small finds, in architecture and art, in Roman-Byzantine Palestine and the Diaspora, and in figurative as well as geometric and floral depictions. His approach is clearly illustrated in his treatment of the Bet Alpha mosaic, where he posited that its three panels represent the ascent of the soul from a state of earthly purification to one of the heavenly sphere and then to the mystical worlds beyond.[32] In discussing the first panel, the *'Aqedah* scene, he argued that the hand of God, with its seven rays and the heavenly sphere from which it emerges, marks the beginnings of the mystical experience.[33]

Despite its comprehensiveness, or perhaps because of it, Goodenough's approach met with a storm of criticism.[34] One of the few who followed his overall mystical thrust, though with some variation, is Bernard M. Goldman,[35] who interprets the sequence of panels at Bet Alpha as symbolizing the human-earthly tradition of sacrifice (the *'Aqedah*), the movement to the heavenly astronomical-astrological sphere, "where the destinies of nations and men were ordered"; the Temple facade in the third panel represents the sacred heavenly portal, "the ubiquitous symbol of transformation."[36]

Magness has recently revisited the issue of mysticism in the Jewish art of Late Antiquity.[37] Relying on Elior's arguments regarding the priestly provenance of Hekhalot mystical literature,[38] Magness offers a sweeping synthesis of the priestly leadership in the Jewish community, the priestly context of the zodiac depictions in ancient synagogues, a pervasive Jewish-Christian polemic, the dominance of the solar calendar followed by the priests as reflected in these zodiac depictions, and the identification of Helios with both Metatron and Enoch. Following Christopher R. A. Morray-Jones, who suggests that these mystical traditions presuppose people who functioned as intercessors between the realm of God and earthly communities,[39] Magness assumes that priests filled this role.[40]

Magness's theory, which she applies to all synagogues featuring representations of Helios and the zodiac, is comprehensive and far-reaching; she also notes that these synagogues were "the locus of an internal Jewish struggle over access to and

32. See chap. 14.

33. Goodenough, *Jewish Symbols*, 1:246–47. See also p. 253 with regard to Bet Alpha: "Mystics who follow the Perennial Philosophy have always tended to see three stages in mystical ascent, stages which have most generally been called purgation, illumination, and unification. The three stages here might well be given the names purgation, ascent, and arrival."

34. For a review of this criticism, see the important article of M. Smith, "Goodenough's 'Jewish Symbols.'"

35. B. M. Goldman, *Sacred Portal*.

36. Ibid., 21, 56–68. Goldman also notes approvingly that the tripartite mosaic represents priesthood, kingdom, and Torah (p. 67).

37. Magness, "Heaven on Earth."

38. Elior, *Three Temples*, 232–65.

39. Morray-Jones, "Transformational Mysticism."

40. Magness, "Heaven on Earth," 37–43.

command of Torah knowledge and revelation."[41] Unquestionably, many of her assertions are creative and revolutionary, while others are provocative and controversial. None, however, appears to have been accorded the argumentation and analysis necessary to establish a persuasive case.

RABBINIC INFLUENCE

Use of the vast corpus of rabbinic material to explain various manifestations of Jewish art has been a mainstay of art-historical analyses for generations. With respect to the Dura synagogue, this connection has been revisited of late by several scholars with new points of reference.[42] Shulamit Laderman interprets a number of panels in the second register—depictions of the Tabernacle, Temple, Ark of the Covenant in Philistia, and the well in the midst of the Israelite camp—in light of *piyyutim*, especially those composed for Yom Kippur, which she assumes were rabbinically inspired.[43] In doing so, she ranges far and wide over centuries and sources, from Ben Sira (ca. 200 BCE) to the Bavli, and later *midrashim*, but focuses primarily on the Palestinian *piyyutim* (sixth and seventh centuries).

More recently, Fine has addressed this topic from a very different perspective, suggesting that many themes in this synagogue's art reflect rabbinic concerns, especially those expressed in the central rabbinic prayer, the *'Amidah* (or *Tefillah*): "The themes of the *Tefillah* are the basic building blocks of rabbinic prayer. Jews in the frontier city of Dura Europos participated with the rabbis in a kind of Jewish *koiné*—a shared or common religion that included theological, midrashic, and liturgical components not inconsistent with these themes."[44]

Both of these scholars incorporate into their discussions two Hebrew parchment fragments containing a blessing over food discovered in the vicinity of the Dura synagogue.[45] Although these fragments have often been overlooked, there is nevertheless a range of opinion over their decipherment, meaning, and significance, since the texts are very fragmentary and only parts of each line are preserved, at times only isolated letters.[46] Is this text an early liturgical form of the rabbinic *Birkat Ha-Mazon* (Grace after Meals), a study text for school purposes, or perhaps a blessing used at local synagogue events or in a local Jewish eating establishment? Both

41. Ibid., 40.

42. With regard to rabbinic influence on the art of Palestinian synagogues, see chap. 20. Other than in Palestine and Babylonia, there was no significant and sustained rabbinic presence anywhere else in the ancient world.

43. Laderman, "New Look."

44. Fine, *Art and Judaism*, 172–83 and esp. 181–83 (quote from p. 183).

45. Torrey, "Parchment and Papyri"; Du Mesnil du Buisson, "Un parchemin liturgique juif"; Sukenik, *Synagogue of Dura Europos*, 157–58; Kraeling, *The Synagogue*, 259; Fine, *Art and Judaism*, 174–77; and Fine, "Liturgy and the Art of the Dura Europos Synagogue."

46. Since two fragments were found, it has been asked whether they are, in fact, one text (as is usually assumed) or two independent pieces. Moreover, it might be significant that these fragments were found in the street, outside the synagogue, and not inside the building.

Laderman and Fine opt for the first possibility—the rabbinic connection—and while Laderman's discussion of the text is somewhat perfunctory, Fine presents a more detailed examination.

The critical question for our purposes is how "rabbinic" this text is. Some terms therein (מכלכל, יצר אדם, מלך העלם) already appear in the Bible and thus should not be considered characteristically rabbinic.[47] Even the opening line of the text, which all scholars read identically, is not uniquely rabbinic since all of its components appear in earlier biblical and Qumranic literature as well as in later tannaitic sources, synagogue inscriptions, and Hekhalot literature.[48]

Furthermore, local versions of blessings over food were not uncommon[49] and are also known from nonrabbinic contexts. Several versions of such a blessing (presumably from the house of a mourner) were found at Qumran as well as in the second-century *Didache*.[50] Indeed, the Qumran text is far closer to some rabbinic formulations than the Dura parchments, but this, in itself, does not make the Qumran piece "rabbinic."

In fact, it is impossible to speak confidently of a rabbinic terminology and formulation for *Birkat Ha-Mazon*, since the earliest texts of this prayer, especially those from the Cairo Genizah, surfaced only many centuries later.[51] Moreover, two of the most renowned talmudists of the twentieth century, Louis Ginzberg and Saul Lieberman, had reservations whether these parchments were "rabbinic" or reflective of local popular practice;[52] indeed, rabbis often borrowed from earlier liturgical formulations in constructing their prayers.[53] Therefore, the Dura parchments provide little basis for the claim "that the Dura parchment is related in language, form, and content to rabbinic prayer texts from Late Antiquity."[54]

47. One phrase on the parchment, חלק מזון, appears in M Shevi'it 9, 8, but not in a Grace after Meals context; it may in fact relate to a person dividing up his produce in a sabbatical year.

48. Kimelman, "Blessing Formulae," 17–20.

49. Eshel, "Review of B. Nitzan, *Qumran Prayer*." Commenting on Weinfeld's suggested affinity between one such Qumran text and Christian practice per Pliny the Younger, Kimelman warns that much caution is required before asserting any sort of tie between remotely related texts ("Note on Weinfeld's 'Grace After Meals'"). On the fluidity of Jewish and Christian prayer traditions regarding meals in the first centuries CE, see Bradshaw, *Search for the Origins of Christian Worship*, 24–29, 131–60, and esp. 158–60.

50. Weinfeld, "Grace after Meals in Qumran."

51. Finkelstein ("Birkat Ha-Mazon," 223–62), whose analysis of Birkat Ha-Mazon remains classic, even if somewhat outdated, attempted to reconstruct the original version on the basis of medieval texts from the Genizah, Seder Rav Amram, Seder Rav Saadiah, and Maimonides.

52. Ginzberg, *Commentary*, 3:354; Lieberman, *Midreshei Teiman*, 40–41.

53. Regarding the development of the main prayers of rabbinic liturgy, the *Shema'* and *'Amidah*, see L. I. Levine, *Ancient Synagogue*, 540–54, and bibliography cited therein.

54. Fine, *Art and Judaism*, 176. Fine elaborates: "The Dura Europos liturgical parchment provides a powerful key for the interpretation of the Dura synagogue and its paintings. This fragment firmly anchors the community at Dura within a religious world that was shared

Once the assumption that these parchments contain a rabbinic blessing is dismissed, other suggestions regarding a rabbinic component in Duran art become speculative. Thus, the claim for the existence of 'Amidah themes in these panels takes its place alongside the myriad theories suggested over the past eight decades regarding rabbinic involvement in this art.[55] For example, the appearance of the biblical Patriarchs (Abraham and Isaac in the 'Aqedah scene, Jacob and the ladder in another one) in two distant panels on the synagogue's walls (the western and northern ones, respectively) does not jibe with their appearance as one Patriarchal group in the first paragraph of the 'Amidah. Nor does the 'Amidah's reference to slanderers, informers, Christians (?), and apostates allow us to assume that the synagogue's depictions of Egyptians or Haman in two different and distant panels represent this particular theme. Moreover, the 'Amidah prayer for the restoration of the Davidic kingdom is not commensurate with the Duran scene of David playing the lyre and enchanting an audience of animals. Finally, a supposed 'Amidah background will not help us understand the centrality of Moses in Duran art since Moses is never mentioned in that prayer!

Over and above these particular issues, there is the overarching question regarding the plausibility of positing any sort of rabbinic influence in early third-century Dura. True enough, scholars in the past simply assumed that rabbinic influence reigned supreme in all the Jewish communities of antiquity; today, however, such an assumption is no longer tenable. Even if one wished to posit such an influence in Late Antique Palestine (itself a most questionable position; see chap. 20 in this volume), the Duran setting is far different, and the issue of rabbinic influence there is especially problematic.

Very few rabbinic figures before the third century CE are identified with Mesopotamia generally (and Babylonia specifically), and even among those who are, it is not clear to what degree they actually functioned in their home country or whether they were residents of Palestine who were identified as Mesopotamian because of their place of origin. Only in the third and fourth decades of the third century did a number of Palestinian sages settle in, or begin visiting, Babylonia, establishing a rabbinic presence hundreds of kilometers southeast of Dura.[56] From that time on, one can speak of some sort of sustained rabbinic presence in Babylonia,[57] but only

by the rabbis of Babylonia and Palestine—a point that was hotly debated during the past century" (p. 183). In response to this type of claim, see also the insightful and trenchant comments of Lapin, "S. Fine, *Art and Judaism*."

55. Fine, *Art and Judaism,* 177–83.

56. Neusner, *History of the Jews in Babylonia,* 1:135–63; Gafni, *Jews of Babylonia,* 81–91; Goodblatt, "Jews in Babylonia," 88–89. Indeed, the boundaries of Jewish Babylonia as defined by the rabbis there (with regard to preserving the purity of Jewish lineage) extended only to Pumbedita in the north; see Oppenheimer, *Between Rome and Babylon,* 339–55.

57. Neusner, *History of the Jews in Babylonia,* vol. 2, passim. See Gafni, *Jews of Babylonia,* 94–109; D. Goodblatt, "Jews in Babylonia," 88–90.

at some point much later on did this presence become institutionalized.[58] Positing a significant rabbinic influence by the 230s and 240s, even in Jewish Babylonia, is unfounded,[59] all the more so for a remote frontier town never mentioned in the Bavli and never visited by a sage (per the extant sources).[60] Moreover, down to the mid-third century Dura was part of the Roman Empire while Babylonia was located in the Parthian, and then Sasanian, realms. And while borders were penetrable, the orientation and dominant culture of each empire differed considerably. Given this situation, it is quite improbable that any significant rabbinic influence was imposed on or absorbed by early third-century Dura that might have been reflected in its synagogue's frescoes created in the 240s.

THE POLEMICAL APPROACH

A widespread approach in contemporary studies places synagogue art in the context of the Jewish-Christian polemic of Late Antiquity. As noted,[61] Christian evidence concerning these polemics far outweighs the Jewish testimony, either as abstract theoretical constructs geared primarily for internal Christian polemical purposes[62] or as a means to counter explicit or implicit Jewish claims against Christianity and thwart the influence of Judaism on the local Christian population.[63]

On the Jewish side, however, the sum total of such material in rabbinic sources and *piyyut* is minimal, limited to a number of passing comments, criticisms, and barbs at Christian beliefs.[64] Only a few independent works have been preserved: a

58. See, for example, Goodblatt, *Rabbinic Instruction*, 263–85; Goodblatt, "History of the Babylonian Academies"; Rubenstein, *Culture of the Babylonian Talmud*, 16–38; Rubenstein, "Social and Institutional Settings," 66–67.

59. Neusner, *History of the Jews in Babylonia*, 2:285: "One must therefore regard as limited the 'revolution' in Babylonian Jewish affairs, resulting from the development of the rabbinic academies."

60. See, e.g., Oppenheimer, *Babylonia Judaica*, 120.

61. See chap. 9. On the attraction of Jewish scholars to issues concerning Jewish-Christian relations in antiquity, not always for strictly academic reasons, see Goshen-Gottstein, "Jewish-Christian Relations and Rabbinic Literature," 15–29.

62. M. S. Taylor, *Anti-Judaism and Early Christian Identity*; Fredriksen and Irshai, "Christian Anti-Judaism," 985–1007.

63. Parkes, *Conflict*, 121–95; Simon, *Verus Israel*, 135–233; Meeks and Wilken, *Jews and Christians in Antioch*, 13–52; Wilken, *John Chrysostom and the Jews*, 66–127.

64. Goodman, "Palestinian Rabbis and the Conversion of Constantine"; Schremer, "Christianization of the Roman Empire." For a recent attempt to cull snippets of Jewish responses embedded in Christian polemics, see Lahey, "Jewish Biblical Interpretation." Moreover, the amount of such material in Palestinian sources is decidedly limited. It has been widely recognized of late that Chrstianity plays a far more central role in the Bavli than in Palestinian rabbinic sources; see Kalmin, "Christians and Heretics"; Schäfer, *Jesus in the Talmud*, 95–122; Boyarin, "Hellenism in Jewish Babylonia," 358.

parody of New Testament accounts about Jesus (*Toledot Yeshu*)[65] and a number of late compositions in which Christian literary motifs have been reworked in presenting a Jewish counternarrative, sometimes referred to as "counterhistory" or "dialogue" (such as *The Apocalypse of Zerubbabel*, *The Legend of the Ten Martyrs*, and perhaps also a few minor *midrashim*).[66] Nowhere in Jewish writings is there any crafted, developed, or sustained argument that either attacks Christianity or defends Judaism's beliefs and practices in the face of Christian assaults. Such systematic polemics first appear in the ninth century, under Islam,[67] and begin to flourish only in early twelfth-century Ashkenaz and thereafter.[68] In short, for antiquity, there is very little in the way of a Jewish polemic, even if one factors in very limited responses to Christian claims or appropriations of Christian ideas or motifs.

In this light, how seriously should claims of a Jewish polemic against Christianity be entertained? What are the criteria for judging such assertions? How many Jews and Christians in the empire were "plugged into" such controversies, or are we dealing with specific local and elitist phenomena? Were the tensions noted in Alexandria and Antioch relevant to and reflective of the Galilee or Dura? And even were we to posit that a particular polemic of a specific church father was indeed directed against the Jews, how much impact might his tirades have had on the local population and how far-reaching geographically was its ripple effect, if at all? There are no simple answers to these questions, and each instance must be judged on its own merits.

In a limited number of cases, Christian polemics are readily discernible when directed against a contemporary Jewish community. When John Chrysostom attacks the synagogue and specific Jewish customs and practices in a series of diatribes against the Judaizing members of his own church, we can be sure that serious ties as well as tensions existed in late fourth-century Antioch.[69] Yet Antiochan social and religious realities cannot be assigned automatically to each and every Christian attack against the Jews. In fact, there is not always a correlation between the intensity of a polemic and presumed local social tensions. As David Satran has pointed out, neither Origen nor Eusebius is particularly vindictive regarding the local Jewish community, although we are well aware that Christians and Jews in Caesarea—and perhaps even Samaritans and pagans—often rubbed shoulders daily and argued

65. Krauss, *Das Leben Jesu*, 246; Horbury, "Critical Examination of the *Toledoth Jeshu*," 432–34; Newman, "Death of Jesus"; Deutsch, "New Evidence." See also Schonfield, *According to the Hebrews*, 35–61.

66. See, e.g., Biale, "Counter-History and Jewish Polemics"; Himmelfarb, "Mother of the Messiah"; Abusch, "Rabbi Ishmael's Miraculous Conception."

67. D. J. Lasker and S. Stroumsa, *Polemic of Nestor the Priest*.

68. See Berger, *Jewish-Christian Debate*, 7–8; D. J. Lasker, "Jewish-Christian Polemics"; Chazan, *Fashioning Jewish Identity*, 67–87.

69. See Wilken, *John Chrysostom and the Jews*, 66–127; and above, chap. 9.

over the truth and authenticity of their respective religions.[70] Conversely, in North Africa, where the diatribes of Tertullian or Cyprian were often quite harsh, there seems to be little evidence of Jewish-Christian interaction.[71]

While a number of scholars have raised the possibility that both Christian and Jewish art served polemical purposes,[72] only in 1990 did H. L. Kessler argue this case extensively with regard to Dura,[73] and again, a decade later, with respect to the Sepphoris mosaic floor;[74] he has been joined in this assessment by a considerable number of Israeli archaeologists and art historians.[75] This approach to explaining the Sepphoris mosaic has become so widespread of late that we can rightfully deem it the *communis opinio*, at least in Israeli circles.

What is required to make a serious and credible claim that behind the art of a particular synagogue lay a polemical intent? Maximally, it would have to take place where both Christians and Jews lived and where a local figure (either Christian or Jewish) articulated explicitly polemical statements. Moreover, the evidence for such a polemic would have to be persuasive and clear-cut; appealing to sources centuries apart or geographically distant does not make for an especially compelling argument. Thus, just as invoking a seventh- or eighth-century midrash to support a suggested polemic in a third-century Duran or fourth-century Galilean setting is problematic, so too are the polemics of Chrysostom, Ephrem, or even Jerome vis-à-vis a supposed Tiberian or Sepphorean polemic. In this light, then, there is little justification for claiming that the Dura synagogue paintings reflect an anti-Christian polemic, given the fact that we know of no such exchanges either in early third-century Dura or contemporary Mesopotamia. Even Dura's local church offers no evidence for any such polemic.

Moreover, as noted above,[76] the pace of Christianity's penetration into Palestine has undergone serious revision in the last decade or two. Whereas earlier scholarship had assumed a fairly rapid takeover of the country in the fourth and fifth centuries, the assessment today calls for a much slower pace. While the Christianization of the main sites closely associated with Jesus (Jerusalem, Bethlehem, Nazareth, and Capernaum) took place in the fourth century, the turn of the fifth century witnessed the construction of churches in prominent locations such as Gaza and perhaps Tiberias. Nevertheless, the serious appearance of Christianity in towns

70. See L. I. Levine, *Caesarea under Roman Rule*, 57–134; de Lange, *Origen and the Jews*, 89–132.

71. Satran, "Anti-Jewish Polemic," 57–58.

72. See, e.g., Simon, *Recherches d'histoire judéo-chrétienne*, 188–208.

73. See chap. 5.

74. H. L. Kessler, "Program and Structure"; H. L. Kessler, "Sepphoris Mosaic and Christian Art."

75. See, inter alia, Kühnel, "Synagogue Floor Mosaic"; Revel-Neher, "From Dream to Reality"; Weiss, *Sepphoris Synagogue*, 249–56; Weiss, "Between Rome and Byzantium," 377–89. Regarding Ḥammat Tiberias and elsewhere, see Magness, "Heaven on Earth," 13–21.

76. See chap. 9.

and villages of Palestine only surfaced well into the fifth century and even more extensively in the sixth.[77] Thus, given this overall picture, to assume a discernible Christian presence throughout the country, especially in Jewish Galilee, that might have fostered a lively Jewish-Christian polemic early on is rather far-fetched. Rabbinic literature attests to a limited number of disputes and exchanges with sectarians (*minim*) in the Galilee (who in many, but not all, cases can be identified as Christians) from the second to fourth centuries. However, not only is the veracity of some of these traditions questionable but there is no way of determining their extent and frequency. Furthermore, there is no evidence whatsoever for the claim that the development of Christian Jerusalem in the fourth century and thereafter affected the Jews of the Galilee in any way.

When it comes to Sepphoris (Diocaesarea), however, the possibilities of contact are more intriguing, straddling the improbability of a Jewish-Christian polemic in Dura and the certainty of these kinds of contacts in Antioch. In this case, we are not entirely bereft of evidence for Sepphoris, as several church sources offer information about the city in the later fourth century. Theodoret, in his *Ecclestiastical History* (4.19), reports—albeit tendentiously—on the persecution of the Catholic leadership in Alexandria during the reign of the Arian emperor Valens (364–378 CE):[78]

> In all, after many fruitless efforts, they drove into exile to Diocaesarea, a city
> inhabited by Jews, murderers of the Lord, eleven of the bishops of Egypt,[79]
> all of them men who from childhood to old age had lived an ascetic life in the
> desert, had subdued their inclinations to pleasure by reason and by discipline,
> had fearlessly preached the true faith of piety, had imbibed the pious doctrines,
> had again and again won victory against demons, were ever putting the adver-
> sary out of countenance by their virtue, and publicly posting the Arian heresy
> by wise argument.[80]

This exile took place soon after Athanasius's death in 373.[81] From a number of communications between these bishops and several Eastern church figures—Apollinaris of Laodicea, eight leaders of the Marcellian community (?) in Ancyra,[82] and Basil

77. I have omitted reference to the Tiberias church (see chap. 9) pending publication of the finds there.

78. On Valens's religious policy generally, see Piganiol, *L'empire chrétien*, 161–65; and on varying assessments of his policies, see Errington, *Roman Imperial Policy*, 175–88; Lenski, *Failure of Empire*, 242–63.

79. Writing a few years later, Epiphanius lists their names (*Panarion* 72.11.1). We also learn from a letter of Eusebius of Verccelae (no. 2.8) that at about the same time he, an orthodox Christian, had likewise been banished to Scythopolis, a city of Arians.

80. Piganiol, *L'empire chrétien*, 162–63.

81. Lietzmann, *Apollinaris von Laodicea*, 60–61; Piganiol, *L'empire chrétien*, 162–63; Avi-Yonah, *Jews of Palestine*, 209.

82. Epiphanius, *Panarion* 72.11.1.

of Caesarea in Cappadocia[83]—it appears that the bishops were regarded by some as important figures in Catholic circles. We do not know what Apollinaris may have wished to convey; the communication may have been primarily of a personal nature, although, based on other letters with these exiles, it is quite possible that Christological issues were being discussed.[84]

Nevertheless, the inclusion of Apollinaris is of especial significance. He was a respected[85] though controversial figure in orthodox circles owing to his beliefs regarding the humanity of Jesus and millenarianism, which, as part of his eschatological platform, included the restoration of the Jerusalem Temple and sacrifices, and the observance of Jewish customs.[86] In fact, we know almost nothing of these latter doctrines, undoubtedly owing to Apollinaris's condemnation by his Catholic colleagues on such matters and the erasure of his writings, which have survived only fragmentarily.[87] While some of his theological disputes are at times treated caustically and critically,[88] others merited a good deal more respect.[89] At one point, Basil attempted to dissuade the bishops in Sepphoris from following Apollinaris's Christological doctrines (theological? millenarian? both?), pleading instead for their assistance in bringing Apollinaris around to see the true light and return to accepted Catholic dogma.[90] Thus, the possibility exists—though admittedly it is far from certain—that these exiles were exposed to, and perhaps even sympathized with, his Jewishly oriented messianic hopes.[91]

For all their importance, these sources leave many questions unanswered. For one, the exile of bishops to Sepphoris clearly points to the fact that the city, referred to specifically as being Jewish, was largely bereft of any significant Christian population. Thus, the teachings of these "heretics" could not cause harm to the Arian cause. It is of interest to note that the Marcellians' letter to the exiles in Diocae-

83. Basil of Caesarea, *Letter* 265.

84. Lietzmann, *Apollinaris von Laodicea*, 22–24. On these bishops' sojourn in the city, see Newman, "Bishops of Sepphoris," 85–94.

85. See Epiphanius, *Panarion* 66.21.3; 77.2.1.

86. Basil of Caesarea, *Letter* 263.4; see also Gregory of Nazianzus, *Letters* 102, 114; Jerome, *De viris illustribus* 18; Epiphanius, *Panarion* 77.36.5–6; 38.1.

87. Lietzmann, *Apollinaris von Laodicea*, 43–78. Gregory of Nyssa (*Epistle* 3.24) cites many statements ostensibly from Apollinaris's *Apodeixis*. Young (*From Nicaea to Chalcedon*, 183–84) remarks that although many fragments are preserved in anti-Apollinarian works, such as Gregory of Nyssa's refutation of the *Apodeixis*, it is difficult to decide whether these are direct quotes or those altered to fit the orthodox position. The reconstruction of Apollinaris's works is further complicated by the fact that his followers published his writings under fictitious names.

88. See Gregory of Nazianzus, *Epistle* 102.14.

89. As, for example, Gregory of Nyssa, *Epistle*, 3.24, composed sometime in the 380s.

90. Basil, *Letter* 265. Marcellus, too, focused on Christological issues in his correspondence with the exiled bishops living in Diocaesarea (see Epiphanius, *Panarion* 72.11-12).

91. See Newman, "Bishops of Sepphoris," 97.

sarea refers to a recent visit, but we have no way of knowing whether it took place in Alexandria or Sepphoris. If the latter, then it might indicate that these bishops remained active in promoting their brand of Christianity while residing in the city. Moreover, if Apollinaris's letter to them addressed his millenarian ideas, including some expressly Jewish components, then we might assume that these ideas were part of these exiles' discourse in the city and might have been familiar to the Jews as well. Furthermore, if we are to give credence to Basil's letter, then we might conclude that the exiled bishops could have espoused Apollinaris's eschatological views, which might have provoked the local Jewish community into making some sort of response, including, perhaps, a message transmitted through one synagogue's mosaic floor.[92]

Regretfully, however, all the above possibilities are mere conjecture. The extent to which the local Jews had contact with these exiles, if at all, or whether they were even aware of these Christian theological discussions is unclear. In many cities, diverse populations lived in close proximity to each other but with little social interaction. Thus, the degree of impact that these Egyptian bishops may have had on the local Jewish population in Sepphoris, in the short or long run, remains unknown.[93]

There is also a chronological issue here. From all appearances, these bishops remained in the city for a short period of time. It is almost certain that they returned to Egypt after Valens's death in 378 and following the ascent of the orthodox Theodosius I to the throne and his reinstatement of Catholic doctrines as the normative and official policy throughout the empire.[94] The question, then, is how much of an impact these bishops might have had on the local Jewish community during their very limited sojourn in Sepphoris. Was it significant enough to have influenced Jewish thinking and attitudes when constructing a synagogue some forty or fifty years later? Would this earlier exposure to Christian doctrine have been so powerful and challenging that a local community might have felt compelled to respond with a full-blown and innovative programmatic artistic composition that attempted, inter alia, to combat Christian claims? There are, of course, no clear-cut answers to these questions, and certainly not to any sort of presumed tie between the bishops' residence in the city and the later synagogue floor.

Therefore, any proposed interpretation in a polemical vein has to be assessed, first and foremost, on its own merit. Is the mosaic's polemical intent compelling? Are the sources cited to support this claim persuasive? In the end, such assertions can be seriously grounded only with the aid of literary material, an issue that has

92. See chap. 13.

93. A letter sent from a Jerusalem synod to Theophilus, bishop of Alexandria around 400 CE, may be relevant in this regard; therein it was announced that a series of heresies, including that of Apollinaris, had been eradicated from Palestine. Did this include Sepphoris as well? See Jerome, *Letter* 93; Lietzmann, *Apollinaris von Laodicea*, 36–37.

94. CT 16.1.2; 16.5.6.

been addressed elsewhere.[95] Moreover, a possible polemical dimension here in Sepphoris should not be divorced from the wider historical context relating to Jewish polemics against Christianity (or the lack thereof) in Late Antiquity.[96]

In summary, it is not altogether impossible that a particular Sepphorean congregation attempted to do what no other community from this period had done, namely, construct a mosaic floor with a well-conceived and systematic polemic against Christianity. However, given the notable absence of any other such effort in Late Antiquity as well as the questionable polemical interpretation of this mosaic, the likelihood of such a controversy having existed in late fourth- or early fifth-century Sepphoris stretches credulity beyond its limits. It would be as unexpected as it is unlikely.

THE LITURGICAL APPROACH

A number of scholars have suggested a connection between *piyyut* and synagogue art, but usually with regard to specific motifs.[97] Basing himself on the studies of a number of scholars of Christian art, Fine goes one step further and assumes that the art of the Sepphoris mosaic was closely related to synagogue liturgy, just as Christian art was closely connected to church liturgy:

> The approach that I am suggesting has, in fact, been used with considerable results by scholars of Christian art. A number of scholars . . . have interpreted the Late Antique church building as the backdrop for the liturgical life of a community. . . . While synagogue remains in Palestine are not nearly as rich as

95. See chaps. 13 and 20, and Newman, "Bishops of Sepphoris," 95–99.

96. Chazan, *Fashioning Jewish Identity*, 67–76. Why polemical responses were not forthcoming from the Jewish side deserves a separate treatment. In the meantime, however, it should be noted that this aversion to constructing a more comprehensive, logical, and systematic synthesis affects not only Jewish polemics but other areas of Jewish culture as well. For example, the rabbinic corpus of Late Antiquity (i.e., the two Talmuds and the many aggadic *midrashim*) shows little interest in systematizing its contents, either in terms of law, thought, or any other topic for that matter. Urbach, in his introduction to *Sages* (p. 4), comments as follows: "Common to all the sources is the fact that none of them provides systematic treatment of the subject of beliefs and conceptions, and there are almost no continuous discourses dealing with a single theme. . . . Such attempts on our part are likely to show contradictions between the conclusions drawn for one set of ideas and those derived from another. It is just this lack of consistency and system that provided subsequent generations with a great measure of freedom in defining the principles of faith. . . . The philosophers of the Middle Ages, the Cabbalists, and the Hasidim all based themselves on Rabbinic dicta in expounding their systems." Indeed, with regard to our topic, any kind of systematic anti-Christian polemic by Jews awaits the Middle Ages as well.

97. See, e.g., Mirsky, *Piyut*, 93–101; Yahalom, "Zodiac Signs"; S. Schwartz, "On the Program and Reception," 181; Münz-Manor, "All about Sarah."

the churches of Rome, Ravenna, and Constantinople, many of the insights of scholars of Christian art are applicable to the Sepphoris mosaic.[98]

Despite the seeming plausibility of this line of argument—that synagogue liturgy and synagogue art are correlated, especially in light of Christian parallels, the problems inherent in this approach are many. Comparing *piyyutim* with the repertoire of motifs in the Sepphoris mosaic floor is an almost foolproof exercise. There are bound to be similarities, as there would be with any comparable corpus of literary sources such as the Bible and Talmuds. In fact, besides *piyyutim*, other contemporary literary genres, such as midrash and *targum*, also contain most, if not all, of the mosaic floor's motifs. Thus, similar subject matter in both *piyyut* and art does not necessarily prove a connection between the two.[99]

Moreover, assuming that *piyyutim* were recited in (some? most? all?) synagogues is indeed a weighty consideration in making such comparisons. The fact remains that we have no idea how widespread the recitation of *piyyutim* was in Late Antiquity, and indeed it may have been quite limited.[100] *Piyyut* was a new genre in Early Byzantine Palestine and seems to have been first introduced into the synagogue setting only in the fifth and sixth centuries, becoming a fully developed liturgical component in the later sixth and seventh centuries. This chronological factor is of importance to our discussion. The examples most often cited are drawn primarily from Yannai, who lived in the mid- to late sixth century, some 150 years *after* the Sepphoris synagogue was purportedly built. In this light, any claim for the confluence of these two types of cultural expression is clearly undermined.[101]

Furthermore, how many people could understand these poetic compositions? With few exceptions, *piyyut* is very often a sophisticated and difficult literary genre for an average synagogue congregant to understand. Most *piyyutim* are in Hebrew, ranked by the extent of its usage a distant third (after Aramaic and Greek) among the Jews of Byzantine Palestine. Epigraphic evidence, especially of synagogue donors and in funerary contexts, comprises the overwhelming bulk of such remains and points to the dominance of Aramaic and Greek, indeed far from the sophisticated Hebrew of *piyyutim*. The fact that the use of *targum* for translating Scriptures in the synagogue into the vernacular was well developed and ubiquitous at this time indicates that Hebrew was not a familiar or widely understood language in most congregations.[102]

98. Fine, "Art and the Liturgical Context," 229–30. And elsewhere: "The art and the liturgy of the synagogue are cut from a single cloth, reflecting differing but always interwoven aspects of the synagogue religiosity in Byzantine Palestine" (Fine, *Art and Judaism*, 189).

99. Contra Shinan, "Synagogues in the Land of Israel," 151–52.

100. On the social context and issues involved in the public recitation of *piyyut*, see L. I. Levine, *Ancient Synagogue*, 585–86.

101. Similarly, for problematic assertions regarding the connection between *piyyut* and the Dura paintings, see Laderman, "New Look."

102. See, however, Fraade ("Rabbinic Views") for a somewhat different emphasis.

Finally, any comparison of the usage of art in a Christian liturgical context with that of a Jewish one in this period is fraught with questionable assumptions. Much of the concern of church art historians in relating artistic material to liturgical ritual is explained by the need to illustrate and concretize complex theological ideas.[103] Thus, the didactic function of art in the church is assumed to be of great importance. In discussing apsidal imagery, Geir Hellemo remarks:

> During the liturgical introductory invocation (*Sursum corda*), the congregation's attention is called upon and mental concentration is requested. As the celebration of the Eucharist involves complicated chains of thought, the participants need all the help they can get in order to understand the depths of meaning contained in the act. To the overall synthesis of the various chains of thought which contribute to the meaning of the Eucharist, the visible pictorial programs are of the greatest value. Imagery's most important quality is to recapitulate in synthesis that which words and ritual acts take much time to present. Thus, all additional elements entering the liturgy as it progresses can be retained by the congregation. In our opinion, apsidal imagery unifies and summarizes the central content of the eucharistic prayer. By doing this it furnishes a certain support for members of the congregation in their participation and understanding of the ritual celebration itself.[104]

One must be extremely cautious in assuming that Judaism had the same need for visual elucidation as Christianity. Both religions were indeed quite different in this respect. Given the striking differences in the nature of their respective liturgies, one would be hard pressed to make a case for comparable complex doctrines among Jews that would require the assistance of a narrative or symbolic art. Whereas Christian liturgy gave expression to the mysteries of faith (as spelled out in the above quotation), Jewish liturgy was relatively straightforward. The prayers and scriptural readings were either self-explanatory or, by the fifth century, already being elucidated in Aramaic and Greek translations, scriptural explanations (*targumim*), and homiletic explications (sermons).

Thus, the potential functions of art in the majority of synagogues from Late Antiquity—to stimulate historical memory; to highlight ritual symbols and through them certain religious observances; to complement the instruction that took place in a variety of educational settings; and to instill messianic hopes—were realized only in a very limited way when compared to the Christian setting.

The above comments are not intended to preclude *piyyut* as shedding light on synagogue art. The overlap of these two realms in the synagogue is certainly conducive to exploring potential ties. However, given the current stage of research and the dearth of data on the Jewish side, any such claim must be regarded with caution.

103. Cormack, "Visual Arts," 894. See also the comments of R. M. Jensen, "Giving Text Vision and Images Voice."

104. Hellemo, *Adventus Domini*, 281.

THE ELUSIVE QUEST FOR ALL-EMBRACING
INTERPRETATIONS

Behind the interpretations surveyed above, and one of the fundamental method-ological issues pervading virtually every area in the study of antiquity, is the matter of finding correlations between isolated sources of information and fathoming their implications. In its most extreme form it has been referred to as parallelomania, as described by Samuel Sandmel in his classic article on the subject a half century ago: "We might for our purposes define parallelomania as that extravagance among scholars which first overdoes the supposed similarity in passages and then proceeds to describe source and derivation as if implying literary connection flowing in an inevitable or predetermined direction."[105] Jonathan Z. Smith has formulated the matter as follows: "It is as if the only choices the comparativist has are to assert either identity or uniqueness, and that the only possibilities for utilizing comparisons are to make assertions regarding dependence. In such an enterprise, it would appear, dissimilarity is assumed to be the norm; similarities are to be explained as either the result of the 'psychic unity' of humankind, or the result of 'borrowing.'"[106] Rather, claims Smith, the case for analogy, that is, pointing out similar and different traits without necessarily making a causal connection, should be the focus of research; other assessments often reflect a scholar's agenda and not the historical/literary reality.[107]

While the comparative approach has often been taken to extremes of parallelo-mania, it has also engendered an opposite, contrastive method. Within Jewish stud-ies, Yehezkel Kaufmann and Urbach represent such an approach, in biblical and rabbinic studies, respectively.[108] Most scholars today have attempted to transcend this polarized dichotomy, each in his/her own way, searching for an appropriate balance that would allow for both perspectives—a balance that would necessarily vary from one case to the next. Often referred to as the "contextual approach," such an understanding aims to restrain the excessive and uncritical aspects of comparisons while limiting the emphasis on contrasts.[109]

In our case, parallelomania might well apply to those scholars who seek to establish a connection between textual sources and artistic remains, positing almost without exception the priority and influence of text over artifact. The assumptions of such an approach are many: (1) two phenomena are integrally related; (2) influence is assumed to be in one direction only; and (3) influences between a particular text and material artifact are direct. This kind of unilateral approach, more than anything else, is apt to reflect a scholar's personal agenda and perspective: "Com-

105. Sandmel, "Parallelomania," and quote from p. 1.

106. J. Z. Smith, *Drudgery Divine*, 47.

107. Ibid., 49–53. For a recent discussion of these distinctions, see Doering, "Parallels without 'Parallelomania,'" 19–26.

108. Kaufmann, *Religion of Israel*; Urbach, *Sages*.

109. See, e.g., Hallo, *Book of the People*, 23–34.

parison provides the means by which *we* 're-vision' phenomena as *our* data in order to solve *our* theoretical problems."[110] Such an approach, moreover, leaves little room for positing the existence of a common heritage or a series of religious trajectories that might have conveyed a similar, if not identical, message.

For all their differences in emphasis, the latter two approaches, polemics and *piyyut*, have one thing in common. They are dependent in varying degrees on Christian models and sources. *Piyyut*'s relevance to synagogue art is accorded the same importance as the relationship between art and liturgy within the Christian context, while the existence of a Jewish-Christian polemic rests largely on the information culled from Christian sources. However, the differences between the study of Christianity and Judaism in these areas are chasmic, given the vastly different quantitative and qualitative evidence available for Christianity on the one hand and for Judaism on the other. Such considerations pertain to both the liturgical and polemical realms. For example, the wealth of Christian art in the fifth to seventh centuries, together with the enormous number of literary sources addressing art and liturgy, allow for rich internal artistic comparisons as well as an assessment of art's relationship to the well-documented liturgical customs and ideologies of contemporary church sources.[111] The absence of such massive evidence on the Jewish side presents a formidable barrier for anyone wishing to draw comparisons when using Jewish evidence.

More generally, however, attempting to invoke any of the five approaches discussed above in interpreting the meaning of Jewish art requires a discussion of the enormous architectural, artistic, and epigraphic diversity among ancient synagogues themselves (which will be treated in detail in the following chapter). It will be argued that this diversity is directly related to the fact that each community was the ultimate arbitrator of what was to be displayed in its respective synagogue building.

110. J. Z. Smith, *Drudgery Divine*, 52. Davila ("Perils of Parallels") notes the following "rules" and criteria for evaluating parallels: (1) make clear what is being compared to what and how; (2) a "parallel" does not necessarily mean something was "borrowed," and if it were, then the direction of the borrowing must be demonstrated, not assumed; (3) take into account both similarities and differences; (4) the compared elements must be understood in their own cultural and linguistic contexts; (5) patterns of parallels are more important than individual parallels; (6) the more widely shared the parallel, the more general (or vacuous) its significance; (7) beware of comparisons that imply an evolutionary goal; and (8) beware of unfalsifiable parallels.

111. When Mathews suggests that the "processional convergence on an axially organized core image provided a formula for the program of the Early Christian church" (*Clash of Gods*, 176), he is relying on: "A confluence of figures toward Christ is prominent in the art of the catacombs and sarcophagi, and this composition governs a surprising number of church programs of the widest diversity in size, shape, and function. Over sixty percent of the apse compositions catalogued by Ihm include centripetal processions. All of the mosaicked churches of Ravenna fall in this class, including basilicas, baptisteries, and the octagon of Saint Vitale" (ibid., 150).

Indeed, this is not very different from what characterizes art generally in Late Antiquity. In noting what he calls the polyvalent dimension in Roman and Byzantine art, Elsner claims: "People relate to works of art in different ways, depending upon different contexts and at different times,"[112] and while discussing portrayals of flora and fauna in Byzantine Christian contexts, Henry Maguire has articulated a similar view:

> Most of the images from natural history that appear in early Byzantine art were not like modern traffic signs, with necessarily fixed and invariable messages, but . . . were more akin to metaphors. The meanings of any given image, an eagle, for example, or a fish, could be nuanced or even completely altered according to the context provided by a given work of art, just as works in a language can change their meanings in different situations. Also, like words in a language, the images employed by artists could change their meanings over the course of time.[113]

In terms of the Jewish context, local needs and tastes were crucial factors in determining synagogue policies, including decisions about how to decorate the building. Why certain motifs were chosen and what they were intended to signify lie ultimately in decisions made by a particular artisan, patron, communal leader, local community, or a combination thereof when embarking on such a project.

Thus, it is the local context that can best account for the many differences between the various Jewish communities, be it in their architecture, liturgy (Torah reading, *piyyutim*, and prayers), epigraphy, and, art, and this is as true for Late Roman and Byzantine Palestine as it is for the Diaspora. It is to an investigation of this local dimension of Jewish art, and secondarily to some wider contexts, that we now turn.

112. Elsner, *Art and the Roman Viewer*, 1. Nevertheless, one must bear in mind that similarities did exist, not only in the representations but also in their interpretations. Unless some hard evidence exists in this regard, and in light of the fact that the representations themselves vary from place to place (as, for instance, with respect to the zodiac), it is unjustified to assume a priori identical meanings and significance.

113. H. Maguire, *Earth and Ocean*, 8.

VI

ART AND SOCIETY

19. THE COMMUNAL DIMENSION OF SYNAGOGUE ART AND OTHER RELATED CONTEXTS

IN ATTEMPTING TO understand Jewish art in Late Antiquity, it is important to determine who made the ultimate decision about the kind of art that would be displayed.[1] All the literary, epigraphic, and artistic sources at our disposal point to the local community as the ultimate arbiter regarding the physical and programmatic aspects of a synagogue's architecture and art. There is no evidence of any overseeing institution or group that might have made such decisions.[2] While the Patriarchate might have been influential in introducing central motifs into the Jewish artistic repertoire, its sway over the local communal level was at best indirect and partial; it was a community's prerogative to decide what motifs would be adopted, adapted, or rejected.[3] Consequently, no two synagogue buildings were identical in their architecture, layout, epigraphy, or art.

The synagogue, as has been noted, functioned as the local Jewish community's institution par excellence, providing a space for a range of services that might in-

1. Our focus here will be on synagogue art, which was the most expressive and developed art within the Jewish community, in contrast to that found in funerary contexts and private dwellings. The latter is understandably diffuse, differing from home to home and from catacomb to catacomb (and often from one hall/room to the next), depending largely on familial and personal preferences.

2. On the major role played by the community and its representatives in determining local issues generally, see Goodman, *State and Society*, 119–34; Gafni, *Jews of Babylonia*, 104–9. Regarding the rabbis in this respect, see chap. 20. A striking statement of local Jewish involvement in communal affairs throughout the Roman world, if indeed historically reliable, is found in the biography of Alexander Severus (*Scriptores Historiae Augustae* 45.6–7). Allegedly following Jewish and Christian practice, the emperor suggested that the names of candidates for imperial appointments be announced beforehand so that anyone could have the opportunity to lodge a protest. See M. Stern, *GLAJJ*, vol. 2, no. 523.

3. See chaps. 6, 16, and 21. On the lesser centrality of communal institutions in Babylonia as compared to contemporary Palestine, including synagogues, see Gafni, *Jews of Babylonia*, 104–17, and my comments thereon (*Ancient Synagogue*, 286–91).

clude a meeting place, educational, social, and charity-oriented activities, communal meals, a local court, and a place of residence.[4] The tendency of some (many?) second-century Jews to refer to the synagogue as a *bet 'am* ("house of [the] people")—to the chagrin of certain rabbis (B Shabbat 32a)—clearly indicates the importance of this dimension of the institution. Indeed, the synagogue belonged to the community, and Mishnah Nedarim (5, 5) clearly assigns the synagogue and its contents a communal context: "And what things belong to the (entire) town itself? For example, the plaza, the bath, the synagogue, the Torah chest, and [holy] books."[5] Synagogue officials were thus beholden to their respective communities, not to any outside authority.

THE COMMUNAL FRAMEWORK OF JEWISH LIFE IN LATE ANTIQUITY

Whether it was the congregation or its chosen representatives who had ultimate authority in synagogue matters, what is certain is that decisions regarding this institution rested squarely on the shoulders of the local community. Addressing the issue of whether or not to sell communal property, the Mishnah (Megillah 3, 1) claims that it was up to the townspeople (בני העיר) to make that decision, while the Tosefta (Megillah 2, 12, p. 351), according to R. Judah, asserts that appointed *parnasim* could act on the institution's behalf only after the local residents grant them the requisite authority. The Yerushalmi (Megillah 3, 2, 74a), too, notes that synagogue officials were dependent upon the agreement and support of the community at large: "The three [representatives] of the synagogue [act on behalf of] the [entire] synagogue; the seven [representatives] of the townspeople [act on behalf of] the [entire] town." Regarding Babylonia, the Bavli (Megillah 26a–b) also reflects this reality in its discussion of the sale of a synagogue or its holy objects.[6]

The above traditions probably refer to most congregations, both rural and urban. However, there were also synagogues, such as the Theodotus synagogue in first-century Jerusalem, that operated under the patronage of a wealthy individual or a group of wealthy members. Judging by the epigraphic remains, it would seem that wealthy and acculturated members of a congregation often shouldered responsibility for the physical appearance of their synagogue—as in Sepphoris, Caesarea, Bet Shean, and elsewhere in Palestine, and in Dura, Sardis, Taphos (Syria), Teos, Phocaea (Asia Minor), and Golgoi (Cyprus) in the Diaspora.[7]

4. See L. I. Levine, *Ancient Synagogue*, 390–411. For an interpretation that the term "small city" (Eccles. 9:14) refers to a synagogue, see Ecclesiastes Rabbah 9, 14.

5. See also B Betzah 39b. The communal dimension of the synagogue is also reflected in a rabbinic dispute ascribed to the academies of Hillel and Shammai; see T Tohorot 8, 10, p. 669.

6. See also B Megillah 27a.

7. See Roth-Gerson, *Greek Inscriptions; Inscriptiones Judaicae Orientis* (3 vols.).

On occasion, a community was spared much of the burden of building and maintaining a synagogue building if the latter was part of a wealthy individual's home or building complex, as may have been the case if the prayer room in Bet Shean was indeed part of Leontis's residence.[8] Alternatively, a wealthy person might have donated the ground floor of a building for use by the community, and this seems to have been the arrangement between Claudius Tiberius Polycharmos and the Stobi congregation.[9] In fact, the talmudic reference to "the synagogue of an individual" (בית הכנסת שליחיד) may refer to such a phenomenon (Y Megillah 3, 1, 73d).[10]

Communities might judge themselves and others by how successful and impressive their respective institutions looked. This sense of pride is reflected in the boastful statement made by R. Ḥama bar Ḥanina to R. Hoshaya while touring the synagogues of Lod: "How much [money] have my ancestors invested here [i.e., in these buildings]!" R. Hoshaya's response is no less interesting, voicing his disdain for this ostentatious "edifice complex": "How many souls have your ancestors lost here [by the misuse of monies]? There is no one studying Torah" (Y Sheqalim 5, 6, 49b; Y Peah 8, 9, 21b).[11]

Local loyalties often ran high, and synagogue buildings and their functionaries could become a cause of rivalry between neighboring communities. Although articulated only in a late midrash, such competition is sufficiently documented—for the Roman world generally and the Galilee in particular—to accord this source an ample degree of credibility: "[Regarding] a small town in Israel, they [the townspeople] built for themselves a synagogue and academy and hired a sage and instructors for their children. When a nearby town saw [this], it [also] built a synagogue and academy, and likewise hired teachers for their children" (Seder Eliyahu Rabbah 11, pp. 54–55).[12]

The local community was, of course, responsible for the synagogue's maintenance; together with salaries, such expenses might prove to be a heavy burden. Some outlays were covered by wealthy laymen or officials such as the archisynagogue, presbyter, or archon. Prayer leaders, Torah readers, liturgical poets, and preachers may have received remuneration for their professional services, but of this we cannot be certain. Other functionaries—the teacher (סופר), *ḥazzan*, *shamash*, and *meturgeman*—did receive some sort of compensation, however minimal.[13] Moreover,

8. Zori, "House of Kyrios Leontis." For the somewhat speculative suggestion that this house belonged to a Judeo-Christian, see Z. Safrai, "House of Leontis 'Kaloubas,'"

9. Hengel, "Die Synagogeninschrift von Stobi," 159ff.

10. See also T Megillah 2, 17, p. 352; for a specific example of this phenomenon, see B Megillah 26a, 27a.

11. On Lod and its Jewish community in this period, see J. J. Schwartz, *Lod (Lydda)*, 101–20.

12. Rivalry between neighboring cities is attested by Josephus, *Life* 35–39, and Lamentations Rabbah 1, 17, p. 46a.

13. See L. I. Levine, *Ancient Synagogue*, chap. 11, as well as B Shabbat 56a; Midrash Hagadol, Exodus 21:1, p. 454. For one of the rare references to a *shamash*, see Y Maʿaser Sheni 5,

the control exercised by the community included the hiring and firing of synagogue functionaries. In one instance, the synagogue community of Tarbanat[14] dismissed one R. Simeon when the latter proved unwilling to comply with its request:

> The villagers said to him: "Pause between your words [when either reading the Torah or rendering the *targum*], so that we may relate this to our children."[15]
> He went and asked [the advice of] R. Ḥanina, who said to him: "Even if they [threaten to] cut off your head, do not listen to them." And he [R. Simeon] did not take heed [of the congregants' request], and they dismissed him from his position as *sofer*. (Y Megillah 4, 5, 75b)[16]

A community's search for competent personnel was not uncommon. Around the turn of the third century, the residents of Simonias solicited R. Judah I for help in finding someone who could preach, judge, be a *ḥazzan* and teacher of children, and "fulfill all our needs" (Y Yevamot 12, 6, 13a; Genesis Rabbah 81, 2, pp. 969–72).[17] His recommendation, Levi b. Sisi, was reportedly interviewed for the position and made an unfavorable first impression. A similar request was made of R. Simeon b. Laqish in the mid-third century when visiting Bostra (Y Shevi'it 6, 1, 36d; Deuteronomy Rabbah, Va'ethanan, p. 60).[18]

Construction or repair of the synagogue building was likewise a communal responsibility, and apparently a binding obligation: "Members of a town [can] force (כופין) one another to build a synagogue for themselves and to purchase a Torah

2, 56a. See also Targum Pseudo-Jonathan to Gen. 25:27, anachronistically referring to the biblical Patriarch Jacob functioning in such a capacity in a school. An inscription from the Bet She'arim synagogue may indeed refer to such a position; see Schwabe and Lifshitz, *Beth She'arim*, vol. 2, no. 205; Roth-Gerson, *Greek Inscriptions*, 141. On the שומר (guard) in a *bet midrash* setting, see B Yoma 35b (= Yalqut Shim'oni, Genesis, 145, p. 753).

14. Although at times disputed, it is usually assumed that Tarbanat was a border town between the Lower Galilee and the Jezreel Valley, northwest of present-day 'Afulah; see Press, *Topographical-Historical Encyclopaedia*, 2:380; Klein, "R. Simeon Sofer of Tarbanat"; Klein, *Galilee*, 110; Avi-Yonah, *Gazetteer*, 99, 108; Reeg, *Ortsnamen*, 278–79. Other identifications include Tarichaeae (Horowitz, *Palestine and the Adjacent Countries*, 1:305) and Trachonitis (M. B. Schwartz, *Torah Reading*, 288).

15. Alternatively: "so that they (i.e., our children) may recite this material to us."

16. The translation follows the traditional commentators. Sokoloff (*Dictionary*, 488), however, suggests that the reference here is specifically to the reading of the Decalogue.

17. Simonias was located in the southwestern sector of the Lower Galilee, on the edge of the Jezreel Valley, northwest of 'Afulah. See Neubauer, *La géographie*, 189; Möller and Schmitt, *Siedlungen Palästinas*, 174–75; Reeg, *Ortsnamen*, 456–57, and the bibliography therein. See also Z. Safrai, *Pirqei Galilee*, 55–57.

18. On Bostra, see Bowersock, *Roman Arabia*, passim; Kindler, *Coinage of Bostra*, 6–11. One can thus understand the irritation, if not outright anger, felt by the community in Cilicia that witnessed the dismissal of its synagogue officials by the Patriarch's emissary Joseph in the early fourth century; see Epiphanius, *Panarion* 30.11.4.

scroll and [books of the] Prophets" (T Bava Metzia 11, 23, p. 125).[19] A number of epigraphic sources from Byzantine Palestine highlight the centrality of this communal dimension, attesting to cases in which the community as a whole was acknowledged for its donations to and support of the synagogue. From Jericho:

> May they be remembered for good. May their memory be for good, the entire holy congregation, the old and the young, whom the King of the Universe has helped, for they have contributed to and made this mosaic.
>
> May He who knows their names, [as well as] their children's and members of their households, write them in the Book of Life together with all the righteous. All the people of Israel are brethren (חברין). Peace. Amen.[20]

And from Bet Shean:

> May they be remembered for good, all members of this holy association, who have supported the repair of the holy place and its well-being. May they be blessed. Amen . . . in great kindness and peace.[21]

An inscription may have been intended not only to thank and bless members for past good deeds, but also to encourage them to continue doing so in the future as well, as this one from Ḥammat Tiberias:

> May peace be with all those who have contributed in this holy place and who will continue to give charity in the future. May that person be blessed. Amen, Amen, Selah. And to me, Amen.[22]

In some places, synagogue inscriptions focus on matters of primary concern to the entire congregation. The monumental inscription at the entrance to the Reḥov synagogue's main hall reflects this community's halakhic orientation, itemizing those foods forbidden or permitted on the sabbatical year and delineating the boundaries of Jewish Palestine within which such laws applied.[23]

A second inscription, located in the western aisle of the 'En Gedi synagogue and written in Aramaic, addresses a number of important communal concerns:

19. See also Lieberman, *Tosefta Ki-Feshuṭah*, 9:320–21. For a suggestion that a communal effort on the part of Sardis Jewry was responsible for the acquisition and remodeling of the local synagogue in the third and fourth centuries, see Bonz, "Differing Approaches to Religious Benefaction."

20. Naveh, *On Stone and Mosaic*, no. 69; Sokoloff, dictionary, 95. Additional examples may be found at Susiya, Ḥuseifa on the Carmel, and perhaps Ḥammat Tiberias. See Naveh, *On Stone and Mosaic*, nos. 76, 39, and 24, respectively. On the expression כל ישראל חברים ("All of Israel are brethren"), see Y Ḥagigah 3, 6, 79d.

21. Naveh, *On Stone and Mosaic*, no. 46, and comments on p. 10.

22. Ibid., no. 26.

23. For other remains from this synagogue, see chap. 20.

He who causes dissension within the community, or speaks slanderously about his friend to the gentiles, or steals something from his friend, or reveals the secret of the community to the gentiles—He, whose eyes observe the entire world and who sees hidden things, will turn His face to this fellow and his offspring and will uproot them from under the heavens. And all the people said: "Amen, Amen, Selah."[24]

Thus, the 'En Gedi community spelled out on its synagogue floor the types of behavior it deemed inappropriate. Here, too, a synagogue inscription served as a main vehicle for expressing communal concerns and expectations.

Communal responsibility did not end with the physical and administrative aspects of the synagogue. Its liturgical components are vividly borne out by an account regarding a Caesarea synagogue whose congregants recited a central prayer in Jewish liturgy, the *Shema'*, in Greek. Clearly, the use of Greek met local needs. What makes this account no less fascinating, and the reason it appears in a rabbinic source at all, is the fact that two sages reacted to this phenomenon, each adopting a totally different position:

R. Levi bar Ḥiyta went to Caesarea. He heard voices reciting the *Shema'* in Greek [and] wished to stop them. R. Yosi heard [of this] and became angry (at R. Levi's reaction). He said, "Thus I would say: 'Whoever does not know how to read it in Hebrew should not recite it [the *Shema'*] at all? Rather, he can fulfill the commandment in any language he knows.'" (Y Sotah 7, 1, 21b)

Thus, we learn that one sage was openly hostile to this communal practice while the other was far more tolerant.[25] It is very clear that their opinions were never solicited beforehand and, once expressed, probably played no role in this synagogue's policy. There can be little question that synagogues such as this one—which would include virtually all Roman Diaspora congregations and quite a few others in Palestine— likewise rendered their sermons and the expounding of Scriptures in Greek.

DIVERSITY AMONG JEWISH COMMUNITIES: THE LITURGICAL EVIDENCE

In a similar vein, there is relatively solid evidence that the specific implementation of the Palestinian Torah-reading practice in a triennial cycle varied from one synagogue to the next; our information from Late Antiquity indicates that Torah

24. L. I. Levine, "Inscription in the 'En Gedi Synagogue." For a full bibliography regarding this inscription, see Tabory, *Bibliography*, 40.

25. Interestingly, neither of these sages' statements reflects the more lenient position of the Mishnah, which makes explicit allowance for the *Shema'* to be recited in any language (Sotah 7, 1). R. Levi's view does, however, correspond to that of R. Judah I, quoted in the Yerushalmi just before the above Caesarean account, namely, that the *Shema'* ought to be recited in Hebrew.

readings might have been divided into 141, 154, 155,[26] 167, and possibly 175 portions over a three-year period.[27] The annual Babylonian Torah-reading cycle is evidenced in Byzantine Palestine as well, and thus it is quite clear that there was a great deal of diversity regarding this very central ceremony, attesting, once again, to the autonomy exercised by the local congregation. This fact is corroborated by a comment appearing in *Differences in Customs*, a composition that compares variant religious practices in Palestine and Babylonia of Late Antiquity; regarding Palestine, it notes: "The section of the Torah read in one area is not read in another" (no. 48, p. 88 n. 125, and p. 173).[28]

Readings from the prophetic books (*haftarot*) that accompanied the Torah recitation were also quite diverse, with some synagogues requiring twenty-one verses to be read (three for each of the seven people called to the Torah; B Megillah 23a). The Yerushalmi explains that in places where a *targum* was recited only three verses were to be read; otherwise the number was twenty-one (Y Megillah 4, 3, 75a).[29] Tractate Soferim (13, 15, pp. 250–51), however, mentions at least four different practices in this regard: "When are these rules (i.e., reading twenty-one verses) applicable? When there is no translation or homily. But if there is a translator or a preacher, then the *maftir* reads three, five, or seven verses in the Prophets, and this is sufficient." Moreover, given its lesser sanctity, the *haftarah* reading was a much more flexible component than the Torah reading; verses on assorted subjects could be drawn from different sections of a biblical book and even from several different books (M Megillah 4, 4; B Megillah 24a).[30] Here, too, the local congregation (or its representatives) decided on the preferred liturgical practice.

The same probably held true of other components in the liturgy. Although evidence for this period is negligible, the prayer liturgy in the synagogue (perhaps similar to a rabbinic context) was most likely in a fluid state; there is no way of determining how fixed the prayer service might have been and what its parameters were. *Piyyut* also made its appearance at this time, yet, as noted above, we have no idea how many congregations at any given time might have incorporated such poetic recitations in the service or how frequently they were recited. The sophisticated Hebrew often used in *piyyut* may well have been a deterrent to congrega-

26. Fleischer, *Pizmonim of the Anonymous*, 33–40; see also Esther Rabbah 1, 3.

27. These numbers derive from lists of *sedarim* found in Genizah manuscripts and early Torah scrolls (Joel, "Bible Manuscript," 126–29), as well as Tractate Soferim 16, 8, pp. 291–92. On the number 175, see Y Shabbat 16, 1, 15c; Tractate Soferim, 16, 8, pp. 291–92; and Elbogen, *Jewish Liturgy*, 133. Shinan ("Sermons, Targums, and the Reading from Scriptures," 101–2) has pointed out that other variations are also reflected in midrashic homilies.

28. See also L. I. Levine, *Ancient Synagogue*, 567–69; as well as Lamentations Rabbah 3, 6, p. 69.

29. While the Yerushalmi notes that in the presence of R. Yoḥanan only three verses of the *haftarah* were normally recited, the Bavli (Megillah 23b) records ten.

30. Variations in the selection of *haftarot* to be read continued throughout the Middle Ages; see D. E. S. Stein, "*Haftarot* of Etz Hayim."

tions composed primarily of Aramaic or Greek speakers.[31] Whatever the case, what should be incorporated and how frequently it should be done were determined by the local congregation.

DIVERSITY AMONG JEWISH COMMUNITIES: THE ARCHAEOLOGICAL EVIDENCE

The local focus of Jewish life in Late Antiquity is clearly reflected in the material culture as well. Beginning with the architectural remains, the rigid classification of Palestinian synagogues that once linked typology with chronology has been largely abandoned. Whereas it was once assumed that synagogues of the Byzantine period were built according to a basilical plan, following the contemporary church model, we are aware today that not only was there a richer variety of basilica-type buildings than previously thought, but also that other types of synagogue buildings were being erected at this time—Galilean-, Golan-, and broadhouse-type structures, as well as the architecturally unique southern Judaean synagogues.[32]

A striking case relating to synagogue diversity (as noted in chap. 11) is evident in the Bet Shean region, where we know of five synagogue buildings that functioned simultaneously in the sixth century. This cluster of buildings includes Bet Shean A, just north of the city wall;[33] Bet Shean B, near the southwestern city gate; Bet Alpha, to the west; Ma'oz Ḥayyim, to the east; and Reḥov, to the south. Although contemporaneous, these buildings are remarkably different from one another in their architectural plans, in the languages used in their inscriptions, and in their art.[34]

Indeed, the artistic representations in the Bet Shean synagogues are about as broad as one could imagine, ranging from strictly conservative to strikingly liberal. At the former end of the spectrum stands the Reḥov building, in which all the decorations are of a geometric (and in one case architectural) nature. However, the mosaic floor in the prayer room of the Bet Shean B synagogue,[35] with its inhabited (or "peopled") scrolls, features figural representations of animals alongside an elaborate floral motif (fig. 120).[36] Most unusual is the mosaic floor of an adjacent room with panels containing scenes from Homer's *Odyssey,* a depiction of the god of the Nile together with Nilotic motifs (a series of animals and fish) and a symbolic representation of Alexandria with its customary Nilometer (see chap. 16, fig. 110).[37]

31. See chap. 18, n. 100, as well as L. I. Levine, *Ancient Synagogue,* 563–88.

32. L. I. Levine, "Synagogues," 1422–23; L. I. Levine, *Ancient Synagogue,* 319–26; Amit, "Architectural Plans"; Amit, "Source of the Architectural Plans"; Amit, "Synagogues of Hurbat Ma'on and Hurbat 'Anim."

33. This synagogue is considered by some to be Samaritan, and not Jewish; see Amit, *Ancient Synagogue,* 215 n. 21.

34. For greater detail, see ibid., 215–20.

35. See chaps. 11 and 16.

36. See A. Ovadiah and Turnheim, *"Peopled" Scrolls,* passim, and esp. 117–27. See also Dauphin, "Development of the 'Inhabited Scroll.'"

37. Between these two panels is a third one containing a Greek dedicatory inscription naming one Leontis as the benefactor or owner of the building.

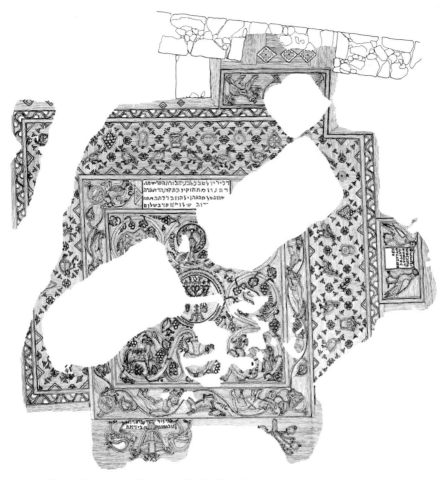

FIG. 120 Mosaic featuring a floral motif with figural representations,
Bet Shean B synagogue/prayer room.

Carrying this inclination toward expansive artistic representation even further
is the Bet Alpha synagogue, richly diverse in Jewish content and pagan motifs ex-
pressed through Jewish symbols, the zodiac, and the *ʿAqedah* scene.[38] Although the
same artisans, Marianos and his son Ḥanina, laid the mosaic floors of both the Bet
Alpha and Bet Shean A synagogues, the style and content at each site are strikingly
different. This is a clear example of two neighboring communities—and not the
artists themselves—choosing contrasting floor designs from various types of pat-
tern books (or oral reports) then in circulation. In summary, the floors of these
contemporaneous Bet Shean synagogues range from strictly aniconic patterns to
elaborate representations of Jewish and non-Jewish figural motifs.[39]

38. See chap. 14.

39. See also chap. 11. In the Jericho region as well, there seem to have been striking
differences between neighboring synagogues. The local sixth-century Jericho synagogue

Thus we can safely posit that the local context of the Late Antique synagogue is the key to understanding Jewish art at this time. Yet while this dimension is the most crucial component, it is nevertheless insufficient in and of itself. Several other factors that had an impact on the local communities must also be considered to complete the picture.

The Regional Factor

In Byzantine Palestine, the regional level is far from being an inconsequential factor. Given the concentration of synagogues in a number of geographical areas, distinctive styles and emphases are often quite evident in shaping the art and architecture of local buildings. The regional dimension has always been recognized with regard to the Galilee, but over recent decades it has become apparent for the Golan and southern Judaea as well.[40]

Galilee. Galilean regionalism was already demarcated by Kohl and Watzinger in their pioneering study from the early twentieth century;[41] E. M. Meyers, in his study from the early 1970s, continued to refine his analysis in a series of subsequent articles,[42] calling attention to a number of distinctive characteristics dividing the Upper and Lower Galilee. The former was more mountainous, had more rainfall and poorer roads, and contained villages and small towns but no cities. As a result, the Upper Galilee was culturally more conservative, and this found expression in the limited use of Greek, few figural representations, and, perhaps not surprisingly, only a smattering of Jewish symbols.[43] With but few exceptions,[44] this region's contact with the outside world seems to have been relatively limited.

The Upper Galilee produced most of what is commonly referred to as the Galilean-type synagogue (fig. 121), characterized by monumental main entrances

has demonstrably aniconic decorations featuring geometric patterns and a stylized ark. Yet, several kilometers away and from about the same time, Na'aran boasted a zodiac design, a representation of biblical Daniel, and an assortment of animal depictions. Both synagogues, however, contain only Aramaic or Hebrew inscriptions; Greek is not in evidence.

40. See Kohl and Watzinger, *Antike Synagogen in Galilaea*; Foerster, "Art and Architecture"; Foerster, "Ancient Synagogues of the Galilee," 290–302; see also above, chap. 11; Ma'oz, "Art and Architecture"; Hachlili, "Late Antique Jewish Art"; Amit, "Architectural Plans of Synagogues." For an attempt to categorize Palestinian synagogues generally on the basis on types and regions, see Kloner, "Ancient Synagogues in Israel."

41. Kohl and Watzinger, *Antike Synagogen in Galilaea*; see also above, chap. 11.

42. E. M. Meyers, "Galilean Regionalism"; and, in subsequent years, E. M. Meyers, "Cultural Setting of Galilee"; E. M. Meyers, "Galilean Regionalism: A Reappraisal," esp. 129 n. 2, for additional bibliography.

43. In this regard, it is interesting to note that two of the Galilean-type synagogues with the most elaborate decorations, Capernaum and Chorazin, are located at the eastern extremity of the region and, geographically speaking, lie more in the Lower Galilee.

44. Such as the large amount of Tyrian coins and imported fine ware found in excavations in this region; see R. S. Hanson, *Tyrian Influence*; Groh, "Fine-Wares from the Patrician and Lintel Houses."

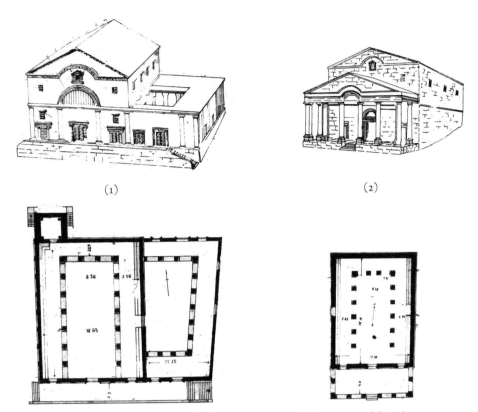

(1) (2)

FIG. 121 Restorations and plans of Galilean synagogues: (1) Capernaum; (2) Barʿam.

oriented toward Jerusalem, large hewn stones, stone floors, stone benches on two or three sides of the main hall, two or three rows of large columns, and stone carvings as the main ornamental element. Such decorations found expression primarily on the buildings' exterior (door and window areas, capitals, lintels, and doorposts, as well as friezes, pilasters, gables, and arches) and to a lesser extent on its interior.[45] However for all these regional similarities, there were also numerous differences between these synagogues, so much so that Gideon Foerster summed up his study of the Galilean-type buildings as follows: "Studying the art and architecture of the Galilean synagogues leads one to conclude that these synagogues are a local, original, and eclectic Jewish creation."[46]

45. See Foerster, "Art and Architecture." It is important to point out that the artistic remains of the Galilean-type synagogues are uneven. Capernaum and Chorazin to the east bear the overwhelming majority of such motifs, whereas the remaining Galilean synagogues have minimal decoration and are far plainer. In the Golan, on the other hand, the repertoire is more evenly spread throughout the region.

46. Ibid., 144.

The Lower Galilee, in contrast, presents a very different cultural panorama. Flanked by the two urban centers, Sepphoris to the west and Tiberias to the east, the region's more navigable terrain boasted better roads and, consequently, closer ties with the surrounding non-Jewish cities and regions. Thus, the prominence of Greek across the Galilee—from the synagogues in Tiberias (ten of the eleven dedicatory inscriptions are in Greek) and Sepphoris (thirteen out of twenty-four are in Greek) to the Bet She'arim necropolis (where over 80 percent of the nearly three hundred inscriptions are in Greek)—reflects a cosmopolitan dimension that stands in sharp contrast to the more provincial Upper Galilee.[47] Rare is the site that does not have some sort of artistic representation, be it the zodiac or Jewish symbols (Tiberias and Sepphoris), biblical scenes (Sepphoris and Khirbet Ḥamam), or, in one case (Japhia), what were apparently animal representations of the tribes of Israel.

Thus, the combined effect of the topographical, geographical, and climatic elements in the Galilee created two very different settlement patterns, which in turn gave rise to dramatically different demographic, cultural, and artistic milieux.

Golan. The twenty-four known Golan-type synagogues (Gamla excluded) are in many respects similar to the Galilean-type buildings.[48] Scholars have noted this connection for some time, as the synagogues in both groups utilized much the same architectural features and building techniques. Nevertheless, the differences are not inconsequential.[49] The Golan-type buildings were constructed of local basalt (in contrast to Galilean limestone), and all (with the exception of e-Dikke) had a single entrance that might face in any direction. In contrast to the Galilean-type building, where there were usually three entrances that almost always faced south, the interior of the Golan synagogues was oriented either to the south or west.[50] Column pedestals and heart-shaped corner columns, so ubiquitous in the Galilee, are absent from the Golan.

The artistic differences between the synagogues of the Upper Galilee (Capernaum and Chorazin aside) and the Golan are also blatant. The latter display a greater range of figural art, including animal (especially the lion and eagle), human (Daniel?), and mythological (Nike) representations. Moreover, the widespread use of religious symbols in the Golan, first and foremost the menorah (frequently accompanied by the shofar, *lulav, ethrog,* and incense shovel), stands in striking contrast to their limited numbers in the Upper Galilee.

The synagogues of the southern Hebron hills. Four synagogues were discovered in the twentieth century at sites in the southern Judaean hills—Eshtemoa, Susiya,

47. See chaps. 6, 12, and 13.

48. On these synagogues and their art, see Ma'oz, "Art and Architecture"; Ma'oz, "Architecture and Art of Ancient Synagogues in the Golan"; Hachlili, "Late Antique Jewish Art."

49. See Ma'oz, "Art and Architecture."

50. See L. I. Levine, *Ancient Synagogue,* 326–30.

Ma'on, and 'Anim[51]—which can be charac-
terized as a distinct architectural group on
the basis of the entrances facing east and
the absence of supporting columns. Never-
theless, these buildings also exhibit a large
degree of diversity, the most prominent ex-
ample being that two are of the broadhouse
type (Eshtemoa and Susiya) and two are of
the more common, elongated basilical type
('Anim and Ma'on). All are oriented to-
ward Jerusalem, whether by a *bima*, niche,
or a combination thereof (fig. 122).

FIG. 122 Plan of the Eshtemoa synagogue.

The phenomenon of entrances oriented
eastward seems to have preserved an early tradition (T Megillah 3, 22, p. 360), pre-
sumably deriving from the memory of the Temple's gates. While this prescription
was scrupulously followed in the southern Hebron hills, it was generally ignored
in the Galilee and elsewhere. The prominence of priests in these southern Judaean
synagogues is likewise noteworthy. In both Eshtemoa and Susiya, priests are men-
tioned in dedicatory inscriptions, and while this number is not large, it becomes
significant in light of the fact that priests are so noted in only two other synagogues
(out of approximately 120 sites) in all of Palestine.

The prominence of the menorah in these synagogues is also noteworthy. In three
of the four buildings (Eshtemoa, Susiya, and Ma'on) there were three-dimensional
menorot, each made of marble imported from Asia Minor. Those in Eshtemoa and
Ma'on reached the height of a human being and were possibly used, inter alia, for
illuminating the sanctuary. Once again, when compared to the rest of Palestine, this
number is impressive; three-dimensional *menorot* were found at four other sites—
Ḥorvat Rimmon, 'En Gedi, Ḥammat Tiberias, and possibly a fragment of one in
Merot.[52]

The above features distinguished the communities in this region, perhaps indi-
cating that the Jews there, being somewhat distant from the centers of contempo-
rary Jewish life in the north, clung to a southern Judaean tradition, in this case a
Jerusalem Temple priestly orientation inherited from the past.[53]

51. See the following analyses of Amit: "Architectural Plans"; "Source of the Architectural
Plans"; "Synagogues of Hurbat Ma'on and Hurbat 'Anim"; "Priests and Memory of the
Temple"; "Priests and Remembrance of the Temple."

52. L. I. Levine, *Ancient Synagogue*, 358–60.

53. An unusual phenomenon in the southern Hebron hills is the use of ossuaries, popular
in Second Temple Jerusalem and its environs, well into Late Antiquity. Their appearance,
together with the above-noted characteristics of the local synagogues, strongly suggests that
there were links between these communities and traditions stemming from Jerusalem in the
pre-70 era.

The regional component holds true for the Diaspora as well, but here it was expressed in a more general, local, context.[54] We have already had occasion to contextualize the Dura synagogue in this respect, and centuries later we find synagogues in disparate geographical areas borrowing heavily from local models. For example, in Elche, Spain, the arrangement and patterns of the synagogue's mosaic floor are quite similar to other Spanish mosaics from the Late Roman era. In Palencia and Bobadilla, as in Elche, large villa pavements have almost identical ornamentations and arrangements.[55] In Naro (Ḥammam Lif, Tunisia), the elaborate mosaic floor features motifs having remarkable parallels with mosaics from contemporary Christian churches in North Africa.[56]

BROADER GEOGRAPHICAL DISTINCTIONS: BETWEEN PALESTINE AND THE DIASPORA

The once widespread theory that the Jews of Palestine and the Jews of the Diaspora represented two antithetical strains of Judaism has long since been discredited, as has the countertheory of an overarching unity, whereby Diaspora affairs were overseen and controlled by authorities in Palestine.[57] Having said this, a number of rather ubiquitous features in Palestine were unknown in the Diaspora. For example, the multiple types of synagogue buildings throughout Palestine appearing alongside the dominant basilical model were largely nonexistent outside its borders.

Discrepancies between Palestine and the Diaspora are also found in the realm of art. As noted, the use of Jewish symbols in synagogue contexts was more ubiquitous in Palestine than in the Diaspora; for example, the cluster of symbols used with regularity in many Palestinian synagogues almost never appears in a similar concentration in the Diaspora,[58] while the incense shovel, regularly depicted in Palestine, is entirely absent from the Diaspora.

54. Ibid., 250–309.

55. Fernández, *La ciudad romana de Ilici*, 241–44; Cantera Burgos, *Sinagogas españolas*, 212–16; Rabello, "Le iscrizioni ebraiche," 659–62 (English translation, "Situation of Jews in Roman Spain," 182–86); Halperin, *Ancient Synagogues of the Iberian Peninsula*, 26–28; Hachlili, *Ancient Jewish Art and Archaeology—Diaspora*, 45–47, 205–7, 407–8.

56. Goodenough, *Jewish Symbols*, 2:89–100; Hachlili, *Ancient Jewish Art and Archaeology—Diaspora*, 47–48, 207–9, 408–9. See also Biebel, "Mosaics of Hammam Lif"; Dunbabin, *Mosaics of Roman North Africa*, 194 n. 32; Foerster, "Survey of Ancient Diaspora Synagogues," 171; Le Bohec, "Inscriptions juives," nos. 13–15; Darmon, "Les mosaïques de la synagogue de Hammam Lif"; K. B. Stern, "Limitations of 'Jewish'"; and above, chap. 17. Jonathan Price has recently asserted that Diaspora Jewish inscriptions likewise reflected their larger contemporary epigraphical context ("The Place of Synagogue Inscriptions in the Epigraphic Culture of the Roman Near East," a lecture delivered at the annual ASOR conference, San Francisco, 2011).

57. L. I. Levine, "Diaspora Judaism," esp. 149–58.

58. The major exceptions to this, but only with regard to a funerary setting, are the gold-glass remains from Rome; see chap. 7.

Even more striking is the proclivity of many Palestinian synagogues to use human figural art that rarely appears in a Diaspora setting. Thus, biblical figures and scenes depicted in Byzantine Palestine have few parallels outside its borders (Dura and Sardis excepted). Most sui generis is, of course, the use of the zodiac, Helios, and the seasons in a half-dozen Palestinian synagogues; nothing comparable is known from the Diaspora.

This is not to say, of course, that these broad geographical distinctions always applied. Palestinian synagogues might differ markedly among themselves, as did their Diasporan counterparts.[59] Still, the first presence of a zodiac model in Palestine opened possibilities for imitation by other congregations, and, as suggested above, quite a few did.[60]

We can only speculate as to why there was a more conservative bent among Diaspora communities when it came to figurative expression. Perhaps they felt the need to erect sharper boundaries between themselves and their neighbors, and this was accomplished by establishing a more restrictive policy vis-à-vis their art.

COMMON JUDAISM IN LATE ANTIQUITY

Beyond the local, regional, and larger geographical spheres, there were also signs of unity and commonality among the Jewish communities throughout the Roman world, some aspects of which have been discussed in chapter 17.[61] It was common in the sense that: (a) it was widespread throughout the Jewish world; and (b) it was an expression of the people and their communities rather than the dictate of

59. See L. I. Levine, "Diaspora Judaism," 142–49.

60. See chap. 16.

61. How might one account for this commonality? Given the dispersion of the Jewish population throughout the Byzantine world, especially in the Diaspora, and the relative paucity of sources, it is extremely difficult to determine how such developments might have crystallized—who initiated them, how might they have spread throughout the Jewish world, and were they in any way imposed or perhaps only spontaneously absorbed. Theoretically, at least three explanations present themselves: (1) a central authority was involved in the creation and diffusion of these changes. The only office that might have functioned in such a capacity would have been the Patriarchate, which gained a measure of authority throughout the Jewish world from the third to early fifth centuries CE (see L. I. Levine, *Ancient Synagogue*, chap. 12, and the bibliography there, esp. 454 n. 1). While some evidence of Patriarchal control and involvement in various aspects of synagogue life (e.g., administration, taxes) exists, it is not known whether it extended to synagogue architecture and art. In any case, the disappearance of the Patriarchate in the first half of the fifth century precludes its having any direct influence on synagogue practice later on (see, however, chap. 16); (2) the similarities were part of the shared heritage of Jewish communities for generations but surfaced only in Late Antiquity. However, as we have no evidence that the above features did exist earlier on, in the first centuries CE, and since these characteristics fit in well with the artistic developments of Late Antique society, such an option remains rather speculative; and (3) these developments originated in the Byzantine era and attest to a remarkable communication network between contemporary Jewish communities. Here again, there is no evidence to substantiate such an assertion.

any sort of authoritative body.[62] Among the main components of this Late Antique common Judaism are: (1) the centrality of the synagogue; (2) the synagogue's sacred status; (3) the building's orientation toward Jerusalem; and (4) the Torah shrine as a focal point in the synagogue's prayer hall. Added to these, of course, is a fifth component—the emergence, *mutatis mutandis*, of a new type of Jewish art, which has been the focus of our discussion.

Significantly, the common Judaism that found expression in the synagogues of Late Antiquity was often heavily influenced by the wider culture (see above). The existence of these two phenomena reveals a delicate balance—or perhaps a tension of sorts—between common and shared Jewish values and modes of expression, on the one hand, and their diverse artistic expressions often governed by styles and models derived from the wider society, on the other. Both factors were always present, yet how they were integrated and negotiated within a given Byzantine-Christian context was, as noted, a decision that rested squarely on the shoulders of each community.[63]

CONCLUSION

Local communal control of the synagogue was the crucial factor in explaining the wide diversity among synagogue buildings, accounting for different artistic tastes and varied preferences for certain decorations and motifs—whether figural, floral, or geometric. A number of decisions regarding this art had to be addressed. For instance, was it to include biblical personalities, biblical scenes, or even non-Jewish motifs such as the zodiac? Was it to depict Jewish symbols, and if so, which ones, and where were they to be placed? Was the menorah to be displayed as a two- or three-dimensional representation? Such decisions were based on economic, aesthetic, or religious considerations, or, more likely, a combination thereof.

Ultimately, it was up to each community to shape its own synagogue. Despite other factors that impacted upon the local community, it was the local congregation that wove them into some sort of pattern through selection, rejection, or adaptation of various options at its disposal.[64]

62. Regarding a similar distinction for fourth-century Christian art, see Miles, *Image as Insight*, 41–42.

63. See Gruen, "Hellenism and Judasim."

64. On the enormous diversity characteristic of Palestine generally at this time, see Dauphin, *La Palestine Byzantine*; Sivan, *Palestine*. For a similar assessment of the provinces of Britian and Africa in terms of hybridity and diversity, see Mattingly, *Imperialism, Power, and Identity*, 213–45.

20. ART AND THE RABBIS

T HIS CHAPTER WILL focus on how the art in synagogues and cemeteries from the third century CE onward relates to rabbinic sources. We will examine the extent to which rabbinic literature is relevant to understanding this art and the degree to which the rabbis played a role in influencing what was portrayed.[1]

Ever since the first archaeological discoveries from Late Antiquity in the early twentieth century, most scholars have assumed a close relationship between Jewish art and rabbinic literature. Since art alone is mute with respect to its intended meaning, as well as to the why and wherefore of its appearance at a particular time and in a specific context, literary material has understandably been invoked to fill the gap. Such an approach has proven especially attractive to those who maintain that the rabbis profoundly influenced and even considerably controlled Jewish life in antiquity.[2] Given this frame of reference, it is assumed that a public communal institution such as the synagogue would not have featured artistic patterns and depictions without having obtained rabbinic endorsement, if not outright inspiration and blessing. In short, this view maintains that Jewish society operated within a rabbinic milieu, and this is reflected in Jewish art as well.

1. We will not discuss the more general issues of visuality, visualization, anthropomorphism, iconography, or the visionary mystical experience with respect to the rabbis and rabbinic literature, for which a growing corpus of scholarship has developed of late. See, e.g., Boyarin, "Eye in the Torah"; E. Wolfson, *Through a Speculum That Shines*, 13–51, 74–124; Goshen-Gottstein, "Body as Image of God"; Bregman, "Aqedah"; Lorberbaum, *Image of God*, 27–82; Neis, "Vision and Visuality." Were we to conclude that the rabbis and rabbinic literature were important factors in the appearance and content of public and private Jewish art in Late Antiquity, the above-noted issues would ipso facto assume greater importance. However, that is not the thrust of what follows.

For a discussion of rabbinic attitudes toward art, see Fine, *Art and Judaism*, 97–123; his definition of "rabbinic community" is rather broadly conceived ("I use the phrase 'rabbinic community' to refer to the rabbis, their immediate social circles, and those who took them and their religious approach into account" [p. 230 n. 81]).

2. See, e.g., Schürer, *History*, 1:524; Alon, *Jews in Their Land*, 1:8–13; Lieberman, *Greek and Hellenism in Jewish Palestine*, xi–xii; Urbach, "Class Status," 2.

This consensus remained undisputed throughout the first half of the twentieth century but was challenged in the 1950s and 1960s by Goodenough and Morton Smith.[3] Since then, two distinct scholarly approaches have crystallized, one continuing the earlier position positing the central role of rabbinic Judaism in interpreting the meaning of Jewish art,[4] the other tending to marginalize rabbinic influence while emphasizing other factors deemed relevant to this art.[5]

Before examining the relationship between the rabbis and their literature on the one hand, and Jewish art on the other, several preliminary caveats are in order. First, there is often a gap between the literary material (rabbinic and other) and the archaeological evidence. For example, while there are virtually no extant Jewish literary sources from the Roman Diaspora of Late Antiquity, more than a score of archaeological sites have been identified; conversely, the massive literary evidence from the Babylonian Talmud is in no way complemented by any significant archaeological material from that region.[6]

Of even greater significance is the chronological disparity between rabbinic sources and artistic remains from Roman-Byzantine Palestine, for which we have substantial literary and archaeological material. While very few archaeological sites with artistic remains date to the third century, the overwhelming majority hail from the fourth to seventh centuries, and in a few instances even later. The relevant rabbinic sources are ascribed to sages who lived between the first and fourth centuries, even though much of this literature was edited at a later date.[7] One may therefore

3. Goodenough, *Jewish Symbols*, passim; Goodenough, "Rabbis and Jewish Art"; M. Smith, "Palestinian Judaism in the First Century"; M. Smith, "Helios in Palestine"; M. Smith, "Image of God"; M. Smith, "Observations on Hekhalot Rabbati."

4. To single out but a few representatives of this approach: Fine, *This Holy Place*; Kühnel, "Synagogue Floor Mosaic in Sepphoris"; S. S. Miller, "Rabbis and the Non-Existent Monolithic Synagogue"; Weiss, *Sepphoris Synagogue*; Weiss, "Sepphoris Synagogue Mosaic"; S. Stern, "Figurative Art and *Halakha*."

5. L. I. Levine, "Sages and the Synagogue in Late Antiquity"; E. Kessler, "Art Leading the Story"; Yahalom, "Sepphoris Synagogue Mosaic"; S. Schwartz, "On the Program and Reception"; Magness, "Heaven on Earth"; Stemberger, "Rabbinic Sources for Historical Study," 173–77. While many historians and others have been inclined of late to assign the rabbis a more limited role within Jewish society of Late Antiquity, art historians have generally assumed the more "traditional" approach, i.e., a close connection between the rabbinic text and the interpretation of artistic remains. See Mack ("Unique Character of the Zippori Synagogue Mosaic"), who distinguishes between instances of rabbinic influence and a lack thereof. A similar tension between text and artifact exists among scholars of Christian art as well; see Snyder, *Ante Pacem*, 3–11; R. M. Jensen, *Understanding Early Christian Art*, 27–31; and below, chaps. 22–23.

6. With the exception of incantation bowls; see Naveh and Shaked, *Amulets and Magic Bowls*, 124–214; Naveh and Shaked, *Magic Spells and Formulae*, 113–43; Levene, *Corpus of Magic Bowls*; Vilozny, *Figure and Image*.

7. Nevertheless, and although relatively limited, there is some overlap between these two corpora in the third and fourth centuries.

ask whether the material finds from the fifth to seventh centuries have any connection whatsoever to rabbinic Judaism, which is virtually unattested in Palestine at this time.[8] The absence of any kind of "historical" information about Jewish society after the fourth century that might point to the continued existence of the rabbis and how they functioned in Byzantine Palestine is a major obstacle when trying to posit rabbinic influence at this time.[9]

A second caveat is that art per se is not a major topic of discussion in rabbinic literature. For the most part, it is mentioned indirectly, primarily with regard to questions concerning idolatry—making or deriving benefit from decorated objects that could be interpreted as pagan images—with most references revolving around the figural aspect of this art. Thus, owing to the silence of these sources regarding more general artistic concerns, determining rabbinic attitudes toward and perhaps their involvement in the artistic enterprises of various communities is seriously impaired. Is this dearth of written testimony coincidental or were the rabbis oblivious or even opposed to this aspect of Jewish culture, just as they seem to have been with regard to other issues beyond their scope of interests?

DIFFERING RABBINIC ATTITUDES TOWARD FIGURAL ART
As was the case with virtually every significant topic raised in rabbinic literature, the attitudes and views espoused by sages vis-à-vis figural art vary considerably, ranging from outright rejection to conditional or reserved acceptance.[10] Such differences would seem quite natural, all the more so given the circumstances of the second century CE onward. Jewish society in Palestine was then emerging from

8. The redaction of many aggadic *midrashim* (e.g., Genesis Rabbah, Leviticus Rabbah, Pesiqta de Rav Kahana, and more) is usually dated to this period, presumably reflecting contemporary rabbinic or para-rabbinic activity. Moreover, *Ma'asim* (a collection of court decisions or responsa), edited sometime in the sixth or seventh century, may reflect contemporary rabbinic halakhic activity. Nevertheless, the social and religious contexts behind these works remain elusive; see Newman, *Ma'asim*.

9. In this light, it is interesting to note the famous anti-Palestine polemic of the Babylonian Pirqoi ben Baboi (ca. 800 CE), who claimed that rabbinic life in Palestine, along with that of the entire Jewish community, was disrupted by persecutions at this time; see Brody, *Geonim of Babylonia*, 17. However, the polemical nature of this text, in addition to its geographical and chronological distance from said events, and the fact that no persecutions as such are recorded in any contemporary source, make it a most problematic source of information.

10. A sardonic view of figural art, particularly that having pagan associations, is reflected in the tradition wherein some statues and images reportedly broke or crashed upon the death of certain sages; see Y 'Avodah Zarah 3, 1, 42c; S. Schwartz, *Imperialism and Jewish Society*, 145–46. A similarly derisive attitude is reflected in parallel traditions concerning a statue in Tiberias (referred to by different names) that was apparently defaced under rabbinic orders (Y Mo'ed Qatan 3, 7, 83c and parallels; Ginzberg, *Commentary* 1:244–46; Lieberman, "Palestine in the Third and Fourth Centuries" [1946], 367 n. 273; Moscovitz, "*Sugyot Muhlafot*," 28–30). My thanks to S. Schwartz for calling my attention to this last reference.

the almost three-hundred-year period of the Hasmonean, Herodian, and post-destruction eras, which was marked by a strictly aniconic orientation.[11] The social and political realities of post-70 offered cultural opportunities, including artistic ones, that were heretofore deliberately eschewed. Rabbinic circles at this time were not oblivious to this transition, and some sages seem to have been more attuned and responsive to it than others.[12]

The earliest rabbinic sources dating to the third century CE offer widely differing assessments regarding the permissibility of figural images.[13] One oft-discussed tradition refers to the Patriarch (or proto-Patriarch) R. Gamaliel II, and another is quoted anonymously, apparently reflecting a more consensual opinion among second-century sages. The former reports a visit of R. Gamaliel to the bathhouse of Aphrodite in Acco, where he espoused a notably benign attitude toward figural art that would have allowed its use in most settings, except when idolatrous worship was clearly intended (M 'Avodah Zarah 3, 4).[14] The second tradition appears in the Mekhilta of R. Ishmael, which states unequivocally that no figural representation is permissible in any way, shape, or form. In commenting on the Second Commandment, the following is recorded:

"You shall not make a sculptured image" (Exod. 20:4). One should not make one that is engraved, but perhaps one may make one that is solid? Scripture says: "Nor any likeness" (ibid.). One should not make a solid one, but perhaps one may plant something? Scripture says: "You shall not plant an *asherah*" (Deut. 16:21). One should not plant something, but perhaps one may make it (i.e., an image) of wood? Scripture says: "Any kind of wood" (ibid.). One should not make it of wood, but perhaps one may make it of stone? Scripture says: "And a figured stone" (Lev. 26:1). One should not make it of stone, but perhaps one may make it of silver? Scripture says: "Gods of silver" (Exod. 20:20). One should not make it of silver, but perhaps one may make it of gold? Scripture says: "Gods of gold" (ibid.). . . . One should not make an image of any of these, but perhaps one may make an image of the abyss, darkness, and deep darkness? Scripture says: "And that which is under the earth" (ibid.) "or in the waters under the earth" (ibid.)—this comes to include even the reflected image, according to R. 'Aqiva. Others say it comes to include the *shavriri* (i.e., the spirit causing blindness). Scripture goes to such great lengths in pursuit of the evil inclination so as not to leave any room for allowing it. (Yithro, 6, pp. 224–25)

11. See chap. 3.

12. The following discussions of the second and third centuries relate in large part to non-Jewish art encountered by the rabbis. Only in the latter part of the third century do instances of art in a Jewish context appear in rabbinic literature.

13. Blidstein, "Tannaim and Plastic Art."

14. See chap. 3, and in more detail chap. 21.

The Mekhilta's absolute ban on the creation of any sort of image may have also precluded contact with such an object lest it lead to idolatry;[15] this distinctly conservative approach was essentially the regnant Jewish attitude of preceding centuries.[16] The assumption that Jews should extricate themselves as much as possible from the world of pagan imagery is stated even more explicitly in another passage forbidding any kind of representation, even for decorative purposes:

> Our sages have taught: "You shall not make [together] with Me gods of silver, nor should you make for yourselves gods of gold" (Exod. 20:2). If, with respect to worshipping them, it has already been said, "You shall not make any sculptured image nor any likeness" (ibid., 4), how, then, should I interpret the verse: "You shall not make [together] with Me?" You should not say: "Just as others make decorations by placing a replica of the sun and moon and serpent on the gates of the city and its entrances, so, too, will I act similarly." Scripture says: "You shall not make [together] with Me"—*do not make them, even for decorative purposes* (emphasis mine). (Mekhilta of R. Simeon bar Yoḥai, p. 222; Midrash Hagadol, Exodus 20:29, p. 442)[17]

The contrast between the story of R. Gamaliel and the above two *midrashim* is indeed striking. The denial and rejection of any figural representation in the Mekhilta versions are completely different from R. Gamaliel's reputed words. Thus, it may be assumed that Gamaliel's position on this matter was not reflective of rab-

15. I have interpreted this passage to mean that the ban includes all figural representations, as does Goodenough, *Jewish Symbols*, 4:3-24; B. Cohen, "Art in Jewish Law," 168; Urbach, "Rabbinical Laws of Idolatry," 235 (English); see also Goodenough, "Rabbis and Jewish Art." In contrast, Blidstein ("Tannaim and Plastic Art," 19-20) and S. Stern ("Figurative Art and *Halakha*," 408-9) suggest that only cultic objects were intended.

16. See L. I. Levine, *Jerusalem*, 142-43, and above, chap. 3. Josephus makes two statements that reflect a similar distinction. In *Ant.* 3.91 he summarizes the Second Commandment as forbidding the making of an "image of any living creature for adoration," while in *Against Apion* 2.75 he notes that Moses "forbade the making of images, alike of any living creature, and much more of God, who . . . is not a creature."

17. Although embedded in a late midrashic compilation, this source dovetails neatly with the above-quoted source from Mekhilta of R. Ishmael and has been assumed by Epstein to have been part of the tannaitic Mekhilta of R. Simeon bar Yoḥai. A similar prohibition also appears in Midrash Hagadol, Exodus 34:14, p. 711. On the problematic character of this midrashic composition, gleaned from multiple sources, see M. I. Kahana, "Halakhic Midrashim," 72-77. Another related tradition appears in Midrash Hagadol, Deuteronomy 5:8, p. 105: " 'You shall not make any sculptured image or any likeness.' This is a warning to one who would make an idolatrous object for himself, whether he makes it with his own hands or others make it for him. And even if he does not worship it, it still is prohibited." Hoffmann includes this source in his Midrash Tannaim (p. 20). Rabbinic tradition also knows of several sages (referred to as holy) who refused to look at coins bearing the image of a ruler; see Y Megillah 3, 2, 74a; B 'Avodah Zarah 50a; B Pesaḥim 104a.

binic opinion generally.[18] Despite his prominence and responsibilities as a leader among the sages (though often disputed), it is not surprising that there would be a discrepancy between the (proto) Patriarch and other rabbis in this regard. R. Gamaliel's more extensive contacts with the outside world, as attested by numerous rabbinic traditions, and, no less importantly, the activities of later Patriarchs in the realm of figural art, lend credence to the likelihood that he was far more worldly in these and other matters than most other sages.[19]

Amoraic literature records the differing views of third-century sages such as Resh Laqish and R. Yoḥanan regarding how Jews should relate to figural images, in this case those with purportedly pagan overtones placed in the public domain (Y Shevi'it 8, 11, 38b–c; B 'Avodah Zarah 58b–59a).[20] Once, when in Bostra (the capital of Provincia Arabia), Resh Laqish was reportedly asked whether it was permissible for a Jew to draw water from the local *nymphaeum* (which often stood at the main intersection of a city) even though it displayed statues (including one of Aphrodite) and on occasion was used for idolatrous worship. Because of its occasional association with idolatry, Resh Laqish is said to have forbade such activity, thus forcing Jews who followed his opinion to draw water elsewhere.

This tradition continues, relating that when Resh Laqish told R. Yoḥanan what had transpired, the latter not only ordered him to return immediately to Bostra and rescind his decision but also reissued an earlier ruling that any statue or image in the public domain (or serving public interest[21]) was not to be considered idolatrous. He was apparently concerned that Jews should be able to function within a contemporary Roman city and thus made allowances for the many statues that graced

18. Contra S. Stern, "Pagan Images," 244–45. See Schubert, "Jewish Art."

19. See chap. 21. On the attitudes and halakhic positions of a series of medieval sages regarding images in synagogues, see V. B. Mann, "Between Worshiper and Wall."

20. See comments in Lieberman, *Hellenism in Jewish Palestine*, 132–33; Blidstein, "R. Yohanan, Idolatry and Public Privilege." Following Blidstein, I regard the Yerushalmi and Bavli versions as complementing one another, that the incident took place in a *nymphaeum* and not a bathhouse, and that the issue at hand was the permissibility of drawing water in front of statuary that was at times associated with pagan ritual. The assumption that these accounts contain a modicum of historicity is based on the following considerations: they deal with halakhic matters (deemed important to the rabbis); they appear in both the Yerushalmi and Bavli; they both relate to sages who lived in a mid-third century context; both versions have much in common, though also several differences. Given these factors and the tradition's realistic setting (the specific legal issue, the particular places noted [Bostra and Tiberias], well-known protagonists, and a resolution with significant implications), it likely has a historical basis.

Despite the valid issues concerning biography in rabbinic literature (see, most recently, D. Levine, "Is Talmudic Biography Still Possible?"), the precise historicity of this account's details is of secondary interest. Even if this tradition attests primarily to the formulation of later tradents or editors, what is important are the different and contrasting rabbinic perspectives it reflects.

21. An interpretation suggested by H. Lapin (personal communication).

its streets and plazas, assuming (although not explicitly stated) that the majority of them were for aesthetic and not overtly religious purposes.[22]

It is not clear whether the position ascribed to R. Yohanan on this matter stemmed from a lenient stance regarding public policy[23] or was influenced by his close relationship with the more cosmopolitan Patriarchal circles.[24] Indeed, one Bavli tradition refers to him as "R. Yohanan of the Patriarchal house" (Sotah 21a), while in another (Ta'anit 24a), regarding a dispute among sages over the Patriarch's call for a fast day, R. Yohanan reputedly counseled acceptance of Patriarchal authority, declaring that in such issues: "We must follow him."

The problems concerning figural representation with which other second- and third-century sages had to grapple are reflected in the following accounts drawn from Mishnah and Yerushalmi 'Avodah Zarah:

[If] one finds objects bearing the figure of the sun or the figure of the moon [and] the figure of a dragon, he should get rid of them (lit., he must throw them into the Dead Sea). R. Simeon b. Gamaliel says: "If the objects are of value they are forbidden; if they are worthless, they are permitted." (M 'Avodah Zarah 3, 3)

A ducenarius honored R. Judah Nesiah with a plateful of dinars. He (R. Judah Nesiah) took one and returned the rest. He then asked Resh Laqish [about keeping it]. He (Resh Laqish) said: Throw its value into the Dead Sea. (Y 'Avodah Zarah 1, 1, 39b)[25]

R. Hiyya bar Vava [Abba] had a pot[26] [at the bottom of] which Tyche (the goddess of fortune) of Rome was depicted. He came and asked the sages [whether it is permissible to use it]. They said: "Since water covers it, then it is [to be regarded as] an insult [to the goddess and is thus permissible to use]." So, too, with a drinking cup[27]: Since one dips it in water, it is considered an insult [and it can also be used]. (Y 'Avodah Zarah 3, 3, 42d)

22. Other issues over which sages were divided include belief in the efficacy of astrology and the significance of zodiac signs; see B Shabbat 156a–b, and the comments of Charlesworth, "Jewish Astrology," 185–88; Charlesworth, "Jewish Interest in Astrology," 930–32; von Stuckrad, "Jewish and Christian Astrology," 26–28; Rubenstein, "Talmudic Astrology"; Gardner, "Astrology in the Talmud"; Kalmin, "Late Antique Babylonian Rabbinic Treatise."

23. The tradition that purportedly has R. Yohanan instructing one Bar Derosa to destroy statues in a bathhouse is not at all consistent with his behavior here, nor is his inability to be more sympathetic about the general use of figural art in Jewish contexts (Y 'Avodah Zarah 3, 3, 42d, and below). Might a distinction between Jewish Tiberias and the largely pagan city of Bostra be behind these seemingly contradictory reactions?

24. Kimelman, *Rabbi Yohanan of Tiberias*, 58–126.

25. On this and the somewhat different parallel account in B 'Avodah Zarah 6a, see Blidstein, "Roman Gift of Strenae."

26. See Lieberman, *Greek in Jewish Palestine*, 171–72 (pitcher); Lieberman, *Hellenism in Jewish Palestine*, 134 (cup); Sokoloff, *Dictionary*, 478 (pot).

27. Sokoloff, *Dictionary*, 492 (drinking cup); Jastrow, *Dictionary*, 371 (ladle).

The above sources, which deal with specific cases, span the second and third centuries and allow us to conclude that rabbinic opinion often remained divided. Simply put, this literature never condones, and certainly never endorses, the use of objects displaying figural art. In contrast, the Bavli expresses a far more explicit opposition to such art and goes to great lengths to explain away the behavior of earlier Palestinian sages, and particularly that of the Patriarch, which it perceives as being halakhically objectionable (e.g., B Rosh Hashanah 24a–b, ʿAvodah Zarah 43a–b).[28]

These ambivalent attitudes among the sages vis-à-vis Greco-Roman culture in many ways resembled those of the church fathers. While Clement adopted features of the larger Greco-Roman world and attempted to mediate its seemingly conflicting claims vis-à-vis Christianity, Tertullian emphasized the dichotomy and inherent irreconcilability of these two worlds.[29] From Clement and Tertullian down to Epiphanius, Jerome, and Augustine, it is generally assumed that church leaders looked askance upon such representations, although they were often willing (or compelled) to make concessions to popular practice.[30] The degree of their fundamental disdain for this type of art, however, remains unclear.[31]

CONTRADICTIONS BETWEEN SYNAGOGUE ART AND RABBINIC SOURCES

There seems to be a considerable gap between a number of quite prominent artistic motifs appearing in synagogues and how, according to rabbinic sources, the sages might have related to them. We will examine four instances of this phenomenon.

28. One possible exception to this rule is the strikingly positive attitude toward figural art found in Targum Pseudo-Jonathan to Lev. 26:1 ("but a pavement [סטיו] figured with images and likenesses you may make on the floor of your synagogues. But do not bow down to it, for I am the Lord your God"). The question is: How indicative of rabbinic views is such a statement? At most, we can assume that it is a minority opinion among the sages, as it finds no comparable parallel elsewhere in rabbinic sources. Alternatively, might it be viewed as a late rabbinic attitude (seventh to eighth centuries), and not an indication of what was considered acceptable among the sages centuries earlier? Finally, perhaps this targumic statement reflects popular folk traditions often preserved in this *targum*, and thus does not represent a rabbinic view per se. See Shinan, "Targumic Additions," 149–50; Shinan, "Aramaic Targum as a Mirror"; Fine, "Iconoclasm," 190–92.

29. Greer, "Alien Citizens"; Barasch, *Icon*, 108–26. Regarding divergent attitudes to Roman institutions of entertainment, see Weiss, "Jews of Ancient Palestine," 448–50.

30. See Chadwick, *Early Church*, 277–78; Barasch, *Icon*, 49–62, 95–126.

31. While most scholars generally take this position, Murray ("Art and the Early Church") has argued that the evidence supporting such hostility is, in fact, nonexistent. Although her position appears to be somewhat extreme, this approach nevertheless indicates that these church leaders were as divided on this question as were their Jewish counterparts. See also Finney, *Invisible God*, 39–68, 86–93; Kitzinger, "Cult of Images," 85–95; Barnard, *Graeco-Roman and Oriental Background*, 89–103; R. M. Jensen, *Face to Face*, 1–15. See above, n. 5.

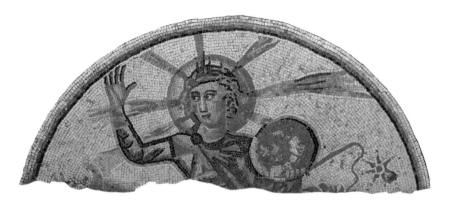

FIG. 123 Mosaic floor featuring zodiac motif with Helios holding sphere and staff in its center, Ḥammat Tiberias synagogue.

Helios in Ḥammat Tiberias

The image of Helios holding a sphere (symbolizing the earth) and a staff (representing a scepter or whip) in his left hand in the Ḥammat Tiberias synagogue mosaic (fig. 123) stands in sharp contrast to the explicit proscription against the use of such symbols in Mishnah 'Avodah Zarah 3, 1 and is a blatant example of the disjuncture between synagogue art and rabbinic dicta:

> All images (צלמים) are forbidden because they are worshipped [at least] once a year. So [says] R. Meir. But the sages say: "Only that is forbidden which holds a staff or bird or sphere in its hand." R. Simeon b. Gamaliel says: "Anything holding an object [is forbidden]."[32]

Such a stunning conflict between text and artifact may be explained in one of three ways: (1) the halakhah had changed sometime between the final redaction of the Mishnah (ca. 220) and the laying of this floor some 150 years later, yet there is no extant source indicating such a change; (2) those responsible for the design and decoration of this synagogue were unfamiliar with this mishnah, but such an assumption would be quite surprising given the fact that this mosaic floor comes from Tiberias, the site of the most important rabbinic center in fourth-century Palestine; and (3) the donors or artisans chose to ignore this rabbinic proscription (a not uncommon phenomenon in Jewish life through the ages). The last of these options seems the most likely, although we have no way of being certain.[33]

32. On צלם, see Jastrow, *Dictionary*, 1284; on images in the biblical period and their ancient Near Eastern context, see Garr, *In His Own Image and Likeness*, 132–65; cf. Urbach, "Rabbinical Laws of Idolatry," 238–39 (English). On this mishnah, see Eliav, "Viewing the Sculptural Environment," 421–26.

33. One might argue that M 'Avodah Zarah, chapter 3, refers to three-dimensional objects, while a mosaic floor reflects only two-dimensional representations. While the three-

Whatever the explanation, the above contradiction attests to the limitations of rabbinic authority and influence over the artwork in this synagogue. In an interesting aside on the precariousness of assuming that certain texts reflect or affect communal practice, we note that Urbach cites this rabbinic source in his study devoted to early rabbinic halakhah and its accommodation to changing economic and social realities in the second and third centuries CE.[34] Citing this mishnah, he concludes by stating that in certain areas the rabbis resisted making any halakhic adjustments that smacked of emperor worship and its related symbols. Urbach's article first appeared in Hebrew in 1958, and in English in 1959; only two years later, this Ḥammat Tiberias synagogue, with its mosaic of Helios accompanied by two of these prohibited symbols, was discovered! What more powerful statement could there be of the limitations of rabbinic prescriptions with regard to Jewish artistic practice in a synagogue setting?[35]

The Menorah

The disconnect between rabbinic tradition and archaeological finds is also evident in the depiction of the menorah (fig. 124). In contrast to numerous comments about the Tabernacle menorah described in the Torah, rabbinic sources rarely address its contemporary appearance or use. Despite this relative silence, the fact remains that the menorah was the most ubiquitous Jewish symbol in Late Antiquity, reproduced artistically over one thousand times throughout Palestine and the Diaspora.[36] This discrepancy between text and artifact is further highlighted by evidence of rabbinic opposition to replicating the seven-branched Temple menorah:

> One should not make a house in the form of the *heikhal*, an exedra like the [Temple] portico (*'ulam*), a courtyard like the [Temple] *'azarah,* a table like the [Temple showbread] table, a menorah like the [Temple] menorah, but he may make one of five, or six, and of eight [branches], but [one] of seven he should not make. (B Menaḥot 28b; B Rosh Hashanah 24a; B 'Avodah Zarah 43a)

This second- to third-century prohibition was seemingly ignored by the archaeological finds from the third century onward, creating a striking disparity between rabbinic tradition and artistic depictions. This discrepancy, however, should be cir-

dimensional prohibition held true for statues and idols, cases of symbolic representation are markedly different. Symbols undoubtedly would have retained their appeal (or revulsion) regardless of whether they were two- or three-dimensional. Moreover, a distinction between two and three dimensions is perhaps hermeneutically interesting but in reality quite artificial. It is doubtful whether any sage (except, perhaps, the most Hellenized among them, such as R. Abbahu—see below) would have considered a two-dimensional representation of Aphrodite, Apollo, or Jupiter innocuous and acceptable since it was *only* two-dimensional. This issue is further addressed below.

34. Urbach, "Rabbinical Laws of Idolatry" (Hebrew and English).
35. See also Friedheim, "Sol Invictus in the Severus Synagogue," 107–28 and esp. 120–26.
36. Hachlili, *Menorah*, xxvi; see above, chap. 17.

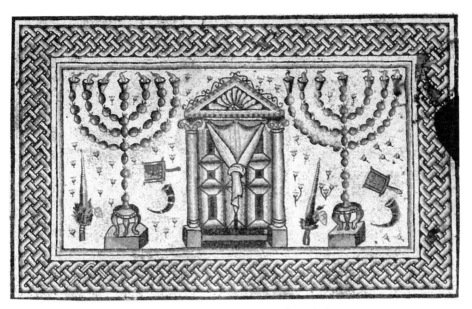

FIG. 124 Mosaic floor featuring a menorah and other Jewish symbols,
Ḥammat Tiberias synagogue.

cumscribed by two caveats. The first relates to the fact that the tradition prohibiting
the making of a seven-branched menorah appears as a *baraita*, but only in the Bavli.
While such a prohibition against imitating or replicating Temple practices and ob-
jects would seem to fit a tannaitic context quite well,[37] the fact remains that no Pal-
estinian rabbinic source from Late Antiquity (neither the Yerushalmi nor early *mid-
rashim*) repeats this injunction. Is this merely coincidental, or did later Palestinian
rabbis change their minds and, in fact, embrace replication of the seven-branched
menorah? Once again, this option remains theoretical, as no source even hints at
such a development. It is also possible, and perhaps even more plausible, that later
sages simply ignored the earlier prohibition because, despite their reservations, this
practice had already become well entrenched in their society.

A second caveat relates to the possible discrepancy between artifact and text—
the difference between two-dimensional artistic representations in the former and
references to three-dimensional objects in the latter.[38] While an assumption of a
three-dimensional prohibition regarding the *baraita* is certainly possible, in this
case it is not a valid distinction; the fact remains that three-dimensional *menorot*
(or fragments thereof) have been found at a number of sites in Palestine (Me-
rot, Ḥammat Tiberias, 'En Gedi, Ḥorvat Rimmon, Esthtemoa, Susiya, and Ma'on

37. On the ambivalent attitude among tannaitic sages with respect to imitating Temple
practices and utensils, see my *Ancient Synagogue*, 193–206; Fine, *This Holy Place*, 49–59.

38. See n. 33.

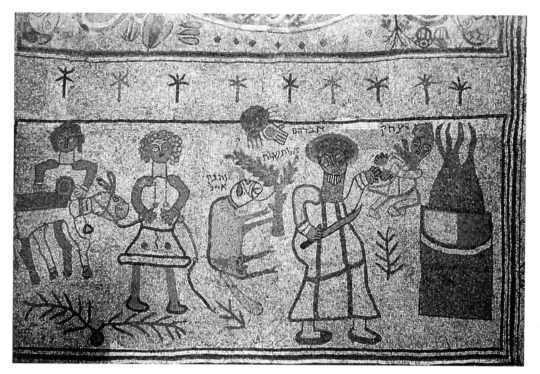

FIG. 125 Mosaic floor depicting Abraham holding Isaac over
(or flinging him onto) the altar, Bet Alpha synagogue.

[Judaea]) and the Diaspora (Sardis, Sidé).[39] Clearly, then, many Jewish communities
were not averse to creating such three-dimensional representations.

The ʾAqedah (The Binding of Isaac)

The ʾAqedah is the most frequently depicted biblical episode in ancient syna-
gogues, appearing in Dura, Sepphoris, and Bet Alpha (fig. 125). In each of these
artistic representations, Abraham stands center stage while Isaac occupies a decid-
edly secondary position, always depicted as a small boy who remains passive at the
dramatic moment of sacrifice, either lying quietly on the altar (Dura) or being flung
toward it (Bet Alpha). In Sepphoris, where the scene of the actual ʾAqedah has been
destroyed, Isaac's youth finds expression in the small pair of shoes beside his father's
larger pair.

In contrast, virtually all rabbinic sources assume that Isaac was an adult at the
time of the ʾAqedah.[40] The age usually noted is thirty-seven, but one tradition relates

39. See Hachlili, *Menorah*, 51–58.

40. See Seder Olam Rabbah 1, p. 6; Genesis Rabbah 56, 7, p. 603, particularly the critical
apparatus and notes on 603–4, citing a first edition and a Yemenite manuscript noting thirty-
seven years and a variant of twenty-six years, respectively; Lamentations Rabbah, Proem
14a, p. 27; Tanḥuma, Vayeraʾ, 42, ed. Buber, p. 55a; Pirqei de Rabbi Eliezer 31; Seder Eliyahu

that he was twenty-six years old.[41] The reasons for this latter assumption appear to be twofold: (1) according to the biblical narrative, Isaac was born when Sarah was ninety years old, and it might be assumed, from the narrative sequence in Genesis, that she died shortly after the 'Aqedah episode at the age of 127; and (2) the rabbis wished to accord Isaac the merit of knowingly and consensually offering himself as a sacrifice, thus turning the episode into a test not only of Abraham's faith, as the biblical account would have it, but of Isaac's willingness and devotion as well. Thus, the three synagogues that preserve this scene, spanning both the Diaspora and Palestine from the third to sixth centuries, follow a very different interpretive tradition of the 'Aqedah than that of the rabbis.

Nudity

Nudity was an integral part of Roman culture[42] upon which all contemporary Jewish literary sources frowned; scholars agree that this phenomenon was "abhorrent" to the Jews.[43] Of course, there may have been varying degrees of revulsion and perhaps also distinctions between the nudity of each gender,[44] local settings (e.g., a bathhouse), wider contexts (a Greco-Roman cultural orbit versus a Semitic one; urban versus rural, and so on), and chronological periods. Nevertheless, these differences pale in light of the distaste and opprobrium generally associated with such behavior.[45]

Rabbah 25, p. 138; Exodus Rabbah 1, 1, pp. 38–39. An early midrash from the Genizah—"A Midrash Composed under the Holy Spirit"—first published by J. Mann (*Bible as Read*, 1:65), likewise states that Isaac was thirty-seven years old; see also Spiegel, *Last Trial*, 48–49.

41. A possible exception to this rule is found in B Sanhedrin 89b, where R. Yoḥanan, in the name of R. Yose b. Zimri, connects God's commandment to Abraham regarding the 'Aqedah (Gen. 22:1) with Isaac's weaning (Gen. 21:8). Assuming a chronological propinquity here, namely, that Isaac was in fact a baby, flies in the face of the biblical narrative that describes him as talking to his father and carrying the wood up the mountain.

42. See, e.g., Hallett, *Roman Nude*; Bowersock, *Mosaics as History*, 59–63.

43. J. Z. Smith ("Garments of Shame"; reprinted in J. Z. Smith, *Map Is Not Territory*, 1–23) notes: "Judaism, in the main, did not share with its Hellenistic neighbors the notion of sacral nudity; indeed, it was prudish to the highest degree. The cultic 'horror of nakedness' (Exod. 20:26) was extended, in rabbinic literature, to a whole series of proscriptions against praying, reading the Torah, wearing the *tefillin*, etc. while nude. The *Rule* of the Qumran community imposed a six months' penalty on one who went naked before his fellow (1QS 7.12) while, quite consistent with this general attitude, the Essenes required men to wear loincloths and the women robes while bathing (Josephus, *Jewish Wars* [sic!] II.161)." This attitude was undoubtedly shared by many other Eastern/Semitic populations. See also Goodman, *Rome and Jerusalem*, 273–84, and esp. 274–75.

44. This is especially addressed by Satlow, "Jewish Constructions."

45. Polemics against nudity can be found in Jewish sources spanning the entire Greco-Roman period (and thereafter), from Jubilees (3, 30–32—the nakedness of gentiles) and 2 Maccabees (4, 12–14—the nakedness of priests participating in the games in Jerusalem) to Pirqei de Rabbi Eliezer (22—citing R. Meir, who said that those who go around naked are

Opposition to nudity characterizes rabbinic sources as well.[46] One cannot greet others, recite prayers, or put on tefillin (T Berakhot 2:20, p. 10) in the presence of naked men. R. Yose and R. Judah I reputedly never looked at their sexual organs, and as a result the latter was purportedly referred to as "our holy teacher" (Y Sanhedrin 10, 5, 29c; B Shabbat 118b). The Torah was not to be studied or discussed where there was nudity, and this view may perhaps be reflected in R. Gamaliel's comment to Proclus that they take their conversation outside of the bathhouse of Aphrodite (M ʿAvodah Zarah 3, 4). Finally, such behavior was regarded as offensive to God, and therefore the overwhelming majority of references to nudity in rabbinic literature is negative in the extreme.

When it came to female nudity, issues of modesty and male desire were of utmost concern. Naked women might stir sexual desires in men, and for this reason men were not to look at women. One statement asserts that looking at a woman's heel is tantamount to looking at her vagina, and looking at her vagina is tantamount to having intercourse with her (Y Ḥallah 2, 3, 58c). In another tradition, the rabbis recommended that one choose death rather than see a naked woman or even hear her voice (B Sanhedrin 75a), and averting one's gaze from female nudity would be duly rewarded.[47] Michael Satlow comments on the rabbinic attitude toward female nudity as follows: "Rabbinic sources understand female nakedness as a sign of sexual and moral dissoluteness."[48]

It is therefore most striking that completely or partially nude figures (both male and female) are often prominently displayed in synagogues. Such is the case at almost all of the main sites where Jewish art has been preserved—Dura Europos, Bet Sheʿarim, Ḥammat Tiberias, and Sepphoris.

Dura Europos.[49] A number of panels show young nude boys, some baring their genitalia. The infant Moses being drawn from the Nile and the boy being resuscitated by Elijah fit the latter description (fig. 126). The drowning Egyptians are depicted nude, as are a number of males in Ezekiel's vision of the dry bones. The most blatant appearance of female nudity is Pharaoh's daughter (sometimes identified as her handmaiden) drawing Moses from the Nile. She stands bare, in frontal view,

like beasts). On similar attitudes among the Syriac church fathers, see Brock, "Clothing Metaphors."

46. See generally Fonrobert, "Regulating the Human Body," esp. 274–80.

47. See Leviticus Rabbah 23, 13, p. 548: "R. Maisha grandson of R. Joshua b. Levi said: We find that anyone who sees [a woman's] nakedness but does not feast his eyes on it will merit receiving the face of the *Shekhinah* (divine presence). What is the [scriptural] basis for this? 'And he shuts his eyes from looking at evil' (Isa. 33:15). What is written [immediately] thereafter: 'Your eyes will behold a king in his beauty' (Isa. 33:17)."

48. Satlow, "Jewish Constructions," 444, 454. See also Moon, "Nudity and Narrative," 595 n. 5. In such matters, the rabbis reacted similarly to church fathers, who also warned of the dangers of gazing at women; Neis, "Vision and Visuality," chap. 6. For an overview of the rabbinic attitude toward women and modesty, see S. Stern, *Jewish Identity*, 237–47.

49. See Moon, "Nudity and Narrative," 595–602.

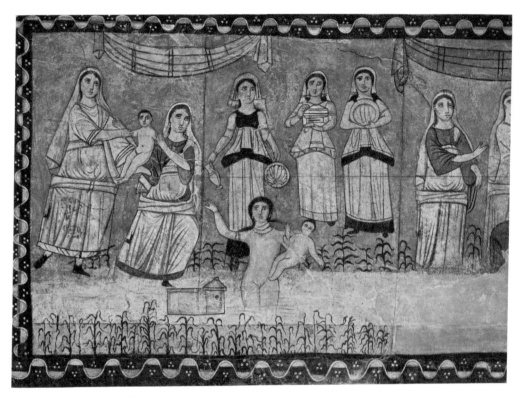

FIG. 126 Panel depicting Pharaoh's naked daughter discovering
the infant Moses, Dura Europos synagogue.

the water reaching just above her pudendum. The mother of the deceased boy in the
Elijah panel is semi-clad, with her feet and upper torso completely bare. Finally, the
middle two panels of the central door of the Temple—Solomon's Temple (accord-
ing to Kraeling) or the Closed Temple (according to Goodenough)—also display
nudity.[50] Each panel depicts a tall nude male figure standing between two smaller
nude women or children; there is no indication, however, of the latter figures' gen-
der. The bottom two panels show the figure of Tyche standing, wearing a sleeveless
chiton and himation and holding a cornucopia and rudder.

Remarking on nudity in the art of Dura, Kraeling notes: "Neither . . . the artists
and the Jewish community which they serve show the slightest feeling that nudity
would be improper in the pictorial decorations of a religious House of Assembly."[51]

Beth She'arim. Two of the most striking figural representations in this necropolis
appear on the Leda sarcophagus found in Catacomb 11. On its short side Leda ap-
pears nude and in profile, while on its long side a nude male figure is shown stand-

50. Kraeling, *The Synagogue*, 108–9; Goodenough, *Jewish Symbols*, 10:44–45.
51. Kraeling, *The Synagogue*, 176 n. 676.

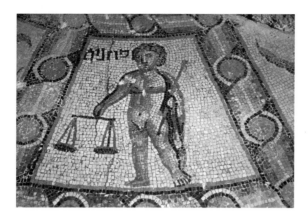

FIG. 127 Mosaic floor depicting the zodiac sign of a nude Libra, Ḥammat Tiberias synagogue.

ing frontward, but the details are unclear owing to the poor state of preservation from the groin down.[52] Of the twenty or so specimens of human figures on the marble sarcophagi found in Catacomb 20, the following nude portrayals have been identified: the upper part of Nike's body, covered in a gown but with the right breast bared; a winged and napping Eros; a body fragment of a naked male. If, as Avigad surmises, one of the sarcophagi originally displayed a scene from the battle of the Amazons against the Greeks, a popular motif on marble sarcophagi in this period, then it most probably displayed naked Greek warriors and at least partially nude Amazons.[53]

Ḥammat Tiberias.[54] Human figures appear in the zodiac cycle of this mosaic. The personifications of autumn and spring wear sleeveless garments, but three male zodiac signs appear nude: Libra, uncircumcised, faces front, with only a chlamys over his left shoulder and arm (fig. 127); the only surviving Gemini figure stands facing front, naked, and apparently also uncircumcised; Aquarius, too, is naked—his upper torso in a near frontal position, the lower part of his body in profile, and his left leg hiding his genitalia. The only female figure preserved is Virgo, fully clad and wearing some sort of footwear.

Sepphoris.[55] Nudity is very pronounced in the Sepphoris synagogue. The personifications of the four seasons in the zodiac panel are dressed appropriately for each respective time of the year: winter is fully clad; spring and autumn are sleeveless; and summer is partially clad, exposing her right shoulder and right breast. The zodiac signs, all represented by young males, likewise display a range of dress, with a clear penchant for partial nudity. Several youths (the Gemini twins and Capricorn) are naked, and three others, only partially preserved (Aries, Taurus, and Leo), may have been naked as well even though only their bare legs are visible. Libra, Scorpio,

52. See Avi-Yonah, *Art in Ancient Palestine*, 259–60, 263–65.

53. Avigad, *Beth She'arim*, 3:165–71.

54. Dothan, *Hammath Tiberias*, 1:43–46.

55. Weiss, *Sepphoris Synagogue*, 104–38.

and Pisces wear a cloak that covers the torso, ending at the waist or covering their genitalia, while their legs are fully exposed. Sagittarius, represented as a centaur, is depicted in near frontal position, with a bare upper torso; the lower part, of course, assumes the body of a horse. Only the youth depicted in the Cancer panel wears a short tunic with long sleeves and shoes, an outfit also worn by Abraham's two servants in the nearby ʿAqedah register.

From what we have presented,[56] it is clear that the artists and communities noted above had only occasional compunctions, if at all, about depicting nude figures on synagogue floors.[57] It is hard to imagine from the rabbinic sources at our disposal that such representations would have pleased the sages, much less won their approval.

In summary, and in light of the above discussion, it seems that those scholars who claim that synagogue art reflects rabbinic values and ideas should find it hard to press their case. From the four examples cited above, it is clear that many prominent depictions and symbols appearing in many synagogues stand in stark contrast to rabbinic views and preferences.[58]

ART AND RABBINIC LITERATURE: SOME METHODOLOGICAL REFLECTIONS

Given the traditional assumption of a pervasive, if not dominant, rabbinic milieu in Jewish society of Late Antiquity, it is little wonder that many scholars have mined rabbinic sources to the fullest for information that might explain the visual art appearing in synagogues and cemeteries. In this process, however, questionable assumptions are often made and methodologies are invoked that tend to mitigate, if not completely vitiate, any conclusions. It would be far beyond the scope of our discussion to catalogue all, or even most, such attempts, and we shall thus confine ourselves to highlighting a few of the more common problematic strategies.[59]

56. One might also add the figure of Sagittarius in the Ḥuseifa synagogue, depicted nude with only a mantle slung over one shoulder; see Avi-Yonah, "Ḥuseifah," 638.

57. Most of the examples of nudity noted above refer to mythological figures, and very few (and then only in Dura) to historical, biblical, ones. I am not sure what to make of this distinction. Can it be said that mythological figures are not human and therefore their nudity is inconsequential (or is that too apologetic a stance)? It has been suggested that such a distinction appears on medieval Byzantine ivory caskets, but this view has been disputed; see J. Hanson, "Erotic Imagery"; Zeitler, "*Ostentatio genitalium.*"

58. Goodenough may have exaggerated this point somewhat when he wrote: "But in the Jewish art of the next three centuries there is not a single reservation of even the most liberal Sages not flouted in the actual representations, and the general position of the 'Avodah Zarah, Mishnah and Gemara', as well as of the tannaitic Midrashim, patently rejects such representations with horror" ("Rabbis and Jewish Art," 274).

59. While much of what is discussed below applies to many scholars who have adopted this harmonizing approach, I have chosen, in particular, examples from two recent comprehensive studies, Weiss's *Sepphoris Synagogue* and Fine's *Art and Judaism.* Weiss has masterfully probed the connection between rabbinic sources and art, and much of what has been written

Chronological discrepancies. As noted at the outset of this chapter, there is a chronological disparity between the artistic remains and the period to which rabbinic sources supposedly refer, the latter based primarily on these sources' attributions to specific sages. However, this gap seems to be even greater when considering the dating of the rabbinic compositions themselves. While synagogue art dates from the third to seventh centuries, rabbinic sources span a millennium, having been edited anywhere between the third and twelfth to thirteenth centuries CE. The problems involved in using earlier tannaitic material to explain later art, or in using late eighth- to twelfth-century sources to explain earlier artistic creations, are obvious; indeed, as frequently happens, invoking a seventh- or eighth-century midrash, a seventh-century *piyyut,* or a late targumic remark to explain a third-century Duran wall painting is methodologically unsound. The same holds true when invoking a late midrash (e.g., Numbers Rabbah 12, 4) to explain the background of the Sepphoris mosaic's substitution of the sun for Helios.[60]

No less problematic is explaining a scene or artifact from synagogues in fifth-century Sepphoris or sixth-century Bet Alpha on the basis of a seventh- to eighth-century source, especially when it quotes a sage who lived many centuries earlier; such attempts are fraught with even greater difficulty if the supposed parallel is only partial.[61] Finally, ascriptions to various rabbis in these sources, particularly in the later *midrashim,* must be assessed with a degree of suspicion, all the more so when there is a greater chronological disparity. Rabbinic sources themselves are not always consistent with regard to such attributions,[62] and modern scholars ought to be no less cautious than the sages themselves.

Geographical considerations. Similarly problematic is ignoring geographical boundaries and distances. Invoking late Palestinian sources to explain a Duran panel from Mesopotamia (putting aside for the moment the chronological considerations just discussed) or, conversely, using the Bavli to elucidate Palestinian art is an exercise rife with pitfalls. The rabbinic context in each place was significantly different,[63]

over the past decade acknowledges his work. Fine has dealt with a wide range of issues, suggesting a number of interesting interpretations, particularly with regard to the synagogues of Dura and Sepphoris, the two richest sites relating to art and rabbinic sources in antiquity. In contrast to most art historians, whose knowledge of rabbinic material is scanty and who cite from secondary sources, these two scholars possess a far greater familiarity with rabbinic literature.

60. See Mack, "Unique Character of the Zippori Synagogue Mosaic."

61. A blatant example of such an anachronistic approach is the attempt to demonstrate the existence of a Jewish-Christian controversy by comparing a comment by Jerome to a statement of R. Simeon b. Gamaliel, who lived some 250 years earlier but is quoted in the Tanḥuma, a work edited only centuries after Jerome (Weiss, *Sepphoris Synagogue,* 252–53).

62. D. C. Kraemer, "On the Reliability of Attributions"; Green, "What's in a Name?"; Bregman, "Pseudepigraphy in Rabbinic Literature."

63. See, e.g., Kalmin, *Sage in Jewish Society;* see also Rosenthal, "Transformation of Eretz Israel Traditions."

and one should not automatically assume that all rabbinic statements are equally applicable everywhere.

This holds true for the Roman Diaspora as well, where rabbinic presence was extremely marginal.[64] Consequently, assuming that rabbinic sources are helpful in explaining the art of Sardis, Ostia, Ḥammam Lif, and elsewhere in the western Diaspora — for which there is no record of rabbinic presence — is unfounded.

Parallelism and its pitfalls. When the same motif appears in both rabbinic literature and archaeological finds, it should not be automatically assumed that such a depiction resulted from a pervasive rabbinic presence and was thus an extension or reflection of rabbinic Judaism.[65] It is quite possible, for example, that a homily or biblical exegesis appearing in other sources from contemporary Jewish (and Christian) society found expression in rabbinic writings as well. Over the past generation or so we have become increasingly aware of the multiple cultural and religious trajectories in Jewish society of Late Antiquity, with the rabbis being but one of them.[66]

So, for example, the flames on the six branches of the menorah in the Ḥammat Tiberias synagogue mosaic all face inward, while the central flame points upward — a pattern noted later on in the Bavli (Menaḥot 98b). Surely this does not mean that a fourth-century synagogue artist was influenced by a rabbinic dictum that is preserved only in a later and geographically distant source. Perhaps this is an instance of a common tradition; or alternatively, as Edward Kessler has claimed, that art led the way — a motif was originally introduced into Jewish cultural life through art and only later found expression in a literary source.[67]

64. See Edrei and Mendels ("Split Jewish Diaspora," 16:91–137, 17:163–87), whose emphasis on the absence of rabbinic influence west of Palestine is well taken, though not other components of their theory.

65. For a discussion of parallelism and its challenges, see chap. 18.

66. See Reeves, *Tracing the Threads*; Reeves, *Trajectories in Near Eastern Apocalyptic*; and above, chap. 10. Such an exercise of connecting text and art is particularly problematic when it is assumed that a practice depicted in art and referred to by the rabbis was, in fact, the norm in the Second Temple period, e.g., the use of pigeons on the baskets of the first fruits that were brought to the Temple (Weiss, *Sepphoris Synagogue*, 101–4). If this were indeed the case, and such practice derived from memories of the Temple, the fact that rabbinic sources preserved this tradition is interesting but means very little with regard to questions of rabbinic influence on this Sepphoris motif. The memory of such a practice might well have reached the local artist or community through other channels, literary or otherwise. For this and other examples, see D. Levine, "Between Leadership and Marginality," 197–204.

67. E. Kessler, "Art Leading the Story." A similar case involves the twelve "paths" in the crossing of the Sea of Reeds in the Exodus story, most clearly and explicitly noted in Targum Pseudo-Jonathan to Exod. 14:21 and the Dura paintings. Given the serious methodological obstacles in connecting Dura with the *targum* (edited around the eighth century CE), such a coincidence may be better explained as part of a widespread tradition in later Judaism that happened to surface in these two places.

Alternative avenues for explaining the ties between art and text are also relevant, as, for example, when interpreting the depictions of the ram tied to a tree in the 'Aqedah scenes that contrast to Genesis 22:13, which describes the ram's horns caught in a thicket. It has been suggested that these scenes reflect a midrash stating, inter alia, that the ram was placed there since Creation specifically in preparation for the 'Aqedah episode (M Avot 5, 3; Pirqei de Rabbi Eliezer 31; Yalqut Shim'oni, Vayera' 101).[68] Ignoring for a moment that such sources are not necessarily contemporaneous or in geographic propinquity with the art, sometimes deriving from compositions many generations earlier or later than the depictions themselves, the fact that such a motif was well known in Christian circles by the third and fourth centuries[69] points to a broader context in which the Jewish representation may have been influenced by Christian models. The ram standing independently, not caught in the thicket, is readily explained in a Christian context as a prefiguration of Jesus, who was also sacrificed.[70]

The disconnect between text and art. Although all would agree that relating a literary source to an artistic representation is highly desirable,[71] too often a close reading of each reveals that such correlations are not always smooth.[72] To cite two examples:

1. The *'Aqedah* scene (a biblical text). It has been suggested that the message of the *'Aqedah* scene in Sepphoris (and elsewhere) lies in the promise that God made to Abraham immediately after the *'Aqedah* episode.[73] However, the setting of the promise does not match the synagogue depictions. The scenes in Dura and Bet Alpha (and undoubtedly the destroyed panel in Sepphoris as well[74]) focus on the moment of sacrifice itself and not on the promise that follows.[75] This is the case

68. See the discussion of these sources in Weiss, *Sepphoris Synagogue*, 148–49, 194 n. 481.

69. On this tradition in Syrian Christian tradition, see Brock, "Jewish Traditions in Syriac Sources," 219–20; Brock, "Genesis 22 in Syriac Tradition," 15–17.

70. See R. M. Jensen, *Understanding Early Christian Art*, 143–48.

71. See R. M. Jensen, "Giving Texts Vision and Images Voice."

72. This conundrum plagues all traditions. See above, n. 5, and the cautionary words of Cameron, "Ideologies and Agendas," 12–13: "It is salutary to remember how difficult it is to match the archaeological evidence to the texts, even when texts are available. There is rarely a good fit, and not infrequently there is no textual evidence whatever to which an archaeologist may turn. Conversely, the case of Procopius's *Buildings* warns against the too-ready attempt to interpret physical evidence in ways that fit a superficially credible ancient text."

73. H. L. Kessler, *Frescoes of the Dura Synagogue*, 156–57; Kühnel, "Synagogue Floor Mosaic in Sepphoris"; Weiss, *Sepphoris Synagogue*, 228–31. Moreover, it should be noted that the promise to Abraham *after* the *'Aqedah* loses some of its poignancy, given the fact that similar promises had already been made to him on a number of occasions earlier in the narrative (Gen. 13:14–17, 15:18–21, 17:1–16).

74. Weiss, *Sepphoris Synagogue*, 141–53.

75. The appearance of God's hand and the command "Do not extend your hand" (Gen. 22:12) are clear indications that the moment of the impending sacrifice is being depicted.

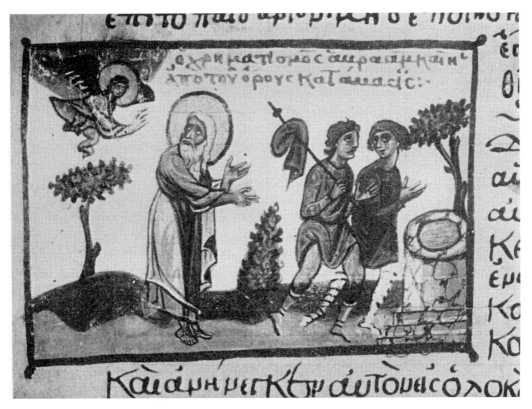

FIG. 128 Byzantine Octateuchs depicting Abraham, having been blessed
by the angel, descending the mountain with the two servants.

not only in synagogue representations but also in scores of instances in
Christian art, both in churches and at burial sites.[76] If the point of this
scene were indeed God's promise, then more apt depictions, as occa-
sionally appear in Christian art, might have been used—for instance,
Abraham and Isaac standing together by the altar after God rescinded
His command, or descending the mountain after the ram was sacrificed
(fig. 128).[77] The imminent sacrifice, and not the promise, is in fact what
is depicted, and we can only assume that this is what both Jews and
Christians wished to highlight.[78]

76. A. M. Smith, "Iconography of the Sacrifice of Isaac"; van Woerden, "Iconography of
the Sacrifice of Abraham."

77. A post-*'Aqedah* scene is occasionally depicted in Christian art, wherein Abraham is
shown walking away, looking back at the hand of God (or of an angel), or together with the
two servants engaged in a conversation; sometimes Isaac and the ass are depicted as well. See
Weitzmann and Bernabò, *Byzantine Octateuchs*, 1:88; vol. 2, nos. 319–22. See also Weitzmann
and Kessler, *Cotton Genesis*, 86.

78. For other interpretations of the *'Aqedah*, see Vermes, *Scripture and Tradition*, 193–227.

2. The sun/Helios (a rabbinic text). There is no component in the Sep-
phoris mosaic floor more striking than the representation of the sun
in place of Helios. While other synagogues depict Helios, here the
sun itself is portrayed riding in a chariot. On the basis of a comment
in Yerushalmi ʿAvodah Zarah 3, 1, 42c, it has been suggested that the
sun represents the *cosmocrator*, and that God, the omnipotent deity, is
higher than the *cosmocrator* and will guarantee that the promise made
to Abraham will be fulfilled in the days to come. The source reads as
follows: "A mortal king[79] has a patron [perhaps: has authority] in one
hyparchy (district), but does not rule in another? And if you should
say that a *cosmocrator* rules on land, then what about the sea? But the
Holy One, Blessed be He, is different: He rules on land and He rules
on the sea."

According to one interpretation of this midrash, "The con-
trast between the power of the emperor—ruler of the universe or
cosmocrator—and the power of God lies at the root of R. Zeʿira's
midrash. The power of the emperor is limited, as he is not omnipotent.
God is the true *cosmocrator,* as He is Almighty and rules everywhere."[80]

But does the art in the Sepphoris mosaic actually reflect this tal-
mudic comment, in which the crucial point is that God is higher than
the emperor and is the "true" *cosmocrator?* This is not what is, in fact,
depicted. The *cosmocrator* is represented as the sun controlling the land
and sea (indeed the sea is represented beneath the chariot). But where
is an image or representation of God? As it does not appear, it might be
construed that the *cosmocrator* in this mosaic, guised as the sun, is the
God of Israel, and this indeed has been suggested on several occasions.[81]
But although those scholars who invoke this midrash claim, as does the
midrash itself, that God is higher than the *cosmocrator*, this is neither
shown nor alluded to in the mosaic. Thus the attempt to make a con-
nection in this case is problematic, since the crucial point or connection
between text and art is missing.[82]

Nevertheless, this midrash may be valuable for viewing the Sep-
phoris depiction in a very different light. Rather than looking for a
similar conception in the art and the text, we may in fact have here two
independent and competing ideas, wherein the mosaic portrays the

79. Jastrow (*Dictionary*, 1158) emends this sentence by omitting the word "king" (מלך) and
reads: "a human being has a patron who may have power in one province."

80. Weiss, *Sepphoris Synagogue*, 233.

81. See, e.g., Goodenough, *Jewish Symbols*, 8:214–15; Goodman, "Jewish Image of God."

82. A further disconnect between rabbinic sources and an archaeological find is reflected
in the Japhia mosaic, where the identification of a bull and ox with Manasseh and Ephraim,
respectively, is reversed in Numbers Rabbah 2, 7.

cosmocrator in Roman terms, as ruling over all, while the midrash asserts that God stands above everything. If so, then this rabbinic source conveys an alternative theological message and not a confirmation of the visual depiction.

The diversity of artistic remains versus an all-inclusive rabbinic umbrella. If the rabbis were indeed involved in some way with the art in various synagogues, how would one account for the enormous diversity of subjects, styles, and emphases exhibited on synagogue floors? Was rabbinic opinion so broad that any sort of pattern, depiction, or composition could be associated with one or another rabbinic view? Given the range of artistic expression among the different Jewish communities of Late Antiquity, both in Byzantine Palestine and the Diaspora, the assumption that they could all be accommodated under one rabbinic umbrella seems implausible. True enough, scholars have devised a wide spectrum of explanations for some of these designs, for which at least one rabbinic source has been invoked. While the sheer creativity demonstrated in these endeavors is quite impressive, one wonders whether there is much value in scouring willy-nilly the rich corpus of rabbinic literature stretching over a millennium in order to find ideas and associations that may explain a depiction in a different time and place.

THE REḤOV SYNAGOGUE AS A TEST CASE

An attempt to put everything under a rabbinic rubric becomes even less credible when we remember that the one synagogue whose credentials as a rabbinically oriented institution are virtually impeccable—the Reḥov synagogue just south of Bet Shean—is in fact far different from other synagogue buildings, especially in the artistic realm.[83] Its unmistakably rabbinic orientation is reflected first and foremost in the unique twenty-nine-line halakhic inscription (the only one of its kind found to date) prominently displayed in the center of the narthex leading into the main hall. The inscription deals with sabbatical year laws and the boundaries of the Holy Land for purposes of halakhic agricultural obligations, and there is a remarkable, almost exact correspondence in form and content between this inscription and a series of parallel rabbinic traditions preserved in the Tosefta, Sifre, and Yerushalmi.[84]

Remains of an abbreviated halakhic inscription—apparently an earlier (fifth century?) version of the above-noted one—were also found at Reḥov, painted on a fresco originally located on one of the synagogue's pillars. Moreover, other fragmentary inscriptions from this earlier stage (some eight altogether) include a list of fast days, a dedicatory inscription containing thirty names, a list of priestly courses, a series of blessings, a long dedicatory inscription (of which eleven lines have survived), and one containing a series of dates (all according to sabbatical years) whose

83. See Vitto, "Rehov."
84. See Sussmann, "Halakhic Inscription"; Sussmann, "Boundaries of Eretz-Israel." See in this vein Millar, "Inscriptions, Synagogues and Rabbis."

contents has yet to be identified. No other synagogue to date has this abundance of epigraphic evidence.[85]

The building itself, with its three stages dating from the fifth to seventh centuries, is a basilica-type hall whose art consists solely of geometric patterns; there are no figural representations and no Greek inscriptions.[86] From the remains, therefore, it is clear that this synagogue's members (or at least those who determined the decor and style of the building) were closely identified with religious matters that were also of importance to the rabbis.

Thus, I would venture to say that most, if not all, rabbis would have felt quite comfortable in this synagogue setting. This does not mean, of course, that rabbis did not attend other synagogues having fewer halakhic "markers," and it appears that many certainly did. However, Reḥov's exceptional character, when compared to other synagogues, may be commensurate to the marginality of the rabbis in these other institutions (see below).[87]

SPECIFIC RABBINIC RESPONSES TO FIGURAL ART

Although few in number, several talmudic traditions vividly capture the lack of unanimity among third- to fourth-century sages with regard to figural art, how they conducted themselves when exposed to such images, and their deep ambivalence toward what was being displayed. One amoraic tradition describes the behavior of a number of sages, almost certainly with reference to a synagogue setting, and the dilemma encountered during fast-day ceremonies, when all were expected to prostrate themselves on a mosaic floor containing images:

> Rav instructed the house of R. Aḥa, and R. Ami instructed his own household: "When you go [to the synagogue] on a [public] fast [day], do not bow down as you are accustomed to (so as not to appear to be bowing to the images decorating the floor of the synagogue)." R. Yonah bowed sideways (i.e., not facedown); R. Aḥa bowed sideways. R. Samuel said: "I saw R. Abbahu bow as usual." R. Yosi said: "I asked R. Abbahu: 'Is it not written, "And a figured stone you shall not

85. See Price and Misgav, "Jewish Inscriptions," 472. These epigraphic remains are soon to be published by Misgav, "List of Fast Days," in a publication of the Israel Museum. My thanks to him for sharing his manuscript with me.

86. To date, only a lion carved on a lintel and a depiction of a fish have been discovered. Since the former was discovered in secondary use, its original context is unknown. The absence of artistic remains should be regarded with some caution, since nothing of the mosaic floor in the main sanctuary has been preserved.

87. In a similar vein though on a different topic, S. Stern writes: "The rabbinic conception of the people of Israel has also led us . . . to conclude that in some contexts the peripheral sections of the Jewish people, and even at times the common people, are ignored in the description of 'Israel'; and hence, that the rabbinic experience of Jewish identity is predicated on the ability to turn away from the reality of the periphery and of its boundaries, and to focus inwardly on the rabbis' own, internal world" ("Being Israel," 199–200).

place in our land to bow down upon it (Lev. 26:1)"?'" *[The difficulty concerning R. Abbahu's behavior] should be solved [by applying it to a situation] wherein one has a fixed place [in the synagogue] for bowing.* (Y 'Avodah Zarah 4, 1, 43d)[88]

Setting aside the last sentence of this source (marked in italics), which is a later editorial addition, it appears that R. Abbahu, unlike other sages, was not troubled by prostration on a decorated synagogue floor on public fast days, a liberal attitude perhaps engendered or reinforced by his residence in Caesarea and his more extensive Hellenistic acculturation.[89] On the other hand, his colleagues were clearly uncomfortable with such behavior, each finding a way to sidestep this predicament.[90]

The most revealing source with respect to rabbinic attitudes toward figural art generally appears in Y 'Avodah Zarah 3, 3, 42d:[91]

In the days of R. Yoḥanan (third century), they began to depict [figural images] on the walls and he did not object (לא מחי בידייהו);[92] in the days of R. Abun (fourth century), they began depicting [figural images] on mosaic floors and he did not object (ולא מחי בידון).[93]

This pericope purportedly describes the reactions of two sages (or at the very least that of a later editor) to the appearance of figural art on the walls and floors of public (and perhaps private) buildings.[94] Clearly, these statements reflect a far from

88. See Blidstein, "Prostration and Mosaics," 33–37; Steinfeld, "Prostration in Prayer," 59–65. On the custom of full prostration at public fasts, see Y Shevi'it 1, 7, 33b; Y Sukkah 4, 1, 54b; and D. Levine, *Communal Fasts and Rabbinic Sermons*, 150–52.

89. See L. I. Levine, "R. Abbahu," 64. Whether prostration was forbidden in order to distinguish current Jewish practice from that of the Temple or from contemporary non-Jewish practice is an open question. In this particular case, however, the problem is linked directly to representations appearing on the floor's pavement. See Ginzberg, *Commentary*, 3:116–23; Blidstein, "Prostration and Mosaics," 33–37. Bowing in third-century Babylonia was customary in Sura but strange to Rav, who had recently arrived from Palestine; see B Megillah 22a.

90. A similar predicament occurred in third-century Tiberias with regard to walking by images/statues found in the public domain. Some rabbis were hesitant about how to act, others recommended passing by, but in a way that would not be interpreted as paying homage to the image; see Y 'Avodah Zarah 3, 8, 43b.

91. Even assuming that this pericope reflects the editorial stage of the Yerushalmi, such a view would still be attested for the late fourth century.

92. On this phrase, see Jastrow, *Dictionary*, 759–60; Sokoloff, *Dictionary*, 300; D. Levine, *Communal Fasts and Rabbinic Sermons*, 134 n. 34. See, most recently, D. Levine, "Between Leadership and Marginality," 201 n. 18. This term is also found in M Pesaḥim 4, 8; T Pesaḥim 3, 19, p. 157, and parallels; M Menaḥot 10, 8; B 'Eruvin 96a and parallels.

93. This text follows the Genizah fragment published in Epstein, "Yerushalmi Fragments," 20.

94. Third-century mosaics are much less known than those from the fourth. On the recent discovery of a third- to fourth-century synagogue mosaic at Khirbet Ḥamam, see Leibner, appendix to chap. 8.

enthusiastic attitude regarding the use of this type of art, and we can safely assume that these rabbis would never have lent support to such a practice *ab initio*. Nevertheless, there was no protest or attempt to halt the practice.[95] Apparently, Jews were now beginning to decorate their buildings with figural art, and despite rabbinic reservations, this reality was considered irreversible by these sages. They therefore adopted a middle position, neither actively supporting nor flatly objecting, one that might be described as benign resignation and a willingness to accept the unfolding reality post facto.[96]

RABBINIC MARGINALITY IN THE SYNAGOGUE
In attempting to gauge rabbinic influence on Jewish art, especially in the synagogue setting, it may be helpful to shift the focus for a moment from art itself to rabbinic involvement in the synagogue generally. As noted elsewhere,[97] while rabbinic activity took place primarily outside the synagogue—in an academy (*bet midrash*) or informal study circles in private homes[98]—there is some evidence of increased rabbinic involvement in the synagogue itself during the third and fourth centuries, particularly in several specific areas of rabbinic competence—preaching, adjudicating, and the educating of children (although this last realm was never clearly defined). It must be noted, however, that even if the sources for these activities are taken at face value, the cumulative evidence of such involvement in the synagogue is not very extensive, and the number of rabbis noted in this regard is quite limited.[99]

Moreover, evidence of rabbinic involvement in the synagogue on the basis of nonrabbinic sources is virtually nonexistent. Of the hundreds of synagogue and funerary inscriptions mentioning synagogue leaders and donors in both Palestine and the Diaspora, not one refers to a rabbi who can be identified with any confidence

95. That some sages might have recommended a more proactive response than that of R. Yoḥanan and R. Abun may be reflected in a midrash set in biblical times, which notes the spread of idolatry from the private to the public sector because no one would protest or object (using the same expression as appears in the above narrative—שלא מיחו בידן; see Lamentations Rabbah, Proem 22, pp. 8b–9a).

96. Lack of enthusiasm for figural art, if not outright rejection of it, is reflected in the remarks of a number of leading medieval authorities as well; see V. B. Mann, "Between Worshiper and Wall."

97. L. I. Levine, *Rabbinic Class*, 134–91; L. I. Levine, *Ancient Synagogue*, 466–98.

98. See chap. 6, n. 51.

99. There is another possibility, namely, that reports of greater rabbinic presence in the synagogue were more a function of the interests of later amoraic sources (the Yerushalmi and aggadic *midrashim*) and their editors rather than of a significant change earlier on in the historical reality. Such a claim, however, ignores the fact that for this same period some rabbinic involvement, though likewise limited, is attested for other areas of Jewish life outside the synagogue; see L. I. Levine, *Rabbinic Class*, 127–33, 151–76; see also S. J. D. Cohen, "Place of the Rabbi," 157–73.

as a talmudic sage. Although the term *rabbi* appears quite frequently, particularly in Palestinian inscriptions in Aramaic and Hebrew, it has been convincingly argued that this title was not limited to talmudic sages alone but was also used as an honorific designation for a wealthy donor, a learned individual, a member of the Patriarchal circle, one appointed as a judge, and more. Thus, the epigraphic evidence supports the perception that synagogues were planned, built, and operated by others, and not by talmudic rabbis.[100]

A series of non-Jewish literary sources from the fourth and early fifth centuries, including the writings of church fathers, Roman law codes, and several pagan sources, indeed take note of a range of synagogue officials, as well as administrative, religious, and honorary offices and titles—but never one that can be identified securely with sages.[101]

One exception to this silence appears in Jerome's Letter 121 (10.19) to Algasia, in which he refers to the descendants of the Pharisees as synagogue leaders (the context is Jesus' dispute with the Pharisees—Matt. 15:1–11), presumably referring to later (contemporary?) sages, although this is never explicitly stated. Some of Jerome's comments are of interest; he knows the names (though notably garbled) of several first- and second-century sages (Barachibas, Simeon, and Helles—presumably 'Aqiva, Shammai, and Hillel), makes reference to rabbinic law concerning Sabbath boundaries, calls Jewish teachers *sophoi*, and at one point even uses the phrase "the wise men teach these traditions," perhaps equivalent to the rabbinic term תנו רבנן, שנו חכמים. Jerome also uses the term *deuterosis* (the "second legislation"), arguably a reference to the Mishnah or some other rabbinic teaching, but more likely referring to Jewish extrabiblical traditions generally (*traditiones*), appearing in the *Didascalia* and in many writings of church fathers, as well as in Justinian's Novella 146.[102]

This having been said, much else in Jerome's letter is confused and piecemeal, and at one point he even makes a rather repugnant accusation that synagogue leaders (the wise men) taste the blood of a virgin or menstruant to determine whether she is pure or impure.[103] However, the only titles Jerome adduces in connection with Hebrew teachers are either vague or generic, such as *praepositos* or *sophoi sapientissimos* (most wise). The latter title is perhaps sarcastic, given the context of the account, i.e., tasting blood. Elsewhere, in his *Commentary on Isaiah* 5.13.10, Jerome refers to his own Jewish teacher as an "instructor" (*praeceptore*).

100. See chap. 6, n. 21.

101. See my *Ancient Synagogue*, 412–53.

102. See chap. 9, n. 27; as well as Millar, "Ethnic Identity in the Roman Near East," 172; S. Schwartz, "Rabbinization," 61–68; S. J. D. Cohen, "Sabbath Law and Mishnah Shabbat," 187 and n. 68.

103. See Fonrobert, *Menstrual Purity*, 115–16.

Thus, Jerome's reference to synagogue leaders as descendants of the Pharisees is found in the least trustworthy section of this letter.[104] The overall tone and language are negative in the extreme, as are many of the labels he gives to Jewish traditions elsewhere—"superstitious," "pernicious," "ridiculous," and *deliramenta*.[105] The last part of the Algasia letter seems to address a school setting (*bet midrash?*), and not a synagogue. Finally, Jerome's rare use of Greek here (he generally wrote in Latin) and in other discussions of postbiblical Jewish traditions raises questions as to the origin and nature of this material, and whether he may have drawn this information from others and subsequently incorporated it into his own work.[106]

The above-noted issues have resulted in diverse scholarly evaluations of this passage. Some have accepted it at face value, surmising that rabbis were central figures in synagogues (Samuel Krauss, Weiss); others have concluded that it tells us more about Jerome's perception of rabbis and synagogues than constituting a reliable historical picture and, at the very most, may reflect the reality of certain synagogues with which he was familiar (Shaye J. D. Cohen); still others have maintained that the reference (at least the second part of the passage) is to an educational setting such as a rabbinical academy (Hillel Newman); and finally, some have asserted that the reference to "heads of synagogues" may refer to pararabbinic figures functioning in synagogue settings who were in some way appointed, associated, or supervised by the sages (Seth Schwartz).[107]

It is indeed difficult to know what reliable information, if any, can be culled from Jerome's testimony and to what extent it is reflective of contemporary Jewish Palestine.[108] There may indeed be some historical kernels here—particularly in light of the fact that Jerome had contact with Jewish teachers and was aware of Jewish exegetical traditions[109]—although, given the issues noted above, it is impossible to

104. See Newman, "Jerome and the Jews," 41–42.

105. See Megan H. Williams, *Monk and the Book*, 225–26. See also A. S. Jacobs (*Remains of the Jews*, 57), who cites Jerome's *Epistle* 84.3.3: "if it is expedient to hate any people and to detest any nation, I have a notable hatred for the circumcised; even now they persecute our Lord Jesus Christ in the synagogues of Satan."

106. Stemberger, "Hieronymus und die Juden seiner Zeit," 354–55; see also S. Schwartz, "Rabbinization," 64. Jerome quotes the traditions of others; for instance, he presents a very confusing and inaccurate picture when referring to the Nazarene tradition regarding early rabbinic history (*Comm. on Isaiah* 8.11–15); see Newman, "Jerome and the Jews," 72–74.

107. Krauss, "Jews in the Works of the Church Fathers," 6:225–61, esp. 229; Weiss, *Sepphoris Synagogue*, 227; S. J. D. Cohen, "Were Pharisees and Rabbis?" 104–15; Newman, "Jerome and the Jews," 49–51; S. Schwartz, "Rabbinization," 64–65. See also S. S. Miller (*Sages and Commoners*, 446–66), who suggests something similar to Schwartz's suggestion.

108. A number of scholars have questioned the veracity of Jerome's claim to have learned certain matters from Jewish teachers, and that he is, in fact, quoting Origen, Eusebius, and others (Bardy, "Saint Jérôme et ses maîtres hébreux"; Rebenich, "Jerome"), or perhaps even a Jewish convert (Stemberger, "Exegetical Contacts," 583).

109. See also Newman, "Jerome and the Jews," 103–22; as well as Bardy, "Saint Jérôme et ses maîtres hébreux"; Braverman, *Jerome's Commentary on Daniel*; A. S. Jacobs, *Remains of the Jews*, 56–100.

conclude from Jerome's text that any sort of rabbinic synagogue leadership existed at this time.[110] Given the above incertitude, another avenue in evaluating the historical probity of Jerome's description of the rabbis and synagogue opens up, requiring us to seriously consider Andrew S. Jacobs's claim that Jerome's writings must be understood in light of his deep hostility toward Jews and Judaism together with his imperial Christian agenda.[111]

In this light, anything Jerome has written on the above topics must be considered ipso facto suspect, and any attempt to find historicity is doomed to a high degree of speculation.[112] An agnostic, if not highly skeptical position in this regard is perhaps the best option available.

Of far more importance for our purposes is rabbinic evidence that confirms the picture gained from nonrabbinic and epigraphic sources indicating the rabbis' marginality in the synagogue. Three such instances bespeak the disparity between the rabbinic descriptions of synagogues and the archaeological remains.

1. The Tosefta (Megillah 3, 22, p. 360) states that synagogue entrances should face east. To date, however, relatively few synagogue buildings in Roman-Byzantine Palestine seem to have adhered to this guideline. Aside from four synagogues in southern Judaea, found in close proximity to each other and built in this manner,[113] only a handful of the remaining 120 or so buildings in the country have their main (or only) entrance facing east.

2. One rabbinic tradition prescribes changing the usual seating arrangements within a synagogue in times of mourning—those sitting in the north should sit in the south and vice versa (B Mo'ed Qatan 22b). It is almost impossible to anchor this tradition in any known archaeological reality, since synagogues regularly faced Jerusalem, with entrances from either the north or the south. Benches, therefore, were almost invariably located on the eastern and western sides of the building (and in the Galilee, often to the north). Thus, determining the *Sitz im Leben* of this rabbinic tradition is almost impossible.

3. The Toseftan statement that elders are to sit facing the congregation with their backs to the holy (a reference either to the Torah ark or to Jerusalem and the Temple) likewise finds almost no expression in synagogue buildings of Late Antiquity (T Megillah 3, 21, p. 360). Benches along the wall facing Jerusalem have been discovered, with very few exceptions, only in buildings from pre-70 Judaea.[114]

110. A. S. Jacobs, *Remains of the Jews*, 67–83 and esp. 96–100.

111. Ibid., 12–13.

112. See also Megan H. Williams, "Lessons from Jerome's Jewish Teachers," esp. 82–86.

113. Amit, "Architectural Plans of Synagogues."

114. See the articles of Yadin, Foerster, Gutman, and Ma'oz, in L. I. Levine, *Ancient Synagogues Revealed*, 19–41. Synagogues not oriented toward Jerusalem (e.g., in the Golan, Sepphoris, Bet Shean A [?], and elsewhere) may be invoked as examples of flouting or

Of no less consequence are the many sources that corroborate rabbinic marginality in what transpired *inside* the synagogue, particularly in the liturgical realm. Rabbinic literature preserves a series of accounts of synagogue practices that ran counter to rabbinic views. In one instance, noted above,[115] two rabbis reacted in very different ways when they encountered a Caesarean synagogue in which it was customary to recite the *Shema'* in Greek (Y Sotah 7, 1, 21b). One was openly hostile to this practice and considered trying to bring the objectionable prayer service to a halt, while the other was more tolerant, responding that it was better to recite the *Shema'* in Greek than not to recite it at all. Ultimately, however, these rabbis determined nothing, and from all appearances had no effect on the synagogue's liturgy; they clearly were reacting to a fait accompli.

Rabbinic literature also preserves a number of instances in which the delivery of the *targum* in the synagogue was at odds with rabbinic dictates.[116] The Yerushalmi, for example, relates a series of stories about local targumic practices that fly in the face of rabbinic prescriptions. Three such instances involved R. Samuel b. Rav Isaac: in the first, he rebuked a *meturgeman* for translating the scriptural reading while standing near a column (instead of next to the Torah reader); in the second, one and the same person (instead of two people, as rabbinically required) read from the Torah and translated the Torah portion; and in the third, the *meturgeman* read the scriptural translation instead of offering a spontaneous one (Y Megillah 4, 1, 74d). The responses of these functionaries, or of the congregation generally, to R. Samuel's correctives—assuming their historicity—are never specified.

On occasion, sages took issue with certain practices involving the synagogue prayer service. The Mishnah lists a number of instances in which prayers recited in local synagogues were considered objectionable to the sages. Reciting the "we give thanks" (מודים) prayer twice, adding a prayer for God's mercy on a bird's nest, or saying that His name be associated only with good were regarded as objectionable behavior raising rabbinic suspicions of dualism (M Berakhot 5, 3; M Megillah 4, 9).[117] Furthermore, a prayer leader wearing only white was declared unacceptable (reminiscent of a sectarian association or perhaps of priestly garments?), as was the priest who insisted on blessing the congregation barefoot, presumably recalling a Temple practice that the sages deemed should be eschewed (M Megillah 4, 8). Any deviation from the rabbinically prescribed way in which a man placed the phylacteries on his head and hand was declared invalid and termed sectarian (דרך החיצונים, דרך המינות; ibid.). R. Yohanan and R. Yose—the latter despite the vigor-

ignoring rabbinic prescriptions (e.g., T Berakhot 3, 15–16, pp. 15–16). However, facing Jerusalem was pre-rabbinic, reaching back to biblical and Second Temple times (1 Kings 8:29–30; Isa. 56:7; Dan. 6:11) and is therefore much earlier than the rabbis of Late Antiquity; see L. I. Levine, *Ancient Synagogue*, 326–30.

115. See chap. 19.

116. See R. Kasher, "Aramaic Targumim," 75–77.

117. On these rabbinic traditions, see A. F. Segal, *Two Powers in Heaven*, 98–108.

ous objections of R. Aḥa—chose not to protest when, contrary to rabbinic practice, the *Shemaʿ* was recited more than three hours after sunrise on a fast day (Y Berakhot 1, 5, 3c).[118] Finally, the rabbis at times expressed dissatisfaction with *baʿalei aggadah* outside their circles who taught or delivered sermons in the synagogue.[119]

The account regarding R. Simeon of Tarbanat demonstrates how one rabbi-*meturgeman* dared to defy the will of the congregation and paid dearly for it. As discussed above,[120] when asked by the congregation to alter his practice by breaking up each verse when translating to allow time for adults to explain to their children what was being read, R. Simeon decided to consult with his teacher, R. Ḥanina (Y Megillah 4, 5, 75b).[121] The latter supported his behavior, but when R. Simeon resumed his targumic activities and followed his former practice, he was summarily dismissed by the congregation. It is important to note, however, that this source also provides a necessary corrective to the claim that there was no ongoing rabbinic involvement in the synagogue. Although Simeon's behavior was decisively rejected by the local congregation, the fact remains that he was willing to serve them and had been hired to do so.

Some sages objected vehemently to synagogues belonging to or associated with ordinary people (*ʿammei ha-aretz*), as well as to the latter's practice of referring to the holy ark as *ʾarana* and to the synagogue as *bet ʿam* (M Avot 3, 10; B Shabbat 32a).[122] In Babylonia as well, it was the custom in one particular synagogue to prostrate oneself, but Rav, who had just arrived from Palestine and was unfamiliar with this practice, refused to do so (B Megillah 22b). In at least one instance, a rabbinic law was reportedly violated from a rabbinic perspective, when R. Jeremiah dragged a bench on the Sabbath in a synagogue in Bostra (B Shabbat 29b). Resh Laqish's comparison of a preacher in the synagogue to a theater mime entertaining the masses reflects a rather condescending attitude, to say the least, toward this homiletic component in synagogue liturgy, ironically one that was practiced by some sages as well (Genesis Rabbah 80, 1, pp. 950–53).[123]

Finally, rabbinic attitudes regarding physical aspects of the synagogue building, though quite limited in number, do not always express an enthusiastic appreciation of this dimension. We have had occasion to note an exchange between two sages in which one boasted about the beautiful synagogue structures built by his predeces-

118. This took place in a public fast setting, which might account for the aberrant practice; still, the rabbis here did not make the final determination.

119. See D. Levine, "Rabbis, Preachers, and Aggadists."

120. See chap. 19.

121. It is not clear what exactly R. Simeon was doing that provoked the annoyance of the local community: translating a passage from the Torah? the *haftarah*? teaching children? The terminology is vague. Immediately thereafter, the Talmud cites the opinions of two sages, one apparently siding with the congregation, the other praising R. Simeon for his tenacity.

122. For a rather speculative suggestion that the latter Bavli source refers to Jewish-Christian communities, see Jaffé, "Les synagogues des *amei-ha-aretz*."

123. See Herr, "Synagogues and Theatres."

sors in Lod, while his colleague took a dim view of this phenomenon, being of the opinion that monies were better spent in supporting Torah study than investing in elaborate buildings (Y Sheqalim 5, 6, 49b; Y Peah 8, 9, 21b).[124] A similar tradition, this time with reference to an academy in Tiberias, states, "R. Abun was passing the gates of the large academy (in Tiberias) when R. Mani approached him. He (R. Abun) said to him: 'Look at what I have made.' He (R. Mani) said: '"Israel has forgotten its Maker and built palaces" (Hos. 8:14). Were there no people to study Torah?'" (Y Sheqalim 5, 6, 49b). It would be gratuitous to extrapolate from these two sources how most rabbis viewed synagogue or academy buildings. Nevertheless, in the absence of any other data to the contrary, it would seem that opinions clearly differed in this regard, as in others.[125]

We may thus conclude that the rabbis' relationship to the synagogue reflected their overall recognition and acceptance of the institution, although not without a fair amount of ambivalence. Sages might have attended the synagogue for many reasons, but because the institution had a central religious component, it engendered respect, on the one hand, and criticism for what they considered errant practices, on the other. The rabbis never assumed (nor were they accorded) leadership positions in the synagogue, and when they commented on what transpired therein, they might have been heeded or simply ignored. Again, it should be remembered that this information is culled from rabbinic accounts, mainly from the Yerushalmi and Bavli; no other source, Jewish or non-Jewish, alludes to this relationship.[126]

The rabbis were most comfortable with their own kind; the bet midrash was their home,[127] while the synagogue was a place to visit in varying degrees of frequency and in which, for some at least, to participate selectively.[128] The synagogue was clearly not the focus of their activity; they were as peripheral to it as it was to them.[129]

124. See chap. 19.

125. See Fraade, "Rabbinic Polysemy and Pluralism Revisited."

126. On the rabbis and other communal settings in the Jewish city/community, see appendix below.

127. On the bet midrash as the focus of rabbinic activity and concern, see L. I. Levine, Rabbinic Class, 25–29; L. I. Levine, Ancient Synagogue, 476–78; Hezser, Social Structure, 195–214. It may not be coincidental, then, that the only epigraphical evidence of a talmudic rabbi clearly associated with a public building is that of R. Eliʿezer ha-Qappar and a bet midrash in Dabbura in the Golan ("This is the bet midrash of R. Eliezer ha-Qappar"); see Gregg and Urman, Jews, Pagans, and Christians in the Golan Heights, 128–29; Urman and Flesher, Ancient Synagogues, 2:432–33; Urman, "Rabbis Eliezer ha-Qappar and Bar Qappara," and below, n. 139. With regard to Babylonia, see Rubenstein, Culture of the Babylonian Talmud, 16–38; Goodblatt, "History of the Babylonian Academies" (referred to as "disciple circles").

128. On the rather ambivalent attitude of some sages vis-à-vis the synagogue, and particularly as regards the desirability of praying therein, see B Berakhot 6a–8a; Y Berakhot 5, 1, 8d.

129. See also Misgav, "Synagogue Inscriptions," 54–55.

CONCLUSION

Our discussion of the rabbis and art has underscored the significant gap between the opinions and practices of the former and the reality of the latter. As a result, their influence was negligible in the selection of synagogue art; there is no indication that they initiated or were consulted in any decision-making process, nor were their views and interpretations represented in the art of any significant synagogue panels. While rabbinic opinions regarding figural art were in some respects multivocal, there can be little question that the common thread running through them was that such art was inherently problematic and should be viewed at best with reservation, and at worst with condemnation.[130] No explicit statement of approval, much less of enthusiastic endorsement, is found in their writings.

The rabbis maintained a religious and social identity that distinguished them from the rest of Jewish society.[131] Their way of life was essentially elitist, or at least separatist, as they adhered to unique patterns of behavior that fostered a deep commitment to learning and piety that could not be, and rarely was, expected of the community at large.[132] The chasm between the elite and the masses, the sophisticated and the superstitious, the learned and the ignorant, whether minimized or exaggerated, was ubiquitous throughout the ancient world. For many, disparagement of or scorn for those outside the elite was never far beneath the surface; Christian and pagan intellectuals and an assortment of religious elites shared much the same prejudice.[133]

One related issue that has been debated repeatedly over the last half century is the degree of rabbinic influence on the wider Jewish community—the synagogue and its art aside. Focusing on Late Antiquity, one wonders whether the degree of rabbinic influence and involvement in society increased from the Late Roman to

130. An example of the contrast between Patriarchal accommodation and rabbinic opposition is reflected in the above-mentioned account of R. Judah II Nesiah, who received a traditional gift of coins from a high-ranking Roman official on the latter's holiday. See p. 409.

131. In this regard, see the comment of Price and Misgav ("Jewish Inscriptions," 480–81): "it is safe to say that the content and style of Jewish epigraphic texts developed with little if any influence from the sages of the Mishna and Talmud. The rabbis of the Mishna did not, for example, establish formulae for burial inscriptions or for dedications in synagogues. But this should cause no surprise given that, from the evidence of the Judaean Desert finds, the rabbinic formulae for legal documents, e.g. marriage contracts and divorce decrees, had apparently not yet solidified by the second century CE, and even if they had, they were certainly not imposed upon, or adopted by a majority of, Jews in the area at that time. Even with the methodological cautions outlined above, it is clear that the current corpus of Jewish inscriptions—both those from the Land of Israel and those of the Diaspora—reflect a different world from the one of the rabbis."

132. L. I. Levine, *Rabbinic Class*, 43–133. On the tendency in later rabbinic sources to problematize commensality between Jew and non-Jew as a reflection of rabbinic elitism, see Rosenblum, "From Their Bread to Their Bed."

133. P. R. L. Brown, "Art and Society," 23.

Byzantine eras (from the third and fourth centuries to the sixth and seventh). Did sages begin to play a greater role in Jewish society generally and in synagogues in particular, as has been suggested?[134] Unfortunately, such an issue is virtually impossible to resolve with any degree of assurance, and any suggestion must remain largely speculative. For one thing, as noted above, we know relatively little about the rabbis in Palestine or Babylonia toward the end of Late Antiquity (the fifth to seventh centuries), whether in the institutional, social, or religious vein. True enough, some sages (or others closely associated with their way of life) were engaged in creatively editing (arranging, shaping, and juxtaposing) or refashioning (reconfiguring and recontextualizing) older rabbinic traditions, as attested by the many aggadic *midrashim* or the rabbinically related *Maʿasim* (collection of court decisions and responsa) from the fifth century onward, but the nature of these compositions was quite different from earlier rabbinic genres.[135] In Babylonia, a great deal of intellectual activity in both the halakhic and aggadic realms revamped and greatly expanded the Babylonian rabbinic corpus under the auspices of the *stam maim/saboraim*. However, virtually nothing is known about these Palestinian and Babylonian groups, individually or collectively.[136]

Secondly, in these centuries, we encounter a newly emerging cadre of poets who were composing *piyyutim* for synagogue liturgy. While many ideas and emphases in their compositions are quite different from those of the rabbis, and in some cases even opposed them, these *paytanim* nevertheless based their liturgical creations on rabbinic prayer models and utilized rabbinic midrashic material. Thus, one might well assume that some synagogues in Late Antique Palestine had adopted a rabbinic liturgy, although the extent of this phenomenon is impossible to gauge. Moreover, the fact that these *piyyutim* used varying degrees of sophisticated Hebrew while most congregations, judging by their epigraphic remains, consisted primarily of Aramaic and Greek speakers raises questions regarding the place and importance of such poetry in the Jewish community generally.[137] Were these poets members of the rabbinic class or did they merely draw on rabbinic as well as other traditions? Unfortunately, we know precious little about the *paytanim*—their backgrounds, scholarly and religious orientations, and communal involvement. Ultimately, we cannot be certain of the degree to which the emergence of the *piyyut* attests to a heightened rabbinic influence and presence in the synagogue, or in Jewish society generally.[138]

134. See, e.g., S. Schwartz, "Rabbinization"; Lapin, "Epigraphical Rabbis: A Reconsideration."

135. See Newman, *Maʿasim*.

136. See Kalmin, *Redaction*, passim; Kalmin, "Formation and Character"; Halivni, "Aspects of the Formation of the Talmud"; Schremer, "Stammaitic Historiography"; Rubenstein, *Talmudic Stories*, 15-22; Rubenstein, *Culture of the Babylonian Talmud*, 1-13.

137. See additional comments on *piyyut* in chaps. 18 and 19.

138. It is also of interest that the emergence of the Hebrew-dominated *piyyut* seems to contrast with much of the contemporary rabbinic literature being produced in Aramaic. See also Alexander, "What Happened to the Jewish Priesthood," 12-16.

The appearance of iconoclastic activity carries no implications regarding rabbinic initiative or involvement either; there is simply no evidence regarding any sort of relationship between iconoclastic remains from several dozen Palestinian synagogues and the rabbis of contemporary Palestine (whoever they were).

Finally, several archaeological finds that might possibly be associated, directly or indirectly, with rabbis of the fifth to seventh centuries are the Reḥov synagogue discussed at some length above and the inscription from Dabbura in the Golan that reads: "This is the Bet Midrash of R. Eliʿezer ha-Qappar."[139] The only other inscription that may possibly allude to (post)talmudic rabbis is from Susiya, but dates to the fifth and sixth centuries.[140] As interesting as this evidence is, it is in fact quite marginal, constituting but a tiny percentage of the total number of Jewish remains from Late Antiquity.

Thus, while suggestions of an increased rabbinic influence and involvement in society toward the very end of Late Antiquity are not completely without foundation, given the limited evidence at hand, they remain tenuous and speculative.[141] It would be prudent to refrain from overly burdening our sources from Late Antiquity by attempting to lay the groundwork (consciously or unconsciously) for the eventual rise of rabbinic Judaism in the early Middle Ages (which in any case took place primarily in Babylonia). Indeed, this transition transpired from the eighth century onward, under Islam, and is best evidenced by the newly established authority garnered by the Babylonian rabbinate.

The purpose of this chapter has not been solely to "deconstruct." Only because of the all-too-common assumption that archaeological finds and rabbinic sources go hand in glove was it necessary to spell out in some detail the problematics of this assertion with regard to art[142] and to restore the credit for artistic creativity to its rightful owners—the artists, patrons, synagogue officials, and congregants of the local communities throughout the empire.[143]

139. Naveh, *On Stone and Mosaic*, no. 6. The dating of the inscription, however, is unclear. While this sage lived around the turn of the third century, ceramic evidence from the site is Late Roman or Byzantine and, indeed, all "Jewish" buildings from the area (i.e., synagogues) date only from the Byzantine era (Ben David, "Late Antique Gaulanitis"). Thus, this *bet midrash* may have been built later on and was only named after him (Z. Safrai, *Missing Century*, 63–64).

140. Naveh, *On Stone and Mosaic*, no. 75.

141. See L. I. Levine, *Ancient Synagogue,* 496–98.

142. For such an understanding of Christian art and church leaders, see R. M. Jensen, *Understanding Early Christian Art*, 23 and 30, respectively: "Christian art from the beginning must have required both community and clerical approval" and "Taking all these issues into consideration, the proposition that the interpretation of early Christian art works may be advanced by considering contemporary written documents and visual art synoptically seems only common sense."

143. See chap. 19. For a different understanding of the relationship between the sages and the synagogue, see S. S. Miller, "Rabbis and the Non-Existent Monolithic Synagogue."

Various aspects of the rabbinic material are important and relevant to our under-
standing of art and its place in Jewish society, and there may be instances in which a
rabbinic interpretation found its way into synagogue art. Nevertheless, such a con-
nection cannot simply be asserted, but must be demonstrated by accepted historical
methods and according to the propinquity of time, place, and similarity of ideas and
details. Any a priori assumption of the normativity of rabbinic behavior and beliefs
should be deemed unacceptable.

Rabbinic sources indeed provide insight into how at least one group, though
admittedly heterogeneous, addressed the art of this period. While the rabbis did
not represent all, or even most, Jews, their sources succeed in conveying how they
coped with this newly emerging Jewish cultural phenomenon.

We are becoming increasingly aware of the scope—far more diverse than here-
tofore realized—of the many cultural and religious currents at play in the Jewish
communities of Palestine and the Diaspora in Late Antiquity.[144] Rabbinic influence
on synagogue art might have been felt to the extent that the sages, as individuals,
wished to be involved, but in the final analysis, they had no decisive voice in these
matters; at best, they may have had a vote—rarely, if ever, a veto.[145] Parties other
than the rabbis were charged with decisions regarding synagogue artistic policy and
its implementation.[146]

144. See chaps. 11 and 22.

145. For indications in the Bavli of rabbinic attempts to consolidate and legitimize
their authority, which clearly was not taken for granted, see Hedner-Zetterholm, "Elijah's
Different Roles," esp. 170–82.

146. In a sense, this situation may not have been so different from the biblical period,
when Israelite art reflected ideas, beliefs, and cultural proclivities of segments of society that
were at odds with those of the elite(s), which promulgated an agenda that was eventually
canonized in the biblical text of later editors.

However, looking toward subsequent rabbinic history, van Bekkum ("Talmudic Tradi-
tion") notes: "The extent of their (i.e., the rabbis') influence upon actual community disci-
pline was limited, and the will of the community was decisive. As a class, the sages enjoyed
recognition within Jewish society as spiritual personalities, yet they had no official position
within the community. The significance of rabbinic literature in medieval Jewish existence is
a completely different story. The authority of the medieval rabbi has put an indelible stamp
upon traditional Jewish life until the early modern and modern period" (p. 61).

APPENDIX

The Rabbis and Other
Communal Settings

Viewing the rabbis' relationship to the synagogue and its art in light of their at-
titudes and conduct vis-à-vis other institutions that operated on the local Jewish
scene in Byzantine Palestine may offer an additional perspective regarding their
place in Late Antique Jewish society. As with the synagogue, there is no evidence of
rabbinic influence, much less control, in other kinds of settings—except, of course,
the rabbinic *bet midrash*.[147]

Bathhouse. The rabbis spoke highly of public bathhouses in general (Ecclesiastes
Rabbah 2, 8) and their literature is replete with information about many facets of
the institution and how it functioned.[148] Towns and cities were "required" to have
bathhouses (M Nedarim 5, 5; B Sanhedrin 17b), and the story of Hillel frequent-
ing them, including his opinion that they helped fulfill the commandment of tak-
ing care of one's body which was created in God's image (Leviticus Rabbah 34, 3,
pp. 376–77), may indicate their legitimacy in rabbinic eyes, or at least according to
this particular tradition. The rabbis themselves visited the bathhouse, told stories of
their colleagues doing so, and even invented connections between certain biblical
figures (Jacob, David, Yoav) and this institution.

At the same time, the rabbis had serious reservations about visiting bathhouses
in specific circumstances and times, such as on the Sabbath or during a sabbatical
year, questioning whether such buildings housed idolatrous objects (which they
then would have prohibited), or regarding matters of nudity and frivolity therein
(whether one may enter if holding a sacred object [Midrash Tannaim, Deut. 17:18,
p. 105], or if one wished to engage in a sacred act therein, such as praying or studying
[T Berakhot 2, 20, p. 10]).[149]

147. See D. Levine, "Between Leadership and Marginality." A significant example of
rabbinic judicial marginality is evidenced in the story regarding Tamar, who appealed a
rabbinic court's rejection of her case by turning to the Roman court in Caesarea, a move that
the rabbis perceived as an affront and as threatening their judicial authority (Y Megillah 3,
3, 74a).

148. Sperber, *City in Roman Palestine*, 58–72; M. Jacobs, "Römische Thermenkultur"; see
also Hoss, *Baths and Bathing*. On the baths in Jewish society and the rabbinic relationship(s)
to them, see Reich, "Hot Bath and the Jewish Community"; Eliav, "Did the Jews at First
Abstain?"; Eliav, "Roman Bath as a Jewish Institution"; Eliav, "Bathhouses as Places of Social
and Cultural Interaction"; Hoss, *Baths and Bathing*, 67–80. See also Dvorjetski, "Relations
between Jews and Gentiles."

149. Dvorjetski, *Leisure, Pleasure and Healing*, 273–314.

Public fast days. Ceremonies for rain seem to have been widespread communal events in Late Antiquity; while, according to rabbinic literature, the sages are never credited with initiating or controlling the proceedings, they indeed sought to be active participants.[150] The ceremony itself, described as being held in the open plaza of a city or town (M Ta'anit 2, 1–3), included local inhabitants and certain defined groups (see below). One important avenue for rabbinic participation was reputedly the sermon or exhortation delivered on such occasions, which, together with communal prayer, was said to have constituted the main part of this ceremony.[151]

Rabbinic sources describe the Patriarch as the most prominent participant; others noted are members of the local court, a respected rainmaker, an elder, a preacher, and sages, as well as a *ḥazzan* and priests in specific instances. The general populace is mentioned as openly criticizing the ritual or the efficacy of those in charge, and such involvement is said to have led to a considerable degree of tension, even among the sages themselves. While the rabbis are described as constantly attempting to assert their religious presence, if not authority, in this public forum, their degree of success is difficult to determine; simply put, the veracity of the rabbinic sources at our disposal in this regard is questionable, given their limited number and tendentiousness.

Miqveh. The *miqveh* continued to be used at this time, and certain sites discovered to date, such as Sepphoris and Susiya, boasted large numbers of such installations while other rural sites sufficed with very few, if any. Since this institution existed for hundreds of years, indeed back to Hasmonean times, long before the emergence of rabbinic Judaism, the rabbis could comment and react but did not have any recognized authority in this realm.[152]

The Patriarchate. The most prestigious Jewish communal institution in the third through early fifth centuries was the Patriarchate, which was not under rabbinic control. In fact, the opposite was the case. Any kind of rabbinic role in official communal affairs was dependent on the agreement and appointment of the Patriarch, which often was not forthcoming.[153]

150. On this institution, its operation, and the degree and nature of rabbinic participation, see D. Levine, *Communal Fasts and Rabbinic Sermons*, passim.

151. Segments of such exhortations are preserved in rabbinic literature; see ibid., 167–83.

152. It may not be coincidental that the overwhelming majority of such installations do not follow rabbinic prescriptions, e.g., the double pool and connecting pipe, and thus may reflect other, nonrabbinic, halakhic standards. The fact that *miqva'ot* were found in the Patriarchal cemetery at Bet She'arim (see chaps. 4 and 6), and that their presence there seems to contravene rabbinic requirements, is also indicative of a nonrabbinic practice, what may be referred to as a kind of folk custom; see Amit and Adler, "*Miqwa'ot* in the Necropolis of Beth She'arim"; Amit and Adler, "Observance of Ritual Purity."

153. On the tensions between the Patriarch and the rabbis, see L. I. Levine, *Rabbinic Class*, 134–91; Hezser, *Social Structure*, 405–49; and above, chap. 6.

Calendrical calculations. Sacha Stern has claimed that although the lunar calendar had been adopted by virtually all Jewish communities after the first century CE, it remained quite variable, being calculated differently by communities throughout Late Antiquity.[154] Referring to the unique calculations in the Zoar inscriptions, he concludes: "This challenges the common assumption that by the later Roman period, the rabbis and rabbinic Judaism had become a dominant force in Jewish Palestinian society."[155]

Finally, two additional public settings over which the rabbis obviously had no control were institutions of mass entertainment and regional fairs. What is interesting in this regard, however, is that while the sages came out strongly against participation in such settings, Jews (some? many?) simply paid no heed.

Entertainment institutions. These buildings included theaters, hippodromes or stadiums, and amphitheaters, and were fairly ubiquitous in Roman-Byzantine Palestine; several such institutions have been found in the major cities of Tiberias, Sepphoris, and Caesarea, where there was a substantial Jewish and rabbinic presence.[156] Rabbinic opposition to such institutions stemmed from a number of considerations—their association with idolatry and bloodshed, the immorality of some of the activities there, and the fact that attending them was considered a waste of people's time, causing the neglect of Torah study (T 'Avodah Zarah 2, 5-7, p. 462; Y 'Avodah Zarah 1, 7, 40a; Sifra, Aḥarei Mot, Pereq 13, 9 [Mekhilta de-'Arayot], p. 86a).[157] The only justification offered for attending was if one's presence could prevent bloodshed or if an important matter, "for the benefit of the public," was to be discussed. Nonetheless, despite rabbinic objections, which was expressed in different ways over the centuries,[158] these institutions are often referred to in rabbinic sources precisely because Jews were familiar with and frequently visited them (Y 'Avodah Zarah, 1, 4, 39d; Genesis Rabbah 47, 10, p. 478).[159]

Fairs. Another interesting example of the disconnect between rabbinic prohibition and Jewish behavior involves pagan fairs, which are noted on occasion in

154. S. Stern, *Calendar and Community*, 62-98; S. Stern, "Jewish Calendar Reckoning."

155. S. Stern, *Calendar and Community*, 97. In another vein, Ben Eliyahu ("Rabbinic Polemic") argues that the rabbis opposed what was presumably a widespread practice among Jews, i.e., to attribute holiness to various sites (connected to the biblical narrative), reserving such an attribution solely for Jerusalem and the Temple Mount. See also van der Horst, *Japheth in the Tents of Shem*, 119-38.

156. J. Schwartz, "Archaeology and the City," 166-70; Weiss, "Buildings for Entertainment"; Weiss, "Adopting a Novelty"; M. Jacobs, "Theaters and Performances"; see also Herr, "External Influences," esp. 89-92. See also Weiss, *Public Spectacles and Competitions*.

157. See Berkowitz, "Limits of 'Their Laws,'" 134-41.

158. Weiss, "Jews of Ancient Palestine," 433-39; Weiss, "Theatres, Hippodromes, Amphitheatres, and Performances," 634-37. On the objections of church leaders to theatrical performances and their antitheatrical polemics, see Webb, *Demons and Dancers*, 197-223.

159. See Belayche, *Iudaea-Palaestina*, 292-96; Dvorjetski, "Theatre in Rabbinic Literature."

rabbinic sources (e.g., Tyre, Gaza, Acco, and Botna). Even though the sages explicitly prohibited attendance at the one held in Botna-Elonei Mamre owing to its idolatrous component (Y 'Avodah Zarah 1, 4, 39d; B 'Avodah Zarah 11b), Sozomen informs us that in fact fifth-century Jews continued to frequent them (*Eccles. Hist.* 2.4).[160]

Common to all these institutions and frameworks is the sages' marginality in their operation and the fact that they had no direct control or influence over them.[161]

160. Belayche, *Iudaea-Palaestina*, 96–104. See also Burns, "Archaeology of Rabbinic Literature."

161. While the sages may have wished that preaching, judiciary appointments, and education were part of their prerogative, a close reading of rabbinic literature reveals the problematics in assuming that they had a monopoly over these realms. For a penetrating analysis of this phenomenon with respect to preaching, see D. Levine, "Rabbis, Preachers, and Aggadists"; regarding adjudication, see Alon, *Jews, Judaism and the Classical World*, 374–435; regarding the education of children, see Aberbach, *Jewish Education*, 33–92.

21. ART, THE PATRIARCHS, AND THE URBAN ARISTOCRACY

THE PATRIARCHATE PLAYED a dominant role in Jewish society from the turn of the third until its demise in the early fifth century; beforehand, it had assumed some sort of leadership status within rabbinic circles, and perhaps also outside of them.[1] Unfortunately, however, at this stage sources relating to the various forms of power and degrees of influence wielded by this dynasty leave much to be desired. We are almost totally dependent on rabbinic literature for what transpired in the second and first part of the third centuries,[2] whereas non-Jewish material (Roman legislation and the writings of the church fathers) as well as archaeology provide the bulk of information beginning in the third through early fifth centuries.[3]

The shift in the types of sources relevant to this office is directly related to the evolution of this dynasty. Until the early third century, its representative (or the

1. On the Patriarchate in the post-70 era, see Mantel, *Studies*, 1–53, 175–253; L. I. Levine, "Jewish Patriarch"; J. Cohen, "Roman Imperial Policy"; S. J. D. Cohen, "Pagan and Christian Evidence," 170–75; Goodman, *State and Society*, 111–18; Goodman, "Roman State and the Jewish Patriarch"; Goodman, "Roman Identity," 94*–99*; Stemberger, *Jews and Christians in the Holy Land*, 230–68; M. Jacobs, *Die Institution*, passim; Rosenfeld, "Crisis of the Patriarchate"; S. A. Cohen, *Three Crowns*, 200–4; Hezser, *Social Structure*, 406–17; S. Schwartz, "Patriarchs and the Diaspora"; S. Schwartz, "Big-Men or Chiefs"; Goodblatt, *Monarchic Principle*, 176–231; Goodblatt, "Patriarchs, Romans and (Modern) Scholars"; Goodblatt, "Political and Social History," 416–23; Sivertsev, *Private Households and Public Politics*, 66–93. Many of the above scholars (e.g., S. J. D. Cohen, Goodman, and S. Schwartz) date the apogee of the Patriarchate to the fourth century.

2. Besides rabbinic material, the remains from the Bet She'arim necropolis, the Stobi inscription, and Origen's testimony are invaluable pieces of information regarding the emergence of a recognized public office known as the Patriarchate under Judah I ca. 200 CE; see L. I. Levine, "Status of the Patriarch," 12–13, 21–23; L. I. Levine, "Emergence of the Patriarchate"; and above, chap. 6.

3. L. I. Levine, "Status of the Patriarch."

proto-Patriarch) was an integral part of rabbinic circles. Rabbinic sources from this period regularly include his opinions in discussions of halakhic matters and not infrequently anecdotes related to or actions taken by this office.[4] However, the third century witnessed a growing rift between the talmudic rabbis and this dynasty,[5] due in large measure to the enhanced communal and political status of the latter and its expanding ties and alliances with the wealthy aristocratic leadership of the cities. Consequently, rabbinic sources from the mid-third through the late fourth centuries tend to ignore what was now an officially recognized office and also exhibit a significant degree of hostility, as reflected in the sages' references to and relationships with the Patriarchs. Concurrently, the enhanced prestige of this office led to a shift in the types of literary evidence; instead of the rabbinic sources that dwell in large part on halakhic matters, the later, non-Jewish, material focuses almost exclusively on the Patriarchs' wider communal profile and activities.

A striking example of these wider horizons on the Patriarchal agenda is found in a decree issued by the emperors Arcadius and Honorius in 397:

> The Jews shall be bound to their rites; while we shall imitate the ancients in conserving their privileges, for it was established in their laws and confirmed by our divinity, that those who are subject to the rule of the Illustrious Patriarchs, that is the archisynagogues, the Patriarchs, the presbyters and the others who are occupied in the rite of that religion, shall persevere in keeping the same privileges that are reverently bestowed on the first clerics of the venerable Christian Law. For this was decreed in divine order also by the divine Emperors Constantine and Constantius, Valentinian and Valens. Let them therefore be exempt even from the curial liturgies, and obey their laws.[6]

This decree clearly spells out the Patriarch's dominance in a wide range of synagogue affairs; he stood at the head of a network of officials, including archisynagogues, patriarchs (possibly local representatives of the office), presbyters, and those charged with the synagogue's religious activities, all of whom had privileges on a par with those of the Christian clergy. This arrangement is said to date back several generations, from the time of Constantine and Constantius. When added to Epiphanius's testimony regarding the degree of Patriarchal control over Diaspora synagogues (however tendentiously presented), Patriarchal correspondence with Libanius, Julian's letter to Hillel II, and the Ḥammat Tiberias synagogue erected

4. See Mantel, *Studies*, 175–253; L. I. Levine, *Ancient Synagogue*, 454–59.

5. See chap. 6.

6. CT 16.8.13, in Linder, *Jews in Roman Imperial Legislation*, 202, no. 27. See also an edict dating to 392, CT 16.8.8, in ibid., 187, no. 20.

by individuals close to the Patriarch,[7] we become aware of the extent of this office's influence and control over many aspects of Jewish life throughout the empire.[8]

The cultural horizons associated with the Patriarchate are also important to bear in mind for our purposes as they go hand in hand with the artistic proclivities (to be addressed below). The significant degree of Hellenization characterizing this dynasty is manifested by its openness to Greek culture from the days of R. Gamaliel II at the turn of the second century to those of his final descendant, R. Gamaliel VI, in the early fifth century. Rabbinic sources report that Gamaliel II was exempt from a ban on the study of Greek owing to his contacts with the imperial government (T Sotah 15, 8, pp. 241–42, and parallels),[9] and the Bavli emphasizes the importance of Greek in his academy, which was reputedly divided equally between the study of Torah and Greek, with five hundred students studying each (B Sotah 49b; B Bava Qama 83a). This tradition was purportedly conveyed by Simeon, Gamaliel's son and successor,[10] who notes that he himself was one of those students. Lieberman accepted the general verisimilitude of this statement under the questionable assumption that a Babylonian source would not have invented such a tradition ex nihilo.[11] Later on, this same Simeon is noted as having favored the use of Greek, commenting that, in addition to Hebrew, biblical books were permitted to be written in Greek only (M Megillah 1, 8). In the following generation, R. Judah I followed suit, affording his children (and perhaps his students as well) a knowledge of Greek; moreover, several other Greek practices, such as the use of mirrors and having Roman coiffures, were also associated with his household (Y Shabbat 6:1, 7d; Y 'Avodah Zarah 2:2, 41a), and it was he who advocated the use of either Hebrew or Greek, but not Syriac (i.e., Aramaic; B Bava Qama 82b–83a).[12]

Our information from the fourth century is far more extensive. The epigraphic evidence from the Ḥammat Tiberias synagogue, clearly associated with Patriarchal circles,[13] is overwhelmingly in Greek; ten of the eleven dedicatory inscriptions are in this language, and the artistic evidence featuring the zodiac signs and Sol Invictus

7. On these instances, see L. I. Levine, "Status of the Patriarch," 19–20. On the Ḥammat Tiberias synagogue, see chap. 12

8. See L. I. Levine, *Ancient Synagogue*, 459–63, and above, chap. 16. On the more extensive authority wielded at this time by the Patriarchs in comparison to the Exilarchs of Bablyonia, see Gafni, *Jews of Babylonia*, 98–104.

9. The ban, cited on a number of occasions in rabbinic sources, is first noted in M Sotah 9, 14. For reservations regarding this ban, see Lieberman, *Hellenism in Jewish Palestine*, 100–14.

10. Simeon appears to have had no contact with the Roman authorities; moreover, there is very little evidence attesting to his communal position within the wider Jewish community.

11. Ibid., 100–14. The numbers of students and the alleged equal division accorded the study of Torah and Greek are undoubtedly highly exaggerated.

12. For a more detailed treatment of R. Judah's Hellenistic proclivities in line with the Second Sophistic, see chap. 4.

13. See the discussion of this building in chap. 12.

are of distinctly Hellenistic-Roman origin. Several Patriarchs presumably commu-
nicated in Greek with the pagan rhetor Libanius, nine of whose epistles have been
preserved although no responses from the Patriarch have survived.[14] Since Libanius
wrote in Greek, the Patriarchs undoubtedly must have responded in kind. The very
fact that such exchanges took place at all between the Patriarchs and one of the lead-
ing intellectuals of the age is, in itself, significant. Also notable is Libanius's refer-
ence in one of his letters to the son of one Patriarch who had been sent to him to
receive an advanced Greek education. The Patriarch in this instance was Gamaliel V,
and it is quite probable that other Patriarchs also considered a Greek education to
be of importance and likewise may have sent their sons abroad for instruction. Such
behavior tells us much about the cultural and intellectual horizons of these leaders
and perhaps of others in their circles as well.[15]

Finally, we have one brief and enigmatic, but thoroughly intriguing, piece of
information regarding the acumen of at least one Patriarch in a more general area
of knowledge. The Christian medical writer Marcellus Empiricus reported that the
last Patriarch, Gamaliel VI, is credited with having found a cure for the treatment
of spleen diseases.[16]

Thus, on the basis of the Patriarch's involvement in broader Hellenistic culture,
it is easy to understand the ongoing proclivity of this dynasty and its circles to ac-
commodate new modes of artistic expression throughout these centuries.[17] More-
over, no less than with respect to issues of communal, social, political, and religious
import, it is patently clear (as noted in third- and fourth-century sources) that the
Patriarch worked side by side with the urban aristocracy.[18] Unfortunately, sources
regarding this urban elite are far more limited than those for the Patriarch, but
had they existed, the information therein would undoubtedly confirm the extent

14. M. Stern, *GLAJJ*, 2:582–83.

15. Ibid., 2:580–99, 596. See also Stemberger, *Jews and Christians in the Holy Land*, 259–61,
and particularly his concluding paragraph: "The letters of Libanius to the patriarch Gamaliel,
mentioned above, complete the picture of the Hellenistic culture pursued at the court of the
patriarchs. In itself the fact that the rhetorician repeatedly addresses the Patriarch in the
course of his extensive correspondence shows clearly that he presupposes a shared degree
of education, and that the Patriarch is known and recognized outside the Jewish world. The
letters often refer to Greek mythology, presupposing a corresponding education on the part
of the Patriarch. He is expected to understand passing allusions to Homer, and it is taken
for granted that the mention of Greek gods does not upset him. The Patriarchal house, and
surely also wider circles among the Jewish communities of the east, must have felt quite at
home in the society and culture of the Roman empire."

16. *De medicamentis* 23.77: "For the spell there is a special remedy which was recently
demonstrated by the Patriarch Gamaliel on the basis of approved experiments." See also van
der Horst, *Japheth in the Tents of Shem*, 27–36.

17. See chaps. 4, 5, 12, and 16 dealing with Bet She'arim and Hammat Tiberias.

18. L. I. Levine, *Rabbinic Class*, 134–39, 176–81; and below.

and closeness of these overlapping agendas.[19] We will review the material available regarding the artistic predilections of the Patriarchate and wealthy classes, presenting a number of facets not discussed in previous chapters and limiting ourselves to brief comments regarding those cases in which the subject has already been treated.

THE SECOND CENTURY

A classic example of this dynasty's attitude toward figural art (often erroneously referred to as the rabbinic perspective) is the episode already referred to on several occasions regarding R. Gamaliel II (fl. ca. 90–120 CE)[20] in the bathhouse of Aphrodite in Acco (M 'Avodah Zarah 3, 4):

> Proklos, the son of Philosophos, asked Rabban Gamaliel while the latter was bathing in the bath of Aphrodite in Acre, saying to him: "It is written in your Torah, 'and there shall not cleave to you any of the devoted (i.e., forbidden) thing' (Deut. 13:18). Why do you thus bathe in the bath of Aphrodite?" He answered: "One may not give an answer in the bath." And when he came out he said: "(1) I did not come into her (Aphrodite's) area (literally, boundary), she came into mine. People do not say, 'Let us make a bath for Aphrodite,' but rather, 'Let us make a [statue of] Aphrodite as an adornment for the bath'; (2) moreover, even if they would offer you much money, you would not enter your place of worship (literally, idolatry) naked and suffering pollution and urinate in front of her (i.e., Aphrodite). But she stands at the edge of the gutter, and everyone urinates in front of her; (3) the verse only refers to 'their gods'; that which they relate to as a god is forbidden and that which they do not relate to as a god is permitted."[21]

R. Gamaliel's appearance in a bathhouse decorated with statues of the pagan goddess Aphrodite was the cause for Proklos's surprise and query. His astonishment may have been especially extreme given the strict avoidance of such art throughout Jewish society in previous centuries, as well as the fact that the absence of figural

19. In contrast, see Gafni, *Jews of Babylonia*, 104–9, on the greater involvement of nonrabbinic figures in communal affairs as compared to the situation in Babylonia.

20. It has been almost universally agreed that the Gamaliel mentioned here is Gamaliel II. For a different dating of this story, to the time of R. Gamaliel III (early third century), see Wasserstein, "Rabban Gamliel." However, Wasserstein's identification is chronologically problematic. The Proklos whom he suggests as conversing with Gamaliel III in Acco lived ca. 140–200, and his (i.e., Proklos's) son was already active in the Severan court in Caracalla's time (211–17). Since R. Gamaliel III functioned as Patriarch beginning only in the 220s, the chronological discrepancy is formidable. A. Yadin's identification of Gamaliel III with the Acco story is also problematic, though for other reasons as well; see his "Rabban Gamliel."

21. L. I. Levine, *Judaism and Hellenism*, 106–10; S. Schwartz, "Gamaliel in Aphrodite's Bath," 211–17; S. Schwartz, "Rabbi in Aphrodite's Bath"; Eliav, "Viewing the Sculptural Environment," 424–25; Friedheim, "Rabban Gamaliel."

representation had heretofore constituted one of the cardinal distinctions between Jewish and non-Jewish societies.[22]

Rabban Gamaliel's threefold response regarding his frequenting a pagan-ornamented bathhouse is as fascinating as it is far reaching. The first deals with the definition of the building's function: Was it built to serve as a pagan sanctuary or a bath? Was the statue of Aphrodite intrinsic to the building's function or was it merely an external ornament? Gamaliel replied that the statue was meant to be purely decorative since the building itself was intended to fulfill a "secular" purpose. His second response involved the nature of the facility, which should be judged by what people actually do there; when one walks around naked and urinates with no regard to the presence of the statue of a deity, the statue is clearly of no consequence to those in attendance. Therefore, the bathhouse was not to be regarded as either specifically pagan or sacred.

R. Gamaliel's third claim, however, is the most sweeping: one should view a place or an object as idolatrous only if it is so regarded by the pagans themselves; if they do not consider an object as deserving of reverence and worship, but only as something decorative, then a more permissive attitude and behavior toward it are justified. This last response is the most revolutionary precisely because it was cast as a guiding principle. Nothing, not even a statue, is inherently forbidden; everything depends on its function, context, and the intention of those who placed it there.

This episode implies a willingness to deal with each instance of figural art in its own circumstances. In this case, Gamaliel clearly adopted a lenient position, possibly because of the new historical reality of the post-70 era and his own heightened contact with non-Jewish society — owing either to his prominent political and social position (certainly within rabbinic circles) or his personal cultural proclivity. R. Gamaliel's actions and words reflect a radical reassessment of the earlier normative prohibition, allowing for greater leeway and flexibility vis-à-vis the display of pagan images. The explanations attributed to Gamaliel restricted this ostensibly biblical prohibition to images bearing cultic significance, similar to the way the Decalogue and Deuteronomy 4:15–19 might be understood.[23]

However, the historical reliability of this account is questionable given the fact that it appears in the Mishnah, which was edited by R. Gamaliel's grandson, R. Judah I, about a century after the purported event took place. A story such as this is most exceptional in a mishnaic context and was clearly meant to highlight Gamaliel's standing and affirm a religious-cultural position with which Judah himself

22. Tacitus, *History* 5.5.4, in M. Stern, *GLAJJ*, 2:26 (and comments on p. 43). The exceptions to this strict avoidance are few and are limited mainly to the Herodian dynasty; see, e.g., *Ant.* 15.25–27, 17.149–63, and 19.357. On the aniconic nature of Jewish art toward the end of the Second Temple period and the exceptions to the rule, see chap 3.

23. A similar accommodation to figural images was made by the local aristocracies of Sepphoris and Tiberias on their second- and third-century coinage; see below, as well as chap. 3.

almost certainly identified. But did Judah invent this story, or did the tradents in the intervening generation or so rework an earlier tradition? These are all legitimate possibilities, and although we have no way of being certain of Gamaliel's actual behavior, several other brief reports about his receptivity to artistic representation might lend credence to the basic veracity of the above tradition (see below). Even if we were to adopt a more skeptical approach and dismiss any element of historicity, it can be said with reasonable certainty that around the turn of the third century, R. Judah himself would have viewed such actions and their implications very positively; otherwise he probably would not have included it in his Mishnah.

However interpreted, this incident appears to have been a defining moment — if not in the time of R. Gamaliel himself, then certainly in that of R. Judah I. It indicates a readiness on the part of this dynasty to make innovative policy adjustments regarding figural images in the post-Temple era. The presence of paganism and pagan society was acutely felt by the Jews in Roman Palestine following the destruction of Jerusalem and its Temple, both of which provided a locus for Jewish identity and a psychological buffer vis-à-vis the non-Jewish world. It is therefore quite possible that R. Gamaliel's emerging communal role, political contacts with Roman authorities, and cultivation of Greek within his own circle are all indications of this (proto) Patriarch's willingness to adapt to the new circumstances in Roman Palestine following the events of 70.[24]

It remains clear that the above episode (or its transmission) was closely associated with the emerging Patriarchal dynasty, whether in the time of Gamaliel or Judah I. All too often this account is regarded as a shift in rabbinic attitudes generally, to one reflecting an openness to Greco-Roman culture and a recognition of the crucial distinction between idolatrous and decorative representations. Such an approach is patently erroneous, as the Patriarchate was a different institution and not necessarily reflective of "mainstream" rabbinic attitudes, despite the many disagreements among the rabbis themselves.[25]

Two other brief reports concerning R. Gamaliel attest to the fact that he was associated with a predisposition toward using figural representations, a practice that was uncommon among Jews at that time, and among the rabbis in particular. In one instance, Gamaliel reportedly used images of the sun and moon on a regular basis

24. Alon, *Jews in Their Land*, 1:206–52; Goodblatt, *Monarchic Principle*, 176–231; L. I. Levine, *Judaism and Hellenism*, 124–31. It may not be coincidental that a remarkable tradition preserved in the fifth- to sixth-century Leviticus Rabbah (34, 3, pp. 776–77) speaks of Hillel (a late Second Temple figure) regularly visiting the bathhouse. The historicity of such a story is undoubtedly nil; nevertheless by this time rabbinic lore had associated the Patriarchate with the seed of David and Hillel. It may be that the Gamaliel tradition, known to us through the Mishnah, influenced its creation.

25. See Mekhilta of R. Ishmael, Yithro, 6, ed. Lauterbach, pp. 224–25; Mekhilta of R. Simeon bar Yoḥai, p. 222; Midrash Hagadol, Exodus 20:29, p. 442; and above, chap. 20. A striking distinction between Rabban Gamaliel and the "Sages of Israel" (חכמי ישראל), albeit in a late midrash, appears in Massekhet Derekh Eretz–Pirqei ben Azzai 3.

when cross-examining witnesses who came to testify to the appearance of the new moon (M Rosh Hashanah 2, 8; M 'Avodah Zarah 3, 3)—a method that many (or most) of his contemporaries would have shunned and which indeed led to some criticism among later Babylonian sages (B Rosh Hashanah 24b; B 'Avodah Zarah 43a–b). The explanations offered by these sages reflect their uneasiness: (1) these figures were created by gentiles and never displayed publicly; (2) they were constructed in sections and assembled only when witnesses appeared; and (3) they were made for the specific setting of testifying to the appearance of the new moon for the purpose of fixing the calendar. In another instance, a statement ascribed to R. Gamaliel's son Ḥanina is likewise revealing in this regard: "In my father's house, they would use seals (or stamps) bearing [all sorts of] images" (T 'Avodah Zarah 5, 2, p. 468).

In another, entirely different, vein Rabban Gamaliel is credited with an aesthetic appreciation of a very different kind. In the context of a blessing required when beholding beautiful sights, the Yerushalmi cites a tradition that singles him out, much to the dismay of some later rabbis:

> It once happened that R. Gamaliel saw a beautiful gentile woman and he uttered the blessing over her. Did not R. Ze'ira in the name of R. Yosi b. Ḥanina . . . say: "You should not show mercy to them" (Deut. 7:3)—you should not acknowledge beauty among them (non-Jews)." He (R. Gamaliel) only said: "Thus [God] has created beautiful creatures in His world. . . ." Was this the practice of R. Gamaliel to look at women? Rather, it was like this winding road (פופסדס),[26] and he looked at her not for his benefit (perhaps to be understood as looking 'inadvertently' or 'against his will')." (Y Berakhot 9, 1, 13b–c)[27]

Once again, the historical value of this late tradition is questionable. But even if deemed apocryphal, it nevertheless attests to later generations of sages associating this Patriarch with an awareness and appreciation of physical beauty.

Our information regarding Gamaliel's son, R. Simeon b. Gamaliel II, is far more limited but still somewhat reflective of his father's more tolerant artistic-aesthetic orientation relative to other sages. In one passage, R. Simeon is noted as adopting a less rigorous position vis-à-vis pagan-related art than the anonymous mishnah: "One who finds vessels bearing the figure of the sun, the figure of the moon, the figure of a dragon should get rid of them (literally, he must throw them into the

26. See Jastrow, *Dictionary*, 1139 (a tortuous street, probably in Tiberias); Sokoloff, *Dictionary*, 445 (a curved path into town).

27. A shorter alternative version appears in Y 'Avodah Zarah 1, 8, 40 a–b. "It happened that R. Simeon b. Gamaliel was standing on the steps leading to the Temple Mount and saw a gentile woman who was very beautiful. He said: 'How great are your works, Lord.'" Perhaps as a rebuttal to this tradition, the Talmud then continues: "Likewise, when R. 'Aqiva saw the wife of the wicked Tinius Rufus, he spit, laughed, and wept" (B 'Avodah Zarah 20a). See also Neis, *Vision and Visuality*, 276–81, 296–99.

Dead Sea). R. Simeon b. Gamaliel says: 'If the objects are of value, they are forbidden; if they are worthless, they are permitted'" (M 'Avodah Zarah 3, 3).[28] Thus, R. Simeon's more permissive stance maintains that images (even with religious overtones) found on everyday utensils should not be regarded as idolatrous and thus prohibited, but rather as essentially decorative and thus permissible.[29]

In the cases of both R. Gamaliel and his son Simeon, as with their respective grandson/son R. Judah, a more lenient attitude toward figural art went hand in hand with their positive bent toward the use of Greek. As noted above, Gamaliel was "allowed" (presumably by the rabbis, who were reflecting their later Babylonian perspective) to teach Greek, since he had ongoing contact with the Roman government (T Sotah 15, 8, p. 242); we have already discussed the Bavli tradition claiming that under his tutelage five hundred studied Torah and five hundred Greek, justifying it for the same reason (Sotah 49b). In a similar vein, the Bavli mentions that R. Simeon b. Gamaliel allowed the Torah to be translated into Greek (see above, and B Megillah 9b).

The second century also provides significant evidence of the Jewish urban aristocracy's willingness to accommodate the new post-70 political and social realities in the Galilee. It will be remembered that Jewish minting authorities during the last several hundred years of the Second Temple period were punctilious in avoiding the use of animal, human, or mythological representations on coins.[30] This was as true of the Hasmonean and Herodian rulers as of the first-century Jewish cities of Tiberias and Sepphoris.[31] However, while the latter followed this normative Judaean practice throughout the first century, by the second and third centuries these same cities began minting coins bearing facades typical of pagan temples as well as images of various gods. Thus, as suggested in chapter 3, it would seem that the leaders of Tiberias and Sepphoris had adjusted to the radical change created by the destruction of the Temple and Jerusalem and had begun utilizing pagan depictions well recognized in the East and the immediate environs of second-century Galilee. Presumably, this was deemed necessary in order to have their coins accepted in the non-Jewish regions in which they circulated.

THE THIRD CENTURY
The first of two major archaeological sites clearly associated with the Patriarchate attests to the use of various types of art, many unknown in Jewish circles for over

28. See also M Rosh Hashanah 2, 8.

29. According to Blidstein ("Nullification," 8): "R. Simeon b. Gamaliel . . . maintains that images of common vessels are purely decorative and nothing more; the utilization of these vessels and objects for menial tasks destroys any thought of the sanctity of their images."

30. See chap. 3.

31. The main exceptions to this rule were the Herodian rulers of pagan territories or cities; see in detail chap. 3.

a millennium. The third-century Patriarchal necropolis of Bet She'arim[32] was used by local Jewish residents hailing from the Galilee and Palestine generally, as well as by Diaspora Jews. A number of the interred held communal positions, such as that of the archisynagogue, and all were Hellenized, so much so that Greek was widely used in the overwhelming majority of the catacombs.[33] It may be assumed that, other than the Patriarchal family itself, quite a few of those buried in Bet She'arim came from the wealthy leadership circles of Jewish communities throughout the region.

The art of the catacombs includes a Hellenistic/mythological component together with a uniquely Jewish one. The use of pagan figural art such as Leda and the Swan or the Amazons attests to a cultural and aesthetic openness that included adopting regnant artistic forms drawn from the wider society. At the same time, the use of Jewish symbols, most prominently the menorah, exhibits a creative and innovative posture toward artistic expression heretofore unknown in a Jewish setting. These ostensibly antithetical dimensions appear side by side in the Bet She'arim catacombs.[34]

A considerable amount of diversity, specifically with respect to art, exists even between the two Patriarchal catacombs (14 and 20) at Bet She'arim.[35] The former very likely contained the remains of R. Judah and his close circle, while Catacomb 20 housed those of the Patriarchal family in subsequent generations. Thus, while R. Judah (or those in charge of his burial) shied away from adorning his burial chamber, such was not the case later on, as exemplified by Catacomb 20's wealth of animal, human, and mythological figures.[36] In this regard, Bet She'arim was distinguished not only from earlier Second Temple practice but also from other Galilean burial sites of the post-70 era that were devoid of such figures.

Another archaeological find from early third-century Sepphoris, whose connection with the Patriarchate admittedly remains questionable, is a very impressive mosaic floor from the triclinium of a large palatial villa on the city's acropolis, between the theater and what appears to have been a Jewish residential area. As will be recalled, this mosaic features 15 well-preserved panels relating to the life and cult of Dionysus.[37] We have no way of knowing who lived in this villa in the early third century;[38] however, given the mosaic's prominent location, its date of construction

32. See chap. 6.

33. The Greek inscriptions, both published and unpublished, amount to over 80 percent of the total; see chap. 6

34. See chap. 6, figs. 61–64.

35. See chap 6.

36. When it came to the use of Greek as against Hebrew, both of these catacombs, in striking contrast to all the others, emphasized Hebrew over Greek.

37. See chap. 4, fig. 38. See C. L. Meyers et al., "Dionysos Mosaic"; and more fully Talgam and Weiss, *Mosaics of the House of Dionysos*.

38. Although *miqv'aot* were found inside the villa, they seem to date from a later period.

(which coincides with R. Judah's move to the city), and the fact that Patriarchs generally were not averse to using visual imagery, it has been suggested that the villa may have belonged to R. Judah himself.[39] If granted, this find would be a stunning case of the Patriarch's receptivity to such pagan (or perhaps more accurately, Hellenistic) motifs, reflecting his ease with this type of artistic expression. However, for the moment at least, all this must remain but an intriguing possibility.

R. Judah's grandson, R. Judah II Nesiah, is likewise described in the mid-third century as having been more open to pagan images than other rabbis. As noted, he purportedly received a present of dinars (clearly bearing images) from a high-ranking Roman officer (the procurator of Caesarea?) on a pagan holiday. So as not to offend the bearer of this gift, R. Judah kept one dinar and returned the rest. Resh Laqish, however, objected to his having retained even one (Y 'Avodah Zarah 1, 1, 39b; B 'Avodah Zarah 6b).[40]

Beginning in the third century and continuing into the fourth (and perhaps beyond), the Patriarchate and urban aristocracy were often in close alliance[41] to promote their mutual interests.[42] With their growing authority and influence in Jewish communal affairs, the Patriarchs were in need of a loyal cadre to share the burdens (and benefits) of such responsibilities, while the wealthy and influential upper classes could only reap recompense for their close cooperation with the Patriarchate. Thus, when the Bavli declared that R. Judah "accorded honor to the wealthy" (B 'Eruvin 86a),[43] it put its finger on an important component of this dynasty's internal social and political policy in the third and fourth centuries.

The Patriarchs appointed judges from this privileged circle, much to the chagrin of the sages (Y Bikkurim 3, 3, 65d; B Sanhedrin 7b), and it was this urban leadership that was accorded priority when visiting the Patriarch. In a ceremony reminiscent of a Roman imperial setting (*salutatio*; see Suetonius, *Vespasian* 21), various aristocratic groups would greet the Patriarch each day: "There were two leading groups (literally, families) in Sepphoris, the *bouleutai* (members of the *boule*) and the *pagani* (commoners or wealthy landowners). They would greet the Patriarch

39. See Talgam and Weiss, *Mosaics of the House of Dionysos*, 127–31; and in much more detail: Weiss ("Between Paganism and Judaism"), who first raised the idea of identifying the villa with R. Judah. For examples of Christian openness to such motifs in the Byzantine period, see Bowersock, *Hellenism in Late Antiquity*, 41–53.

40. Blidstein, "Roman Gift of Strenae"; and above, chap. 20.

41. Additional powers associated in rabbinic literature with the third-century Patriarchs include some sort of involvement with or supervision of educational institutions and tax collection; see L. I. Levine, "Jewish Patriarch (Nasi)," 663–76.

42. L. I. Levine, *Rabbinic Class*, 167–81.

43. The close relationship of Rabbi and his circle and the wealthy of his generation is further reflected in B Shabbat 119a: "Rabbi asked R. Ishmael son of R. Yosi: 'The wealthy of Eretz-Israel, what is their merit?' He said: 'Because they give tithes, as is written, "You must surely tithe" (עשר תעשר—Deut. 14:22), tithe so that you may become rich (עשר בשביל שתתעשר).'" See also parallels: Midrash Hagadol, Exodus 20:8, p. 413; Yalqut Shim'oni, Isaiah, 496.

daily, the *bouleutai* entering first and leaving first" (Y Shabbat 12, 3, 13c; Y Horayot 3, 3, 48c). Moreover, it was this urban leadership that may have been instrumental in building "the synagogue of the *boule*" (כנישתא דבולי – Y Taʿanit 1, 1, 64a) and erecting "the statue of the *boule*" (צלמא דבולי – Y ʿAvodah Zarah 3, 11, 43b) in Tiberias. The prominence of these wealthy people in Bet Sheʿarim is thus not surprising, nor is their participation in financing a fourth-century synagogue in Tiberias associated with the Patriarch, as discussed below.

THE FOURTH CENTURY

We have precious little information about subsequent Patriarchal attitudes toward figural art, partly because rabbinic literature increasingly ignores this office from the mid-third century onward. Moreover, from the early third century and for the subsequent hundred and fifty years, very little relevant archaeological material exists, Bet Sheʿarim aside, and certainly none that can be linked in any way to the Patriarchate.

The latter fourth century, however, has yielded the second major archaeological site clearly associated with a Patriarch, the Ḥammat Tiberias synagogue. This building was connected either directly or indirectly to the Patriarchal office[44] through the efforts and contributions of one Severus, referred to on two occasions as a "protégé (Θρεπτός) of the Illustrious Patriarchs." The many Greek donor inscriptions here, ten out of a total of eleven, cite benefactors with either Greek or Latin names. Thus, once again, we have evidence for the participation of a wealthy group of Tiberian citizens closely associated with the Patriarch, in this case those who contributed to a synagogue whose artistic depictions were no less extraordinary than those of Bet Sheʿarim. In addition to the many Greek inscriptions, this mosaic floor provides impressive testimony to the fascinating cultural integration forged by and identified with the Patriarchs. On the one hand, they initiated the prominent display of a cluster of Jewish symbols that was subsequently reproduced in one form or another in many other synagogues, and on the other, they introduced the earliest representation of the zodiac motif in a synagogue setting that included a stunning portrayal of Helios representing Sol Invictus. Thus, the Ḥammat Tiberias mosaic provides a further link and, archaeologically speaking, a fitting culmination of the process of acculturation and accommodation first attested under R. Gamaliel II in Acco and subsequently highlighted in Bet Sheʿarim.[45]

The Patriarchs were not responsible for all or even most Jewish art in Late Antiquity. Yet, together with the urban aristocracy with whom they maintained a close

44. See chap. 12.

45. Similarly, as discussed above, knowledge of Greek and its ongoing use continued to characterize the Patriarch and his circles. We have noted above (nn. 14–16) Libanius's correspondence with the Patriarch in the fourth century that attests to this, as well as the medical expertise of Gamaliel VI at the turn of the fifth century.

political and social alliance, they introduced innovative and apparently, for the first time, revolutionary components into Late Antique Jewish art.[46] Some of the most impressive and long-lasting creations of Jewish art in this period first made their appearance in Patriarchal settings, and these motifs continued to be used for generations, long after the disappearance of this office in the early fifth century.[47]

46. See chaps. 4, 6, 11, and 16; as well as J. Baumgarten, "Art in the Synagogue."

47. See chap. 16. On the continued attraction of the Bet She'arim cemetery long after the political demise of the Patriarchate, see Weiss, "Burial Practices in Beth She'arim," 225–31.

22. ART AND JEWISH IDENTITY IN LATE ANTIQUITY

WE HAVE NOTED above that Jews and Judaism in Late Antiquity have been regularly portrayed in a rather negative light owing in large measure to hostile Christian sources that heretofore have shaped our image of this period.[1] Imperial and ecclesiastical sources are rife with restrictive laws, descriptions of violent attacks against Jews and their synagogues, and incessant polemics of church leaders deprecating all facets of Judaism. The cumulative effect of the above was assumed to have heightened the tension and pressure under which Jews lived, ostensibly transforming them into a persecuted minority suffering from ongoing discrimination.[2]

Indeed, between the fourth and seventh centuries, following the relentless elimination of the threat posed by Christian sects that were deemed heretical, they viewed the Jewish people as the despised "other," together with the pagans, making them a primary target of Christian hostility. In a heuristic vein, we might designate the new status of the Jews as a transition from a subculture under pagan Rome to a counterculture under Christendom.[3] By invoking this terminology, it

1. See chap. 9.

2. It is obviously impossible to pinpoint when Jews grasped the reality of Christian domination and its implications. It undoubtedly occurred at different times, depending on the particular locale, how an individual or community interpreted the political and religious events of the day, and which aspects of Jewish life were being considered (e.g., economic, political, social, or religious). Moreover, there was likely to have been little unanimity among Jews about the ramifications and implications of these developments. For example, the contradictory legislation stemming from imperial circles, at least throughout the fourth and early fifth centuries, as well as the totally unexpected Julian phenomenon, allowed for varying assessments of these new developments in the long and short run.

3. I am using these terms in a modified sense, since most discussions today address them with respect to twentieth-century contexts, i.e., groups that advocate deviancy, insurrection, anti-authoritarianism, antirationalism, individuality, etc. On rare occasion are Jews and Judaism introduced into these discussions as precedents, for example, with regard to the biblical Abraham or the modern-day kibbutz (see, e.g., Roszak, *Making of a Counter Culture*; Westhues, *Society's Shadow*; Yinger, *Countercultures*; Goffman and Joy, *Counterculture through*

is implied that the Jews under pagan Rome were generally tolerated and enjoyed a wide range of privileges despite their different ethnic and religious practices; under Christendom, however, with restrictions, discrimination, and intermittent harassment becoming the order of the day, Jews were reduced in the eyes of the ruling political and religious elites to the status of an inferior and loathed alien.[4] It was assumed, at least in some leadership circles, that the transition to a Christian society striving for a maximum degree of homogeneity would lead sooner or late, to far-reaching changes in the attitudes and behavior of the Jews, hopefully leading to their conversion.

In earlier eras, many Jews had developed an attachment and loyalty to ruling powers (be they Persia, the Hellenistic empires, or Rome), but it is safe to assume that any overall identification with Byzantine-Christian society was severely attenuated, if it even existed. It goes without saying, of course, that a final parting of the ways between Judaism and Christianity took place in the course of Late Antiquity, affecting all strata of society and not just the elite.[5]

Given the revolutionary circumstances of Christianity's rise to power, it is hard to imagine that issues of identity were not high on the agenda of many Jewish communities. Never before in antiquity had challenges and tensions of such proportions confronted Jews and Judaism. In a world whose spokespersons proclaimed that Judaism had been superseded by a triumphant Christianity, this new *Verus Israel* indeed constituted an unprecedented threat to the Jews.[6]

the Ages). Counterculture in Byzantine Judaism did not share most of these modern characteristics. For one, it did not surface in opposition ("counter") to Christianity since it was an already existing culture; rather, the Jews' alien status was the result of a relationship imposed by Christian society.

4. Understanding a counterculture as a set of norms and values shared by a group that radically differs from those of the dominant society and, as a result, acts in what can readily be viewed by others as nonconformist ways would seem to fit the circumstances of Jews and Judaism in Byzantine society.

5. While recent scholarship has discussed the extent to which Jews and Christians still maintained (close?) relations in the first centuries CE, there can be little question that sometime between the fourth and sixth centuries—if not from the time of Constantine, then certainly by the Justinian era—a significant social, political, and religious rift was created, causing an ever-widening chasm between these communities. True enough, there was some blurring and overlapping at the edges; Judaeo-Christians may have continued to function in certain locales, while Judaizing Christians, not infrequently stemming from Christian sectarian groups, continued to be attracted to Judaism's practices and symbols as well as to the synagogue (e.g., Antioch and Aphrodisias; see chap. 9). However, by the sixth and seventh centuries such instances were far more likely to have constituted isolated remnants of the past rather than the tip of a significant contemporary iceberg.

6. Linder, "Legal Status of the Jews"; Fredriksen and Irshai, "Christian Anti-Judaism"; Parkes, *Conflict*. With the notable exception of Augustine and those who followed his view; see Fredriksen, *Augustine and the Jews*, passim, and esp. 213–352.

From the Jewish perspective, the complex relationship with Byzantine-Christian society certainly included a mixture of defensiveness, suspicion, fear, and rejection. However, what has become clear of late is that, despite this adversity, Jews also demonstrated a significant measure of resilience, creating new ways to reinforce and strengthen their self-identity. As discussed above, they were able to maintain and even enhance their communal institutions, as well as assimilate a wide variety of contemporary artistic themes, thus bolstering Jewish identity through the use of symbols and biblical motifs. In short, art demonstrates the willingness and ability of many communities to assert their Jewishness while maintaining cultural bridges with their surroundings.

The literary and material evidence reveal striking differences in emphasis with regard to Jewish reactions to the new Byzantine-Christian circumstances. The former largely reflects a proclivity toward withdrawal, isolation, and defensiveness, the latter a considerably greater willingness to engage and respond to external stimuli. While Christian culture played only a partial and secondary role in Jewish literary sources, it constituted a far more significant factor in the material realm. We will first examine the major literary corpora in this regard and then turn to the material culture and its implications.

Rabbinic literature is silent about Christianity's rise to power; neither the Yerushalmi, edited in the late fourth century, nor later midrashic compositions relate to this phenomenon in any sustained or systematic manner. Given the temporal and geographic propinquity of the rabbinic sources to the Christianization process generally, this almost deafening silence is remarkable, though far from unusual. Ignoring major events of the day or noting them only *en passant* when relating to a particular sage or halakhic issue is fairly characteristic of rabbinic literature generally. For example, with regard to the fourth century, little, if anything, is known about the Gallus revolt of 351–52, Julian's plan to rebuild the Temple in 363, or even the enhanced prestige and status of the Patriarchate at this time (if not earlier). Generally speaking, Christianity occupied a negligible place on the rabbinic agenda over the first centuries CE.[7] Even if some references to *minim* or the "nations of the world" refer to Jewish or gentile Christians, contacts with such people, whether in the Galilee or Caesarea, were very sporadic.[8] Rabbinic references to "Rome,"

7. For a discussion of the first two centuries, see Katz, "Rabbinic Response to Christianity." This, of course does not mean that the rabbis were entirely unaware of Christian claims and rhetoric on a local or individual level. From the second century on, there is evidence, especially from the Galilee, that some rabbis had contact with assorted Christians and their beliefs via discussions, debates, or hearsay; see Baer, "Israel, the Christian Church, and the Roman Empire," 112–15; Urbach, "Homiletical Interpretations"; Kimelman, "Rabbi Yohanan and Origen"; Baskin, "Rabbinic-Patristic Exegetical Contacts"; Hirshman, *A Rivalry of Genius*, 13–22; Visotzky, *Fathers of the World*, 1–17, 121–25.

8. Herford, *Christianity in Talmud and Midrash*. An intriguing instance of a rabbi being suspected of "Christianizing" concerns the second-century sage R. Eliezer b. Hyrcanus; see

once presumed to relate to the fourth-century Christian city, have recently been interpreted as referring to the earlier pagan one.[9] Moreover, this literature ignores some of Christianity's most significant political and religious advances, such as its increasing status as the official and then exclusive imperial religion or the reshaping of Jerusalem as a Christian city.[10]

Piyyut has been linked to a series of anti-Christian barbs.[11] Indeed, this topic has often engaged scholars of *piyyut* in the early twentieth century, many of whom mined these compositions for hints of polemics or reactions to Christianity. However, truth be told, such references to Christianity are relatively few in number and even then often articulated in the guise of Rome or Edom. Wout Jac. van Bekkum has collected many of these anti-Christian statements, concluding that "specific allusions to the political and religious status of the Jews in Byzantium are sparse. As official (*sic!*) representatives of the Jewish community, the *paytanim* are not primarily interested in direct religious polemics and no explicit support can be derived from their works."[12]

Hekhalot compositions, first coalescing in Late Antiquity, exhibit no concern for Christianity, its doctrines, or polemical attacks. An examination of the *Konkordanz zur Hekhalot-Literatur* reveals no references to Jesus or Christianity as such.[13]

Targum, too, contains only scant information that can be securely identified as referring to Christianity.[14] In contrast, a number of references to Ishmael and Islam reflect a later redaction.[15]

Whether the relatively few references to Christianity in the above literary works were a conscious decision of their editors to ignore an undesirable and problematic reality by "sweeping it under the rug," an outcome of their own narrow purview

T Ḥullin 2, 24, p. 503; B ʿAvodah Zarah 16b–17a; and Herford, *Christianity in Talmud and Midrash*, 137–45; Boyarin, *Dying For God*, 26–41.

9. Schremer, "Christianization of the Roman Empire."

10. Goodman, "Palestinian Rabbis and the Conversion of Constantine." A vigorous advocate of an active rabbinic polemic against Christianity throughout this period is I. J. Yuval (*Two Nations in Your Womb*, 1–91), who, following Scott (*Domination*), invoked the concept of a "hidden transcript" to explain some relatively unrecognizable rabbinic references to Christianity. In another vein, the transformation of Jerusalem into a Christian city has been trumpeted as a key catalyst in the creation of certain forms of Jewish art, be it the use of specific motifs or in the alleged programmatic message on the Sepphoris mosaic floor, per Kühnel, "Synagogue Floor Mosaic in Sepphoris," 40–41, and Weiss, *Sepphoris Synagogue*, 249–56.

11. See, e.g., Yahalom, *Poetry and Society*, 67–80.

12. Van Bekkum, "Anti-Christian Polemics" (quote on p. 308). See also Maier, "'Ha'omrim le-khilay shoa' and Anti-Christian Polemics." See, however, Yahalom, *Poetry and Society*, 67–80.

13. On the absence of terms relating to Christianity, see Schäfer et al., *Konkordanz zur Hekhalot-Literatur*.

14. On the omission of terms relating to Christianity, see, e.g., Houtman and de Moor, *Bilingual Concordance*.

15. Shinan, *Embroidered Targum*, 156–64.

and particularistic focus, or both is difficult to assess. While Christian society and culture indeed served as a catalyst in generating more intensive religious creativity among Jews,[16] evidence from the above literary genres indicates that their authors/ redactors by and large did not care to engage in active polemics, but rather sought religious meaning and comfort in their own common memories, texts, and particular way of life. The above literary genres were thus geared primarily toward highlighting and reinforcing internal religious agendas.[17]

A further example of Jewish literary silence vis-à-vis Christianity is evident with regard to supposed Jewish violence. In fact, many Christian sources have preserved a considerable number of references to active Jewish resistance to Christians and Christian hegemony. For example, Jews were often accused of fomenting violence against Christians, their leaders, and their sacred symbols. A law in the Theodosian Code from 408 warns the Jews to desist from mocking Jesus, supposedly under the guise of Haman on Purim,[18] and other sources blamed them for desecrating the statue of Mary, attacking Christians, accosting Christian clergy (a patriarch of Antioch as well as an archdeacon of Laodicea), disturbing Christian services, and massacring Christians in Jerusalem and Najar, Arabia. Ambrose relates that under Julian, Jews allegedly destroyed churches in Alexandria, Beirut, Gaza, and Ashkelon, while not a few sources tell of Jewish conversions to Christianity, either as individuals (such as Joseph the Comes) or entire communities (Minorca). Many

16. As discussed in chap. 10.

17. In contrast to the above-noted genres, where Christianity is given short shrift, there are several Jewish literary works that clearly articulate anti-Christian sentiments (or at times respond to Christian influences) in a rather poignant fashion: (1) The Late Antique Hebrew parody of the New Testament, *Toldot Yeshu*, in which much of the New Testament narrative is ridiculed and reworked to serve the polemical/apologetic agenda of its author or authors, e.g., that Jesus was born of an adulterous relationship and was essentially a magician; (2) *Sefer Zerubbabel*, a sixth- to seventh-century apocalyptic treatise with a clear-cut messianic/ eschatological orientation borrowed Christian themes and motifs and used them to assert the superiority of Jews and Judaism; and (3) *The Ten Martyrs*, a midrash that relates the suffering and death of ten sages in atonement for the sin of biblical Joseph's brothers, who had sold him into slavery. The midrash itself focuses on the figure of R. Ishmael and is suffused with anti-Christian—or perhaps counter-Christian—traditions, beginning with the basic narrative that the death of the ten rabbinic martyrs was intended as vicarious atonement of Israel's sins. For a discussion of the above three works, see: (1) *Toldot Yeshu*—Krauss, *Das Leben Jesu*, 246–48; Schonfield, *According to the Hebrews*; Horbury, "Critical Examination of the *Toledoth Jeshu*"; Schlichting, *Ein jüdisches Leben Jesu*; see also Horbury, "Trial of Jesus," 116–121; Basser, "Acts of Jesus"; Newman, "Death of Jesus"; (2) *Sefer Zerubbabel*—Himmelfarb, "Mother of the Messiah," 369–89; see also J. Dan, "Armilus"; and (3) *The Ten Martyrs*—Boustan, *From Martyr to Mystic*; Abusch (Boustan), "Rabbi Ishmael's Miraculous Conception."

18. See Linder, *Jews in Roman Imperial Legislation*, no. 36.

works describe Jews being defeated in polemics against Christians or being swept up in false messianic activity that always ended in failure.[19]

Nevertheless, as fascinating and diverse as these Jewish responses preserved in Christian sources seem to be, the historical value of the latter remains somewhat problematic. The fact that these sources are hostile and blatantly anti-Jewish (degrading Jews and attributing to them the basest of motives as well as cruel and sacrilegious actions) raises serious questions about their credibility, if not their disqualification, with respect to their historical reliability. Moreover, none of the above-noted episodes finds any corroboration in Jewish sources. Even if one were to assume a modicum of truth in some of these Christian reports (such as the conversion of the Jews in Minorca in 418), it is impossible to determine what and how much to accept.[20]

Having reviewed the various literary sources, which have precious little to say about Jewish reactions to the emerging hegemony of Christianity, we now turn to responses reflected in the material culture, which offer a significantly different perspective. The material culture exhibits neither withdrawal nor insulation, but rather a willingness to engage, imitate, selectively appropriate, and perhaps even reciprocate.[21] Each of the various facets of the material culture of Late Antiquity is extraordinarily rich and all are in some way connected to models and practices

19. Parkes, *Conflict*, passim, but esp. 121–95; Avi Yonah, *Jews of Palestine*, 166–74, 223–25, 251–53; Irshai, "Jewish Violence," 402–10.

20. Granted the appropriateness of skepticism in this regard, sources reporting the above-noted incidents raise far broader questions, such as whether this Christian literary material indeed reflects popular reality in the streets of cities and villages at the time. *Mutatis mutandis*, the same may be asked of Jewish literary sources as well, although they are far more limited quantitatively and qualitatively. How accurately do they reflect what transpired in Jewish communities across the empire and how widespread were the views and attitudes articulated therein?

For a similar kind of dissonance, this time between Christian anti-Jewish polemics and the realities of Jewish life in the Mediterranean city that often attest to close and amicable relationships been Jew and Christian, see Fredriksen, "What 'Parting of the Ways'?"; Fredriksen, *Augustine and the Jews*, xvii–xviii.

21. The gap between literary and archaeological evidence in the Jewish context is felt no less in the Byzantine-Christian world: "early Christian art and architecture are not mainly based on texts, on theological principles and conciliar decisions, although ecclesiastical art may sometimes reflect the content of such texts. Thus, we find a latent tension between the function of art and architecture as a medium, on the one hand, and theological teaching and dogma, on the other hand—and this tension sometimes produces unexpected results. . . . A work of art or architecture may well confront the viewer with creations, assertions and claims that reflect the patron's wishes in a more or less camouflaged or subtle manner. These assertions and claims are addressed not to the jurist or theologian, but rather to the visually adept observer. It is certainly wrong to assume that Christian art is a mere visual gloss on Christian doctrine" (Brenk, "Art and *Propaganda Fide*," 692).

of the wider Byzantine society. Jewish communities throughout Palestine and the Diaspora built communal edifices, often of impressive proportions and always in the regnant styles of their immediate surroundings,[22] while their art ranges from common and neutral themes characteristic of Byzantine society to those of religious content, also often shared, *mutatis mutandis*, by Christians. Hundreds of Jewish donor inscriptions from this era attest to the widespread practice of euergetism by both individuals and communities, among Jews as among Christians, while elements of Jewish communal prayer and funerary formulas are notable among their neighbors as well.[23] Finally, another expression of popularly based artistic representations can be found on magical artifacts from Palestine and Babylonia—incantation bowls, mirror-plaques, figurines, and amulets. The images displayed include human and animal depictions as well as demonic figures (usually shackled). This art draws heavily from the neighboring cultures and only very rarely exhibits Jewish symbols such as the menorah and Torah shrine.[24]

However, given the above similarities between Jewish and Christian material culture, what do the artistic remains from Jewish contexts tell us about issues of identity at this time? It would seem that this material reflects Jewish communities that shared the following characteristics in varying degrees:

Openness to outside cultural influences. Throughout antiquity, the material culture of the Jews has consistently reflected a willingness to absorb influences from outside the fold. We have noted this phenomenon on many occasions, from the earliest phase of Israelite society down to the close of Late Antiquity.[25] Under Byzantine rule this dimension becomes most pronounced, as the common motifs—with the exception of specific religious symbols and the zodiac cluster—became legion. Even the widespread use of Jewish religious symbols, beginning in the third century and increasing exponentially from the fourth century onward, can be linked to the burgeoning use of symbols in Late Roman and Christian society. Thus few Jewish communities had compunctions about borrowing and reworking Christian artistic models or using similar motifs.[26] Details regarding the nature of this Jewish-Christian connection remain unknown—whether direct or indirect, local or regional, imitation or parallel development—but they clearly involved a significant degree of commonality and mechanisms for communication. Indeed, it appears that Jews borrowed motifs not only for aesthetic and religious reasons, but also as a means of

22. See L. I. Levine, *Ancient Synagogue*, 313–60.

23. Price and Misgav, "Jewish Inscriptions"; the three volumes of *Inscriptiones Judaicae Orientis* and the two volumes of *JIWE*; Foerster, "Synagogue Inscriptions," 12–40.

24. Naveh and Shaked, *Amulets and Magic Bowls*, 35–38; Shaked, "Popular Religion"; Bohak, *Ancient Jewish Magic*, 227–90; Harari, *Early Jewish Magic, passim*; Vilozny, *Figure and Image*, 230–328; see chap. 10, nn. 52–53.

25. See above.

26. See chaps. 11 and 17.

further asserting their distinct identity by reclaiming a sense of individuality and separateness (see below).

Pluralism and diversity among Jewish communities. Given the local focus of each community and its autonomy in all communal affairs,[27] material culture has made it eminently clear that a wide range of practices were simultaneously in vogue. No two communities built the exact same structure, decorated it with identical motifs, or used the same epigraphic formulas for donors or for addressing communal matters. Some synagogues displayed figural art with no reservations, others limited the range of such representations, while still others eschewed this dimension altogether. As noted above, the Bet Shean region provides a striking example of sixth-century synagogues that differed from one another in each of the above categories.[28] In fact, some communities even changed their preferences from one stage to the next. In Ḥammat Tiberias, for example, the richly decorated fourth-century floor was replaced later on by a completely aniconic one.[29]

When we add certain literary data to the material culture, the picture of diversity and variety becomes even richer. Jewish society produced at this time a wide range of religiously related cultural expressions—from *piyyut* to Hekhalot mysticism, from magical and astrological compositions to aggadic *midrashim,* from apocalyptic literature to martyrological tracts, and from targum to art. In all the above, Jews either renewed, reinvented, or created ex nihilo a range of cultural channels to give expression to their nuanced religious, spiritual, and social identities.

Stability and self-confidence. The synagogue buildings of the Byzantine era seem to have exuded a sense of self-confidence and pride as Jews continued to build new ones and repair old ones—despite repeated imperial prohibitions.[30] A good number of these structures were monumental in their proportions, and this is undoubtedly related to the stable economic and political conditions at that time. Impressive synagogue buildings in both Capernaum and Sardis are outstanding cases in point, the former overshadowing a church at an important fifth- and sixth-century Christian pilgrimage site, the latter occupying an important location in the center of a major provincial city for some three centuries, down to the destruction of the city.[31]

Prominent display of distinctly Jewish components. For all their similarities to Byzantine-Christian buildings, synagogues regularly display motifs and other features that highlight Jewish distinctiveness. Rarely is the presence of one or more unique Jewish components missing in any given Late Antique synagogue, and these might include the following Jewish markers: orientation toward Jerusalem; the presence of a Torah shrine; inscriptions indicating the sanctity of the community; Jewish

27. See chap. 19.
28. Ibid.; and L. I. Levine, *Ancient Synagogue,* 215–21.
29. See chap. 12; as well as Dothan, *Hammath Tiberias,* vol. 2.
30. Linder, *Jews in Roman Imperial Legislation,* no. 65.
31. See chap. 9.

symbols; and biblical scenes. In fact, even though Hebrew was far from being a dominant language among Jews, it appears in quite a few Palestinian synagogues, at times noting benefactions, identifying biblical figures and scenes, portraying the zodiac signs and months, and finally, though infrequently, citing quotations or alluding to biblical verses.[32] Thus, the reassertion of Jewish cultural markers and memories of the past was unabashedly ubiquitous.[33]

Consequently, material culture affords a perspective on Jewish society quite different from that of the literary sources.[34] As the archaeological lens focuses on the local scene, allowing us to perceive how a variety of Jewish communities operated de facto in antiquity, it may not be surprising that the communal and cultural perspectives reflected therein are different from those of more elitist religious circles.[35] Indeed, we might aptly describe this communal phenomenon as an instance of a resilient common Judaism, perhaps an example, especially with regard to the synagogue, of *vox populi vox Dei.* Although various Jewish elites at that time might have related to such an assertion with reservation, if not outright rejection, such a reality seems to have been at work within the Jewish body politic of antiquity.[36]

We have already noted several examples of these different perspectives, especially with regard to the rabbis. While many Jews in the second century CE viewed the synagogue primarily as a communal center, and not as a sacred religious institution, the sages (or many of them, at least) clearly preferred the latter perception.[37] Throughout Late Antiquity, Jews regularly replicated the seven-branched menorah even though an early rabbinic tradition, thrice quoted in the Babylonian Talmud, objected to this practice,[38] and a daring portrayal of Helios was displayed in the fourth-century Ḥammat Tiberias synagogue together with several symbols that had been explicitly forbidden by the Mishnah some 150 years earlier.[39] Finally, several Palestinian *amoraim* remained silent in light of the popularity of figural art among Jews in the third and fourth centuries, even though they clearly found this position uncomfortable and problematic.[40]

32. In the Diaspora, where Greek was dominant (and in the East, together with Aramaic), a Hebrew text was often introduced by the word *Shalom.*

33. Whether this type of art should be labeled "resistance" and "negotiation," as often invoked of late, rather than as an assertion of local self-identity, is difficult to determine. See J. Webster, "Art as Resistance and Negotiation."

34. For an attempt to treat the challenges and crises experienced by the Jews of antiquity from a strictly literary perspective, see Neusner, *Transformations in Ancient Judaism.*

35. See chap. 19.

36. See also van der Horst, *Ancient Jewish Epitaphs,* 11. On a similar situation in the Christian context, see Miles, *Image as Insight,* 29–39: Snyder, *Ante-Pacem,* 7–11.

37. B Shabbat 32a; T Megillah 2, 18, p. 353. See also L. I. Levine, *Ancient Synagogue,* 193–206.

38. B Rosh Hashanah 24a–b, and parallels; see chaps. 17 and 20 for more detailed discussions.

39. M ʿAvodah Zarah 3, 1; and chap. 20.

40. Y ʿAvodah Zarah 3, 3, 42d; and chap. 20.

Indeed, material culture is inherently quite responsive to contextual influences. Given the fact that the Jews were a small people living amid a series of large, dominant cultures and empires from the Persian era onward, they could not help but be affected, often profoundly, by their surroundings (except, perhaps, on rare occasion), sometimes in a creative and innovative way. Homi K. Bhabha notes the following with respect to art in times of cultural transition:

> The borderline work of culture demands an encounter with "newness" that is not part of the continuum of past and present. It creates a sense of the new as an insurgent act of cultural translation. Such art does not merely recall the past as social cause or aesthetic precedent; it renews the past, refiguring it as a contingent "in-between" space, that innovates and interrupts the performance of the present.[41]

Moreover, the phenomenon of Hellenism in Late Antiquity on the popular level, so abundantly reflected in the material remains, was quite different from some of the overtones associated with this term in the earlier Greco-Roman era; at this juncture it is not an inimical threat aiming to reduce, if not obliterate, local traditions. Rather, Glen Bowersock has perceptively defined this Late Antique Hellenism as follows:

> Hellenism, which is a genuine Greek word for Greek culture (*Hellênismos*), represented language, thought, mythology, and images that constituted an extraordinarily flexible medium of both cultural and religious expression. It was a medium not necessarily antithetical to local or indigenous traditions. On the contrary, it provided a new and more eloquent way of giving voice to them.[42]

In this light, one can readily understand how outside influences could have played a central role in allowing Jews to exploit the artistic medium for their designated communal and religious needs.

Cultural interfacing—whether Hellenistic or later Byzantine-Christian—has indeed been one of the most fruitful areas of research in modern times, highlighting the many influences that figured significantly in the evolution and development of Jewish culture.[43] There can be no question that the emergence of a vigorous Jewish art in Late Antiquity, in so many places and in so many varieties, was in no small measure a product of the Byzantine-Christian orbit. For a brief three hundred or so years, art became an important medium of cultural and religious expression for many Jewish communities. On one level, it served a social function, enhancing the

41. Bhabha, *Location of Culture*, 7. An interesting example of cross-cultural contacts in literary sources is the folk narrative found in rabbinic sources; see Hasan-Rokem, *Web of Life*, 67–87.

42. Bowersock, *Hellenism in Late Antiquity*, 7. See also Sartre, "Nature of Syrian Hellenism."

43. On the attraction and splendor of Christian buildings and art in the fourth century, see Miles, *Image as Insight*, 41–43, 48–55.

importance and sanctity of the synagogue hall, stirring religious sentiment, and offering prestige and stature to its donors and patrons.

On a deeper level, however, use of the past through symbols and biblical scenes was a means of transmitting to the Jews, and perhaps to others as well, a cultural and religious identity that addressed the needs of many communities, serving to reaffirm their collective memories. The resultant sense of continuity is what Danièle Hervieu-Léger calls *anamnesis*, a recollection of the past, "affirmed and manifested in the essentially religious act of recalling a past which gives meaning to the present and contains the future."[44] In this way, a lineage of belief and memory is combined with a belief in the lineage of the people, with both of these dimensions being realized by placing components of Jewish antiquity center stage. Needless to say, Jewish art did not stand alone in this regard. Jews had already forged a wide variety of other reminders for this purpose, ranging from regular recourse to the Bible in their liturgy to the cyclical observance of the holidays with their varied historical foci. But the new circumstances of Christian domination not only unleashed the need for many Jewish communities to adopt additional avenues of expression and reinforcement of their identity but, perhaps ironically, also provided models to be adopted and adapted for these purposes.

Reshaping identity (and this applies to other groups as well) in the light of new and unexpected historical circumstances is a never-ending challenge. It requires the utilization of existing modes and themes, be they of Jewish or non-Jewish origin, as well as the creation of new ones. The Byzantine-Christian orbit of Late Antiquity was a historical context that threatened the very core of Jewish identity but that, at the same time, had the potential to provide Jews with an opportunity to develop cultural media to bolster their identity. In this context, the visual medium was utilized as never before to meet this challenge.

CONCLUSION

Archaeological finds (architecture, art, and epigraphy) have thus alerted us to the resilience and creativity, as well as the remarkable self-confidence, of many Jewish communities in antiquity. The mere existence of so many synagogues in both Palestine and the Diaspora, often in prominent locations and of monumental size, refutes the impression that this was a period characterized only by persecution, discrimination, and suffering. The apparent economic, social, and political stability of many communities, as well as Judaism's continuing allure to non-Jews well into the Byzantine era, have revealed a far more complex reality than heretofore imagined, and along with it a far greater range of identities fashioned by Jews throughout the empire.

44. Hervieu-Léger, *Religion as a Chain of Memory*, 125. On a wider scope in this regard, see Millar, "Narrative and Identity."

While archaeological material can always be critiqued as being fortuitous and narrowly focused (dealing, as it does, with specific sites and buildings), and thus not truly representative of the Jewish community at large, the cumulative evidence from multiple sites, which is the reality of Late Antiquity, should not be dismissed so easily. Furthermore, archaeological material's one significant advantage over the literary evidence is that it does not run the risk of being reflective of only one individual or a limited elite, but represents a wide spectrum of society. Synagogue art on the local level gave expression to what the community wished to see or, minimally, what it was willing to tolerate. From this perspective, Jewish life in Late Antiquity looks quite different from the picture conveyed by the literary evidence.[45]

Late Antiquity thus emerges as an era in which Jews were actively engaged in a broad range of cultural and religious areas, often in tandem with the surrounding culture. If the term *Late Antiquity*, as suggested by Peter Brown, indeed points to processes of renewal, vitality, and creativity in Byzantine-Christian society, then it is not difficult to identify similar developments within the contemporaneous Jewish sphere as well.[46] It is this realization, together with the dramatically new sense of vulnerability and powerlessness that now began enveloping Jewish life, that most characterizes this particular era of Jewish history.

45. In this regard, see Deleeuw, "Peaceful Pluralism." Although focusing on folk narrative, Hasan-Rokem offers a comment that is apt for our present discussion: "Delving into the materials of popular culture leads us to the assumption that polemics were mainly typical of the leadership stratum, whereas everyday life was characterized by softer and more open modes of intercultural communication" (*Web of Life*, 7).

46. See chap. 10.

23. EPILOGUE

On our two-thousand-year journey through the prismatic dimension of Israelite-Jewish art, from circa 1200 BCE until the seventh century CE, we have witnessed Jewish society undergoing an extraordinary series of upheavals—so much so that it is doubtful whether an Israelite living in the First Temple period would have recognized, much less have had much in common with, a Jew living at the end of this era. What bound them were a common lineage and a continuous cultural and religious tradition spanning centuries. However, along the way every facet of Jewish life had undergone dramatic transformation, including issues of self-definition (e.g., from Israelite and Judahite to Jew and Judaism), the geography of Jewish settlement, central political and religious institutions, varieties of leadership, forms of worship and specific ritual observances, the number and nature of holidays, the corpus of sacred literature, and more.

These far-reaching changes were brought about by a series of dramatic events that repeatedly challenged, and sometimes threatened, Jewish society, requiring varying degrees of political, social, religious, and cultural adjustment at each turn. The most momentous of these early challenges included the destruction of Samaria and Jerusalem in the Israelite period, the exilic period, the conquest of Alexander and the introduction of Hellenism, the religious persecutions decreed by Antiochus IV followed by the emergence of the Hasmonean state, and the establishment of a far-flung Diaspora. These were followed by Rome's conquest of Judaea and the rise of the Herodian dynasty, the catastrophic failures of the Jewish revolt against Rome (66–74) and the Bar-Kokhba rebellion (132–35), and finally the triumph of Christianity, all of which led to monumental changes in the Jewish political, social, and religious landscape. Jewish artistic creativity fluctuated in response to these changing historical circumstances, and while Jews were neither pioneers nor notable practitioners of the visual arts, they did make use of this medium throughout the ages.[1]

The number of artifacts from the Israelite era recovered to date is quite small, even when including the related literary evidence from the Bible. The Second Tem-

1. For a more detailed discussed of these changes, see L. I. Levine, "Jewish Identities in Antiquity," 12–40.

ple period presents a striking contrast in the nature and scope of Jewish art. While the remains for the first four hundred or so years continue to be limited, the next two centuries witnessed a veritable explosion in the number of artifacts. This sharp increase is inextricably intertwined with the emergence of the Hasmonean and Herodian kingdoms, as well as the dramatically improved economic circumstances fostered by the Hellenistic and Roman eras. Artistic evidence for this period comes from various strata of society, but primarily from the royal families and the wealthy classes associated with them. No less dramatic than the quantitative increase was the sudden and revolutionary abandonment of figural art promulgated by the Hasmoneans. The use of figural images, which had been the generally accepted practice among Israelites-Jews for almost a millennium, was now eschewed by almost the entire population. Very few exceptions to this rule have been discovered, and even then almost always within the confines of the ruling, especially Herodian, families.

Looking back over the earlier periods, from circa 1200 BCE to 135 CE, two related features stand out. First, Israelite-Jewish art was heavily dependent on the artistic productivity of foreign cultures. Whether as an independent kingdom in the First Temple era or under Persian, Hellenistic, and Roman hegemony, Jewish art consisted almost exclusively of borrowed motifs, with virtually nothing specifically Jewish surfacing until the very end of this period. Secondly, when Jewish motifs began to appear in the first century BCE, they were extremely limited in number.[2] Thus, whatever the aesthetic or religious importance of this artistic medium, it neither played an important religious or political role nor included any symbol or motif that might have facilitated the strengthening of Jewish identity.[3] The turn toward an aniconic policy under the Hasmoneans and its continuation for some three centuries further accentuated the limited role art played in the Jewish consciousness at the time, especially when compared to the place of figural images in contemporary Greco-Roman society.

However, in the early third century CE, precisely when figural art began to reappear on the Jewish scene, artistic expressions likewise surfaced more expansively and significantly.[4] Only now did distinctively Jewish motifs that included biblical scenes and figures as well as religious symbols appear, as evidenced in Dura, Bet She'arim, and Rome. Whether this dramatic change was in some measure linked to the loss of independence (or, more accurately, extensive autonomy) in the late Second Temple period, or to the destruction of two major bastions of Jewish identity, Jerusalem and its Temple, is not clear. In all events, the most significant factor in stimulating this new type of art was undoubtedly the development of a more vigorous and multifaceted religious world in the second and third centuries, one that

2. See chap. 3.

3. Excluding, perhaps, some Temple-related motifs that appear on coins of the two revolts against Rome; see chap. 3.

4. See chaps. 4–8.

fostered figural art and the large-scale use of religious symbols. It is at this point that Jewish art began developing in similar directions.[5]

The artistic changes first emerging on the Jewish scene in the Late Roman era became more intensive from the fourth century CE on, together with the ascendance of Christianity. In general, the religious component in the art of Late Antiquity became far more prominent with this dramatic turn of events, as did imperial and ecclesiastical efforts in constructing and decorating grandiose church edifices.[6] It is not surprising, then, that Jewish communities throughout the empire soon followed suit, so much so that no area of Jewish culture was more affected by Byzantine civilization than its architectural and artistic dimensions. Never before had Jewish communities produced such a wide array of artistic motifs as during the three hundred years from the fourth to seventh centuries. From neutral geometric and floral designs to biblical themes, Jewish symbols in various combinations, and even the pagan motifs of the zodiac and Helios, the art of the synagogues and cemeteries now displayed an artistic creativity unmatched in any earlier Jewish context.[7]

The importance of art for the study of Jewish history in antiquity—and this includes artistic, architectural, and epigraphic evidence—lies first and foremost in the new information it provides. In a period of relatively meager historical sources, the value of such data for an expanded and richer understanding of Late Antique Jewish culture is obvious. The archaeological material is no less invaluable for the very different perspectives it provides in contrast to the literary remains. Indeed, we have noted several instances of these diverse vantage points, examining the differences between biblical and rabbinic views of art and religion, on the one hand, and the lens provided by material culture, on the other. For Late Antiquity, as has been noted, the literary remains stem from individuals or groups comprising a small number of elite religious strata of Jewish society in Palestine and Babylonia; the material culture is a product of Jewish communities from all over the world.[8] While literary sources often promote themes of separatism, distinctiveness, and elitism, archaeological finds provide a plethora of examples of integration, commonality, and adaptability, owing perhaps in part to their broader, more popular contexts.

Such a realization, however, has taken hold only gradually, having been obstructed by one of the most recurring dichotomies in the study of Jewish history— the contrast between the insistence of classical Jewish sources (e.g., the Bible and Talmud) on the need for differentiation from the outside world (עם לבד ישכון; Num. 23:9) and the recognition, via both literary and archaeological material, of the many influences that Jews did in fact adopt and adapt throughout the ages.[9] Thus, for example, while biblical literature demanded distinctiveness and separation from

5. See also Kaizer, "Religion in the Roman East."

6. See Miles, *Image as Insight*, 41–62.

7. See chaps. 11, 16–17.

8. See chaps. 2, 20, and 22.

9. See L. I. Levine, "Jewish Identities in Antiquity," 37–39.

the surrounding cultures, material remains from the early Israelite era provide evidence that Israelites were interacting with their surroundings, absorbing (and at times rejecting) outside influences. Even though Deuteronomy (chapter 7, for example) warns the people repeatedly and emphatically not to have anything to do with the Canaanites, there is general agreement today that early Israelite society was beholden to Canaanite society in many aspects of its social, cultural, and religious life.[10]

In the Hellenistic-Roman period as well, the degree of Hellenization among Jews and the profound changes in Jewish religious practices and beliefs are extensively documented in ancient sources and often discussed in modern scholarly literature.[11] Nevertheless, Philo chose to claim that the Jews remained totally and exclusively committed to their traditions and customs, denying that any changes or adaptations transpired in the religious realm:[12]

> But Moses is alone in this, that his laws, firm, unshaken, unmovable, stamped, as it were, with the seals of nature herself, remain secure from the day when they were first enacted to now, and we may hope that they will remain for all future ages as though immortal, so long as the sun and the moon and the whole heaven and universe exist. Thus, though the nation has undergone so many changes, both to increased prosperity and the reverse, nothing—not even the smallest part of the ordinances—has been disturbed. (*Life of Moses* 2.14-15)

Josephus likewise embraces this view of the Jews' complete immersion in ancestral tradition with no innovation or change on their part (*Against Apion* 2.182–83, 189).

This overall particularistic internal focus holds true for rabbinic sources as well.[13] Commenting on Leviticus 18:3: "You shall not copy the practices of the land of Egypt where you dwelt, or of the land of Canaan to which I am taking you; nor shall you follow their customs," the Sifra offers a series of comments,[14] and at one point (Pereq 13, 9, p. 86a, in an interpolation referred to as Mekhilta de-'Arayot), issues a warning to avoid gentile cultural and social norms (נימוסות, understood as referring to theaters, circuses, and stadiums).[15] The text continues: "You should not say: 'since they go out in a toga, so too will I wear a toga; since they go out in purple, so too

10. See chap. 2.

11. See L. I. Levine, *Judaism and Hellenism*, 33–95; and above, chap. 3. See also Kraft and Nickelsburg, *Early Judaism and Its Modern Interpreters.*

12. See in this regard Weitzman, *Surviving Sacrilege*, 1–12.

13. L. I. Levine, *Judaism and Hellenism*, 124–31.

14. See in detail Berkowitz, "Limits of 'Their Laws.'"

15. The Tosefta's prohibition against attending pagan entertainment institutions is predicated as follows: pagan worship often accompanied these theater performances (according to R. Meir); such places were considered a waste of time, coming at the expense of Torah study; and undesirable elements of society were in attendance, about whom it was said, "One should not sit in the seat of scorners" (Ps. 1:1). The circus was forbidden to the Jews because of the bloody spectacles held there, although at least one sage permitted attendance if it

will I wear purple; since they go out in round hats (or pants),[16] so too will I'—'And I too will do this'" (Sifre Deuteronomy 81, p. 147).[17] The rabbis' desire to distance themselves and others from Greek culture seems clear-cut when one adds to these traditions the apparent prohibition against teaching Greek (M Sotah 9, 14).[18]

Clearly, then, the agenda of much of this literary material was to separate Jew from non-Jew. Naturally there are different nuances within each of the books of the Bible and the various corpora of rabbinic literature), but the basic thrust is nevertheless obvious, and it is in this regard that the material culture offers a contrasting perspective.

Most of our discussion has focused on Late Antiquity, when the dichotomy between the prescriptions and views expressed in the literary sources (mostly rabbinic) on the one hand, and the archaeological, epigraphic, and artistic evidence on the other, is particularly striking. This is especially noticeable not only in light of the ever-increasing amount of archaeological data, but even more so owing to the fact that material data relating to Late Antiquity come primarily from the synagogue, the communal institution par excellence belonging to the congregation and reflecting its tastes and preferences. Perhaps indicative of an elitist-populistic tension within Jewish society is one rabbinic tradition, cited in the Bavli (Shabbat 32a) but attributed to a second-century Palestinian sage, that refers disparagingly to the common people ('ammei ha-aratzot) who refer to the synagogue as a bet 'am ("house of [the] people").[19] Indeed, while the sages emphasized the sacred dimension of the synagogue early on, this same building was understood by the common folk primarily as a communal institution with myriad activities.[20] The extensive amount of archaeological material associated with the synagogue now enables us to focus, at least in part, on those nonelitist components among the Jews that are often neglected in literary sources; thereby, we can better understand the cultural proclivities and expressions of religiosity of the communities responsible for this institution.[21]

Moreover, given the relative paucity of historical sources from Late Antiquity, the archaeological material has assumed an even greater role as the primary source of information regarding this popular perspective, which happens to be well documented for ancient Christianity as well. The enormous quantity of Christian literary material is matched by rich archaeological finds, and this has allowed scholars to

meant being able to save someone's life, often determined by those in attendance (T 'Avodah Zarah 2, 5–7, p. 462); see also S. Stern, *Jewish Identity*, 170–94.

16. There are a number of suggestions regarding the meaning of some of these terms; see the remarks of L. Finkelstein, *Sifre Deuteronomy*, 147.

17. Elsewhere, Sifre Deuteronomy lists another half-dozen types of garments that should not be worn by Jews, but obviously were (Sifre Deuteronomy 234, pp. 266–67).

18. See Lieberman, *Hellenism in Jewish Palestine*, 100–14.

19. B Shabbat 32a.

20. See, e.g., M Megillah 3, 1, 2–3; T Megillah 2, 18, p. 353, and chap. 20.

21. For a similar effort in this direction with regard to Christian evidence, see MacMullen, *Second Church*, ix–xii, 95–114.

address the issue of popular Christian culture with illuminating results.[22] Indeed, the study of a more popular, social history in the twentieth century has emerged as an important field in historical studies in reaction to the conventional histories that beforehand had concentrated almost exclusively on great leaders and events of the past.[23] By one estimate, ignoring this popular dimension would leave some 95 percent of the Byzantine Christian population unaccounted for![24]

As a result, the picture that emerges from the archaeological remains of Late Antiquity is far more diverse, heterogeneous, and locally oriented than that derived from literary sources–although, truth to tell, recent research has made considerable strides in dispelling the presumed homogeneity of the latter. Only by taking into account the entire span of both the literary and archaeological evidence (specifically art, as it relates to our discussion) does it become eminently clear that the changing climate of Late Antiquity led to complex negotiations by Jews, as individuals and communities, regarding their relationships vis-à-vis Byzantine-Christian society generally and specifically their willingness to integrate non-Jewish components into their daily lives.[25] As might be expected, this outcome engendered a wide variety of syntheses, ranging from a more open and flexible orientation (such as the use of a plethora of artistic depictions, including the zodiac and Helios motifs) to a more restricted and conservative one. In the latter category, some synagogues eschewed any and all figural representation of pagan or even neutral content and may have demonstrated a clear proclivity for Aramaic and Hebrew, but not Greek. Judaism, like other religious traditions, varied along a spectrum ranging from separation to accommodation.

We opened this chapter with an overview of the changing nature of Jewish identity throughout antiquity resulting from a series of ruptures and destabilizing events. While each of these crises led to a reassessment and adjustment in many facets of life, arguably the most challenging disruption occurred in the Byzantine era, with the domination of a zealous and often hostile Christianity. If one's identity is shaped largely through an encounter with the "other,"[26] then the circumstances and milieu created by a triumphant Christianity were no less challenging than anything heretofore known.

Indeed, it was at this time that religious self-definition assumed center stage regarding all components of society. With the territorial empire of pagan Rome being transformed into a Christian religious realm centered in Constantinople, religious identity became the primary focus in art as well. It was in this context that Jews turned to art to reinforce their self-identity, and in doing so they utilized, inter

22. Ibid.; as well as e.g., Burrus, *Late Ancient Christianity*; Krueger, *Byzantine Christianity*.
23. Bianchi Bandinelli, "Arte plebea"; Bianchi Bandinelli, *Rome*, 457 (Glossary-Index: "Plebeian [Art]"); P. Stewart, *Social History of Roman Art*, 162–72.
24. Janz, "General Editor's Foreword," xiv; MacMullen, *Second Church*, 111–14.
25. See K. B. Stern, "Limitations of 'Jewish,'" 327–36.
26. Barth, *Ethnic Groups and Boundaries*, 9–38.

alia, a series of symbols, foremost among which was the menorah.[27] These symbols constituted the most ubiquitous of Jewish motifs, although there was also a fairly significant representation of biblical motifs, predominantly in Palestine.[28]

This religious dimension found significant expression in Byzantine synagogues, which, in contrast to those from the first century, placed considerable emphasis on this feature—as did contemporary churches. Almost every aspect of the synagogue building reflects this dimension: the architectural orientation toward Jerusalem; Aramaic and Greek inscriptions attesting to the sanctity of the space (אתרה קדישה, ἅγίος τόπος); and the aforementioned artistic representations.

This religious dimension was not new to the Jews. In fact, it had been a crucial component of their self-identity, setting them apart from their pagan surroundings for a good part of the first millennium BCE. On the one hand, such contrasts proved to be a source of tension; to wit, intellectuals in Hellenistic-Roman society might have vented their anger on Jews, labeling them as the "other," the alien, the stranger. On the other hand, Judaism also proved to be a source of attraction and emulation, with many gentiles associating themselves in one way or another with the Jewish enterprise.

Nevertheless, it was the dominance of a triumphant Christianity that forced the Jews to reassess their status and self-identity, both internally and externally; given the fact that they soon became the "other" par excellence, it remained to be determined how much such a reality was to be a cause for impotence and vulnerability or a goad toward reassertion and reinvention.

The material evidence regarding Jewish communal life in Late Antiquity points to creative, vibrant, and diverse communities, willing and able—each according to its means and cultural-religious proclivities—to erect public buildings while borrowing heavily from the regnant Byzantine artistic repertoire. Jewish identity, whether expressed in the form of a building, biblical art, inscriptions, religious symbols, or a combination thereof, appears as vigorous as it was widespread, bespeaking a serious degree of self-assurance. Certainly the scores of dedicatory inscriptions attest to the fact that individuals and whole communities considered it a privilege (or good deed—מצותה—to borrow a term from a Ḥammat Tiberias inscription)[29] to support their local synagogue, which functioned no less as their community center than as their place of worship.

In this respect, archaeological material has contributed a great deal in shattering the myth of Jewish decline and passive submission to Byzantine-Christian rule.[30] While an overall synthesis of the nature of Jewish society in this Late Antique

27. See chap. 17.

28. Whether we call the active use of Jewish art a response to Christianity or an expression of cultural resistance (following a post-colonial view) makes little difference, since we know so little about the motivation of the Jews behind this art.

29. Naveh, *On Stone and Mosaic*, no. 26.

30. See chaps. 9–10.

context is bound to differ from one assessment to another owing to the range and complexity of the sources at our disposal, one thing is certain: it will never be the same as before. Sufficient data have accumulated over the past decades to alter radically the former picture of Jewish decline and suppression.

At the same time, however, it should be recognized that the material culture at our disposal is often too limited and thus incapable of making an informed assessment of what exactly the Jewish communities of antiquity intended to convey through their art. Like so many literary sources, artistic remains do not allow for unequivocal historical generalizations and assessments. When taken together with the realization that no central authority exercised control over the synagogues and their art, and that the determination of all matters relevant to the institution rested squarely with the local community,[31] then any possibility of identifying widespread theological and cultural messages reflected in this art becomes unrealistic.

One conclusion of our study should be clear: if we are to understand the circumstances of a given era in antiquity to the greatest extent possible, literary and archaeological evidence as well as both internal (Jewish) and external (non-Jewish) sources must be fully utilized and integrated.[32] If the resultant picture turns out to be somewhat contradictory and complex, more heterogeneous and messier than before, so be it. Chances are that we will be nearer to the truth if we conclude that diversity was no less the order of the day in this era than it was in others.[33]

31. See chap. 19.

32. For an upbeat presentation in this vein with regard to the Christian materials, see R. M. Jensen, "Giving Texts Vision and Images Voice." On identity issues within church circles at this time, see Drake, "Afterword and Conclusion."

33. Burrus and Lyman, "Shifting the Focus of History." See also K. B. Stern, "Limitations of 'Jewish.'"

GLOSSARY

aedicula (pl. *aediculae*)	Small shrine composed of columns supporting a pediment.
aggadah	Nonhalakhic rabbinic tradition.
aisle	Side area of a synagogue hall or basilica, separated from the central nave by columns.
ambo	Lectern, pulpit.
amora (pl. *amoraim*)	Sage who lived after the compilation of the Mishnah, active in the talmudic era (ca. 200–650 CE).
amphora (pl. amphorae)	Vase with a large oval body, a neck, and two handles reaching the top of the vessel.
aniconic	Devoid of figural representation.
apse	Semicircular recess in a hall, found mainly in a basilica.
'Aqedah	The binding of Isaac (Genesis 22).
archisynagogue	Head of a synagogue.
architrave	Lowermost part of an entablature that rests horizontally on top of columns.
archon	Leader, synagogue or community official.
arcosolium (pl. *arcosolia*)	Arched recess used as a burial place.
atrium	Courtyard leading into a basilica.
av bet din	Head of a rabbinic court.
baraita	"External" tannaitic tradition not included in the Mishnah compiled by R. Judah I.
balustrade	Barrier separating the front section of a church or synagogue from the rest of the hall. *See also* chancel screen, *soreg*.
basilica	Large rectangular Roman civic building.
Bavli	Babylonian Talmud.
bima (pl. *bimot*)	Raised platform in a synagogue or church.
boule	City council of a *polis*.
bulla (pl. bullae)	Clay seal.

catacomb	A network of underground burial chambers and passageways.
chancel screen	Partition around a *bima* consisting of stone posts and panels. *See also* balustrade, *soreg*.
collegia	Societies or associations in the Roman world that functioned as guilds, social clubs, and/or funerary societies.
columbaria	Chambers for the storage of cinerary urns holding a deceased's cremated remains.
conch	Shell pattern often decorating the top of a niche.
cornice	Top projecting member of an entablature.
cubiculum (pl. *cubicula*)	Underground burial chamber.
damnatio memoriae	Literally, one's memory damned; an erasure ordered by successors, often the fate of unpopular emperors.
entablature	Horizontal superstructure supported by columns and composed of an architrave, frieze, and cornice.
ethrog (pl. *ethrogim*)	Citron; one of the four species used on the Sukkot holiday.
fresco	Painting composed by the application of watercolors on a wall of wet plaster.
frieze	Architectural ornament of a horizontal sculpted band between the architrave and cornice.
gable	Triangular superstructure of a building's facade.
gallery	Passageway with *loculi* in the walls of a catacomb.
gaon (pl. *geonim*)	Head of a Babylonian academy in the early Middle Ages.
genizah	Depository for sacred books and ritual objects.
gerousiarch	Elder; member of the *gerousia* (governing council of elders).
haftarah (pl. *haftarot*)	Reading from the Prophets following the Torah reading on Sabbaths and holidays.
ḥazzan	Synagogue functionary charged with a variety of tasks.
Hekhalot	Mystical traditions first appearing in Palestine in Late Antiquity.
Helios	Greco-Roman sun god.
hypogea	Subterranean burial complexes, smaller than catacombs.
insula (pl. *insulae*)	Multistoried tenement in ancient Rome.
kokh (pl. *kokhim*)	Burial niche.
lintel	Horizontal beam above a doorway or window.
loculus (pl. *loculi*)	An individual burial niche positioned perpendicular to a wall.
lulav (pl. *lulavim*)	Palm branch; one of the four species used on the Sukkot holiday.
maftir	Last person to be called to the Torah; one who recites the *haftarah*.
mater	Title for a female patron or benefactor of a synagogue.

menorah (pl. *menorot*)	Seven-branched candelabrum; most widespread Jewish symbol.
metope	Space between two triglyphs on a Doric frieze. *See also* triglyph.
midrash (pl. *midrashim*)	Commentary on a biblical text.
miqveh (pl. *miqva'ot*)	Stepped cistern used as a ritual bath.
narthex	Entrance corridor leading into the nave and aisles of a synagogue or basilica.
Nasi, Nesiut	Patriarch, Patriarchate.
nave	Central hall of a synagogue or basilica, separated from the side aisles by a row of columns or pillars.
necropolis (pl. *necropoleis*)	Cemetery.
nefesh	Rabbinic term for a funerary monument.
niche	Rectangular or curved recess in a wall.
nymphaeum	Public water fountain, often decorated with statues.
opus sectile	Technique whereby stones were cut and inlaid into walls and floors to make a design or pattern.
pater	Title for a male patron or benefactor of a synagogue.
Patriarch, Patriarchate	Highest communal office(r) of the Jews from the third to fifth centuries; recognized by Roman authorities. *See also Nasi, Nesiut.*
paytan (pl. *paytanim*)	Composer of synagogue liturgical poetry (*piyyut*).
pediment	Triangular gable between a horizontal entablature and a sloping roof.
pilaster	Column connected to a wall (structurally a pier, architecturally a column).
pithos (pl. *pithoi*)	Storage jar.
piyyut (pl. *piyyutim*)	Liturgical poetry composed for synagogue use.
polis (pl. *poleis*)	Greek city.
politeuma	Autonomous political body in a *polis* recognized by civil or imperial authorities.
pomerium	Sacred boundary of Rome.
portico	Roofed entrance to a building, with colonnades on three sides. *See also* stoa.
priestly courses	Division of priests into twenty-four clans, each officiating in the Temple on different weeks of the year.
proseuche (pl. *proseuchae*)	"House of prayer"; termed used frequently in the Diaspora; equivalent of the Palestinian *synagoge* ("place of gathering").
prostates	Leader or representative of an association or institution.
saboraim	Traditional name for an anonymous group of Babylonian rabbinic figures responsible for composing and editing the anonymous traditions in the Bavli. *See also stammaim.*
sarcophagus (pl. sarcophagi)	Stone or lead box for a corpse.

Sasanian	Relating to the Persian Empire that ruled from the third to the seventh centuries.
satrap	Persian governor under Achaemenid Empire (539–332 BCE).
sebomenoi	Literally, "God-fearers"; pagan sympathizers of Judaism.
secco	Painting composed by the application of watercolors to a wall after the plaster is dry.
shofar (pl. *shofarot*)	Ram's horn; a popular Jewish symbol associated with Rosh Hashanah.
skoutlosis	Marble panels (revetments) decorating the walls of a hall.
Sol Invictus	"Unconquerable Sun"; Latin name for the sun god Helios.
spolia	Art or architectural elements reused in later buildings.
stammaim	Modern designation for anonymous Babylonian sages (fifth–sixth to eighth centuries) who edited, reworked, and composed large parts of the Bavli. See also *saboraim*.
stoa	Roofed area of a building, with multiple colonnades opening onto one side.
tanna (pl. *tannaim*)	Talmudic sage who lived up to the time of the compilation of the Mishnah (ca. 200 CE).
targum (pl. *targumim*)	Translation of the Bible (into Aramaic or Greek).
tetrapylon	Monument at the crossroads of a city with passageways in all directions.
tituli	Early Christian churches in ancient Rome.
triclinium (pl. triclinia)	Dining room, originally furnished with three couches.
triglyph	Ornament on a Doric frieze, consisting of a projecting block with two parallel vertical grooves and two half grooves separating metopes at either end. *See also* metope.
tympanum (pl. tympana)	Faced surface of a pediment, between the lintel of a doorway and the arch above it.
Yerushalmi	Jerusalem Talmud.

ABBREVIATIONS

AJA	*American Journal of Archaeology*
ANRW	*Aufstieg und Niedergang der römischen Welt*
B	Bavli (Babylonian Talmud)
b.	ben, bar (son of)
BA	*Biblical Archaeologist*
BAR	*Biblical Archaeology Review*
BASOR	*Bulletin of the American Schools of Oriental Research*
BJRL	*Bulletin of the John Rylands Library*
ByzF	*Byzantinische Forschungen*
CBQ	*Catholic Biblical Quarterly*
CHC	*Cambridge History of Christianity*
CHJ	*Cambridge History of Judaism*
CIJ	*Corpus Inscriptionum Judaicarum* (J.-B. Frey, 2 vols.)
CT	Codex Theodosianus (Theodosian Code)
DOP	*Dumbarton Oaks Papers*
EI	*Eretz-Israel*
GLAJJ	*Greek and Latin Authors on Jews and Judaism* (M. Stern, 3 vols.)
HSCP	*Harvard Studies in Classical Philology*
HTR	*Harvard Theological Review*
HUCA	*Hebrew Union College Annual*
IEJ	*Israel Exploration Journal*
INJ	*Israel Numismatic Journal*
INR	*Israel Numismatic Research*
JA	*Jewish Art*
JAC	*Jahrbuch für Antike und Christentum*
JAOS	*Journal of the American Oriental Society*
JBL	*Journal of Biblical Literature*
JECS	*Journal of Early Christian Studies*
JGS	*Journal of Glass Studies*
JIWE	*Jewish Inscriptions of Western Europe* (D. Noy, 2 vols.)

JJA	*Journal of Jewish Art*
JJS	*Journal of Jewish Studies*
JNES	*Journal of Near Eastern Studies*
JPOS	*Journal of the Palestine Oriental Society*
JQR	*Jewish Quarterly Review*
JRA	*Journal of Roman Archaeology*
JRS	*Journal of Roman Studies*
JSJ	*Journal for the Study of Judaism*
JSQ	*Jewish Studies Quarterly*
JSS	*Jewish Social Studies*
JTS	*Journal of Theological Studies*
LA	*Liber Annuus*
LCL	Loeb Classical Library
M	Mishnah
NEA	*Near Eastern Archaeology*
NEAEHL	*New Encyclopedia of Archaeological Excavations in the Holy Land* (E. Stern, 5 vols.)
NTS	*New Testament Studies*
PAAJR	*Proceedings of the American Academy for Jewish Research*
PBSR	*Papers of the British School at Rome*
PEQ	*Palestine Exploration Quarterly*
PL	Patrologia Latina
R.	Rabbi, Rabban
RAC	*Rivista di Archeologia Cristiana*
RB	*Revue Biblique*
REJ	*Revue des Etudes Juives*
SCI	*Scripta Classica Israelica*
T	Tosefta
VC	*Vigiliae Christianae*
Y	Yerushalmi (Jerusalem, or Palestinian, Talmud)
ZDPV	*Zeitschrift des Deutschen Palästina-Vereins*
ZNW	*Zeitschrift für die Neutestamentliche Wissenschaft*
ZPE	*Zeitschrift für Papyrologie und Epigraphik*

BIBLIOGRAPHY

Modern Literature

Aberbach, M. *Jewish Education in the Period of the Mishnah and Talmud*. Jerusalem: R. Mass, 1982. Hebrew.

Abusch (Boustan), R. S. "Rabbi Ishmael's Miraculous Conception: Jewish Redemption History in Anti-Christian Polemic." In Becker and Reed, *Ways That Never Parted*, 307–43.

Ackerman, S. *Under Every Green Tree: Popular Religion in Sixth-Century Judah*. Atlanta: Scholars, 1992.

———. "The Queen Mother and the Cult in Ancient Israel." *JBL* 112 (1993): 385–401.

Adelman, R. *The Return of the Repressed: Pirqe de-Rabbi Eliezer and the Pseudepigrapha*. Leiden: Brill, 2009.

Aharoni, Y., and M. Avi-Yonah, eds. *The Macmillan Bible Atlas*. Rev. ed. New York: Macmillan, 1977.

Ahituv, S. *Echoes from the Past: Hebrew and Cognate Inscriptions from the Biblical Period*. Jerusalem: Carta, 2008.

Ahlström, G. W. *Psalm 89: Eine Liturgie aus dem Ritual des leidenden Königs*. Lund: C. W. K. Gleerup, 1959.

———. *Who Were the Israelites?* Winona Lake: Eisenbrauns, 1986.

———. "The Bull Figurine from Dhahrat et-Tawileh." *BASOR* 280 (1990): 77–82.

Åkerström-Hougen, G. *The Calendar and Hunting Mosaics of the Villa of the Falconer in Argos: A Study in Early Byzantine Iconography*. Stockholm: Svenska Institutet i Athen, 1974.

Albani, M. "Der Zodiakos in 4Q318 und die Henoch-Astronomie." *Forschungsstelle Judentum: Mitteilungen und Beiträge* 7 (1992): 3–42.

Albertz, R. *A History of Israelite Religion in the Old Testament Period*. 2 vols. Louisville, KY: Westminster/John Knox, 1994.

Alchermes, J. D. "Art and Architecture in the Age of Justinian." In Maas, *Cambridge Companion to the Age of Justinian*, 13:343–75.

Alcock, S., ed. *The Early Roman Empire in the East*. Oxford: Oxbow, 1997.

Alexander, P. S. "The Historical Setting of the Hebrew Book of Enoch." *JJS* 28 (1977): 156–80.

———. "Incantations and Books of Magic." In Schürer, *History of the Jewish People*, 3:342–79.

———. *The Mystical Texts: Songs of the Sabbath Sacrifice and Related Manuscripts*. London: T & T Clark, 2006.

———. "What Happened to the Jewish Priesthood after 70?" In Rodgers et al., *Wandering Galilean*, 5–33. Leiden: Brill, 2009.

Allen, P. "The Definition and Enforcement of Orthodoxy." In Cameron, Ward-Perkins, and Whitby, *Cambridge Ancient History*, 14:811–34.

Allison, D. C., Jr. *A New Moses: A Matthean Typology*. Minneapolis: Fortress, 1993.

Alon, G. *Jews, Judaism and the Classical World: Studies in Jewish History in the Times of the Second Temple and the Talmud*. Jerusalem: Magnes, 1977.

———. *The Jews in Their Land in the Talmudic Age*. 2 vols. Jerusalem: Magnes, 1980.

Alston, R. "Settlement Dynamics in Third- and Fourth-Century Roman Egypt." In Lewin and Pellegrini, *Settlements and Demography*, 23–34.

Ameling, W. *Inscriptiones Judaicae Orientis*. Vol. 2, *Kleinasien*. Tübingen: Mohr Siebeck, 2004.

Ameling, W., et al., eds. *Corpus Inscriptionum Iudaeae/Palaestinae: A Multi-lingual Corpus of the Inscriptions from Alexander to Muhammad*. Berlin: de Gruyter, 2010–.

Amir, R. "Style as a Means of Periodization: The Relative Chronology of Synagogues in the Golan." *Cathedra* 124 (2007): 29–50. Hebrew.

Amit, D., "The Source of the Architectural Plans of the Synagogues in Southern Judea." *Cathedra* 68 (1993): 6–35. Hebrew.

———. "Architectural Plans of Synagogues in the Southern Judean Hills and the 'Halakah.'" In Urman and Flesher, *Ancient Synagogues*, 1:129–56.

———. "The Synagogues of Hurbat Maʿon and Hurbat ʿAnim and the Jewish Settlement in Southern Judea." Ph.D. diss., Hebrew University of Jerusalem, 2003. Hebrew.

———. "Priests and Memory of the Temple in the Synagogues of Southern Judaea." In L. I. Levine, *Continuity and Renewal*, 143–54. Hebrew.

———. "Priests and Remembrance of the Temple in the Synagogues of Southern Judea." In Y. Eshel et al., *And Let Them Make Me a Sanctuary*, 43–47.

———."Iconoclasm in the Ancient Synagogues in Eretz-Israel." In *Proceedings of the Eleventh World Congress of Jewish Studies*, B/1, 9–16. Jerusalem: World Union of Jewish Studies, 1994. Hebrew.

Amit, D., and Y. Adler. "The Observance of Ritual Purity after 70 C.E.: A Reevaluation of the Evidence in Light of Recent Archaeological Discoveries." In Weiss et al., *"Follow the Wise,"* 121–43.

———. "*Miqwaʾot* in the Necropolis of Beth Sheʿarim." *IEJ* 60 (2010): 72–88.

Amit, Y., et al. *Essays on Ancient Israel and Its Near Eastern Context: A Tribute to Nadav Naʾaman*. Winona Lake: Eisenbrauns, 2006.

Anderson, G. *Philostratus: Biography and Belles Lettres in the Third Century A.D.* London: Croom Helm, 1986.

———. "The *Pepaideumenos* in Action: Sophists and Their Outlook in the Early Empire." *ANRW* II.33.1 (1989): 79–208.

———. *The Second Sophistic: A Cultural Phenomenon in the Roman Empire*. London: Routledge, 1993.

Arav, R., et al. "Bethsaida Rediscovered: Long-Lost City Found North of Galilee Shore." *BAR* 26, no. 1 (2000): 44–56.

Ariel, D. "A Survey of Coin Finds in Jerusalem, until the End of the Byzantine Period." *LA* 32 (1982): 273–326.

———. *Excavations at the City of David, 1978-85, Directed by Yigal Shiloh*. Vol. 2, *Imported Stamped Amphora Handles, Coins, Worked Bone, Ivory, and Glass*. Jerusalem: Institute of Archaeology, Hebrew University, 1990.

———. "Imported Greek Stamped Amphora Handles." In Geva, *Jewish Quarter Excavations*, 1:267–83.

———. "The Jerusalem Mint of Herod the Great: A Relative Chronology." In Barag, "Studies in Memory of Leo Mildenberg," special issue, *INJ* 14 (2002): 99–124.

———. "The Coins of Herod the Great in the Context of the Augustan Empire." In Jacobson and Kokkinos, *Herod and Augustus*, 113–26.

Ariel, D., and Y. Shoham. "Locally Stamped Handles and Associated Body Fragments of the

Persian and Hellenistic Periods." In *Excavations at the City of David, 1978-85, Directed by Yigal Shiloh*, edited by D. Ariel, vol. 6, *Inscriptions*, 137–71. Jerusalem: Institute of Archaeology, Hebrew University, 2000.

Ascough, R. S., ed. *Religious Rivalries and the Struggle for Success in Sardis and Smyrna*. Waterloo, ON: Wilfred Laurier University Press, 2005.

Aster, S. Z. "Transmission of Neo-Assyrian Claims of Empire to Judah in the Late Eighth Century B.C.E." *HUCA* 78 (2007): 1–44.

Athanassakis, A. N. *The Orphic Hymns: Text, Translation, and Notes*. Missoula: Scholars, 1977.

Athanassiadi, P., and M. Frede, eds. *Pagan Monotheism in Late Antiquity*. Oxford: Clarendon, 1999.

Auerbach, E. *Mimesis: The Representation of Reality in Western Literature*. Princeton: Princeton University Press, 1971.

Avery-Peck, A. J., and J. Neusner, eds. *Where We Stand: Issues and Debates in Ancient Judaism*. Pt. 3 of *Judaism in Late Antiquity*. 4 vols. Leiden: Brill, 2001.

Avery-Peck, A. J., and J. Neusner, eds. *The Mishnah in Contemporary Perspective*. Pt. 1. Leiden: Brill, 2002.

Aviam, M. "The Ancient Synagogue at Bar'am." In Avery-Peck and Neusner, *Judaism in Late Antiquity*, pt. 3, *Where We Stand*, 4:155–69.

———. "The Ancient Synagogues at Bar'am." In L. I. Levine, *Continuity and Renewal*, 544–53. Hebrew.

Aviam, M., and A. Amitai. "The Cemeteries of Sepphoris," *Cathedra* 141 (2011): 7–26. Hebrew.

Aviam, M., and D. Syon. "Jewish Ossilegium in Galilee." In Rutgers, *What Athens Has to Do with Jerusalem*, 151–87.

Avigad, N. *Ancient Monuments in the Kidron Valley*. Jerusalem: Bialik, 1954. Hebrew.

———. "The Mosaic Pavement of the Beth-Alpha Synagogue and Its Place in the History of Jewish Art." In *The Beth Shean Valley: The 17th Archaeological Convention*, 63–70. Jerusalem: Israel Exploration Society, 1962. Hebrew.

———. "More Evidence on the Judean Post-Exilic Stamps." *IEJ* 24 (1974): 52–58.

———. *Beth She'arim: Report on the Excavations during 1953-1958*. Vol. 3, *Catacombs 12-23*. New Brunswick, NJ: Rutgers University Press, 1976.

———. *Bullae and Seals from a Post-Exilic Judean Archive*. Jerusalem: Institute of Archaeology, Hebrew University, 1976.

———. *Discovering Jerusalem*. Nashville: Thomas Nelson, 1983.

———. *Hebrew Bullae from the Time of Jeremiah: Remnants of a Burnt Archive*. Jerusalem: Israel Exploration Society, 1986.

———. "Beth Alpha." In E. Stern, *NEAEHL*, 1:190–92.

———. "Jerusalem." In E. Stern, *NEAEHL*, 2:750–53.

———. "Samaria (City)." In E. Stern, *NEAEHL*, 4:1300–10.

Avigad, N., and B. Mazar. "Beth She'arim." In E. Stern, *NEAEHL*, 1:236–48.

Avigad, N., and B. Sass. *Corpus of West Semitic Stamp Seals*. Jerusalem: Israel Academy of Sciences and Humanities, 1997.

Avissar, O., ed. *Sefer Teveria*. Jerusalem: Keter, 1973. Hebrew.

Avi-Yonah, M. "Mosaic Pavements in Palestine." *Quarterly of the Department of Antiquities of Palestine* 2 (1932): 136–81; 3 (1933): 26–72; 4 (1934): 187–93; 5 (1935): 11–30.

———. *The Madaba Mosaic Map, with Introduction and Commentary*. Jerusalem: Israel Exploration Society, 1954.

———. "The Economics of Byzantine Palestine." *IEJ* 8 (1958): 39–51.

———. "Mosaic Pavement of the Ma'on Synagogue." *Bulletin of the Louis M. Rabinowitz Fund for the Exploration of Ancient Synagogues* 3 (1960): 25–35.

———. *Oriental Art in Roman Palestine*. Rome: Universita di Roma, 1961.

———. *In the Days of Rome and Byzantium*. Jerusalem: Bialik, 1962. Hebrew.

———. "The Caesarea Inscription of the Twenty-Four Priestly Courses." In *The Teacher's Yoke: Studies in Memory of Henry Trantham*, edited by E. J. Vardaman and J. L. Garrett, 45–57. Waco, TX: Baylor University Press, 1964.

———. *Gazetteer of Roman Palestine*. Jerusalem: Institute of Archaeology, Hebrew University and Carta, 1976.

———. *The Jews of Palestine: A Political History from the Bar Kokhba War to the Arab Conquest*. New York: Schocken, 1976.

———. *Art in Ancient Palestine*. Jerusalem: Magnes, 1981.

———. "The Mosaics of Mopsuestia—Church or Synagogue?" In L. I. Levine, *Ancient Synagogues Revealed*, 186–90.

———. "Ḥammat Gader." In E. Stern, *NEAEHL*, 2:566–69.

———. "Ḥuseifah." In E. Stern, *NEAEHL*, 2:637–38.

———. "Naʿaran." In E. Stern, *NEAEHL*, 3:1075–76.

———. *The Holy Land: From the Persian to the Arab Conquests, 536 B.C. to A.D. 640*. Grand Rapids: Baker, 1966; rev. ed., edited by A. F. Rainey, Jerusalem: Carta, 2002.

Avner, U. "Studies in the Material and Spiritual Culture of the Negev and Sinai Populations, during the 6th–3rd Millennia B.C." Ph.D. diss., Hebrew University of Jerusalem, 2002.

Avni, G., U. Dahari, and A. Kloner. *The Necropolis of Bet Guvrin-Eleutheropolis*. Jerusalem: Israel Antiquities Authority, 2008.

Baer, Y. "Israel, the Christian Church, and the Roman Empire." *Scripta Hierosolymitana* 7 (1961): 79–149.

Bagatti, B. "La posizione dell'ariete nell'iconografia del sacrificio di Abramo." *LA* 34 (1984): 283–98.

Bahat, D. "A Synagogue at Beth-Shean." In L. I. Levine, *Ancient Synagogues Revealed*, 82–85.

Balty, J. "Apamea in Syria in the Second and Third Centuries A.D." *JRS* 78 (1988): 91–104.

Bianchi Bandinelli, R. "Arte plebea." *Dialoghi di Archeologia* 1 (1967): 7–19.

———. *Rome: The Late Empire—Roman Art, AD 200–400*. London: Thames and Hudson, 1971.

Bar, D. "Was There a 3rd-c. Economic Crisis in Palestine?" In Humphrey, *Roman and Byzantine Near East*, 3:43–54.

———. "The Christianisation of Rural Palestine during Late Antiquity." *Journal of Ecclesiastical History* 54 (2003): 401–21.

———. "Settlement and Economy in Eretz-Israel during the Late Roman and the Byzantine Periods (70–641 CE)." *Cathedra* 107 (2003): 27–46. Hebrew.

———. "Geographical Implications of Population and Settlement Growth in Late Antique Palestine." *Journal of Historical Geography* 30 (2004): 1–10.

———. "Roman Legislation as Reflected in the Settlement History of Late Antique Palestine." *SCI* 24 (2005): 195–206.

———. "Rural Monasticism as a Key Element in the Christianization of Byzantine Palestine." *HTR* 98 (2005): 49–65.

———. *"Fill the Earth": Settlement in Palestine during the Late Roman and Byzantine Periods, 135–640 C.E.* Jerusalem: Yad Izhak Ben-Zvi, 2008. Hebrew.

Barag, D. "Glass Pilgrim Vessels from Jerusalem." *JGS* 12 (1970): 35–63; 13 (1971): 45–63.

———. "Glass." In *Encyclopedia Judaica*, 7:604–14. Jerusalem: Keter, 1971.

———. "Some Notes on a Silver Coin of Johanan the High Priest." *BA* 48 (1985): 166–72.

———. "The *Menorah* in the Roman and Byzantine Periods: A Messianic Symbol." *Bulletin of the Anglo-Israel Archaeological Society* (1985–86): 44–47.

———. "A Silver Coin of Yohanan the High Priest and the Coinage of Judea in the Fourth Century B.C." *INJ* 9 (1986–87): 4–21.

———. "A Coin of Bagoas with a Representation of God on a Winged-Wheel." *Qadmoniot* 25, nos. 99–100 (1992): 97–99. Hebrew.

———. "Japhia." In E. Stern, *NEAEHL*, 2:659–60.

———. "The Showbread Table and the Façade of the Temple on Coins of the Bar-Kokhba Revolt." In Geva, *Ancient Jerusalem Revealed*, 272–76. Reprinted as "The Table of the Showbread and the Façade of the Temple." *Qadmoniot* 20, nos. 79–80 (1987): 22–25. Hebrew.

———. "The Temple Cult Objects Graffito from the Jewish Quarter Excavations at Jerusalem." In Geva, *Ancient Jerusalem Revealed*, 277–78.

———. "The Coinage of Yehud and the Ptolemies." In "Studies in Honour of Arie Kindler," special issue, *INJ* 13 (1994–99): 27–38.

———, ed. "Studies in Memory of Leo Mildenberg," special issue, *INJ* 14 (2002).

———. "The 2000–2001 Exploration of the Tombs of Benei Hezir and Zecharia." *IEJ* 53 (2003): 78–110.

———. "The Tomb of Jason Reconsidered." In Weiss et al., *"Follow the Wise,"* 145–61.

Barag, D., and M. Hershkovitz. *Masada: The Yigael Yadin Excavations, 1963–1965; Final Reports.* Vol. 4, *Lamps, Ballista Balls, Wood Remains, Basketry, Cordage and Related Artifacts, Textiles.* Jerusalem: Israel Exploration Society, 1994.

Baramki, D. C. "A Byzantine Church at Mahatt el Urdi, Beit Jibrin, 1941–1942." *LA* 22 (1972): 130–52.

Baras, Z., et al. *Eretz-Israel from the Destruction of the Second Temple to the Muslim Conquest.* 2 vols. Jerusalem: Yad Izhak Ben-Zvi, 1982, 1984. Hebrew.

Barasch, M. "The David Mosaic of Gaza." *Assaph, Section B: Studies in Art History* 1 (1980): 1–42.

———. *Imago Hominis: Studies in the Language of Art.* Vienna: IRSA, 1991.

———. *Icon: Studies in the History of an Idea.* New York: New York University Press, 1992.

———. "Job: The History of *Exemplum Doloris*." In Barasch, *The Language of Art: Studies in Interpretation*, 93–111. New York: New York University Press, 1997.

Barber, C. "The Truth in Painting, Iconoclasm and Identity in Early-Medieval Art." *Speculum* 72 (1997): 1019–36.

Barclay, J. M. G. *Jews in the Mediterranean Diaspora: From Alexander to Trajan (323 BCE–117 CE).* Edinburgh: T & T Clark, 1996.

———. "Snarling Sweetly: Josephus on Images and Idolatry." In Barton, *Idolatry*, 73–87.

Bardy, G. "Saint Jérôme et ses maîtres hébreux." *Revue Bénédictine* 46 (1934): 145–64.

Bar-Ilan, M. *The Mysteries of Jewish Prayer and Hekhalot: An Analysis of Ma'aseh Merkavah.* Ramat Gan: Bar-Ilan University Press, 1987. Hebrew.

Barkay, R. "Samaritan Sarcophagi." In E. Stern and H. Eshel, *The Samaritans*, 310–38.

Barkhuizen, J. H. "Proclus of Constantinople: A Popular Preacher in Fifth-Century Constantinople." In *Preacher and Audience: Studies in Early Christian and Byzantine Homiletics*, edited by M. B. Cunningham and P. Allen, 179–200. Leiden: Brill, 1998.

Barnard, L. W. *The Graeco-Roman and Oriental Background of the Iconoclastic Controversy.* Leiden: Brill, 1974.

Bar-Nathan, R. *Masada: The Yigael Yadin Excavations, 1963–1965; Final Reports.* Vol. 7, *The Pottery of Masada.* Jerusalem: Israel Exploration Society, 2006.

Barnes, T. D. *Constantine and Eusebius.* Cambridge, MA: Harvard University Press, 1981.

———. "Christians and Pagans in the Reign of Constantius." In *L'Eglise et l'empire au IVe siècle: Sept exposés suivis de discussions par Friedrich Vittinghoff*, edited by A. Dihle, 306–21. Geneva: Fondation Hardt, 1989.

Barnett, R. D. *Ancient Ivories in the Middle East [and Adjacent Countries].* Jerusalem: Institute of Archaeology, Hebrew University of Jerusalem, 1982.

Baron, S. *The Jewish Community: Its History and Structure to the American Revolution.* 3 vols. Philadelphia: Jewish Publication Society, 1942.

———. *A Social and Religious History of the Jews.* 2nd ed. 18 vols. New York: Columbia University Press, 1952–83.

Barrett, T. "About Art Interpretation for Art Education." *Studies in Art Education* 42, no. 1 (Autumn 2000): 3–19.

Barth, F., ed. *Ethnic Groups and Boundaries: The Social Organization of Culture Difference.* London: Allen and Unwin, 1969.

Barton, S. C., ed. *Idolatry: False Worship in the Bible, Early Judaism and Christianity.* London: T & T Clark, 2007.

Baskin, J. R. "Rabbinic-Patristic Exegetical Contacts in Late Antiquity: A Bibliographical Reappraisal." In *Approaches to Ancient Judaism,* vol. 5, *Studies in Judaism and Its Greco-Roman Context,* edited by W. S. Green, 53–80. Atlanta: Scholars, 1985.

Basser, H. W. "The Acts of Jesus." In *The Frank Talmage Memorial Volume,* edited by B. Walfish, 273–82. Haifa: Haifa University Press, 1993.

Baumgarten, A. I. "Justinian and the Jews." In *Rabbi Joseph H. Lookstein Memorial Volume,* edited by L. Landman, 37–44. New York: KTAV, 1980.

———. "Bilingual Jews and the Greek Bible." In *Shem in the Tents of Japhet: Essays on the Encounter of Judaism and Hellenism,* edited by J. L. Kugel, 13–30. Leiden: Brill, 2002.

Baumgarten, J. "Art in the Synagogue: Some Talmudic Views." *Judaism* 19, no. 2 (1970): 196–206.

Beaucamp, J., F. Briquel-Chatonnet, and C. J. Robin. "La persécution des chrétiens de Nagrân et la chronologie himyarite." *ARAM* 11–12 (1999–2000): 15–83.

Beck, P. "The Drawings from Horvat Teiman (Kuntillet Ajrud)." *Tel Aviv* 9 (1982): 3–68.

———. "The Cult-Stands from Taanach: Aspects of the Iconographic Tradition of Early Iron Age Cult Objects in Palestine." In *From Nomadism to Monarchy: Archaeological and Historical Aspects of Early Israel,* edited by I. Finkelstein and N. Na'aman, 352–81. Jerusalem: Yad Izhak Ben-Zvi and Israel Exploration Society; Washington, D.C.: Biblical Archaeology Society, 1994.

———. "The Art of Palestine during the Iron Age II: Local Traditions and External Influences (10th–8th Centuries BCE)." In *Images as Media: Sources for the Cultural History of the Near East and the Eastern Mediterranean (1st Millennium BCE),* edited by C. Uehlinger, 165–83. Fribourg: University Press; Göttingen: Vandenhoeck & Ruprecht, 2000.

———. "The Art of Palestine during the Iron Age II: Local Traditions and External Influences, 10th–8th Centuries BCE." In *Imagery and Representation: Studies in the Art and Iconography of Ancient Palestine—Collected Articles,* edited by N. Na'aman et al., 203–22. Tel Aviv: Emery and Claire Yass Publications in Archaeology, 2002.

Beck, R. *Planetary Gods and Planetary Orders in the Mysteries of Mithras.* Leiden: Brill, 1988.

———. *The Religion of the Mithras Cult in the Roman Empire: Mysteries of the Unconquered Sun.* Oxford: Oxford University Press, 2006.

Becker, A. H., and A. Y. Reed, eds. *The Ways That Never Parted: Jews and Christians in Late Antiquity and the Early Middle Ages.* Tübingen: Mohr Siebeck, 2003.

Becking, B. *The Fall of Samaria: An Historical and Archaeological Study.* Leiden: Brill, 1992.

———. "Assyrian Evidence for Iconic Polytheism in Ancient Israel?" In van der Toorn, *Image and the Book,* 157–71.

———, et al., eds. *Only One God? Monotheism in Ancient Israel and the Veneration of the Goddess Asherah.* London: Sheffield Academic, 2001.

Beckman, G., and T. J. Lewis, eds. *Text, Artifact, and Image: Revealing Ancient Israelite Religion.* Providence, RI: Brown Judaic Studies, 2006.

BeDuhn, J. D. "Magical Bowls and Manichaeans." In *Ancient Magic and Ritual Power,* edited by M. W. Meyer and P. A. Mirecki, 419–34. Leiden: Brill, 2001.

Beer, M. *The Babylonian Exilarchate in the Arsacid and Sassanian Periods.* Tel Aviv: Dvir, 1976. Hebrew.

Beit-Arieh, I. "Qitmit, Horbat." In E. Stern, *NEAEHL,* 4:1230–33.

Bejaoui, F. "Christian Mosaics in Tunisia." In *Stories in Stone: Conserving Mosaics of Roman Africa: Masterpieces from the National Museums of Tunisia*, edited by A. Ben Abed, 93–100. Los Angeles: J. Paul Getty Museum/Getty Conservation Institute, 2006.

Bekkum, W. J. van. "Anti-Christian Polemics in Hebrew Liturgical Poetry (*Piyyut*) of the Sixth and Seventh Centuries." In *Early Christian Poetry: A Collection of Essays*, edited by J. Den Boeft and A. Hilhorst, 297–308. Leiden: Brill, 1993.

———. "Talmudic Tradition in a Changing Society." In *Learned Antiquity: Scholarship and Society in the Near-East, the Greco-Roman World, and the Early Medieval West*, edited by A. A. MacDonald, M. W. Twomey, and G. J. Reinink, 53–61. Leuven: Peeters, 2003.

———. "The New Liturgical Poetry of Byzantine Palestine: Recent Research and New Perspectives." *Prooftexts* 28 (2008): 232–46.

———. "The Future of Ancient Piyyut." In Goodman and Alexander, *Rabbinic Texts and the History of Late-Roman Palestine*, 217–33.

Belayche, N. *Iudaea-Palaestina: The Pagan Cults in Roman Palestine, Second to Fourth Century*. Tübingen: Mohr Siebeck, 2001.

Ben Abed, A. *Tunisian Mosaics: Treasures from Roman Africa*. Los Angeles: Getty Conservation Institute, 2006.

Ben David, Ch. *The Jewish Settlement on the Golan*. Qazrin: Golan Research Institute, 2005. Hebrew.

———. "Late Antique Gaulanitis: Settlement Patterns of Christians and Jews in Rural Landscape." In Lewin and Pellegrini, *Settlements and Demography*, 35–50.

Ben Eliyahu, E. "The Rabbinic Polemic against the Sanctification of Sites." *JSJ* 40 (2009): 260–80.

Ben-Haim-Trifon, D. "Some Aspects of Internal Politics Connected with the Bar-Kokhva Revolt." In Oppenheimer and Rappaport, *Bar-Kokhva Revolt*, 13–26.

Berg, B. "Alcestis and Hercules in the Catacomb of Via Latina." *VC* 48 (1994): 219–34.

Berger, D. *The Jewish-Christian Debate in the High Middle Ages*. Philadelphia: Jewish Publication Society, 1979.

Berkowitz, B. "The Limits of 'Their Laws': Ancient Rabbinic Controversies about Jewishness (and Non-Jewishness)." *JQR* 99 (2009): 121–57.

Berlin, A. "Between Large Forces: Palestine in the Hellenistic Period." *BA* 60 (1997): 2–51.

———. "Power and Its Afterlife: Tombs in Hellenistic Palestine." *NEA* 65 (2002): 138–48.

———. "Jewish Life before the Revolt: The Archaeological Evidence." *JSJ* 36 (2005): 417–70.

Berliner (Landau), R. "The Interpretation of the Presence of Daniel and the Lions in the Temple Panel of the Ancient Synagogue at Naʿaran." In *Judea and Samaria Research Studies* 3, *Proceedings of the 3rd Annual Meeting—1993*, edited by Z. H. Erlich and Y. Eshel, 213–19. Kedumim-Ariel: Research Institute, College of Judea and Samaria, 1994. Hebrew.

———. "The Circle of the Zodiac and the Scientific Reasons for Its Use in the Ancient Synagogues in Israel." *Judea and Samaria Studies* 4 (1995): 179–88. Hebrew.

Berlinerblau, J. *The Vow and the "Popular Religious Groups" of Ancient Israel: A Philological and Sociological Inquiry*. Sheffield: Sheffield Academic, 1996.

———. "Preliminary Remarks for the Sociological Study of Israelite 'Official Religion.'" In *Ki Baruch Hu: Ancient Near Eastern, Biblical, and Judaic Studies in Honor of Baruch A. Levine*, by R. Chazan et al., 153–70. Winona Lake: Eisenbrauns, 1999.

Berquist, J. L. *Judaism in Persia's Shadow: A Social and Historical Approach*. Minneapolis: Fortress, 1995.

Berrens, S. *Sonnenkult und Kaisertum von den Severern bis zu Constantin I (193–337 n. Chr.)*. Stuttgart: Steiner, 2004.

Besserman, L. "*Imitatio Christi* in the Later Middle Ages and in Contemporary Film: Three Paradigms." *Florilegium* 23 (2006): 231–41.

Betz, H. D. *The Greek Magical Papyri in Translation, including the Demotic Spells.* 2nd ed. Chicago: University of Chicago Press, 1996.

Beyer, H. W., and H. Lietzmann. *Die jüdische Katakombe der Villa Torlonia in Rom.* Berlin: de Gruyter, 1930.

Bhabha, H. K. *The Location of Culture.* London: Routledge, 1994.

Biale, D. "Counter-History and Jewish Polemics against Christianity: The *Sefer Toldot Yeshu* and the *Sefer Zerubavel.*" *JSS* 6 (1999): 130–45.

———, ed. *Cultures of the Jews: A New History.* New York: Schocken, 2002.

Bickerman, E. *From Ezra to the Last of the Maccabees.* New York: Schocken, 1962.

Biebel, F. M. "The Mosaics of Hammam Lif." *Art Bulletin* 18 (1936): 541–51.

Birdsall, J. N. "Problems of the Clementine Literature." In *Jews and Christians: The Parting of the Ways, A. D. 70 to 135,* edited by J. D. G. Dunn, 347–61. Tübingen: Mohr Siebeck, 1992.

Bitner, A. "Illustrated Midrashim in the 'Aqedah Mosaic of Beth Alpha." *Derekh Aggadah* 2 (1999): 91–104. Hebrew.

———. "Illustrated Midrashim in the 'Aqedah Mosaic of Beth Alpha." In *The Binding of Isaac for His Seed: An Israeli Perspective,* edited by I. Rozensohn and B. Lau, 205–14. Tel Aviv: I. Hirschberg Memorial Fund, 2003. Hebrew.

Bitton-Ashkelony, B., and A. Kofsky, eds. *Christian Gaza in Late Antiquity.* Leiden: Brill, 2004.

Blanchard-Lemée, M., and G. Mermet, eds. *Mosaics of Roman Africa: Floor Mosaics from Tunisia.* New York: Braziller, 1996.

Bleiberg, E. *The Tree of Paradise: Jewish Mosaics from the Roman Empire.* New York: Brooklyn Museum, 2005.

Blenkinsopp, J. "The Mission of Udjahorresnet and Those of Ezra and Nehemiah." *JBL* 106 (1987): 409–21.

Blidstein, G. "Nullification of Idolatry in Rabbinic Law." *PAAJR* 41–42 (1973–74): 1–44.

———. "Prostration and Mosaics in Talmudic Law." *Bulletin of the Institute of Jewish Studies* 2 (1974): 19–39.

———. "A Roman Gift of Strenae to the Patriarch Judah II." *IEJ* 22 (1972): 150–52.

———. "The Tannaim and Plastic Art: Problems and Prospects." In *Perspectives in Jewish Learning,* edited by B. L. Sherwin, 5:13–27. Chicago: Spertus College of Judaica Press, 1973.

———. "R. Yohanan, Idolatry and Public Privilege." *JSJ* 5 (1974): 154–61.

Bloch, M. *The Historian's Craft.* New York: Vintage, 1953.

Bloch-Smith, E. "Solomon's Temple. The Politics of Ritual Space." In *Sacred Time, Sacred Place: Archaeology and the Religion of Israel,* edited by B. M. Gittlen, 83–94. Winona Lake: Eisenbrauns, 2002.

———. "Israelite Ethnicity in Iron I: Archaeology Preserves What Is Remembered and What Is Forgotten in Israel's History." *JBL* 122 (2003): 401–25.

———. "*Massebôt* in the Israelite Cult: An Argument for Rendering Implicit Cultic Criteria Explicit." In *Temple and Worship in Biblical Israel,* edited by J. Day, 28–39. London: T & T Clark International, 2005.

———. "Will the Real *Massebot* Please Stand Up: Cases of Real and Mistakenly Identified Standing Stones in Ancient Israel." In Beckman and Lewis, *Text, Artifact, and Image,* 64–79.

Bloch-Smith, E., and B. Alpert-Nakhai. "A Landscape Comes to Life: The Iron I Period." *NEA* 62 (1999): 62–92.

Blumenkranz, B. *Juifs et chrétiens dans le monde occidental, 430–1096.* Paris: Mouton, 1960.

Boddens Hosang, F. J. E. *Establishing Boundaries: Christian-Jewish Relations in Early Council Texts and the Writings of Church Fathers.* Leiden: Brill, 2010.

Bodel, J. P. "Dealing with the Dead: Undertakers, Executioners and Potter's Fields in Ancient Rome." In Hope and Marshall, *Death and Disease,* 128–51.

———. "From *Columbaria* to Catacombs: Collective Burial in Pagan and Christian Rome." In *Commemorating the Dead: Texts and Artifacts in Context: Studies of Roman, Jewish, and Christian Burials*, edited by L. Brink and D. Greene, 177–242. Berlin: de Gruyter, 2008.

Bohak, G. *Ancient Jewish Magic: A History*. Cambridge, UK: Cambridge University Press, 2008.

———. "The Jewish Magical Tradition from Late Antique Palestine in the Cairo Genizah." In Cotton, *From Hellenism to Islam*, 324–42.

Bokser, B. M. "An Annotated Bibliographical Guide to the Study of the Palestinian Talmud." *ANRW* II.19.2 (1979): 139–256.

———. *The Origins of the Seder: The Passover Rite and Early Rabbinic Judaism*. Berkeley: University of California Press, 1984.

Bond, H. K. " 'Standards, Shields and Coins: Jewish Reactions to Aspects of the Roman Cult in the Time of Pilate." In Barton, *Idolatry*, 88–106.

Bonner, C. *Studies in Magical Amulets, Chiefly Graeco-Egyptian*. University of Michigan Studies. Ann Arbor: University of Michigan Press, 1950.

Bonz, M. P. "The Jewish Community of Ancient Sardis: A Reassessment of its Rise to Prominence." *HSCP* 93 (1990): 343–59.

———. "Differing Approaches to Religious Benefaction: The Late Third-Century Acquisition of the Sardis Synagogue." *HTR* 86 (1993): 139–54.

———. "The Jewish Donor Inscriptions from Aphrodisias: Are They Both Third-Century, and Who Are the *Theosebeis?*" *HSCP* 96 (1994): 281–99.

Bornstein, H. Y. "The Latest Phases in the Study of Intercalation." *Hatekufah* 14–15 (1922): 321–72. Hebrew.

Botermann, H. "Die Synagoge von Sardes: Eine Synagoge aus dem 4. Jahrhundert?" *ZNW* 81 (1990): 103–21.

———. "Griechisch-jüdische Epigraphik: Zur Datierung der Aphrodisias-Inschriften." *ZPE* 98 (1993): 184–94.

Boustan, R. S. *From Martyr to Mystic: Rabbinic Martyrology and the Making of Merkavah Mysticism*. Tübingen: Mohr Siebeck, 2005.

———. "The Emergence of Pseudonymous Attribution in Heikhalot Literature: Empirical Evidence from the Jewish 'Magical' Corpus." *JSQ* 14 (2007): 18–38.

———. "The Study of Heikhalot Literature: Between Mystical Experience and Textual Artifact." *Currents in Biblical Research* 6 (2007): 130–60.

Bowder, D. *The Age of Constantine and Julian*. London: Paul Elek, 1978.

Bowersock, G. W. *Greek Sophists in the Roman Empire*. Oxford: Clarendon, 1969.

———, ed. *Approaches to the Second Sophistic*. University Park, PA: American Philological Association, 1974.

———. *Julian the Apostate*. Cambridge, MA: Harvard University Press, 1978.

———. "The Imperial Cult: Perceptions and Persistence." In *Jewish and Christian Self-Definition*. Vol. 3, *Self-Definition in the Greco-Roman World*, edited by B. F. Meyer and E. P. Sanders, 171–82. Philadelphia: Fortress, 1982.

———. *Roman Arabia*. Cambridge, MA: Harvard University Press, 1983.

———. *Hellenism in Late Antiquity*. Cambridge, UK: Cambridge University Press, 1990.

———. *Studies on the Eastern Roman Empire: Social, Economic and Administrative History, Religion, Historiography*. Goldbach: Keip, 1994.

———. "The Greek Moses: Confusion of Ethnic and Cultural Components in Later Roman and Early Byzantine Palestine." In Lapin, *Religious and Ethnic Communities*, 31–48.

———. "The Hadramawt between Persia and Byzantium." In *La Persia e Bisanzio: Convegno internazionale la Persia e Bisanzio: Roma, 14–18 ottobre 2002*, edited by Accademia Nazionale dei Lincei and Istituto Italiano per l'Africa e l'Oriente, 263–73. Rome: Accademia Nazionale dei Lincei, 2004.

———. *Mosaics as History: The Near East from Late Antiquity to Islam*. Cambridge, MA: Harvard University Press, 2006.

Bowersock, G. W., P. R. L. Brown, and O. Grabar, eds. *Late Antiquity: A Guide to the Postclassical World*. Cambridge, MA: Harvard University Press, 1999.

———, eds. *Interpreting Late Antiquity: Essays on the Postclassical World*. Cambridge, MA: Harvard University Press, 2001.

Bowes, K. *Private Worship, Public Values, and Religious Change in Late Antiquity*. Cambridge, UK: Cambridge University Press, 2008.

Bowie, E. L. "Greeks and Their Past in the Second Sophistic." *Past and Present* 46 (1970): 3–41.

Bowman, S. "Jews in Byzantium." In Katz, *Late Roman–Rabbinic Period*, 1035–52.

Boyarin, D. "The Eye in the Torah: Ocular Desire in Midrashic Hermeneutic." *Critical Inquiry* 16 (1990): 532–50.

———. *Dying for God: Martyrdom and the Making of Christianity and Judaism*. Stanford: Stanford University Press, 1999.

———. "Hellenism in Jewish Babylonia." In Fonrobert and Jaffee, *Cambridge Companion to the Talmud and Rabbinic Literature*, 336–63.

———. "Rethinking Jewish Christianity: An Argument for Dismantling a Dubious Category (to Which Is Appended a Correction of My 'Border Lines')." *JQR* 99 (2009): 7–36.

Bradbury, S., ed. and trans. *Severus of Minorca: Letter on the Conversion of the Jews*. Oxford: Clarendon, 1996.

———. "The Jews of Spain, c. 235–638." In Katz, *Late Roman–Rabbinic Period*, 508–18.

Bradshaw, P. *The Search for the Origins of Christian Worship: Sources and Methods for the Study of Early Liturgy*. London: SPCK, 1992.

Brändle, R. "Christen und Juden in Antiochien in den Jahren 386–387: ein Beitrag zur Geschichte altkirchlicher Judenfeindschaft." *Judaica* 43 (1987): 142–60.

Branham, J. "Sacred Space under Erasure in Ancient Synagogues and Early Churches." *Art Bulletin* 74 (1992): 375–94.

———. "Vicarious Sacrality: Temple Space in Ancient Synagogues." In Urman and Flesher, *Ancient Synagogues*, 2:319–45.

———. "Mapping Sacrifice on Bodies and Spaces in Late Antique Judaism and Early Christianity." In *Architecture of the Sacred: Space, Ritual, and Experience from Classical Greece to Byzantium*, edited by B. D. Wescoat and R. G. Ousterhout, 201–30. Cambridge, UK: Cambridge University Press, 2012.

Braslawski, Y. "Symbols and Mythological Figures in Ancient Galilean Synagogues." In *All the Land of Naphtali*, edited by H. Hirschberg, 106–29. Jerusalem: Israel Exploration Society, 1969. Hebrew.

Braverman, J. *Jerome's Commentary on Daniel: A Study of Comparative Jewish and Christian Interpretations of the Hebrew Bible*. Washington, DC: Catholic Biblical Association, 1978.

Bregman, M. "The Riddle of the Ram in Genesis Chapter 22: Jewish-Christian Contacts in Late Antiquity." In *The Sacrifice of Isaac in the Three Monotheistic Religions*, edited by F. Mann, 127–45. Jerusalem: Franciscan Printing, 1995.

———. "Pseudepigraphy in Rabbinic Literature." In *Pseudepigraphic Perspectives: The Apocrypha and Pseudepigrapha in Light of the Dead Sea Scrolls*, edited by E. G. Chazon and M. E. Stone, 27–41. Leiden: Brill, 1999.

———. "Aqedah: Midrash as Visualization." *Journal of the Society for Textual Reasoning*, n.s. 2, no. 1 (2003). http://etext.lib.virginia.edu/journals/tr/volume2/bregman.html. Accessed November 2011.

Brenk, B. "The Imperial Heritage of Early Christian Art." In Weitzmann, *Age of Spirituality: A Symposium*, 39–52.

———. "Art and *Propaganda Fide*: Christian Art and Architecture, 300–600." In Casiday and Norris, *Constantine to c. 600*, 691–725.

Brennan, B. "The Conversion of the Jews of Clermont in AD 576." *JTS* 36 (1985): 321–38.

Brent, A. *Hippolytus and the Roman Church in the Third Century: Communities in Tension before the Emergence of a Monarch-Bishop.* Leiden: Brill, 1995.

Bretscheider, J. "Götter in Schreinen: eine Untersuchung zu den syrischen und levantinischen Tempelmodellen, ihrer Bauplastik und ihrer Götterbildern." *Ugarit-Forschungen* 23 (1991): 13–32.

Brilliant, R. "Painting at Dura-Europos and Roman Art." In Gutmann, *Dura-Europos Synagogue: A Re-evaluation*, 23–30.

———. "Jewish Art and Culture in Ancient Italy." In *Gardens and Ghettos: The Art of Jewish Life in Italy*, edited by V. B. Mann, 67–91. Berkeley: University of California Press, 1989.

Brock, S. P. "Jewish Traditions in Syriac Sources." *JJS* 30 (1979): 212–32.

———. "Genesis 22 in Syriac Tradition." In *Mélanges Dominique Barthélemy: Études bibliques offertes a l'occasion de son 60e anniversaire*, edited by P. Casetti, O. Keel, and A. Schenker, 1–30. Fribourg: Éditions universitaires, 1981.

———. "Clothing Metaphors as a Means of Theological Expression in Syriac Tradition." In *Typus, Symbol, Allegorie bein den östlichen Vätern und ihren Parallelen im Mittlealter*, edited by M. Schmidt and K. F. Geyer, 11–38. Regensburg: F. Pustet, 1982.

———. "Greek and Syriac in Late Antique Syria." In *Literacy and Power in the Ancient World*, edited by A. K. Bowman and G. Woolf, 149–60. Cambridge, UK: Cambridge University Press, 1994.

———. *The Bible in the Syriac Tradition.* 2nd ed. Piscataway, NJ: Gorgias, 2006.

Brody, L. R., and G. L. Hoffman, eds. *Dura Europos: Crossroads of Antiquity* (Boston: McMullen Museum of Art, Boston College, 2011).

Brody, R., "Judaism in the Sasanian Empire: A Case Study in Religious Coexistence." In Shaked and A. Netzer, *Irano-Judaica*, 2:52–62.

———. *The Geonim of Babylonia and the Shaping of Medieval Jewish Culture.* New Haven: Yale University Press, 1998.

———. "On the Sources for the Chronology of the Talmudic Period." *Tarbiz* 70 (2000): 75–107. Hebrew.

Brooks, E. W., ed. and trans. *John of Ephesus, Lives of the Eastern Saints.* 3 vols. Paris: Firmin-Didot, 1923–25.

Brown, P. R. L. "Aspects of the Christianization of the Roman Aristocracy." *JRS* 51 (1961): 1–11.

———. *The World of Late Antiquity, AD 150–750.* London: Thames and Hudson, 1971.

———. "Art and Society in Late Antiquity." In Weitzmann, *Age of Spirituality: A Symposium*, 17–27.

———. *The Cult of the Saints: Its Rise and Function in Latin Christianity.* Chicago: University of Chicago Press, 1981.

———. *Society and the Holy in Late Antiquity.* London: Faber & Faber, 1982.

———. "Christianization and Religious Conflict." In *The Cambridge Ancient History.* Vol. 8, *The Late Empire, A.D. 337–425*, edited by A. Cameron and P. Garnsey, 632–64. Cambridge, UK: Cambridge University Press, 1997.

———. "The Rise and Function of the Holy Man, 1971–1997." *JECS* 6 (1998): 353–76.

Brown, P. R. L., et al. "The World of Late Antiquity Revisited." *Symbolae Osloenses* 72 (1997): 5–90.

Brown, R. E. "Further Reflections on the Origins of the Church of Rome." In *The Conversation Continues: Studies in Paul and John—In Honour of J. Louis Martyn*, edited by R. T. Fortna and B. R. Gaventa, 98–115. Nashville: Abington, 1990.

Browning, R. *The Emperor Julian.* Berkeley: University of California Press, 1976.

Brunt, P. A. "The Bubble of the Second Sophistic." *Bulletin of the Institute of Classical Studies* 39 (1994): 25–52.

Buckler, W. H., and D. M. Robinson. *Greek and Latin Inscriptions.* Leiden: Brill, 1932.

Büchler, A. *The Political and Social Leaders of the Jewish Community of Sepphoris in the Second and Third Centuries*. London: Jews' College, 1909.

————. *Studies in Jewish History*. London: Oxford University Press, 1956.

————. *The Priests and Their Cult in the Last Decade of the Temple in Jerusalem*. Jerusalem: Mossad Harav Kook, 1966. Hebrew.

Burns, J. E. "The Special Purim and the Reception of the Book of Esther in the Hellenistic and Early Roman Eras." *JSJ* 37 (2006): 1–34.

————. "The Archaeology of Rabbinic Literature and the Study of Jewish-Christian Relations in Late Antiquity: A Methodological Evaluation." In Zangenberg, Attridge, and Martin, *Religion, Ethnicity, and Identity in Ancient Galilee*, 411–24.

Burrus, V., ed. *Late Ancient Christianity*. Minneapolis: Fortress, 2005.

Burrus, V., and R. Lyman. "Shifting the Focus of History." In Burrus, *Late Ancient Christianity*, 1–23.

Callaway, J. A. "The Settlement in Canaan: The Period of the Judges." Revised by J. M. Miller. In *Ancient Israel: From Abraham to the Roman Destruction of the Temple,* edited by H. Shanks, 55–89. Rev. and expanded ed. Washington, DC: Biblical Archaeology Society, 1999.

Cameron, A. "Θρεπτός and Related Terms in the Inscriptions of Asia Minor." In *Anatolian Studies Presented to William H. Buckler*, edited by W. M. Calder and J. Keil, 27–62. Manchester: Manchester University Press, 1939.

————. *Procopius and the Sixth Century*. Berkeley: University of California Press, 1985.

————. "The Language of Images: The Rise of Icons and Christian Representation." In Wood, *Church and the Arts*, 1–42.

————. *The Later Roman Empire, AD 284–430*. Cambridge, MA: Harvard University Press, 1993.

————. *The Mediterranean World in Late Antiquity, AD 395–600*. London: Routledge, 1993.

————. "The Jews in Seventh-Century Palestine." *SCI* 13 (1994): 75–93.

————. "Remaking the Past." In Bowersock, Brown, and Grabar, *Interpreting Late Antiquity*, 1–20.

————. "Ideologies and Agendas in Late Antique Studies." In Lavan and Bowden, *Theory and Practice in Late Antique Archaeology*, 3–21.

————. "Jews and Heretics—A Category Error?" In Becker and Reed, *Ways That Never Parted*, 345–60.

Cameron, A., B. Ward-Perkins, and M. Whitby, eds. *The Cambridge Ancient History*. Vol. 14, *Late Antiquity: Empire and Successors, A. D. 425–600*. Cambridge, UK: Cambridge University Press, 2000.

Campbell, L. A. *Mithraic Iconography and Ideology*. Leiden: Brill, 1968.

Campbell, S. *The Mosaics of Antioch*. Toronto: Pontifical Institute of Mediaeval Studies, 1988.

Cantera Burgos, F. *Sinagogas españolas*. Madrid: Instituto "Arias Montano," 1955.

Capelletti, S. *The Jewish Community of Rome: From the Second Century B. C. to the Third Century C.E.* Leiden: Brill, 2006.

Case, S. J. "Popular Competitors of Early Christianity." *Journal of Religion* 10 (1930): 55–73.

Casiday, A., and F. W. Norris, eds. *Constantine to c. 600*. Vol. 2 of *CHC*, 691–725. Cambridge, UK: Cambridge University Press, 2007.

Cassuto, U. *The Goddess Anath: Canaanite Epics of the Patriarchal Age*. Jerusalem: Magnes, 1971.

Cassuto Salzmann, M. "Bibliography of M. Avi-Yonah." *IEJ* 24 (1974): 287–315; 34 (1984): 184–86.

Cauville, S. *Le zodiaque d'Osiris*. Leuven: Peeters, 1997.

Çevik, N., and H. Eshel. "A Byzantine Synagogue at Andriake in Southern Turkey." *Qadmoniot* 43, no. 139 (2010): 41–43. Hebrew.

Çevik, N., et al. "A Unique Discovery in Lycia: The Ancient Synagogue at Andriake, Port of Myra." *Adalya* 13 (2010): 335–66.

Chadwick, H. *The Early Church*. Baltimore: Penguin, 1967.

Chancey, M. A. "The Cultural Milieu of Ancient Sepphoris." *NTS* 47 (2001): 127–45.

Chaniotis, A. "The Jews of Aphrodisias: New Evidence and Old Problems." *SCI* 21 (2002): 209–42.

———. "Godfearers in the City of Love." *BAR* 36, no. 3 (May/June 2010): 32–44, 77.

Charlesworth, J. H. "Jewish Astrology in the Talmud, Pseudepigrapha, the Dead Sea Scrolls, and Early Palestinian Synagogues." *HTR* 70 (1977): 183–200.

———. *The Old Testament Pseudepigrapha: Apocalyptic Literature and Testaments*. 2 vols. Garden City, NY: Doubleday, 1983–85.

———. "Jewish Interest in Astrology during the Hellenistic and Roman Period," *ANRW* II. 20.2 (1987): 926–50.

Chazan, R. *Fashioning Jewish Identity in Medieval Western Christendom*. Cambridge, UK: Cambridge University Press, 2004.

Chernus, I. "The Pilgrimage to the Merkavah: An Interpretation of Early Jewish Mysticism." In J. Dan, *Early Jewish Mysticism*, 1–35.

Chiat, M. J. "Synagogues and Churches in Byzantine Beit She'an." *JJA* 7 (1980): 6–24.

Christie, N. *From Constantine to Charlemagne: An Archaeology of Italy, AD 300-800*. Aldershot: Ashgate, 2006.

Clifford, H. "Moses as Philosopher-Sage in Philo." In *Moses in Biblical and Extra-Biblical Traditions*, edited by A. Graupner and M. Wolter, 151–67. Berlin: de Gruyter, 2007.

Coates-Stephens, R. "Attitudes to *Spolia* in Some Late Antique Texts." In Lavan and Bowden, *Theory and Practice in Late Antique Archaeology*, 341–58.

Cogan, M. *Imperialism and Religion: Assyria, Judah, and Israel in the Eighth and Seventh Centuries B.C.E.* Missoula: Scholars, 1974.

———. *1 Kings: A New Translation with Introduction and Commentary*. New York: Doubleday, 2001.

Cohen, B. "Art in Jewish Law." *Judaism* 3 (1954): 165–77.

Cohen, J. "Roman Imperial Policy toward the Jews from Constantine until the End of the Palestinian Patriarchate (ca. 429)." *Byzantine Studies* 3 (1976): 1–29.

Cohen, R. I. *Jewish Icons: Art and Society in Modern Europe*. Berkeley: University of California Press, 1998.

Cohen, S. A. *The Three Crowns: Structures of Communal Politics in Early Rabbinic Jewry*. Cambridge, UK: Cambridge University Press, 1990.

Cohen, S. J. D. *Josephus in Galilee and Rome: His Vita and Development as a Historian*. Leiden: Brill, 1979.

———. "Epigraphical Rabbis." *JQR* 72 (1981–82): 1–17.

———. "Pagan and Christian Evidence on the Ancient Synagogue." In L. I. Levine, *Synagogue in Late Antiquity*, 159–81.

———. "The Place of the Rabbi in Jewish Society of the Second Century." In L. I. Levine, *Galilee in Late Antiquity*, 157–73.

———. "The Conversion of Antoninus." In Schäfer, *Talmud Yerushalmi and Graeco-Roman Culture*, 1:141–71.

———. *Beginnings of Jewishness: Boundaries, Varieties, Uncertainties*. Berkeley: University of California Press, 1999.

———. "Were Pharisees and Rabbis the Leaders of Communal Prayer and Torah Study in Antiquity?" In Kee and Cohick, *Evolution of the Synagogue*, 99–114.

———. "Sabbath Law and Mishnah Shabbat in Origen De Principiis." *JSQ* 17 (2010): 160–89.

Cohick, L. H. "Melito's *Peri Pascha*: Its Relationship to Judaism and Sardis in Recent Scholarly Discussion." In Kee and Cohick, *Evolution of the Synagogue*, 123–40.

Collins, A. Y. *Cosmology and Eschatology in Jewish and Christian Apocalypticism*. Leiden: Brill, 1996.

Collins, J. J. "L. H. Feldman, *Jew and Gentile in the Ancient World*" (review). *JBL* 113 (1994): 716–18.

Colorni, V. *L'uso del Greco nella liturgia del giudaismo ellenistico e la Novella 146 di Giustiniano.* Milan: Giuffrè, 1964.

Coogan, M. D. "Canaanite Origins and Lineage: Reflections on the Religion of Ancient Israel." In P. D. Miller, Jr., et al., *Ancient Israelite Religion,* 115–24.

———. "Of Cults and Cultures: Reflections on the Interpretation of Archaeological Evidence." *PEQ* 119 (1987): 1–8.

Cook, A. B. *Zeus: A Study in Ancient Religion.* 2 vols. Reprint, New York: Biblio and Tannen, 1964–65.

Cook, S. L. *The Social Roots of Biblical Yahwism.* Leiden: Brill, 2004.

Corbo, V. C. *Herodion.* Vol. 1, *Gli edifici della reggia-fortezza.* Jerusalem: Franciscan Printing, 1989.

Cormack, R. "The Visual Arts." In Cameron, Ward-Perkins, and Whitby, *Cambridge Ancient History* 14:884–917.

Cormack, S. "Funerary Monuments and Mortuary Practice in Roman Asia Minor." In Alcock, *Early Roman Empire in the East,* 137–56.

Cornelius, I. "The Many Faces of God: Divine Images and Symbols in Ancient Near Eastern Religions." In van der Toorn, *Image and the Book,* 21–43.

Coser, L. *The Functions of Social Conflict.* Glencoe: Free Press, 1956.

Cotton, H., ed. *From Hellenism to Islam: Cultural and Linguistic Change in the Roman Near East.* Cambridge, UK: Cambridge University Press, 2009.

Crawford, J. S. *The Byzantine Shops at Sardis.* Cambridge, MA: Harvard University Press, 1990.

———. "Multiculturalism at Sardis." *BAR* 22 (1996): 38–48.

———. "Jews, Christians, and Polytheists in Late-Antique Sardis." In Fine, *Jews, Christians, and Polytheists,* 190–200.

Crawford, S. W., et al., eds. *"Up to the Gates of Ekron": Essays on the Archaeology and History of the Eastern Mediterranean in Honor of Seymour Gitin.* Jerusalem: W. F. Albright Institute of Archaeological Research and Israel Exploration Society, 2007.

Cross, F. M. "Judean Stamps." *EI* 9 (1969): 20–27.

———. *Canaanite Myth and Hebrew Epic: Essays in the History of the Religion of Israel.* Cambridge, MA: Harvard University Press, 1973.

———. "The Hebrew Inscriptions from Sardis." *HTR* 95 (2002): 3–19.

Crowfoot, J. W., and G. M. Crowfoot. *Early Ivories from Samaria.* London: Palestine Exploration Fund, 1938.

Crowfoot, J. W., et al. *The Objects from Samaria.* London: Palestine Exploration Fund, 1957.

Crown, A. D. "The Samaritans in the Byzantine Orbit." *BJRL* 69 (1986): 96–138.

———. "Samaritan Religion in the Fourth Century A.D." *Nederlands Theologisch Tijdschrift* 41 (1987): 29–47.

———. "The Byzantine and Moslem Period." In *The Samaritans,* edited by A. D. Crown, 68–76. Tübingen: Mohr, 1989.

Cumont, F. V. M. *Recherches sur le symbolisme funéraire des romains.* Paris: P. Geuthner, 1942.

———. *The Mysteries of Mithra.* New York: Dover, 1956.

Curran, J. R. *Pagan City and Christian Capital: Rome in the Fourth Century.* Oxford: Clarendon, 2000.

Dacy, M. "'Minim' in Rabbinical Literature." In *Feasts and Fasts: A Festschrift in Honour of Alan David Crown,* edited by M. Dacey, J. Dowling, and S. Faigan, 167–77. Sydney: Mandelbaum, 2005.

Dagron, G., and V. Déroche. "Juifs et chrétiens dans l'Orient du VIIe siècle." *Travaux et Memoires* 11 (1991): 17–273.

Daly, R. J. "The Soteriological Significance of the Sacrifice of Isaac." *CBQ* 39 (1977): 45–75.

Dan, J. ed. *Early Jewish Mysticism.* Jerusalem: Hamakor, 1987. Hebrew.

———. "Armilus: The Jewish Antichrist and the Origins and Dating of the *Sefer Zerubbavel.*" In *Toward the Millennium: Messianic Expectations from the Bible to Waco,* edited by P. Schäfer and M. Cohen, 73–104. Leiden: Brill, 1998.

———. *Jewish Mysticism.* Vol. 1, *Late Antiquity.* Northvale, NJ: Jason Aronson, 1998.

Dan, Y. "The Byzantine Period, 395–640." In *The History of Eretz Israel,* edited by M. D. Herr, vol. 5, 233–374. Jerusalem: Keter and Yad Izhak Ben-Zvi, 1985. Hebrew.

Darmon, J.-P. "Les mosaïques de la synagogue de Hammam Lif: Un réexamen du dossier." In *Fifth International Colloquium on Ancient Mosaics Held at Bath, England, on September 5–12, 1987,* edited by R. Long, 7–29. Ann Arbor: Journal of Roman Archaeology, 1995.

Dauphin, C. "The Development of the 'Inhabited Scroll' in Architectural Sculpture and Mosaic Art from Late Imperial Times to the Seventh Century A.D." *Levant* 19 (1987): 183–205.

———. *La Palestine Byzantine: Peuplement et Populations.* 3 vols. Oxford: Archaeopress, 1998.

Davies, P. R., and B. D. Chilton. "The Aqedah: A Revised Tradition History." *CBQ* 40 (1978): 514–46.

Davila, J. R. "The Perils of Parallels." http://www.st-andrews.ac.uk/divinity/rt/dss/abstracts/parallels/. Accessed November 2011.

Day, J. *Yahweh and the Gods and Goddesses of Canaan.* Sheffield: Sheffield Academic, 2000.

Deleeuw, P. "A Peaceful Pluralism: The Durene Mithraeum, Synagogue, and Christian Building." In L. R. Brody and Hoffman, *Dura Europos: Crossroads of Antiquity,* 189–99.

Dentzer, J.-M., et al. "The Monumental Gateway and Princely Estate of Araq el-Emir." In *The Excavations at 'Araq el-Emir,* edited by N. L. Lapp, 133–48. Cambridge, MA: American Schools of Oriental Research; Winona Lake: Eisenbrauns, 1983.

Der Nersessian, S. "The Illustrations of the Homilies of Gregory of Nazianzus: Paris gr. 510: A Study of the Connection between Text and Images." *DOP* 16 (1962): 195–228.

Deutsch, Y. "New Evidence of Early Versions of *Toldot Yeshu.*" *Tarbiz* 69 (2000): 177–97. Hebrew.

Dever, W. G. "Iron Age Epigraphic Material from the Area of Khirbet el-Kôm." *HUCA* 40–41 (1969–70): 139–204.

———. "Asherah, Consort of Yahweh?: New Evidence from Kuntillet 'Ajrud." *BASOR* 255 (1984): 21–37.

———. "The Contribution of Archaeology to the Study of Canaanite and Early Israelite Religion." In P. D. Miller, Jr., et al., *Ancient Israelite Religion,* 209–47.

———. *Recent Archaeological Discoveries and Biblical Research.* Seattle: University of Washington Press, 1990.

———. "Will the Real Israel Please Stand Up?: Part II: Archaeology and the Religions of Ancient Israel." *BASOR* 298 (1995): 37–58.

———. "Archaeology and the Ancient Israelite Cult: How the Kh. El-Qôm and Kuntillet Ajrûd 'Asherah' Texts Have Changed the Picture." *EI* 26 (1999): 9*–15*.

———. *Did God Have a Wife? Archaeology and Folk Religion in Ancient Israel.* Grand Rapids: Eerdmans, 2005.

Dever, W. G., and S. Gitin, eds. *Symbiosis, Symbolism, and the Power of the Past: Canaan, Ancient Israel, and Their Neighbors from the Late Bronze Age through Roman Palaestina.* Winona Lake: Eisenbrauns, 2003.

Dijkstra, M. "I have Blessed you by YHWH of Samaria and his Asherah: Texts with Religious Elements from the Soil Archive of Ancient Israel." In Becking et al., *Only One God?* 17–44.

Dirksen, P. B. "The Old Testament Peshitta." In Mulder, *Mikra,* 255–97.

Dirven, L. *The Palmyrenes of Dura Europos: A Study of Religious Interaction in Roman Syria.* Leiden: Brill, 1999.

———. "Religious Competition and the Decoration of Sanctuaries: The Case of Dura-Europos." *Eastern Christian Art* 1 (2004): 1–19.

Di Segni, L., "Inscriptions of Tiberias." In Hirschfeld, *Tiberias,* 70–95.

———. "The Involvement of Local, Municipal and Provincial Authorities in Urban Building in Late Antique Palestine and Arabia." In Humphrey, *Roman and Byzantine Near East,* 1:312–32.

———. "Epigraphic Documentation on Building in the Provinces of *Palaestina* and *Arabia,* 4th–7th centuries." In Humphrey, *Roman and Byzantine Near East,* 2:149–78.

———. "Samaritan Revolts in Byzantine Palestine." In E. Stern and H. Eshel, *The Samaritans,* 454–80.

———. "The Greek Inscriptions." In Weiss, *The Sepphoris Synagogue: Deciphering an Ancient Message through Its Archaeological and Socio-Historical Contexts,* 209–16.

———. "Greek Inscriptions in Transiton from the Byzantine Era to the Early Islamic Perod." In Cotton, *From Hellenism to Islam: Cultural and Linguistic Change in the Roman Near East,* 352–373.

Dobbs-Allsopp, F. W., et al., eds. *Hebrew Inscriptions: Texts from the Biblical Period of the Monarchy with Concordance.* New Haven: Yale University Press, 2005.

Doering, L., "Parallels without 'Parallelomania': Methodological Reflections on Comparative Analysis of Halakhah in the Dead Sea Scrolls." In *Rabbinic Perspectives: Rabbinic Literature and the Dead Sea Scrolls: Proceedings of the Eighth International Symposium of the Orion Center for the Study of the Dead Sea Scrolls and Associated Literature, 7–9 January, 2003,* edited by S. D. Fraade, A. Shemesh, and R. A. Clements, 13–42. Leiden: Brill, 2006.

Doeve, J. W., "Official and Popular Religion in Judaism." In *Official and Popular Religion: Analysis of a Theme for Religious Studies,* edited by P. H. Vrijhof and J. Waardenburg, 325–39. The Hague: Mouton, 1979.

Donfried, K. P., and P. Richardson, eds. *Judaism and Christianity in First-Century Rome.* Grand Rapids: Eerdmans, 1998.

Donner, H., and W. Röllig. *Kanaanäische und Aramäische Inschriften.* 3 vols. Wiesbaden: O. Harrassowitz, 1962–64.

Dothan, M. *Hammath Tiberias.* Vol. 1, *Early Synagogues and the Hellenistic and Roman Remains.* Jerusalem: Israel Exploration Society, 1983.

———. *Hammath Tiberias.* Vol. 2, *Late Synagogues.* Jerusalem: Israel Exploration Society, 2000.

Downey, S. B. *Mesopotamian Religious Architecture: Alexander through the Parthians* Princeton: Princeton University Press, 1988.

———. "The Transformation of Seleucid Dura Europos." In *Romanization and the City: Creation, Transformations and Failures,* edited by E. Fentress, 154–72. Portsmouth, RI: Journal of Roman Archaeology, 2000.

Drake, H. A. "Lambs into Lions: Explaining Early Christian Intolerance." *Past and Present* 153 (1996): 3–36.

———. "Models of Christian Expansion." In *The Spread of Christianity in the First Four Centuries: Essays in Explanation,* edited by W. V. Harris, 1–13. Leiden: Brill, 2005.

———. "Afterword and Conclusion: Socrates' Question." In *Religious Identity in Late Antiquity,* edited by R. M. Frakes and E. DePalma Digeser, 228–41. Toronto: Edgar Kent, 2006.

———, ed. *Violence in Late Antiquity: Perceptions and Practices.* Aldershot: Ashgate, 2006.

———. "Introduction: Gauging Violence in Late Antiquity." In Drake, *Violence in Late Antiquity,* 1–11.

———. "Solar Power in Late Antiquity." In *The Power of Religion in Late Antiquity,* edited by A. Cain and N. Lenski, 215–26. Farnham, UK: Ashgate, 2009.

Drijvers, H. J. W. "Jews and Christians at Edessa." *JJS* 36 (1985): 88–102.

————. "Syrian Christianity and Judaism." In Lieu et al., *Jews among Pagans and Christians*, 124–46.

Dulaey, M. "Le chandelier à sept branches dans le christianisme ancien." *Revue d'etudes augustiniennes et patristiques* 29 (1983): 3–26.

Du Mesnil du Buisson, R. "Un parchemin liturgique juif et la gargote de la synagogue à Doura-Europos." *Syria* 20 (1939): 23–34.

————. *Les peintures de la synagogue de Doura-Europos, 245–256 après J.-C.* Rome: Pontificio Istituto Biblico, 1939.

Dunbabin, K. M. D. *Mosaics of Roman North Africa: Studies in Iconography and Patronage.* Oxford: Clarendon, 1978.

————. *Mosaics of the Greek and Roman World.* Cambridge, UK: Cambridge University Press, 1999.

Dvorjetski, E., "The Theatre in Rabbinic Literature." In *Aspects of Theatre and Culture in the Graeco-Roman World*, edited by A. Segal, 51–68. Haifa: University of Haifa, 1994. Hebrew.

————. "Relations between Jews and Gentiles in the Thermal Baths of Eretz Israel in the Mishnaic and Talmudic Eras." In *Jews and Gentiles in Eretz-Israel in the Second Temple, Mishnaic and Talmudic Periods*, edited by M. Mor et al., 9–39. Jerusalem: Yad Izhak Ben-Zvi, 2003. Hebrew.

————. "The Synagogue-Church at Gerasa in Jordan: A Contribution to the Study of Ancient Synagogues." *ZDPV* 121 (2005): 140–67.

————. *Leisure, Pleasure and Healing: Spa Culture and Medicine in Ancient Eastern Mediterranean.* Leiden: Brill, 2007.

Edelman, D. V. ed. *The Triumph of Elohim: From Yahwisms to Judaisms.* Kampen: Pharos, 1995.

————. "Tracking Observance of the Aniconic Tradition through Numismatics." In Edelman, *Triumph of Elohim*, 185–225.

Edrei, A., and D. Mendels. "A Split Jewish Diaspora: Its Dramatic Consequences." *Journal for the Study of the Pseudepigrapha* 16 (2007): 91–137; 17 (2008): 163–87.

Edwards, C., and G. Woolf. *Rome the Cosmopolis.* Cambridge, UK: Cambridge University Press, 2003.

————. "Cosmopolis: Rome as World City." In C. Edwards and Woolf, *Rome the Cosmopolis*, 1–20.

Edwards, D. R., and C. T. McCollough, eds. *Archaeology and the Galilee: Texts and Contexts in the Greco-Roman and Byzantine Periods.* Atlanta: Scholars, 1997.

————, eds. *Archaeology of Difference — Gender, Ethnicity, Class and the "Other" in Antiquity: Studies in Honor of Eric M. Meyers.* Boston: American Schools of Oriental Research, 2007.

Edwards, J. R. "A *Nomen Sacrum* in the Sardis Synagogue." *JBL* 128 (2009): 813–21.

Edwell, P. M. *Between Rome and Persia: The Middle Euphrates, Mesopotamia and Palmyra under Roman Control.* London: Routledge, 2008.

Ehrenkrook, J. von. *Sculpting Idolatry in Flavian Rome: (An)iconic Rhetoric in the Writings of Flavius Josephus.* Atlanta: Society of Biblical Literature, 2011.

Elbogen, I. *Jewish Liturgy: A Comprehensive History.* Philadelphia: Jewish Publication Society, 1993.

Eliav, Y. Z. "Did the Jews at First Abstain from Using the Roman Bath-House?" *Cathedra* 75 (1995): 3–35. Hebrew.

————. *Sites, Institutions and Daily Life in Tiberias during the Talmudic Period.* Tiberias: Center for the Study of Tiberias, 1995. Hebrew.

————. "The Roman Bath as a Jewish Institution: Another Look at the Encounter between Judaism and the Greco-Roman Culture." *JSJ* 31 (2000): 416–54.

————. "Viewing the Sculptural Environment: Shaping the Second Commandment." In Schäfer, *Talmud Yerushalmi and Graeco-Roman Culture*, 3:411–33.

———. "Bathhouses as Places of Social and Cultural Interaction." In Hezser, *Oxford Handbook of Jewish Daily Life*, 605–22.

Eliav, Y. Z., et al., eds. *Sculptural Environment of the Roman Near East: Reflections on Culture, Ideology, and Power*. Leuven and Dudley, MA: Peeters, 2008.

Elior, R. "From Earthly Temple to Heavenly Shrines: Prayer and Sacred Song in the Hekhalot Literature and Its Relation to Temple Traditions." *JSQ* 4 (1997): 217–67.

———. "The *Merkavah* Tradition and the Emergence of Jewish Mysticism: From Temple to *Merkavah*, from *Hekhal* to *Hekhalot*, from Priestly Opposition to Gazing upon the *Merkavah*." In *Sino-Judaica: Jews and Chinese in Historical Dialogue*, edited by A. Oppenheimer, 101–58. Tel Aviv: Tel Aviv University Press, 1999.

———. "*Hekhalot* and *Merkavah* Literature: Its Relation to the Temple, the Heavenly Temple, and the 'Diminished' Temple.'" In L. I. Levine, *Continuity and Renewal*, 107–42. Hebrew.

———. *The Three Temples: On the Emergence of Jewish Mysticism*. Oxford: Littman Library of Jewish Civilization, 2004.

———. "Early Forms of Jewish Mysticism." In Katz, *Late Roman-Rabbinic Period*, 749–91.

Elsner, J. *Art and the Roman Viewer: The Transformation of Art from the Pagan World to Christianity*. Cambridge, UK: Cambridge University Press, 1995.

———. "The Origins of the Icon: Pilgrimage, Religion, and Visual Culture in the Roman East as 'Resistance' to the Centre." In Alcock, *Early Roman Empire in the East*, 184–91.

———. *Imperial Rome and Christian Triumph: The Art of the Roman Empire, AD 100–450*. Oxford: Oxford University Press, 1998.

———. "From the Culture of *Spolia* to the Cult of Relics: The Arch of Constantine and the Genesis of Late Antique Forms." *PBSR* 68 (2000): 149–84.

———. "Cultural Resistance and the Visual Image: The Case of Dura Europos." *Classical Philology* 96 (2001): 269–304.

———. "Archaeologies and Agendas: Reflections on Late Ancient Jewish Art and Early Christian Art." *JRS* 93 (2003): 114–28.

———. "Inventing Christian Rome: The Role of Early Christian Art." In C. Edwards and Woolf, *Rome the Cosmopolis*, 71–99.

Engemann, J. "Bemerkungen zu römischen Gläsern mit Goldfoliendekor." *JAC* 11–12 (1968–69): 7–25.

Englard, Y. "The Eschatological Significance of the Zodiac Panels in the Mosaic Pavements of Ancient Synagogues in Israel." *Cathedra* 98 (2000): 33–48. Hebrew.

———. "Mosaics as Midrash: The Zodiacs of the Ancient Synagogues and the Conflict between Judaism and Christianity." *Review of Rabbinic Judaism* 6 (2003): 189–214.

Eph'al, I. "Changes in Palestine during the Persian Period in Light of Epigraphic Sources." *IEJ* 48 (1998): 106–19.

Epstein, J. N. "Yerushalmi Fragments." *Tarbiz* 3 (1932): 15–26. Hebrew.

Erlich, A. *The Art of Hellenistic Palestine*. Oxford: Archaeopress, 2009.

Errington, R. M. *Roman Imperial Policy from Julian to Theodosius*. Chapel Hill: University of North Carolina Press, 2006.

Eshel, H. "Review of B. Nitzan, *Qumran Prayer and Religious Poetry*." *AJS Review* 21 (1996): 389–92.

———. "A Note on 'Miqvaot' at Sepphoris." In D. R. Edwards and McCollough, *Archaeology and the Galilee*, 131–33.

———. "The Bar Kochba Revolt, 132–135." In Katz, *Late Roman-Rabbinic Period*, 105–27.

Eshel, H., and E. M. Meyers. "The Pools of Sepphoris: Ritual Baths or Bathtubs?" *BAR* 26, no. 4 (2000): 42–49, 60–61.

Eshel, Y. et al., eds. *And Let Them Make Me a Sanctuary: Synagogues from Ancient Times to the Present Day*. Ariel: College of Judea and Samaria, 2004. Hebrew.

Fasola, U. M. "Le due catacombe ebraiche di Villa Torlonia." *RAC* 52 (1976): 7–62.

———. "Un tardo cimitero christiano inserito in una necropoli pagana della via Appia: L'area 'sub divo': La catacomba." *RAC* 60 (1984): 7–42.

Fears, J. R. "The Theology of Victory at Rome: Approaches and Problems." *ANRW* II.17.2 (1981): 736–826.

Fedak, J. *Monumental Tombs of the Hellenistic Age: A Study of Selected Tombs from the Pre-Classical to the Early Imperial Era.* Toronto: University of Toronto Press, 1990.

Fedalto, G. *Hierarchia ecclesiastica orientalis.* 2 vols. Padua, Italy: Messaggero, 1988.

Feldman, L. H., trans. *Josephus,* vol. 9. Cambridge, MA: Harvard University Press, 1965.

———. *Jew and Gentile in the Ancient World: Attitudes and Interactions from Alexander to Justinian.* Princeton: Princeton University Press, 1993.

———. "Diaspora Synagogues: New Light from Inscriptions and Papyri." In Fine, *Sacred Realm,* 48–66.

Fernández, R. Ramos, *La ciudad romana de Ilici: estudio arqueológico.* Alicante: Instituto de Estudios Alicantinos, 1975.

Ferrari, G., and C. R. Mordy, eds. *The Gold-Glass Collection of the Vatican Library.* Rome: Biblioteca Apostolica Vaticana, 1959.

Ferrua, A. *The Unknown Catacomb: A Unique Discovery of Early Christian Art.* New Lanark, Scotland: Geddes & Grosset, 1991.

Figueras, P. *Decorated Jewish Ossuaries.* Leiden: Brill, 1983.

———. "Epigraphic Evidence for Proselytism in Ancient Judaism." *Immanuel* 24–25 (1990): 194–206.

Filipowski, H., ed. *Sefer Ha-'Ibbur,* vol. 3. London: Longman, Brown, Green, and Longman, 1851.

———, ed. *Abraham ben. Samuel Zacuto, Sefer Yuḥasin (Liber Juchassin).* London: Me'orerei Yeshenim, 1857.

Fine, S., ed. *Sacred Realm: The Emergence of the Synagogue in the Ancient World.* New York: Oxford University Press, 1996.

———. *This Holy Place: On the Sanctity of Synagogues during the Greco-Roman Period.* Notre Dame: University of Notre Dame Press, 1997.

———. "Art and the Liturgical Context of the Sepphoris Synagogue Mosaic." In E. M. Meyers et al., *Galilee through the Centuries,* 227–37.

———, ed. *Jews, Christians, and Polytheists in the Ancient SynagogueCultural: Interaction in the Greco-Roman Period.* London: Routledge, 1999.

———. "Iconoclasm and the Art of Late-Antique Palestinian Synagogues." In L. I. Levine and Weiss, *From Dura to Sepphoris,* 183–94.

———. *Art and Identity in Latter Second Temple Judaea: The Hasmonean Royal Tombs at Modi'in, The Twenty-fourth Annual Rabbi Louis Feinberg Memorial Lecture in Judaic Studies—May 19, 2001.* Cincinnati: Dept. of Judaic Studies, University of Cincinnati, 2002.

———. *Art and Judaism in the Greco-Roman World: Toward a New Jewish Archaeology.* Cambridge, UK: Cambridge University Press, 2005.

———. "Liturgy and the Art of the Dura Europos Synagogue." In Langer and Fine, *Liturgy in the Life of the Synagogue,* 41–71.

———. "Between Liturgy and Social History: Priestly Power in Late Antique Palestinian Synagogues?" *JJS* 56 (2005): 1–9.

———. "Jewish Identity at the *Limus:* the Earliest Reception of the Dura Europos Synagogue Paintings." In *Cultural Identity in the Ancient Mediterranean,* edited by E. Gruen, 303–20. Los Angeles: Getty Research Institute, 2011.

Fine, S., and B. Zuckerman. "The Menorah as a Symbol of Jewish Minority Status." In *Fusion in the Hellenistic East,* edited by S. Fine, 24–30. Los Angeles: University of Southern California/Fisher Gallery, 1985.

Finkelstein, I. *The Archaeology of the Israelite Settlement.* Jerusalem: Israel Exploration Society, 1988.

———. "State Formation in Israel and Judah: A Contrast in Context, a Contrast in Trajectory." *NEA* 62 (1999): 35–52.

Finkelstein, I., and N. A. Silberman. *The Bible Unearthed: Archaeology's New Vision of Ancient Israel and the Origin of Its Sacred Texts.* New York: Free Press, 2001.

Finkelstein, L. "The Birkat Ha-Mazon." *JQR* 19 (1929): 211–62.

———, ed. *Sifre Deuteronomy.* New York: Jewish Theological Seminary, 1969. Hebrew.

Finney, P. C. *The Invisible God: The Earliest Christians on Art.* New York: Oxford University Press, 1994.

———. "Art." In *Encyclopedia of Early Christianity,* edited by E. Ferguson, 120–26. 2nd ed. New York: Garland, 1998.

Fittschen, K. "Wall Decorations in Herod's Kingdom: Their Relationship with Wall Decorations in Greece and Italy." In Fittschen and Foerster, *Judaea and the Greco-Roman World,* 139–61.

Fittschen, K., and G. Foerster, eds. *Judaea and the Greco-Roman World in the Time of Herod in the Light of Archaeological Evidence.* Göttingen: Vandenhoeck & Ruprecht, 1996.

Fitzmyer, J. A., and D. J. Harrington. *A Manual of Palestinian Aramaic Texts: Second Century B.C.-Second Century A.D.* Rome: Biblical Institute, 1978.

Fleischer, E. "Early Paytanim of Tiberias." In Avissar, *Sefer Teveria,* 368–71.

———. *The Pizmonim of the Anonymous.* Jerusalem: Israel Academy of Sciences and Humanities, 1974. Hebrew.

———. "Early Hebrew Liturgical Poetry in Its Cultural Setting (Comparative Experiments)." In *Moises Starosta Memorial Lectures: First Series,* edited by J. Geiger, 63–97. Jerusalem: Hebrew University, 1993. Hebrew.

Flesher, P. V. M. "Rereading the Reredos: David, Orpheus, and Messianism in the Dura Europos Synagogue." In Urman and Flesher, *Ancient Synagogues,* 2:346–66.

———. "Conflict or Co-operation? Non-Jews in the Dura Synagogue Paintings." In *Hellenic and Jewish Arts: Interaction, Tradition and Renewal,* edited by A. Ovadiah, 199–221. Tel Aviv: Tel Aviv University Press, 1998

———. "The Literary Legacy of the Priests? The Pentateuchal Targums of Israel and Their Social and Linguistic Context." In *The Ancient Synagogue: From Its Origins until 200 C.E., Papers Presented at an International Conference at Lund University, October 14–17, 2001,* edited by B. Olsson and M. Zetterholm, 467–508. Stockholm: Almqvist & Wiksell International, 2003.

Foerster, G. "Architectural Fragments from 'Jason's Tomb' Reconsidered." *IEJ* 28 (1978): 152–56.

———. "Synagogue Inscriptions and Their Relation to Liturgical Versions." *Cathedra* 19 (1981): 33–40. Hebrew.

———. "A Survey of Ancient Diaspora Synagogues." In L. I. Levine, *Ancient Synagogues Revealed,* 164–71.

———. "Representations of the Zodiac in Ancient Synagogues and Their Iconographic Sources." *EI* 18 (1985): 380–91. Hebrew.

———. "The Art and Architecture of the Synagogue in Its Late Roman Setting." In L. I. Levine, *Synagogue in Late Antiquity,* 139–46.

———. "The Zodiac in Ancient Synagogues and Its Place in Jewish Thought and Literature." *EI* 19 (1987): 225–34. Hebrew.

———. "Decorated Marble Chancel Screens in Sixth Century Synagogues in Palestine and Their Relation to Christian Art and Architecture." In *Actes du XIe congrès international d'archéologie chrétienne,* 1809–20. Rome: Ecole Française de Rome, 1989.

———. "Allegorical and Symbolic Motifs with Christian Significance from Mosaic Pave-

ments of Sixth-Century Palestinian Synagogues." In *Christian Archaeology in the Holy Land: New Discoveries: Essays in Honour of Virgilio C. Corbo, OFM*, edited by G. T. Bottini, L. Di Segni, and E. Alliata, 545–52. Jerusalem: Franciscan Printing, 1990.

———. "The Ancient Synagogues of the Galilee." L. I. Levine, *Galilee in Late Antiquity*, 289–319.

———. "Beth-Shean." In E. Stern, *NEAEHL*, 1:223–35.

———. "Dating Synagogues with a 'Basilical' Plan and an Apse." In Urman and Flesher, *Ancient Synagogues*, 1:87–94.

———. "Has There Indeed Been a Revolution in the Dating of Galilean Synagogues?" In L. I. Levine, *Continuity and Renewal*, 526–29. Hebrew.

Fonrobert, C. E. *Menstrual Purity: Rabbinic and Christian Reconstructions of Biblical Gender.* Stanford: Stanford University Press, 2000.

———. "Jewish Christians, Judaizers, and Anti-Judaism." In Burrus, *Late Ancient Christianity*, 234–54.

———. "Regulating the Human Body: Rabbinic Legal Discourse and the Making of Jewish Gender." In Fonrobert and Jaffee, *Cambridge Companion to the Talmud and Rabbinic Literature*, 270–94.

Fonrobert, C. E., and M. S. Jaffee, eds. *The Cambridge Companion to the Talmud and Rabbinic Literature.* Cambridge, UK: Cambridge University Press, 2007.

Fontanille, J.-P., and D. T. Ariel. "The Large Dated Coin of Herod the Great: The First Die Series." *INR* 1 (2006): 73–86.

Foss, C. "The Persians in Asia Minor and the End of Antiquity." *The English Historical Review* 90 (1975): 721–47.

———. "Syria in Transition, A.D. 550–750: An Archaeological Approach." *DOP* 51 (1997): 189–269.

Fowden, G. "The Pagan Holy Man in Late Antique Society." *Journal of Hellenic Studies* 102 (1982): 33–59.

Fraade, S. D. *From Tradition to Commentary: Torah and Its Interpretation in the Midrash Sifre to Deuteronomy.* Albany: State University of New York Press, 1991.

———. "Rabbinic Views on the Practice of Targum, and Multilingualism in the Jewish Galilee of the Third-Sixth Centuries." In L. I. Levine, *Galilee in Late Antiquity*, 253–86.

———. "Moses and the Commandments: Can Hermeneutics, History, and Rhetoric be Disentangled?" In *The Idea of Biblical Interpretation: Essays in Honor of James L. Kugel*, edited by H. Najman and J. H. Newman, 399–422. Leiden: Brill, 2004.

———. "Rabbinic Polysemy and Pluralism Revisited: Between Praxis and Thematization." *AJS Review* 31 (2007): 1–40.

———. "The Temple as a Marker of Jewish Identity Before and After 70 CE: The Role of the Holy Vessels in Rabbinic Memory and Imagination." In L. I. Levine and D. R. Schwartz, *Jewish Identities in Antiquity*, 237–65.

Frankfurter, D. *Religion in Roman Egypt: Assimilation and Resistance.* Princeton: Princeton University Press, 1998.

Frankfurter, D. "Beyond Magic and Superstition." In Burrus, *Late Ancient Christianity*, 266–83.

Fredriksen, P. "What 'Parting of the Ways'?" In Becker and Reed, *Ways That Never Parted*, 35–63.

———. *Augustine and the Jews: A Christian Defense of Jews and Judaism.* New York: Doubleday, 2008.

Fredriksen, P., and O. Irshai. "Christian Anti-Judaism: Polemics and Policies." In Katz, *Late Roman-Rabbinic Period*, 977–1034.

Freedman, D. N. "Yahweh of Samaria and His Asherah." *BA* 50 (1987): 241–49.

———, ed. *The Anchor Bible Dictionary.* 6 vols. New York: Doubleday, 1992.

Freund, R. A. "The Incense Shovel of Bethsaida and Synagogue Iconography in Late Antiquity." In *Bethsaida: A City by the North Shore of the Sea of Galilee*, edited by R. Arav and R. A. Freund, 2:413–57. Kirksville, MS: Truman State University Press, 1999.

Frey, J.-B. "Les communautés juives à Rome aux premiers temps de l'église." *Recherches de science religieuse* 20 (1930): 269–97; 21 (1931): 129–68.

———. *Corpus Inscriptionum Judaicarum*. 2 vols. Rome: Pontificio Istituto di Archeologia Cristiana, 1936–52. Reprint, vol. 2, New York: KTAV, 1975.

Frick, F. S. *The Iron Age Cultic Structure*. Vol. 4, pt. 2, *Tell Taannek, 1963-1968*. Birzeit: Palestinian Institute of Archaeology, 2000.

Friedenberg, D. M. *Sasanian Jewry and Its Culture: A Lexicon of Jewish and Related Seals*. Urbana: University of Illinois Press, 2009.

Friedheim, E. "Rabban Gamaliel and the Bathhouse of Aphrodite in Akko: A Study of Eretz-Israel Realia in the 2nd and 3rd Centuries CE." *Cathedra* 105 (2002): 7–32. Hebrew.

———. "Sol Invictus in the Severus Synagogue at Hammat Tiberias, the Rabbis, and Jewish Society: A Different Approach." *Review of Rabbinic Judaism* 12 (2009): 89–128.

Friedman, M. "Pagan Images in Jewish Art." *JA* 19–20 (1993–94): 124–47.

———. "More on the Mosaic Floor in Beth Alpha and Other Synagogues." Lecture delivered at the Twelfth World Congress of Jewish Studies, 1997.

———. "The Meaning of the Zodiac in Synagogues in the Land of Israel during the Byzantine Period." *Ars Judaica* 1 (2005): 51–62.

Friedman, S. "A Critical Study of *Yevamot* X with a Methodological Introduction." In *Texts and Studies: Analecta Judaica*, edited by H. Z. Dimitrovsky, 1:275–441. New York: Jewish Theological Seminary, 1977. Hebrew.

———. "Literary Developments and Historicity in the Aggadic Narrative of the Babylonian Talmud: A Study Based upon B.M. 83–86a." In *Community and Culture: Essays in Jewish Studies in Honor of the Ninetieth Anniversary of the Founding of Gratz College, 1895-1985*, edited by N. M. Waldman, 67–81. Philadelphia: Gratz College and Seth Press, 1987.

———. "On the Historical Aggadah in the Babylonian Talmud." In *Saul Lieberman Memorial Volume*, edited by S. Friedman, 119–64. New York: Jewish Theological Seminary, 1993. Hebrew.

Fritz, V., and P. R. Davies, eds. *The Origins of the Ancient Israelite States*. Sheffield: Sheffield Academic, 1996.

Gadd, C. J. "Inscribed Prisms of Sargon II from Nimrud." *Iraq* 16 (1954): 173–201.

Gaddis, M. *There Is No Crime for Those Who Have Christ: Religious Violence in the Christian Roman Empire*. Berkeley: University of California Press, 2005.

Gafni, I. M. *The Jews of Babylonia in the Talmudic Era: A Social and Cultural History*. Jerusalem: Zalman Shazar Center for Jewish History, 1990. Hebrew.

———. "Babylonian Rabbinic Culture." In Biale, *Cultures of the Jews*, 223–65.

Gager, J. *Moses in Greco-Roman Paganism*. Nashville: Abingdon, 1972.

———. *The Origins of Anti-Semitism: Attitudes toward Judaism in Pagan and Christian Antiquity*. New York: Oxford University Press, 1983.

———. "Jews, Christians and the Dangerous Ones in Between." In *Interpretation in Religion*, edited by S. Biderman and B. Scharfstein, 249–57. Leiden: Brill, 1992.

Galling, K. "Beschriftete Bildsiegel des ersten Jahrtausends v. Chr. vornehmlich aus Syrien und Palästina: Ein Beitrag zur Geschichte der phönizischen Kunst." *ZDPV* 64 (1941): 121–202.

Galor, K. "The Stepped Water Installations of the Sepphoris Acropolis." In D. R. Edwards and McCollough, *Archaeology of Difference*, 201–13.

Gardner, G. "Astrology in the Talmud: An Analysis of Bavli Shabbat 156." In Iricinschi and Zellentin, *Heresy and Identity*, 313–38.

Garr, W. R. *In His Own Image and Likeness: Humanity, Divinity, and Monotheism*. Leiden: Brill, 2003.

Garte, E. "The Theme of Resurrection in the Dura-Europos Synagogue Paintings." *JQR* 64 (1973): 1–15.

Gaster, M. *The Samaritans: Their History, Doctrines, and Literature*. London: H. Milford, Oxford University Press, 1925.

Gates, M.-H. "Dura-Europos: A Fortress of Syro-Mesopotamian Art." *BA* 47 (1984): 166–81.

Gavin, F. S. B. *Aphraates and the Jews: A Study of the Controversial Homilies of the Persian Sage in Their Relation to Jewish Thought*. Toronto: Journal of the Society of Oriental Research, 1923.

Geiger, J. "Athens in Syria: Greek Intellectuals of Gadara." *Cathedra* 35 (1985): 3–16. Hebrew.

———. "Local Patriotism in the Hellenistic Cities of Palestine." In Kasher, Fuchs, and Rappaport, *Greece and Rome in Eretz Israel*, 141–50. Hebrew.

———. "Greek Intellectuals of Ascalon." *Cathedra* 60 (1991): 5–16. Hebrew.

———. "Notes on the Second Sophistic in Palestine." *Illinois Classical Studies* 19 (1994): 221–30.

———. "Sophists and Rabbis: Jews and their Past in the Severan Age." In Swain et al., *Severan Culture*, 440–48.

Geller, M. J. "Deconstructing Talmudic Magic." In *Magic and the Classical Tradition*, edited by C. Burnett and W. F. Ryan, 1–18. London: Warburg Institute, 2006.

Geller, S. A. "Fiery Wisdom: Logos and Lexis in Deuteronomy 4." *Prooftexts* 14 (1994): 103–39.

Geva, H., ed. *Ancient Jerusalem Revealed*. Jerusalem: Israel Exploration Society, 1994.

———, ed. *Jewish Quarter Excavations in the Old City of Jerusalem, Conducted by Nahman Avigad, 1969–1982*. Vol. 1, *Architecture, Stratigraphy, Areas A, W, and X-2: Final Report*. Jerusalem: Israel Exploration Society, 2000. Vol. 2, *The Finds from Areas A, W, X-2: Final Report*. Jerusalem: Israel Exploration Society, 2003.

Geva, H., and N. Avigad. "Jerusalem—Tombs." In E. Stern, *NEAEHL*, 2:747–57.

Geva, H., and R. Rosenthal-Heginbottom. "Local Pottery from Area A." In Geva, *Jewish Quarter Excavations*, 2:176–91.

Gibbon, E. *The History of the Decline and Fall of the Roman Empire*. 6 vols. London: Dent, 1962–66.

Gibson, E. L. "Jewish Antagonism or Christian Polemic: The Case of the Martyrdom of Pionius." *JECS* (2001): 339–58.

———. "The Jews and Christians in the *Martyrdom of Polycarp*: Entangled or Parted Ways?" In Becker and Reed, *Ways That Never Parted*, 145–58.

Gilbert, G. "Jews in Imperial Administration and Its Significance for Dating the Jewish Donor Inscriptions from Aphrodisias." *JSJ* 35 (2004): 169–84.

Gilbert-Peretz, D. "Ceramic Figurines." In *Excavations at the City of David, 1978–1985, Directed by Yigal Shiloh*, edited by D. T. Ariel and A. De Groot, 4:29–41. Jerusalem: Institute of Archaeology, Hebrew University, 1996.

Gilula, M. "To Yahweh Shomron and His Asherah." *Shnaton* 3 (1978): 129–37. Hebrew.

Ginzberg, L. *A Commentary on the Palestinian Talmud*. 4 vols. New York: Jewish Theological Seminary, 1941–61. Hebrew.

Gitler, H., and O. Tal. *The Coinage of Philistia of the Fifth and Fourth Centuries BC: A Study of the Earliest Coins of Palestine*. Milan: Ennerre; New York: Amphora, 2006.

Gleadow, R. *The Origin of the Zodiac*. New York: Atheneum, 1969.

Glock, A. E. "Taanach." In E. Stern, *NEAEHL*, 4:1428–33.

Glueck, N. "The Zodiac of Khirbet Et-Tannûr." *BASOR* 126 (1952): 5–10.

Goffman, K., and D. Joy. *Counterculture through the Ages: From Abraham to Acid House*. New York: Villard, 2004.

Goldman, B. M. *The Sacred Portal: A Primary Symbol in Ancient Judaic Art*. Detroit: Wayne State University Press, 1966.

Goldman, N. "Roman Footwear." In *The World of Roman Costume*, edited by J. L. Sebesta and L. Bonfante, 101–29. Madison: University of Wisconsin Press, 1994.

Goldstein, I., and J.-P. Fontanille. "A New Study of the Coins of the First Jewish Revolt against Rome, 66–70 C.E.: Minting Authorities, Processes and Output." *ANA Journal: Advanced Studies in Numismatics* 1, no. 2 (2006): 9–32.

Goldstein, J. A. "The Judaism of the Synagogues (Focusing on the Synagogue of Dura Europos)." In Neusner, *Judaism in Late Antiquity*, pt. 2, 109–57.

Goodblatt, D. *Rabbinic Instruction in Sasanian Babylonia.* Leiden: Brill, 1975.

———. "The Babylonian Talmud." *ANRW* II.19.2 (1979): 257–336.

———. "The Title 'Nasi' and the Ideological Background of the Second Revolt." In Oppenheimer and Rappaport, *Bar-Kokhva Revolt*, 113–32.

———. *The Monarchic Principle: Studies in Jewish Self-Government in Antiquity.* Tübingen: Mohr Siebeck, 1994.

———. "Priestly Ideologies of the Judean Resistance." *JSQ* 3, no. 3 (1996): 225–49.

———. "Patriarchs, Romans and (Modern) Scholars: A Response to Seth Schwartz." *JJS* 51 (2000): 313–18.

———. *Elements of Ancient Jewish Nationalism.* New York: Cambridge University Press, 2006.

———. "The History of the Babylonian Academies." In Katz, *Late Roman–Rabbinic Period*, 821–39.

———. "The Jews in Babylonia, 66–c. 235 ce." In Katz, *Late Roman–Rabbinic Period*, 82–90.

———. "The Political and Social History of the Jewish Community in the Land of Israel, c. 235–638." In Katz, *Late Roman–Rabbinic Period*, 404–30.

Goodenough, E. R. *Jewish Symbols in the Greco-Roman Period.* 13 vols. New York: Pantheon, 1953–68.

———. "The Rabbis and Jewish Art in the Greco-Roman Period." *HUCA* 32 (1961): 269–79.

———. "Catacomb Art." *JBL* 81 (1962): 113–42.

———. *An Introduction to Philo Judaeus.* Oxford: Blackwell, 1962.

Goodman, M. *State and Society in Roman Galilee, A.D. 132–212.* Totowa, NJ: Rowman & Allenheld, 1983.

———. "The Roman State and the Jewish Patriarch in the Third Century." In L. I. Levine, *Galilee in Late Antiquity*, 127–39.

———. "Jews and Judaism in the Mediterranean Diaspora in the Late Roman Period: The Limitations of Evidence." *Journal of Mediterranean Studies* 4 (1994): 208–24.

———. "The Roman Identity of Roman Jews." In *The Jews in the Hellenistic-Roman Worlds: Studies in Memory of Menahem Stern*, edited by I. M. Gafni, A. Oppenheimer, and D. R. Schwartz, 85*–99*. Jerusalem: Zalman Shazar Center for Jewish History, 1996.

———. "Sacred Space in Diaspora Judaism." In Isaac and Oppenheimer, *Studies on the Jewish Diaspora*, 1–16.

———, ed. *Jews in a Graeco-Roman World.* Oxford: Clarendon, 1998.

———. "Palestinian Rabbis and the Conversion of Constantine to Christianity." In *The Talmud Yerushalmi and Graeco-Roman Culture*, edited by P. Schäfer and C. Hezser, 2:1–9. Tübingen: Mohr Siebeck, 2000.

———. "The Jewish Image of God in Late Antiquity." In Kalmin and S. Schwartz, *Jewish Culture and Society*, 133–45.

———. "Coinage and Identity: The Jewish Evidence." In *Coinage and Identity in the Roman Provinces*, edited by C. Howgego et al., 163–66. Oxford: Oxford University Press, 2005.

———. "The Function of *Minim* in Early Rabbinic Judaism." In *Judaism in the Roman World: Collected Essays,* edited by M. Goodman, 163–173. Leiden: Brill, 2007.

———. *Rome and Jerusalem: The Clash of Ancient Civilizations.* New York: Knopf, 2007.

Goodman, M. and P. Alexander, eds. *Rabbinic Texts and the History of Late-Roman Palestine.* Oxford: Oxford University Press, 2010.

Goranson, S. "The Battle Over the Holy Day at Dura-Europos." *Bible Review* 12 (1996): 22–33, 44.

———. "Joseph of Tiberias Revisited; Orthodoxies and Heresies in Fourth-Century Galilee." In E. M. Meyers et al., *Galilee through the Centuries*, 335–43.

Gordon, R. L. "Mithraism and Roman Society: Social Factors in the Explanation of Religious Change in the Roman Empire." *Religion* 2 (1972): 92–121.

Goshen-Gottstein, A. "The Body as Image of God in Rabbinic Literature." *HTR* 87 (1994): 171–95.

———. "Jewish-Christian Relations and Rabbinic Literature—Shifting Scholarly and Relational Paradigms: The Case of Two Powers." In *Interaction between Judaism and Christianity in History, Religion, Art and Literature*, edited by M. Poorthius et al., 15–43. Leiden: Brill, 2009.

Gough, M. *The Origins of Christian Art*. London: Thames and Hudson, 1973.

Govrin, Y. "Sarcophagus-Shaped Ossuaries from South Mount Hebron ('Droma')." *Judea and Samaria Research Studies* 6 (1996): 203–16. Hebrew.

Grabar, A. "La thème religieux des fresques de la synagogue de Doura." *Revue de l'histoire des religions* 123 (1941): 143–92; 124 (1941): 5–35.

———. *L'iconoclasme byzantin: dossier archéologique*. Paris: Collège de France, 1957.

———. *Ampoules de Terre Sainte (Monza, Bobbio)*. Paris: C. Klincksieck, 1958.

———. *The Beginnings of Christian Art, 200–395*. London: Thames and Hudson, 1967.

———. *Christian Iconography: A Study of Its Origins*. Princeton: Princeton University Press, 1968.

———. "Images bibliques d'Apamée et fresques de la synagogue de Doura." In Gutmann, *No Graven Images*, 114–19.

Graesser, C. F. "Standing Stones in Ancient Palestine." *BA* 35 (1972): 34–63.

Graetz, H. *Geschichte der Juden von den ältesten Zeiten bis auf die Gegenwart*. Vol. 4. Leipzig: O. Leiner, 1908.

———. *History of the Jews*. Vol. 2. Philadelphia: Jewish Publication Society, 1956.

Grant, M. *Herod the Great*. London: Weidenfeld and Nicolson, 1971.

Gray, A. M. "The Power Conferred by Distance from Power: Redaction and Meaning in b. A.Z. 10a–11a." In Rubenstein, *Creation and Composition*, 23–69.

Gray, P. T. R. "Palestine and Justinian's Legislation on Non-Christians." In *Law, Politics and Society in the Ancient Mediterranean World*, edited by B. Halpern and D. W. Hobson, 241–70. Sheffield: Sheffield Academic, 1993.

———. "The Legacy of Chalcedon: Christological Problems and Their Significance." In Maas, *Cambridge Companion to the Age of Justinian*, 13:215–38.

Grayzel, S. "The Jews and Roman Law." *JQR* 59 (1968–69): 93–117.

Green, B. *Christianity in Ancient Rome: The First Three Centuries*. London: T & T Clark, 2010.

Green, W. S. "What's in a Name? The Problem of Rabbinic 'Biography.'" In *Approaches to Ancient Judaism: Theory and Practice*, edited by W. S. Green, 1:77–96. Missoula: Scholars, 1978.

Greenberg, M. *Ezekiel 1–20: A New Translation with Introduction and Commentary*. Garden City, NY: Doubleday, 1983.

Greenfield, J. C. "The Names of the Zodiacal Signs in Aramaic and Hebrew." In Gyselen, *Au carrefour des religions*, 95–103.

Greenfield, J. C., and M. Sokoloff. "Astrological and Related Omen Texts in Jewish Palestinian Aramaic." *JNES* 48 (1989): 201–14.

Greer, R. "Alien Citizens: A Marvellous Paradox." In *Civitas: Religious Interpretations of the City*, edited by P. S. Hawkins, 39–56. Atlanta: Scholars, 1986

Gregg, R. C., and D. Urman. *Jews, Pagans, and Christians in the Golan Heights: Greek and Other Inscriptions of the Roman and Byzantine Eras*. Atlanta: Scholars, 1996.

Gressmann, H. "Jewish Life in Ancient Rome." In *Jewish Studies in Memory of Israel Abrahams*, edited by Jewish Institute of Religion, 177–84. Reprint, New York: Arno, 1980.

Groh, D. E. "The Fine-Wares from the Patrician and Lintel Houses." In *Excavations at Ancient Meiron, Upper Galilee, Israel 1971-72, 1974-75, 1977*, edited by E. M. Meyers, J. F. Strange, and C. L. Meyers, 129-38. Cambridge, MA: American Schools of Oriental Research, 1981.

———. "Jews and Christians in Late Roman Palestine: Towards a New Chronology." *BA* 51 (1988): 80-96.

Gruen, E. S. *Studies in Greek Culture and Roman Policy*. Leiden: Brill, 1990.

———. "The Origins and Objectives of Onias' Temple." *SCI* 16 (1997): 47-70.

———. "Hellenism and Judasim: Fluid Boundaries." In Weiss et al., *"Follow the Wise,"* 53-70.

Gruenwald, I. "Yannai and Hekhalot Literature." *Tarbiz* 36 (1967): 257-77. Hebrew.

———. "The Impact of Priestly Traditions on the Creation of Merkabah Mysticism and the Shiur Komah." In J. Dan, *Early Jewish Mysticism*, 65-120.

———. *From Apocalypticism to Gnosticism: Studies in Apocalypticism, Merkabah Mysticism and Gnosticism*. Frankfurt am Main: Peter Lang, 1988.

Guidi, I., ed. *Chronica Minora*. Vol. 1. Paris: E Typographeo Reipublicae, 1903.

Gundel, H. G. *Zodiakos: Tierkreisbilder im Altertum: kosmische Bezüge und Jenseitsvorstellungen im antiken Alltagsleben*. Mainz: Philipp von Zabern, 1992.

Gutfeld, O., and M. Haber. *A Guide to Beit Loya (Lehi): An Archaeological Site in the Judean Lowland*. Jerusalem: Beit Lehi Foundation, 2009.

Gutmann, J. "The Illustrated Jewish Manuscript in Antiquity: The Present State of the Question." In Gutmann, *No Graven Images*, 232-48.

———, ed. *No Graven Images: Studies in Art and the Hebrew Bible*. New York: KTAV, 1971.

———. "The 'Second Commandment' and the Image in Judaism." In Gutmann, *No Graven Images*, 1-14.

———, ed. *The Dura-Europos Synagogue: A Re-evaluation, 1932-1972*. Missoula: American Academy of Religion and Society of Biblical Literature, 1973.

———. "Programmatic Painting in the Dura Synagogue." In Gutmann, *Dura-Europos Synagogue: A Re-evaluation*, 137-54.

———. "Early Synagogue and Jewish Catacomb Art and Its Relation to Christian Art." *ANRW* II.21.2 (1984): 1313-42.

———. "The Dura Synagogue Paintings: The State of Research." In L. I. Levine, *Synagogue in Late Antiquity*, 61-72.

———. *Sacred Images: Studies in Jewish Art from Antiquity to the Middle Ages*. Northampton, MA: Variorum Reprints, 1989.

———. "Revisiting the 'Binding of Isaac' Mosaic in the Beth-Alpha Synagogue." *Bulletin of the Asia Institute* 6 (1992): 79-85.

———. "Is There a Jewish Art?" In Moore, *Visual Dimension*, 1-19.

———. "The Synagogue of Dura Europos: A Critical Analysis." In Kee and Cohick, *Evolution of the Synagogue*, 73-88.

Guyon, J. *Le cimetière aux deux lauriers: Recherches sur les catacombes romaines*. Rome: École Française de Rome, 1987.

Gyselen, R., ed. *Au carrefour des religions: Mélanges offerts à Philippe Gignoux*. Bures-sur-Yvette: Groupe pour l'étude de la civilisation du Moyen-Orient, 1995.

Haas, C. *Alexandria in Late Antiquity: Topography and Social Conflict*. Baltimore: Johns Hopkins University Press, 1997.

Habas, L. "An Incised Depiction of the Temple Menorah and Other Cult Objects of the Second Temple Period." In Geva, *Jewish Quarter Excavations*, 2:329-42.

———. "The Byzantine Churches of *Provincia Arabia*: Architectural Structure and the Relationship with the Compositional Scheme and Iconographic Program of Mosaic Pavements." 2 vols. Ph.D. diss., Hebrew University of Jerusalem, 2005. Hebrew.

Hachlili, R. "A Jewish Funerary Wall-Painting of the First Century AD." *PEQ* 117 (1985): 112–27.

———. "On the Gaza School of Mosaicists." *EI* 19 (1987): 46–58. Hebrew.

———. *Ancient Jewish Art and Archaeology in the Land of Israel*. Leiden: Brill, 1988.

———. "Late Antique Jewish Art from the Golan." In Humphrey, *Roman and Byzantine Near East*, 1:183–212.

———. "Aspects of Similarity and Diversity in the Architecture and Art of Ancient Synagogues and Churches in the Land of Israel." *ZDPV* 113 (1997): 92–122.

———. *Ancient Jewish Art and Archaeology in the Diaspora*. Leiden: Brill, 1998.

———. "Torah Shrine and Ark in Ancient Synagogues: A Re-evaluation." *ZDPV* 116 (2000): 146–83.

———. *The Menorah, the Ancient Seven-armed Candelabrum: Origin, Form and Significance*. Leiden: Brill, 2001.

———. "The Zodiac in Ancient Synagogal Art: A Review." *JSQ* 9 (2002): 219–58.

———. *Jewish Funerary Customs, Practices and Rites in the Second Temple Period*. Leiden: Brill, 2005.

———. *Ancient Mosaic Pavements: Themes, Issues, and Trends—Selected Studies*. Leiden: Brill, 2009.

———. "The Dura-Europos Synagogue Wall Paintings: A Question of Origin and Interpretation." In Weiss et al., *"Follow the Wise,"* 403–20.

Hadley, J. M. *The Cult of Asherah in Ancient Israel and Judah: Evidence for a Hebrew Goddess*. Cambridge, UK: Cambridge University Press, 2000.

Hahn, J. "Die jüdische Gemeinde im spätantiken Antiochia: Leben im Spannungsfeld von sozialer Einbindung, religiösssem Wettbewerb und gewaltsamem Konflikt." In Jütte and Kustermann, *Jüdische Gemeinden und Organisationsformen*, 57–89.

Haldon, J. F. *Byzantium in the Seventh Century: The Transformation of a Culture*. Cambridge, UK: Cambridge University Press, 1990.

Halivni, D. "Aspects of the Formation of the Talmud." In Rubenstein, *Creation and Composition*, 339–60.

Hall, S. G. *Melito of Sardis, On Pascha and Fragments*. Oxford: Clarendon, 1979.

Hallett, C. H. *The Roman Nude: Heroic Portrait Statuary, 200 B.C.–A.D. 300*. Oxford: Oxford University Press, 2005.

Hallo, W. W. *The Book of the People*. Atlanta: Scholars, 1991.

Halperin, D. A. *The Ancient Synagogues of the Iberian Peninsula*. Gainesville: University Press of Florida, 1969.

Halperin, D. J. *The Faces of the Chariot: Early Jewish Responses to Ezekiel's Vision*. Tübingen: Mohr, 1988.

Halpern, B. *The Emergence of Israel in Canaan*. Chico: Scholars, 1983.

———. "The Construction of the Davidic State: An Exercise in Historiography." In Fritz and Davies, *Origins of the Ancient Israelite States*, 44–75.

Halsberghe, G. H. *The Cult of Sol Invictus*. Leiden: Brill, 1972.

Handy, L. K., ed. *The Age of Solomon: Scholarship at the Turn of the Millennium*. Leiden: Brill, 1997.

Hanfmann, G. M. A. *The Season Sarcophagus in Dumbarton Oaks*. 2 vols. Cambridge, MA: Harvard University Press, 1951.

———. *Letters from Sardis*. Cambridge, MA: Harvard University Press, 1972.

———. *From Croesus to Constantine: The Cities of Western Asia Minor and Their Arts in Greek and Roman Times*. Ann Arbor: University of Michigan Press, 1975.

———. "The Continuity of Classical Art: Culture, Myth, and Faith." In Weitzmann, *Age of Spirituality: A Symposium*, 75–99.

Hanfmann, G. M. A., and J. B. Bloom. "Samoe, Priest and Teacher of Wisdom." *EI* 9 (1987): 10*–14*.

Hansen, M. F. *The Eloquence of Appropriation: Prolegomena to an Understanding of Spolia in Early Christian Rome.* Rome: "L'Erma" di Bretschneider, 2003.

Hanson, J. "Erotic Imagery on Byzantine Ivory Caskets." In L. James, *Desire and Denial*, 171–84.

Hanson, R. S. *Tyrian Influence in the Upper Galilee.* Cambridge, MA: American Schools of Oriental Research, 1980.

Haran, M. *Temples and Temple-Service in Ancient Israel: An Inquiry into the Character of Cult Phenomena and the Historical Setting of the Priestly School.* Oxford: Clarendon, 1978.

———. "'Incense Altars': Are They?" In *Biblical Archaeology Today, 1990*, edited by A. Biran et al., 237–47. Jerusalem: Israel Exploration Society, 1993.

Harari, Y. *Early Jewish Magic: Research, Methods, Sources.* Jerusalem: Bialik and Yad Izhak Ben-Zvi, 2010. Hebrew.

Harkins, P. W. Introduction to *Saint John Chrysostom, Discourses against Judaizing Christians*, translated by Harkins, xxxvii–xlvii. Washington, DC: Catholic University of America Press, 1979.

Harland, P. A. *Associations, Synagogues, and Congregations: Claiming a Place in Ancient Mediterranean Society.* Minneapolis: Fortress, 2003.

———. "Acculturation and Identity in the Diaspora: A Jewish Family and 'Pagan' Guilds at Hierapolis." *JJS* 57 (2006): 222–44.

Harnack, A. von. *Die Altercatio Simonis Iudaei et Theophili Christiani: nebst Untersuchungen über die antijüdische Polemik in der alten Kirche.* Leipzig: Hinrichs, 1883.

———. *The Mission and Expansion of Christianity in the First Three Centuries.* New York: Harper, 1962.

Harries, J. *Law and Empire in Late Antiquity.* Cambridge, UK: Cambridge University Press, 1999.

Harrison, J. R. "Benefaction Ideology and Christian Responsibility for Widows." In *New Documents Illustrating Early Christianity*, edited by S. R. Llewelyn, 8:106–16. Grand Rapids: Eerdmans, 1997.

Hasan-Rokem, G. *Web of Life: Folklore and Midrash in Rabbinic Literature.* Contraversions. Stanford: Stanford University Press, 2000.

Hauck, E. *American Capitols: An Encyclopedia of the State, National, and Territorial Capital Edifices of the United States.* Jefferson, NC: McFarland, 1991.

Hayes, J. H., and J. M. Miller. *Israelite and Judaean History.* London: SCM Press, 1977.

Hayman, A. P. "The Image of the Jew in the Syriac Anti-Jewish Polemical Literature." In *"To See Ourselves as Others See Us": Christians, Jews, and "Others" in Late Antiquity*, edited by J. Neusner and E. S. Frerichs, 423–41. Chico: Scholars, 1985.

Hayward, C. T. R. "The Date of Targum Pseudo-Jonathan: Some Comments." *JJS* 40 (1989): 7–30.

———. "The Sacrifice of Isaac and Jewish Polemic against Christianity." *CBQ* 52 (1990): 292–306.

Hedner-Zetterholm, K. "Elijah's Different Roles: A Reflection of the Rabbinic Struggle for Authority." *JSQ* 16 (2009): 163–82.

Hellemo, G. *Adventus Domini: Eschatological Thought in Fourth-Century Apses and Catecheses.* Leiden: Brill, 1989.

Hendel, R. S. "Aniconism and Anthropomorphism in Ancient Israel." In van der Toorn, *Image and the Book*, 205–28.

———. "Israel among the Nations: Biblical Culture in the Ancient Near East." In Biale, *Cultures of the Jews*, 43–75.

Hendin, D. "New Discovery on a Coin of Herod I." *INJ* 11 (1990–91): 32.

———. *Guide to Biblical Coins.* 3rd ed. New York: Amphora, 1996.

Hengel, M. "Die Synagogeninschrift von Stobi." *ZNW* 57 (1966): 145–83.

———. *Judaism and Hellenism: Studies in Their Encounter in Palestine during the Early Hellenistic Period*. 2 vols. London: SCM Press, 1974.

———. *The "Hellenization" of Judaea in the First Century after Christ*. London: SCM Press, 1989.

———. *The Zealots: Investigations into the Jewish Freedom Movement in the Period from Herod I until 70 A.D*. Edinburgh: T & T Clark, 1989.

Henig, M. *A Handbook of Roman Art: A Survey of the Visual Arts of the Roman World*. Oxford: Phaidon, 1983.

Henten, J. W. van. "Ruler or God? The Demolition of Herod's Eagle." In *The New Testament and Early Christian Literature in Greco-Roman Context: Studies in Honor of David E. Aune*, edited by J. Fotopoulos, 257–86. Leiden: Brill, 2006.

Henten, J. W. van, and P. W. van der Horst, eds. *Studies in Early Jewish Epigraphy*. Leiden: Brill, 1994.

Herbert, S. "The Orientation of Greek Temples." *PEQ* 116 (1984): 31–34.

Herford, R. T. *Christianity in Talmud and Midrash*. Reprint, Clifton, NJ: Reference Book Publishers, 1966.

Herr, M. D. "External Influences in the World of the Palestinian Sages." In *Acculturation and Assimilation: Continuity and Change in the Cultures of Israel and the Nations*, edited by Y. Kaplan and M. Stern, 88–102. Jerusalem: Zalman Shazar Center for Jewish History, 1989. Hebrew.

———. "Synagogues and Theatres (Sermons and Satiric Plays)." In *Knesset Ezra—Literature and Life in the Synagogue: Studies Presented to Ezra Fleischer*, edited by S. Eliezer et al., 105–19. Jerusalem: Yad Izhak Ben-Zvi, 1994. Hebrew.

Hershkovitz, M. "Gemstones." In Geva, *Jewish Quarter Excavations*, 2:296–301.

———. "Herodian Pottery." In Jacobson and Kokkinos, *Herod and Augustus*, 267–78.

Hervieu-Léger, D. *Religion as a Chain of Memory*. New Brunswick, NJ: Rutgers University Press, 2000.

Hestrin, R. "The Cult Stand from Ta'anach and Its Religious Background." In *Phoenicia and the East Mediterranean in the First Millennium B.C.*, edited by E. Lipiński, 61–77. Leuven: Peeters, 1987

———. "Understanding Asherah: Exploring Semitic Iconography." *BAR* 17, no. 5 (1991): 50–59.

Hezser, C. *The Social Structure of the Rabbinic Movement in Roman Palestine*. Tübingen: J. C. B. Mohr, 1997.

———. "The Impact of Household Slaves on the Jewish Family in Roman Palestine." *JSJ* 34 (2003): 375–424.

———, ed. *The Oxford Handbook of Jewish Daily Life in Roman Palestine*. Oxford: Oxford University Press, 2010.

Himmelfarb, M. "R. Moses the Preacher and the Testaments of the Twelve Patriarchs." *AJS Review* 9 (1984): 55–78.

———. "Heavenly Ascent in the Relationship of the Apocalypses and the Hekhalot Literature." *HUCA* 59 (1988): 73–100.

———. "The Mother of the Messiah in the Talmud Yerushalmi and Sefer Zerubbabel." In Schäfer, *Talmud Yerushalmi and Graeco-Roman Culture*, 3:369–89.

Hirsch, E. D., Jr. *Validity in Interpretation*. New Haven: Yale University Press, 1967.

———. *The Aims of Interpretation*. Chicago: University of Chicago Press, 1976.

Hirschberg, H. Z. *History of the Jews in North Africa*. Vol. 1, *From Antiquity to the Sixteenth Century*. 2nd rev. ed. Leiden: Brill, 1974.

Hirschfeld, Y., ed. *Tiberias: From Its Foundation until the Muslim Conquest*. Jerusalem: Yad Izhak Ben-Zvi, 1988. Hebrew.

———. "A Climatic Change in the Early Byzantine Period? Some Archaeological Evidence." *PEQ* 136 (2004): 133–49.

Hirshman, M. *A Rivalry of Genius: Jewish and Christian Biblical Interpretation.* Albany: State University of New York Press, 1996.

Hoehner, H. W. *Herod Antipas.* Cambridge, UK: Cambridge University Press, 1972.

Hoffmann, R. J., ed. and trans. *Julian's "Against the Galileans."* Amherst, NY: Prometheus, 2004.

Hoglund, K. G., and E. M. Meyers. "The Residential Quarter on the Western Summit." In Nagy et al., *Sepphoris in Galilee,* 39–49.

Holladay, J. S., Jr. "Religion in Israel and Judah under the Monarchy: An Explicitly Archaeological Approach." In P. D. Miller, Jr., et al., *Ancient Israelite Religion,* 249–99.

Holland, T. A. "A Study of Palestinian Iron Age Baked Clay Figurines with Special Reference to Jerusalem Cave I." *Levant* 9 (1977): 121–55.

Hope, V. M., and E. Marshall, eds. *Death and Disease in the Ancient City.* London: Routledge, 2000.

Hopkins, C. "The Siege of Dura." *Classical Journal* 42 (1947): 251–59.

Hopkins, K. *Death and Renewal.* Cambridge, UK: Cambridge University Press, 1983.

Horbury, W. "The Trial of Jesus in Jewish Tradition [especially in *Toledoth Jeshu*]." In *The Trial of Jesus: Cambridge Studies in Honour of C. F. D. Moule,* edited by E. Bammel, 103–21. London: SCM Press, 1970.

———. "A Critical Examination of the *Toledoth Jeshu.*" Ph.D. diss., Cambridge University, 1971.

———. *Jews and Christians in Contact and Controversy.* Edinburgh: T & T Clark, 1998.

———. *Herodian Judaism and New Testament Study.* Tübingen: Mohr Siebeck, 2006.

Horbury, W., W. D. Davies, and J. Sturdy, eds. *The Early Roman Period.* Vol. 3 of *CHJ.* Cambridge, UK: Cambridge University Press, 1999.

Horbury, W., and D. Noy. *Jewish Inscriptions of Graeco-Roman Egypt.* Cambridge, UK: Cambridge University Press, 1992.

Horowitz, I. H. *Palestine and the Adjacent Countries.* Vienna: A. Horowitz, 1923. Hebrew.

Horst, P. W. van der. *Ancient Jewish Epitaphs: An Introductory Survey of a Millennium of Jewish Funerary Epigraphy (300 BCE–700 CE).* Kampen: Pharos, 1991.

———. "Jewish Poetical Tomb Inscriptions." In van Henten and van der Horst, *Studies in Early Jewish Epigraphy,* 129–47.

———. "Greek in Jewish Palestine in Light of Jewish Epigraphy." In *Hellenism in the Land of Israel,* edited by J. J. Collins and G. E. Sterling, 154–74. Notre Dame: University of Notre Dame Press, 2001. Reprinted in van der Horst, *Japheth in the Tents of Shem,* 9–26.

———. *Japheth in the Tents of Shem: Studies on Jewish Hellenism in Antiquity.* Leuven: Peeters, 2002.

———. *Jews and Christians in Their Graeco-Roman Context: Selected Essays on Early Judaism, Samaritanism, Hellenism, and Christianity.* Tübingen: Mohr Siebeck, 2006.

Hoss, S. *Baths and Bathing: The Culture of Bathing and the Baths and Thermae in Palestine from the Hasmoneans to the Moslem Conquest.* Oxford: Archaeopress, 2005.

Houtman, A., and J. C. de Moor, eds. *A Bilingual Concordance to the Targum of the Prophets.* Vol. 21, *Introduction, Additions and Corrections, Indices.* Leiden Brill, 2005.

Humphrey, J. H., ed. *The Roman and Byzantine Near East.* Vol. 1, *Some Recent Archaeological Research.* Ann Arbor: Journal of Roman Archaeology, 1995. Vol. 2, *Some Recent Archaeological Research.* Ann Arbor: Journal of Roman Archaeology, 1999. Vol. 3, *Late-Antique Petra, Nile Festival Building at Sepphoris . . . and Other Studies.* Portsmouth, RI, 2002.

Hunt, E. D. "St. Stephen in Minorca: An Episode in Jewish-Christian Relations in the Early 5th Century A.D." *JTS* 33 (1982): 106–23.

Hurowitz, V. "Picturing Imageless Deities: Iconography in the Ancient Near East" (review). *BAR* 23, no. 3 (1997): 46–51.

Hüttenmeister, F., and G. Reeg. *Die antiken Synagogen in Israel*. Wiesbaden: Reichert, 1977.

Ilan, T. "The New Jewish Inscriptions from Hierapolis and the Question of Jewish Diaspora Cemeteries." *SCI* 25 (2006): 71–86.

Ilan, Z. "The Synagogue—General Description." In *Meroth: The Ancient Jewish Village, Excavations at the Synagogue and Bet-Midrash*, edited by Z. Ilan and E. Damati, 43–71. Tel Aviv: Society for the Protection of Nature, 1987. Hebrew.

———. *Ancient Synagogues in Israel*. Tel Aviv: Ministry of Defense, 1991. Hebrew.

———. "The Synagogue and Study House at Meroth." In Urman and Flesher, *Ancient Synagogues*, 1:256–88.

Ilan, Z., and E. Damati. *Meroth: The Ancient Jewish Village*. Tel Aviv: Society for the Protection of Nature, 1987. Hebrew.

Iricinschi, E., and H. M. Zellentin, eds. *Heresy and Identity in Late Antiquity*. Tübingen: Mohr Siebeck, 2008.

Irshai, O. "The Jews of Tiberias and Their Leadership toward the End of Byzantine Rule." In Hirschfeld, *Tiberias*, 57–64.

———. "Dating the Eschaton: Jewish and Christian Apocalyptic Calculations in Late Antiquity." In *Apocalyptic Time*, edited by A. I. Baumgarten, 113–53. Leiden: Brill, 2000.

———. "The Priesthood in Jewish Society of Late Antiquity." In L. I. Levine, *Continuity and Renewal*, 67–106. Hebrew.

———. "Jewish Violence in the Fourth Century CE—Fantasy and Reality: Behind the Scenes under the Emperors Gallus and Julian." In L. I. Levine and D. R. Schwartz, *Jewish Identities in Antiquity*, 391–416.

Isaac, B., and A. Oppenheimer, eds. *Studies on the Jewish Diaspora in the Hellenistic and Roman Periods*. Tel Aviv: Ramot, 1996.

Isaac, B., and I. Roll. "Judaea in the Early Years of Hadrian's Reign." *Latomus* 38 (1979): 54–66.

Israeli, Y., ed. *By the Light of the Menorah: The Evolution of a Symbol—Israel Museum Catalogue*. Jerusalem: Israel Museum, 1998.

Isserlin, B. S. "Israelite Art during the Period of the Monarchy." In Roth, *Jewish Art*, 35–50.

Jacobs, A. S. *Remains of the Jews: The Holy Land and Christian Empire in Late Antiquity*. Stanford: Stanford University Press, 2004.

Jacobs, L. *Structure and Form in the Babylonian Talmud*. Cambridge, UK: Cambridge University Press, 1991.

Jacobs, M. *Die Institution des jüdischen Patriarchen*. Tübingen: Mohr, 1995.

———. "Römische Thermenkultur im Spiegel des Talmud Yerushalmi." In Schäfer, *Talmud Yerushalmi and Graeco-Roman Culture*, 1:219–311.

———. "Theaters and Performances as Reflected in the Talmud Yerushalmi." In Schäfer, *Talmud Yerushalmi and Graeco-Roman Culture*, 1:327–47.

Jacobsen, Th. *Toward the Image of Tammuz and Other Essays on Mesopotamian History and Culture*. Cambridge, MA: Harvard University Press, 1976.

———. *The Treasures of Darkness: A History of Mesopotamian Religion*. New Haven: Yale University Press, 1976.

Jacobson, D. M. "A New Interpretation of the Reverse of Herod's Largest Coins." *American Numismatic Society: Museum Notes* 31 (1986): 145–65.

———. "Herod the Great Shows His True Colors." *NEA* 64 (2001): 100–4.

Jacobson, D. M., and N. Kokkinos, eds. *Herod and Augustus: Papers Presented at the Institute of Jewish Studies Conference, 21st–23rd June 2005*. Leiden: Brill, 2009.

Jacoby, R. "The Four Species in Jewish and Samaritan Tradition." In L. I. Levine and Weiss, *From Dura to Sepphoris*, 225–30.

———. "The Four Seasons in Zodiac Mosaics: The Tallaras Baths in Astypalaea, Greece." *IEJ* 51 (2001): 225–30.

Jaffé, D. "Les synagogues des *amei-ha-aretz:* hypothèses pour l'histoire et l'archéologie." *Studies in Religion/Sciences Religieuses* 32 (2003): 59–82.

Jaffe, Z. H. *History of Calendar Computation: Studies in the Clarification of the Mystery of the True Calculation.* Jerusalem: Darom, 1931. Hebrew.

James, E. "The Rise and Function of the Concept 'Late Antiquity.'" *Journal of Late Antiquity* 1 (2008): 20–30.

James, L., ed. *Desire and Denial in Byzantium.* Aldershot: Variorum, 1999.

James, S. "Dura Europos and the Chronology of Syria in the 250s AD." *Chiron* 15 (1985): 111–24.

Janowitz, N. "Rabbis and Their Opponents: The Construction of the 'Min' in Rabbinic Anecdotes." *JECS* 6 (1998): 449–62.

Janz, D. "General Editor's Foreword." In Krueger, *Byzantine Christianity,* xiii–xiv.

Japp, S. "Public and Private Decorative Art in the Time of Herod the Great." In *The World of the Herods.* Vol. 1 of *The International Conference, The World of the Herods and the Nabataeans, Held at the British Museum, 17–19 April 2001,* edited by N. Kokkinos, 227–46. Stuttgart: Franz Steiner, 2007.

Jastrow, M. *A Dictionary of the Targumim, the Talmud Babli and Yerushalmi, and the Midrashic Literature.* Reprint, New York: Judaica, 1971.

Jensen, M. H. *Herod Antipas in Galilee: The Literary and Archaeological Sources on the Reign of Herod Antipas and Its Socio-Economic Impact on Galilee.* Tübingen: Mohr Siebeck, 2006.

Jensen, R. M. "The Offering of Isaac in Jewish and Christian Tradition: Image and Text." *Bible Interpretation* 2 (1994): 85–110.

———. "Giving Texts Vision and Images Voice: The Promise and Problems of Interdisciplinary Scholarship." In *Common Life in the Early Church: Essays Honoring Graydon F. Snyder,* edited by J. V. Hills, 344–56. Harrisburg, PA: Trinity Press International, 1998.

———. "The Dura Europos Synagogue, Early-Christian Art, and Religious Life in Dura Europos." In Fine, *Jews, Christians, and Polytheists,* 174–89.

———. *Understanding Early Christian Art.* London: Routledge, 2000.

———. *Face to Face: Portraits of the Divine in Early Christianity.* Minneapolis: Fortress, 2005.

Jentel, M. O. "Une Scylla méconnue sur une mosaïque de Beth Shean?" In *Agathos daimon. Mythes et cultes: Études d'iconographie en l'honneur de Lilly Kahil,* edited by J. Balty, J.-C. Balty, and J. Bazant, 241–49. Athens: École Française d'Athènes, 2000.

Ji, C. C. "A New Look at the Tobiads in 'Iraq al-Emir." *LA* 48 (1998): 417–40.

Joel, I. "A Bible Manuscript Written in 1260 (with Two Facsimiles)." *Qiryat Sefer* 38 (1962): 122–32. Hebrew.

Johnson, M. J. "Pagan-Christian Burial Practices of the Fourth Century: Shared Tombs?" *JECS* 5 (1997): 37–59.

Johnson, S. E. "Asia Minor and Early Christianity." In *Christianity, Judaism, and Other Greco-Roman Cults: Studies for Morton Smith at Sixty.* Vol. 2, *Early Christianity,* edited by J. Neusner, 77–145. Leiden: Brill, 1975.

Jones, A.H. M. *Cities of the Eastern Roman Provinces.* Oxford: Clarendon, 1937.

———. *The Herods of Judaea.* Oxford: Clarendon, 1938.

———. *The Later Roman Empire, 284–602: A Social, Economic and Administrative Survey.* 2 vols. Norman: University of Oklahoma Press, 1964.

Jones, A. H. M., J. R. Martindale, and J. Morris. *The Prosopography of the Later Roman Empire.* Vol. 1, *AD 260–395.* Cambridge, UK: Cambridge University Press, 1971.

Jones, C. P. "The Reliability of Philostratus." In Bowersock, *Approaches to the Second Sophistic,* 11–16.

Josephus. LCL. 9 vols. Cambridge, MA: Harvard University Press, 1958–65.

Joyce, H. "Hadrian's Villa and the 'Dome of Heaven.'" *Mitteilungen des Deutschen Archäologischen Instituts, Römische Abteilung* 97 (1990): 347–81.

Jütte, R., and A. P. Kustermann, eds. *Jüdische Gemeinden und Organisationsformen von der Antike bis zur Gegenwart.* Vienna: Böhlau, 1996.

Juster, J. *Les juifs dans l'empire romain.* 2 vols. Paris: Geuthner, 1914.

Kadman, L. *The Coins of the Jewish War of 66–73 C.E.* Tel Aviv: Schocken, 1960.

Kahana, M. I. "The Halakhic Midrashim." In Safrai et al., *Literature of the Sages*, 2:3–107.

Kahana, T. "The Priestly Courses and Their Geographical Settlements." *Tarbiz* 48 (1978–79): 9–29. Hebrew.

Kahlos, M. *Debate and Dialogue: Christian and Pagan Cultures, c. 360–430.* Aldershot: Ashgate, 2007.

Kaimio, J. *The Romans and the Greek Language.* Helsinki: Societas Scientiarum Fennica, 1979.

Kaizer, T. "Religion in the Roman East." In *A Companion to Roman Religion*, edited by Jörg Rüpke, 446–56. Oxford: Blackwell, 2007.

——— "Religion and Language in Dura-Europos." In Cotton, *From Hellenism to Islam*, 235–53.

Kajanto, I. "A Study of the Greek Epitaphs of Rome." *Acta Instituti Romani Finlandiae* 2, no. 3 (1963): 1–47.

Kalmin, R. L. *The Redaction of the Babylonian Talmud: Amoraic or Saboraic?* Cincinnati: Hebrew Union College Press, 1989.

———. "Christians and Heretics in Rabbinic Literature of Late Antiquity." *HTR* 87 (1994): 155–69.

———. *Sages, Stories, Authors, and Editors in Rabbinic Babylonia.* Atlanta: Scholars, 1994.

———. *The Sage in Jewish Society of Late Antiquity.* London: Routledge, 1999.

———. "Holy Men, Rabbis, and Demonic Sages in Late Antiquity." In Kalmin and S. Schwartz, *Jewish Culture and Society*, 213–49.

———. "The Formation and Character of the Babylonian Talmud." In Katz, *Late Roman-Rabbinic Period*, 840–76.

———. *Jewish Babylonia between Persia and Roman Palestine.* Oxford: Oxford University Press, 2006.

———. "Problems in the Use of the Babylonian Talmud for the History of Late-Roman Palestine: The Example of Astrology." In Goodman and Alexander, *Rabbinic Texts and the History of Late-Roman Palestine*, 165–83.

———. "A Late Antique Babylonian Rabbinic Treatise on Astrology." In *Shoshanat Yaakov: Ancient Jewish and Iranian Studies in Honor of Professor Yaakov Elman*, edited by S. Fine and S. Secunda. Leiden: Brill, forthcoming.

Kalmin, R., and S. Schwartz, eds. *Jewish Culture and Society under the Christian Roman Empire.* Leuven: Peeters, 2003.

Kaminsky, J., and A. Stewart. "God of All the World: Universalism and Developing Monotheism in Isaiah, 40–66." *HTR* 99 (2006): 139–63.

Kanael, B. "Ancient Jewish Coins and Their Historical Importance." *BA* 26 (1963): 38–62.

Kant, L. "Jewish Inscriptions in Greek and Latin." *ANRW* II.20.2 (1987): 671–713.

Kasher, A., G. Fuchs, and U. Rappaport, eds. *Greece and Rome in Eretz-Israel: Collected Essays.* Jerusalem: Yad Izhak Ben-Zvi, 1989. Hebrew.

Kasher, M. M. *Torah Shelemah.* Vol. 8. Jerusalem: Bet Torah Shelemah, 1992. Hebrew.

Kasher, R. "The Aramaic Targumim and Their Sitz im Leben." *Proceedings of the Ninth World Congress of Jewish Studies—Panel Sessions: Bible Studies and the Ancient Near East*, 75–85. Jerusalem: World Union of Jewish Studies, 1988.

Katz, S. T., ed. *The Late Roman-Rabbinic Period.* Vol. 4 of *CHJ*. Cambridge, UK: Cambridge University Press, 2006.

———. "The Rabbinic Response to Christianity." In Katz, *Late Roman-Rabbinic Period*, 259–98.

Kaufman, J. C. *Unrecorded Hasmonean Coins from the J. C. Kaufman Collection.* 2 parts. Jerusalem: Israel Numismatic Society, 1995–2004.

Kaufmann, Y. *The Religion of Israel: From Its Beginnings to the Babylonian Exile.* Abridged and translated by M. Greenberg. Chicago: University of Chicago Press, 1960.

Kayser, S. S. "Defining Jewish Art." In *Mordecai M. Kaplan: Jubilee Volume on the Occasion of His Seventieth Birthday*, edited by M. Davis, 457–67. New York: Jewish Theological Seminary, 1953.

Kazan, S. "Isaac of Antioch's Homily Against the Jews." *Oriens Christianus* 46 (1962): 87–98; 47 (1963): 89–97; 49 (1965): 57–78.

Kee, H. C., and L. H. Cohick, eds. *Evolution of the Synagogue: Problems and Progress*. Harrisburg, PA: Trinity Press International, 1999.

Keel, O., and C. Uehlinger. *Gods, Goddesses, and Images of God in Ancient Israel*. Minneapolis: Fortress, 1998.

Kennedy, H. "From *Polis* to *Madina*: Urban Change in Late Antique and Early Islamic Syria." *Past and Present* 106 (1985): 3–27.

———. "The Last Century of Byzantine Syria: A Reinterpretation." *ByzF* 10 (1985): 141–83.

———. "Antioch: From Byzantium to Islam and Back Again." In Rich, *City in Late Antiquity*, 181–98.

Kenyon, K. M. *Digging up Jericho*. London: E. Benn, 1957.

———. *Digging up Jerusalem*. London: E. Benn, 1974.

Kessler, E. "Art Leading the Story: The *'Aqedah* in Early Synagogue Art." In L. I. Levine and Weiss, *From Dura to Sepphoris*, 73–81.

———. *Bound by the Bible: Jews, Christians and the Sacrifice of Isaac*. Cambridge, UK: Cambridge University Press, 2004.

Kessler, H. L. "The Christian Realm: Narrative Representations." In *Age of Spirituality: Late Antique and Early Christian Art, Third to Seventh Century: Catalogue of the Exhibition at the Metropolitan Museum of Art, November 19, 1977 through February 12, 1978*, edited by K. Weitzmann, 449–512. New York: Metropolitan Museum of Art, 1979.

———. "Program and Structure." In Weitzmann and H. L. Kessler, *Frescoes of the Dura Synagogue and Christian Art*, 153–83.

———. "The Sepphoris Mosaic and Christian Art." In L. I. Levine and Weiss, *From Dura to Sepphoris*, 64–72.

Kienle, H. *Der Gott auf dem Flügelrad: zu den ungelösten Fragen der "synkretischen" Münze, BMC Palestine S. 181, Nr. 29*. Wiesbaden: O. Harrassowitz, 1975.

Killebrew, A. E. *Biblical Peoples and Ethnicity: An Archaeological Study of Egyptians, Canaanites, Philistines, and Early Israel (1300–1100 B.C.E.)*. Atlanta: Society of Biblical Literature, 2005.

Kimelman, R. *Rabbi Yohanan of Tiberias: Aspects of the Social and Religious History of Third Century Palestine*. Ann Arbor: University Microfilms, 1977.

———. "Rabbi Yohanan and Origen on the Song of Songs: A Third-Century Jewish-Christian Disputation." *HTR* 73 (1980): 567–95.

———. "The Conflict between the Priestly Oligarchy and the Sages in the Talmudic Period (on Explication of PT Shabbat 12:3, 13C = Horayot 3:4, 48C)." *Zion* 48 (1983): 135–47. Hebrew.

———. "A Note on Weinfeld's 'Grace after Meals in Qumran.'" *JBL* 112 (1993): 695–96.

———. "Blessing Formulae and Divine Sovereignty in Rabbinic Liturgy." In Langer and Fine, *Liturgy in the Life of the Synagogue*, 1–39.

Kindler, A. "The Coinage of the Bar-Kokhba War." In *The Dating and Meaning of Ancient Jewish Coins and Symbols: Six Essays in Jewish Numismatics*, by A. Kindler, J. Mayshan, L. Kadman, and E. W. Klimowsky, 62–80. Jerusalem: Schocken, 1958.

———. *The Coinage of Bostra*. Warminster: Aris & Phillips, 1983.

King, N. Q. "The Theodosian Code as a Source for the Religious Policies of the First Byzantine Emperors." *Nottingham Medieval Studies* 6 (1962): 12–17.

King, P. J., and L. E. Stager. *Life in Biblical Israel*. Louisville: Westminster John Knox, 2001.

Kinzig, W. "'Non-Separation': Closeness and Co-operation between Jews and Christians in the Fourth Century." *VC* 45 (1991): 27–53.

Kister, J. M. "'Do Not Assimilate Yourselves . . . ' ('La tashabbahu')." *Jerusalem Studies in Arabic and Islam* 12 (1989): 321-53.

Kitzinger, E. "The Cult of Images in the Age Before Iconoclasm." *DOP* 8 (1954): 83-150.

———. *Israeli Mosaics of the Byzantine Period.* New York: New American Library, 1965.

———. "Observations on the Samson Floor at Mopsuestia." *DOP* 27 (1973): 133-44.

———. *Byzantine Art in the Making: Main Lines of Stylistic Development in Mediterranean Art, 3rd-7th Century.* Cambridge, MA: Harvard University Press, 1995.

Klagsbald, V. A. "La symbolique dans l'art juif." *REJ* 144 (1985): 408-38.

———. "The Menorah as Symbol: Its Meaning and Origin in Early Jewish Art." *JA* 12 (1987): 126-34.

Klein, S. *The Galilee.* Jerusalem: Mossad Harav Kook, 1946. Hebrew.

———. "R. Simeon the Sofer of Tarbanat." In *Minhah L'David: Festschrift for D. Yellin*, 96-99. Jerusalem: R. Mass, 1935. Hebrew.

Kletter, R. *The Judean Pillar-Figurines and the Archaeology of Asherah.* Oxford: Tempus Reparatum, 1996.

Kloner, A. "Ancient Synagogues in Israel: An Archeological Survey." In L. I. Levine, *Ancient Synagogues Revealed*, 11-18.

Kloner, A., and Zissu, B. *The Necropolis of Jerusalem in the Second Temple Period.* Leuven and Dudley, MA: Peeters, 2007.

Knauf, E. A. "The Nabataean Connection of the Benei Hezir." In Cotton, *From Hellenism to Islam*, 345-51.

Koch, G. "Jüdische Sarkophage der Kaiserzeit und der Spätantike." In Rutgers, *What Athens Has to Do with Jerusalem*, 189-210.

Kohl, H., and C. Watzinger. *Antike Synagogen in Galilaea.* Leipzig: Heinrichs, 1916.

Koenen, K. *Bethel: Geschichte, Kult und Theologie.* Göttingen: Vandenhoeck & Ruprecht, 2003.

Kogman-Appel, K. "Jewish Art and Non-Jewish Culture: The Dynamics of Artistic Borrowing in Medieval Hebrew Manuscript Illumination." *Jewish History* 15 (2001): 187-234.

Kokkinos, N. *The Herodian Dynasty: Origins, Role in Society and Eclipse.* Sheffield: Sheffield Academic, 1998.

Konikoff, A. *Sarcophagi from the Jewish Catacombs of Ancient Rome: A Catalogue Raisonné* Stuttgart: Stein, 1986.

Kraabel, A. T. "Impact of the Discovery of the Sardis Synagogue." In Overman and MacLennan, *Diaspora Jews and Judaism*, 269-91.

———. "Melito the Bishop and the Synagogue at Sardis: Text and Context." In Overman and MacLennan, *Diaspora Jews and Judaism*, 197-207.

———. "*Pronoia* at Sardis." In Isaac and Oppenheimer, *Studies on the Jewish Diaspora*, 75-96.

Kraeling, C. H. *The Excavations at Dura-Europos.* Vol. 8, pt. 2, *The Christian Building.* New Haven: Dura Europos Publications, 1967.

———. *The Excavations at Dura-Europos.* Vol. 8, pt. 1, *The Synagogue.* New Haven: Yale University Press, 1956. Reprint, New York: KTAV, 1979.

Kraemer, D. C. "On the Reliability of Attributions in the Babylonian Talmud." *HUCA* 60 (1989): 175-90.

Kraemer, R. S. "Jewish Tuna and Christian Fish: Identifying Religious Affiliation in Epigraphic Sources." *HTR* 84 (1991): 141-62.

———. *When Aseneth Met Joseph: A Late Antique Tale of the Biblical Patriarch and His Egyptian Wife, Reconsidered.* New York: Oxford University Press, 1998.

———. "Jewish Women's Resistance to Christianity in the Early Fifth Century: The Account of Severus, Bishop of Minorca." *JECS* 17 (2009): 635-65.

Kraft, R. A., and G. W. E. Nickelsburg, eds. *Early Judaism and Its Modern Interpreters.* Atlanta: Scholars, 1986.

Krauss, S. "The Jews in the Works of the Church Fathers." *JQR* 5 (1893): 122–57; 6 (1894): 82–99, 225–61.

———. *Das Leben Jesu nach jüdischen Quellen*. Berlin: S. Calvary, 1902.

———. *Studien zur byzantinisch-jüdischen Geschichte*. Leipzig: G. Fock, 1914.

———. *Synagogale Altertümer*. Berlin: Harz, 1922. Reprint, Hildesheim: Olms, 1966.

Krautheimer, R. *Rome: Profile of a City, 312–1308*. Princeton: Princeton University Press, 1980.

Kroll, J. H. "The Greek Inscriptions of the Sardis Synagogue." *HTR* 94 (2001): 5–127.

Kronholm, T. *Motifs from Genesis 1–11 in the Genuine Hymns of Ephrem the Syrian with Particular Reference to the Influence of Jewish Exegetical Tradition*. Lund: Gleerup, 1978.

Krueger, D. "Christian Piety and Practice in the Sixth Century." In Maas, *Cambridge Companion to the Age of Justinian*, 13:291–315.

———, ed. *Byzantine Christianity*. Minneapolis: Fortress, 2006.

Kühnel, B. "The Synagogue Floor Mosaic in Sepphoris: Between Paganism and Christianity." In L. I. Levine and Weiss, *From Dura to Sepphoris*, 31–43.

———. "Jewish Art in Its Pagan-Christian Context: Questions of Identity." In L. I. Levine, *Continuity and Renewal*, 49–64. Hebrew.

Kushnir-Stein, A. "The Coins of Agrippa II." *SCI* 21 (2002): 123–31.

Lacerenza, G. "Jewish Magicians and Christian Clients in Late Antiquity: The Testimony of Amulets and Inscriptions." In Rutgers, *What Athens Has to Do with Jerusalem*, 393–419.

Laderman, S. "A New Look at the Second Register of the West Wall in Dura Europos." *Cahiers Archéologiques* 45 (1997): 5–18.

Lahey, L. "Jewish Biblical Interpretation and Genuine Jewish-Christian Debate in 'The Dialogue of Timothy and Aquila.'" *JJS* 51 (2000): 281–96.

Lamberton, R. *Homer the Theologian: Neoplatonist Allegorical Reading and the Growth of the Epic Tradition*. Berkeley: University of California Press, 1986.

Lampe, P. *From Paul to Valentinus: Christians at Rome in the First Two Centuries*. Minneapolis: Fortress, 2003.

———. "Early Christians in the City of Rome: Topographical and Social Historical Aspects of the First Three Centuries." In Zangenberg and Labahn, *Christians as a Religious Minority in a Multicultural City*, 20–32.

Lançon, B. *Rome in Late Antiquity: Everyday Life and Urban Change, AD 312–609*. New York: Routledge, 2000.

Lane Fox, R. *Pagans and Christians*. New York: Knopf, 1987.

Lange, N. de. *Origen and the Jews: Studies in Jewish-Christian Relations in Third-Century Palestine*. Cambridge, UK: Cambridge University Press, 1976.

———. "Jews and Christians in the Byzantine Empire: Problems and Prospects." In *Christianity and Judaism: Papers Read at the 1991 Summer Meeting and the 1992 Winter Meeting of the Ecclesiastical History Society*, edited by D. Wood, 15–32. Cambridge, MA: Ecclesiastical History Society, 1992.

———. "The Hebrew Language in the European Diaspora." In Isaac and Oppenheimer, *Studies on the Jewish Diaspora*, 111–37.

———. "The Revival of the Hebrew Language in the Third Century CE." *JSQ* 3 (1996): 342–58.

———. "A Thousand Years of Hebrew in Byzantium." In *Hebrew Study from Ezra to Ben-Yehuda*, edited by W. Horbury, 147–61. Edinburgh: T & T Clark, 1999.

———. "Jews in the Age of Justinian." In Maas, *Cambridge Companion to the Age of Justinian*, 13:401–26.

Langer, R., and S. Fine, eds. *Liturgy in the Life of the Synagogue: Studies in the History of Jewish Prayer*. Winona Lake: Eisenbrauns, 2005.

Langermann, Y. T. *The Jews and the Sciences in the Middle Ages*. Aldershot: Ashgate, 1999.

La Piana, G. "The Roman Church at the End of the Second Century: The Episcopate of Victor, the Latinization of the Roman Church, the Easter Controversy, Consolidation of Power and Doctrinal Development, the Catacomb of Callistus." *HTR* 18 (1925): 201–77.

———. "Foreign Groups in Rome during the First Centuries of the Empire." *HTR* 20 (1927): 341–76.

Lapin, H., ed. *Religious and Ethnic Communities in Later Roman Palestine.* Potomac: University of Maryland Press, 1998.

———. "Palestinian Inscriptions and Jewish Ethnicity in Late Antiquity." In E. M. Meyers et al., *Galilee through the Centuries*, 239–68.

———. *Economy, Geography, and Provincial History in Later Roman Palestine.* Tübingen: Mohr Siebeck, 2001.

———. "The Origins and Development of the Rabbinic Movement in the Land of Israel." In Katz, *Late Roman-Rabbinic Period*, 206–29.

———. "S. Fine, *Art and Judaism in the Greco-Roman World: Toward a New Jewish Archaeology*" (review). *Review of Biblical Literature*, September 2006. http://www.bookreviews. org/pdf/5001_5267.pdf. Accessed November 2011.

———. "Epigraphical Rabbis: A Reconsideration." *JQR* 101 (2011): 311–46.

Lapp, N. L. "'Iraq el-Emir." In E. Stern, *NEAEHL*, 2:646–49.

Lapp, P. W. "Soundings at 'Araq el-Emir (Jordan)." *BASOR* 165 (1962): 16–34.

Larché, F. *'Iraq al-Amir — Le château du Tobiade Hyrcan.* 2 vols. Beyrouth: Institute Français du Proche-Orient, 2005.

LaRocca-Pitts, E. C. *"Of Wood and Stone": The Significance of Israelite Cultic Items in the Bible and Its Early Interpreters.* Winona Lake: Eisenbrauns, 2001.

Lash, E., trans. *St. Romanos the Melodist, Kontakia: On the Life of Christ.* San Francisco: HarperCollins, 1995.

Lasker, A. A., and D. J. Lasker. "642 Parts — More Concerning the Saadya-Ben Meir Controversy." *Tarbiz* 60 (1990): 119–28. Hebrew.

Lasker, D. J. "Jewish-Christian Polemics at the Turning Point: Jewish Evidence from the Twelfth Century." *HTR* 89 (1996): 161–73.

Lasker, D. J., and S. Stroumsa, eds. *The Polemic of Nestor the Priest: Qiṣṣat mujādalat al-usquf and Sefer Nestor ha-Komer.* 2 vols. Jerusalem: Yad Izhak Ben-Zvi, 1996.

Lauterbach, J. Z. *Mekhilta of Rabbi Ishmael.* 3 vols. Philadelphia: Jewish Publication Society, 1949.

———. *Rabbinic Essays.* Cincinnati: Hebrew Union College Press, 1951.

Lavan, L., and W. Bowden, eds. *Theory and Practice in Late Antique Archaeology.* Leiden: Brill, 2003.

Le Bohec, Y. "Inscriptions juives et judaïsantes de l'Afrique romaine." *Antiquités africaines* 17 (1981): 165–207.

Le Déaut, R. *La nuit pascale: Essai sur la signification de la Pâque juive à partir du Targum d'Exode XII 42.* Rome: Pontificio Istituto Biblico, 1963.

Lee, A. D. *Pagans and Christians in Late Antiquity: A Sourcebook.* London: Routledge, 2000.

Lehmann, K. "The Dome of Heaven." *Art Bulletin* 27 (1945): 1–27.

Leibner, U. "Settlement and Demography in Late Roman and Byzantine Eastern Galilee." In Lewin and Pellegrini, *Settlements and Demography*, 105–29.

———. *Settlement and History in Hellenistic, Roman, and Byzantine Galilee.* Tübingen: Mohr Siebeck, 2009.

———. "The Settlement Crisis in the Eastern Galilee during the Late Roman and Early Byzantine Periods: Response to Jodi Magness." In L. I. Levine and D. R. Schwartz, *Jewish Identities in Antiquity*, 314–19.

———. "Settlement Patterns in the Eastern Galilee: Implications Regarding the Transformation of Rabbinic Culture in Late Antiquity." In L. I. Levine and D. R. Schwartz, *Jewish Identities in Antiquity*, 269–95.

Leibner, U. "Excavations at Khirbet Wadi Hamam (Lower Galilee): The Synagogue and the Settlement." *JRA* 23 (2010): 220–63.

Leibner, U., and S. Miller. "Appendix: A Figural Mosaic in the Synagogue at Khirbet Wadi Hamam." *JRA* 23 (2010): 238–63.

Lemaire, A. "Les inscriptions de Khirbet el-Qôm et l'Ashérah de YHWH." *RB* 84 (1977): 595–608.

———. "Khirbet el-Qôm and Hebrew and Aramaic Epigraphy." In *Confronting the Past: Archaeological and Historical Essays on Ancient History in Honor of William G. Dever*, edited by S. Gitin et al., 231–39. Winona Lake: Eisenbrauns, 2006.

Lemerle, P. *Byzantine Humanism: The First Phase. Notes and Remarks on Education and Culture in Byzantium from Its Origins to the Tenth Century.* Canberra: Australian Association for Byzantine Studies, 1986.

LeMon, J. M. *Yahweh's Winged Form in the Psalms: Exploring Congruent Iconography and Texts.* Fribourg: Academic, 2010; Göttingen: Vandenhoeck & Ruprecht, 2010.

Lenski, N. *Failure of Empire: Valens and the Roman State in the Fourth Century A.D.* Berkeley: University of California Press, 2002.

Leon, H. J. "Jews of Venusia." *JQR* 44 (1954): 267–84.

———. *The Jews of Ancient Rome.* Philadelphia: Jewish Publication Society of America, 1960.

Le Quien, M. *Oriens Christianus.* Vol. 3. Graz: Akademische Druck—U. Verlagsanstalt, 1958.

Lesses, R. M. "Speaking with Angels: Jewish and Greco-Egyptian Revelatory Adjurations." *HTR* 89 (1996): 41–60.

———. *Ritual Practices to Gain Power: Angels, Incantations, and Revelation in Early Jewish Mysticism.* Harrisburg, PA: Trinity Press International, 1998.

Levene, D. *A Corpus of Magic Bowls: Incantation Texts in Jewish Aramaic from Late Antiquity.* London: Kegan Paul, 2003.

Levi, D. "The Allegories of the Months in Classical Art." *Art Bulletin* 23 (1941): 251–92.

———. *Antioch Mosaics Pavements.* 2 vols. Princeton: Princeton University Press, 1947.

Levine, B. A. "The Cultic Scene in Biblical Religion: Hebrew 'Al Pānâi (על פני) and the Ban on Divine Images." In S. W. Crawford, *"Up to the Gates of Ekron"*, 358–69.

Levine, D. *Communal Fasts and Rabbinic Sermons: Theory and Practice in the Talmudic Period.* Tel Aviv: Hakibbutz Hameuchad, 2001. Hebrew.

———. "Between Leadership and Marginality: Models for Evaluating the Role of the Rabbis in the Early Centuries CE." In L. I. Levine and D. R. Schwartz, *Jewish Identities in Antiquity*, 195–209.

———. "Rabbi Judah the Patriarch and the Boundaries of Palestinian Cities: A Literary-Historical Study." *Cathedra* 138 (2010): 7–42. Hebrew.

———. "Is Talmudic Biography Still Possible?" *Jewish Studies (Journal of the World Union of Jewish Studies)* 46 (2009): 41–64. Hebrew.

———. "Rabbis, Preachers, and Aggadists: An Aspect of Jewish Culture in Third-and Fourth-Century Palestine." In Weiss et al., *"Follow the Wise,"* 275–96.

Levine, L. I. *Caesarea under Roman Rule.* Leiden: Brill, 1975.

———. "Rabbi Abbahu of Caesarea." In *Christianity, Judaism and Other Greco-Roman Cults: Studies for Morton Smith at Sixty.* Vol. 4, *Judaism after 70*, edited by J. Neusner, 56–76. Leiden: Brill, 1975.

———. "R. Simeon b. Yoḥai and the Purification of Tiberias: History and Tradition." *HUCA* 49 (1978): 143–85.

———. "The Jewish Patriarch (Nasi) in Third Century Palestine." *ANRW* II.19.2 (1979): 649–88.

———. "Ancient Synagogues—A Historical Introduction." In L. I. Levine, *Ancient Synagogues Revealed*, 1–10.

————, ed. *Ancient Synagogues Revealed*. Jerusalem: Israel Exploration Society, 1981.

————. "The Inscription in the 'En Gedi Synagogue." In L. I. Levine, *Ancient Synagogues Revealed*, 140–45.

————, ed. *The Jerusalem Cathedra: Studies in History, Archaeology, Geography and Ethnography of the Land of Israel*. 3 vols. Jerusalem: Yad Izhak Ben-Zvi; Detroit: Wayne State University Press, 1981–83.

————. "The Age of R. Judah I." In *Eretz-Israel from the Destruction of the Second Temple to the Muslim Conquest*, edited by Z. Baras et al., 1:93–118. Jerusalem: Yad Izhak Ben-Zvi, 1982. Hebrew.

————. "The Finds from Beth-She'arim and Their Importance for the Study of the Talmudic Period." *EI* 18 (1985): 277–81. Hebrew.

————, ed. *The Synagogue in Late Antiquity*. Philadelphia: American Schools of Oriental Research and Jewish Theological Seminary, 1987.

————. *The Rabbinic Class of Roman Palestine in Late Antiquity*. Jerusalem: Yad Izhak Ben-Zvi and Jewish Theological Seminary, 1989.

————, ed. *The Galilee in Late Antiquity*. New York: Jewish Theological Seminary, 1992.

————. "The Sages and the Synagogue in Late Antiquity: The Evidence of the Galilee." In L. I. Levine, *Galilee in Late Antiquity*, 201–22.

————. "Synagogues." In E. Stern, *NEAEHL*, 4:1421–24.

————. "Diaspora Judaism of Late Antiquity and Its Relationship to Palestine: Evidence from the Ancient Synagogue." In Isaac and Oppenheimer, *Studies on the Jewish Diaspora*, 139–58.

————. "The Status of the Patriarch in the Third and Fourth Centuries: Sources and Methodology." *JJS* 47 (1996): 1–32.

————. *Judaism and Hellenism in Antiquity: Conflict or Confluence?* Seattle: University of Washington Press, 1998.

————. "The History and Significance of the Menorah in Antiquity." In L. I. Levine and Weiss, *From Dura to Sepphoris*, 131–53.

————. *Jerusalem: Portrait of the City in the Second Temple Period (538 B.C.E.–70 C.E.)*. Philadelphia: Jewish Publication Society, 2002.

————, ed. *Continuity and Renewal: Jews and Judaism in Byzantine-Christian Palestine*. Jerusalem: Dinur Center (Hebrew University), Yad Izhak Ben-Zvi, and Jewish Theological Seminary, 2004. English and Hebrew.

————. *The Ancient Synagogue: The First Thousand Years*. 2nd ed. New Haven: Yale University Press, 2005.

————. "Figural Art in Ancient Judaism." *Ars Judaica* 1 (2005): 9–26.

————. "Common Judaism: The Contribution of the Ancient Synagogue." In McCready and Reinhartz, *Common Judaism*, 27–46, 232–37.

————. "Jewish Identities in Antiquity: An Introductory Essay." In L. I. Levine and D. R. Schwartz, *Jewish Identities in Antiquity*, 12–40.

————. "Israelite Art." In *Ve-Hinnei Rahel: Jewish Art and Archaeology in Honor of Rachel Hachlili*, edited by A. E. Killebrew, A. Segal, and S. Fine. Leiden: Brill, forthcoming.

————. "The Emergence of the Patriarchate in the Third Century." In *Peter Schäfer Festschrift*, edited by R. Boustan et al. Tübingen: Mohr Siebeck, forthcoming.

Levine, L. I., and D. R. Schwartz, eds. *Jewish Identities in Antiquity: Studies in Memory of Menahem Stern*. Tübingen: Mohr Siebeck, 2009.

Levine, L. I., and Z. Weiss. *From Dura to Sepphoris: Studies in Jewish Art and Society in Late Antiquity*. Portsmouth, RI: Journal of Roman Archaeology, 2000.

Levit-Tawil, D. "The Purim Panel in Dura in the Light of Parthian and Sasanian Art." *JNES* 38 (1979): 93–109.

———. "The Enthroned King Ahasuerus at Dura in Light of the Iconography of Kingship in Iran." *BASOR* 250 (1983): 57–78.

———. "Queen Esther at Dura: Her Imagery in Light of Third-Century C.E. Oriental Syncretism." In Shaked and A. Netzer, *Irano-Judaica*, 4:274–97

Levy, B. "Tyrian Shekels and the First Jewish War." In *Proceedings of the XIth International Numismatic Congress (1991)*, 267–74. Louvain-la-Neuve: Séminaire de numismatique Marcel Hoc, 1993.

———. "Tyrian Shekels: The Myth of the Jerusalem Mint." *Journal of the Society for Ancient Numismatics* 19 (1995): 33–35.

Lewin, A. S., and P. Pellegrini, eds. *Settlements and Demography in the Near East in Late Antiquity*. Rome: Istituti Editoriali e Poligrafici Internazionali, 2006.

Lewis, T. J. "Divine Images and Aniconism in Ancient Israel." *JAOS* 118 (1998): 36–53.

Lewy, Y. H. *Studies in Jewish Hellenism*. Jerusalem: Bialik, 1960. Hebrew.

———. "Julian the Apostate and the Building of the Temple." In L. I. Levine, *Jerusalem Cathedra*, 3:70–96.

Lichtenberger, H. "Organisationsformen und Ämter im antiken Griechenland und Italien." In Jütte and Kustermann, *Jüdische Gemeinden und Organisationsformen*, 11–27.

Lieber, L. S. *Yannai on Genesis: An Invitation to Piyyut*. Cincinnati: Hebrew Union College Press, 2010.

Lieberman, S. *Hayerushalmi Kiphshuto*. Jerusalem: Darom, 1934. Hebrew.

———. *Midreshei Teiman*. Jerusalem: Mercaz, 1940. Hebrew.

———. *Greek in Jewish Palestine: Studies in the Life and Manners of Jewish Palestine in the II–IV Centuries C.E.* New York: Jewish Theological Seminary, 1942.

———. "Palestine in the Third and Fourth Centuries." *JQR* 36 (1946): 329–70; 37 (1947): 31–54.

———. *Hellenism in Jewish Palestine: Studies in the Literary Transmission, Beliefs and Manners of Jewish Palestine in the I Century B.C.E.–IV Century C.E.* New York: Jewish Theological Seminary, 1950.

———. *Tosefta Ki-Feshuṭah: A Comprehensive Commentary on the Tosefta*. 10 vols. New York: Jewish Theological Seminary, 1955–88. Hebrew.

———. "Appendix D: Mishnat Shir ha-shirim." In Scholem, *Jewish Gnosticism, Merkavah Mysticism and Talmudic Tradition*, 118–26.

———. *Greek and Hellenism in Jewish Palestine*, 2nd ed. Jerusalem: Bialik and Yad Izhak Ben-Zvi, 1984. Hebrew.

———. *Studies in Palestinian Talmudic Literature*, edited by D. Rosenthal. Jerusalem: Magnes, 1991. Hebrew.

Liebeschuetz, J. H. W. G. *Continuity and Change in Roman Religion*. Oxford: Clarendon; New York: Oxford University Press, 1979.

———. "The End of the Ancient City." In Rich, *City in Late Antiquity*, 1–49.

———. "The Significance of the Speech of Praetextatus." In Athanassiadi and Frede, *Pagan Monotheism in Late Antiquity*, 185–205.

———. *The Decline and Fall of the Roman City*. Oxford: Oxford University Press, 2001.

Lietzmann, H. *Apollinaris von Laodicea und seine Schule: Texte und Untersuchungen*. Tübingen: Mohr [Siebeck], 1904.

Lieu, J. M. "History and Theology in Christian Views of Judaism." In Lieu, North, and Rajak, *Jews among Pagans and Christians*, 79–96.

———. *Image and Reality: The Jews in the World of the Christians in the Second Century*. Edinburgh: T & T Clark, 1996.

———. "Forging of Christian Identity." *Mediterranean Archaeology* 11 (1998): 71–82.

Lieu, J. M., J. North, and T. Rajak, eds. *The Jews among Pagans and Christians in the Roman Empire*. London: Routledge, 1992.

Lifshitz, B. *Donateurs et fondateurs dans les synagogues juives: répertoires des dédicaces grecques relatives à la construction et à la refection des synagogues.* Paris: Gabalda, 1967.

Lightstone, J. N. "Mishnah's Rhetoric, Other Material Artifacts of Late-Roman Galilee and the Social Formation of the Early Rabbinic Guild." In Wilson and Desjardins, *Text and Artifact in the Religions of Mediterranean Antiquity,* 474-502.

Lexicon Iconographicum Mythologiae Classicae (LIMC), vol. 4, pts. 1 and 2. Zurich: Artemis, 1988.

Linder, A. *The Jews in Roman Imperial Legislation.* Detroit: Wayne State University Press, 1987.

———. *The Jews in the Legal Sources of the Early Middle Ages.* Detroit: Wayne State University Press; Jerusalem: Israel Academy of Sciences and Humanities, 1997.

———. "The Legal Status of the Jews in the Roman Empire." In Katz, *Late Roman-Rabbinic Period,* 128-73.

Lingas, A. "The Liturgical Use of the Kontakion in Constantinople." In *Liturgy, Architecture and Art of the Byzantine World: Papers of the XVIII International Byzantine Congress (Moscow, 8-15 August 1991) and Other Essays Dedicated to the Memory of Fr. John Meyendorff,* edited by C. C. Akentiev, 50-57. St. Petersburg: Byzantinorossica, 1995.

Loehr, H. "The Concept of *Deuterosis* in Jewish-Christian Dialogue and Controversy." Lecture delivered at the Fourteenth World Congress of Jewish Studies, Jerusalem, 2005.

Loffreda, S. "Capernaum." In E. Stern, *NEAEHL,* 1:291-95.

L'Orange, H. P. *Art Forms and Civic Life in the Late Roman Empire.* Princeton: Princeton University Press, 1965.

———. *Likeness and Icon: Selected Studies in Classical and Early Medieval Art.* Odense: Odense University Press, 1973.

Lorberbaum, Y. *Image of God: Halakhah and Aggadah.* Tel Aviv: Schocken, 2004. Hebrew.

Lowrie, W. *Art in the Early Church.* New York: Pantheon, 1947.

Lüderitz, G. "What Is the *Politeuma?*" In van Henten and van der Horst, *Studies in Early Jewish Epigraphy,* 183-225.

Maas, M. *Exegesis and Empire in the Early Byzantine Mediterranean: Junillus Africanus and the Instituta Regularia Divinae Legis.* Tübingen: Mohr Siebeck, 2003.

———, ed. *The Cambridge Companion to the Age of Justinian.* Vol. 13. Cambridge, UK: Cambridge University Press, 2005.

MacDonald, D. "Dating the Fall of Dura-Europos." *Historia: Zeitschrift für Alte Geschichte* 35 (1986): 45-68.

MacDonald, J. *The Theology of the Samaritans.* London: SCM Press, 1964.

Machinist, P. "Assyria and Its Image in the First Isaiah." *JAOS* 103 (1983): 719-37.

———. "The First Coins of Judah and Samaria: Numismatics and History in the Achaemenid and Early Hellenistic Periods." In *Achaemenid History,* vol. 8, *Continuity and Change,* edited by H. Sancisi-Weerdenburg et al., 365-80. Leiden: Nederlands Instituut voor het Nabije Oosten, 1994.

———. "Mesopotamian Imperialism and Israelite Religion: A Case Study from the Second Isaiah." In Dever and Gitin, *Symbiosis, Symbolism, and the Power of the Past,* 237-64.

Mack, H. "The Unique Character of the Zippori Synagogue Mosaic and Eretz Israel *Midrashim.*" *Cathedra* 88 (1998): 39-56. Hebrew.

MacMullen, R. "Social Mobility and the Theodosian Code." *JRS* 54 (1964): 49-53.

———. *Paganism in the Roman Empire.* New Haven: Yale University Press, 1981.

———. "The Epigraphic Habit in the Roman Empire." *American Journal of Philology* 103 (1982): 233-46.

———. *Christianizing the Roman Empire, A. D. 100-400.* New Haven: Yale University Press, 1984.

———. "The Unromanized in Rome." In *Diasporas in Antiquity,* edited by S. J. D. Cohen and E. S. Frerichs, 47-64. Atlanta: Scholars, 1993.

————. *Christianity and Paganism in the Fourth to Eighth Centuries.* New Haven: Yale University Press, 1997.

————. *The Second Church: Popular Christianity, A.D. 200–400.* Atlanta: Society of Biblical Literature, 2009.

————. "Christian Ancestor Worship in Rome." *JBL* 129 (2010): 597–613.

Magen, Y. "Samaritan Synagogues." In *Early Christianity in Context: Monuments and Documents*, edited by F. Manns, 193–230. Jerusalem: Franciscan Printing, 1993.

————. "Samaritan Synagogues." In E. Stern and H. Eshel, *The Samaritans*, 382–443.

Magness, J. *Jerusalem Ceramic Chronology, circa 200–800 CE.* Sheffield: Journal for the Study of the Old Testament, 1993.

————. "The Cults of Isis and Kore at Samaria-Sebaste in the Hellenistic and Roman Periods." *HTR* 94 (2001): 157–77.

————. "The Question of the Synagogue: The Problem of Typology." In Avery-Peck and Neusner, *Judaism in Late Antiquity*, pt. 3, *Where We Stand*, 4:1–49.

————. "A Response to Eric M. Meyers and James F. Strange." In Avery-Peck and Neusner, *Judaism in Late Antiquity*, pt. 3, *Where We Stand*, 4:79–91.

————. "Synagogues in Ancient Palestine: Problems of Typology and Chronology." In L. I. Levine, *Continuity and Renewal*, 507–25. Hebrew.

————. "The Date of the Sardis Synagogue in Light of the Numismatic Evidence." *AJA* 109 (2005): 443–75.

————. "Heaven on Earth: Helios and the Zodiac Cycle in Ancient Palestinian Synagogues." *DOP* 59 (2005): 1–52.

————. "Ossuaries and the Burials of Jesus and James." *JBL* 124 (2005): 121–54.

————. "Did Galilee Decline in the Fifth Century? The Synagogue at Chorazin Reconsidered." In Zangenberg, Attridge, and Martin, *Religion, Ethnicity, and Identity in Ancient Galilee*, 259–74.

————. "The Arch of Titus at Rome and the Fate of the God of Israel." *JJS* 59 (2008): 201–17.

————. "Did Galilee Experience a Settlement Crisis in the Mid-Fourth Century?" In L. I. Levine and D. R. Schwartz, *Jewish Identities in Antiquity*, 296–313.

————. "Third Century Jews and Judaism at Beth Shearim and Dura Europus." In *Religious Diversity in Late Antiquity*, edited by D. M. Gwynn and S. Bangert, 143–64. Leiden: Brill, 2010.

————. *Stone and Dung, Oil and Spit: Jewish Daily Life in the Time of Jesus.* Grand Rapids: Eerdmans, 2011.

Magness, J., and G. Avni. "Jews and Christians in a Late Roman Cemetery at Beth Govrin." In Lapin, *Religious and Ethnic Communities*, 87–114.

Maguire, E. D. *Art and Holy Powers in the Early Christian House.* Urbana: Krannert Art Museum, University of Illinois at Urbana-Champaign, and University of Illinois Press, 1989.

Maguire, H. *The Earth and Ocean: the Terrestrial World in Early Byzantine Art.* University Park: College Art Association of America/Pennsylvania State University Press, 1987.

————, ed. *Byzantine Magic.* Washington, DC: Dumbarton Oaks Research Library and Collection, 1995.

————. "The Good Life." In Bowersock, Brown, and Grabar, *Interpreting Late Antiquity*, 238–57.

Maier, J. "Die Sonne im religiösen Denken des antiken Judentums." *ANRW* II.19.1 (1979): 346–412.

————. "The Piyyut 'Ha'omrim le-khilay shoa' and Anti-Christian Polemics." In *Studies in Aggadah, Targum and Jewish Liturgy in Memory of Joseph Heinemann*, edited by J. J. Petuchowski and E. Fleischer, 100–10. Jerusalem: Magnes and Hebrew Union College Press, 1981. Hebrew.

Mainstone, R. J. *Hagia Sophia: Architecture, Structure and Liturgy of Justinian's Great Church.* London: Thames and Hudson, 1988.

Majewski, L. J. "Evidence for the Interior Decoration of the Synagogue." *BASOR* 187 (1967): 32–50.

Mancini, I. *Archaeological Discoveries Relative to the Judaeo-Christians: Historical Survey.* Jerusalem: Franciscan Printing, 1970.

Mango, C. A. *The Art of the Byzantine Empire, 312-1453: Sources and Documents.* Englewood Cliffs, NJ: Prentice-Hall, 1972.

Mango, M. M. "Building and Architecture." In Cameron, Ward-Perkins, and Whitby, *Cambridge Ancient History,* 14:918–71.

Mann, J. "Gaonic Studies." In *Hebrew Union College Jubilee Volume, 1875-1925,* edited by D. Philipson et al., 237–48. Cincinnati: Hebrew Union College Press, 1925.

———. *The Bible as Read and Preached in the Old Synagogue.* 2 vols. Reprint, New York: KTAV, 1971. Hebrew.

Mann, V. B. "Between Worshiper and Wall: The Place of Art in Liturgical Spaces." In Langer and Fine, *Liturgy in the Life of the Synagogue,* 109–19. Winona Lake: Eisenbrauns, 2005.

Mann, V. B., and G. Tucker. *The Seminar on Jewish Art, January-September 1984—Proceedings.* New York: Jewish Theological Seminary and Jewish Museum, 1985.

Manor, D. W. "Massebah." In Freedman, *Anchor Bible Dictionary,* 4:602.

Mantel, H. *Studies in the History of the Sanhedrin.* Cambridge, MA: Harvard University Press, 1961.

Ma'oz, Z. U. "The Art and Architecture of the Synagogues of the Golan." In L. I. Levine, *Ancient Synagogues Revealed,* 98–115.

———. "Ancient Synagogues of the Golan." *BA* 51 (1988): 116–27.

———. "The Architecture and Art of Ancient Synagogues in the Golan." Ph.D. diss., Hebrew University, 1993. Hebrew.

———. "The Synagogue at Capernaum: A Radical Solution." In Humphrey, *Roman and Byzantine Near East,* 2:137–48.

———. *The Ghassanids and the Fall of the Golan Synagogue.* Qatzrin: Archaostyle, 2008.

Marazzi, F. "Rome in Transition: Economic and Political Change in the Fourth and Fifth Centuries." In *Early Medieval Rome and the Christian West: Essays in Honour of Donald A. Bullough,* edited by J. M. H. Smith, 21–41. Leiden: Brill, 2000.

Margoliot, M. *Palestinian Halakhah from the Genizah.* Jerusalem: Mossad Harav Kook, 1973. Hebrew.

Margalioth, M. *Sepher Ha-Razim: A Newly Recovered Book of Magic from the Talmudic Period.* Jerusalem: Yediot Achronot, 1966. Hebrew.

Markus, R. A. *The End of Ancient Christianity.* Cambridge, UK: Cambridge University Press, 1990.

———. "How on Earth Could Places Become Holy? Origins of the Christian Idea of Holy Places." *JECS* 2 (1994): 257–71.

Martin, D. B. "The Construction of the Ancient Family: Methodological Considerations." *JRS* 86 (1996): 40–60.

Mason, S. "Jews, Judaeans, Judaizing, Judaism: Problems of Categorization in Ancient History." *JSJ* 38 (2007): 457–512.

Mathews, T. F. *The Clash of Gods: A Reinterpretation of Early Christian Art* Princeton: Princeton University Press, 1993.

Matons, J. G. de, "Liturgie et hymnographie: kontakion et canon." *DOP* 34–35 (1980–81): 31–43.

Mattingly, D. J. *Imperialism, Power, and Identity: Experiencing the Roman Empire.* Princeton: Princeton University Press, 2011.

Maxwell, J. L. *Christianization and Communication in Late Antiquity: John Chrysostom and His Congregation in Antioch.* Cambridge, UK: Cambridge University Press, 2006.

May, N. "The Decor of the Korazim Synagogue Reliefs." In *The Synagogue of Korazim: The 1962-1964, 1980-1987 Excavations*, edited by Z. Yeivin, 111-56. Jerusalem: Israel Antiquities Authority, 2000. Hebrew (English summary, 51*-54*).

Mayer, L. A. *Bibliograpny of Jewish Art.* Jerusalem: Magnes, 1967.

Mazar, A. "'Bull' Site—an Iron Age I Open Cult Place." *BASOR* 247 (1982): 27-42.

———. "On Cult Places and Early Israelites: A Response to Michael Coogan." *BAR* 14, no. 4 (1988): 45.

———. *Archaeology of the Land of the Bible, 10,000-586 B.C.E.* New York: Doubleday, 1990.

———. "Jerusalem in the 10th Century B.C.E.: The Glass Half Full." In Y. Amit et al., *Essays on Ancient Israel and Its Near Eastern Context*, 255-72.

———. "An Ivory Statuette Depicting an Enthroned Figure from Tel Rehov." In *Bilder als Quellen, Images as Sources: Studies on Ancient Near Eastern Artefacts and the Bible Inspired by the Work of Othmar Keel*, edited by S. Bickel et al., 101-10. Fribourg: Academic; Göttingen: Vandenhoeck & Ruprecht, 2007.

Mazar, B. *Beth She'arim: Report on the Excavations during 1936-1940.* Vol. 1, *Catacombs 1-4.* New Brunswick, NJ: Rutgers University Press, 1973.

———. "'Those Who Buried Their Dead in Beth Shearim.'" *EI* 18 (1985): 293-99. Hebrew.

McCarter, P. K., Jr. "Aspects of the Religion of the Israelite Monarchy: Biblical and Epigraphic Data." In P. D. Miller, Jr., et al., *Ancient Israelite Religion*, 137-55.

McCollough, C. T. *Theodore of Cyrus as Biblical Interpreter and the Presence of Judaism in Later Roman Syria.* Ann Arbor: University Microfilms, 1985.

McCready, W. O., and A. Reinhartz, eds. *Common Judaism: Explorations in Second-Temple Judaism.* Minneapolis: Fortress, 2008.

McDonough, S. J. "A Question of Faith? Persecution and Political Centralization in the Sasanian Empire of Yazdgard II (438-457 CE)." In Drake, *Violence in Late Antiquity: Perceptions and Practices*, 69-81.

McGinn, B. *The Foundations of Mysticism: Origins to the Fifth Century.* Vol. 1 of *The Presence of God: A History of Western Christian Mysticism.* New York: Crossroad, 1995.

McKay, J. W. *Religion in Judah under the Assyrians, 732-609 BC.* Naperville, IL: A. R. Allenson, 1973.

McLaren, J. S. "The Coinage of the First Year as a Point of Reference for the Jewish Revolt, 66-70 CE." *SCI* 22 (2003): 135-52.

McVey, K. E., trans. and introduction. *Ephrem the Syrian: Hymns.* New York: Paulist, 1989.

Meecham, H. G., trans. and notes. *The Epistle to Diognetus.* Manchester, UK: Manchester University Press, 1949.

Meeks, W. A. *The Prophet-King: Moses Traditions and the Johannine Christology.* Leiden: Brill, 1967.

Meeks, W. A., and R. L. Wilken. *Jews and Christians in Antioch in the First Four Centuries of the Common Era.* Missoula: Scholars, 1978.

Meir, O. *Rabbi Judah the Patriarch: Palestinian and Babylonian Portrait of a Leader.* Tel Aviv: Hakibbutz Hameuchad, 1999. Hebrew.

Mendenhall, G. E. "The Hebrew Conquest of Palestine." *BA* 25 (1962): 66-87.

Merrony, M. W. "The Reconciliation of Paganism and Christianity in the Early Byzantine Mosaic Pavements of Arabia and Palestine." *LA* 48 (1998): 441-82.

Meshel, Z. "Kuntillet 'Ajrud." In Freedman, *Anchor Bible Dictionary*, 4:103-9.

———. "Kuntillet 'Ajrud." In E. M. Meyers, *Oxford Encyclopedia of Archaeology*, 3:310-12.

Meshorer, Y. "Sepphoris and Rome." In Morkholm and Waggoner, *Greek Numismatics and Archaeology*, 159-72.

———. "One Hundred Ninety Years of Tyrian Shekels." In *Studies in Honor of Leo Mildenberg: Numismatics, Art History, Archeology*, edited by A. Houghton et al., 171–80. Wetteren: Cultura, 1984.

———. *City Coins of Eretz-Israel and the Decapolis in the Roman Period*. Jerusalem: Israel Museum, 1985.

———. *A Treasury of Jewish Coins: From the Persian Period to Bar-Kokhba*. Jerusalem: Yad Izhak Ben-Zvi, 2001.

Mettinger, T. N. D. "The Veto on Images and the Aniconic God in Ancient Israel." In *Humanitas Religiosa: Festschrift für Haralds Biezais zu seinem 70. Geburtstag,* edited by Friends and Colleagues, 15–29. Stockholm: Almqvist & Wiksell International, 1979. Reprinted in *Religious Symbols and Their Functions: Based on Papers Read at the Symposium on Religious Symbols and Their Functions, Held at Åbo on the 28th–30th of August 1978: Turku, Finland*, edited by H. Biezais, 15–29. Stockholm: Almqvist & Wiksell International, 1979.

———. "YHWH SABAOTH—the Heavenly King on the Cherubim Throne." In *Studies in the Period of David and Solomon and Other Essays*, edited by T. Ishida, 109–38. Winona Lake: Eisenbrauns, 1982.

———. *No Graven Image? Israelite Aniconism in Its Ancient Near Eastern Context*. Stockholm: Almqvist & Wiksell International, 1995.

———. "Israelite Aniconism: Developments and Origins." In van der Toorn, *Image and the Book*, 173–204.

———. "A Conversation with My Critics: Cultic Image or Aniconism in the First Temple?" In Y. Amit et al., *Essays on Ancient Israel and Its Near Eastern Context*, 273–96.

Metzger, B. M. "Considerations of Methodology in the Study of the Mystery Religions and Early Christianity." *HTR* 48 (1955): 1–20.

Meyer, E. A. "Explaining the Epigraphic Habit in the Roman Empire: The Evidence of Epitaphs." *JRS* 80 (1990): 74–96.

Meyers, C. L. *The Tabernacle Menorah: A Synthetic Study of a Symbol from the Biblical Cult*. Missoula: Scholars, 1976.

———. "A Terracotta at the Harvard Semitic Museum and Disc-Holding Female Figures Reconsidered." *IEJ* 37 (1987): 116–22.

———. *Discovering Eve: Ancient Israelite Women in Context*. New York: Oxford University Press, 1988.

———. "Of Drums and Damsels: Women's Performance in Ancient Israel." *BAR* 54 (1991): 16–27.

———. "Cherubim." In Freedman, *Anchor Bible Dictionary*, 1:899–900.

Meyers, C. L., and E. M. Meyers. "Sepphoris." In E. M. Meyers, *Oxford Encyclopedia of Archaeology*, 4:531–36.

Meyers, C. L., et al. "The Dionysos Mosaic." In Nagy et al., *Sepphoris in Galilee*, 111–15.

Meyers, E. M. "Galilean Regionalism as a Factor in Historical Reconstruction." *BASOR* 221 (1976): 93–101.

———. "The Cultural Setting of Galilee: The Case of Regionalism and Early Judaism." *ANRW* II.19.1 (1979): 686–702.

———. "Galilean Regionalism: A Reappraisal." In *Approaches to the Study of Ancient Judaism*, edited by W. S. Green, 5:115–31. Chico: Scholars, 1985.

———. "Early Judaism and Christianity in the Light of Archaeology." *BA* 51 (1988): 69–79.

———. "Nabratein." In E. Stern, *NEAEHL*, 3:1077–79.

———, ed. *The Oxford Encyclopedia of Archaeology in the Near East*. 5 vols. New York: Oxford University Press, 1997.

———. "The Torah Shrine in the Ancient Synagogue: Another Look at the Evidence." *JSQ* 4 (1997): 303–38.

———. "The Early Roman Period at Sepphoris: Chronological, Archaeological, Literary, and Social Considerations." In *Hesed ve-Emet: Studies in Honor of Ernest S. Frerichs*, edited by J. Magness and S. Gitin, 343–55. Atlanta: Scholars, 1998.

———. "The Dating of the Gush Halav Synagogue: A Response to Jodi Magness." In Avery-Peck and Neusner, *Judaism in Late Antiquity*, pt. 3, *Where We Stand*, 4:49–70.

———. "Jewish Art and Architecture in the Land of Israel, 70–c.235." In Katz, *Late Roman-Rabbinic Period*, 174–90.

———. "Were the Hasmoneans Really Aniconic?" *Images: A Journal of Jewish Art and Visual Culture* 1 (2007): 24–25.

———. "Sanders's 'Common Judaism' and the Common Judaism of Material Culture." In Undoh et al., *Redefining First-Century Jewish and Christian Identities*, 153–74.

Meyers, E. M., and C. L. Meyers. *Excavations at Ancient Nabratein: Synagogue and Environs*. Winona Lake: Eisenbrauns, 2009.

Meyers, E. M., et al., eds. *Galilee through the Centuries: Confluence of Cultures, Proceedings of the Second International Conference in Galilee*. Winona Lake: Eisenbrauns, 1999.

Meyshan, J. "The Symbols on the Coinage of Herod the Great and Their Meanings." *PEQ* 91 (1959): 109–21.

———. *Essays in Jewish Numismatics*. Jerusalem: Israel Numismatic Society, 1968.

Michael, R. "Antisemitism and the Church Fathers." In *Jewish-Christian Encounters over the Centuries*, edited by M. Perry and F. M. Schweitzer, 101–29. New York: P. Lang, 1994.

Milburn, R. L. P. *Early Christian Art and Architecture*. Berkeley: University of California Press, 1988.

Mildenberg, L. "Yehud: A Preliminary Study of the Provincial Coinage of Judaea." In Morkholm and Waggoner, *Greek Numismatics and Archaeology*, 183–96.

———. *The Coinage of the Bar Kokhba War*. Aarau: Sauerländer, 1984.

———. *Vestigia Leonis: Studien zur antiken Numismatik Israels, Palästinas und der östlichen Mittelmeerwelt*, ed. U. Hübner and E. A. Knauf. Freiburg: Universitätsverlag; Göttingen: Vanderhoeck & Ruprecht, 1998.

Miles, M. R. *Image as Insight: Visual Understanding in Western Christianity and Secular Culture*. Boston: Beacon, 1985.

Milgrom, J. *The JPS Commentary—Numbers*. Philadelphia: Jewish Publication Society, 1990.

———. "The Nature of Revelation and Mosaic Origins." In *Etz Hayim: Torah and Commentary*, edited by D. L. Lieber et al., 1405–7. Philadelphia: Jewish Publication Society, 2001.

Millar, F. *The Emperor in the Roman World (31 BC–AD 337)*. Ithaca: Cornell University Press, 1992.

———. "The Jews of the Graeco-Roman Diaspora between Paganism and Christianity, A.D. 312–438." In Lieu, North, and Rajak, *Jews among Pagans and Christians*, 97–123.

———. *The Roman Near East, 31 B.C.–A.D. 337*. Cambridge, MA: Harvard University Press, 1993.

———. "Ethnic Identity in the Roman Near East, 325–450: Language, Religion, and Culture." *Mediterranean Archaeology* 11 (1998): 159–76.

———. "Christian Emperors, Christian Church and the Jews of the Diaspora in the Greek East, CE 379–450." *JJS* 55 (2004): 1–24.

———. "Repentant Heretics in Fifth-Century Lydia: Identity and Literacy." *SCI* 23 (2004): 111–30.

———. "*The Many Worlds of the Late Antique Diaspora:* Supplements to the *Cambridge History of Judaism*, vol. IV" (review). *JJS* 59 (2008): 120–38.

———. "Inscriptions, Synagogues and Rabbis in Late Antique Palestine." *JSJ* 42 (2011): 253–77.

———. "Narrative and Identity in Mosaics from the Late Roman Near East: Pagan, Jewish, and Christian." In Eliav et al., *Sculptural Environment*, 225–56.

————. "The Palestinian Context of Rabbinic Judaism." In Goodman and Alexander, *Rabbinic Texts and the History of Late-Roman Palestine*, 25–49.

Miller, J. H. "Deconstructing the Deconstructors." *Diacritics* 5 (1975): 24–31.

Miller, J. M., and J. H. Hayes. *A History of Ancient Israel and Judah,* 2nd ed. Louisville: Westminster John Knox, 2006.

Miller, P. D., Jr. *Ancient Israelite Religion: Essays in Honor of Frank Moore Cross*, 115–24. Philadelphia: Fortress, 1987.

————. *The Religion of Ancient Israel*. Louisville: Westminster John Knox, 2000.

Miller, S. S. *Studies in the History and Traditions of Sepphoris*. Leiden: Brill, 1984.

————. "Stepped Pools and the Non-Existent Monolithic 'Miqveh.'" In D. R. Edwards and McCollough, *Archaeology of Difference*, 215–31.

————. "Intercity Relations in Roman Palestine: The Case of Sepphoris and Tiberias." *AJS Review* 12 (1987): 1–24.

————. "The *Minim* of Sepphoris Reconsidered." *HTR* 86 (1993): 377–402.

————. "Further Thoughts on the *Minim* of Sepphoris." In *Proceedings of the Eleventh World Congress of Jewish Studies,* Division B/1, *The History of the Jewish People*, 1–8. Jerusalem: World Union of Jewish Studies, 1994.

————. "Jewish Sepphoris: A Great City of Scholars and Scribes." In Nagy et al., *Sepphoris in Galilee*, 59–65.

————. "On the Number of Synagogues in the Cities of 'Erez Israel." *JJS* 49 (1998): 51–66.

————. "The Rabbis and the Non-Existent Monolithic Synagogue." In Fine, *Jews, Christians, and Polytheists in the Ancient Synagogue*, 57–70.

————. "Some Observations on Stone Vessel Finds and Ritual Purity in Light of Talmudic Sources." In *Zeichen aus Text und Stein: Studien auf dem Weg zu einer Archäologie des Neuen Testaments*, edited by S. Alkier and J. Zangenberg, 402–19. Tübingen: Francke, 2003.

————. "'Epigraphical' Rabbis, Helios, and Psalm 19: Were the Synagogues of Archaeology and the Synagogues of the Sages One and the Same?" *JQR* 94 (2004): 27–76.

————. *Sages and Commoners in Late Antique 'Erez Israel: A Philological Inquiry into Local Traditions in Talmud Yerushalmi*. Tübingen: Mohr Siebeck, 2006.

Milson, D. "Ecclesiastical Furniture in Late Antique Synagogues in Palestine." In Mitchell and Greatrex, *Ethnicity and Culture in Late Antiquity*, 221–40.

Mirsky, A. *Yosse ben Yosse: Poems*. Jerusalem: Bialik, 1977. Hebrew.

————. *The Piyut: The Development of Post-Biblical Poetry in Eretz Israel and the Diaspora*. Jerusalem: Magnes, 1990. Hebrew.

Misgav, H. "Synagogue Inscriptions from the Mishnah and Talmud Period." In Y. Eshel et al., *And Let Them Make Me a Sanctuary*, 49–56.

————. *The List of Fast Days Found in the Synagogue of Rehov*. Jerusalem: Israel Museum, forthcoming.

Mitchell, S. *Anatolia: Land, Men, and Gods in Asia Minor*. Vol. 2, *The Rise of the Church*. Oxford: Clarendon, 1993.

————. "The Cult of Theos Hypsistos between Pagans, Jews, and Christians." In Athanassiadi and Frede, *Pagan Monotheism in Late Antiquity*, 81–148.

————. "An Apostle to Ankara from the New Jerusalem: Montanists and Jews in Late Roman Asia Minor." *SCI* 24 (2005): 207–23.

————. *A History of the Later Roman Empire, AD 284–641: The Transformation of the Ancient World*. Malden, MA and Oxford: Blackwell, 2007.

Mitchell, S., and G. Greatrex, eds. *Ethnicity and Culture in Late Antiquity*. London: Duckworth and Classical Press of Wales, 2000.

Mitten, D. G., and A. F. Scorziello. "Reappropriating Antiquity: Some Spolia from the Synagogue at Sardis." In *Love for Lydia: A Sardis Anniversary Volume Presented to Crawford H. Greenewalt, Jr.*, edited by N. D. Cahill, 135–46. Cambridge, MA: Archaeological Exploration of Sardis, 2008.

Mittmann, S. *Beiträge zur Siedlungs-und Territorialgeschichte des nördlichen Ostjordanlandes.* Wiesbaden: O. Harrassowitz, 1970.

Moberg, A. *The Book of the Himyarites: Fragments of a Hitherto Unknown Syriac Work.* Lund: Gleerup, 1924.

Möller, C., and G. Schmitt. *Siedlungen Palästinas nach Flavius Josephus.* Wiesbaden: L. Reichert, 1976.

Momigliano, A. "I nomi delle prime sinagoghe romane, e la condizione giuridica delle comunità in Roma sotto Augusto." *La rassegna mensile di Israel* 6 (1931): 283–92.

———. *On Pagans, Jews, and Christians.* Middletown, CT: Wesleyan University Press, 1987.

Montgomery, J. A. *The Samaritans, the Earliest Jewish Sect: Their History, Theology, and Literature.* Reprint, New York: KTAV, 1968.

Moon, W. G. "Nudity and Narrative: Observations on the Frescoes from the Dura Synagogue." *Journal of the American Academy of Religion* 55 (1992): 587–658.

Moore, C., ed. *The Visual Dimension: Aspects of Jewish Art, Published in Memory of Isaiah Shachar (1935–1977).* Boulder: Westview, 1993.

Mor, M. *From Samaria to Shechem: The Samaritan Community in Antiquity.* Jerusalem: Zalman Shazar Center for Jewish History, 2003. Hebrew.

Morgan, M. A. *Sepher Ha-Razim (The Book of the Mysteries).* Chico: Scholars, 1983.

Morgenstern, J. *The Fire upon the Altar.* Chicago: Quadrangle, 1963.

Mørkholm, O., and N. M. Waggoner, eds. *Greek Numismatics and Archaeology: Essays in Honor of Margaret Thompson.* Wetteren: Cultura, 1979.

Morony, M. G. "Teleology and the Significance of Change." In *Tradition and Innovation in Late Antiquity*, edited by F. M. Clover and R. S. Humphreys, 21–26. Madison: University of Wisconsin Press, 1989.

Morray-Jones, C. R. A. "Transformational Mysticism in the Apocalyptic-Merkabah Tradition," *JJS* 43 (1992): 1–31.

Morris, I. *Death-Ritual and Social Structure in Classical Antiquity.* Cambridge, UK: Cambridge University Press, 1992.

Mortensen, B. P. *The Priesthood in Targum Pseudo-Jonathan: Renewing the Profession.* 2 vols. Leiden: Brill, 2006.

Moscovitz, L. "*Sugyot Muhlafot* in the Talmud Yerushalmi." *Tarbiz* 60 (1990): 19–66. Hebrew.

Mucznik, S. A. Ovadiah, and Gomez de Silva, C. "The Meroth Mosaic Reconsidered." *JJS* 47 (1996): 286–93.

Müller, N. *Die jüdische Katakombe am Monteverde zu Rom: der älteste bisher bekannt gewordene jüdische Friedhof des Abendlandes.* Leipzig: G. Fock, 1912.

Müller, N., and N. A. Bees. *Die Inschriften der judischen Katakombe am Monteverde zu Rom.* Leipzig: O. Harrassowitz, 1919.

Münz-Manor, O. "All about Sarah: Questions of Gender in Yannai's Poems on Sarah's (and Abraham's) Barrenness." *Prooftexts* 26 (2006): 344–74.

———. "Reflections on the Nature of Jewish and Christian Poetry in Late Antiquity." *Pe'amim* 119 (2009): 131–72. Hebrew.

———. "Liturgical Poetry in the Late Antique Near East: A Comparative Approach," *Journal of Ancient Judaism* 1, no. 3 (2010): 336–61.

Mulder, M. J., ed. *Mikra: Text, Translation, Reading and Interpretation of the Hebrew Bible in Ancient Judaism and Early Christianity.* Assen: Van Gorcum, 1988.

Murphy, C. *Rebirth and Afterlife: A Study of the Transmutation of Some Pagan Imagery in Early Christian Funerary Art.* Oxford: B.A.R., 1981.

Murray, (M.) C. "Art and the Early Church." *JTS* 28 (1977): 303–45.

———. "The Christian Zodiac on a Font at Hook Norton: Theology, Church, and Art." In Wood, *Church and the Arts*, 87–97.

Mussies, G. "Jewish Personal Names in Some Non-Literary Sources." In van Henten and van der Horst, *Studies in Early Jewish Epigraphy*, 242–76.

Na'aman, N. "Sources and Composition in the History of David." In Fritz and Davies, *Origins of the Ancient Israelite States*, 170–86.

———. "No Anthropomorphic Graven Image: Notes on the Assumed Anthropomorphic Cult Statues in the Temples of YHWH in the Pre-Exilic Period." *Ugarit-Forschungen* 31 (1999): 391–415.

———. *Ancient Israel's History and Historiography: The First Temple Period*. Winona Lake: Eisenbrauns, 2006.

Naeh, S. "The Structure and the Division of *Torah Kohanim* (B): *Parashot, Perakim, Halakhot*." *Tarbiz* 69 (1999): 59–104. Hebrew.

Nagy, R. M., et al., eds. *Sepphoris in Galilee: Crosscurrents of Culture*. Raleigh: North Carolina Museum of Art, 1996.

Nakhai, B. A. *Archaeology and the Religions of Canaan and Israel*. Boston: American Schools of Oriental Research, 2001.

Namenyi, E. *The Essence of Jewish Art*. New York: Thomas Yoseloff, 1960.

Nani, T. G. "ΘΡΕΠΤΟ." *Epigraphica* 5–6 (1943–44): 45–84.

Narkiss, B. "The Image of Jerusalem in Art." *Ha'universita* 13 (1968): 11–20.

———. "A Scheme of the Sanctuary from the Time of Herod the Great." *JJA* 1 (1974): 6–15.

———. "Pagan, Christian, and Jewish Elements in the Art of Ancient Synagogues." In L. I. Levine, *Synagogue in Late Antiquity*, 183–88.

Narkiss, M. "The Snuff-Shovel as a Jewish Symbol." *JPOS* 15 (1935): 14–28.

Nau, F. "Résumé de monographies syriaques: Histoires de Barsauma de Nisibe." *Revue de l'Orient Chrétien* 18 (1913): 382–85.

———. "Deux épisodes de l'histoire juive sous Théodose II (423 et 438) d'après la vie de Barsauma le Syrien." *REJ* 83 (1927): 184–206.

Naveh, J. *On Stone and Mosaic: The Aramaic and Hebrew Inscriptions from Ancient Synagogues*. Jerusalem: Israel Exploration Society and Carta, 1978. Hebrew.

———. "Graffiti and Dedications." *BASOR* 235 (1979): 27–30.

Naveh, J., and S. Shaked. *Amulets and Magical Bowls: Aramaic Incantations of Late Antiquity*. Jerusalem: Magnes, 1985.

———. *Magic Spells and Formulae: Aramaic Incantations of Late Antiquity*. Jerusalem: Magnes, 1993.

Nedomački, V. "A Contribution to the Discussion: 'Is There a Jewish Art?'" In Moore, *Visual Dimension*, 21–23.

Ne'eman, Y. *Sepphoris in the Period of the Second Temple, the Mishnah and the Talmud*. Jerusalem: Shem, 1993. Hebrew.

Neis, R. "Vision and Visuality in Late Antique Rabbinic Culture." Ph.D. diss., Harvard University, 2007.

Ness, L. J. *Astrology and Judaism in Late Antiquity*. Ann Arbor: University Microfilms International, 1990.

———. "Astrology and Judaism in Late Antiquity." *The Ancient World* 26 (1995): 126–33.

———. "The Zodiac in the Synagogue." *Journal of Ancient Civilization* 12 (1997): 81–92.

Netzer, E. "Tyros, 'The Floating Palace.'" In Wilson and Desjardins, *Text and Artifact in the Religions of Mediterranean Antiquity*, 340–53.

———. *Hasmonean and Herodian Palaces at Jericho*. Vol. 1. Jerusalem: Israel Exploration Society, 2001.

———. *Architecture of Herod, the Great Builder*. Tübingen: Mohr Siebeck, 2006.

Netzer, E., and G. Foerster. "The Synagogue at Saranda, Albania." *Qadmoniot* 38, no. 129 (2005): 45–53. Hebrew.

Neubauer, A. *La géographie du Talmud*. Hildesheim: G. Olms, 1967.

Neuberg, F. *Glass in Antiquity*. London: Art Trade, 1949.

Neusner, J. *A History of the Jews in Babylonia,* 5 vols. Leiden: Brill, 1965–70.

———. *Aphrahat and Judaism: The Christian-Jewish Argument in Fourth-Century Iran*. Leiden: Brill, 1971.

———. *Eliezer Ben Hyrcanus: The Tradition and the Man*, 2 vols. Leiden: Brill, 1973.

———. *The Death and Birth of Judaism: The Impact of Christianity, Secularism, and the Holocaust on Jewish Faith*. New York: Basic, 1987.

———. *Judaism and Christianity in the Age of Constantine: History, Messiah, Israel, and the Initial Confrontation*. Chicago: University of Chicago Press, 1987.

———. *Judaism in the Matrix of Christianity*. Atlanta: Scholars, 1992.

———, ed. *Judaism in Late Antiquity*. Pt. 1, *The Literary and Archaeological Sources*. Leiden: Brill, 1995. Reprinted as vol. 1, pt. 1. Leiden: Brill, 2001.

———, ed. *Judaism in Late Antiquity*. Pt. 2, *Historical Syntheses*. Leiden: Brill, 1995. Reprinted as vol. 1, pt. 2. Leiden: Brill, 2001.

———. "The Mishnah in Roman and Christian Contexts." In Avery-Peck and Neusner, *Mishnah in Contemporary Perspective*, 121–48.

———. *Transformations in Ancient Judaism: Textual Evidence for Creative Responses to Crisis*. Peabody, MA: Hendrickson, 2004.

Newby, Z. "Art and Identity in Asia Minor." In S. Scott and J. Webster, *Roman Imperialism and Provincial Art*, 192–213.

———. "Art at the Crossroads? Themes and Styles in Severan Art." In Swain et al., *Severan Culture*, 201–49.

Newman, H. I. "Jerome and the Jews." Ph.D. diss., Hebrew University of Jerusalem, 1997. Hebrew.

———. "The Death of Jesus in the 'Toledot Yeshu' Literature." *JTS* 50 (1999): 59–79.

———. *The Ma'asim of the People of the Land of Israel: Halakhah and History in Byzantine Palestine*. Jerusalem: Yad Izhak Ben-Zvi, 2011. Hebrew.

———. "The Bishops of Sepphoris: Christianity and Synagogue Iconography in the Late Fourth and Early Fifth Centuries." In Weiss et al., *"Follow the Wise,"* 85–99.

Nicolai, V. F., F. Bisconti, and D. Mazzoleni. *The Christian Catacombs of Rome: History, Decoration, Inscriptions*. Regensburg: Schnell & Steiner, 1999.

Niehr, H. "The Rise of YHWH in Judahite and Israelite Religion: Methodological and Religio-Historical Aspects." In Edelman, *Triumph of Elohim*, 45–74.

———. "In Search of YHWH's Cult Statue in the First Temple." In van der Toorn, *Image and the Book*, 73–96.

———. "'Israelite' Religion and 'Canaanite' Religion." In *Religious Diversity in Ancient Israel and Judah*, edited by F. Stavrakopoulou and J. Barton, 23–36. London: T & T Clark, 2010.

Nijf, O. M. van, *The Civic World of Professional Associations in the Roman East*. Amsterdam: J. C. Gieben, 1997.

Niquet, H. "Jews in the Iberian Peninsula in Roman Times." *SCI* 23 (2004): 159–82.

Nock, A. D. *Conversion: The Old and the New in Religion from Alexander the Great to Augustine of Hippo*. Oxford: Clarendon, 1933.

Noethlichs, K.-L. *Die Juden im christlichen Imperium Romanum (4.-6. Jahrhundert)*. Berlin: Akademie, 2001.

Norman, A. F. *Libanius, Selected Orations*. Vol. 1, *Julianic Orations*. Cambridge, MA: Harvard University Press, 1969.

North, J. "The Development of Religious Pluralism." In Lieu, North, and Rajak, *Jews among Pagans and Christians*, 174–93.

Noy, D. *Jewish Inscriptions of Western Europe*. Vol. 1, *Italy (excluding the City of Rome), Spain and Gaul*. Cambridge, UK: Cambridge University Press, 1993.

———. "The Jewish Communities of Leontopolis and Venosa." In van Henten and van der Horst, *Studies in Early Jewish Epigraphy*, 162–82.

———. *Jewish Inscriptions of Western Europe.* Vol. 2, *The City of Rome.* Cambridge, UK: Cambridge University Press, 1995.

———. "Writing in Tongues: The Use of Greek, Latin and Hebrew in Jewish Inscriptions from Roman Italy." *JJS* 48 (1997): 300–11.

———. "Where Were the Jews of the Diaspora Buried?" In Goodman, *Jews in a Graeco-Roman World*, 75–89.

———. *Foreigners at Rome: Citizens and Strangers.* London: Duckworth, 2000.

———. "Immigrants in Late Imperial Rome." In Mitchell and Greatrex, *Ethnicity and Culture in Late Antiquity*, 15–30.

———. "The Jews in Italy in the First to Sixth Centuries C.E." In *The Jews of Italy: Memory and Identity*, edited by B. D. Cooperman and B. Garvin, 47–64. Bethesda: University Press of Maryland, 2000.

———. "Being an Egyptian in Rome. Strategies of Identity Formation." In Zangenberg and Labahn, *Christians as a Religious Minority in a Multicultural City*, 47–76.

———. "Rabbi Aqiba Comes to Rome: A Jewish Pilgrimage in Reverse?" In *Pilgrimage in Graeco-Roman & Early Christian Antiquity: Seeing the Gods*, edited by J. Elsner and I. Rutherford, 373–85. Oxford: Oxford University Press, 2005.

Noy, D., and H. Bloedhorn. *Inscriptiones Judaicae Orientis.* Vol. 3, *Syria and Cyprus.* Tübingen: Mohr Siebeck, 2004.

Noy, D., A. Panayotov, and H. Bloedhorn. *Inscriptiones Judaicae Orientis.* Vol. 1, *Eastern Europe.* Tübingen: Mohr Siebeck, 2004.

Olin, M. "From Bezal'el to Max Liebermann: Jewish Art in Nineteenth-Century Historical Texts." In *Jewish Identity in Modern Art History*, edited by C. M. Soussloff, 19–40. Berkeley: University of California Press, 1999.

Olster, D. M. *Roman Defeat, Christian Response, and the Literary Construction of the Jew.* Philadelphia: University of Pennsylvania Press, 1994.

Olyan, S. M. *Asherah and the Cult of Yahweh in Israel.* Atlanta: Scholars, 1988.

O'Meara, D. J. *Plotinus: An Introduction to the Enneads.* Oxford: Clarendon, 1993.

Oppenheimer, A. *Babylonia Judaica in the Talmudic Period.* Wiesbaden: L. Reichert, 1983.

———. *Galilee in the Mishnaic Period.* Jerusalem: Zalman Shazar Center for Jewish History, 1991. Hebrew.

———. *Between Rome and Babylon: Studies in Jewish Leadership and Society.* Tübingen: Mohr Siebeck, 2005.

———. "The Severan Emperors, Rabbi Judah ha-Nasi and the Cities of Palestine." In *"The Words of a Wise Man's Mouth are Gracious" (Qoh 10, 12): Festschrift for Günter Stemberger on the Occasion of his 65th Birthday*, edited by M. Perani, 171–81. Berlin: de Gruyter, 2005.

———. *Rabbi Judah ha-Nasi.* Jerusalem: Zalman Shazar Center for Jewish History, 2007. Hebrew.

Oppenheimer, A., and U. Rappaport, eds. *The Bar-Kokhva Revolt: A New Approach.* Jerusalem: Yad Izhak Ben-Zvi, 1984. Hebrew.

Ornan, T. *The Triumph of the Symbol: Pictorial Representation of Deities in Mesopotamia and the Biblical Image Ban.* Fribourg: Academic; Göttingen: Vandenhoeck & Ruprecht, 2005.

Osterloh, K. L. "Judea, Rome and the Hellenistic *Oikoumenê*: Emulation and the Reinvention of Communal Identity." In Iricinschi and Zellentin, *Heresy and Identity*, 168–206.

Otto, W. F. *Herodes: Beiträge zur Geschichte des letzten jüdischen Königshauses.* Stuttgart: J. B. Metzler, 1913.

Ovadiah, A. "Excavations in the Area of the Ancient Synagogue at Gaza (Preliminary Report)." *IEJ* 19 (1969): 193–98.

———. *Corpus of the Byzantine Churches in the Holy Land.* Bonn: P. Hanstein, 1970.

———. "Mutual Influences between Synagogues and Churches in Byzantine Palestine." In *Between Hermon and Sinai: Memorial to Amnon,* edited by M. Broshi, 163–70. Jerusalem: Yedidim, 1977. Hebrew.

———. "The Synagogue at Gaza." In L. I. Levine, *Ancient Synagogues Revealed,* 129–32.

———. "Art of the Ancient Synagogues in Israel." In Urman and Flesher, *Ancient Synagogues,* 2:301–18.

———. "The Mosaic Workshop of Gaza in Christian Antiquity." In Urman and Flesher, *Ancient Synagogues,* 2:367–72.

———. *Art and Archaeology in Israel and Neighbouring Countries: Antiquity and Late Antiquity.* London: Pindar, 2002.

———. "Mosaic Pavements of the Herodian Period in Israel." In A. Ovadiah, *Art and Archaeology in Israel and Neighbouring Countries,* 328–43.

———. "Orpheus from Jerusalem—Pagan or Christian Image?" In A. Ovadiah, *Art and Archaeology in Israel and Neighbouring Countries,* 427–46.

———. "Orpheus Mosaics in the Roman and Early Byzantine Periods." In A. Ovadiah, *Art and Archaeology in Israel and Neighbouring Countries,* 528–46.

Ovadiah, A., and S. Mucznik. "Orpheus from Jerusalem—Pagan or Christian Image?" In L. I. Levine, *Jerusalem Cathedra,* 1:152–66.

———. "The End of Days in the Mosaics of the Meroth Synagogue." In *Art in Eretz Israel in Late Antiquity: Collectanea,* edited by S. Mucznik, A. Ovadiah, and Y. Turnheim, 209–22. Tel Aviv: Tel Aviv University, 2004.

Ovadiah, A., and Y. Turnheim. *"Peopled" Scrolls in Roman Architectural Decoration in Israel: The Roman Theatre at Beth Shean/Scythopolis.* Rome: Bretschneider, 1994.

Ovadiah, R. "Jonah in a Mosaic Pavement at Beth Guvrin." *IEJ* 24 (1974): 214–15.

Ovadiah, R. and A. *Hellenistic, Roman, and Early Byzantine Mosaic Pavements in Israel.* Rome: "L'Erma" di Bretschneider, 1987.

Overman, J. A., and R. S. MacLennan, eds. *Diaspora Jews and Judaism: Essays in Honor of, and in Dialogue with, A. Thomas Kraabel.* Atlanta: Scholars, 1992.

Palmer, R. E. A. "The Topography and Social History of Rome's Trastevere (Southern Sector)." *Proceedings of the American Philosophical Society* 125 (1981): 368–97.

Panofsky, E. *Idea: A Concept in Art Theory.* Columbia: University of South Carolina Press, 1968.

Parker, S. T. "An Empire's New Holy Land: The Byzantine Period." *NEA* 62 (1999): 134–80.

Parkes, J. *The Conflict of the Church and the Synagogue: A Study in the Origins of Antisemitism.* Cleveland: Meridian, 1961.

Parlasca, K. *Die römischen Mosaiken in Deutschland.* Berlin: de Gruyter, 1959.

Parrish, D. *Season Mosaics of Roman North Africa.* Rome: Bretschneider, 1984.

———, ed. *Urbanism in Western Asia Minor: New Studies on Aphrodisias, Ephesos, Hierapolis, Pergamon, Perge and Xanthos.* Portsmouth, RI: Journal of Roman Archaeology, 2001.

Patrich, J. "Caves of Refuge and Jewish Inscriptions on the Cliffs of Nahal Michmas." *EI* 18 (1985): 153–66. Hebrew.

———. *The Formation of Nabatean Art: Prohibition of a Graven Image among the Nabateans.* Jerusalem: Magnes; Leiden: Brill, 1990.

———. "The Golden Vine, the Sanctuary Portal, and Its Depiction on the Bar-Kokhba Coins." *JA* 19–20 (1993–94): 56–61.

———. "Church, State and the Transformation of Palestine: The Byzantine Period, 324–640." In *The Archaeology of Society in the Holy Land,* by T. E. Levy, 470–84. London: Leicester University Press, 1995.

Patterson, J. R. "On the Margins of the City of Rome." In Hope and Marshall, *Death and Disease,* 85–103.

Paz, S. *Drums, Women, and Goddesses: Drumming and Gender in Iron Age II Israel*. Fribourg: Academic; Göttingen: Vandenhoeck & Ruprecht, 2007.

Peckham, B. "Israel and Phoenicia." In *Magnalia Dei, The Mighty Acts of God: Essays on the Bible and Archaeology in Memory of G. Ernest Wright*, edited by Frank M. Cross et al., 224–48. Garden City, NY: Doubleday, 1976.

Pedley, J. G. *Ancient Literary Sources on Sardis*. Cambridge, MA: Harvard University Press, 1972.

Peleg, O. "Herodian Architectural Decoration." In Netzer, *Architecture of Herod*, 320–38.

Penna, R. "Les juifs à Rome au temps de l'Apôtre Paul." *NTS* 28 (1982): 321–47.

Pergola, P. "Le catacombe romane, miti e realtà (a proposito del cimitero del Domitilla)." In *Societa romana e impero tardoantico*. Vol. 2, *Roma: politica, economia, paesaggio urbano*, edited by A. Giardina, 332–50. Rome: Laterza, 1986.

———. *Le catacombe romane: storia e topografia*. Rome: Carocci, 1997.

———. *Christian Rome: Early Christian Rome, Catacombs and Basilicas*. Rome: Vision, 2000.

Perkins, A. *The Art of Dura-Europos*. Oxford: Clarendon, 1973.

Person, R. F., Jr. *The Deuteronomic School: History, Social Setting, and Literature*. Atlanta: Society of Biblical Literature, 2002.

Pfanner, M. *Der Titusbogen*. Mainz am Rhein: Philipp von Zabern, 1983.

Pharr, C. *The Theodosian Code*. Princeton: Princeton University Press, 1952.

Philo. LCL. 11 vols. Cambridge, MA: Harvard University, 1949–62.

Pietri, Ch. *Roma Christiana: Recherches sur l'Eglise de Rome, son organisation, sa politique, son idéologie de Miltiade à Sixte III (311-440)*. Rome: École Française de Rome, 1976.

Piccirillo, M. *The Mosaics of Jordan*. Amman: American Center of Oriental Research, 1993.

Piccirillo, M., and E. Alliata. *Mount Nebo: New Archaeological Excavations, 1967-1997*. 2 vols. Jerusalem: Studium Biblicum Franciscanum, 1998.

Piganiol, A. *L'empire chrétien (325-395)*. Paris: Presses universitaires de France, 1947.

Ponce, N. *Arabesques antiques des bains de Livie, et de la Ville Adrienne*. Paris: M. Ponce, 1789.

Posèq, A. W. G. "The 'Aqedah' of Bet Alpha and the Problem of Perspective in Ancient Jewish Art." *Rimonim* 2 (1986): 22–31. Hebrew.

———. "Toward a Semiotic Approach to Jewish Art." *Ars Judaica* 1 (2005): 27–50.

Press, I. *A Topographical-Historical Encyclopaedia of Palestine*, 4 vols. Jerusalem: R. Mass, 1946–55. Hebrew.

Price, J. J. "The Place of Synagogue Inscriptions in the Epigraphic Culture of the Roman Near East." Lecture delivered at the annual ASOR conference, San Francisco, 2011.

Price, J. J., and H. Misgav. "Jewish Inscriptions and Their Use." In S. Safrai et al., *Literature of the Sages*, 2:461–83.

Price, S. R. F. *Rituals and Power: The Roman Imperial Cult in Asia Minor*. Cambridge, UK: Cambridge University Press, 1984.

Pritchard, J. B. *Palestinian Figurines in Relation to Certain Goddesses Known through Literature*. New Haven: American Oriental Society, 1943.

———. *The Ancient Near East in Pictures Relating to the Old Testament* Princeton: Princeton University Press, 1954.

Pucci Ben Zeev, M. *Jewish Rights in the Roman World: The Greek and Roman Documents Quoted by Josephus Flavius*. Tübingen: Mohr Siebeck, 1998.

Puech, E. "Inscriptions funéraires palestiniennes: tombeau de Jason et ossuaires." *RB* 90 (1983): 481–533.

Purcell, N. "The Populace of Rome in Late Antiquity: Problems of Classification and Historical Description." In *The Transformations of Urbs Roma in Late Antiquity*, edited by W. V. Harris, 135–61. Portsmouth, RI: Journal of Roman Archaeology, 1999.

Rabb, T. K., and J. Brown. "The Evidence of Art: Images and Meaning in History." *Journal of Interdisciplinary History* 17 (1986): 1–6.

Rabello, A. M. "Le iscrizioni ebraiche della Spagna romana e visigotica." In *Studi in onore di Cesare Sanfilippo*, edited by Facoltà di Giurisprudenza, Università di Catania, 647–62. Milan: Giuffrè, 1985.

———. *Giustiniano, ebrei e samaritani: alla luce delle fonti storico-letterarie, ecclesiastiche e giuridiche*. 2 vols. Milan: Giuffrè, 1987–88.

———. "The Situation of the Jews in Roman Spain." In Isaac and Oppenheimer, *Studies on the Jewish Diaspora*, 160–90.

———. "Civic Jewish Jurisdiction in the Days of Emperor Justinian (527–565): Codex Justinianus 1.9.8." *Israel Law Review* 33 (1999): 51–66.

———. *The Jews in the Roman Empire: Legal Problems, from Herod to Justinian*. Aldershot: Ashgate, 2000.

———. "Justinian and the Revision of Jewish Legal Status." In Katz, *Late Roman–Rabbinic Period*, 1073–76.

Rabinowitz, R. *Diqduqei Soferim*. 12 vols. 1868; facsimile ed., Jerusalem: Or Hahokhma, 2002. Hebrew.

Rahmani, L. Y. "Jason's Tomb." *IEJ* 17 (1967): 61–113.

———. *A Catalogue of Jewish Ossuaries in the Collections of the State of Israel*. Jerusalem: Israel Antiquities Authority and Israel Academy of Sciences and Humanities, 1994.

———. "Representations of the Menorah on Ossuaries." In Geva, *Ancient Jerusalem Revealed*, 239–43.

Rainey, A. F. "Whence Came the Israelites and Their Language?" *IEJ* 57 (2007): 41–64.

Rajak, T. "The Hasmoneans and the Uses of Hellenism." In *A Tribute to Geza Vermes: Essays on Jewish and Christian Literature and History*, edited by P. R. Davies and R. T. White, 261–80. Sheffield: Journal for the Study of the Old Testament, 1990.

———. "The Jewish Community and Its Boundaries." In Lieu et al., *Jews among Pagans and Christians*, 9–28.

———. "Inscription and Context: Reading the Jewish Catacombs of Rome." In van Henten and van der Horst, *Studies in Early Jewish Epigraphy*, 226–41.

———. "The Gifts of God at Sardis." In Goodman, *Jews in a Graeco-Roman World*, 229–39.

———. "The Rabbinic Dead and the Diaspora Dead at Beth She'arim." In Schäfer, *Talmud Yerushalmi and Graeco-Roman Culture*, 1:349–66.

———. "'Torah shall go forth from Zion: Common Judaism and the Greek Bible." In McCready and Reinhartz, *Common Judaism*, 145–58.

———. "The Dura-Europos Synagogue: Images of a Competitive Community." In L. R. Brody and Hoffman, *Dura Europos: Crossroads of Antiquity*, 141–54.

Ramsay, W. M. *The Cities and Bishoprics of Phrygia: Being an Essay of the Local History of Phrygia from the Earliest Times to the Turkish Conquest*. 2 vols. Oxford: Clarendon, 1895–97.

Rappaport, U. "The First Judean Coinage." *JJS* 32 (1981): 1–17.

———. "On the Hellenization of the Hasmoneans." *Tarbiz* 60 (1991): 477–503. Hebrew.

———. "Who Minted the Jewish War's Coins?" *INR* 2 (2007): 103–16.

Ratner, B. *Ahavat Zion v'Yerushalayim*. 12 vols. Reprint, Jerusalem: n.p., 1967. Hebrew.

Rautman, M. "Daniel at Sardis." *BASOR* 358 (2010): 47–60.

———. "Two Menorahs from the Synagogue at Sardis." *Qadmoniot* 43, no. 139 (2010): 44–48. Hebrew.

Reardon, B. P. "The Second Sophistic and the Novel." In Bowersock, *Approaches to the Second Sophistic*, 23–29.

Rebenich, S. "Jerome: The 'Vir Trilinguis' and the 'Hebraica Veritas.'" *VC* 47 (1993): 50–77.

Reed, A. Y. "From Asael and Šemihazah to Uzzah, Azzah, and Azael." *JSQ* 8 (2001): 105–36.

———. *Fallen Angels and the History of Judaism and Christianity: The Reception of Enochic Literature*. New York: Cambridge University Press, 2005.

Reed, J. L. *Archaeology and the Galilean Jesus: A Re-examination of the Evidence.* Harrisburg, PA: Trinity Press International, 2000.

Reeg, G. *Die Ortsnamen Israels nach der rabbinischen Literatur.* Wiesbaden: L. Reichert, 1989.

Reeves, J. C., ed. *Tracing the Threads: Studies in the Vitality of Jewish Pseudepigrapha.* Atlanta: Scholars, 1994.

———, ed. *Trajectories in Near Eastern Apocalyptic: A Postrabbinic Jewish Apocalypse Reader.* Atlanta: Society of Biblical Literature, 2005.

Regan, P. "Veneration of the Cross." *Worship* 52 (1978): 2–13.

Reich, R. "The Hot Bath and the Jewish Community in the Early Roman Period (The Second Temple Era)." In Kasher, Fuchs, and Rappaport, *Greece and Rome in Eretz-Israel,* 207–11. Hebrew.

———. "The Synagogue and the *Miqweh* in Eretz-Israel in the Second-Temple, Mishnaic, and Talmudic Periods." In Urman and Flesher, *Ancient Synagogues,* 1:289–301.

———. "Samaritan Amulets from the Late Roman and Byzantine Periods." In E. Stern and H. Eshel, *The Samaritans,* 289–309.

Reifenberg, A. "Ancient Jewish Stamps and Seals." *PEQ* 71 (1939): 193–98.

Reiner, E. "Joseph the Comes of Tiberias and the Jewish-Christian Dialogue in Fourth Century Galilee." In L. I. Levine, *Continuity and Renewal,* 355–86. Hebrew.

Renov, I. "The Relation of Helios and the Quadriga to the Rest of the Beth Alpha Mosaic." *Bulletin of the Israel Exploration Society* 18 (1954): 198–201. Hebrew.

Renz, J., and W. Röllig. *Die althebräischen Inschriften.* Vol. 1, *Handbuch der althebräischen Epigraphik.* Darmstadt: Wissenschaftliche Buchgesellschaft, 1995.

Reuther, R. R. "Judaism and Christianity: Two Fourth-Century Religions." *Studies in Religion* 2 (1972): 1–10.

Revel-Neher, E. *L'Arche d'Alliance dans l'art juif et chrétien du second au dixième siècles: le signe de la rencontre.* Paris: Association des Amis des Études Archéologiques Byzantino-Slaves et du Christianisme Oriental, 1984.

———. "From Dream to Reality: Evaluation and Continuity in Jewish Art." In L. I. Levine and Weiss, *From Dura to Sepphoris,* 53–63.

———. "An Additional Key to the Program of the Dura-Europos Synagogue Frescoes: Ezekiel 37." In Y. Eshel et al., *And Let Them Make Me a Sanctuary,* 67–75.

———. "The Offerings of the King-Priest: Judeo-Christian Polemics and the Early Byzantine Iconography of Melchizedek." In L. I. Levine, *Continuity and Renewal,* 270–98.

Reynolds, J., and R. Tannenbaum. *Jews and God-Fearers at Aphrodisias: Greek Inscriptions with Commentary.* Cambridge, UK: Cambridge University Press, 1987.

Rich, J., ed. *The City in Late Antiquity.* London: Routledge, 1992.

Richardson, P. "Augustan-Era Synagogues in Rome." In Donfried and Richardson, *Judaism and Christianity in First-Century Rome,* 17–29.

———. *Herod: King of the Jews and Friend of the Romans.* Minneapolis: Fortress, 1999.

Ricl, M. "Legal and Social Status of *Threptoi* and Related Categories in Narrative and Documentary Sources." In Cotton, *From Hellenism to Islam,* 93–114.

Riegl, A. *Die ägyptischen Textilfunde im K. K. österreichisches Museum.* Vienna: R. von Waldheim, 1889.

Riesenfeld, H. "The Resurrection in Ezekiel XXXVII and in the Dura Europos Paintings." In Gutmann, *No Graven Images,* 120–55.

Rives, J. *Religion and Authority in Roman Carthage from Augustus to Constantine.* Oxford: Clarendon; New York: Oxford University Press, 1995.

Roberts, A., et al., eds. *The Ante-Nicene Fathers.* Vol. 7. Reprint, Grand Rapids: Eerdmans, 1975.

Robin, C. "Himyar et Israël." *Comptes-rendus des séances de l'Académie des Inscriptions et Belles-Lettres* 148/2 (2004): 831–908.

Rodgers, Z., et al., eds. *A Wandering Galilean: Essays in Honour of Seán Freyne*. Leiden: Brill, 2009.

Rofé, A. *Introduction to Deuteronomy: Part 1 and Further Chapters*. Jerusalem: Academon, 1988. Hebrew.

Romanoff, P. *Jewish Symbols on Ancient Jewish Coins*. Philadelphia: Dropsie College, 1944.

Rompay, L. Van. "Society and Community in the Christian East." In Maas, *Cambridge Companion to the Age of Justinian*, 13:239–66.

Rosenberg, S. G. *Airaq al-Amir: The Architecture of the Tobiads*. Oxford: John and Erica Hedges, 2006.

Rosenblum, J. D. "From Their Bread to Their Bed: Commensality, Intermarriage, and Idolatry in Tannaitic Literature." *JJS* 61 (2010): 18–29.

Rosenfeld, B. Z. "The Crisis of the Patriarchate in Eretz-Israel in the Fourth Century." *Zion* 53 (1988): 239–57. Hebrew.

———. "Rabbi Joshua ben Levi and His Wife Kyra Mega—Interpretation of Inscriptions from Beth-She'arim." *Cathedra* 114 (2004): 11–36. Hebrew.

———. "The Title 'Rabbi' in Third-to Seventh-Century Inscriptions in Palestine: Revisited." *JJS* 61 (2010): 234–56.

Rosenfeld, B. Z., and R. Potchebutzky. "The Civilian-Military Community in the Two Phases of the Synagogue at Dura Europos: A New Approach." *Levant* 41 (2009): 195–222.

Rosenthal, D. "The Transformation of Eretz Israel Traditions in Babylonia." *Cathedra* 92 (1999): 7–48. Hebrew.

Rosenthal-Heginbottom, R. "Jewish Lamp Depicting the Sacrifice of Isaac." *EI* 25 (1996): 52*–60*.

———. "Hellenistic and Early Roman Fine Ward from Area A." In Geva, *Jewish Quarter Excavations*, 2:192–223.

Rostovtzeff, M. I. *Caravan Cities*. Oxford: Clarendon, 1932.

———. "Dura and the Problem of Parthian Art." *Yale Classical Studies* 5 (1935): 157–301.

———. *Dura-Europos and Its Art*. Oxford: Clarendon, 1938.

Rostovtzeff, M. I. et al. *The Excavations at Dura-Europos: Preliminary Report of the Seventh and Eighth Seasons of Work—1933-1934 and 1934-1935*. New Haven: Yale University Press, 1939.

Roszak, T. *The Making of a Counter Culture: Reflections on the Technocratic Society and Its Youthful Opposition*. Garden City, NY: Doubleday, 1969.

Roth, C. "Messianic Symbols in Palestinian Archaeology." *PEQ* 87 (1955): 151–64.

———, ed. *Jewish Art: An Illustrated History*. New York: McGraw-Hill, 1961. Rev. ed., edited by B. Narkiss, Greenwich, CT: New York Graphic Society, 1971.

Roth-Gerson, L. *The Greek Inscriptions from the Synagogues in Eretz-Israel*. Jerusalem: Yad Izhak Ben-Zvi, 1987. Hebrew.

———. *The Jews of Syria as Reflected in the Greek Inscriptions*. Jerusalem: Zalman Shazar Center for Jewish History, 2001. Hebrew.

Rousseau, P. *The Early Christian Centuries*. London: Longman Pearson Education, 2002.

Roussin, L. A. "The Bet Leontis Mosaic: An Eschatological Interpretation." *JJA* 8 (1981): 6–19.

———. "The Zodiac in Synagogue Decoration." In D. R. Edwards and McCollough, *Archaeology and the Galilee*, 83–96.

Rozenberg, S. "The Wall Paintings of the Herodian Palace at Jericho." In Fittschen and Foester, *Judaea and the Greco-Roman World*, 121–38.

———. "Wall Painting Fragments from Area A." In Geva, *Jewish Quarter Excavations*, 2:302–28.

———. "Herodian Stuccowork Ceilings." In Netzer, *Architecture of Herod*, 339–49.

———. "Herodian Wall Paintings." In Netzer, *Architecture of Herod*, 350–76.

———. *Hasmonean and Herodian Palaces at Jericho: Final Reports of the 1973-1987 Excavations*.

Vol. 4, *The Decoration of Herod's Third Palace at Jericho*. Jerusalem: Israel Exploration Society, 2008.

————. "Wall Paintings." In Jacobson and Kokkinos, *Herod and Augustus*, 249–65.

Rozensohn, I. "Beth Alpha—A Mosaic of Aggadot: On Aggadah and Archaeology—A View into the World of the Sages of Aggadah." *Derekh Ephratah* 3 (1993): 85–117. Hebrew.

Rubenstein, J. L. "Cultic Themes in Sukkot Piyyutim." *PAAJR* 59 (1993): 185–209.

————. *Talmudic Stories: Narrative Art, Composition, and Culture*. Baltimore: Johns Hopkins University Press, 1999.

————. *The Culture of the Babylonian Talmud*. Baltimore: Johns Hopkins University Press, 2003.

————. *Creation and Composition: The Contribution of the Bavli Redactors* (Stammaim) *to the Aggada*. Tübingen: Mohr Siebeck, 2005.

————. "Introduction." In Rubenstein, *Creation and Composition*, 1–20.

————. "Criteria of Stammaitic Intervention in Aggada." In Rubenstein, *Creation and Composition*, 417–40.

————. "Social and Institutional Settings of Rabbinic Literature." In Fonrobert and Jaffee, *Cambridge Companion to the Talmud and Rabbinic Literature*, 58–74.

————. "Talmudic Astrology: Bavli Šabbat 156a–b." *HUCA* 78 (2007): 109–48.

Rubin, Z. "Joseph the Comes and the Attempts to Convert the Galilee to Christianity in the Fourth Century C.E." *Cathedra* 26 (1983): 105–16. Hebrew.

Runesson, A. "The Synagogue at Ancient Ostia: The Building and Its History from the First to the Fifth Century." In *The Synagogue of Ancient Ostia and the Jews of Rome: Interdisciplinary Studies*, edited by B. Olsson, D. Mitternacht, and O. Brandt, 29–99. Stockholm: Paul Åströms, 2001.

————. "Architecture, Conflict, and Identity Formation: Jews and Christians in Capernaum from the First to the Sixth Century." In Zangenberg, Attridge, and Martin, *Religion, Ethnicity, and Identity in Ancient Galilee*, 231–57. Tübingen: Mohr Siebeck, 2007.

Runesson, A., D. D. Binder, and B. Olsson. *The Ancient Synagogue from Its Origins until 200 C.E.: A Source Book*. Leiden: Brill, 2008.

Rutgers, L. V. "Ein in situ erhaltenes Sarkophagfragment in der jüdischen Katakombe an der Via Appia." *JA* 14 (1988): 16–27.

————. "Überlegungen zu den jüdischen Katakomben Roms." *JAC* 33 (1990): 140–57.

————. "Archaeological Evidence for the Interaction of Jews and Non-Jews in Late Antiquity." *AJA* 96 (1992): 101–18.

————. *The Jews in Late Ancient Rome: Evidence of Cultural Interaction in the Roman Diaspora*. Leiden: Brill, 1995.

————. *The Hidden Heritage of Diaspora Judaism*. Leuven: Peeters, 1998.

————. "Incense Shovels at Sepphoris?" In E. M. Meyers et al., *Galilee through the Centuries*, 177–98.

————. *Subterranean Rome: In Search of the Roots of Christianity in the Catacombs of the Eternal City*. Leuven: Peeters, 2000.

————, ed. *What Athens Has to Do with Jerusalem: Essays on Classical, Jewish, and Early Christian Art and Archaeology in Honor of Gideon Foerster*, 151–87. Leuven: Peeters, 2002.

————. "Justinian's *Novella* 146 Between Jews and Christians." In Kalmin and S. Schwartz, *Jewish Culture and Society*, 385–407.

————. "Radiocarbon Dates from the Catacombs of St. Callixtus in Rome." *Radiocarbon* 47 (2005): 395–400.

————." Reflections on the Demography of the Jewish Community of Ancient Rome." In *Les cités de l'Italie tardo-antique (IVe–VIe siècle): Institutions, économie, société, culture et religion*, edited by M. Ghilardi, C. J. Goddard, and P. Porena, 345–58. Rome: Ecole Française de Rome, 2006.

————. *Making Myths: Jews in Early Christian Identity Formation*. Leuven: Peeters, 2009.

Rutgers, L. V., K. van der Borg, and A. F. M. de Jong. "Radiocarbon Dates from the Jewish Catacombs of Rome." *Radiocarbon* 44 (2002): 541–47.

Rutgers, L. V., K. van der Borg, A. F. M. de Jong, and I. Poole. "Radiocarbon Dating: Jewish Inspiration of Christian Catacombs." *Nature* 436 (21 July 2005): 339. <http://www.nature.com/nature/journal/v436/n7049/full/436339a.html>. Accessed November 2011.

———. "The Jews of Italy, c. 235–638." In Katz, *Late Roman–Rabbinic Period*, 492–508.

Sabar, S. "The Purim Panel at Dura: A Socio-Historical Interpretation." In L. I. Levine and Weiss, *From Dura to Sepphoris*, 155–63.

Safrai, S. "Bet She'arim in Talmudic Literature." In *EI* 5 (1958): 206–12. Reprinted in S. Safrai, *Eretz-Israel and Her Sages in the Period of the Mishnah and Talmud*, 71–85. Jerusalem: Hakibbutz Hameuchad, 1983. Hebrew.

Safrai, S., et al., ed. *The Literature of the Sages*. Vol. 2. Assen: Van Gorcum; Philadelphia: Fortress, 2006.

Safrai, Z. *Pirqei Galil*. Ma'alot: Shorashim, 1981. Hebrew.

———. *The Economy of Roman Palestine*. London: Routledge, 1994.

———. *The Missing Century: Palestine in the Fifth Century; Growth and Decline*. Leuven: Peeters, 1998.

———, "Beit Shearim—An Important Jewish Settlement in the Galilee." *'Al-'Atar: Journal of Land of Israel Studies* 8–9 (Av 5761/July 2001): 45–82. Hebrew.

———. "The House of Leontis 'Kaloubas'—a Judaeo-Christian?" In Tomson and Lambers-Petry, *Image of the Judaeo-Christians*, 245–66.

Salzman, M. R. *On Roman Time: The Codex-Calendar of 354 and the Rhythms of Urban Life in Late Antiquity*. Berkeley: University of California Press, 1990.

Sanders, E. P. *Judaism: Practice and Belief, 63 BCE–66 CE*. Philadelphia: Trinity, 1992.

———. "The Dead Sea Sect and Other Jews: Commonalities, Overlaps and Differences." In *The Dead Sea Scrolls in Their Historical Context*, edited by T. W. Lim, 7–43. Edinburgh: T & T Clark, 2000.

Sandmel, S. "Parallelomania." *JBL* 81 (1962): 1–13.

Sandwell, I. *Religious Identity in Late Antiquity: Greeks, Jews, and Christians in Antioch*. Cambridge, UK: Cambridge University Press, 2007.

Sarfatti, G. B. "An Introduction to 'Barayta De-Mazzalot.'" *Bar-Ilan* 3 (1965): 56–82. Hebrew.

Sarna, N. M. "Psalm XIX and the Near Eastern Sun-god Literature." In *Proceedings of the Fourth World Congress of Jewish Studies*, vol. 1, 171–75. Jerusalem: World Union of Jewish Studies, 1967.

———. *The JPS Torah Commentary—Exodus*. Philadelphia: Jewish Publication Society, 1991.

———. *Studies in Biblical Interpretation*. Philadelphia: Jewish Publication Society, 2000.

Sartre, M. "The Nature of Syrian Hellenism in the Late Roman and Early Byzantine Periods." In Eliav et al., *Sculptural Environment*, 25–49.

Sass, B. "The Pre-Exilic Hebrew Seals: Iconism vs. Aniconism." In *Studies in the Iconography of Northwest Semitic Inscribed Seals*, edited by B. Sass and C. Uehlinger, 194–256. Fribourg: University Press; Göttingen: Vandenhoeck & Ruprecht. 1993.

Satlow, M. "Jewish Constructions of Nakedness in Late Antiquity." *JBL* 116 (1997): 429–54.

Satran, D. "Anti-Jewish Polemic in the *Peri Pascha* of Melito of Sardis: The Problem of Social Context." In *Contra Iudaeos: Ancient and Medieval Polemics between Christians and Jews*, edited by O. Limor and G. G. Stroumsa, 49–58. Tübingen: Mohr Siebeck, 1996.

Schäfer, P., ed. *Synopse zur Hekhalot-Literatur*. Tübingen: Mohr, 1981.

———. *Hekhalot-Studien*. Tübingen: Mohr, 1988.

———. "Jewish Magic Literature in Late Antiquity and Early Middle Ages." *JJS* 41 (1990): 75–91.

———. "Magic and Religion in Ancient Judaism." In *Envisioning Magic: A Princeton Seminar and Symposium*, edited by P. Schäfer and H. G. Kippenberg, 19–43. Leiden: Brill, 1997.

————, ed. *The Talmud Yerushalmi and Graeco-Roman Culture.* Vols. 1 and 3. Tübingen: Mohr Siebeck, 1998, 2002.

————. "Bar Kokhba and the Rabbis." In *The Bar Kokhba War Reconsidered: New Perspectives on the Second Jewish Revolt against Rome*, edited by P. Schäfer, 8–22. Tübingen: Mohr Siebeck, 2003.

————. *Jesus in the Talmud.* Princeton: Princeton University Press, 2007.

————. *The Origins of Jewish Mysticism.* Tübingen: Mohr Siebeck, 2009.

Schäfer, P., et al. *Konkordanz zur Hekhalot-Literatur.* 2 vols. Tübingen: Mohr, 1986–88.

Schalit, A. "The Letter of Antiochus III to Zeuxis regarding the Establishment of Jewish Military Colonies in Phrygia and Lydia." *JQR* 50 (1959–60): 289–318.

Schatkin, M. "The Maccabean Martyrs." *VC* 28 (1974): 97–113.

Schick, R. *The Christian Communities of Palestine from Byzantine to Islamic Rule: A Historical and Archaeological Study.* Princeton: Darwin, 1995.

Schiffman, L. H. "The Conversion of the Royal House of Adiabene in Josephus and Rabbinic Sources." In *Josephus, Judaism, and Christianity*, edited by L. H. Feldman and G. Hata, 293–312. Leiden: Brill, 1987.

Schiffman, L. H., and M. D. Swartz. *Hebrew and Aramaic Incantation Texts from the Cairo Genizah: Selected Texts from Taylor-Schechter Box K1.* Sheffield: Journal for the Study of the Old Testament, 1992.

Schirmann, J. "Hebrew Liturgical Poetry and Christian Hymnology." *JQR* 44 (1953–54): 123–61.

Schlichting, G. *Ein jüdisches Leben Jesu.* Tübingen: Mohr Siebeck, 1982.

Schmidt, B. B. "The Aniconic Tradition: On Reading Images and Viewing Texts." In Edelman, *Triumph of Elohim*, 75–105.

Schmidt-Colinet, A. "Aspects of 'Romanisation': The Tomb Architecture at Palmyra and Its Decoration." In Alcock, *Early Roman Empire in the East*, 164–70.

Scholem, G. *Major Trends in Jewish Mysticism.* New York: Schocken, 1941.

————. *Jewish Gnosticism, Merkavah Mysticism and Talmudic Tradition.* 2nd ed. New York: Jewish Theological Seminary, 1965.

Schonfield, H. J. *According to the Hebrews: A New Translation of the Jewish Life of Jesus (Toledot Yeshu).* London: Duckworth, 1937.

Schork, R. J. *Sacred Song from the Byzantine Pulpit: Romanos the Melodist.* Gainesville: University Press of Florida, 1995.

Schreiber, A. *Jewish Inscriptions in Hungary, from the 3rd Century to 1686.* Leiden: Brill, 1983.

Schremer, A. "Stammaitic Historiography." In Rubenstein, *Creation and Composition*, 219–35.

————. "The Christianization of the Roman Empire and Rabbinic Literature." In L. I. Levine and D. R. Schwartz, *Jewish Identities in Antiquity*, 349–66.

Schroer, S. *In Israel gab es Bilder: Nachrichten von darstellender Kunst im Alten Testament.* Fribourg: University Press; Göttingen: Vandenhoeck & Ruprecht, 1987.

Schubert, K. "Jewish Art in the Light of Jewish Tradition." In H. Schreckenberg and K. Schubert, *Jewish Historiography and Iconography in Early and Medieval Christianity.* Assen: Van Gorcum, 1992, 147–59.

Schüler, I. "A Note on Jewish Gold Glasses." *JGS* 8 [1966]: 48–61.

Schürer, E. *The History of the Jewish People in the Age of Jesus Christ (175 B.C.–A.D. 135)*, edited by G. Vermes et al. 3 vols. Rev. ed., Edinburgh: T & T Clark, 1973–87.

Schwabe, M., and B. Lifshitz. *Beth She'arim.* Vol. 2, *Greek Inscriptions.* New Brunswick, NJ: Rutgers University Press, 1974.

Schwartz, D. R. *Agrippa I: The Last King of Judaea.* Tübingen: Mohr Siebeck, 1990.

Schwartz, D. R., and Z. Weiss, eds. *Was 70 CE a Watershed in Jewish History?* Leiden: Brill, forthcoming.

Schwartz, J. J. *Lod (Lydda), Israel: From Its Origins through the Byzantine Period, 5600 B.C.E.–640 C.E.* Oxford: Tempus Reparatum, 1991.

———. "Archaeology and the City." In Sperber, *City in Roman Palestine*, 149–94.

Schwartz, M. B. *Torah Reading in the Ancient Synagogues*. Ann Arbor: University Microfilms International, 1975.

Schwartz, S. "Gamaliel in Aphrodite's Bath: Palestinian Judaism and Urban Culture in the Third and Fourth Centuries." In Schäfer, *Talmud Yerushalmi and Graeco-Roman Culture*, 1:203–17.

———. "The Patriarchs and the Diaspora." *JJS* 50 (1999): 208–22.

———. "On the Program and Reception of the Synagogue Mosaics." In L. I. Levine and Weiss, *From Dura to Sepphoris*, 165–81.

———. *Imperialism and Jewish Society, 200 B.C.E. to 640 C.E.* Princeton: Princeton University Press, 2001.

———. "The Rabbi in Aphrodite's Bath: Palestinian Society and Jewish Identity in the High Roman Empire." In *Being Greek under Rome: Cultural Identity, The Second Sophistic, and the Development of Empire*, edited by S. Goldhill, 335–61. Cambridge, UK: Cambridge University Press, 2001.

———. "Rabbinization in the Sixth Century." In Schäfer, *Talmud Yerushalmi and Graeco-Roman Culture*, 3:55–69.

———. "Big-Men or Chiefs: Against an Institutional History of the Palestinian Patriarchate." In *Jewish Religious Leadership: Image or Reality*, edited by J. Wertheimer, 1:155–73. New York: Jewish Theological Seminary, 2004.

———. "Political, Social, and Economic Life in the Land of Israel, 66--c. 235." In Katz, *Late Roman-Rabbinic Period*, 23–52.

Scott, J. C. *Domination and the Arts of Resistance: Hidden Transcripts*. New Haven: Yale University Press, 1990.

Scott, S., and J. Webster, eds. *Roman Imperialism and Provincial Art*. Cambridge, UK: Cambridge University Press, 2003.

Seager, A. "The Building History of the Sardis Synagogue." *AJA* 76 (1972): 425–35.

Seager, A. R., and A. T. Kraabel. "The Synagogue and the Jewish Community." In *Sardis from Prehistory to Roman Times: Results of the Archaeological Exploration at Sardis, 1958-1975*, edited by G. M. A. Hanfmann, 168–90. Cambridge, MA: Harvard University Press, 1983.

Sed-Rajna, G. *Jewish Art*. New York: H. N. Abrams, 1997.

———. "A Missing Link: Some Thoughts on the Sepphoris Synagogue Mosaic." In L. I. Levine and Weiss, *From Dura to Sepphoris*, 44–51.

Sedov, A. V. *Temples of Ancient Hadramawt*. Pisa: Plus-Pisa University Press, 2005.

Segal, A. F. *Two Powers in Heaven: Early Rabbinic Reports about Christianity and Gnosticism*. Leiden: Brill, 1977.

———. *The Other Judaisms of Late Antiquity*. Atlanta: Scholars, 1987.

Segal, J. B. "The Jews of Northern Mesopotamia before the Rise of Islam." In *Studies in the Bible Presented to M. H. Segal*, edited by J. M. Grintz and J. Liver, 32*-63*. Jerusalem: Kiryat Sepher, 1964. Hebrew.

Seyrig, H. "Le culte du Soleil en Syrie à l'époque romaine." *Syria* 48 (1971): 337–73.

Shaked, S. "Jewish Sasanian Sigillography." In Gyselen, *Au carrefour des religions*, 239–56.

———. "Popular Religion in Sasanian Babylonia." *Jerusalem Studies in Arabic and Islam* 21 (1997): 103–17.

Shaked, S., and A. Netzer, eds. *Irano-Judaica*. Vols. 2 and 4. Jerusalem: Yad Izhak Ben-Zvi, 1990, 1999.

Shanks, H., ed. *Christianity and Rabbinic Judaism: A Parallel History of Their Origins and Early Development*. Washington, DC: Biblical Archaeology Society, 1992.

Sharf, A. *Byzantine Jewry: From Justinian to the Fourth Crusade*. London: Routledge and Kegan Paul, 1971.

Shavit, Y., ed. *The History of Eretz Israel*. 10 vols. Jerusalem: Keter, 1981–85. Hebrew.

Shaw, G. *Theurgy and the Soul: The Neoplatonism of Iamblichus.* University Park, PA: Pennsylvania State University Press, 1995.

Shenk, K. L. "Temple, Community, and Sacred Narrative in the Dura-Europos Synagogue." *AJS Review* 34 (2010): 195–229.

Shepardson, C. *Anti-Judaism and Christian Orthodoxy: Ephrem's Hymns in Fourth-Century Syria.* Washington, DC: Catholic University of America Press, 2008.

Sheppard, A. R. "Jews, Christians and Heretics in Acmonia and Eumeneia." *Anatolian Studies* 29 (1979): 169–80.

Shiloh, Y. "Torah Scrolls and the Menorah Plaque from Sardis." *IEJ* 18 (1968): 54–57.

———. "Iron Age Sanctuaries and Cult Elements in Palestine." In *Symposia Celebrating the Seventy-Fifth Anniversary of the Founding of the American Schools of Oriental Research (1900–1975)*, edited by F. M. Cross, 147–57. Cambridge, MA: American Schools of Oriental Research, 1979.

———. "A Group of Hebrew Bullae from the City of David." *IEJ* 36 (1986): 16–38.

Shinan, A. "Sermons, Targums and the Reading from Scriptures in the Ancient Synagogue." In L. I. Levine, *Synagogue in Late Antiquity*, 97–110.

———. "Dating Targum Pseudo-Jonathan: Some More Comments." *JJS* 41 (1990): 57–61.

———. "Targumic Additions in Targum Pseudo-Jonathan." *Textus* 16 (1991): 139–55.

———. "The Aramaic Targum as a Mirror of Galilean Jewry." In L. I. Levine, *Galilee in Late Antiquity*, 241–51.

———. *The Embroidered Targum: The Aggadah in Targum Pseudo-Jonathan of the Pentateuch.* Jerusalem: Magnes, 1992. Hebrew.

———. "Synagogues in the Land of Israel: The Literature of the Ancient Synagogue and Synagogue Archaeology." In Fine, *Sacred Realm*, 130–52.

———. "The Late Midrashic, Paytanic, and Targumic Literature." In Katz, *Late Roman-Rabbinic Period*, 678–98.

Siker, J. S. *Disinheriting the Jews: Abraham in Early Christian Controversy.* Louisville: Westminster/John Knox, 1991.

Silver, A. H. *A History of Messianic Speculation in Israel: From the First through the Seventeenth Centuries.* New York: Macmillan, 1927.

Simmel, G. *Conflict: The Web of Group Affiliations.* Glencoe, IL: Free Press, 1955.

Simon, M. *Recherches d'histoire judéo-chrétienne.* Paris: Mouton & Co. 1962.

———. *Verus Israel: A Study of the Relations between Christians and Jews in the Roman Empire (135–425).* New York: Oxford University Press, 1986.

Simonsohn, S. "The Hebrew Revival among Early Medieval European Jews." In *Salo Wittmayer Baron Jubilee Volume: On the Occasion of His Eightieth Birthday*, edited by S. Lieberman and A. Hyman, 2:831–58. Jerusalem: American Academy for Jewish Research, 1974.

Sivan, H. *Palestine in Late Antiquity.* Oxford: Oxford University Press, 2008.

Sivertsev, A. *Private Households and Public Politics in 3rd–5th Century Jewish Palestine.* Tübingen: Mohr Siebeck, 2002.

Smallwood, E. M. *The Jews under Roman Rule: From Pompey to Diocletian.* Leiden: Brill, 1976.

Smith, A. M. "The Iconography of the Sacrifice of Isaac in Early Christian Art." *AJA* 26 (1922): 159–73.

Smith, J. Z. "The Garments of Shame." *History of Religions* 5 (1966): 217–38.

———. *Map Is Not Territory: Studies in the History of Religions.* Chicago: University of Chicago Press, 1978, 1–23.

———. *Drudgery Divine: On the Comparison of Early Christianities and the Religions of Late Antiquity.* Chicago: University of Chicago Press, 1990.

Smith, M. "The Common Theology of the Ancient Near East." *JBL* 71 (1952): 135–47.

———. "Palestinian Judaism in the First Century." In *Israel: Its Role in Civilization*, edited by M. Davis, 67–81. New York: Jewish Theological Seminary, 1956.

———. "The Image of God: Notes on the Hellenization of Judaism." *BJRL* 40 (1958): 473–512.

———. "Observations on Hekhalot Rabbati." In *Biblical and Other Studies*, edited by A. Altmann, 142–60. Cambridge, MA: Harvard University Press, 1963.

———. "Goodenough's 'Jewish Symbols' in Retrospect." *JBL* 86 (1967): 53–68.

———. *Palestinian Parties and Politics that Shaped the Old Testament*. New York: Columbia University Press, 1971.

———. "Helios in Palestine." *EI* 16 (1982): 199*–214*.

Smith, M. S. "The Near Eastern Background of Solar Language for Yahweh." *JBL* 109 (1990): 29–39.

———. "Berlinerblau's *The Vow and the 'Popular Religious Groups' of Ancient Israel: A Philological and Sociological Inquiry*" (review). *JSS* 43 (1998): 148–51.

———. *The Early History of God: Yahweh and the Other Deities in Ancient Israel*. 2nd ed. Grand Rapids: Eerdmans, 2002.

———. "When the Heavens Darkened: Yahweh, El, and the Divine Astral Family in Iron Age II Judah." In Dever and Gitin, *Symbiosis, Symbolism, and the Power of the Past*, 265–77.

———. "The Structure of Divinity at Ugarit and Israel: The Case of Anthropomorphic Deities versus Monstrous Divinities." In Beckman and Lewis, *Text, Artifact, and Image*, 38–63.

———. "Counting the Calves at Bethel." In S. W. Crawford, *"Up to the Gates of Ekron,"* 382–94.

Smith, R. B. E. *Julian's Gods: Religion and Philosophy in the Thought and Action of Julian the Apostate*. London: Routledge, 1995.

Smith, R. R. R. "The Use of Images: Visual History and Ancient History." In *Classics in Progress: Essays on Ancient Greece and Rome*, edited by T. P. Wiseman, 59–109. Oxford: Oxford University Press, 2002.

Snyder, G. F. *Ante-Pacem: Archaeological Evidence of Church Life before Constantine*. Macon, GA: Mercer, 1985.

———. "The Interaction of Jews with Non-Jews in Rome." In Donfried and Richardson, *Judaism and Christianity in First-Century Rome*, 69–90.

Sokoloff, M. *Dictionary of Jewish Palestinian Aramaic of the Byzantine Period*. Ramat Gan: Bar Ilan University Press, 1990.

Solin, H. "Juden und Syrer im westlichen Teil der römischen Welt." *ANRW* II.29.2 (1983): 587–789.

Sommer, B. D. *The Bodies of God and the World of Ancient Israel*. Cambridge, UK: Cambridge University Press, 2009.

Sonne, I. "The Paintings of the Dura Synagogue." *HUCA* 20 (1947): 255–362.

———. "Review of Wischnitzer's *Messianic Theme*." *AJA* 53 (1949): 230–33.

———. "The Zodiac Theme in Ancient Synagogues and in Hebrew Printed Books." *Studies in Bibliography and Booklore* 1 (1953): 3–13, 82–83.

Spatharakis, I. "Some Observations on the Ptolemy Ms. Vat. Gr. 1291: Its Date and the Two Initial 1260 Miniatures." *Byzantinische Zeitschrift* 71 (1978): 41–49.

Spence, S. *The Parting of the Ways: The Roman Church as a Case Study*. Leuven: Peeters, 2004.

Spera, L. *Il paesaggio suburbano di Roma dall'antichità al medioevo: il comprensorio tra le Vie Latina e ardeatina dalle mura Aureliane al III Miglio*. Rome: "L'Erma" di Bretschneider, 1999.

Sperber, D. "The History of the Menorah." *JJS* 16 (1965): 135–59.

———. *Magic and Folklore in Rabbinic Literature*. Ramat-Gan: Bar-Ilan University, 1994.

———, ed. *The City in Roman Palestine*. New York: Oxford University Press, 1998.

Spieckermann, H. *Juda unter Assur in der Sargonidenzeit*. Göttingen: Vandenhoeck & Ruprecht, 1982.

Spier, J., ed. *Picturing the Bible: The Earliest Christian Art*. New Haven: Yale University Press, 2007.

St. Clair, A. "God's House of Peace in Paradise: The Feast of Tabernacles on a Jewish Gold Glass." *JJA* 11 (1985): 6-15.

———. "The Torah Shrine at Dura-Europos: A Re-evaluation." *JAC* 29 (1986): 109-17.

Stager, L. E. "Merneptah, Israel and Sea Peoples: New Light on an Old Relief." *EI* 18 (1985): 56*-64*.

———. "Forging an Identity: The Emergence of Ancient Israel." In *The Oxford History of the Biblical World*, edited by M. D. Coogan, 123-75. Oxford: Oxford University Press, 1998.

Stähli, H.-P. *Solare Elemente im Jahweglauben des Alten Testaments.* Fribourg: University Press; Göttingen: Vandenhoeck & Ruprecht, 1985.

Štaerman, E. M. "Le culte impérial, le cult du Soleil et celui du Temps." In *Mélanges Pierre Lévêque.* Vol. 4, *Religion*, edited by M.-M. Mactoux and E. Gény, 361-79. Paris: Les Belles Lettres, 1990.

Stambaugh, J. *The Ancient Roman City.* Baltimore: Johns Hopkins University Press, 1988.

Stark, R. *The Rise of Christianity: A Sociologist Reconsiders History.* Princeton: Princeton University Press, 1996.

Stein, D. E. S. "The *Haftarot* of *Etz Hayim*: Exploring the Historical Interplay of Customs, *Ḥumashim*, and Halakhah." *Conservative Judaism* 54 (2002): 60-88.

Stein, S. "The Influence of Symposia Literature on the Literary Form of the Pesaḥ Haggadah." *JJS* 8 (1957): 13-44.

Steinberg, L. *The Sexuality of Christ in Renaissance Art and in Modern Oblivion,* 2nd ed. Chicago: University of Chicago Press, 1996.

Steinfeld, Z. A. "Prostration in Prayer and the Prohibition of the Paving Stone." *Sidra* 3 (1987): 53-79. Hebrew.

Steinmetz, D. "Must the Patriarch Know *Uqtzin?* The *Nasi* as Scholar in Babylonian Aggada." *AJS Review* 23 (1998): 163-89.

Stemberger, G. "Die Bedeutung des Tierkreises auf Mosaikfussböden spätantiker Synagogen." *Kairos* 17 (1975): 23-56.

———. "Hieronymus und die Juden seiner Zeit." In *Begegnungen zwischen Christentum und Judentum in Antike und Mittelalter: Festschrift für Heinz Schreckenberg*, edited by D.-A. Koch and J. Lichtenberger, 349-64. Göttingen: Vandenhoek & Ruprecht, 1993.

———. "Non-Rabbinic Literature." In Neusner, *Judaism in Late Antiquity*, pt. 1, 13-39.

———. "Exegetical Contacts between Christians and Jews in the Roman Empire." In *Hebrew Bible, Old Testament: The History of Its Interpretation*, edited by M. Saebø, 1:569-86. 2 vols. Göttingen: Vandenhoeck & Ruprecht, 1996-2008.

———. "Jewish-Christian Contacts in Galilee (Fifth to Seventh Centuries)." In *Sharing the Sacred: Religious Contacts and Conflicts in the Holy Land: First-Fifteenth Centuries CE,* edited by A. Kofsky and G. G. Stroumsa, 131-46. Jerusalem: Yad Izhak Ben-Zvi, 1998.

———. "Jerusalem in the Early Seventh Century: Hopes and Aspirations of Christians and Jews." In *Jerusalem: Its Sanctity and Centrality to Judaism, Christianity, and Islam*, edited by L. I. Levine, 260-72. New York: Continuum, 1999.

———. "Rabbinic Sources for Historical Study." In Avery-Peck and Neusner, *Judaism in Late Antiquity*, pt. 3, *Where We Stand*, 1:169-86.

———. *Jews and Christians in the Holy Land: Palestine in the Fourth Century.* Edinburgh: T & T Clark, 2000.

———. "Die Verbindung von Juden mit Häretikern in der spätantiken römischen Gesetzgebung." In *Hairesis: Festschrift für Karl Hoheisel zum 65. Geburtstag*, edited by M. Hutter, W. Klein, and U. Vollmer, 203-14. Münster Westfalen: Aschendorff, 2002.

Stern, E. "The Archaeology of Persian Palestine." In *The Persian Period*, edited by W. D. Davies and L. Finkelstein, 88-114. Vol. 1 of *CHJ.* Cambridge, UK: Cambridge University Press, 1984.

———, ed. *New Encyclopedia of Archaeological Excavations in the Holy Land (NEAEHL).* 5 vols. Jerusalem: Israel Exploration Society and Carta, 1993.

Stern, E., and H. Eshel, eds. *The Samaritans*. Jerusalem: Yad Izhak Ben-Zvi and Israel Antiquities Authority, 2002. Hebrew.

Stern, H. *Le calendrier de 354: Étude sur son texte et ses illustrations*. Institut Français d'Archéologie de Beyrouth. Paris: Geuthner, 1953.

———. "Le zodiaque de Bet-Alpha." *L'Oeil: Revue d'Art Mensuelle* 21 (1956): 14–19.

———. "The Orpheus in the Synagogue of Dura-Europos." *Journal of the Warburg and Courtauld Institutes* 21 (1958): 1–6.

Stern, K. B. "Limitations of 'Jewish' as a Label in Roman North Africa." *JSJ* 39 (2008): 307–36.

———. "Mapping Devotion in Roman Dura Europos: A Reconsideration of the Synagogue Ceiling." *AJA* 114 (2010): 473–504.

Stern, M. *Greek and Latin Authors on Jews and Judaism (GLAJJ)*. 3 vols. Jerusalem: Israel Academy of Sciences and Humanities, 1974–84.

———. "Social and Political Realignments in Herodian Judaea." In L. I. Levine, *Jerusalem Cathedra*, 2:40–62.

———. "Jews of Italy." In Stern, *Diaspora in the Hellenistic-Roman World*, 134–51.

———, ed. *The Diaspora in the Hellenistic-Roman World*. Jerusalem: 'Am Oved, 1983. Hebrew.

Stern, S. "Being Israel: Solipsism, Introversion and Transcendence." In S. Stern, *Jewish Identity in Early Rabbinic Writings*, 199–259.

———. *Jewish Identity in Early Rabbinic Writings*. Leiden: Brill, 1994.

———. "Synagogue Art and Rabbinic Halakhah." *Le'ela* 38 (1994): 33–37.

———. "Figurative Art and *Halakha* in the Mishnaic-Talmudic Period." *Zion* 61 (1996): 397–419. Hebrew.

———. "Pagan Images in Late Antique Palestine Synagogues." In Mitchell and Greatrex, *Ethnicity and Culture in Late Antiquity*, 241–52.

———. *Calendar and Community: A History of the Jewish Calendar: Second Century BCE–Tenth Century CE*. Oxford: Oxford University Press, 2001.

———. "Jewish Calendar Reckoning in the Graeco-Roman Cities." In *Jews in the Hellenistic and Roman Cities*, edited by J. R. Bartlett, 107–16. London: Routledge, 2002.

———. "Rabbi and the Origins of the Patriarchate." *JJS* 54 (2003): 193–215.

Sternberg, A. G. *The Zodiac of Tiberias*. Tiberias: Ot, 1972. Hebrew.

Stertz, S. A. "Roman Legal Codification in the Second Century." In Avery-Peck and Neusner, *Mishnah in Contemporary Perspective*, 149–64.

Stevenson, J. *The Catacombs: Rediscovered Monuments of Early Christianity*. London: Thames and Hudson, 1978.

Stewart, A., trans. *Of the Holy Places Visited by Antoninus Martyr (circ. 530 [570] A.D.)*. London: Palestine Pilgrims' Text Society, 1896.

Stewart, P. *The Social History of Roman Art*. Cambridge, UK: Cambridge University Press, 2008.

Stillwell, R. "The Siting of Classical Greek Temples." *Journal of the Society of Architectural Historians* 13 (1954): 3–8.

Stökl Ben Ezra, D. "'Christians' Observing 'Jewish' Festivals of Autumn." In Tombson and Lambers-Petry, *Image of the Judaeo-Christians*, 53–73.

Stone, M., ed. *Jewish Writings of the Second Temple Period: Apocrypha, Pseudepigrapha, Qumran Sectarian Writings, Philo, Josephus*. Assen: Van Gorcum, 1984.

Stone, N. "Notes on the Shellal Mosaic ('Ein Ha-Besor) and the Mosaic Workshops at Gaza." In *Jews, Samaritans and Christians in Byzantine Palestine*, edited by D. Jacoby and Y. Tsafrir, 207–14. Jerusalem: Yad Izhak Ben-Zvi, 1988. Hebrew.

Stoneman, R. *Palmyra and Its Empire: Zenobia's Revolt against Rome*. Ann Arbor: University of Michigan Press, 1994.

Strack, H. L., and G. Stemberger. *Introduction to the Talmud and Midrash*. Minneapolis: Fortress, 1992.

Strange, J. F. "Synagogue Typology and Khirbet Shema': A Response to Jodi Magness." In Avery-Peck and Neusner, *Judaism in Late Antiquity*, pt. 3, *Where We Stand*, 4:71–78.

———. "Some Remarks on the Synagogues of Capernaum and Khirbet Shema': A Response to Jodi Magness." In L. I. Levine, *Continuity and Renewal*, 530–43.

Stratton, K. B. "The Mithras Liturgy and Sepher Ha-Razim." In *Religions of Late Antiquity in Practice*, edited by R. Valantasis, 303–15. Princeton: Princeton University Press, 2000.

Strauss, H. "Jewish Art as a Minority Problem." *Jewish Journal of Sociology* 2 (1960): 147–71.

———. "Jüdische Quellen frühchristlicher Kunst: Optische oder literarische Anregung?" *ZNW* 57 (1966): 114–36. Reprinted in Gutmann, *No Graven Images*, 362–84.

———. *Die Kunst der Juden im Wandel der Zeit und Umwelt: Das Judenproblem im Spiegel der Kunst*. Tübingen: E. Wasmuth, 1972.

Strobel, K. "Jüdisches Patriarchat, Rabbinentum und Priesterdynastie von Emesa: Historische Phänomene innerhalb des Imperium Romanum der Kaiserzeit." *Ktema* 14 (1989): 39–77.

Stroumsa, G. G. "'To See or not to See': On the Early History of the Visio Beatifica." In *Wege mystischer Gotteserfahrung: Judentum, Christenum, und Islam/Mystical Approaches to God: Judaism, Christianity, and Islam*, edited by P. Schäfer, 67–80. Munich: Oldenbourg, 2006.

———. "Religious Dynamics between Christians and Jews in Late Antiquity (312–640)." In Casiday and Norris, *Constantine to c. 600*, 151–72.

Strzygowski, J. "Das neugefundene Orpheus-Mosaik in Jerusalem." *ZDPV* 24 (1901): 139–71.

Stuckrad, K. von. "Jewish and Christian Astrology in Late Antiquity: A New Approach." *Numen* 47 (2000): 1–40.

Sugimoto, D. T. *Female Figurines with a Disk from the Southern Levant and the Formation of Monotheism*. Tokyo: Keio University Press, 2008.

Sukenik, E. L. *The Ancient Synagogue of Beth Alpha: An Account of Excavations Conducted on Behalf of the Hebrew University, Jerusalem*. Jerusalem: University Press; London: Oxford University Press, 1932.

———. "The Oldest Coin of Judaea." *JPOS* 14 (1934): 178–84.

———. *The Synagogue of Dura Europos and Its Frescoes*. Jerusalem: Bialik, 1947. Hebrew.

———. "The Ancient Synagogue at Yafa near Nazareth, Preliminary Report." *Bulletin of the Louis M. Rabinowitz Fund for the Exploration of Ancient Synagogues* 2 (1951): 6–24.

Sussman, V. "Samaritan Lamps of the Third–Fourth Centuries A.D." *IEJ* 28 (1978): 238–50.

———. *Ornamented Jewish Oil-Lamps: From the Destruction of the Second Temple through the Bar-Kokhba Revolt*. Warminster, UK: Aris & Phillips, 1982.

———. "The Samaritan Oil Lamps from Apollonia-Arsuf." *Tel Aviv* 10 (1983): 71–96.

———. "The Binding of Isaac as Depicted on a Samaritan Lamp." *IEJ* 48 (1998): 183–89.

———. "Samaritan Oil Lamps." In E. Stern and H. Eshel, *The Samaritans*, 339–71. Hebrew.

Sussmann, J. "A Halakhic Inscription from the Beth-Shean Valley." *Tarbiz* 43 (1974): 88–158. Hebrew.

———. "The Boundaries of Eretz-Israel." *Tarbiz* 45 (1976): 213–57. Hebrew.

———. "The Inscription in the Synagogue at Rehob." In L. I. Levine, *Ancient Synagogues Revealed*, 146–53.

———. "Once Again Yerushalmi Neziqin." In Sussmann and Rosenthal, *Mehqerei Talmud*, 1:55–133.

———. "Oral Torah, Its Literal Meaning: The Power of the Tip of an Iota." In Sussmann and Rosenthal, *Mehqerei Talmud*, 3:209–384.

Sussmann, J., and D. Rosenthal, eds. *Mehqerei Talmud*. 3 vols. Jerusalem: Magnes, 1990–2005. Hebrew.

Sutherland, C. H. V., and R. A. G. Carson, eds. *The Roman Imperial Coinage*. Vol. 1, *From 31 BC-AD 69*. Rev. ed. London: Spink & Son, 1984.

Swain, S. *Hellenism and Empire: Language, Classicism, and Power in the Greek World: AD 50-250*. Oxford: Clarendon and Oxford University Press, 1996.

Swain S., et al., eds. *Severan Culture*. Cambridge, UK: Cambridge University Press, 2007.

Swartz, M. D. "'Alay Le-Shabbeah: A Liturgical Prayer in Ma'aseh Merkabah." *JQR* 77 (1986-87): 179-90.

———. *Mystical Prayer in Ancient Judaism: An Analysis of Ma'aseh Merkavah*. Tübingen: Mohr, 1992.

———. "Ritual about Myth about Ritual: Towards an Understanding of the *Avodah* in the Rabbinic Period." *Journal of Jewish Thought and Philosophy* 6 (1997): 135-55.

———. "Sage, Priest and Poet: Typologies of Religious Leadership in the Ancient Synagogue." In Fine, *Jews, Christians, and Polytheists*, 101-17.

———. "The Dead Sea Scrolls and Later Jewish Magic and Mysticism." *Dead Sea Discoveries* 8 (2001): 182-93.

———. "Jewish Magic in Late Antiquity." In Katz, *Late Roman-Rabbinic Period*, 699-720.

Swetnam, J. *Jesus and Isaac: A Study of the Epistle to the Hebrews in the Light of the Aqedah*. Rome: Biblical Institute, 1981.

Syme, R. "Ipse ille Patriarcha." In *Bonner Historia Augusta Colloquium — 1966/67*, 119-30. Bonn: R. Habelt, 1968-69.

Tabbernee, W. *Montanist Inscriptions and Testimonia: Epigraphic Sources Illustrating the History of Montanism*. Macon, GA: Mercer University Press, 1997.

Tabory, J. *Bibliography on Synagogues*. Ramat Gan: Bar Ilan University Press, 2000.

Tal, O. "On the Origin and Concept of the Loculi Tombs of Hellenistic Palestine." *Ancient West & East* 2 (2003): 288-306.

———. "Hellenism in Transition from Empire to Kingdom: Changes in the Material Culture of Hellenistic Palestine." In L. I. Levine and D. R. Schwartz, *Jewish Identities in Antiquity*, 55-73.

Talgam, R. "Mosaic Floors in Tiberias." In Hirschfeld, *Tiberias,*, 123-32.

———. "Similarities and Differences between Synagogue and Church Mosaics in Palestine during the Byzantine and Umayyad Periods." In L. I. Levine and Weiss, *From Dura to Sepphoris*, 93-110.

———. "Comments of the Judean-Christian Dialogue in the Mosaic Floor of the Sepphoris Synagogue." In Y. Eshel et al., *And Let Them Make Me a Sanctuary*, 77-86.

———. "The Zodiac and Helios in the Synagogue: Between Paganism and Christianity." In Weiss et al., *"Follow the Wise,"* 63*-80*. Hebrew.

———. *Mosaics of Faith: Floors of Pagans, Jews, Samaritans, Christians, and Muslims in the Holy Land*. Jerusalem: Yad Izhak Ben-Zvi; University Park: Pennsylvania State University Press, in press.

Talgam, R., and Peleg, O. "Herodian Mosaic Pavements." In Netzer, *Architecture of Herod*, 377-83.

Talgam, R., and Weiss, Z. *The Mosaics of the House of Dionysos at Sepphoris*. Jerusalem: Institute of Archaeology, Hebrew University, 2004.

Taubes, H. Z. *Otzar Ha-Geonim leMassekhet Sanhedrin*. Jerusalem: Mossad Harav Kook, 1966. Hebrew.

Taylor, J. G. *Yahweh and the Sun: Biblical and Archaeological Evidence for Sun Worship in Ancient Israel*. Sheffield: Journal for the Study of the Old Testament, 1993.

Taylor, M. S. *Anti-Judaism and Early Christian Identity: A Critique of the Scholarly Consensus*. Leiden: Brill, 1995.

Tcherikover, V., A. Fuks, and M. Stern. *Corpus Papyrorum Judaicarum,* 3 vols. Cambridge, MA: Harvard University Press, 1957-64.

Teeple, H. M. *The Mosaic Eschatological Prophet*. Philadelphia: Society of Biblical Literature, 1957.

Teicher, J. L. "Ancient Eucharistic Prayers in Hebrew." *JQR* 54 (1963–64): 99–109.

Teixidor, J. *The Pantheon of Palmyra*. Leiden: Brill, 1979.

Tepper, Y., and Y. Tepper. *Beth She'arim: The Village and Nearby Burials*. Tel Aviv: Hakibbutz Hameuchad, 2004. Hebrew.

Testa, E. *Il simbolismo dei giudeo-cristiani*. Jerusalem: Studium Biblicum Franciscanum, 1962.

Thompson, M. L. "Hypothetical Models of the Dura Paintings." In Gutmann, *Dura-Europos Synagogue: A Re-evaluation*, 31–52.

Thornton, T. C. G. "The Stories of Joseph of Tiberias." *VC* 44 (1990): 54–63.

Tigay, J. H. *"You Shall Have No Other Gods": Israelite Religion in the Light of Hebrew Inscriptions*. Atlanta: Scholars, 1986.

———. *Deuteronomy: The Traditional Hebrew Text with the New JPS Translation*. Philadelphia: Jewish Publication Society, 1996.

Tobler, T., and A. Molinier, eds. *Itinera hierosolymitana et descriptiones Terrae Sanctae*. 2 vols. Geneva: J.-G. Fick, 1879–85.

Tomson, P. J., and D. Lambers-Petry, eds. *The Image of the Judaeo-Christians in Ancient Jewish and Christian Literature*. Tübingen: Mohr Siebeck, 2003.

Toorn, K. van der. *Family Religion in Babylonia, Syria, and Israel: Continuity and Change in the Forms of Religious Life*. Leiden: Brill, 1996.

———, ed. *The Image and the Book: Iconic Cults, Aniconism, and the Rise of Book Religion in Israel and the Ancient Near East*. Leuven: Peeters, 1997.

Torrey, C. "Parchment and Papyri: Hebrew Texts." In *The Excavations at Dura: Preliminary Report of the Sixth Season of Work*, edited by P. V. C. Baur and M. Rostovtzeff, 417–19. New Haven: Yale University Press, 1936.

Toynbee, J. M. C. "Roma and Constantinopolis in Late-Antique Art from 312 to 365." *JRS* 37 (1947): 135–44.

———. *Death and Burial in the Roman World*. Ithaca: Cornell University Press, 1971.

Toynbee, J. M. C., and J. Ward-Perkins. *The Shrine of St. Peter and the Vatican Excavations*. London: Longmans, Green and Co., 1956.

Trebilco, P. R. *Jewish Communities in Asia Minor*. Cambridge, UK: Cambridge University Press, 1991.

Trifon, D. "The Priests from the Destruction of the Temple to the Rise of Christianity." Ph.D. diss., Tel Aviv University, 1985. Hebrew.

———. "Did the Priestly Courses (*Mishmarot*) Transfer from Judaea to Galilee after the Bar Kokhba Revolt?" *Tarbiz* 59 (1989–90): 77–93. Hebrew.

Tropper, A. *Wisdom, Politics, and Historiography: Tractate Avot in the Context of the Graeco-Roman Near East*. Oxford: Oxford University Press, 2004.

Trout, D. E. "Damasus and the Invention of Early Christian Rome." In *The Cultural Turn in Late Ancient Studies: Gender, Asceticism, and Historiography*, edited by D. B. Martin and P. C. Miller, 298–315. Durham, NC: Duke University Press, 2005.

Tsafrir, Y. *Eretz Israel from the Destruction of the Second Temple to the Muslim Conquest*. Vol. 2, *Archaeology and Art*. Jerusalem: Yad Izhak Ben-Zvi, 1982. Hebrew.

———. "The Byzantine Setting and Its Influence on Ancient Synagogues." In L. I. Levine, *Synagogue in Late Antiquity*, 147–57.

———. "Some Notes on the Settlement and Demography of Palestine in the Byzantine Period: The Archaeological Evidence." In *Retrieving the Past: Essays on Archaeological Research and Methodology in Honor of Gus W. van Beek*, edited by J. D. Seger, 269–83. Winona Lake: Eisenbrauns, 1996.

Tsafrir, Y., L. Di Segni, and J. Green. *Tabula Imperii Romani: Iudaea, Palaestina: Eretz Israel in*

Hellenistic, Roman and Byzantine Periods. Jerusalem: Israel Academy of Sciences and Humanities, 1994.

Tsafrir, Y., and G. Foerster. "Urbanism at Scythopolis-Beth Shean in the Fourth–Seventh Centuries." *DOP* 51 (1997): 85–146.

Tsafrir, Y., and S. Safrai, eds. *Sefer Yerushalaym: The Roman and Byzantine Periods, 70–638.* Jerusalem: Yad Izhak Ben-Zvi, 1999. Hebrew.

Turcan, R. *The Cults of the Roman Empire.* Oxford and Cambridge, MA: Blackwell, 1996.

———. *The Gods of Ancient Rome: Religion in Everyday Life from Archaic to Imperial Times.* Edinburgh: Edinburgh University Press, 2001.

Uehlinger, C. "Anthropomorphic Cult Statuary in Iron Age Palestine and the Search for Yahweh's Cult Images." In van der Toorn, *Image and the Book,* 97–156.

———. "Figurative Policy, Propaganda und Prophetie." In *Congress Volume: Cambridge, 1995,* edited by J. A. Emerton, 297–349. Leiden: Brill, 1997.

———. "Arad, Qitmit—Judahite Aniconism vs. Edomite Iconic Cult? Questioning the Evidence." In Beckman and Lewis, *Text, Artifact, and Image,* 80–112.

Undoh, F. E., et al., eds. *Redefining First-Century Jewish and Christian Identities: Essays in Honor of Ed Parish Sanders.* Notre Dame: University of Notre Dame Press, 2008.

Urbach, E. E. "The Rabbinical Laws of Idolatry in the Second and Third Centuries in the Light of Archaeological and Historical Facts." *IEJ* 9 (1959): 149–65, 229–45.

———. "The Rabbinical Laws of Idolatry in the Second and Third Centuries in the Light of Archaeological and Historical Facts." *EI* 5 (1959): 189–205. Hebrew.

———. "Class Status and Leadership in the World of the Palestinian Sages." *Proceedings of the Israel Academy of Sciences and Humanities* 2 (1966): 1–37.

———. "The Homiletical Interpretations of the Sages and the Expositions of Origen on Canticles and the Jewish-Christian Disputation." *Scripta Hierosolymitana* 22 (1971): 247–75.

———. *The Sages: Their Concepts and Beliefs.* 2 vols. Jerusalem: Magnes, 1979.

———. *The World of the Sages: Collected Studies.* Jerusalem: Magnes, 1988. Hebrew.

Urman, D. "Rabbis Eliezer ha-Qappar and Bar Qappara—Father and Son?" *Beer-Sheva* 2 (1985): 7–25. Hebrew.

Urman, D., and P. V. M. Flesher, eds. *Ancient Synagogues: Historical Analysis and Archaeological Discovery.* 2 vols. Leiden: Brill, 1995.

Vallée, G. *The Shaping of Christianity: The History and Literature of its Formative Centuries (100–800).* New York: Paulist Press, 1999.

VanderKam, J. C. *Calendars in the Dead Sea Scrolls: Measuring Time.* London: Routledge, 1998.

———. *From Joshua to Caiaphas: High Priests after the Exile.* Minneapolis: Fortress, 2004.

Vasiliev, A. A. "The Iconoclastic Edict of the Caliph Yazid II, A.D. 721." *DOP* 9–10 (1956): 23–47.

Vaughn, A. G., and A. E. Killebrew, eds. *Jerusalem in Bible and Archaeology: The First Temple Period.* Leiden: Brill, 2003.

Veltri, G. *Magie und Halakhah: Ansätze zu einem empirischen Wissenschaftsbegriff im spätantiken und frühmittelalterlichen Judentum.* Tübingen: Mohr, 1997.

———. "The Rabbis and Pliny the Elder: Jewish and Greco-Roman Attitudes toward Magic and Empirical Knowledge." *Poetics Today* 19 (1998): 63–89.

———. "Magic and Healing." In Hezser, *Oxford Handbook of Jewish Daily Life,* 587–602.

Vermes, G. *Scripture and Tradition in Judaism: Haggadic Studies.* Leiden: Brill, 1961.

———. "The Decalogue and the Minim." In *In Memoriam Paul Kahle,* edited by M. Black and G. Fohrer, 232–40. Berlin: Alfred Töpelmann, 1968.

———. "Redemption and Genesis XXII." In G. Vermes, *Scripture and Tradition in Judaism: Haggadic Studies,* 193–227. 2nd, rev. ed. Leiden: Brill, 1973.

Versluis, A. *TheoSophia: Hidden Dimensions of Christianity.* Hudson, NY: Lindisfarne, 1994.

Vessey, M. "The Demise of the Christian Writer and the Remaking of 'Late Antiquity': From H.-I. Marrou's Saint Augustine (1938) to Peter Brown's Holy Man (1983)." *JECS* 6 (1998): 377–411.

Vikan, G. *Byzantine Pilgrimage Art*. Washington, DC: Dumbarton Oaks Center for Byzantine Studies, 1982.

Villefosse, H. de. "Le soleil maitrisant ses chevaux (mosaïque découverte à Sens)." *Monuments et mémoires* 21 (1913): 89–109.

Vilozny, N. "Figure and Image in Magic and Popular Art: Between Babylonia and Palestine, during the Roman and Byzantine Periods." Ph.D. diss., Hebrew University of Jerusalem, 2010. Hebrew.

Vincent, L. H., and B. Carrière. "Le synagogue de Noarah." *RB* 30 (1921): 579–601.

Vismara, C. "I cimiteri ebraici di Roma." In *Società romana e impero tardoantico*. Vol. 2, *Roma: politica economia e paesaggio urbano*, edited by A. Giardina, 351–92, 490–503. Rome: Laterza, 1986.

Visotsky, B. *Fathers of the World: Essays in Rabbinic and Patristic Literatures*. Tübingen: Mohr Siebeck, 1995.

Vitto, F. "Rehov." In E. Stern, *NEAEHL*, 4:1272–74.

———. "The Interior Decoration of Palestinian Churches and Synagogues." *ByzF* 21 (1995): 283–300.

———. "Byzantine Mosaics at Bet She'arim: New Evidence for the History of the Site." In *'Atiqot* 28 (1996): 115–46.

Viviano, B. T. "Synagogues and Spirituality: The Case of Beth Alfa." In *Jesus and Archaeology*, edited by J. H. Charlesworth, 223–35. Grand Rapids: Eerdmans, 2006.

Vogel, C. "Sol aequinoctialis: Problèmes et technique de l'orientation dans le culte chrétien." *Revue des sciences religieuses* 36 (1962): 175–211.

———. "L'orientation vers l'Est du célébrant et des fidèlès pendant la célebration eucharistique." *L'Orient syrien* 9 (1964): 3–38.

Vogelstein, H. *Rome*. Philadelphia: Jewish Publication Society, 1940.

Vopel, H. *Die altchristlichen Goldgläser: Ein Beitrag zur altchristlichen Kunst-und Kulturgeschichte*. Freiburg: Mohr, 1899.

Vriezen, K. J. H. "Archaeological Traces of Cult in Ancient Israel." In Becking et al., *Only One God?* 45–80.

Wadeson, L. "Chariots of Fire: Elijah and the Zodiac in Synagogue Floor Mosaics of Late Antique Palestine." *ARAM* 20 (2008): 1–41.

Wagner, M. F. "Plotinus on the Nature of Physical Reality." In *The Cambridge Companion to Plotinus*, edited by L. P. Gerson, 130–70. Cambridge, UK: Cambridge University Press, 1996.

Waldbaum, J. C. *Metalwork from Sardis: The Finds through 1974*. Cambridge, MA: Harvard University Press, 1983.

Walker, P. W. L. *Holy City, Holy Places? Christian Attitudes to Jerusalem and the Holy Land in the Fourth Century*. Oxford: Clarendon, 1990.

Walmsley, A. "Byzantine Palestine and Arabia: Urban Prosperity in Late Antiquity." In *Towns in Transition: Urban Evolution in Late Antiquity and the Early Middle Ages*, edited by N. Christie and S. T. Loseby. Aldershot: Scolar, 1996, 126–58.

Ward-Perkins, B. "Continuists, Catastrophists, and the Towns of Post-Roman Northern Italy." *PBSR* 65 (1997): 157–76.

———. "Re-Using the Architectural Legacy of the Past, *entre idéologie et pragmatisme*." In *The Idea and Ideal of the Town between Late Antiquity and the Early Middle Ages*, edited by G. P. Brogiolo and B. Ward-Perkins, 225–44. Leiden: Brill, 1999.

Wasserstein, A. "Rabban Gamliel and Proclus the Philosopher (Mishna Aboda Zara 3, 4)." *Zion* 45 (1980): 257–67. Hebrew.

Watts, J. W. *Persia and Torah: The Theory of Imperial Authorization of the Pentateuch*. Atlanta: Society of Biblical Literature, 2001.

Waywell, G. B. "The Mausoleum at Halicarnassus." In *The Seven Wonders of the Ancient World*, edited by P. A. Clayton and M. J. Price, 100–23. London: Routledge, 1988.

Waywell, G. B., and A. Berlin. "Monumental Tombs: From Maussollos to the Maccabees." *BAR* 33, no. 3 (May–June 2007): 54–65.

Webb, R. *Demons and Dancers: Performance in Late Antiquity*. Cambridge, MA: Harvard University Press, 2008.

Webster, J. "Art as Resistance and Negotiation." In S. Scott and J. Webster, *Roman Imperialism and Provincial Art*, 24–51.

Webster, J. C. *The Labors of the Months in Antique and Mediaeval Art to the End of the Twelfth Century*. Princeton: Princeton University Press, 1938.

Weinfeld, M. "God the Creator in Gen. I and in the Prophecy of Second Isaiah." *Tarbiz* 37 (1968): 105–32. Hebrew.

———. "Kuntillet Ajrud Inscriptions and Their Significance." *Studi epigrafici e linguistici sul Vicino Oriente Antico* 1 (1984): 121–30.

———. *Deuteronomy 1–11: A New Translation*. New York: Doubleday, 1991.

———. *Deuteronomy and the Deuteronomic School*. Winona Lake: Eisenbrauns, 1992.

———. "Grace after Meals in Qumran (4Q434)." *JBL* 111 (1992): 427–40.

———. "Feminine Features in the Imagery of God in Israel: The Sacred Marriage and the Sacred Tree." *Vetus Testamentum* 46 (1996): 515–29.

Weiss, Z. "Ancient Synagogues in Tiberias and Hammat." In Hirschfeld, *Tiberias*, 34–48.

———. "Social Aspects of Burial in Beth She'arim: Archeological Finds and Talmudic Sources." In L. I. Levine, *Galilee in Late Antiquity*, 357–71.

———. "The Synagogue at Hammat Tiberias (Stratum II): A Suggestion for Reconstruction." *EI* 23 (1992): 320–26. Hebrew.

———. "Sepphoris." In E. Stern, *NEAEHL*, 5:2029–35.

———. "Hellenistic Influences on Jewish Burial Customs in the Galilee during the Mishnaic and Talmudic Period." *EI* 25 (1996): 356–64. Hebrew.

———. "Buildings for Entertainment." In Sperber, *City in Roman Palestine*, 77–91, 94–102.

———. "Adopting a Novelty: The Jews and the Roman Games in Palestine." In Humphrey, *Roman and Byzantine Near East*, 2:23–49.

———. "The Sepphoris Synagogue Mosaic and the Rôle of Talmudic Literature in its Iconographical Study." In L. I. Levine and Weiss, *From Dura to Sepphoris*, 15–30.

———. "Between Paganism and Judaism: Toward Identification of the 'Dionysiac Building' Residents at Roman Sepphoris." *Cathedra* 99 (2001): 7–26. Hebrew.

———. "The Jews of Ancient Palestine and the Roman Games: Rabbinic Dicta vs. Communal Practice." *Zion* 66 (2001): 427–50. Hebrew.

———. *The Sepphoris Synagogue: Deciphering an Ancient Message through Its Archaeological and Socio-Historical Contexts*. Jerusalem: Israel Exploration Society and Institute of Archaeology, Hebrew University, 2005.

———. "Tiberias and Sepphoris in the First Century CE: Urban Topography and Herod Antipas's Building Projects in the Galilee." *Cathedra* 120 (2006): 11–32. Hebrew.

———. "Josephus and Archaeology on the Cities of the Galilee." In *Making History: Josephus and Historical Method*, edited by Z. Rodgers, 385–414. Leiden: Brill, 2007.

———. "Between Rome and Byzantium: Pagan Motifs in Synagogue Art and Their Place in the Judaeo-Christian Controversy." In L. I. Levine and D. R. Schwartz, *Jewish Identities in Antiquity*, 367–90.

———. "Stratum II Synagogue at Hammath Tiberias: Reconsidering its Access, Internal Space, and Architecture." In Rodgers et al., *Wandering Galilean*, 321–42.

———. "Theatres, Hippodromes, Amphitheatres, and Performances." In Hezser, *Oxford Handbook of Jewish Daily Life*, 623–40.

————. "Burial Practices in Beth She'arim and the Question of Dating the Patriarchal Necropolis." In Weiss et al., *"Follow the Wise,"* 207–31.

————. *Public Spectacles and Competitions in Ancient Palestine: A Historical Study of Expanding Cultural Horizons.* Cambridge, MA: Harvard University Press, forthcoming.

Weiss, Z., and E. Netzer. "Hellenistic and Roman Sepphoris: The Archaeological Evidence." In Nagy et al., *Sepphoris in Galilee,* 29–37.

————. *Promise and Redemption: A Synagogue Mosaic from Sepphoris.* Jerusalem: Israel Museum, 1996.

————. "Sepphoris during the Byzantine Period." In Nagy et al., *Sepphoris in Galilee,* 81–89.

Weiss, Z. et al., ed. *"Follow the Wise": Studies in Jewish History and Culture in Honor of Lee I. Levine.* Winona Lake: Jewish Theological Seminary, Hebrew University of Jerusalem, and Eisenbrauns, 2010. English and Hebrew.

Weiss-Halivni, D. *Midrash, Mishnah, and Gemara: The Jewish Predeliction for Justified Law.* Cambridge, MA: Harvard University Press, 1986.

Weitzman, S. "Sensory Reform in Deuteronomy." In *Religion and the Self in Antiquity,* edited by D. Brakke et al., 123–39. Bloomington: Indiana University Press, 2005.

————. *Surviving Sacrilege: Cultural Persistence in Jewish Antiquity.* Cambridge, MA: Harvard University Press, 2005.

Weitzmann, K. *Greek Mythology in Byzantine Art.* Princeton: Princeton University Press, 1951.

————. *Ancient Book Illumination.* Cambridge, MA: Harvard University Press, 1959.

————. "The Illustration of the Septuagint." In Gutmann, *No Graven Images,* 201–31.

————. "The Question of the Influence of Jewish Pictorial Sources on Old Testament Illustration." In Gutmann, *No Graven Images,* 309–28.

————. *The Miniatures of the Sacra Parallela, Parisinus Graecus 923.* Princeton: Princeton University Press, 1979.

————, ed. *Age of Spirituality: A Symposium.* New York: Metropolitan Museum of Art, 1980.

————. *Classical Heritage in Byzantine and Near Eastern Art.* London: Variorum Reprints, 1981.

————. "Various Aspects of Byzantine Influence on the Latin Countries from the Sixth to the Twelfth Century." In *Art in the Medieval West and Its Contacts with Byzantium,* by K. Weitzmann, 3–24. London: Variorum Reprints, 1982.

————. "The Individual Panels and Their Christian Parallels." In Weitzmann and H. L. Kessler, *Frescoes of the Dura Synagogue and Christian Art,* 15–150.

Weitzmann, K., and M. Bernabò. *The Byzantine Octateuchs.* Princeton: Princeton University Press, 1999.

Weitzmann, K., and H. L. Kessler. *The Cotton Genesis: British Library Codex Cotton Otho B. VI.* Princeton: Princeton University Press, 1986.

————. *The Frescoes of the Dura Synagogue and Christian Art.* Washington, DC: Dumbarton Oaks, 1990.

Welles, C. B. "The Population of Roman Dura." In *Studies in Roman Economic and Social History in Honor of Allan Chester Johnson,* edited by P. R. Coleman-Norton, 251–74. Princeton: Princeton University Press, 1951.

————. "The Gods of Dura-Europos." In *Beiträge zur alten Geschichte und deren Nachleben: Festschrift für Franz Altheim,* edited by R. Stiehl and J. E. Stier, 2:50–65. Berlin: de Gruyter, 1970.

Wenning, R., and E. Zenger. "Ein bäuerliches Baal-Heiligtum in samarischen Gebirge aus der Zeit der Anfänge Israels." *ZDPV* 102 (1986): 75–86.

Werner, E. *Sacred Bridge: Liturgical Parallels in Synagogue and Early Church.* Vol. 1. New York: Schocken, 1970. Vol. 2. New York: KTAV, 1984.

West, M. L. *The Orphic Poems.* Oxford: Clarendon; New York: Oxford University Press, 1983.

Westenholz, J. G. "The Synagogues of Rome." In *The Jewish Presence in Ancient-Rome,* edited by J. G. Westenholz, 23–27. Jerusalem: Bible Lands Museum, 1995.

————, ed. *Images of Inspiration: The Old Testament in Early Christian Art.* Jerusalem: Bible Lands Museum, 2000.

Westhues, K. *Society's Shadow: Studies in the Sociology of Countercultures.* Toronto: McGraw-Hill Ryerson, 1972.

Wharton, A. J. "Good and Bad Images from the Synagogue of Dura Europos: Contexts, Subtexts, Intertexts." *Art History* 17 (1994): 1–25.

————. *Refiguring the Post Classical City: Dura Europos, Jerash, Jerusalem and Ravenna.* Cambridge, UK: Cambridge University Press, 1995.

White, L. M. *Building God's House in the Roman World: Architectural Adaptation among Pagans, Jews, and Christians.* Baltimore: Johns Hopkins University Press, 1990.

————. *The Social Origins of Christian Architecture.* 2 vols. Valley Forge, PA: Trinity, 1996–97.

————. "Synagogue and Society in Imperial Ostia: Archaeological and Epigraphic Evidence." In Donfried and Richardson, *Judaism and Christianity in First-Century Rome,* 30–68.

Whitmarsh, T. *The Second Sophistic.* Oxford: Oxford University Press, 2005.

Whittow, M. "Decline and Fall? Studying Long-Term Change in the East." In Lavan and Bowden, *Theory and Practice in Late Antique Archaeology,* 404–23.

Wilken, R. L. *Judaism and the Early Christian Mind: A Study of Cyril of Alexandria's Exegesis and Theology.* New Haven: Yale University Press, 1971.

————. *John Chrysostom and the Jews: Rhetoric and Reality in the Late Fourth Century.* Berkeley: University of California Press, 1983.

————. *The Land Called Holy: Palestine in Christian History and Thought.* New Haven: Yale University Press, 1992.

Wilkinson, J. "The Beit Alpha Synagogue Mosaic: Towards an Interpretation." *JJA* 5 (1978): 16–28.

Will, E., and F. Larché. *'Iraq al-Amir: Le château du tobiade Hyrcan.* Paris: P. Geuthner, 1991.

Williams, A. L. *Adversus Judaeos: A Bird's Eye View of Christian Apologiae until the Renaissance.* Cambridge, UK: Cambridge University Press, 1935.

Williams, Margaret H. "The Jews and Godfearers Inscription from Aphrodisias: A Case of Patriarchal Interference in Early Third Century Caria?" *Historia* 41 (1992): 297–310.

————. "The Organisation of Jewish Burials in Ancient Rome in the Light of Evidence from Palestine and the Diaspora." *ZPE* 101 (1994): 165–82.

————. "The Structure of Roman Jewry Re-Considered: Were the Synagogues of Ancient Rome Entirely Homogeneous?" *ZPE* 104 (1994): 129–41.

————. "The Structure of the Jewish Community in Rome." In Goodman, *Jews in a Graeco-Roman World,* 215–28.

————. "The Jews of Early Byzantine Venusia: The Family of Faustinus I, the Father." *JJS* 50 (1999): 38–52.

————. "The Shaping of the Identity of the Jewish Community in Rome in Antiquity." In Zangenberg and Labahn, *Christians as a Religious Minority in a Multicultural City,* 33–46.

————. "Image and Text in the Jewish Epitaphs of Late Ancient Rome." *JSJ* 42 (2011): 328–50.

Williams, Megan H. *The Monk and the Book: Jerome and the Making of Christian Scholarship.* Chicago: University of Chicago Press, 2006.

————. "Lessons from Jerome's Jewish Teachers: Exegesis and Cultural Interaction in Late Antique Palestine." In *Jewish Biblical Interpretation and Cultural Exchange: Comparative Exegesis in Context,* edited by N. B. Dohrmann and D. Stern, 66–86. Philadelphia: University of Pennsylvania Press, 2008.

Wilson, D. S. *Darwin's Cathedral: Evolution, Religion, and the Nature of Society.* Chicago: University of Chicago Press, 2002.

Wilson, S. G., and M. R. Desjardins, *Text and Artifact in the Religions of Mediterranean Antiquity: Essays in Honour of Peter Richardson*. Waterloo, Ont.: Canadian Corporation for Studies in Religion, 2000.

Wineland, J. D. "Sepharad." In Freedman, *Anchor Bible Dictionary*, 5:1089–90.

Winston, D. "Sage and Super-sage in Philo of Alexandria." In *Pomegranates and Golden Bells: Studies in Biblical, Jewish, and Near Eastern Ritual, Law, and Literature in Honor of Jacob Milgrom*, edited by D. P. Wright, D. N. Freedman, and A. Hurvitz, 815–24. Winona Lake: Eisenbrauns, 1995.

———. "Judaism and Hellenism: Hidden Tensions in Philo's Thought." *Studia Philonica Annual* 2 (1990): 1–19.

Winter, I. J. "Phoenician and Northern Syrian Ivory Carving in Historical Context: Questions of Style and Distribution." *Iraq* 38 (1976): 1–22.

Wirgin, W. "The Menorah as Symbol of Judaism." *IEJ* 12 (1962): 140–42.

———. "The Menorah as Symbol of After Life." *IEJ* 14 (1964): 102–4.

Wischnitzer R. *The Messianic Theme in the Paintings of the Dura Synagogue*. Chicago: University of Chicago Press, 1948.

———. "The Beth Alpha Mosaic: A New Interpretation." *JSS* 17 (1955): 133–44.

Woerden, I. S. van. "The Iconography of the Sacrifice of Abraham." *VC* 15 (1961): 214–55.

Wohl, B. L. "Constantine's Use of Spolia." In *Late Antiquity: Art in Context*, edited by J. Fleischer, J. Lund, and M. Nielsen, 85–116. Copenhagen: Museum Tusculanum Press, University of Copenhagen, 2001.

Wolfson, E. *Through a Speculum That Shines: Vision and Imagination in Medieval Jewish Mysticism*. Princeton: Princeton University Press, 1994.

Wolfson, H. A. *Philo: Foundations of Religious Philosophy*. 2 vols. Cambridge, MA: Harvard University Press, 1948.

Wood, D., ed. *The Church and the Arts: Papers Read at the 1990 Summer Meeting and the 1991 Winter Meeting of the Ecclesiastical History Society*. Oxford: Blackwell, 1992.

Wright, W. C., trans. *The Works of the Emperor Julian*. 3 vols. Cambridge, MA: Harvard University Press, 1913–23.

Wright III, B. G. "Jewish Ritual Baths — Interpreting the Digs and the Texts: Some Issues in the Social History of Second Temple Judaism." In *The Archaeology of Israel: Constructing the Past, Interpreting the Present*, edited by N. A. Silberman and D. Small, 190–214. Sheffield: Sheffield Academic, 1997.

Yadin, A. "Rabban Gamliel, Aphrodite's Bath, and the Question of Pagan Monotheism." *JQR* 96 (2006): 149–79.

Yadin, Y. *Hazor: The Rediscovery of a Great Citadel of the Bible*. London: Weidenfeld and Nicolson, 1975.

Yadin, Y. et al. *Bar-Kokhba: The Rediscovery of the Legendary Hero of the Second Jewish Revolt against Rome*. Jerusalem: Weidenfeld and Nicolson, 1971.

———. *The Documents from the Bar Kokhba Period in the Cave of Letters: Hebrew, Aramaic and Nabatean-Aramaic Papyri*. Jerusalem: Israel Exploration Society and Hebrew University, 2002.

Yahalom, J. "Zodiac Signs in the Palestinian *Piyyut*." *Jerusalem Studies in Hebrew Literature* 9 (1986): 313–22. Hebrew.

———. "*Piyyût*, as Poetry." In L. I. Levine, *Synagogue in Late Antiquity*, 111–26.

———. *Priestly Palestinian Poetry: A Narrative Liturgy for the Day of Atonement*. Jerusalem: Magnes, 1996. Hebrew.

———. *Poetry and Society in Jewish Galilee of Late Antiquity*. Tel Aviv: Hakibbutz Hameuchad, 1999. Hebrew.

———. "The Story of Mosaic Stones in Early Synagogues in Eretz Israel." *Et-Hada'at* 3 (1999): 37–50. Hebrew.

———. "The Sepphoris Synagogue Mosaic and Its Story." In L. I. Levine and Weiss, *From Dura to Sepphoris*, 83–91.

Yarden, L. *The Tree of Light: A Study of the Menorah*. Uppsala: Skriv Service AB, 1972.

Yegül, F. K. *The Bath-Gymnasium Complex at Sardis*. Cambridge, MA: Harvard University Press, 1986.

Yeivin, S. "The Sacrifice of Isaac in the Beth-Alpha Mosaic." *Bulletin of the Jewish Palestine Exploration Society* 12 (1945–46): 20–24. Hebrew.

Yeivin, Z. "Susiya, Khirbet." In E. Stern, *NEAEHL*, 4:1412–21.

Yinger, J. M. *Countercultures: The Promise and Peril of a World Turned Upside Down*. New York: Free Press, 1982.

Young, F. M. *From Nicaea to Chalcedon: A Guide to the Literature and Its Background*. London: SCM Press, 1983.

Yuval, I. J. *Two Nations in Your Womb: Perceptions of Jews and Christians in Late Antiquity and the Middle Ages*. Berkeley: University of California Press, 2006.

Yuval-Hacham, N. "'You Shall Not Make for Yourself Any Graven Image . . .': On Jewish Iconoclasm in Late Antiquity." *Ars Judaica* 6 (2010): 7–22.

———. " 'Like an Eagle Who Rouses His Nestlings': The Meaning of the Eagle Motif in Ancient Synagogues in the Golan and Galilee." *Cathedra* 124 (2007): 65–80. Hebrew.

Zangenberg, J. "Common Judaism and the Multidimensional Character of Material Culture." In Undoh et al., *Redefining First-Century Jewish and Christian Identities*, 175–93.

Zangenberg, J., H. W. Attridge, and D. B. Martin, eds. *Religion, Ethnicity, and Identity in Ancient Galilee: A Region in Transition*. Tübingen: Mohr Siebeck, 2007.

Zangenberg, J., and M. Labahn, eds. *Christians as a Religious Minority in a Multicultural City: Modes of Interaction and Identity Formation in Early Imperial Rome*. London: T & T Clark, 2004.

Zanker, P. *The Power of Images in the Age of Augustus*. Ann Arbor: University of Michigan Press, 1988.

Zeitler, B. "Ostentatio genitalium: Displays of Nudity in Byzantium." In L. James, *Desire and Denial*, 185–201.

Zevit, Z. "The Khirbet el-Qôm Inscription Mentioning a Goddess." *BASOR* 255 (1984): 39–47.

———. *The Religions of Ancient Israel: A Synthesis of Parallactic Approaches*. London: Continuum, 2001.

———. "False Dichotomies in Descriptions of Israelite Religion: A Problem, Its Origin, and a Proposed Solution." In Dever and Gitin, *Symbiosis, Symbolism, and the Power of the Past*, 223–36.

Zimmermann, M. "Conclusion: Violence in Late Antiquity Reconsidered." In Drake, *Violence in Late Antiquity*, 343–57.

Zissu, B. "Roman Period Burial Caves and Mausolea at Eshtemoa in Southern Judaea." *Judea & Samaria Research Studies* 11 (2002): 165–74.

Zohar, D. "The Iconography of the Zodiac and the Months in the Synagogue of Sepphoris: A Study in Diffusion of Artistic Models." *Mo'ed: Annual for Jewish Studies* 16 (2006): 1–26.

Zori, N. "The House of Kyrios Leontis at Beth Shean." *IEJ* 16 (1966): 123–34.

Zoref, E. "A Note on an Ancient Mosaic." *Sinai* 60 (1966): 91–92. Hebrew.

Zuckerman, C. "Hellenistic *Politeumata* and the Jews: A Reconsideration." *SCI* 8–9 (1985–88): 171–85.

Critical Editions of Rabbinic Sources

Batei Midrashot. Edited by A. Y. Wertheimer. Jerusalem: Mosad Harav Kook, 1954. Hebrew.

Deuteronomy Rabbah. Edited by S. Lieberman. Jerusalem: Wahrmann, 1964. Hebrew.

Differences in Customs between the People of the East and the People of Eretz-Israel. Edited by M. Margalioth. Jerusalem: R. Mass, 1938. Hebrew.

Exodus Rabbah. Edited by A. Shinan. Jerusalem: Mosad Rav Kook, 1994. Hebrew.

Genesis Rabbah. Edited by Y. Theodor and Ch. Albeck. 3 vols. Jerusalem: Wahrmann, 1965. Hebrew.

Genesis Rabbati. Edited by Ch. Albeck. Jerusalem: Meqitzei Nirdamim, 1967. Hebrew.

Lamentations Rabbah. Edited by S. Buber. Vilna: Romm, 1899. Hebrew.

Leviticus Rabbah. Edited by M. Margulies. 5 vols. Jerusalem: Jewish Theological Seminary, 1953–60. Hebrew.

Mekhilta of R. Ishmael. Edited by H. Horowitz and I. Rabin. Jerusalem: Bamberger and Wahrmann, 1960. Hebrew.

Mekhilta of R. Simeon b. Yoḥai. Edited by J. N. Epstein and E. Z. Melamed. Jerusalem: Meqitzei Nirdamim, 1956. Hebrew.

Midrash Hagadol, Exodus. Edited by M. Margaliot. Jerusalem: Mosad Harav Kook, 1957. Hebrew.

Midrash on Psalms. Edited by S. Buber. New York: Om, 1948. Hebrew.

Midrash Tannaim. Edited by D. Hoffman. 2 vols. Berlin: Itzkowski, 1909. Hebrew.

Midreshei Geulah. Edited by Y. Ibn-Shmuel. Jerusalem: Bialik, 1954. Hebrew.

Pesiqta de Rav Kahana. Edited by B. Mandelbaum. 2 vols. New York: Jewish Theological Seminary, 1962. Hebrew.

Pesiqta Zutreta (Midrash Leqaḥ Tov). Edited by S. Buber. Vilna: Romm, 1884.

Seder Eliyahu Rabbah. Edited by M. Friedmann. Jerusalem: Bamberger & Wahrmann, 1960. Hebrew.

Seder 'Olam Rabbah. Edited by D. B. Ratner. New York: Orot, 1966. Hebrew.

Seder Olam Zuta. Edited by A. Neubauer. *Seder Ha-Hakhamim ve-Qorot Hayamim.* 2 vols. Oxford: Clarendon, 1887.

Sifra (Mekhilta de-'Arayot). Edited by I. H. Weiss. New York: Om, 1946. Hebrew.

Sifre Deuteronomy. Edited by L. Finkelstein. New York: Jewish Theological Seminary, 1969. Hebrew.

Tanhuma. Edited by S. Buber. Facsimile edition. Jerusalem: Ortsel, 1964. Hebrew.

The Alphabet of Rabbi Akiba. In *Bet Hamidrash,* edited by A. Jellinek. 6 parts. Facsimile edition. Jerusalem: Wahrmann, 1967. Hebrew.

Tosefta. Orders Zera'im–Neziqin (through Bava Batra). Edited by S. Lieberman. New York: Jewish Theological Seminary, 1955–88. Hebrew.

———. Orders Neziqin (from Sanhedrin)–Tohorot. Edited by M. Zuckermandel. Jerusalem: Bamberger & Wahrmann, 1937. Hebrew.

Tractate Soferim. Edited by M. Higger. Reprint. Jerusalem: Makor, 1970. Hebrew.

Yalqut Shim'oni, Genesis. Edited by Y. Shiloni. Jerusalem: Mosad Harav Kook, 1973. Hebrew.

Yalqut Shim'oni, Leviticus. Edited by D. Hyman. Jerusalem: Mosad Harav Kook, 1977–80. Hebrew.

ILLUSTRATION CREDITS

Full references for the publications mentioned below appear in the Bibliography.

Courtesy of the Israel Exploration Society
Fig. 13/1, 2, 5: *IEJ* 17 (1957), Pls. 13, 15A, 20A
Fig. 17: *NEAEHL*, II, 751
Fig. 22: N. Avigad, *Discovering Jerusalem*, figs. 105, 167
Fig. 34: *NEAEHL*, I, 236
Fig. 35/1: *NEAEHL*, I, 248
Fig. 36/2: *NEAEHL*, I, 243
Fig. 38: E. Netzer and Z. Weiss, *Zippori*, 36
Fig. 59: *NEAEHL*, I, p. 244
Fig. 60: *NEAEHL*, I, 241
Fig. 61/1: *NEAEHL*, 242
Fig. 79/1: *EAEHL*, IV, 1128
Fig. 83: L. Levine, ed., *Ancient Synagogues Revealed*, 164, 166
Fig. 100: L. Levine, ed., *Ancient Synagogues Revealed*, 179
Figs. 84-86: Netzer and Foerster. "Synagogue at Saranda."
Fig. 90: Dothan, *Hammath Tiberias*, Pls. 10-11
Fig. 123: Dothan, *Hammath Tiberias*, Pl. 13.

Courtesy of the Archives of the Institute of Archaeology, Hebrew University of
 Jerusalem
Figs. 1, 2, 3, 4, 7, 8, 9, 11, 12/3, 13/3-4, 14, 15, 16, 18, 19 (photos by Gabi Laron), 20,
 21, 23, 24/1-4, 25, 26, 27, 28, 31, 32, 33, 35/2, 36/1, 37, 40, 41, 42, 43, 44/2, 45, 46,
 47, 48, 49, 50, 51, 52, 53, 54, 55, 56, 57, 58, 61/2-4, 62, 63, 64, 67, 68, 72, 76, 77, 78,
 79/2, 80, 81, 82, 87, 88, 89, 91, 96, 97, 98, 99, 101, 103, 104, 105, 106, 107, 109, 110,
 111, 112, 114, 116, 117, 118, 119, 120, 121, 122, 124, 125, 126, 127, 128

Courtesy of L. Levine
Fig. 65: Levine, *Rabbinic Class*, 50

SOURCE INDEX

SUBJECT INDEX

Page numbers in **bold** refer to extensive discussions in the text.

Philostratus, 86

Phocaea (Asia Minor), 388

Phoenicia/Phoenician, influence of, 17, 24, 28, 42, 123

Phrygia. *See* Laodicea

Phrygian, Phrygianism, 70, 317, 349

Pinḥas HaCohen of Kafra, 278

Pirqei Avot (Ethics of the Fathers), 88

Pirqoi ben Baboi, 405

pithoi, drawings on, 17–18

piyyut, 107, 186, 191, 208, 215–16, 269, 274, 277, 278, 284, 287, 292, 293, 321, 327, 328, 348, 357, 362, 365, 367, 368, 370, 373, 379–80, 381, 383, 384, 393, 420, 436, 459, 463

Plotinus, 344

Plovdiv, 235, 236

Pompey, 34, 45

Pontius Pilate, 49

portico, 46, 296, 297, 412

Poseidon, 61

presbyter, 91, 211, 301, 389, 444

Priene, 1, 235, 355

priestly courses, 190–91, 274–75, 278–357, 425

priests, priestly, priesthood, 25, 30, 32, 35, 36, 39, 40, 42, 45, 53, 55, 56, 59, 61, 76, 78, 90, 91, 106, 116, 158, 168–69, 185, 191, 214, 234, 248, 252, 253, 255, 258, 269–77, 278–79, 286, 301, 310, 327, 328, 338, 339, 357, 360, 362, 366, 369, 399, 415, 425, 432, 440

Priscilla, catacomb, 142

Proclus (archibishop of Constantinople), 181

Proclus (Neoplatonist philosopher), 250

Proklos, 447

proseuche (Egyptian), 354

Pseudo-Clementines, 197–98

Ptolemies, Ptolemaic Empire, 34–36

Pumbedita, 372

Qaṣr al-Abd, 36–37

Qatzion, 84

Qidron Valley, 42–43, 47

Qiryat Sefer, 213, 354

Quartodecimans, 188, 196, 255

Queen Helena of Adiabene, 47, 117

Qumran, 217, 218, 272, 322, 348, 371, 415

R. ʿAqiva, 130, 406, 429, 450

R. Abbahu, 219, 412, 426–27

R. Abun, 229, 427, 428, 434

R. Aḥa, 426, 433

R. Ami, 426

R. Aniana (R. Ḥanina b. Ḥama), 132, 133, 390, 433

R. Elazar, 139

R. Eliʿezer ha-Qappar, 434, 437

R. Gamaliel b. Aniana, 132

R. Gamaliel b. Nehemiah, 132

R. Gamaliel b. R. Eliezer, 132

R. Gamaliel II, 11, 61, 88, 130–31, 133, 138, 246, 406, 407, 408, 416, 445, 447–50, 451, 454

R. Gamaliel III, 447

R. Gamaliel V, 446

R. Gamaliel VI, 246, 445, 446, 454

R. Ḥama bar Ḥanina, 212, 389

R. Ḥanina b. Ḥama. *See* R. Aniana

R. Hillel b. Levi, 132

R. Ḥiyya bar Abba, 139, 275, 409

R. Hoshaya, 212, 389

R. Isaac, 220

R. Ishmael, 460

R. Jeremiah, 433

R. Jonathan, 132, 133

R. Joshua b. Levi, 131, 132, 133, 135, 416

R. Joshua b. R. Hillel, 132

R. Judah b. Ilai, 388

R. Judah I, 11, 81, 83–84, 85, 87–89, 120, 128–32, 133–34, 135, 136, 137, 138, 139, 167, 184, 243, 260, 275, 390, 392, 416, 443, 445, 448–49, 451–53

R. Judah II, 138, 139, 275, 409, 435, 453

R. Judah III, 138, 139, 253, 275

R. Judan b. R. Miasha, 132

R. Levi bar Ḥiyta, 392

R. Mani, 434

R. Meir, 411, 415, 471

R. Safra, 219

R. Samuel b. R. Isaac, 358, 426,432

R. Simeon b. Gamaliel, 367, 409, 411, 420, 445, 450–51

R. Simeon b. Laqish (Resh Laqish), 390, 408, 409, 433, 453

R. Simeon of Tarbanat, 390, 433

R. Yoḥanan (third century), 235, 243, 276, 408–9, 415, 427, 428, 432

R. Yoḥanan b. Nuri, 119

R. Yonah, 426

R. Yose b. Zimri, 415

R. Yosi, 254–55, 392, 426

R. Yosi b. Ḥanina, 450

R. Zeʿira, 275, 424, 450

Rabbanites, 356

rabbi (title), 135–36

rabbis, influence on synagogue art, 108, 365, 370–73, 404–5, 421, 428–38; on other communal settings, 439–42

Rabbula (bishop of Edessa), 198

Ramat Rachel, 15

Rav, 228, 426, 427, 433

Torah shrine, 60, 73, 76, 82, 96, 99, 102, 103, 104, 105, 112, 115, 116, 118, 126, 146, 148, 153, 154, 169, 190, 227, 228, 235, 237, 240, 245, 266, 267, 280, 284, 285, 286, 292, 300, 302, 317, 331, 338, 339, 340, 349, 350, 356, 362, 364, 365, 366, 367, 402, 462, 463
Tours (France), 181
Tower of Babel, 173
Trachonitis, 49, 52, 117, 390
Trajan, 62, 97, 305
Trastevere, 159
triclinium, 55, 195, 323, 324, 325, 452
triglyph, 42
trumpet, 60, 127, 265, 266, 270, 273, 278, 325, 340, 362
Tyche, 61–62, 323, 409, 417
Tyre, 49, 51, 87, 126, 359, 442
Tyrian shekel, 62, 396

Ulpian of Tyre, 87
Umm al-Rasas, 172
Umm el-Qanatir, 227
urban aristocracy/elite, 11, 62, 63, 81, 91, 130, 135, 137–38, 246–47, 258–59, 329, 446–47, 453–55
Usha, 129

Valens (Arian emperor), 376, 444
Valentinian I, 355
Venusia (Venosa), 141, 156, 182, 196
Vespasian, 70
Via Appia, 91, 142, 144, 159, 349
Via Latina, 149, 174, 284, 344
Via Torlonia, catacomb, 144, 145, 148, 153, 156, 157, 159
Victor (first bishop of Rome), 143, 159–60
Vigna Randanini, catacomb, 93, 144, 145, 146, 147, 148–49, 150, 153, 155, 156, 157, 349

wall paintings, 4, 341; catacombs, 96, 125, 145, 147, 155, 161; Christian buildings, 346; domestic, 53; synagogues, 73, 76, 101–17, 239, 352, 363, 364–65, 371, 375, 380, 421; tombs, 46. *See also* Dura Europos
Watzinger, Carl, 1, 396
wine, 58, 152, 227, 360; gentile 36–37
workshops, 76, 93, 112, 117, 126, 162, 165, 230

Yahweh, 17, 18–19, 22–23, 25–26, 28–30, 32–33
Yannai (*paytan*), 216, 269, 278, 292, 380
Yavneh, 129, 130
Yeda'yah (priestly course), 274–75
Yehud, 34; coins, 32–34, 35, 44, 58, 62; inscription, 33, 35
Yemen, 201, 274, 414
Yerushalmi, 87, 203, 208, 348, 432, 458
Yoav, 439
Yohanan HaCohen b. Joshua HaCohen, 278
Yom Kippur, 196, 199, 269, 278, 340, 341, 370
Yose b. Yose, 278

Zaghouan (Tunisia), 324–25
Zechariah, 34, 365
Zechariah's Tomb, 42, 46
Zenodorus, 52
Zerubbabel, 34, 366
Zeus, 33, 61, 62, 73, 76, 128, 227, 249, 250
zodiac, 5, 6, 10, 28, 78, 101, 150, 191, 217, 227, 229, 232, 233, 245, 246, 247, 250, 253, 256–59, 261, 263–64, 265, 267, 268, 271, 272, 273, 284, 286, 287, 292, **319–36**, 350, 352, 360, 367, 369, 384, 395, 396, 398, 401, 402, 409, 411, 418, 445, 454, 462, 464, 470, 473. *See also* Helios; Sol, Sol Invictus